CYCLOPEDIA
ANATOMICAE

CYCLOPEDIA ANATOMICAE

More than 1,500 Illustrations of the Human and Animal Figure for the Artist

BY GYÖRGY FEHÉR

•

ILLUSTRATED BY
ANDRÁS SZUNYOGHY

BLACK DOG
& LEVENTHAL
PUBLISHERS

Published by
BLACK DOG & LEVENTHAL PUBLISHERS, INC.
151 West 19th Street
New York, NY 10011

Distributed by
WORKMAN PUBLISHING COMPANY
708 Broadway
New York, NY 10003

Printed and bound in Spain by Artes Gráficas Toledo S.A.U.
D.L. TO: 1739-2000

ISBN: 1-884822-87-8

h g f e d c b

CONTENTS

INTRODUCTION 7

DRAWING SCHOOL 13
 PORTRAIT DRAWING 14
 FIGURE DRAWING 22
 MOVEMENT STUDIES 32
 DRAPERY STUDIES 42

HUMAN ANATOMY 47
 THE BONES, JOINTS AND MUSCLES 48
 THE BONES AND JOINTS OF THE UPPER LIMBS 60
 THE MOVEMENT OF THE UPPER LIMBS 80
 THE MUSCLES OF THE UPPER LIMBS 94
 THE BONES AND JOINTS OF THE LOWER LIMBS 110
 THE MUSCLES OF THE LOWER LIMBS 128
 THE BONES OF THE TRUNK 144
 THE MUSCLES OF THE TRUNK 166
 THE BONES AND MUSCLES OF THE HEAD 180
 THE EYE 196
 THE MOUTH 198
 THE NOSE 202
 THE EAR 204

ANIMAL ANATOMY 207
 THE HORSE 209
 THE DOG 327
 THE CAT 359
 THE PIG 377
 THE APE 395
 THE SHEEP 413
 THE BEAR 435
 THE DEER 445
 THE COW 459
 THE CAMEL 495
 THE LION 503

COMPARATIVE ANATOMY 521

MUSCLE CHART 587

INTRODUCTION

Painting living subjects, and drawing compositions and sketches of them, requires an exact knowledge of anatomy – the shape and structure of living organisms – and of the basic principles of morphology (the study of form).

Anatomy is an applied science which underpins fine art; the study of structure is essential for artistic representation. The skeleton, joints and muscular system of a creature determine its proportions and the movements of its body. Sensory organs such as the eyes, nose, ears and mouth, and surface structures such as the skin, fur and claws give every animal its individual character.

Any artist representing a living creature first establishes the outline of the skeleton to give a framework to the composition. Then the muscles are added to form the basic shape which is characteristic of the particular species. Finally, the shape is covered with skin, allowing the artist to depict individuality and a chosen facial expression.

All the greatest artists – Michelangelo, Leonardo da Vinci, Raphael, Titian, Dürer – felt it necessary to study anatomy, since anatomical and biological knowledge are vital in choosing models, finding the most appropriate pose, determining the composition and adding fine detail to the picture. This knowledge also extends the artist's faculty of observation, while enhancing artistic vision and developing the sense of form.

This book offers practical help in acquiring the necessary knowledge by illustrating the anatomy of the human body and that of a few animals, and by making some comparisons between them. The representation of human beings and animals has a number of similarities, but there are also functional and morphological differences.

In order to make this book easier to use, a brief summary of the basic concepts needed by the artist is included below. As it is also vital to have a clear knowledge of the bones comprising the skeleton, along with the muscles and joints, there is a more detailed description of these structures and the corresponding organ systems.

ONTOGENESIS

This process is the origin and development of an individual creature, beginning with conception and ending with death. The different speed of development of different organs results in changes in the proportion of various body parts. For example, the early rapid development of the nervous system means that the eyes and head of a newborn human baby are large, whilst the trunk and limbs are short. After birth the limb bones develop, becoming first longer and then thicker. The number of muscle fibres is fixed but their length and thickness – and their final shape – evolve in parallel with the bones. Finally, the sexual organs assume their final shape and size after puberty, towards the end of the growing period.

The basic position of any mature living organism is taken to be when it is standing still; changes in the proportion of the body parts are related to this.

ANATOMICAL TERMS

Bilateral Symmetry. Certain body parts on the right and left side of the midline (effectively the spine) exhibit bilateral symmetry, i.e. they are reflections of each other and may be called antimers.

Metamerism. In some vertebrates metamers can be observed, i.e. similar structures located one behind the other along the body.

Proportionality. This is the dimensional relationship of the different body parts and of the tissues, bone and skin to each other. It is determined by the species, sexual character and the actual stage of development of the body.

Condition. This refers to the physical fitness of an animal, which in turn greatly depends on its standard of nutrition. Any animal that is in good condition is well fed, with a subtly rounded figure. One that is pathologically overweight, or obese, has an excess of fatty tissue all over the body.

Sexual Character. Male and female characteristics manifest themselves in two different ways. Firstly, there are differences in sexual glands and organs, and in their location and development. Secondly, there are differences in physiology and behaviour.

Constitution. This is a complex feature of the individual. It incorporates physical characteristics such as the thickness of bones, which can give rise to either a delicate or robust frame, and also qualities such as temperament, stamina and adaptability.

BONE

Bone is a creamy-white, relatively elastic tissue which consists of bone cells and intercellular substance. Thirty per cent of the latter is elastic connective tissue in the form of collagen, and the rest is hard inorganic material (calcium phosphate, calcium carbonate and magnesium phosphate).

Individual bones have a hard outer layer or cortex of compact bone, and an internal lattice-work of spongy or cancellous bone where the bone marrow is found. Marrow is important in the production of red blood cells and may be of two types; red marrow is highly cellular, while yellow marrow contains a higher proportion of fat.

TISSUES ASSOCIATED WITH BONE

Cartilage. Cartilage is a solid, highly elastic tissue. In the newborn, most of the skeleton is made up of cartilage, which is gradually converted to bone as the individual grows. Two of the most important sites of cartilage in the adult are at the ends of the ribs (the costal cartilages) and covering the ends of the limb bones.

Periosteum. The periosteum is a thin membrane which covers the surface of bone. It has a rich supply of nerves and blood vessels, and is responsible for the nutrition and maintenance of the bone beneath.

MUSCLE

The movement of any creature is achieved using its muscles, organs which are capable of conducting an electrical impulse and contracting in response to stimuli. They make up the "flesh" of the animal. Normally, some 200–250 muscles account for 36–45% of body mass. Most are arranged in opposed pairs so that, for example, one muscle bends the elbow whilst its partner straightens it. In addition to being active organs of movement, muscles control the position of joints, partially support the weight of the animal, protect its internal organs, maintain a state of equilibrium and determine the shape, size and contours of its body.

Under the microscope, voluntary muscles (i.e. those over which the animal has conscious control) can be seen to be made of striated fibres. These are long filamentous cells with very many nuclei and bundles of

myofibrils, which contain actin and myosin – the compounds responsible for contraction. Muscle fibres are attached to the skeleton by tendinous fibres in the form of tendons, tendinous sheets or septa.

Muscles are generally covered by a sheet of fibrous connective tissue, or fascia. In some regions of the body, muscle groups are attached to the skeleton by the deep fascia. The entire surface of the body is covered by a double layer of superficial fascia; between the two layers are thick muscle sheets, known as the cutaneous muscles in horses and ruminants. The skin can be raised from the superficial fascia and folded into wrinkles.

TISSUES AND STRUCTURES ASSOCIATED WITH MUSCLES

Tendon. A tendon is a thick, shiny, flat or cylindrical cord which forms the continuation of a muscle and is attached to bone.

Tendinous Septum. Tendinous septa are found within muscles and divide them into sections. The muscle fibres are attached to them at an acute angle, an arrangement known as pennation.

Ligament. A ligament is a white, elastic fibrous bundle which attaches one bone to another.

Joint. A joint or articulation is a connection between different parts of the skeleton, and it may be either fixed or movable. In the case of a movable joint, the ends of the bones are covered in cartilage and the joint is enclosed in a fibrous, thick-walled joint capsule. This contains synovial fluid which acts as a lubricant and allows smooth movement of the joint.

THE LOCATION OF ORGANS

The position of individual organs in the body is described by a number of technical terms. For this purpose the body is divided by several imaginary planes. The *median plane* divides the body into symmetrical right and left halves. *Sagittal planes* are parallel to the median plane and to the left or right of it. They allow structures to be classified as *medial* (closer to the midline) or *lateral* (further from the midline). At right angles to the median plane along the longitudinal axis of the body is the *frontal plane* (or *horizontal plane* in animals). This allows structures to be classified as *dorsal* (towards the back) or *ventral* (towards the belly). A *transverse plane* is any plane at right angles to the longitudinal axis of the body, which it divides into a front or *cranial* section and a rear or *caudal* section. In a human figure standing upright, all transverse planes are horizontal.

When referring to limbs, the terms *proximal* (towards the body) or *distal* (away from the body) are used. Organs on the front or anterior surface of the limbs have a *dorsal* location, whilst those on the posterior or caudal surface are *palmar* in the case of the forelimb and *plantar* in the case of the hind limb. Where animals have a number of toes, i.e. are polydactyl, the digital surface towards the axis of the limb is *axial* and the opposite surface *abaxial*.

Structures on the head of an animal may be *rostral* (towards the nose) or *caudal* (towards the tail). Organs which lie near to the surface of the body are described as being *superficial*, in order to distinguish them from others which lie *deep*. Finally, the term *external* is used to refer to structures outside an area, space or structure, and the term *internal* for those within.

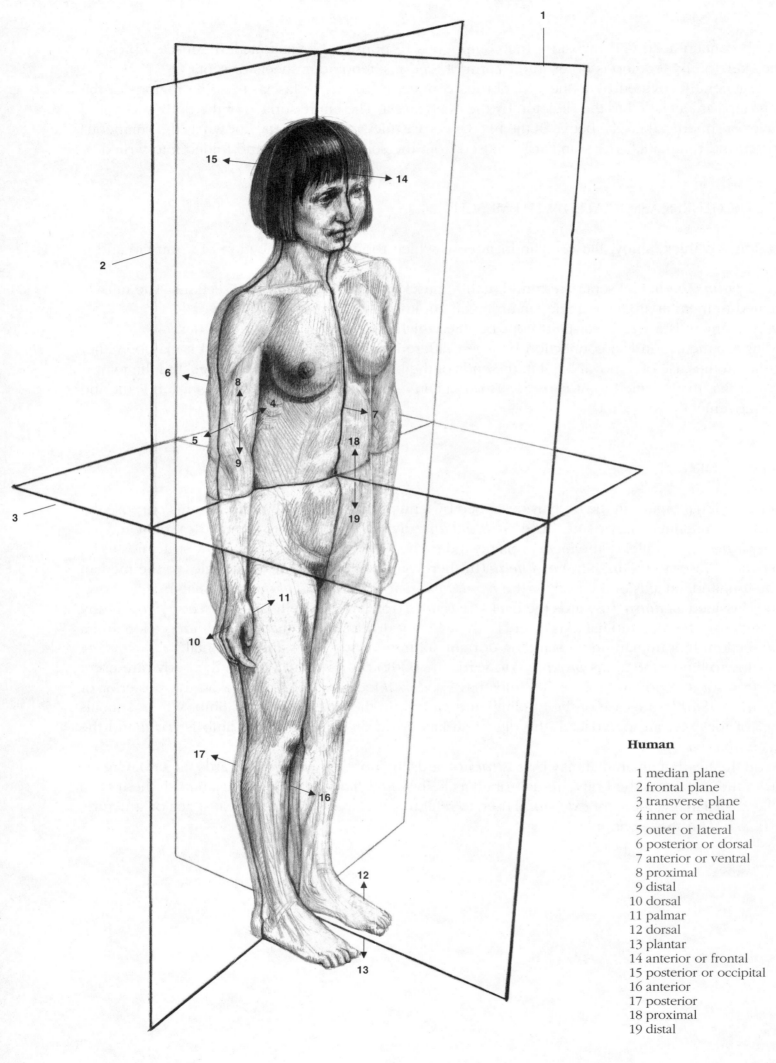

Human

1 median plane
2 frontal plane
3 transverse plane
4 inner or medial
5 outer or lateral
6 posterior or dorsal
7 anterior or ventral
8 proximal
9 distal
10 dorsal
11 palmar
12 dorsal
13 plantar
14 anterior or frontal
15 posterior or occipital
16 anterior
17 posterior
18 proximal
19 distal

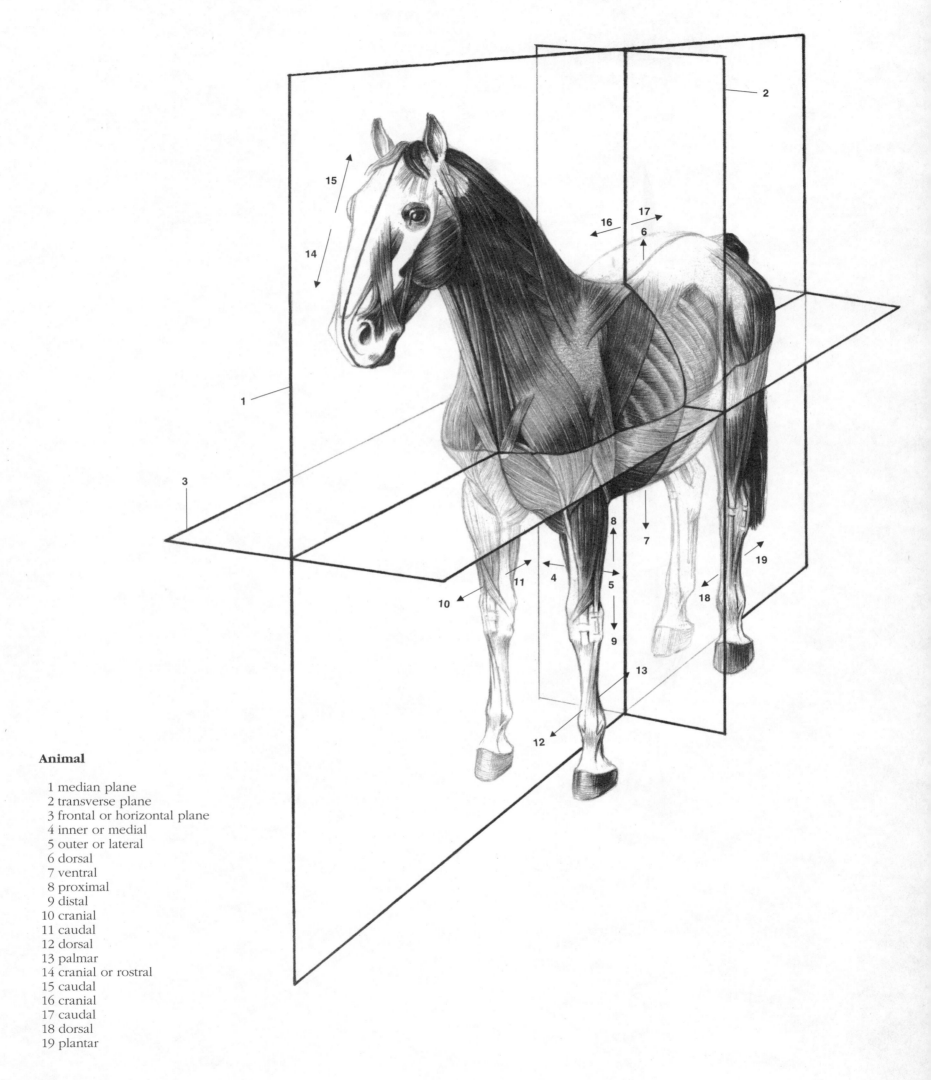

Animal

1 median plane
2 transverse plane
3 frontal or horizontal plane
4 inner or medial
5 outer or lateral
6 dorsal
7 ventral
8 proximal
9 distal
10 cranial
11 caudal
12 dorsal
13 palmar
14 cranial or rostral
15 caudal
16 cranial
17 caudal
18 dorsal
19 plantar

DRAWING SCHOOL

PORTRAIT DRAWING

A human head resembles an egg-shape.

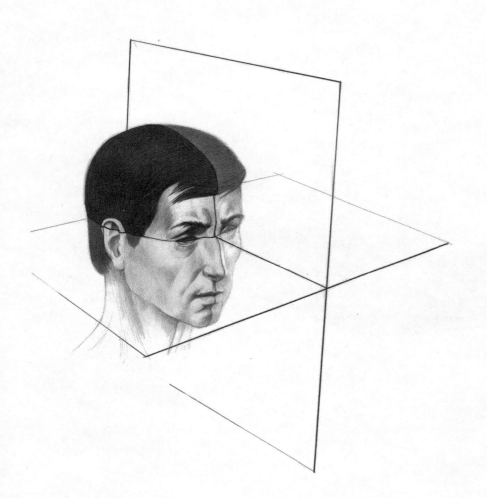

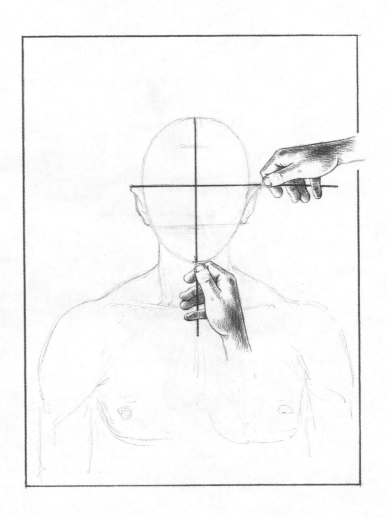

A vertical plane or axis divides the head into two nearly identical and symmetrical halves.
A horizontal plane or axis divides it into two parts which are equal in height.

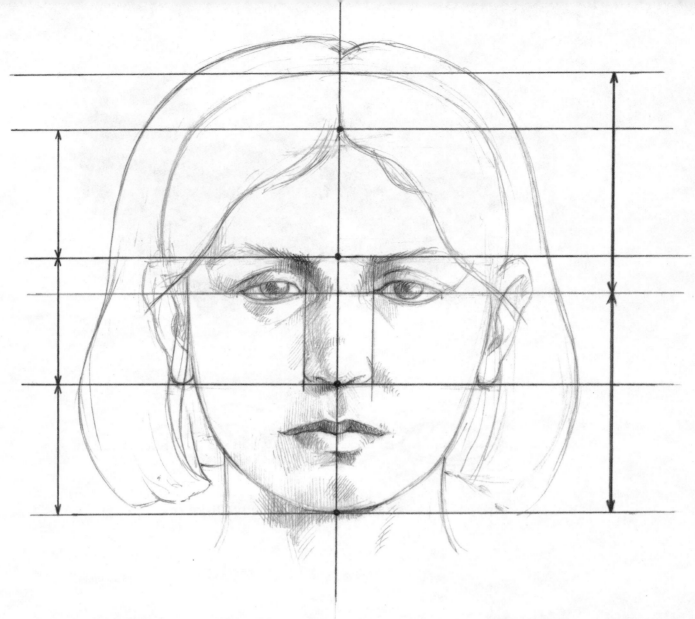

Besides the main vertical and horizontal axes the face can be divided into three regions of equal height:
the region between the border of the hair and the eyebrow
the region between the eyebrow and the tip of the nose
the region between the tip of the nose and the chin
The main horizontal axis and these regions can be indicated by horizontal parallel lines.

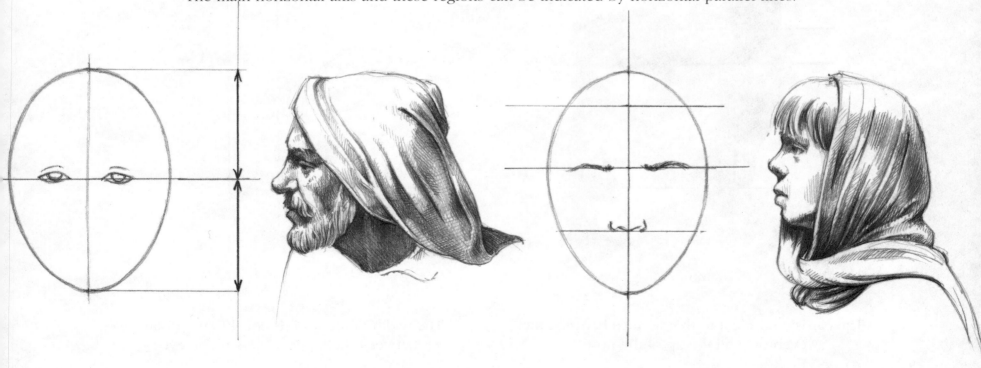

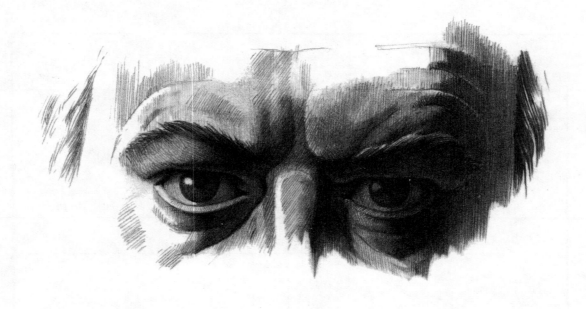

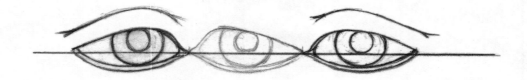

The distance between the two eyes is the width of one eye.

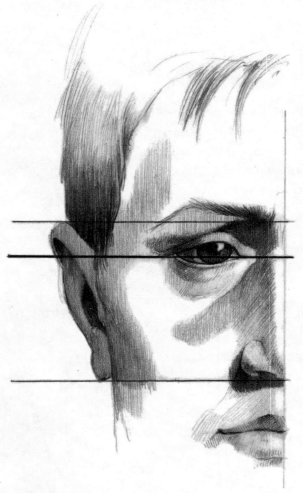

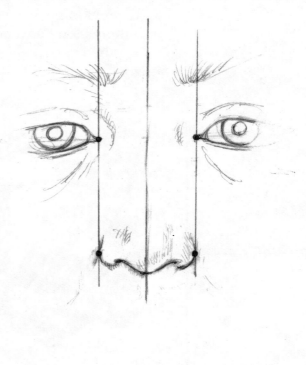

The ear is equivalent to the distance between the
eyebrow and the tip of the nose.

The width of the nose is equal to the distance
between the inner corners of the eyes.

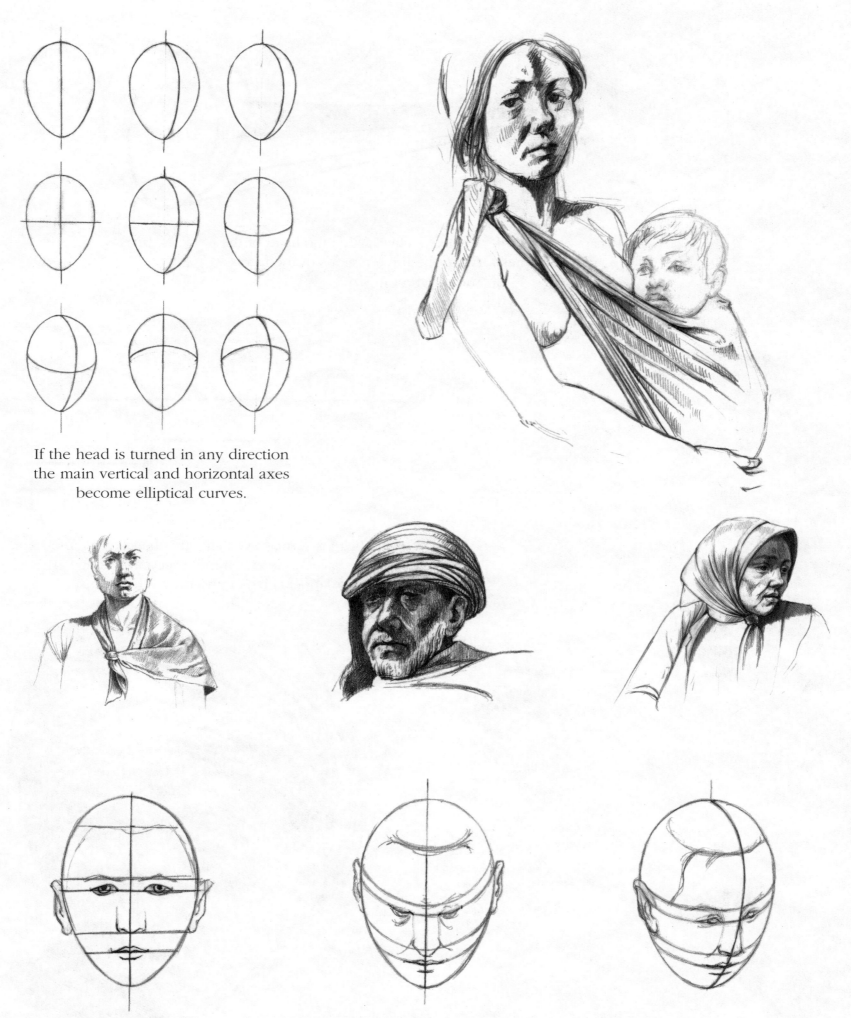

If the head is turned in any direction the main vertical and horizontal axes become elliptical curves.

If the head is turned in any direction the parallel horizontal lines become parallel elliptical curves.

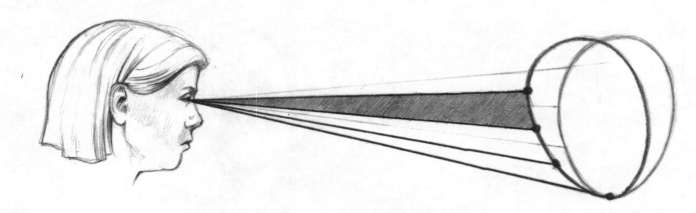

Because of the rules of perspective, when the head of the
model inclines forward the three regions of the face
appear different in size.

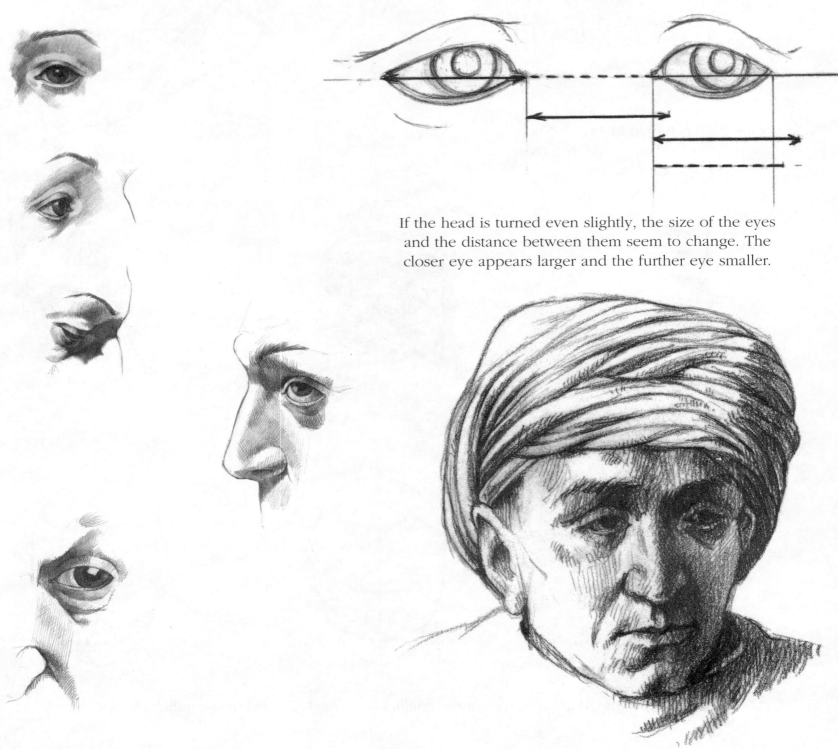

If the head is turned even slightly, the size of the eyes
and the distance between them seem to change. The
closer eye appears larger and the further eye smaller.

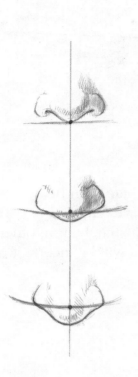

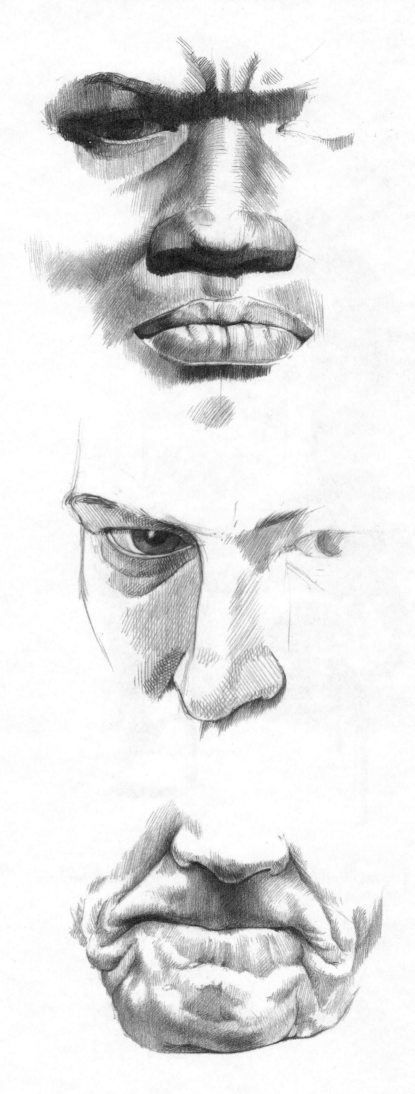

If the head is inclined forward the region between the tip of the nose and the chin appears smaller and is partly covered by the nose.

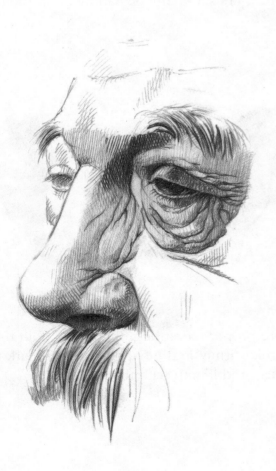

19

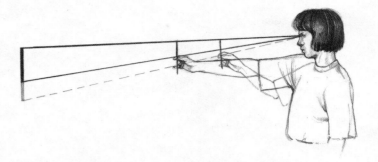

The proportions of the face can be determined with the help of a pencil or ruler. It is advisable to take measurements with a straight arm, otherwise the proportions will be incorrect.

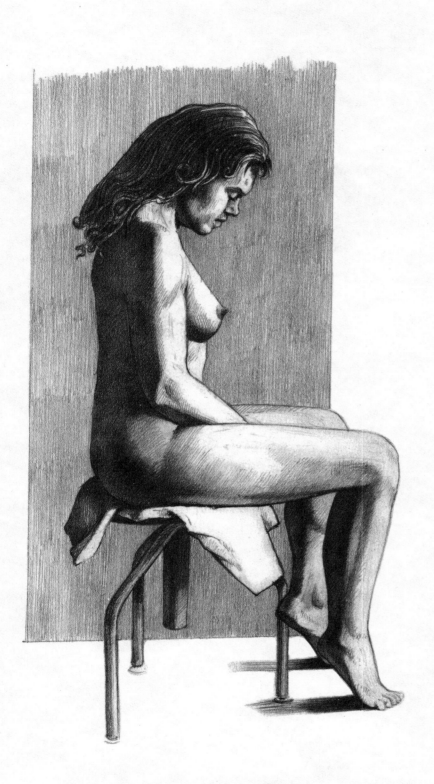

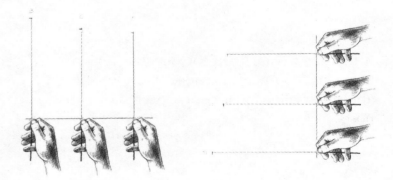

A pencil or ruler can help to determine the horizontal and vertical lines and any deviations from them.

The required distance between the model and the artist is about 1.5–2 meters (5–7 feet).

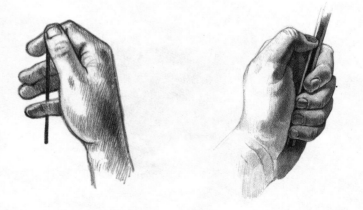

To ensure proper measuring one has to hold the pencil or ruler firmly in the hand. One can mark the measured length with the thumbnail.

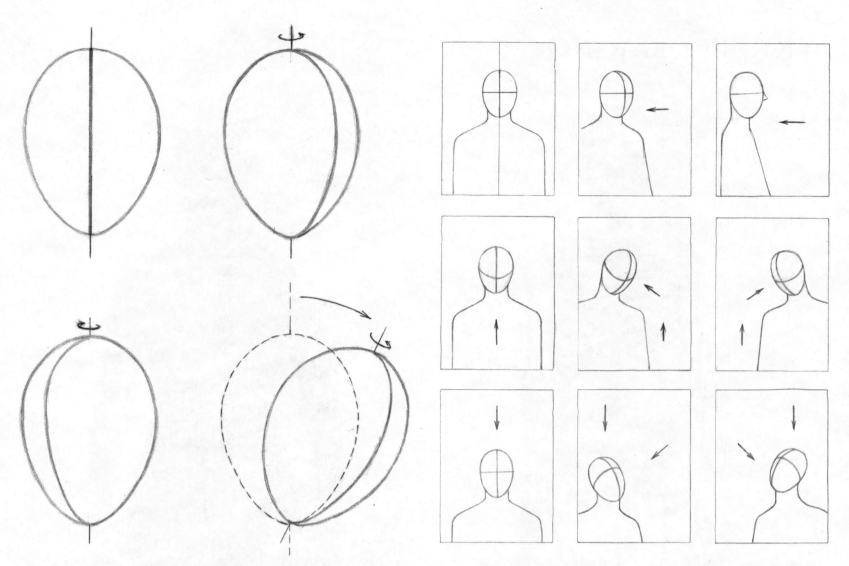

Before starting drawing it is worthwhile observing the main horizontal and vertical axes of the head carefully.

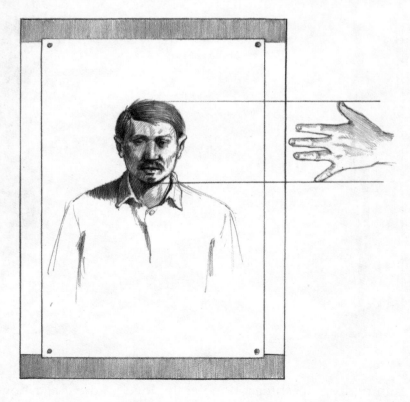

If the portrait is full face, one can ensure a pleasant image by placing the head in the middle of the sheet. If the size of the head is equivalent to one hand span, it gives the impression of being lifesize.

FIGURE DRAWING

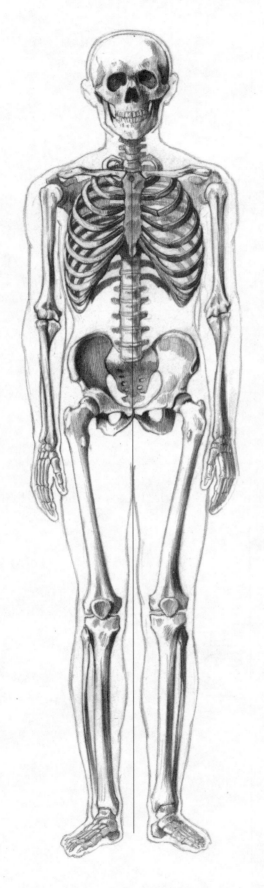
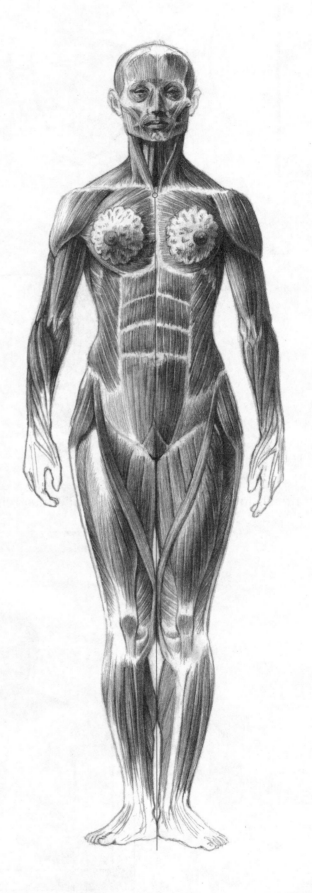

An imaginary vertical axis starting from the breast-bone at the level of the collar bones divides the human body
into two symmetrical parts.
If the model is facing the artist and stands straight, the vertical axis reaches the ground between the legs.

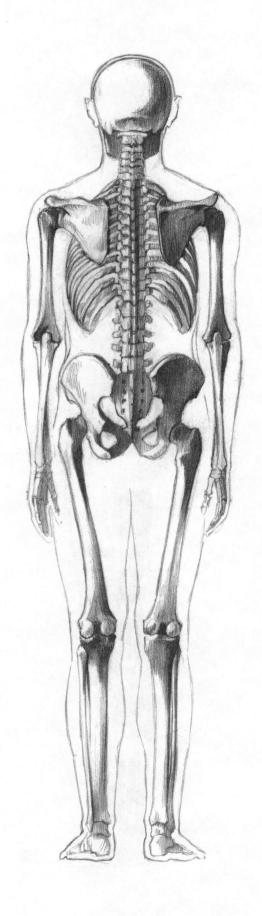
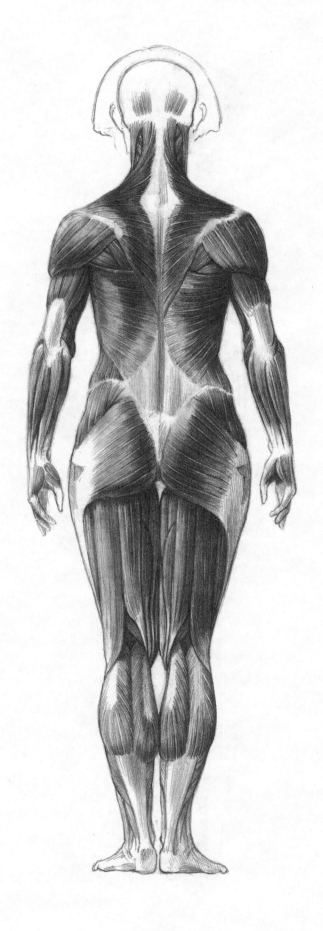

The symmetry of the bones and muscles can be observed from the rear of the human body, too.
Drawing the figure from the rear, the vertebral column can be the imaginary vertical axis.

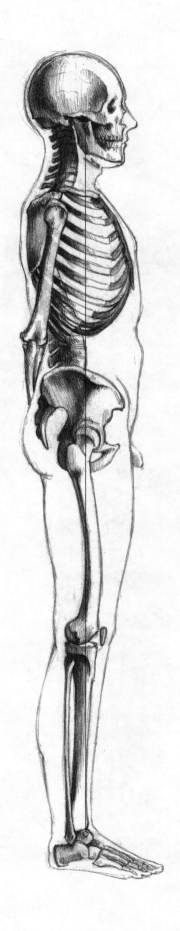
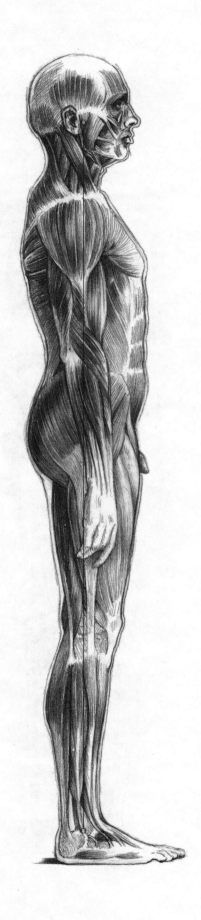

When the model is viewed in profile, an imaginary vertical line can be drawn from the ear to the navicular bone. The imaginary vertical line helps to keep the figure straight and prevents it leaning forward or backward.

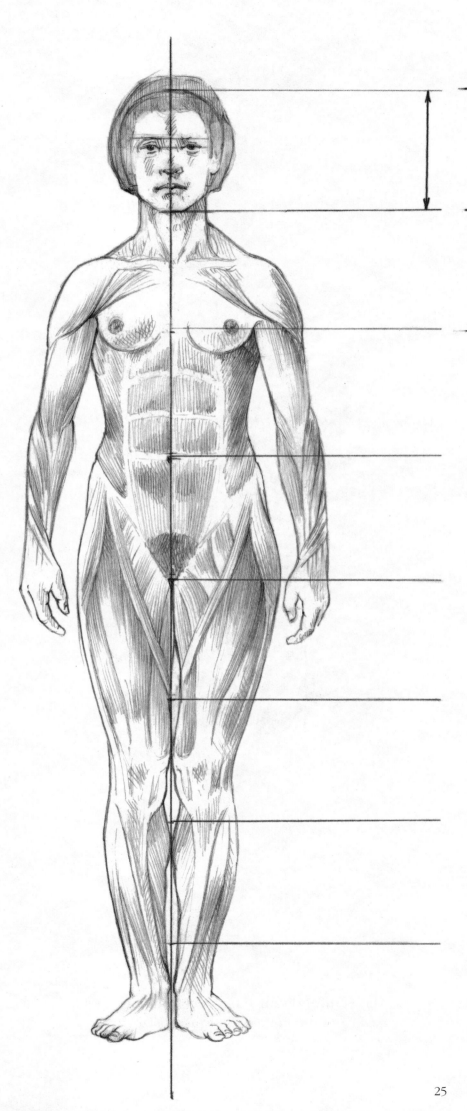

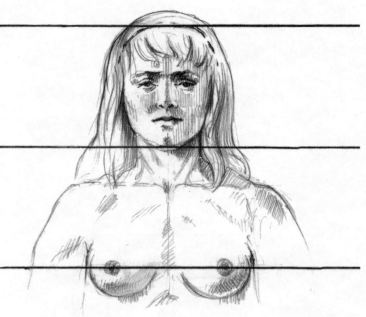

The vertical distance between the chin and the nipples is one "head-size".

The correct proportions of the human body can be determined by the size of the head. The height of the human body is 6.5–8 "head-sizes", most commonly 7.5.

As women tend to have larger heads than men, their body height is generally between 6.5 and 7.5 "head-sizes".

Half the height of the body is at the level of the pubic bone.

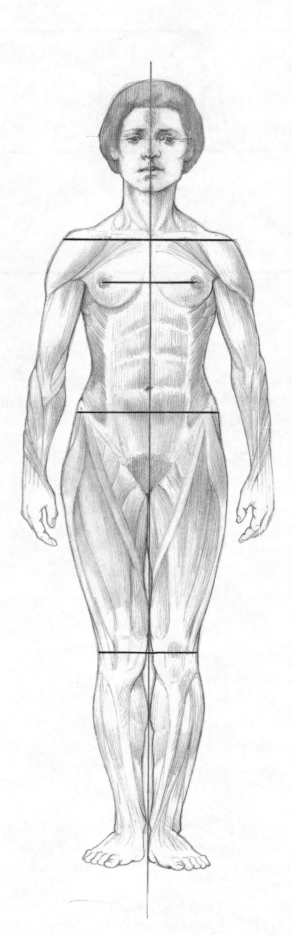

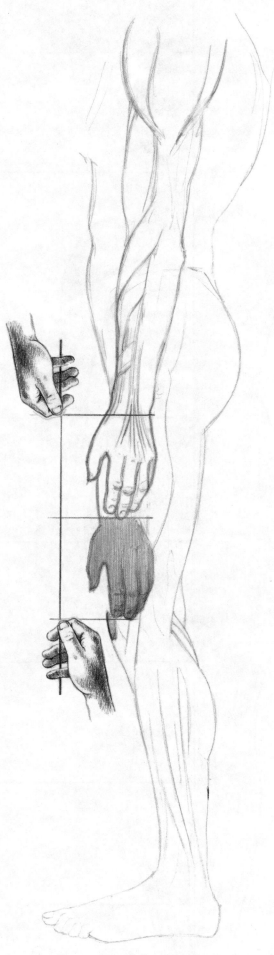

The main horizontal axes of the human body are at the level of the shoulders, the nipples, the navel and the knee.

The vertical distance between the fingertips and the knee is one "hand-size".

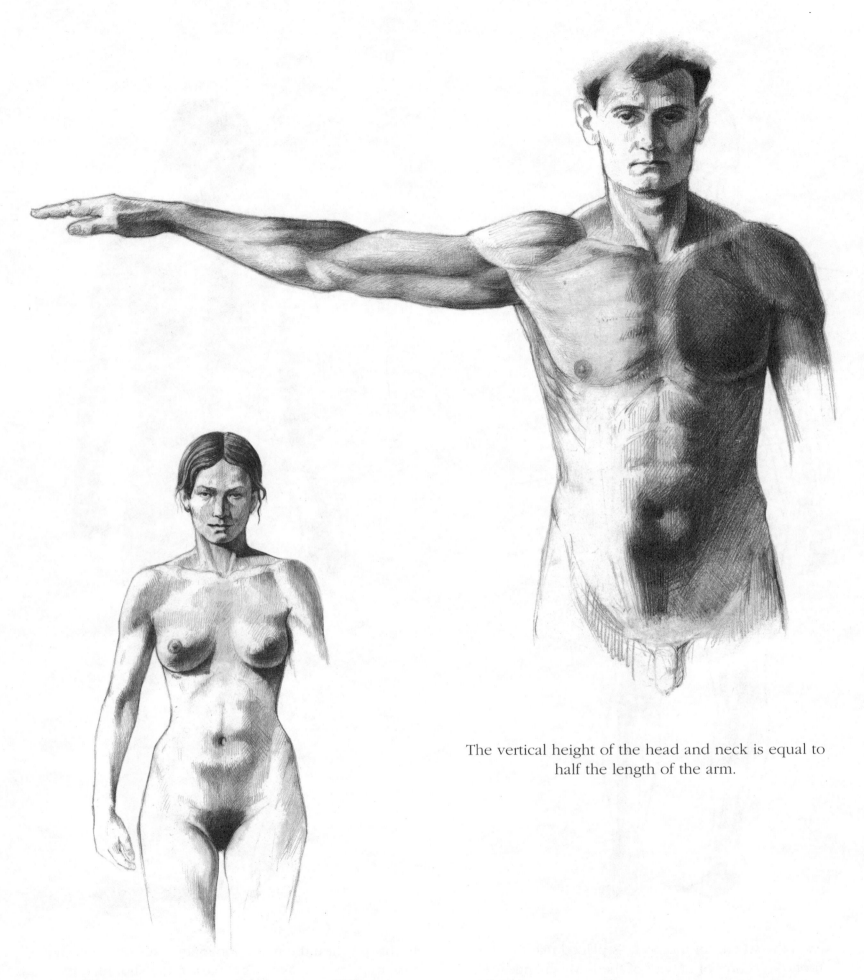

The vertical height of the head and neck is equal to
half the length of the arm.

The length of the arm can be determined by position-
ing the wrist of the straight arm at the same horizontal
level as the hip joint.

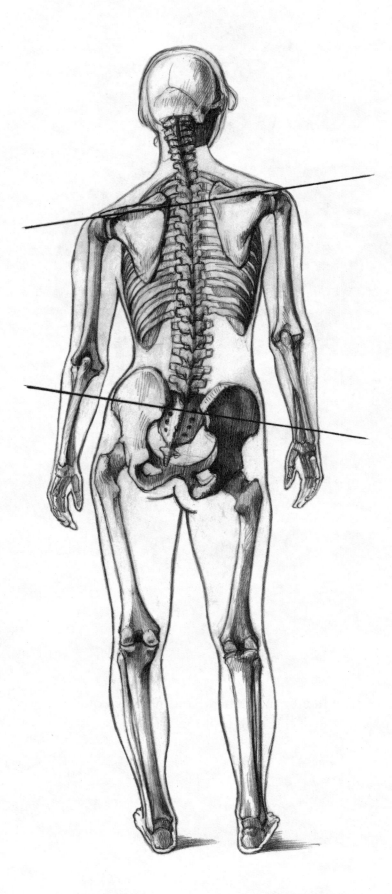

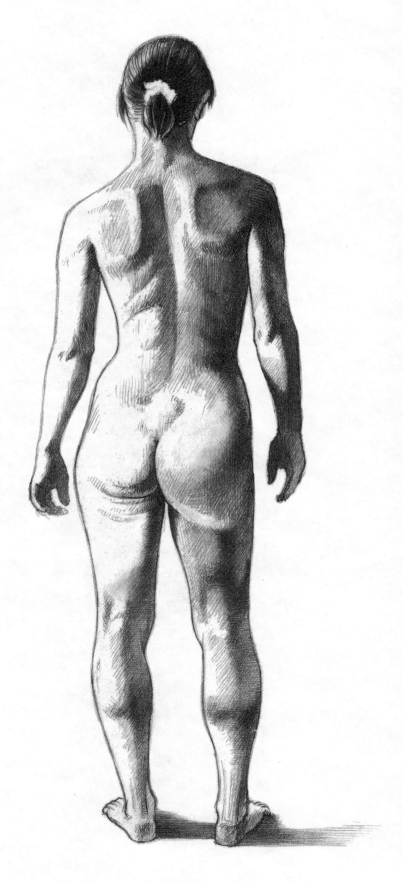

When the weight of the body is placed mainly on one foot, the centre of gravity of the body changes. The imaginary vertical axis of the body passes through the inner ankle.

In this position the main horizontal axes of the body are no longer parallel. The axes of the shoulder and breast incline in the opposite direction to the axes of the hip and knee.

The shoulder is lower and the buttock is higher on the side which bears the body weight.

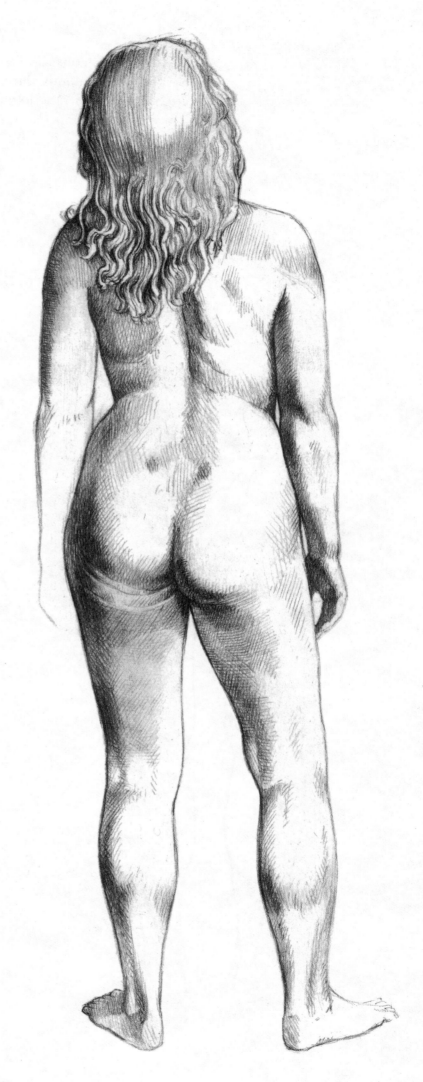

A slow walk consists of consecutive shifts of body weight. Consequently the body and hips swing to the right and then to the left. The axis of the shoulders moves in the opposite direction to that of the hip.

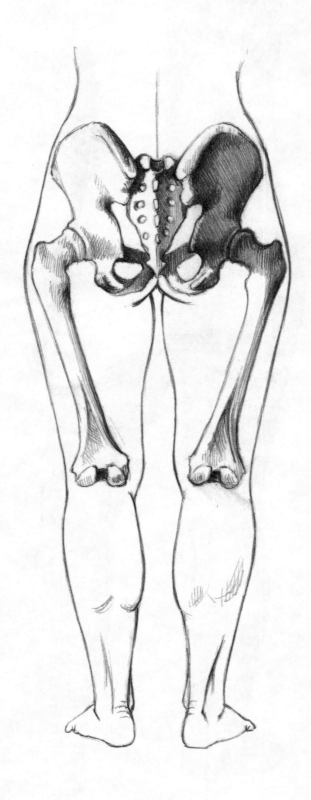

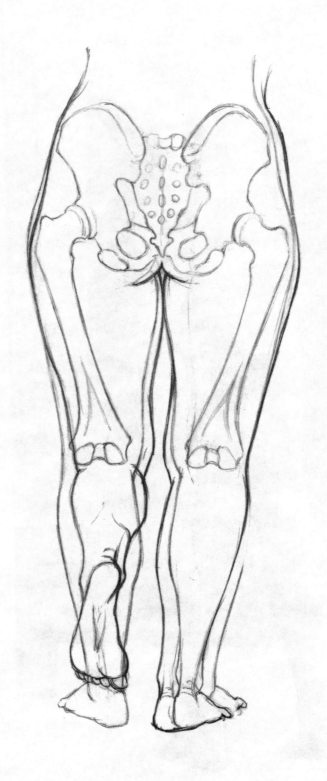

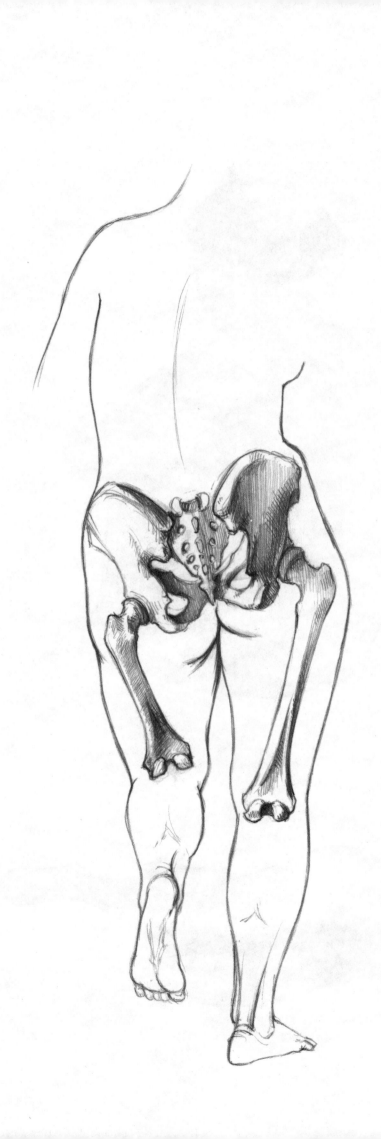

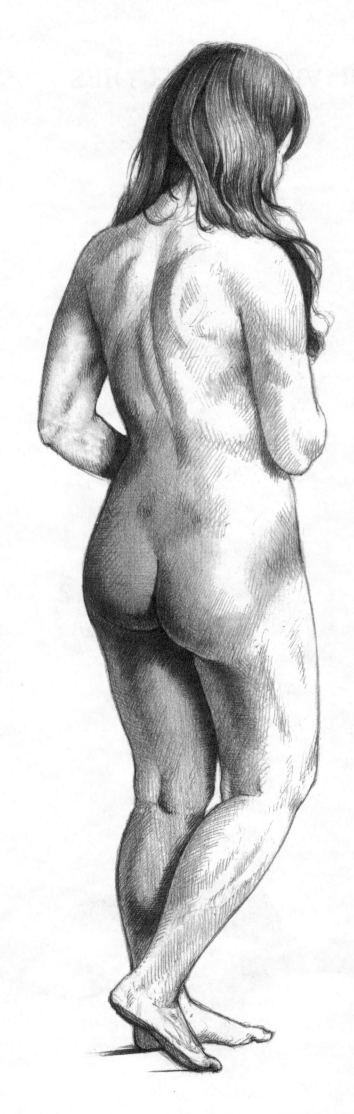

MOVEMENT STUDIES

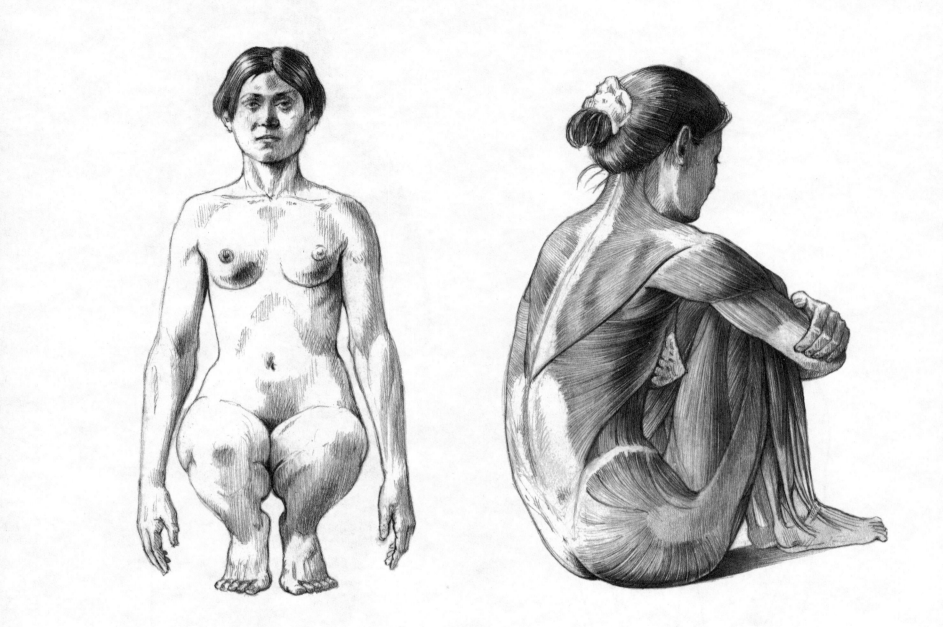

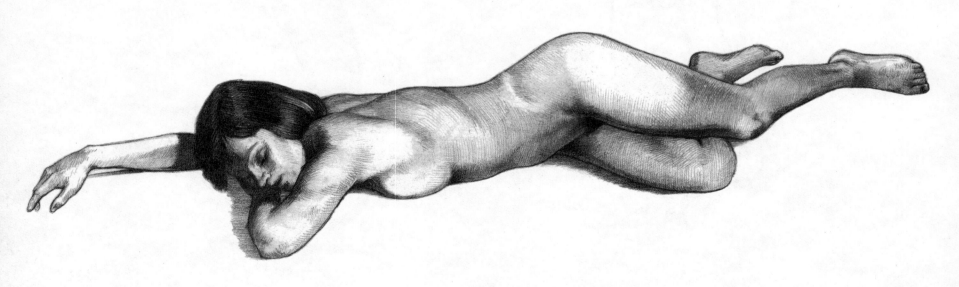

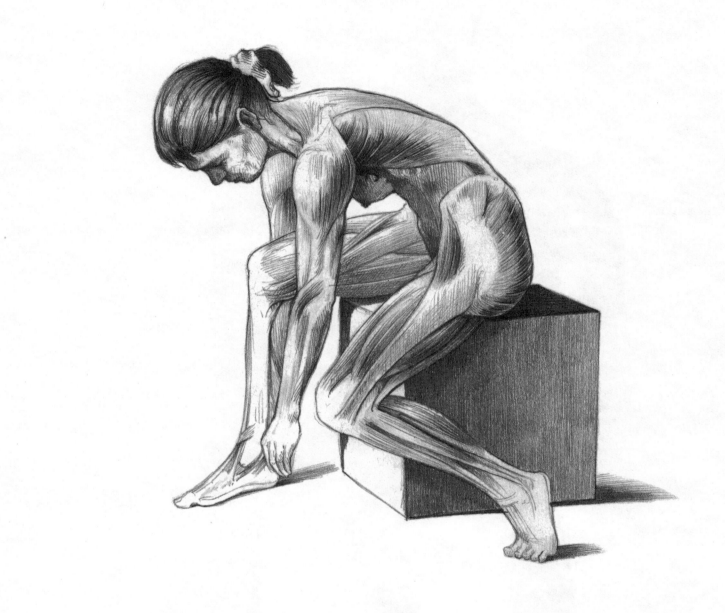

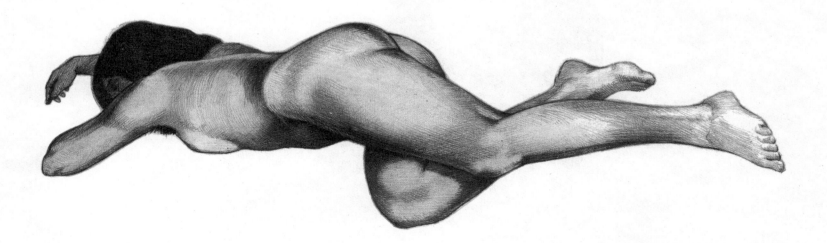

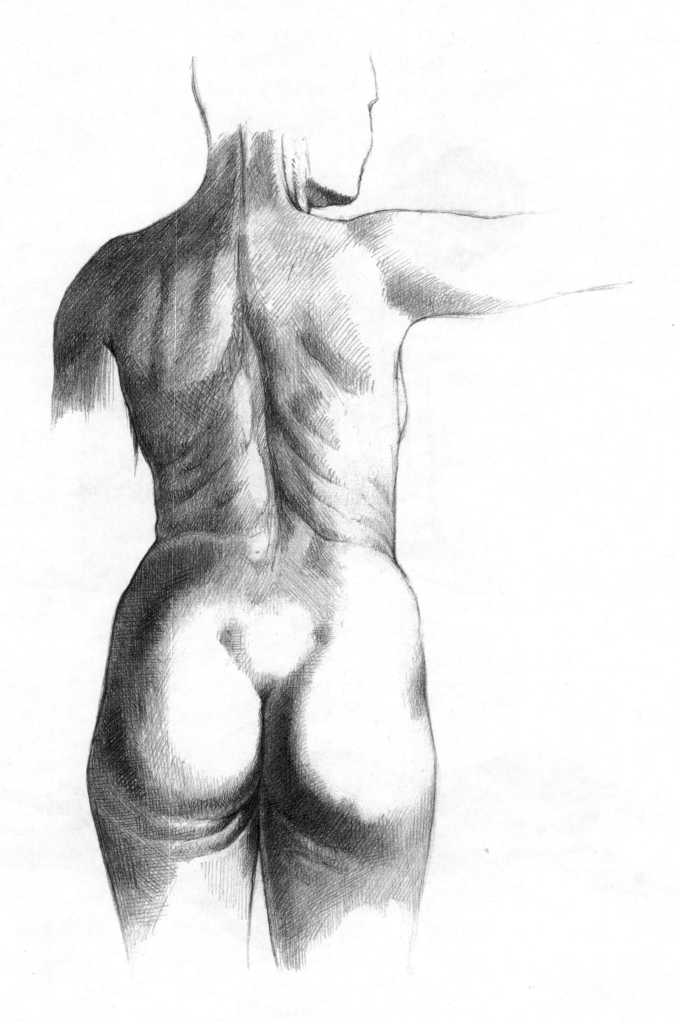

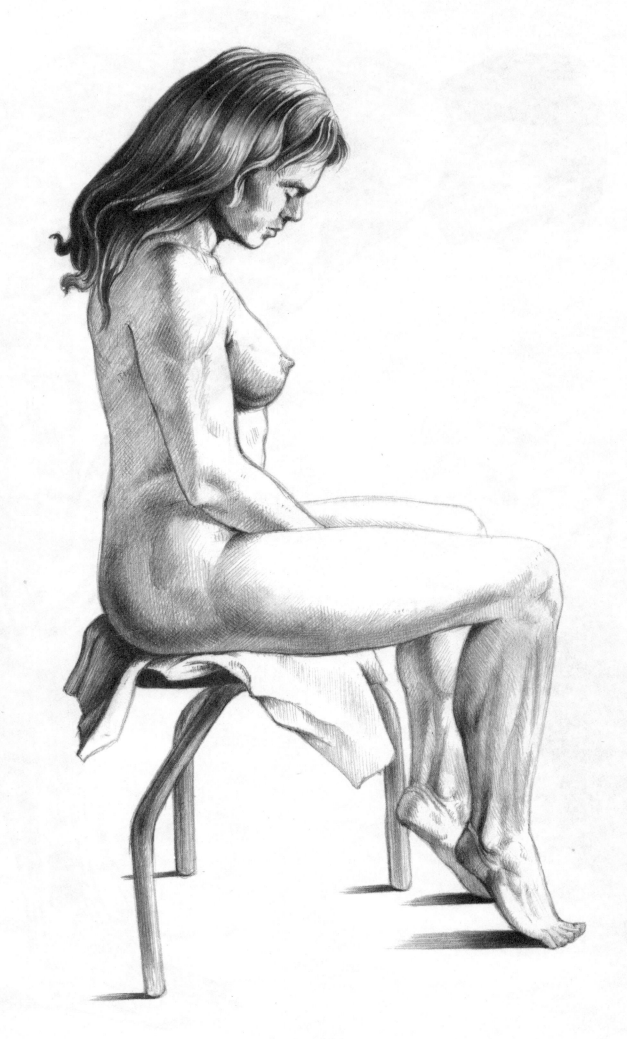

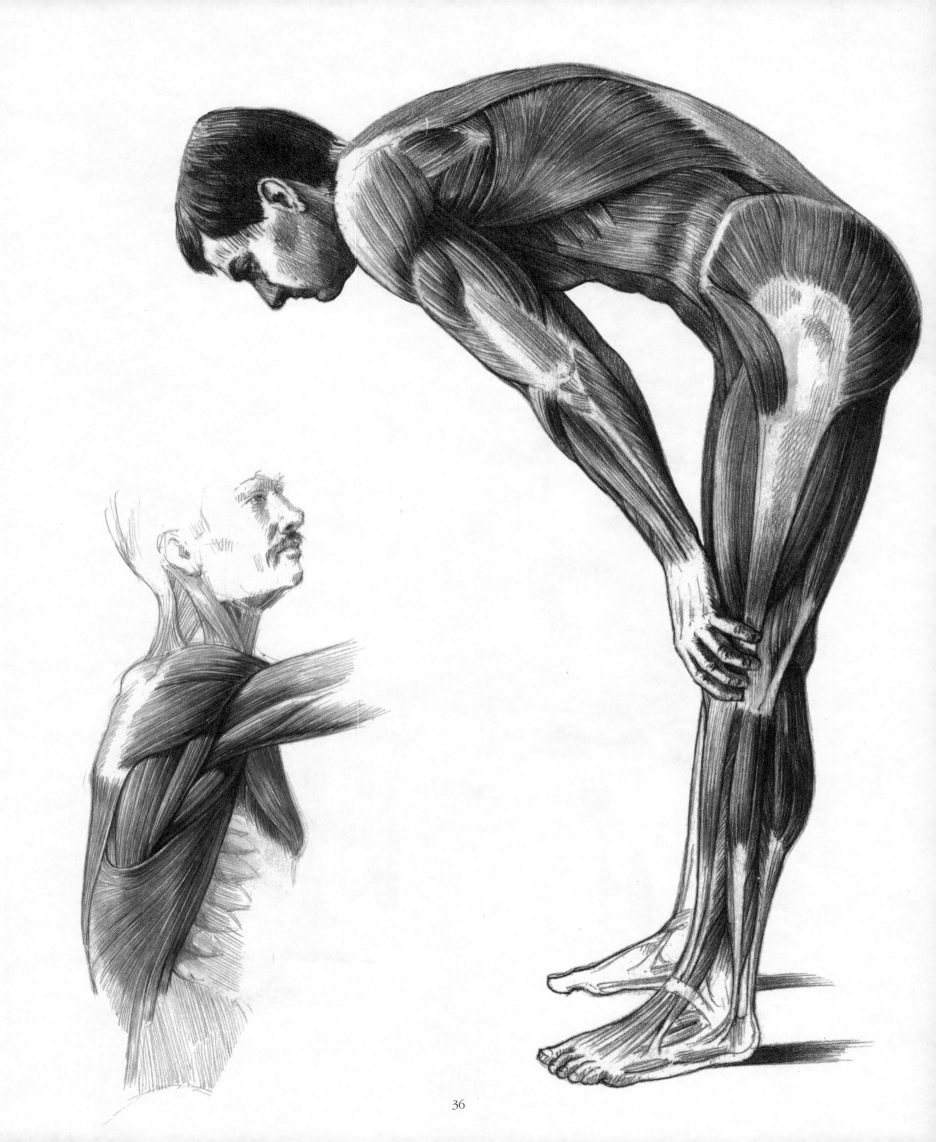

36

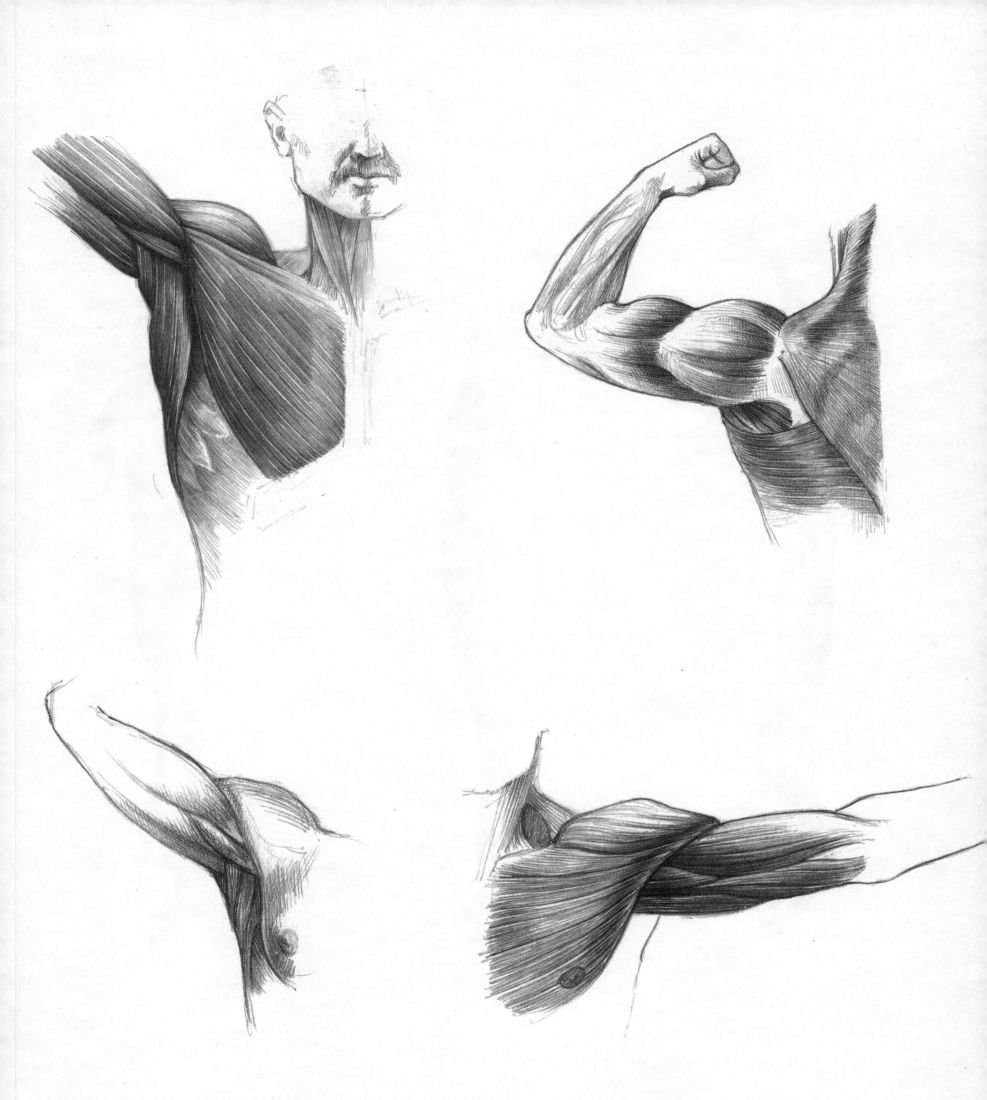

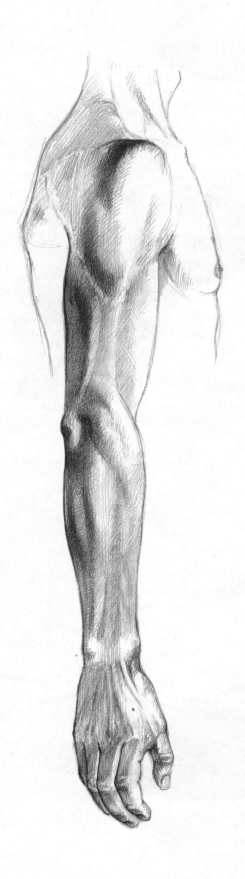
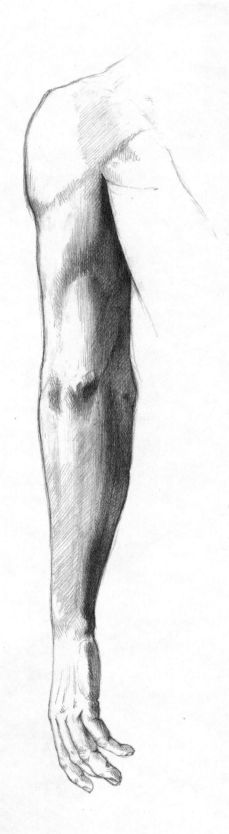
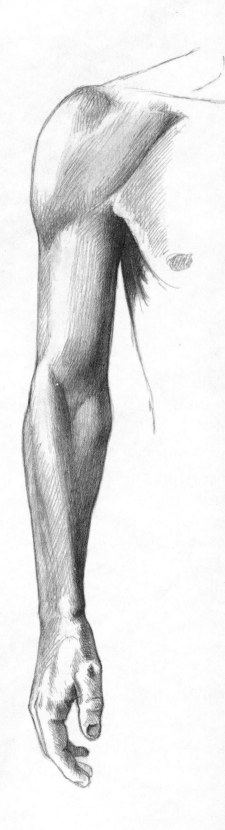

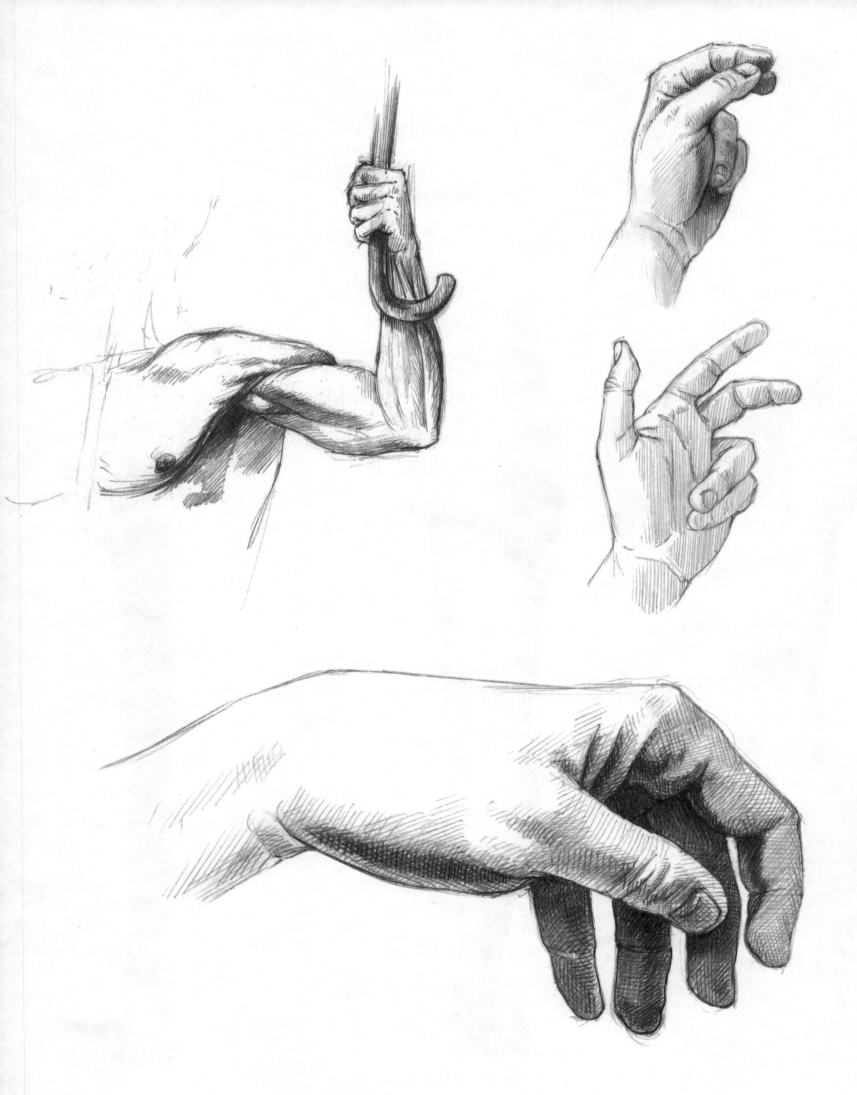

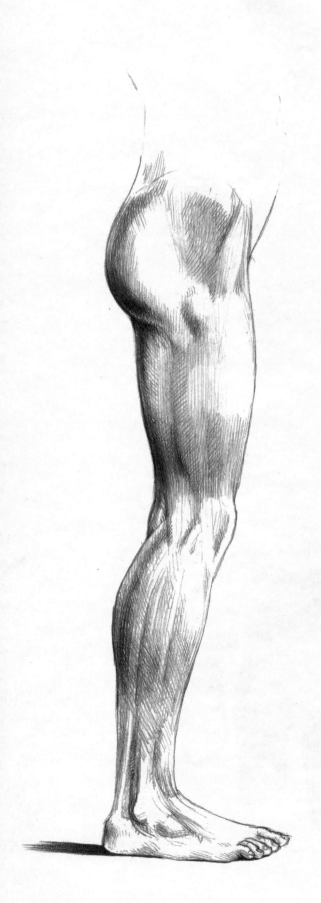
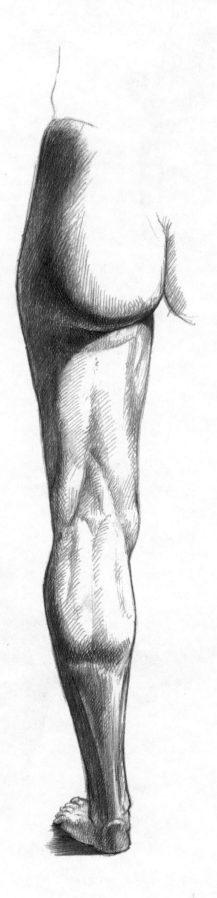
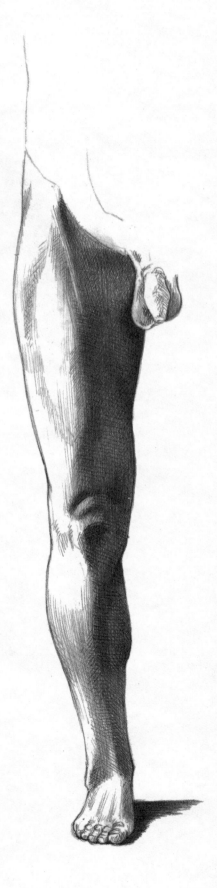

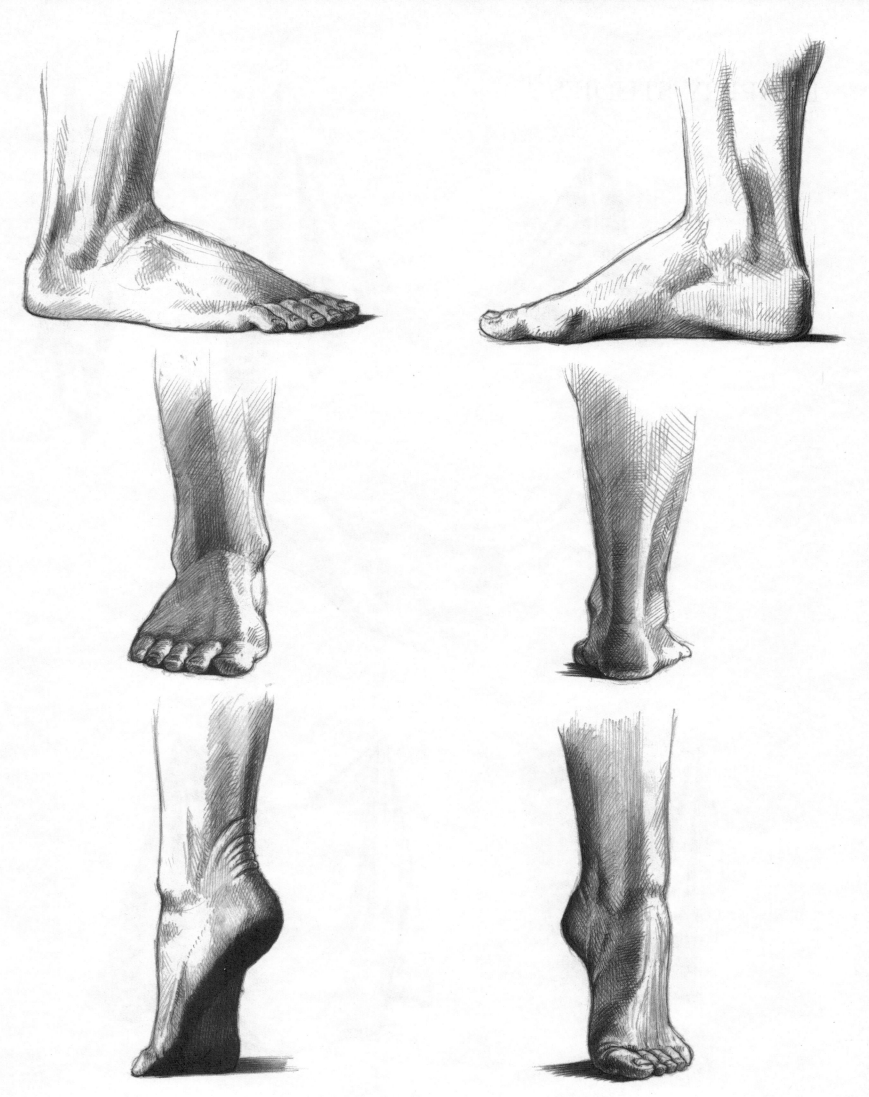

41

DRAPERY STUDIES

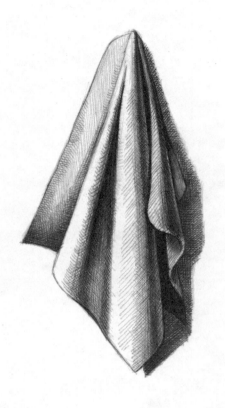

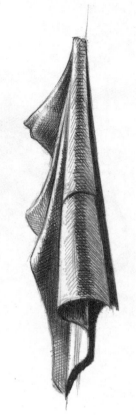

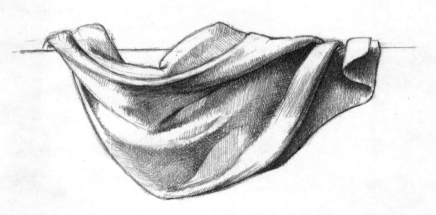

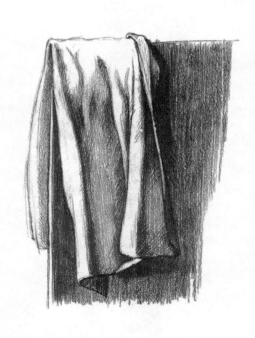

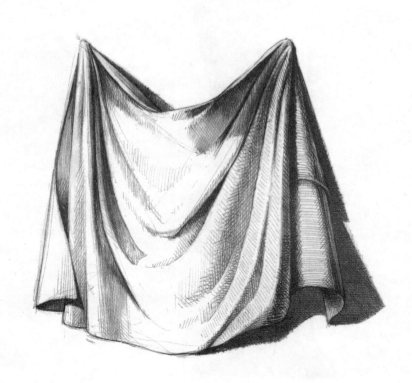

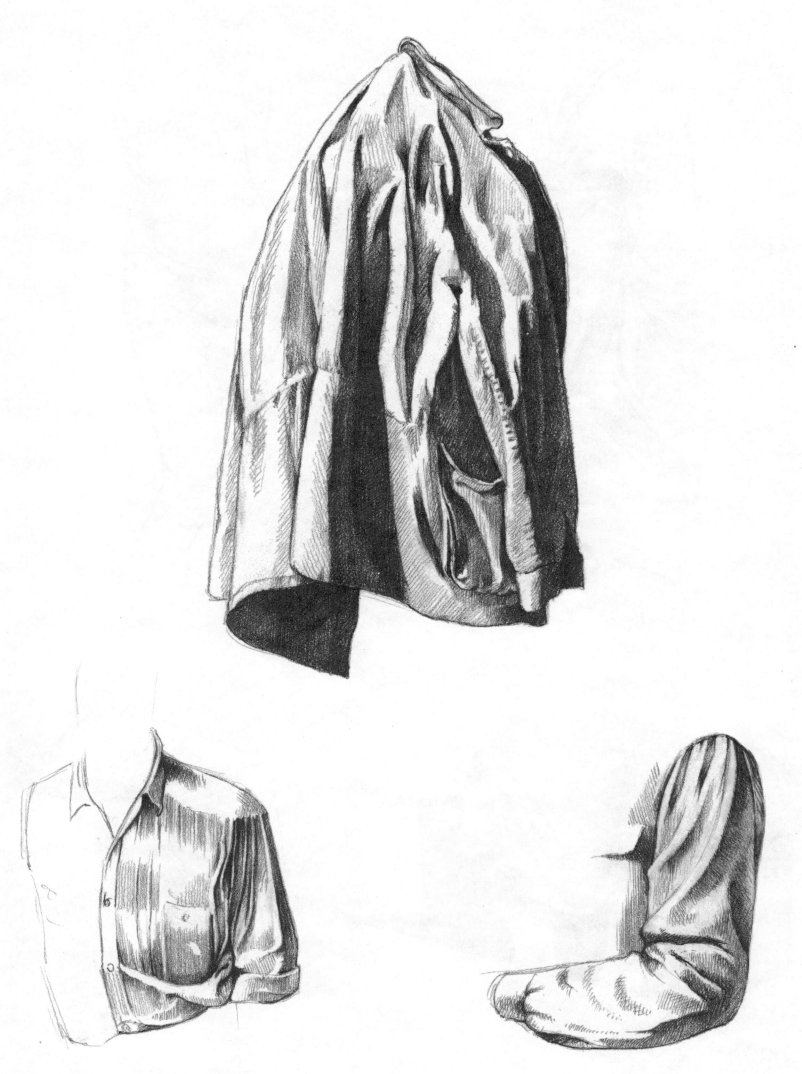

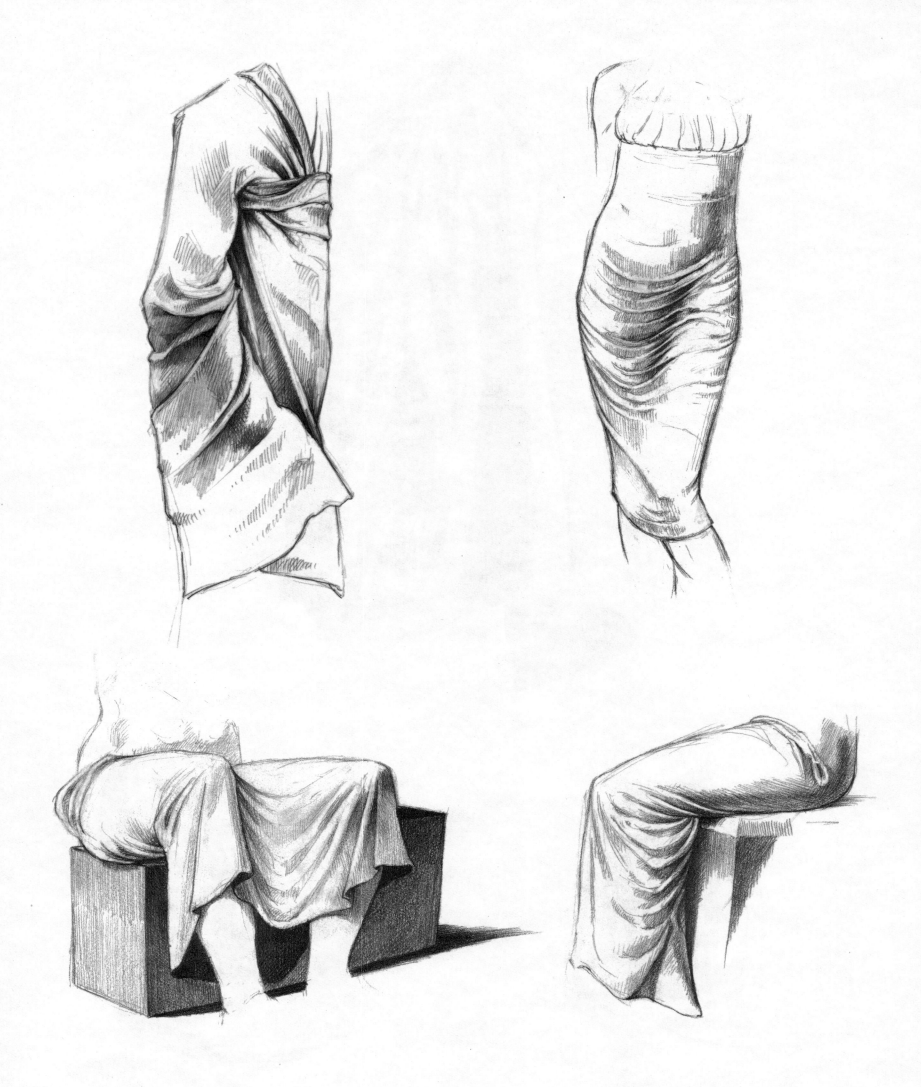

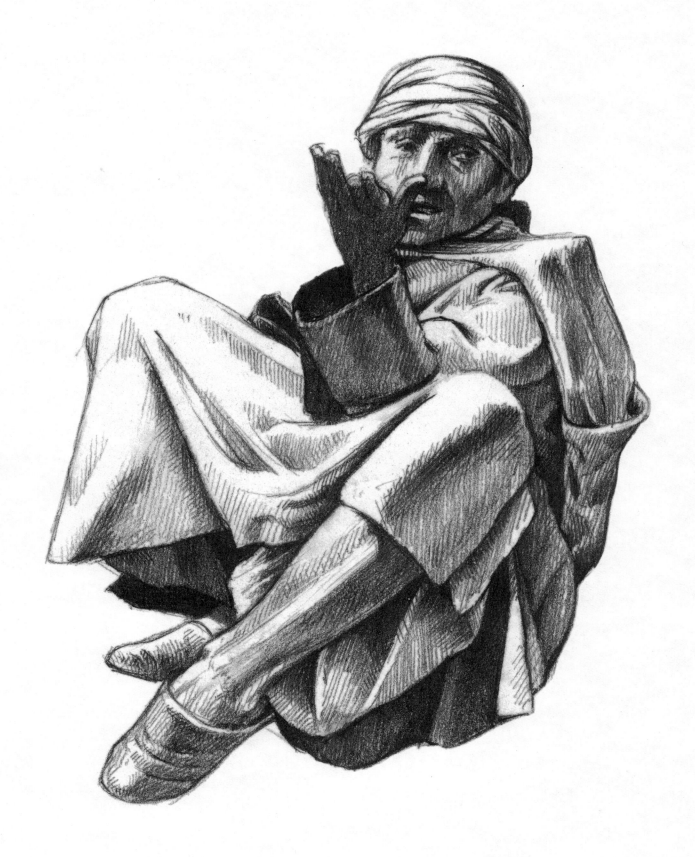

HUMAN ANATOMY

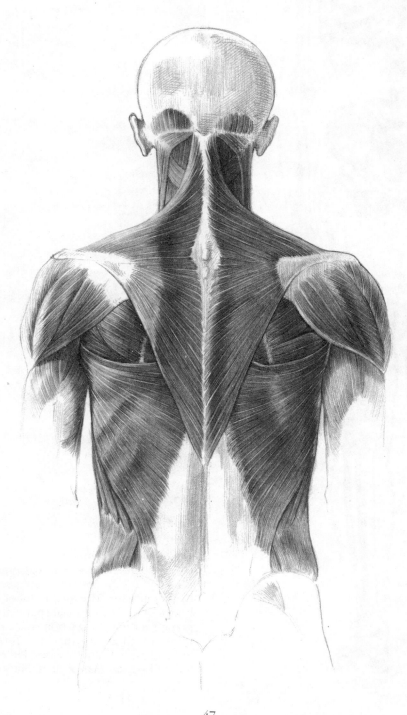

THE BONES, JOINTS AND MUSCLES

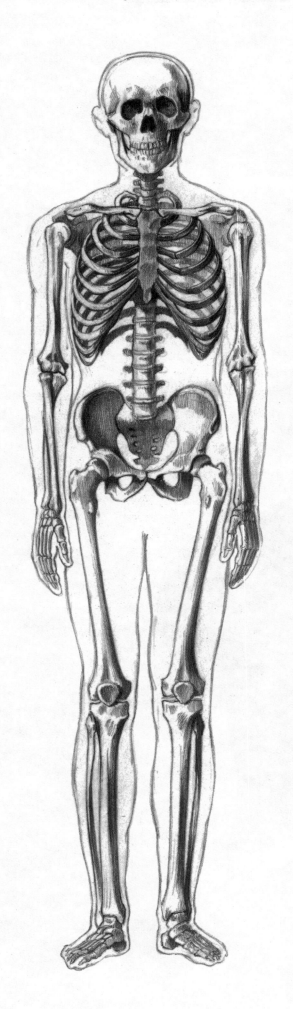

Fig. 1

The skeleton

The skeleton forms an internal solid framework for the human body. It protects the internal organs and also makes locomotion possible; the bones act as single or double levers and are moved by the muscles. The total number of bones is . There are paired bones of nearly identical shape and also single ones in the median plane (vertebrae). As bones are continuously rebuilt during their life-span, their structure and form change. They may be rigidly linked to each other by ossified or cartilaginous joints, or flexibly linked by muscular or ligamentous joints.

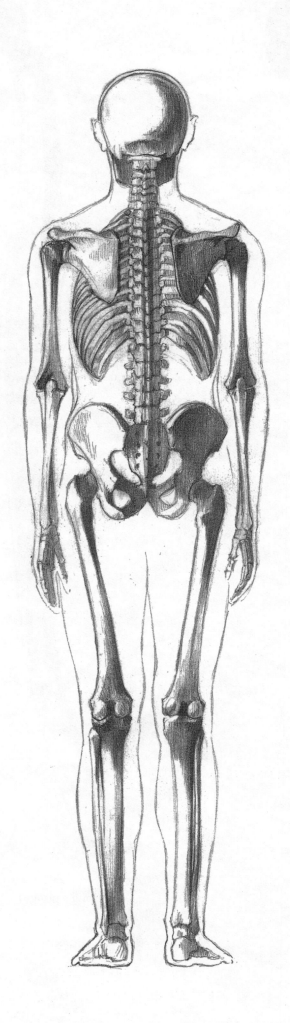
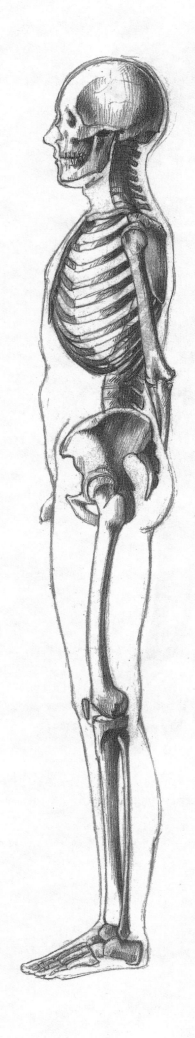

49

Humerus (long, tubular)

Femur (long, tubular)

Rib (long, spongy)

Fig. 2

The form and structure of bones

According to their shape bones may be classified as long, short, flat or laminiform. Individual bones have a hard outer layer of compact bone and an inner region of spongy or cancellous bone.

Heel bone (short)

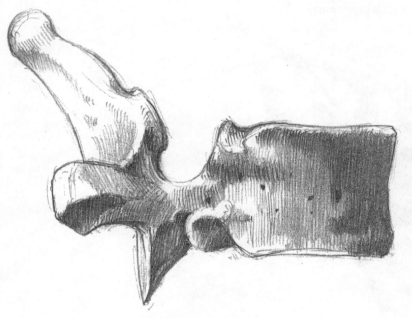

Thoracic vertebra (short)

Carpal bones (short)

Fig. 3

The form and structure of bones (*continued*)

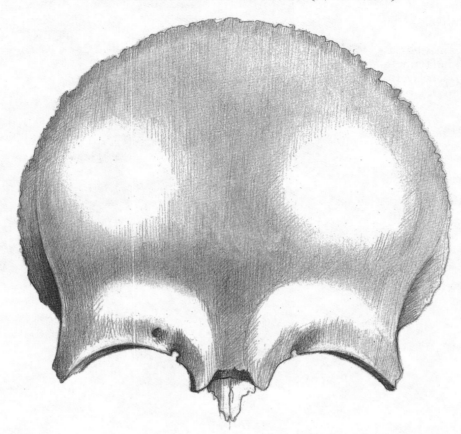

Occipital and parietal bone (laminiform)

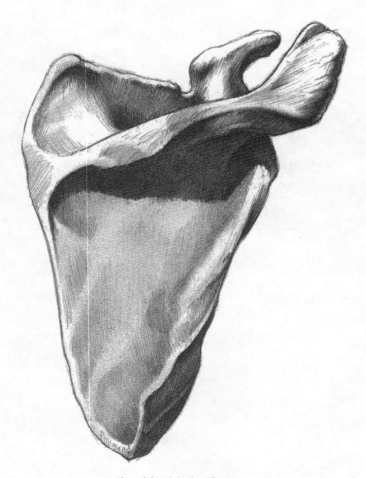

Shoulder blade (flat)

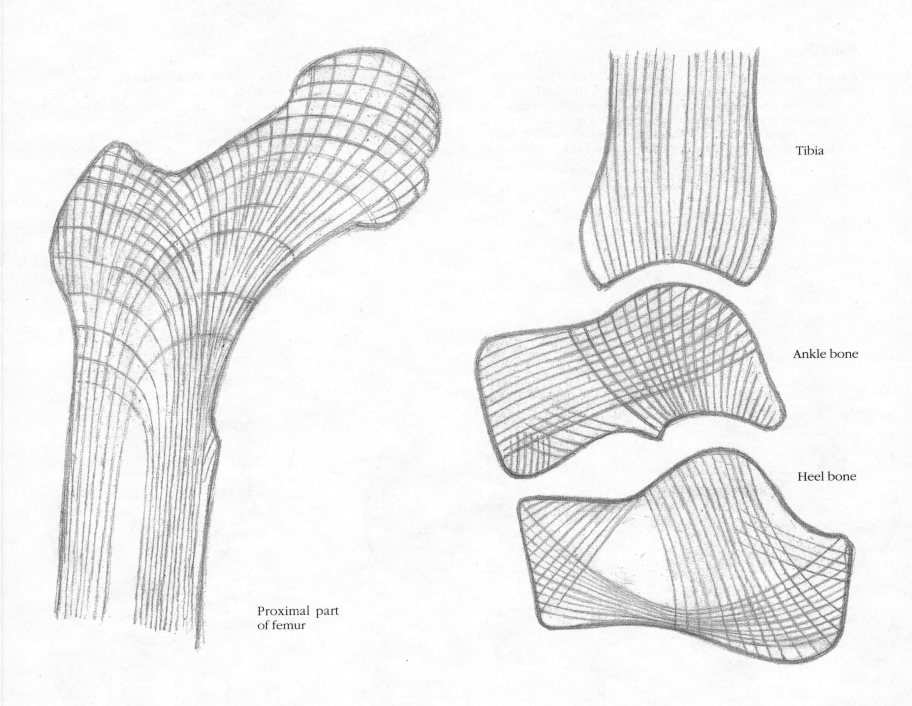

Tibia

Ankle bone

Heel bone

Proximal part
of femur

Fig. 4

The functional structure of bone

The trabeculae in spongy bone are arranged
according to the direction and strength of
the forces to which the bone is subjected.
They form so-called trajectory systems.

JOINTS

A flexible joint is a connection between two or more bones which fit closely together. The connecting surfaces are covered by hyaline cartilage. The joint is separated from the neighbouring tissues and enclosed by the joint capsule. This surrounds a joint cavity, which contains synovial fluid. The fluid acts as a lubricant; it moistens the cartilage and reduces friction between the surfaces as they glide over each other. Outside the joint capsule, thick connective tissue ligaments hold the bones of the joint tightly together.

According to their shape joints may be classified as spheroid, condylar, rotary or cochlear; according to their movement they may be classified as free, uniaxial, biaxial or polyaxial.

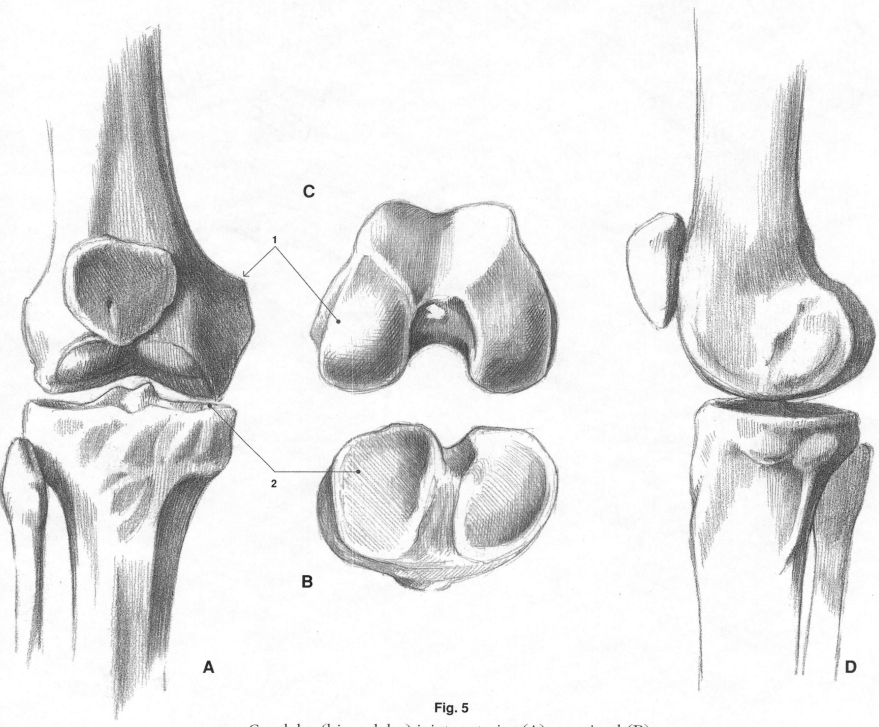

Fig. 5

Condylar (bicondylar) joint; anterior (A), proximal (B),
distal (C) and lateral (D) aspects

The femoro-tibial joint is comprised of the condyles of the femur (1) and the flat articular surfaces of the tibia (2). This disparity in shape is taken up by the 'C'-shaped cartilage situated between them.

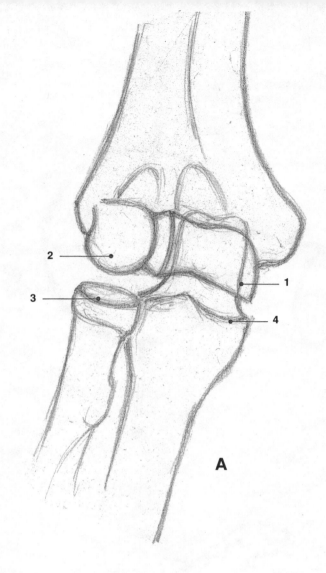

A

Fig. 6

Complex (rotary and condylar)
joint; posterior (A)
and distal (B) aspects

The elbow joint comprises the trochlea (1)
and capitulum (2) of the humerus, and
the articular grooves of the radius (3) and
ulna (4).

B

B

B

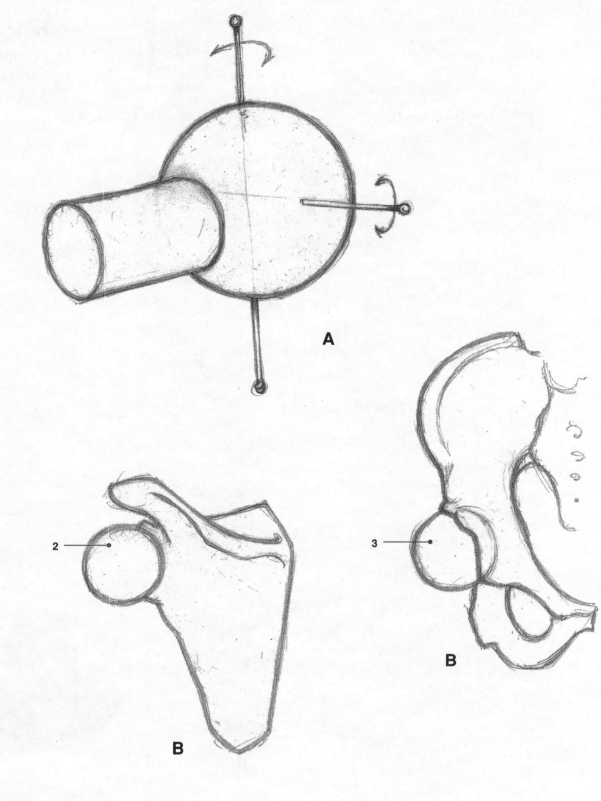

Fig. 7

Spheroid or free joint; proximal (A)
and lateral (B) aspects

This diagram illustrates the shoulder and hip joints. The shoulder
joint is comprised of the spherical head of the humerus (1) and the
glenoid cavity of the scapula (2). The hip joint is comprised of the
hemispherical head of the femur and the acetabulum of the pelvis
(3).

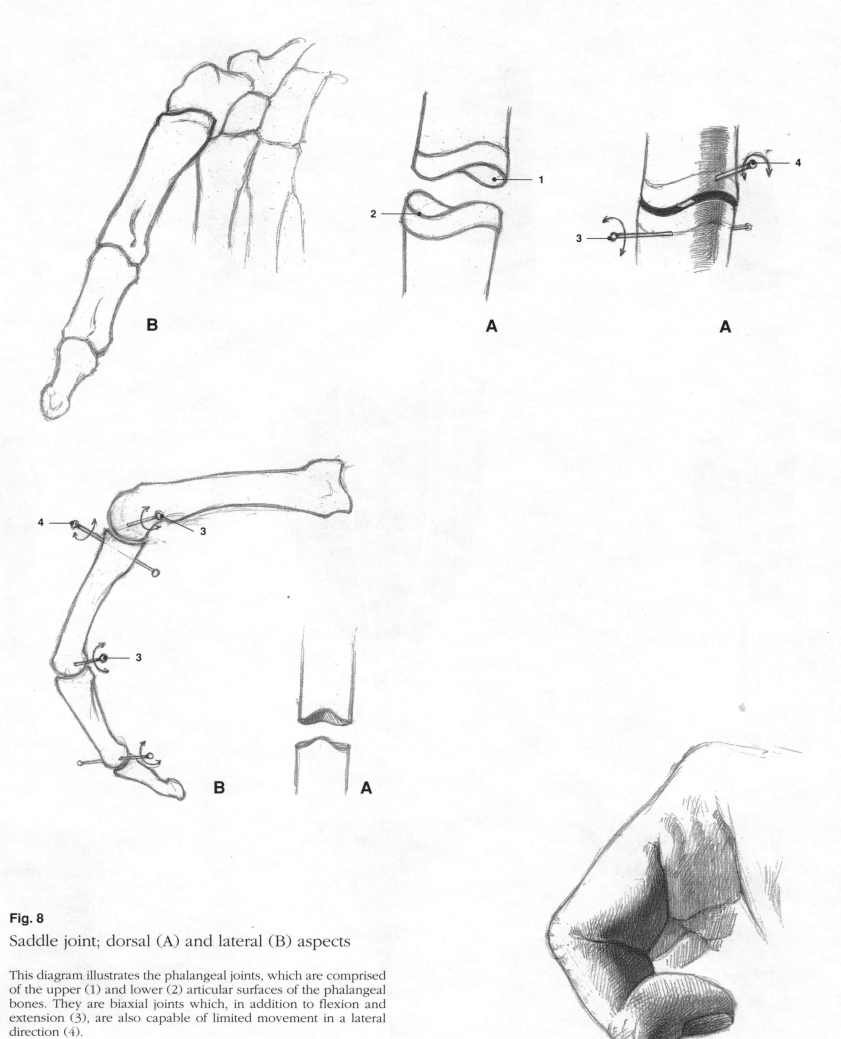

Fig. 8

Saddle joint; dorsal (A) and lateral (B) aspects

This diagram illustrates the phalangeal joints, which are comprised of the upper (1) and lower (2) articular surfaces of the phalangeal bones. They are biaxial joints which, in addition to flexion and extension (3), are also capable of limited movement in a lateral direction (4).

Fig. 9
Muscle types

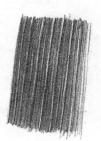

quadrangular

styloid

muscle with tendinous
intersection

unipennate

bipennate

multipennate

spindle-shaped or fusiform

triangular

spiral muscle plates

spiral styloid

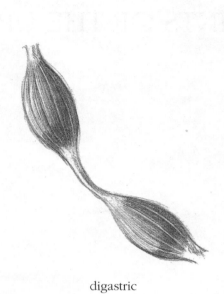

digastric

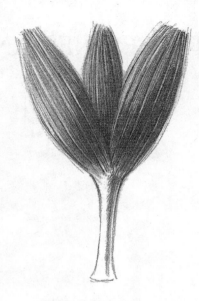

three-headed (triceps)

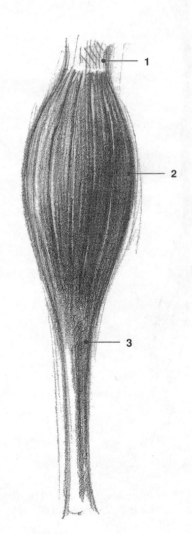

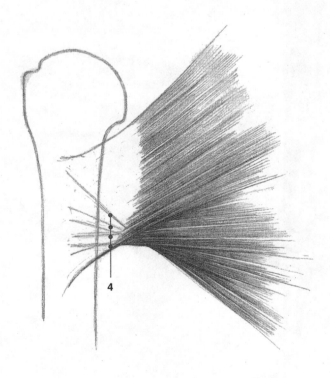

Fig. 10

The structure of muscles

1 Head of the muscle with the tendon of origin
2 Belly of the muscle
3 End of the muscle with the tendon of insertion
4 Tendinous muscle fibres penetrating fan-wise into
 periosteum and bone at the point of insertion

THE BONES AND JOINTS OF THE UPPER LIMBS

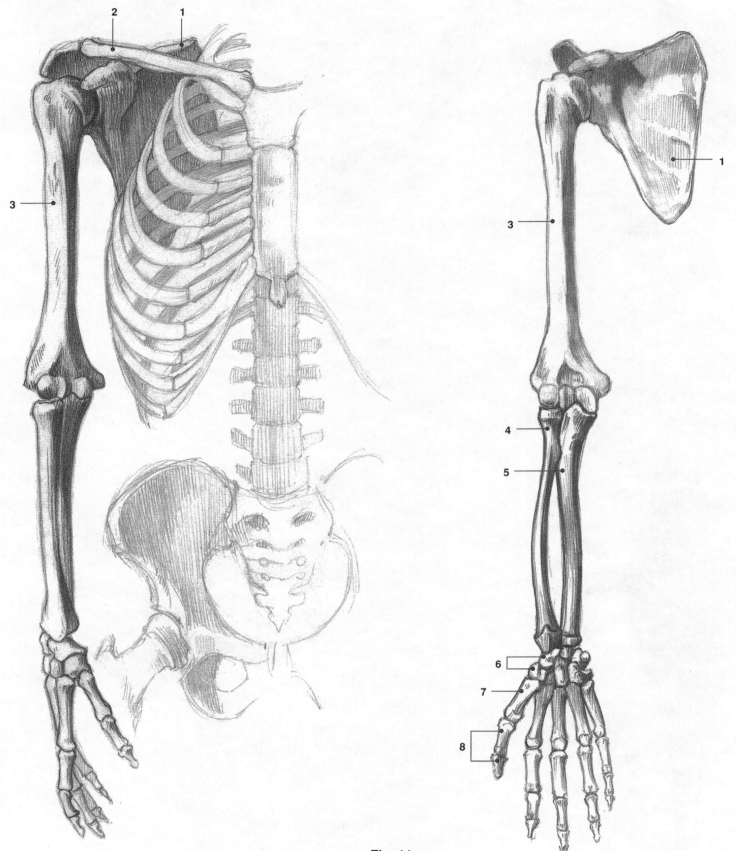

Fig. 11

The bones of the shoulder girdle and upper limb, anterior aspect

The shoulder girdle is comprised of the scapula (1) and the clavicle (2). The humerus (3) is long. The radius (4) is thin, while the proximal part of the ulna (5) is thick. The carpus (6) consists of small bones, the metacarpus (7) has five longer ones. The fingers consists of three phalanges (8), but the thumb consists of only two.

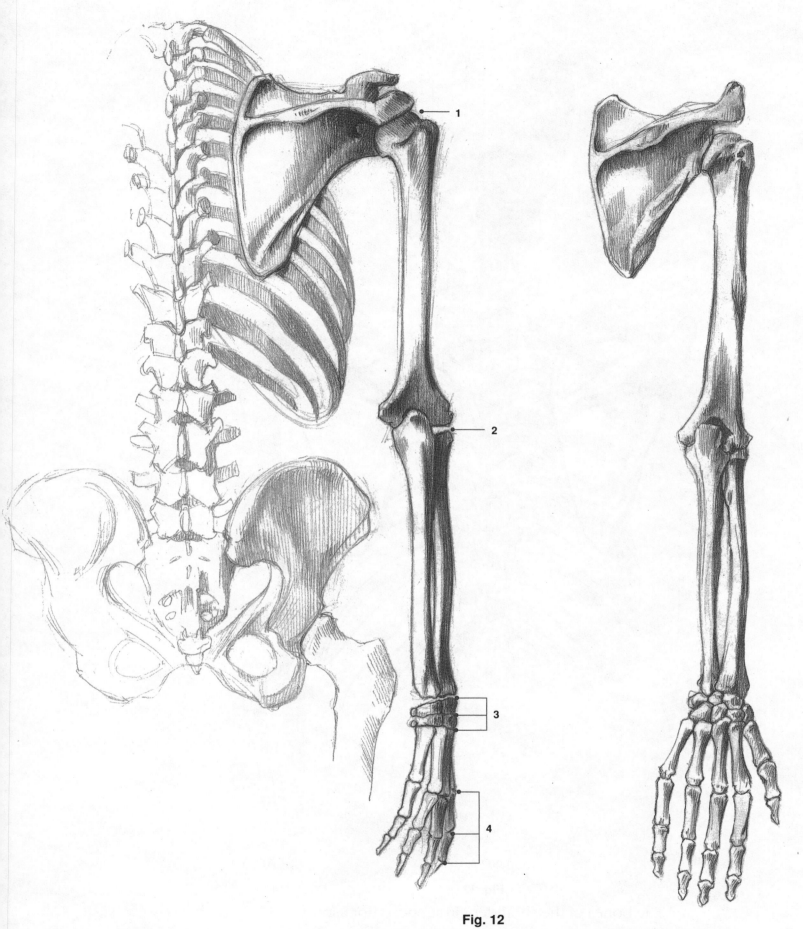

Fig. 12

The joints of the shoulder girdle and the upper limb, posterior aspect

1 Shoulder joint
2 Elbow joint
3 Carpal joint
4 Phalangeal joints

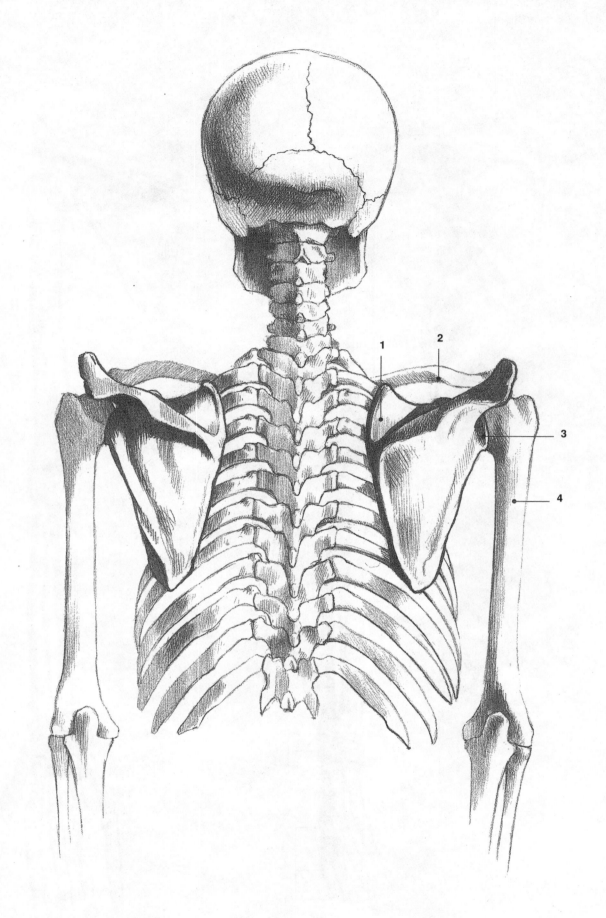

Fig. 13

The bones of the shoulder girdle, posterior aspect

The shoulder girdle links the upper limb to
the trunk, and is comprised of the scapula
(1) and the clavicle (2). The scapula and the
humerus (4) form the shoulder joint (3).

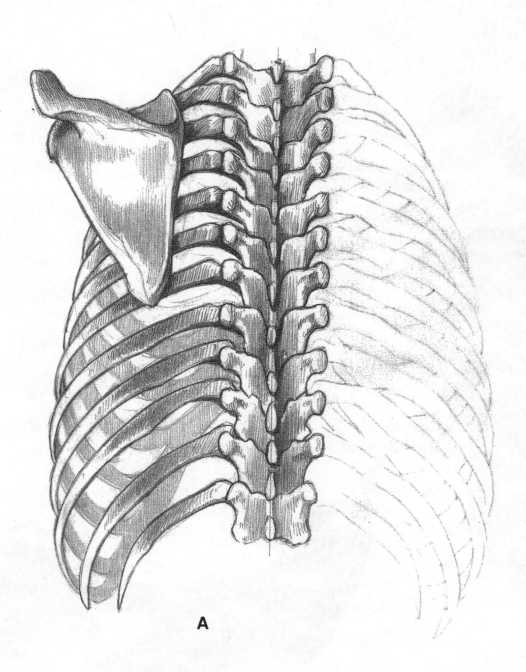

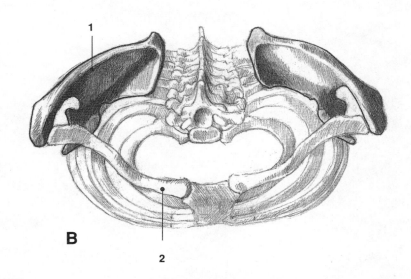

Fig. 14

The scapula; posterior (A)
and superior (B) aspects

The scapula abuts the posterior surfaces of the IInd–VIIth ribs on
both sides of the vertebral column.

1 Scapula
2 Clavicle

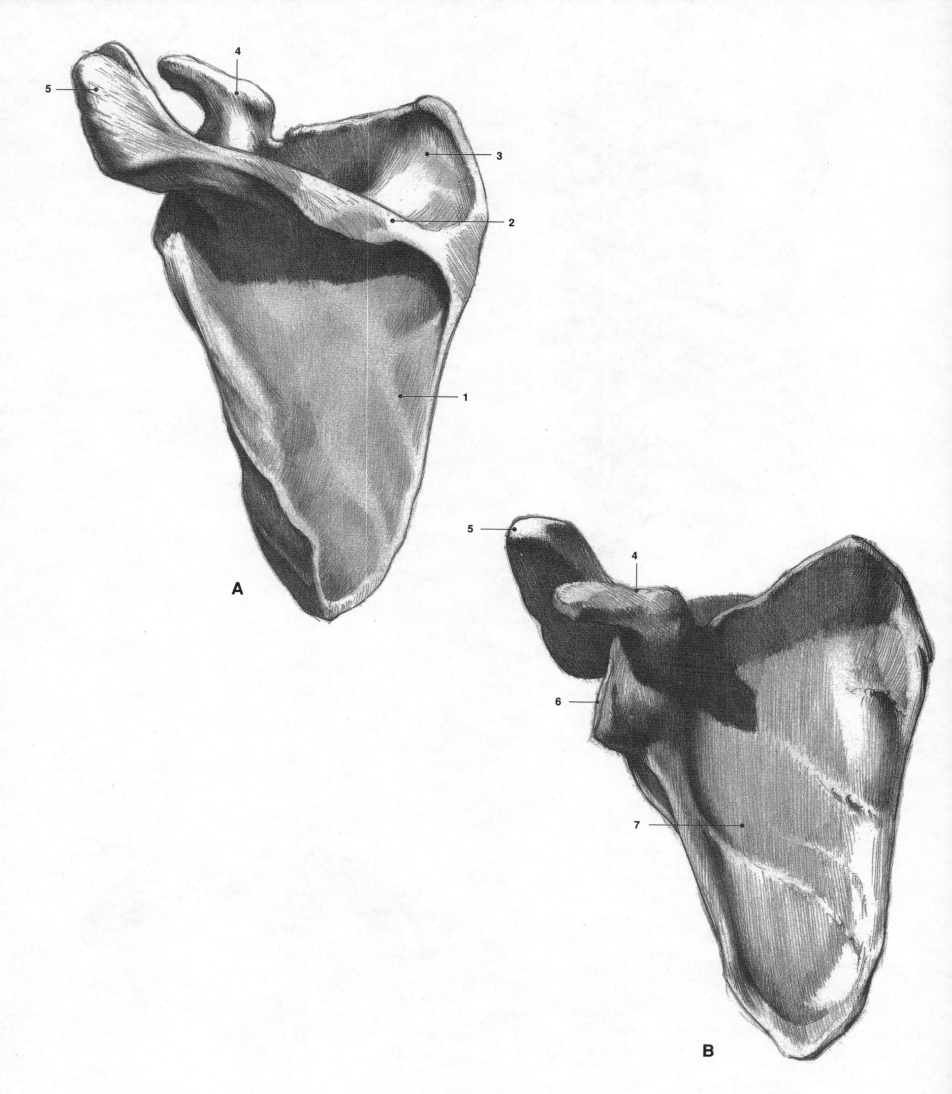

A

B

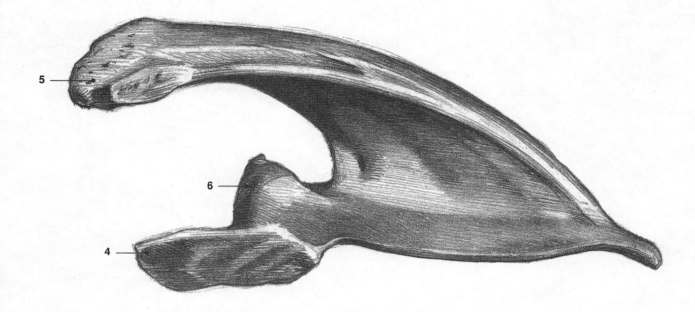

C

D

Fig. 15

The scapula; outer (A), inner (B),
superior (C) and lateral (D) aspects

The scapula is a flat bone, shaped like an acute-angled triangle.
The glenoid cavity forms the shoulder joint with the head of the
humerus. The muscles of the shoulder and elbow joints originate
from the coracoid process. The inner surface of the scapula is con-
cave, the bony crest or spine on its outer surface extends above
the shoulder joint to form the acromion.

1 Infraspinous fossa
2 Scapula spine
3 Supraspinous fossa
4 Coracoid process
5 Acromion
6 Glenoid cavity
7 Subscapular fossa

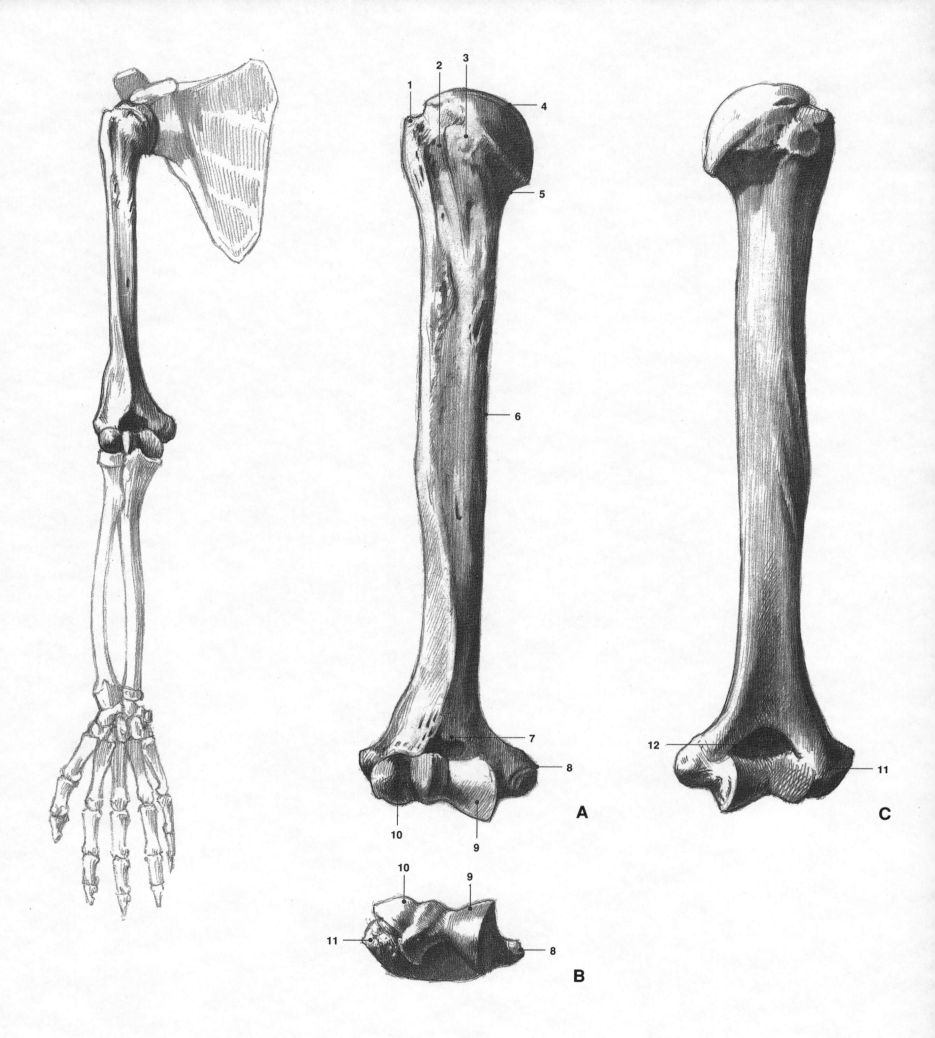

A

B

C

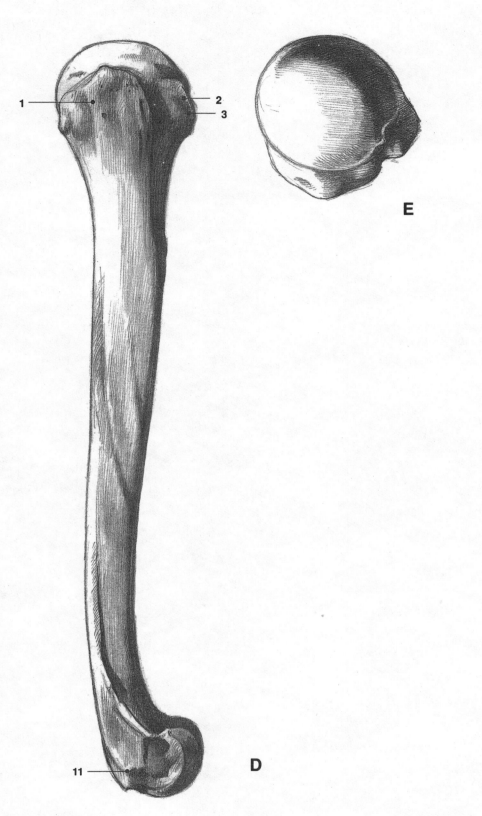

Fig. 19

The humerus (the bone of the upper arm); anterior (A), distal (B), posterior (C), lateral (D), proximal (E) and medial (F) aspects

The humerus is a long tubular bone, twisted around its axis. Its two ends are enlarged. The proximal end forms the shoulder joint, while the distal end forms the elbow joint.

1 Greater tubercle	7 Coronoid fossa
2 Bicipital groove	8 Medial epicondyle
3 Lesser tubercle	9 Trochlea
4 Head	10 Capitulum
5 Neck	11 Lateral epicondyle
6 Shaft of the humerus	12 Olecranon fossa

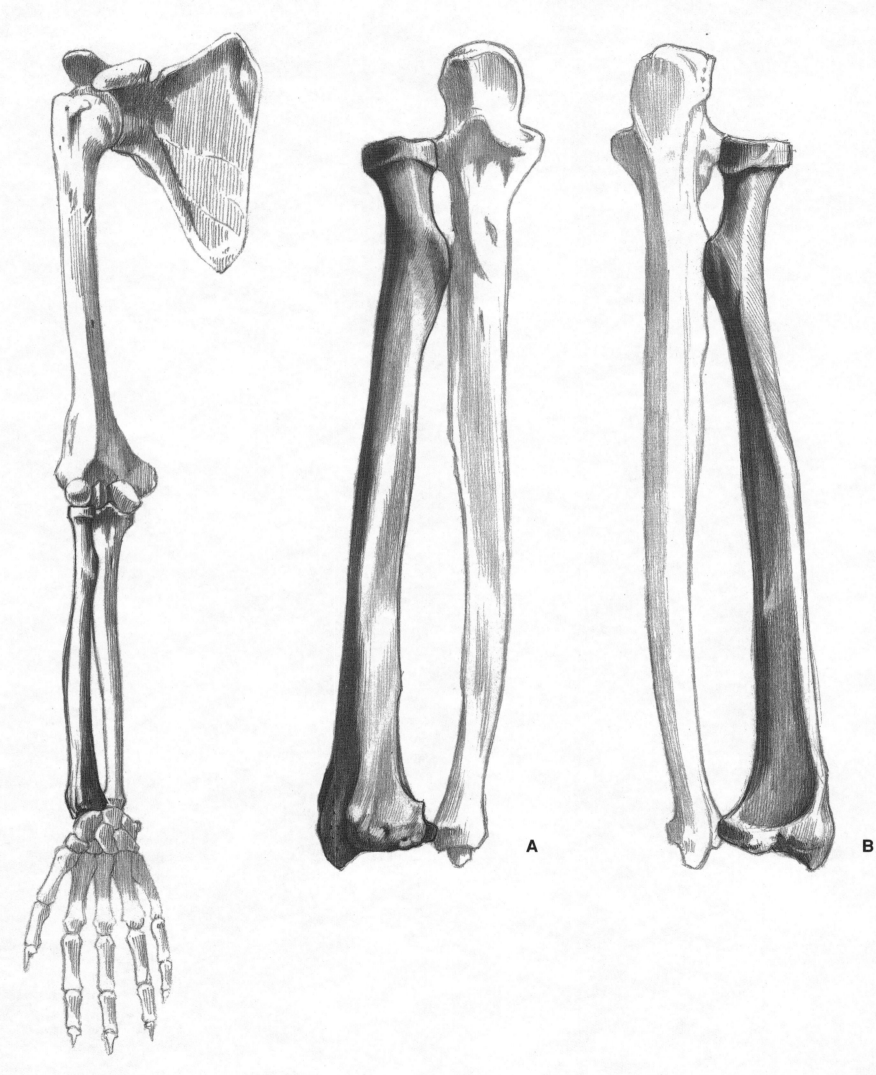

A

B

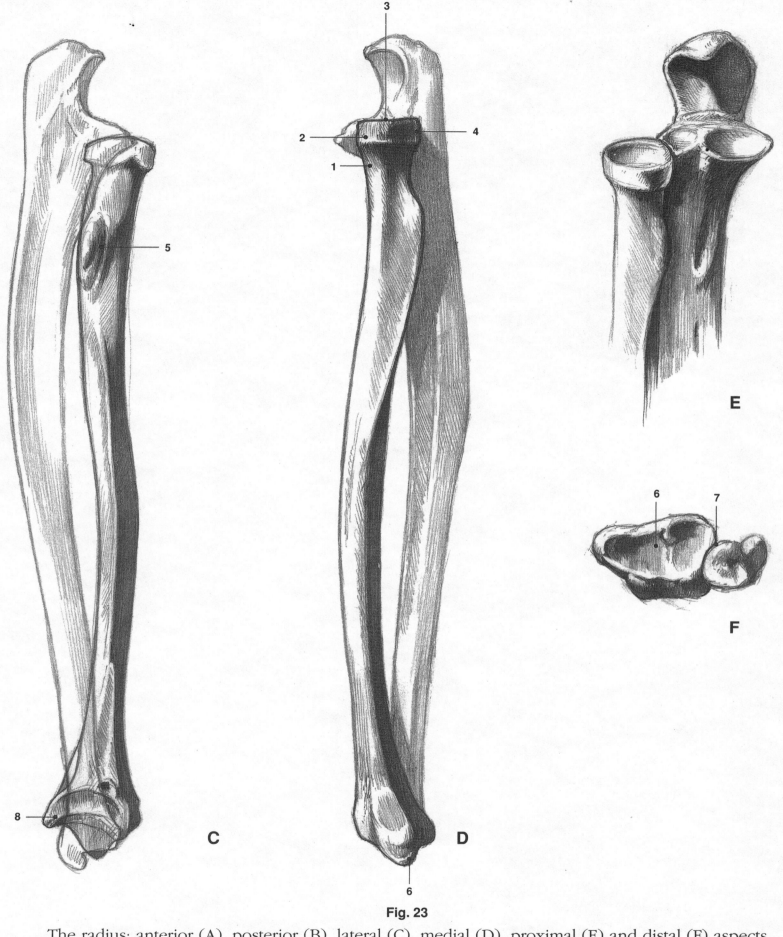

Fig. 23

The radius; anterior (A), posterior (B), lateral (C), medial (D), proximal (E) and distal (F) aspects

The bones of the forearm are the S-shaped radius and the ulna. On its proximal end above the neck (1) the radius has a head (2), the cupped surface of which (3) articulates with the humerus, while the articular surface on its side (4) forms a joint with the ulna. The tuberosity on the upper part of its shaft (5) is the site of insertion of the musculus biceps brachii. The articular surface of its distal end (6) forms a mobile joint with the carpal bones. The ulna fits into its ulnar notch (7). The process on its medial side is the styloid process (8).

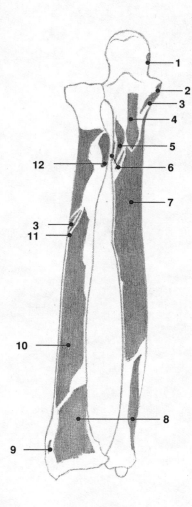

Fig. 25

The sites of origin or insertion
of muscles on the bones of the forearm,
anterior aspect

1 Flexor carpi ulnaris muscle *(57)*
2 Flexor digitorum superficialis muscle *(58)*
3 Pronator teres muscle *(55)*
4 Brachialis muscle *(50)*
5 Supinator muscle *(68)*
6 Extensor carpi ulnaris muscle *(65)*
7 Flexor digitorum profundus muscle *(59)*
8 Pronator quadratus muscle *(62)*
9 Brachioradialis muscle *(63)*
10 Flexor digiti Ist longus muscle *(60)*
11 Flexor digitorum superficialis muscle *(58)*
12 Biceps brachii muscle *(51)*

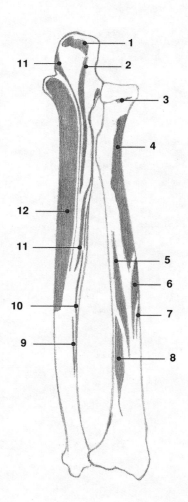

Fig. 26

The sites of origin or insertion
of muscles on the bones of the forearm,
posterior aspect

1 Triceps brachii muscle *(52)*
2 Anconeus muscle *(53)*
3 Extensor carpi ulnaris muscle *(65)*
4 Supinator muscle *(68)*
5 Abductor digiti Ist longus *(70)*
6 Pronator teres muscle *(55)*
7 Flexor digitorum superficialis muscle *(58)*
8 Extensor digiti Ist brevis muscle *(71)*
9 Extensor digiti IInd muscle *(72)*
10 Extensor digiti Ist longus *(71)*
11 Flexor carpi ulnaris muscle *(57)*
12 Flexor digitorum profundus muscle *(59)*

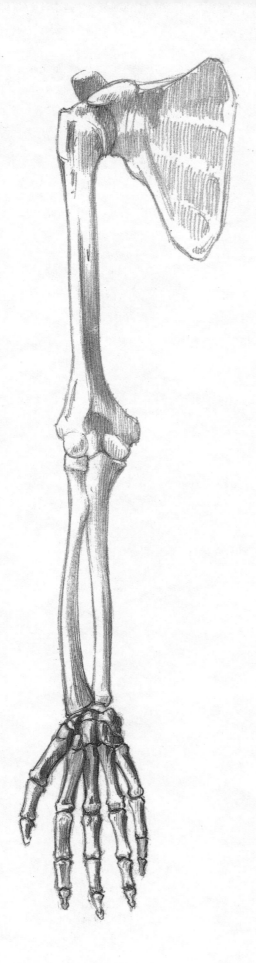

A

B

Fig. 27

The carpal bones; dorsal (A) and palmar (B) aspects

The bones are demonstrated in Fig. 29.

THE MOVEMENT OF THE UPPER LIMBS

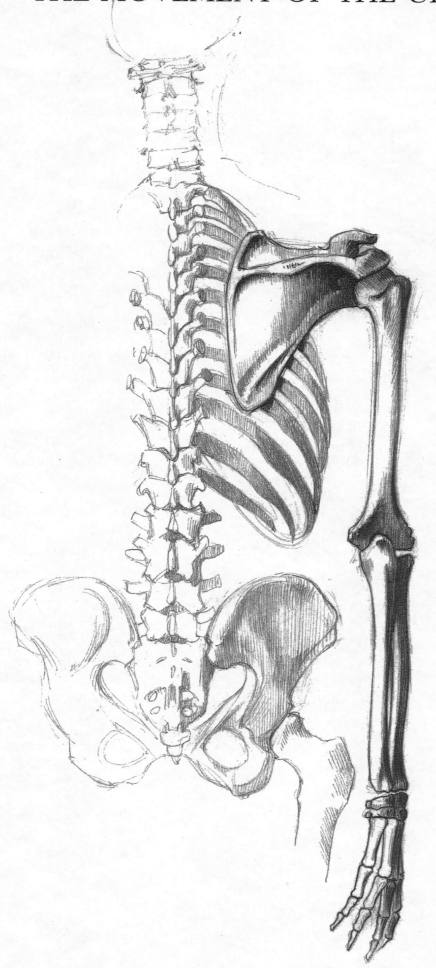

Fig. 30

The upper limb at rest

The shoulder joint is located away from the trunk, so that the upper limb can move freely. At rest the limb hangs vertically beside the trunk. The clavicle is nearly horizontal, the elbow joint and the joints of the palm are slightly flexed and the palm faces the trunk.

Fig. 31

Supination and pronation

Both the humerus and the bones of the fore-arm can rotate around their long axis.

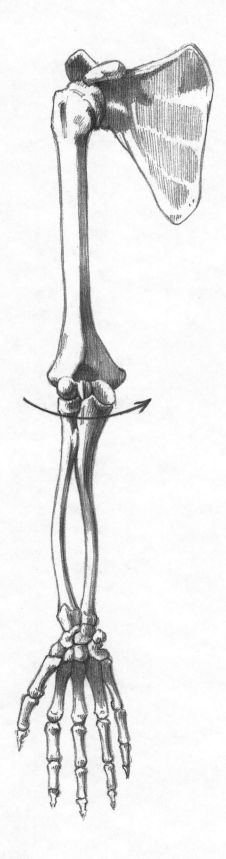

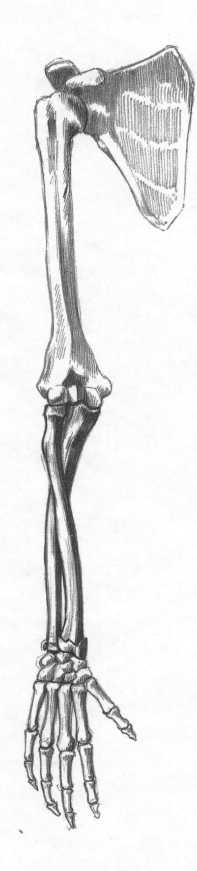

Fig. 32

Connections between the bones of the forearm

There are articular and ligamentous connections between the radius and ulna. The bones can rotate around each other.

1 Upper radio-ulnar joint
2 Annular ligament
3 Upper oblique interosseal ligament
4 Interosseal membrane
5 Lower annular ligament

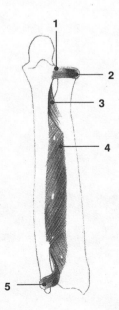

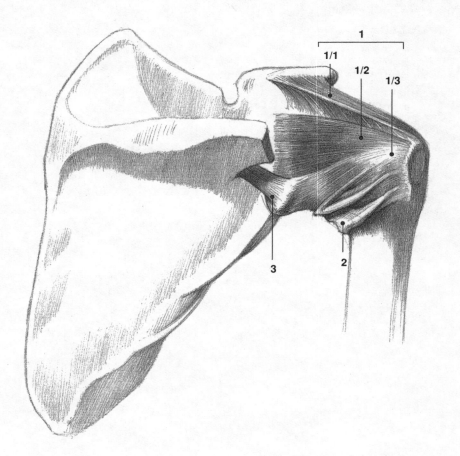

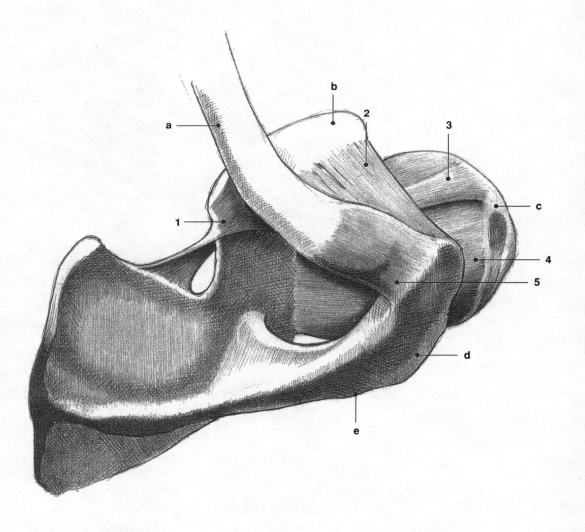

Fig. 36

The ligaments
of the shoulder joint,
posterior aspect

The shoulder joint allows a great variety of
movements.

1 Humeroscapular ligament
 1/1 Upper humeroscapular ligament
 1/2 Intermediate humeroscapular
 ligament
 1/3 Lower humeroscapular ligament
2 Articular capsule
3 Coracoacromial ligament

Fig. 37

The ligaments of the shoulder
joint and the claviculo-acromial
joint, superior–posterior aspect

1 Transverse ligament of the scapula
2 Coracoacromial ligament
3 Coracohumeral ligament
4 Capsule of the shoulder joint
5 Claviculo-acromial ligament

a) Clavicle
b) Coracoid process of the shoulder blade
c) The greater tubercle of the humerus
d) Acromion
e) Scapular spine

84

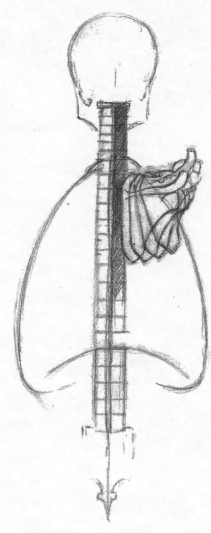

Fig. 38

Movement
of the scapula

The scapula is loosely attached to the back region by flat muscles. Raising the arm causes the inferior border of the scapula to move laterally.

If the shoulder is pulled anteriorly the scapula moves away from the vertebral column.

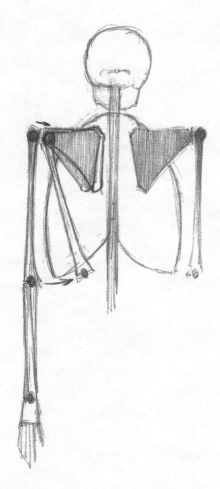

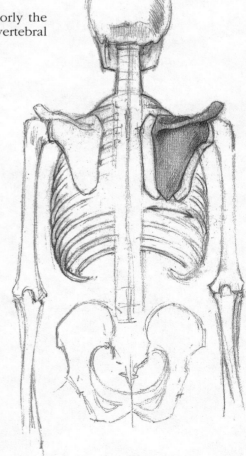

If the limb is pulled anteriorly, the scapula moves laterally.

When the shoulder joint is pulled posteriorly the scapula moves closer to the vertebral column.

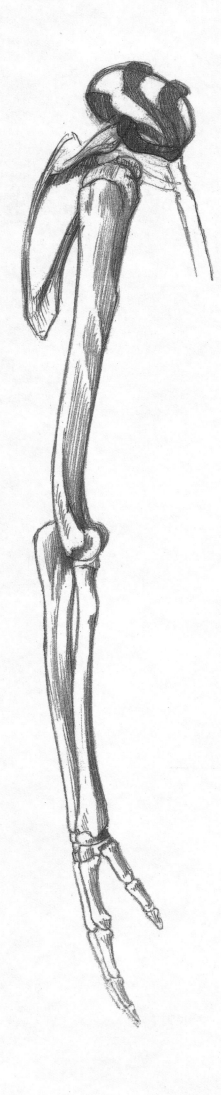

Fig. 40

Movement of the clavicle *(continued)*

During anterior and posterior movements, the clavicle moves
simultaneously with the scapula. Horizontal rotation around the
trunk is also possible.

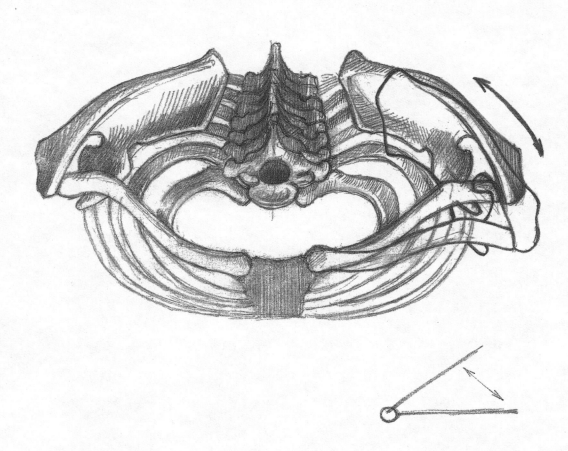

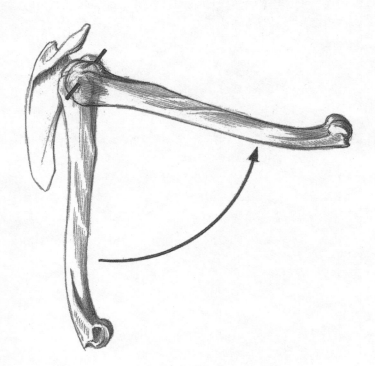

sagittal movement

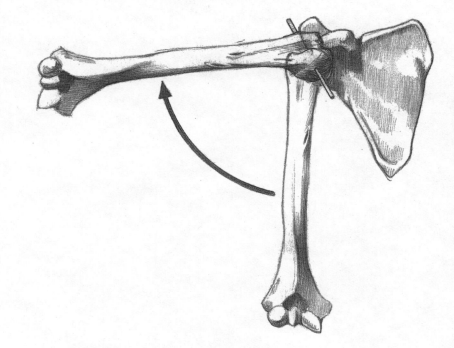

lateral movement

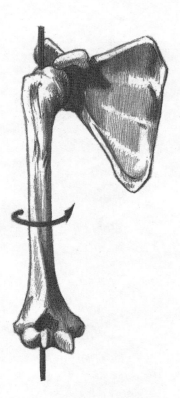

pronation

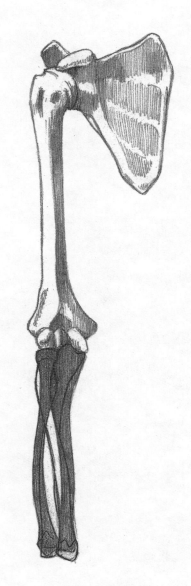

rotation

Fig 41

Movement of the humerus

As the shoulder joint is a free joint, the humerus can move in many directions.

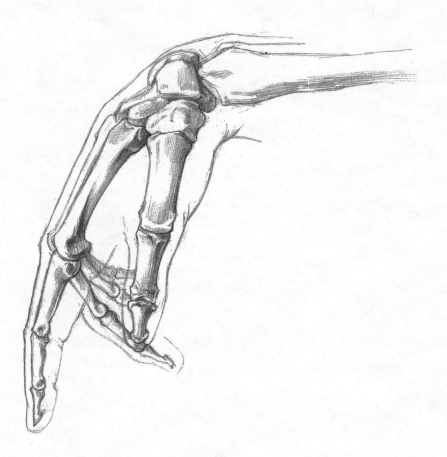

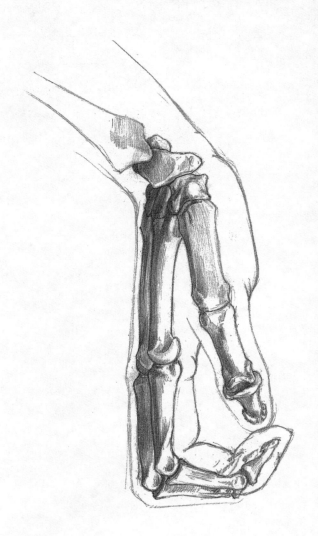

Fig. 44

Movement of the hand

The hand can be flexed, extended and moved laterally.

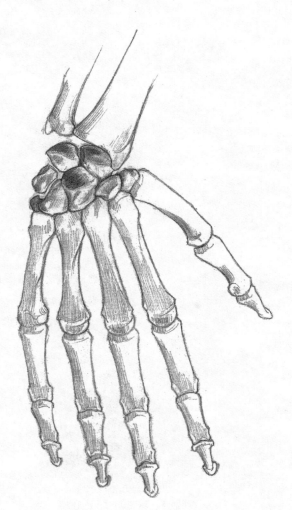

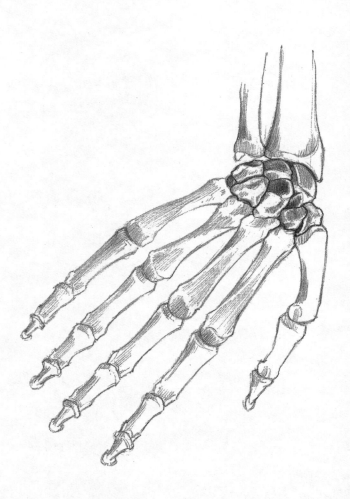

Fig. 45
Movement of the fingers

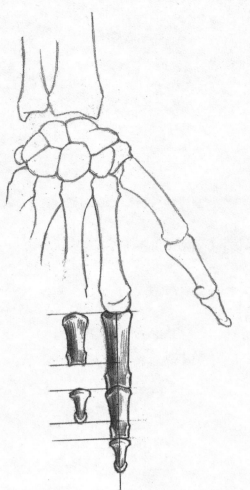

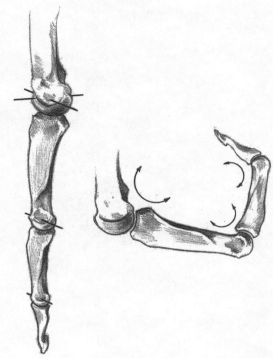

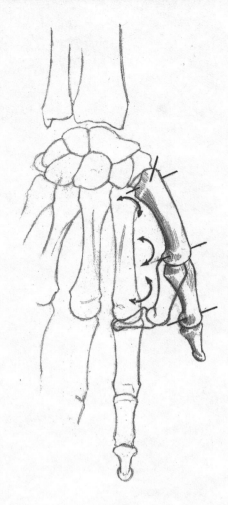

The second phalanx is shorter by one-third than the first. Similarly, the third phalanx is shorter by one-third than the second.

The phalangeal joints can be flexed from 45° to almost 90°.

The thumb cannot be flexed to the same extent as the other fingers.

The base of the little finger can be palpated with the thumb.

The fingers can move laterally and perform circular movements.

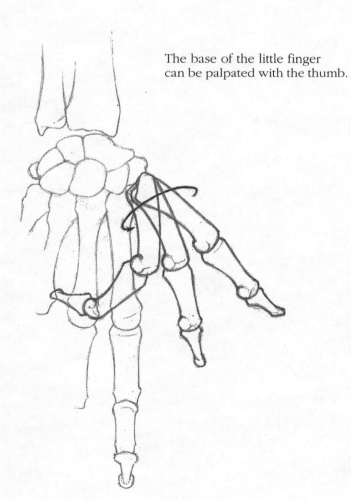

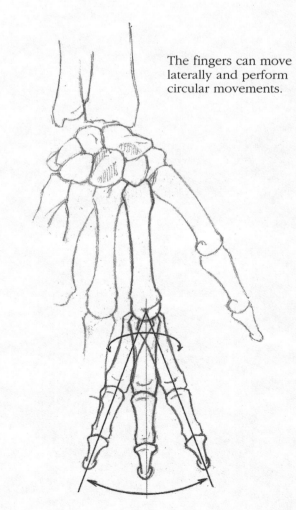

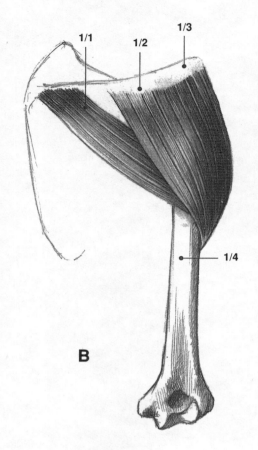

Fig. 48

The deltoideus muscle *(43)*; posterio-lateral (A) and posterior (B) aspects

The deltoideus muscle originates on the scapular spine (1/1), the acromion (1/2) and the clavicle (1/3). Its convergent fibres are inserted into the deltoid tuberosity of the humerus (1/4). This muscle forms the contour of the shoulder.

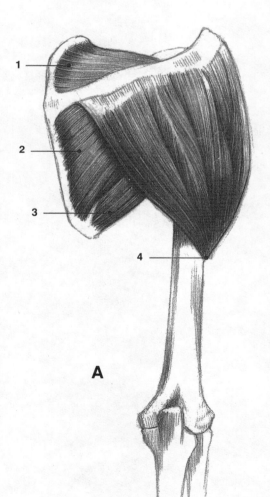

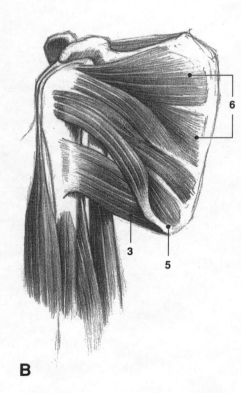

Fig. 49

The muscles of the shoulder; lateral (A) and medial (B) aspects

1 Supraspinatus muscle *(44)*
2 Infraspinatus muscle *(45)*
3 Teres major muscle *(47)*
4 Deltoideus muscle *(43)*
5 Teres minor muscle *(46)*
6 Subscapularis muscle *(48)*

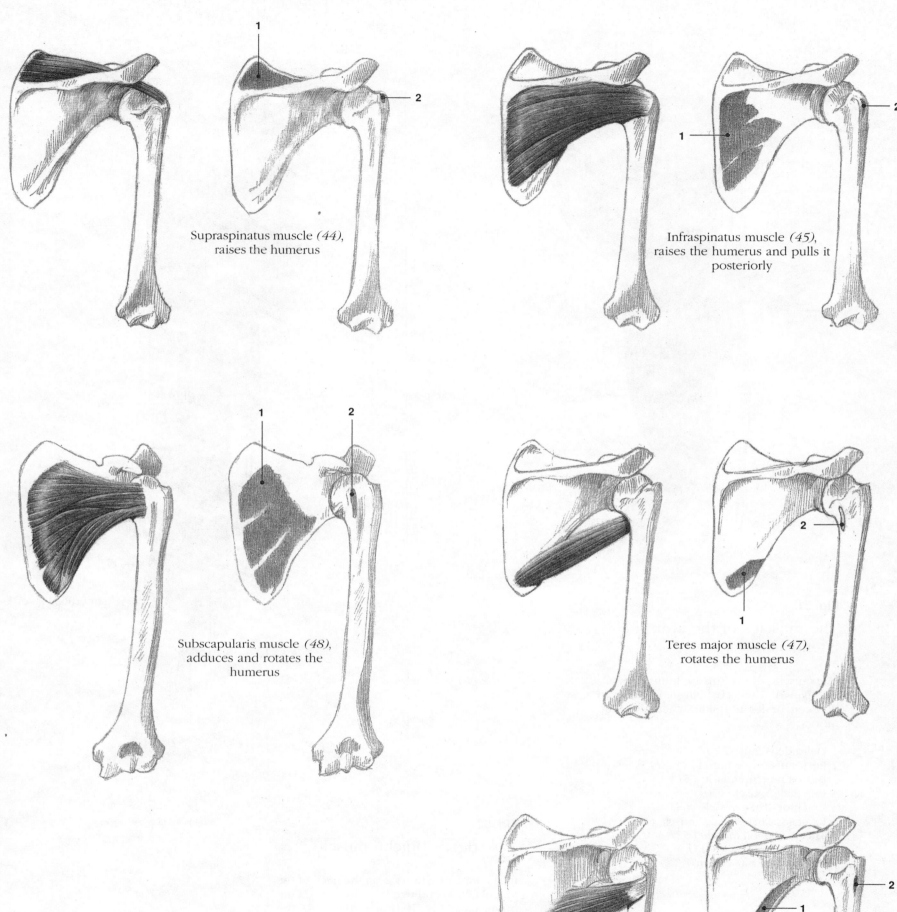

Supraspinatus muscle *(44)*, raises the humerus

Infraspinatus muscle *(45)*, raises the humerus and pulls it posteriorly

Subscapularis muscle *(48)*, adduces and rotates the humerus

Teres major muscle *(47)*, rotates the humerus

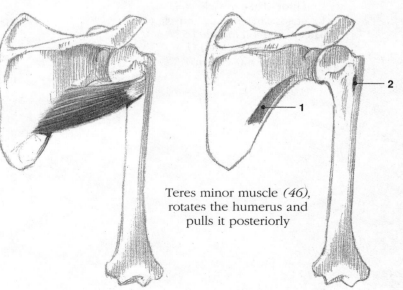

Teres minor muscle *(46)*, rotates the humerus and pulls it posteriorly

Fig. 50

The muscles of the shoulder joint and their functions

1 Site of origin
2 Site of insertion

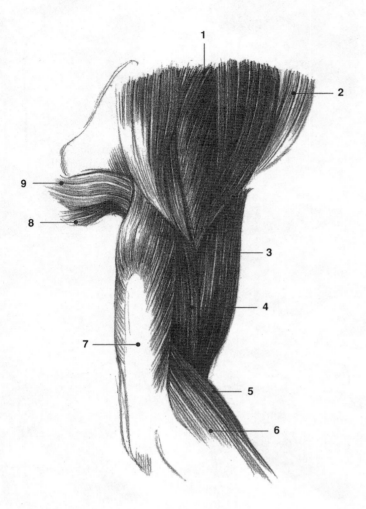

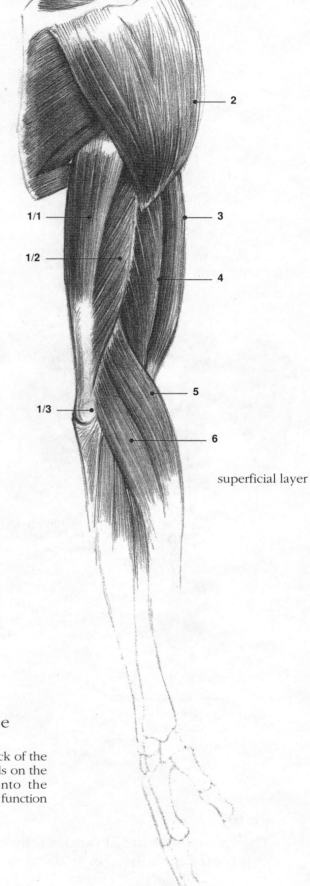

superficial layer

Fig. 51

The muscles of the arm, lateral aspect

The muscles of the arm are long and spindle-shaped. Their changing contours can be seen under the skin when the limb moves.

1 Deltoideus muscle *(43)*
2 Pectoralis major muscle *(27/1)*
3 Biceps brachii muscle *(51)*
4 Brachialis muscle *(50)*
5 Brachioradialis muscle *(63)*
6 Extensor carpi radialis muscle *(64)*
7 Triceps brachii muscle *(52)*
8 Teres major muscle *(47)*
9 Teres minor muscle *(46)*

Fig. 52

The triceps brachii muscle

It has three origins: one on the neck of the scapula (1/1) and two lateral heads on the humerus (1/2). It is inserted into the olecranon of the ulna (1/3) and its function is to extend the elbow joint.

1 Triceps brachii muscle *(52)*
2 Deltoideus muscle *(43)*
3 Biceps brachii muscle *(51)*
4 Brachialis muscle *(50)*
5 Brachioradialis muscle *(63)*
6 Extensor carpi radialis muscle *(64)*

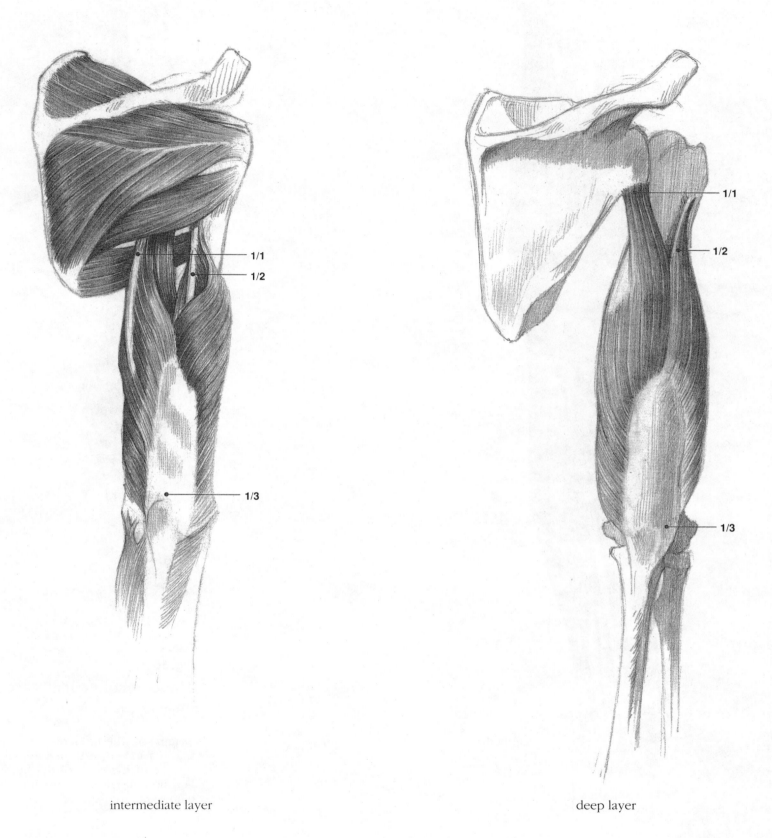

intermediate layer

deep layer

Fig. 53

The triceps brachii muscle *(continued)*

Explanation see Fig. 52.

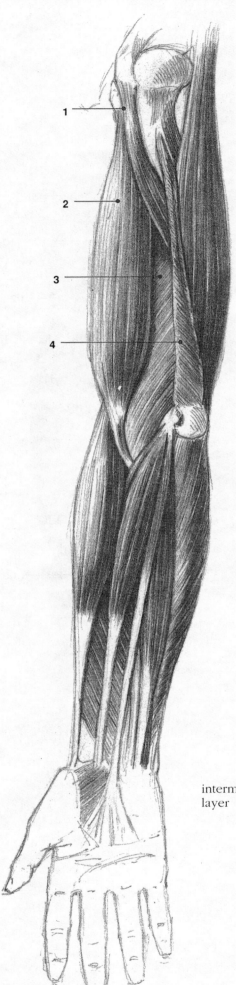

intermediate
layer

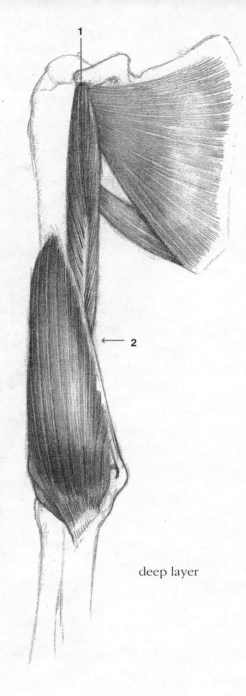

deep layer

Fig. 55

The coracobrachialis
muscle *(49)*

Origin: on the coracoid process of the
scapula (1). Insertion: into the medial
surface of the shaft of the humerus (2).
Function: to raise the arm and adduct the
limb to the trunk.

Fig. 54

The muscles of the arm,
posterior aspect

1 Coracobrachialis muscle *(49)*
2 Biceps brachii muscle *(51)*
3 Brachialis muscle *(50)*
4 Triceps brachii muscle *(52)*

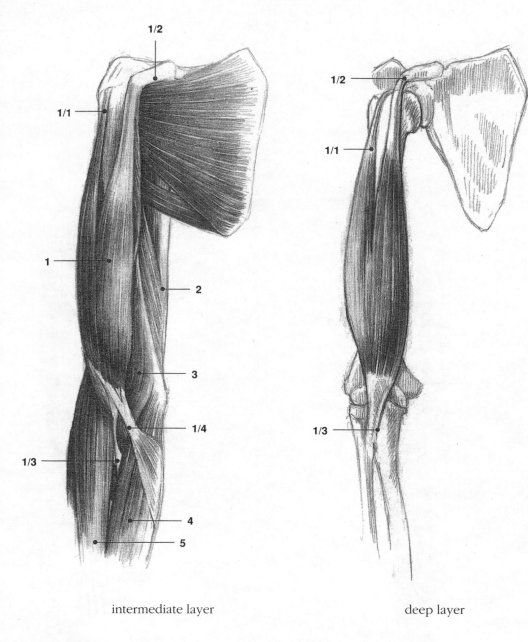

intermediate layer

deep layer

deep layer

Fig. 56

The biceps brachii muscle *(51)*

The short head (1/1) has an origin on the coracoid process of the scapula, while the long head (1/2) has an origin on the supraglenoid tubercle above the shoulder joint. Insertion: into the radial tuberosity (1/3). Function: flexion of the elbow joint and, via its connection to the belly of the extensor carpi radialis (1/4), extension of the digits.

1 Biceps brachii muscle *(51)*
2 Triceps brachii muscle *(52)*
3 Brachialis muscle *(50)*
4 Pronator teres muscle *(55)*
5 Extensor carpi radialis muscle *(64)*

Fig. 57

The brachialis muscle *(50)*

Origin: on the shaft of the humerus below the deltoid tuberosity (1). Insertion: into the coronoid process of the ulna (2). Function: to flex the elbow joint.

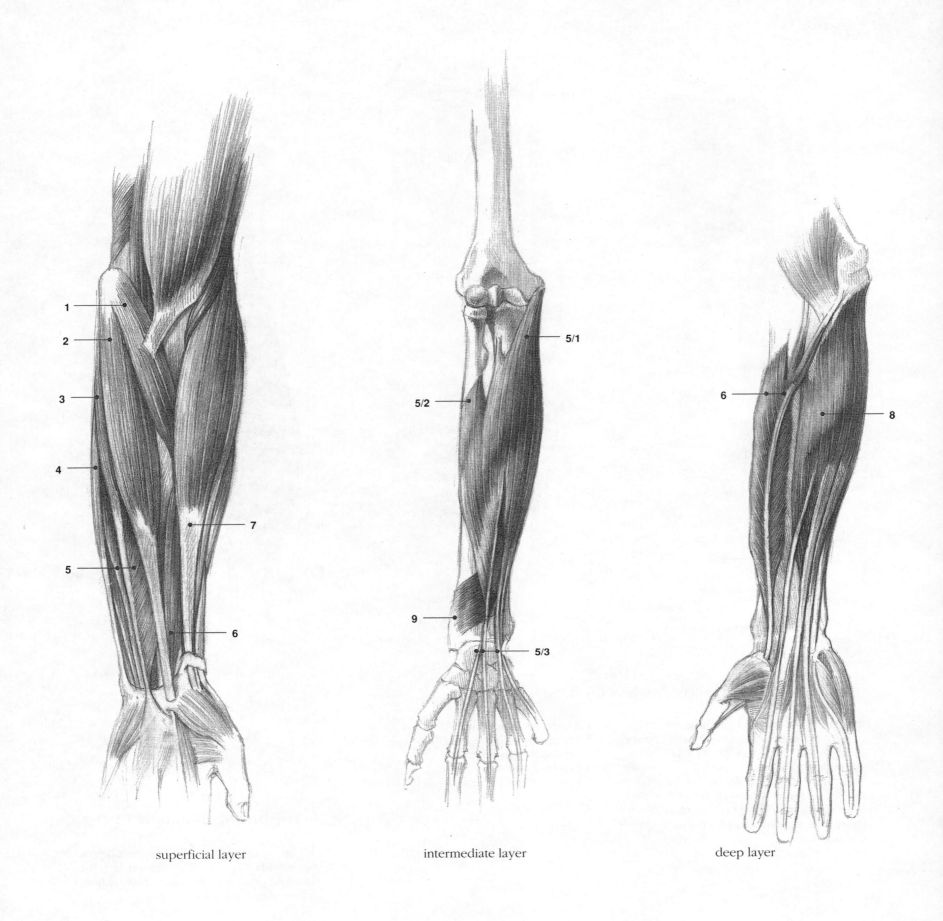

superficial layer

intermediate layer

deep layer

Fig. 58

The muscles of the forearm, palmar aspect

1 Pronator teres muscle *(55)*
2 Flexor carpi radialis muscle *(56)*
3 Palmaris longus muscle *(61)*
4 Flexor carpi ulnaris muscle *(57)*

5 Flexor digitorum superficialis muscle *(58)*
 5/1 humeral head
 5/2 radial head
 5/3 tendons

6 Flexor digiti Ist longus muscle *(60)*
7 Brachioradialis muscle *(63)*
8 Flexor digitorum profundus muscle *(59)*
9 Pronator quadratus muscle *(62)*

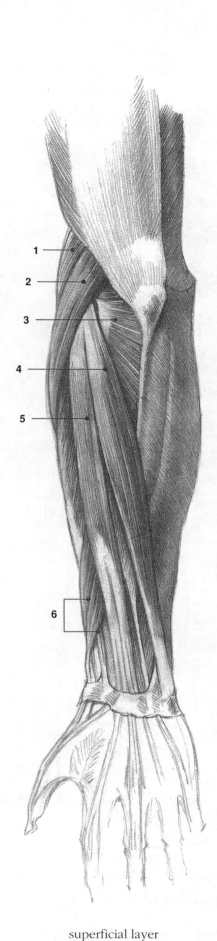

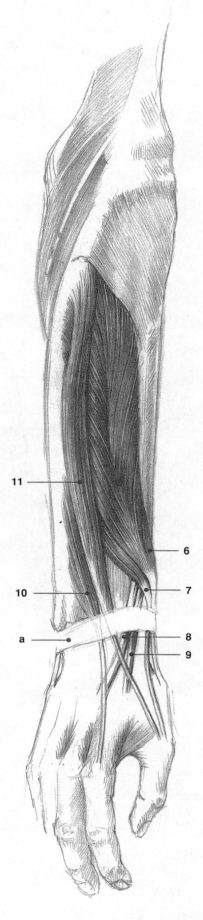

Fig. 59

The muscles of the forearm, dorsal aspect

1 Brachioradialis muscle *(63)*
2 Extensor carpi radialis muscle *(64)*
3 Anconeus muscle *(53)*
4 Extensor carpi ulnaris muscle *(65)*
5 Extensor digitorum communis muscle *(66)*
6 Abductor digiti Ist longus *(70)* and brevis *(76)* muscles
7 Extensor digiti Ist muscle *(71)*
8 Extensor carpi radialis brevis muscle *(64)*
9 Extensor carpi radialis longus muscle *(64)*
10 Extensor digiti IInd muscle *(72)*
11 Flexor digiti Ist longus muscle *(60)*

a) Extensor retinacular ligament

superficial layer

deep layer

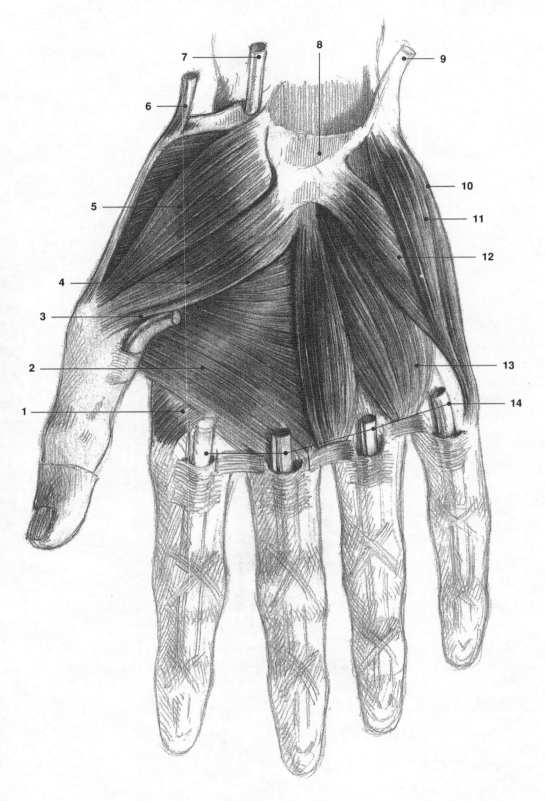

Fig. 60

The muscles of the hand, palmar aspect

The flat spindle-shaped muscles of the palm form a bilaterally convex and centrally concave surface. The muscles of the thumb bulge considerably.

1 Interosseus dorsalis digiti IInd muscle *(86)*
2 Adductor digiti Ist muscle, transverse part *(75)*
3 Adductor digiti Ist muscle, oblique part *(75)*
4 Flexor digiti Ist brevis muscle *(74)*
5 Abductor digiti Ist brevis muscle *(76)*
6 Abductor digiti Ist longus muscle *(70)*
7 Flexor carpi radialis muscle *(56)*
8 Transverse carpal ligament
9 Tendon of the flexor carpi ulnaris muscle *(57)*
10 Abductor digiti Vth muscle *(81)*
11 Flexor digiti Vth muscle *(82)*
12 Opponens digiti Vth muscle *(89)*
13 Lumbricalis muscles *(85)*
14 Tendons of the superficial and deep digital flexors *(58, 59)*

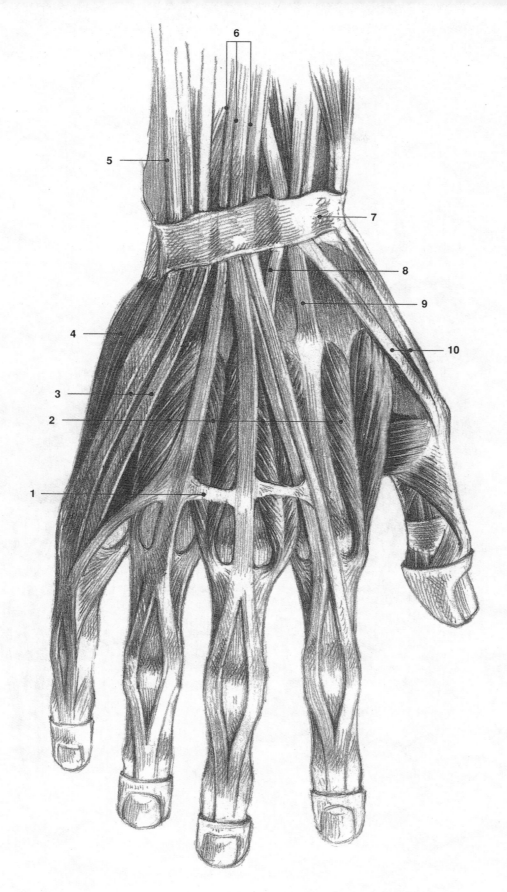

Fig. 61

The muscles of the hand, dorsal aspect

The muscles protrude only at the sides. The back of the hand is lean and tendinous, with the muscles situated between the bones.

1 The transverse ligament fastening the tendons together

2 Interosseus dorsalis muscle *(86)*
3 Extensor digiti Vth proprius muscle *(84)*
4 Abductor digiti Vth muscle *(81)*
5 Extensor carpi ulnaris muscle *(65)*
6 Extensor digitorum communis muscle *(66)*

7 Dorsal retinacular transverse carpal ligament
8 Extensor carpi radialis longus muscle *(64)*
9 Extensor carpi radialis brevis muscle *(64)*
10 Extensor digiti Ist longus and brevis muscles *(71)*

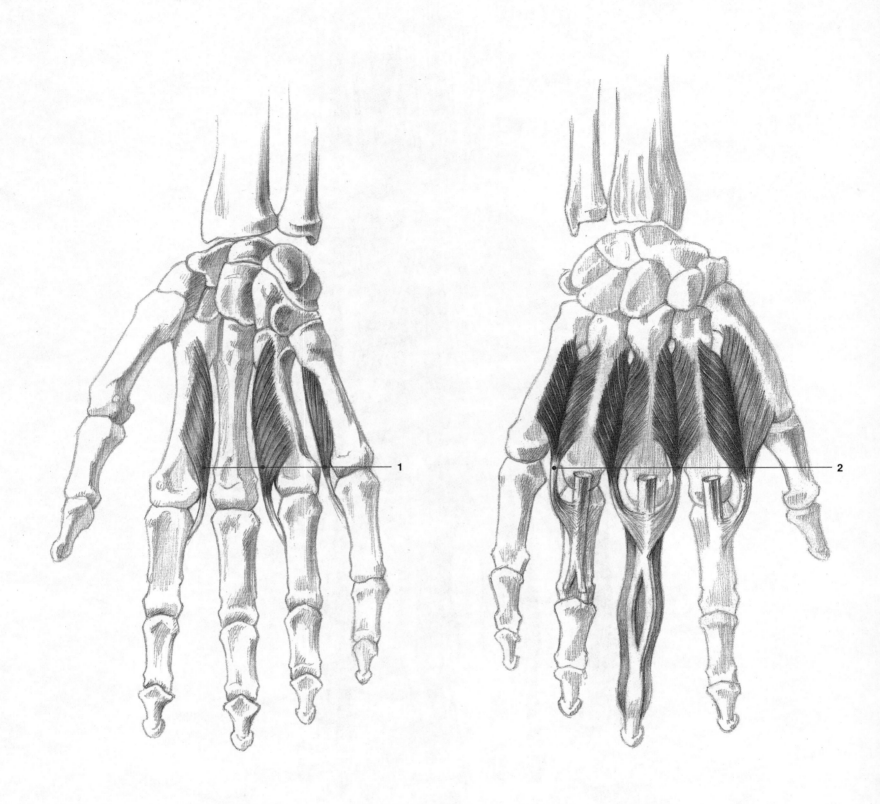

Fig. 62

The interosseus muscles, palmar aspect

1 The palmar interosseus muscles (right hand)
2 The dorsal interosseus muscles (left hand)

106

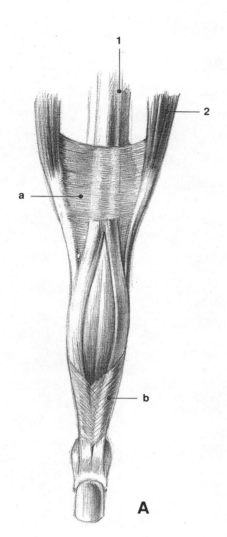

A

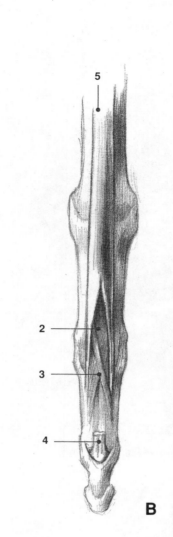

B

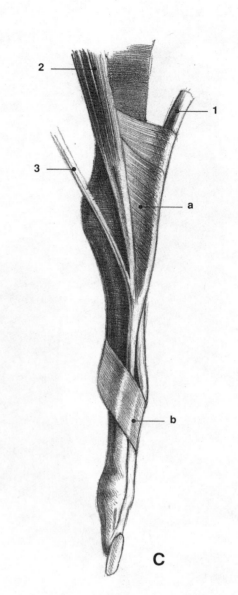

C

Fig. 63

The muscles of the IIIrd finger;
dorsal (A), palmar (B)
and lateral (C) aspects, and
(D) with spread tendons

1 Tendon of the extensor digitorum
 communis muscle *(66)*
2 Interosseus dorsalis muscles *(86)*
3 Lumbricalis muscles *(85)*
4 Tendon of the flexor digitorum
 profundus muscle *(59)*
5 Tendon of the flexor digitorum
 superficialis muscle *(58)*

a) Metacarpal cruciform fibres
b) Digital cruciform fibres

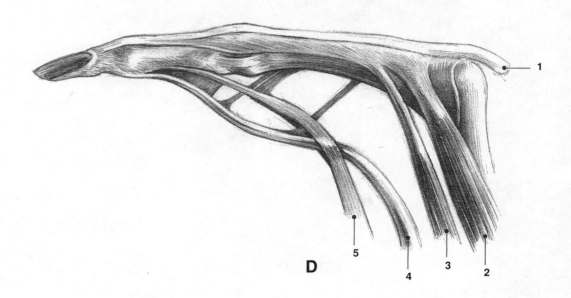

D

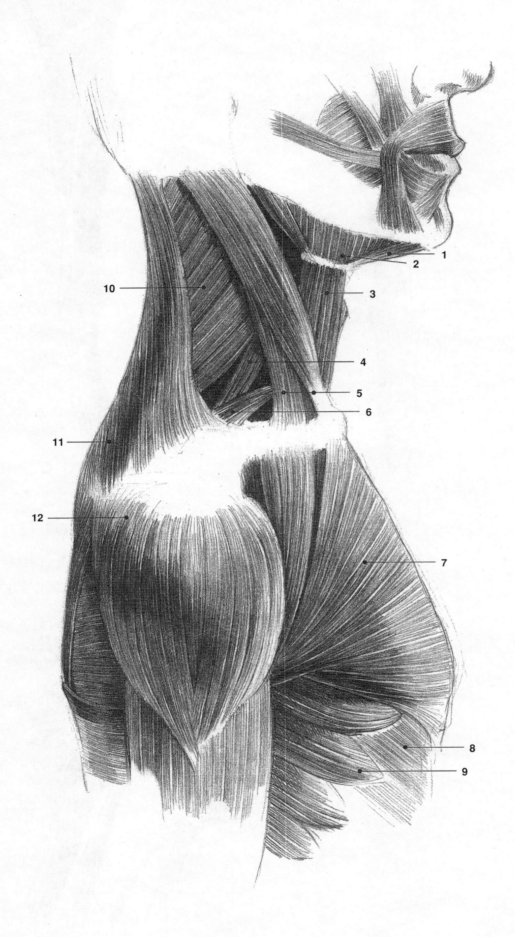

Fig. 64

The muscles of the neck and
shoulder, lateral aspect

 1 Biventer mandibulae muscle *(12)*
 2 Mylohyoideus muscle *(176)*
 3 Sternohyoideus muscle *(9)*
 4 Scalenus anterior muscle *(11/1)*
 5 Two heads of the
 sternocleidomastoideus muscle *(6)*
 6 Omohyoideus muscle *(10)*
 7 Pectoralis major muscle *(27/1)*
 8 Obliquus externus abdominis
 muscle *(36)*
 9 Serratus anterior muscle *(18)*
10 Splenius capitis et cervicis muscle *(5)*
11 Trapezius muscle *(14)*
12 Deltoideus muscle *(43)*

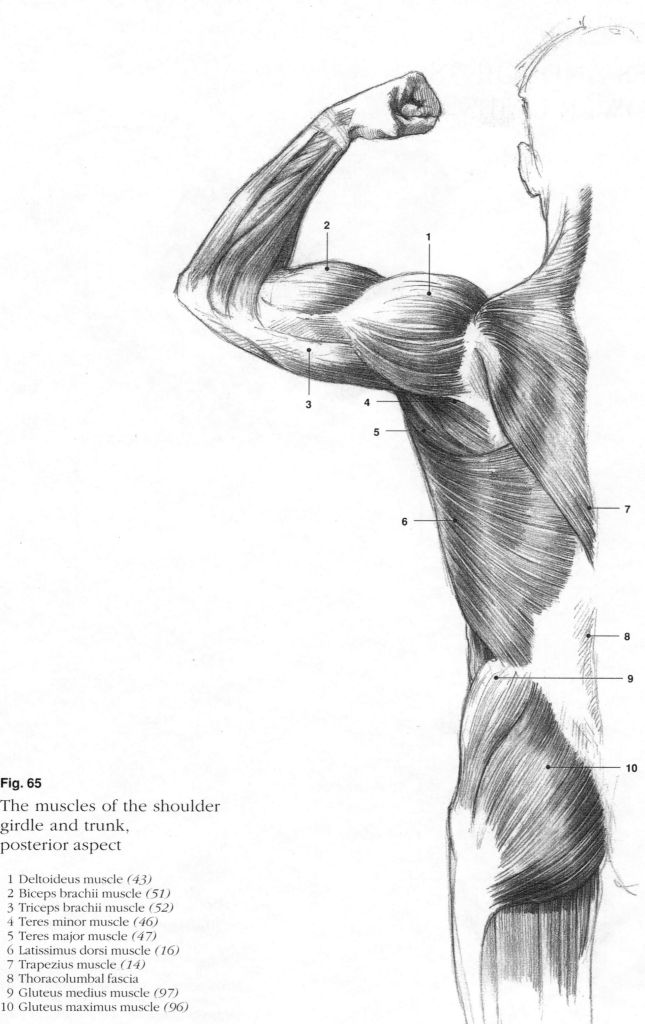

Fig. 65

The muscles of the shoulder girdle and trunk, posterior aspect

 1 Deltoideus muscle *(43)*
 2 Biceps brachii muscle *(51)*
 3 Triceps brachii muscle *(52)*
 4 Teres minor muscle *(46)*
 5 Teres major muscle *(47)*
 6 Latissimus dorsi muscle *(16)*
 7 Trapezius muscle *(14)*
 8 Thoracolumbal fascia
 9 Gluteus medius muscle *(97)*
10 Gluteus maximus muscle *(96)*

THE BONES AND JOINTS OF THE LOWER LIMBS

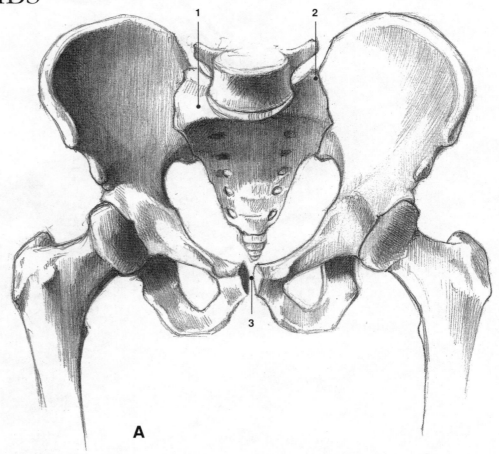

A

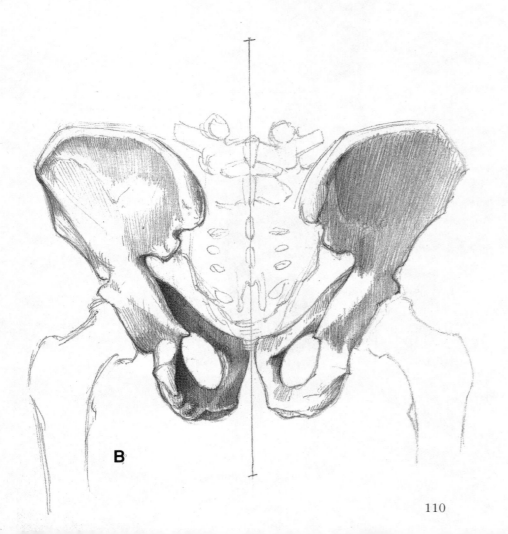

B

Fig. 66

The male pelvis; anterior (A) and posterior (B) aspects

The pelvic girdle bears the weight of the trunk. It is composed of the right and left hip bones, which are joined posteriorly by the sacrum (1) and the fixed coxosacral joints (2). Anteriorly the pelvic bones are rigidly connected at the pubic symphysis (3).

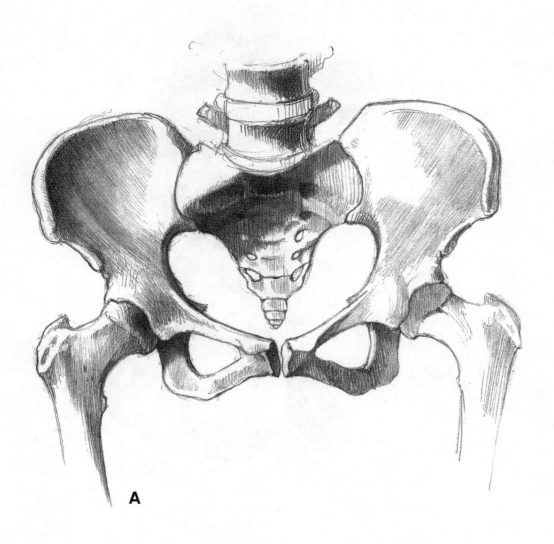

A

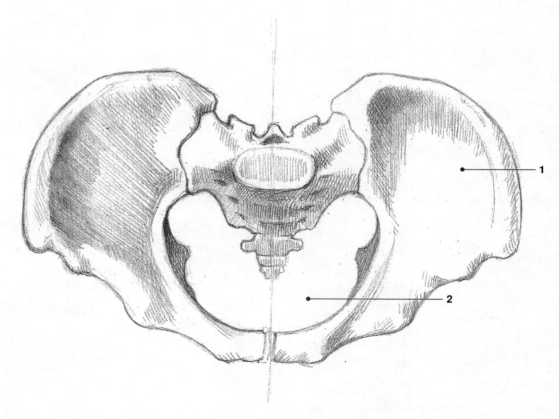

B

Fig. 67

Female pelvis; anterior (A) and
superior (B) aspects

The greater pelvis (1) forms the lower
border of the abdominal cavity and is open
anteriorly. The lesser pelvis is the cavity of
the complete bony ring (2), or birth canal.
Its entrance is inclined anteriorly. The
female pelvis is broader than that of the
male.

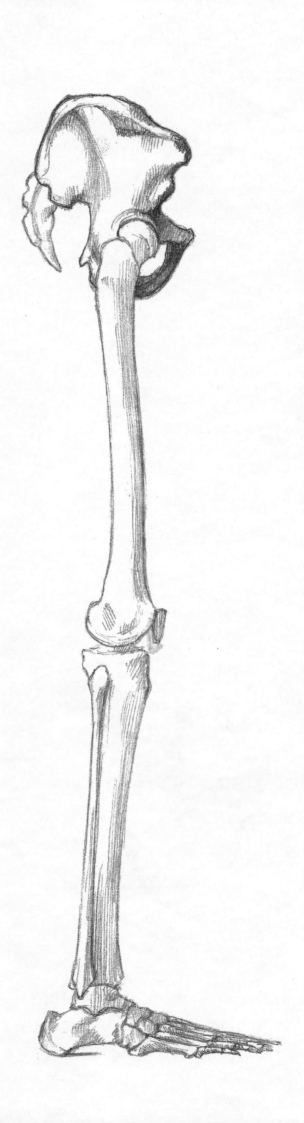

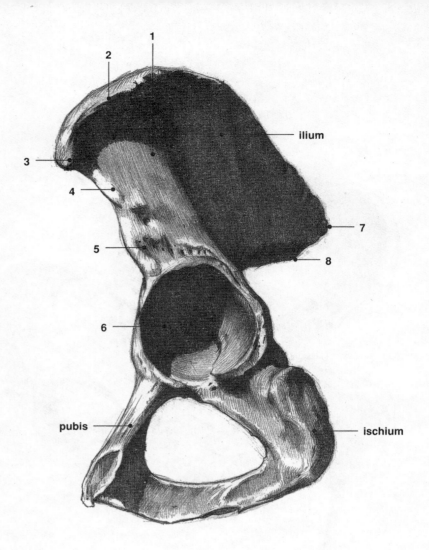

Fig. 68

The hipbone, lateral aspect

The hipbone consists of the ilium, pubis and ischium.
The ilium is flat and triangular (1), convex on the outer surface and concave on the inner. The superior border is the S-shaped iliac crest (2). At the antero-lateral end of this is the anterior superior iliac spine (3). Below this, on the body of the ilium is the anterior inferior iliac spine (4). In the articular cavity (acetabulum) (6) the body of the ilium (5), is fused with the pubis and the ischium. At the posterior end of the iliac crest the posterior superior iliac spine (7) and posterior inferior iliac spine (8) are clearly visible.

Fig. 69

The hipbone; anterior (A),
posterior (B) and medial (C)
aspects

A

On the anterior part of the body of the
pubis (1) is the pubic crest (2). The inferior
ramus of the pubis (3) joins that of the op-
posite side in a cartilaginous and later ossi-
fied symphysis (4). On the upper ramus
(5) the iliopubic eminence (6) and the
pecten (7) can be seen. The pubis borders
the obturator foramen (8).

B

The body of the ischium forms the articular
cavity (1). The ramus (2) ends in the ischial
tuberosity (3). The protruding crest is the
ischial spine (4).

C

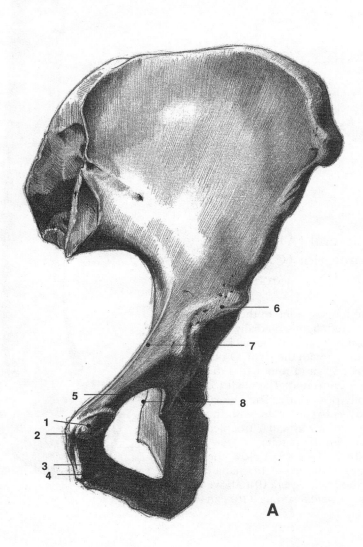

A

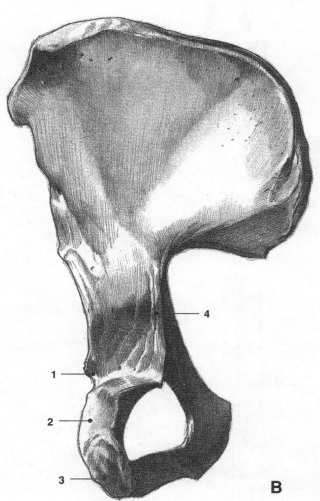

B

Fig. 70

The femur; lateral (A),
medial (B), anterior (C)
and posterior (D) aspects

The femur is the longest bone in the body
and its axis is directed slightly medially. The
head (1) is hemispherical, and the neck (2)
forms an angle of 45° with the shaft. On its
trochanters (major (3) and minor (4)) the
gluteal muscles are inserted. The shaft (5)
is inclined slightly posteriorly. The medial
and lateral condyles (6) articulate with the
tibia, while the anterior articular trochlea
(7) forms a joint with the patella.
On the posterior surface (8) below the
greater trochanter is the lesser trochanter
and below this the linea aspera (9). Above
the condyles the popliteal surface (10) can
be seen.

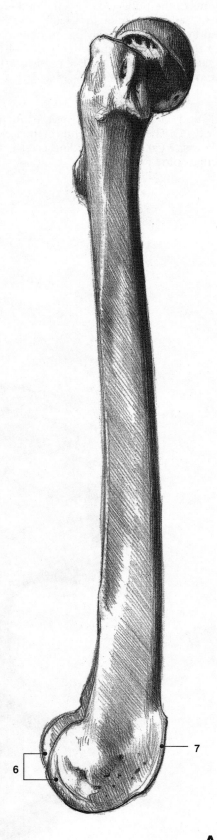

A

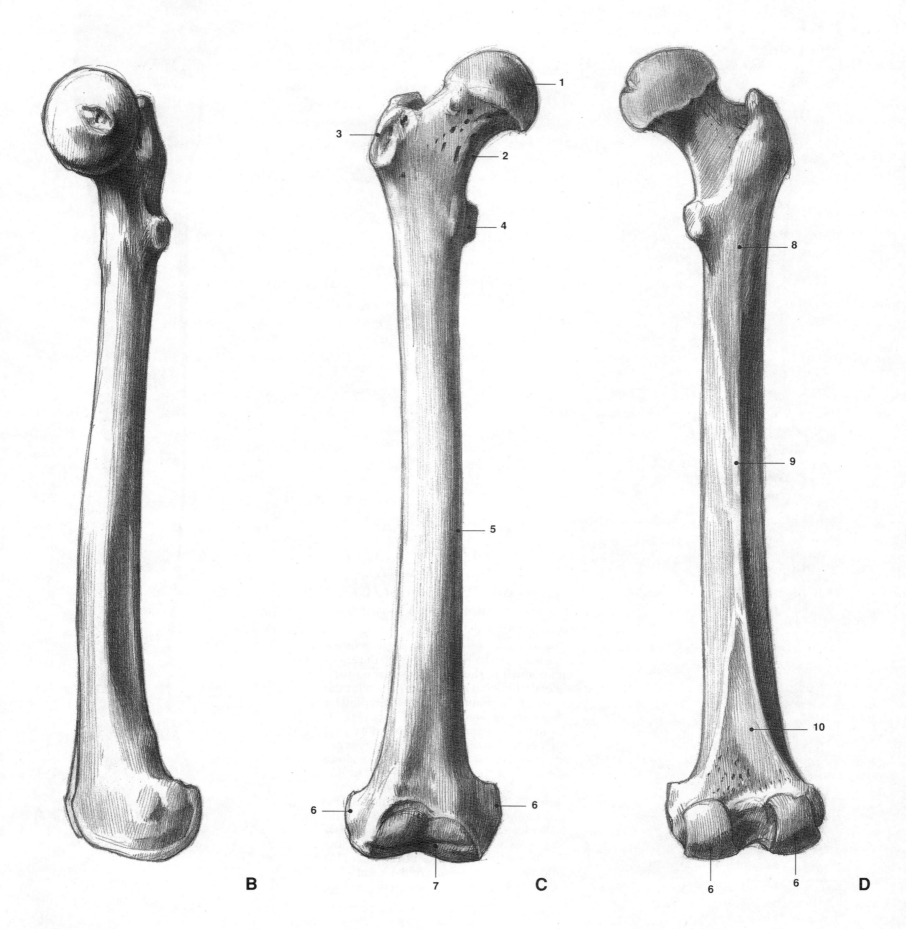

B

C

D

Fig. 71

The tibia; lateral (A),
medial (B), anterior (C)
and posterior (D) aspects

The tibia has two flat condyles at its proximal end (1) which articulate with the femoral condyles. The articular surface of the lateral condyle (2) forms a joint with the head of the fibula. On the intercondylar eminence between the two condyles (3) the inner ligaments of the femoro-tibial joint are inserted. From the tuberosity on its anterior surface (4) a bony crest (5) runs along the shaft of the bone (6). Medial to this crest the bone lies immediately below the skin (7). The medial prominence at the distal end of the bone is the medial malleolus (8). The distal end of the fibula articulates with the distal end of the tibia (9). The articular surface of the tibia (10) articulates with the talus of the tarsal joint.

A

116

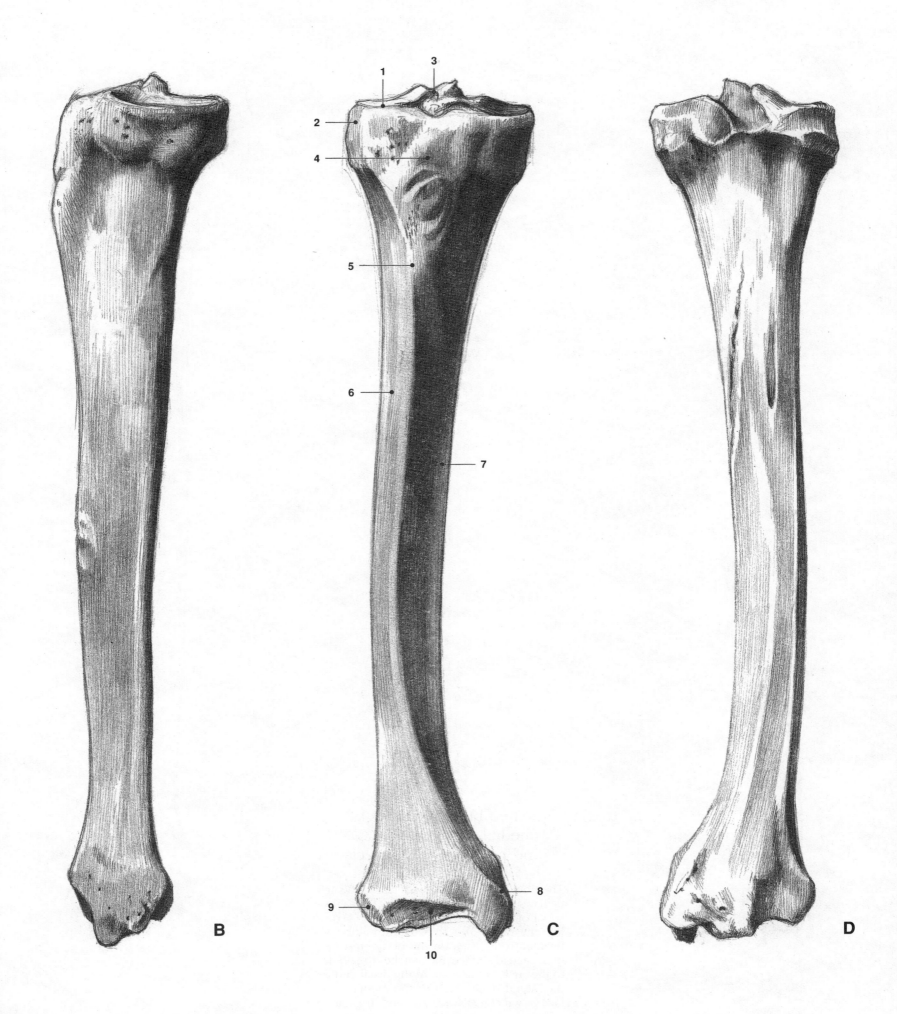

B

C

D

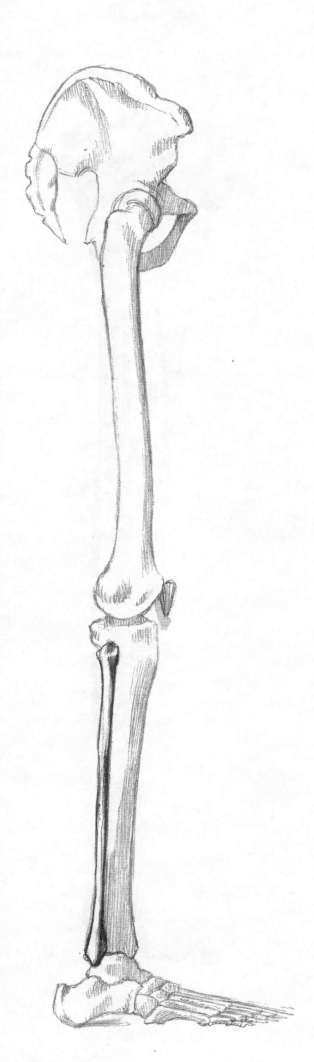

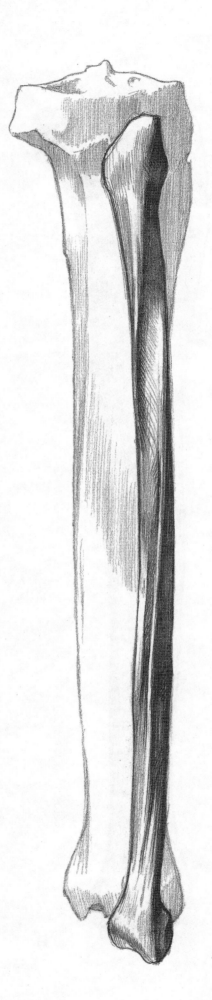

Fig. 72

The fibula; lateral (A),
medial (B), anterior (C)
and posterior (D) aspects

The fibula is thinner than the tibia. The articular surface (2) of its head (1) forms the superior tibio-fibular joint. The shaft (4) below the neck (3) is thin. The tibio-fibular ligament originates on the bony crest (5) of its medial surface and attaches the fibula to the shaft of the tibia. At the distal end is the lateral malleolus (6), the medial surface of which (7) articulates with the talus.

A

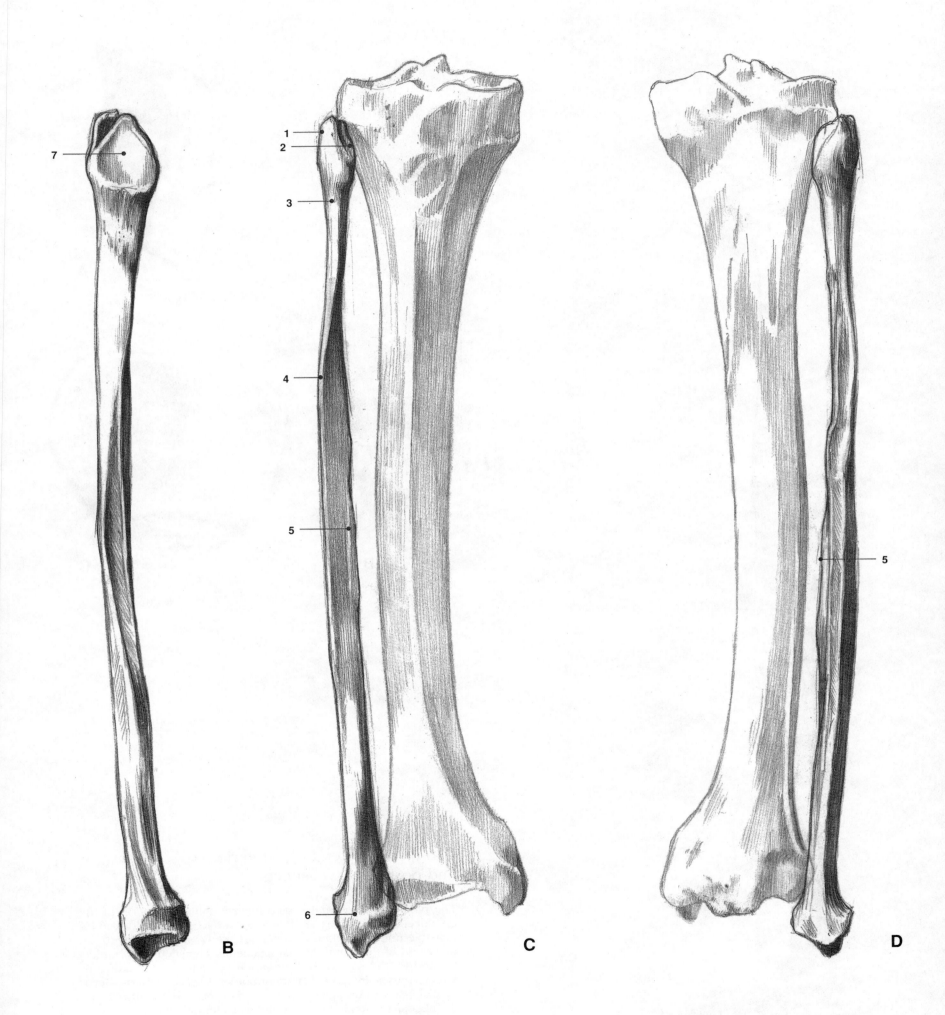

B

C

D

119

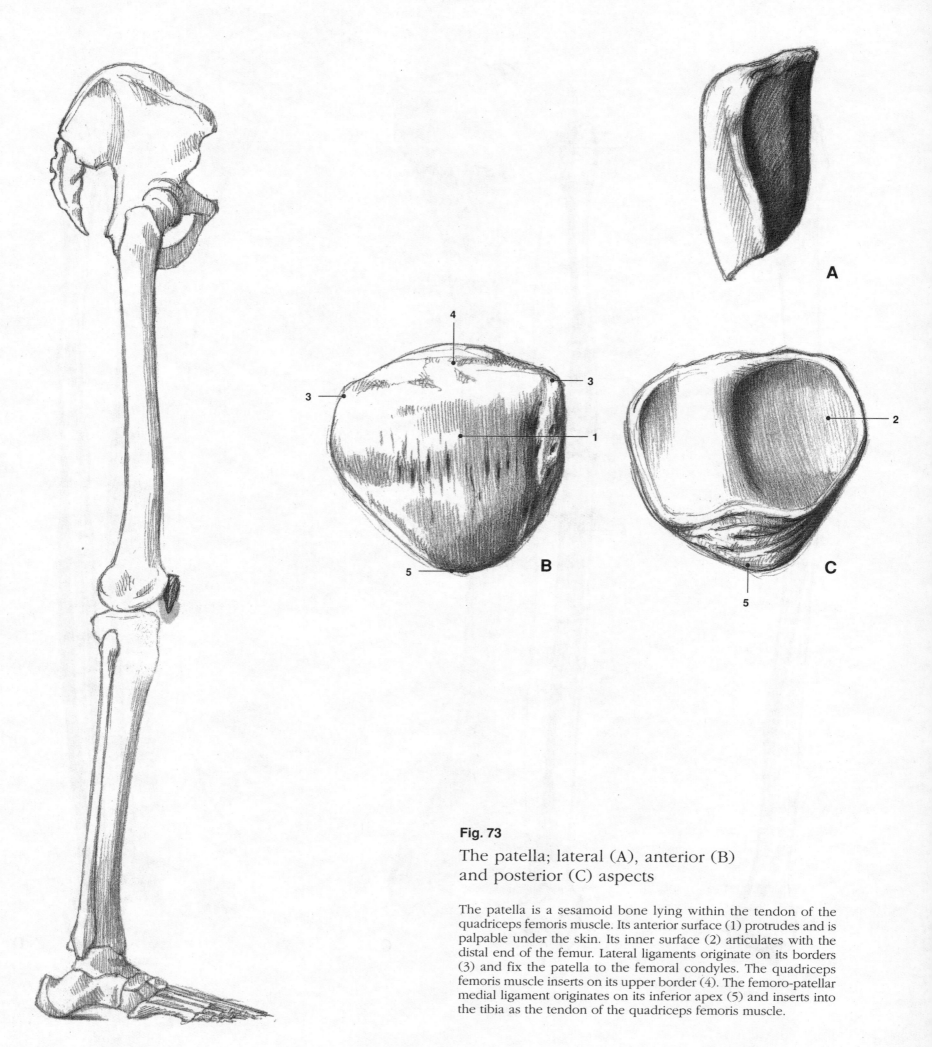

Fig. 73

The patella; lateral (A), anterior (B) and posterior (C) aspects

The patella is a sesamoid bone lying within the tendon of the quadriceps femoris muscle. Its anterior surface (1) protrudes and is palpable under the skin. Its inner surface (2) articulates with the distal end of the femur. Lateral ligaments originate on its borders (3) and fix the patella to the femoral condyles. The quadriceps femoris muscle inserts on its upper border (4). The femoro-patellar medial ligament originates on its inferior apex (5) and inserts into the tibia as the tendon of the quadriceps femoris muscle.

Fig. 74

The ligaments of the hip joint,
anterior aspect

1 Articular capsule
2 Hip joint
3 Pubofemoral ligament
4 Ligament of the obturator foramen
5 Ischiofemoral ligament
6 Coxofemoral ligament

a) Anterior superior iliac spine
b) Anterior inferior iliac spine
c) Pecten of the pubis
d) Ischial tuberosity
e) Trochanteric crest between
 the femoral trochanters
f) Greater trochanter of the femur

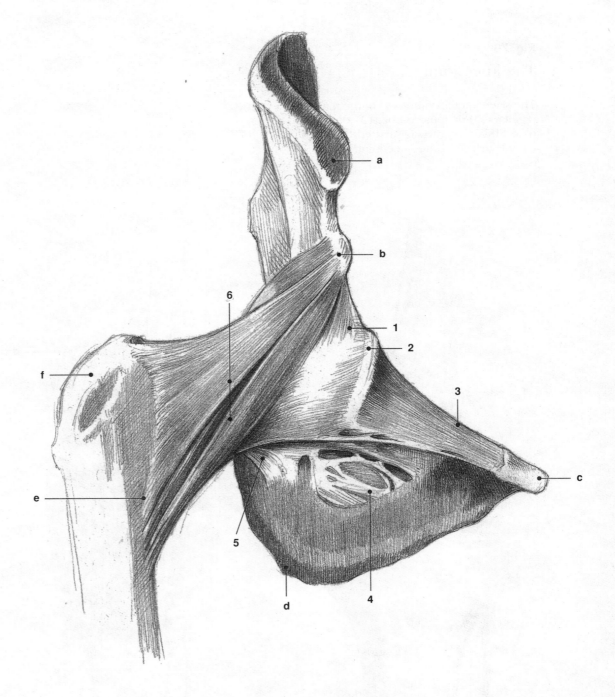

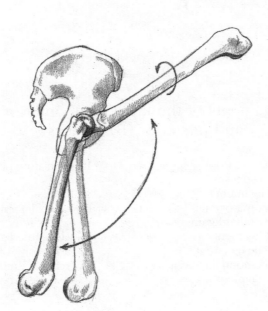

Fig. 75

Movement of the hip joint, lateral aspect

The limb swings forward and backward around the hip joint. Adduction and abduction are limited, and depend on the depth of the articular fossa.

Fig. 76

The knee joint

The knee joint is composed of the femoro-patellar (1) and femoro-tibial (2) joints. The tibio-fibular joint (3) is situated below the lateral surface of the knee joint.

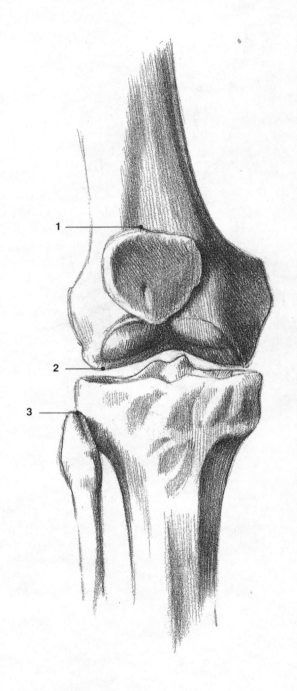

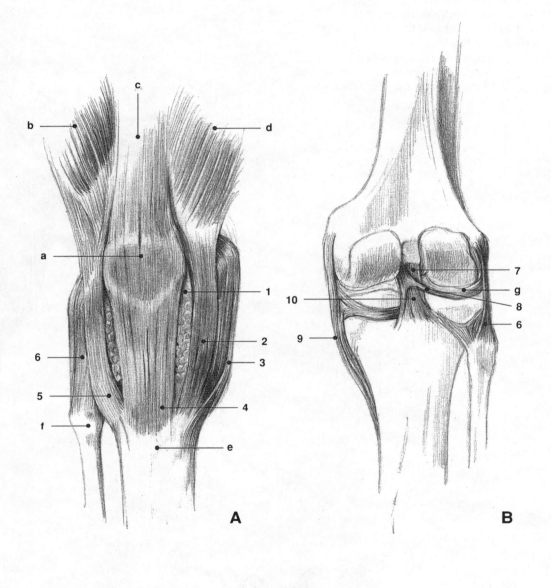

Fig. 77

The ligaments of the knee joint; anterior (A) and posterior (B) aspects

1 Articular capsule
2 Medial straight ligament
3 Inner collateral ligament
4 Intermediate straight patellar ligament
5 Lateral straight patellar ligament
6 Outer collateral ligament
7 Cruciatum craniale ligament
8 Lateral meniscofemoral ligament
9 Inner collateral ligament

10 Cruciatum posterior ligament

a) Patella
b) Vastus lateralis muscle *(112/4)*
c) Rectus femoris muscle *(112/1)*
d) Vastus medialis muscle *(112/2)*
e) Tuberosity of the tibia
f) Head of the fibula
g) C-shaped meniscus

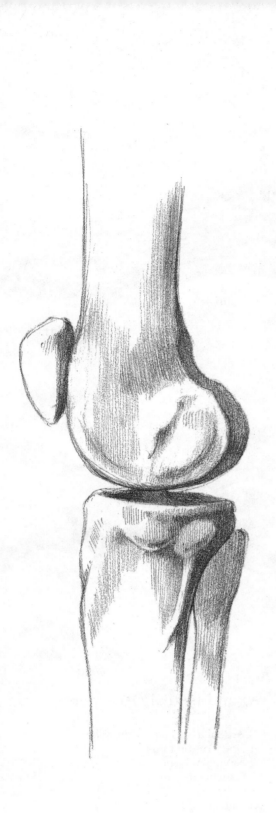

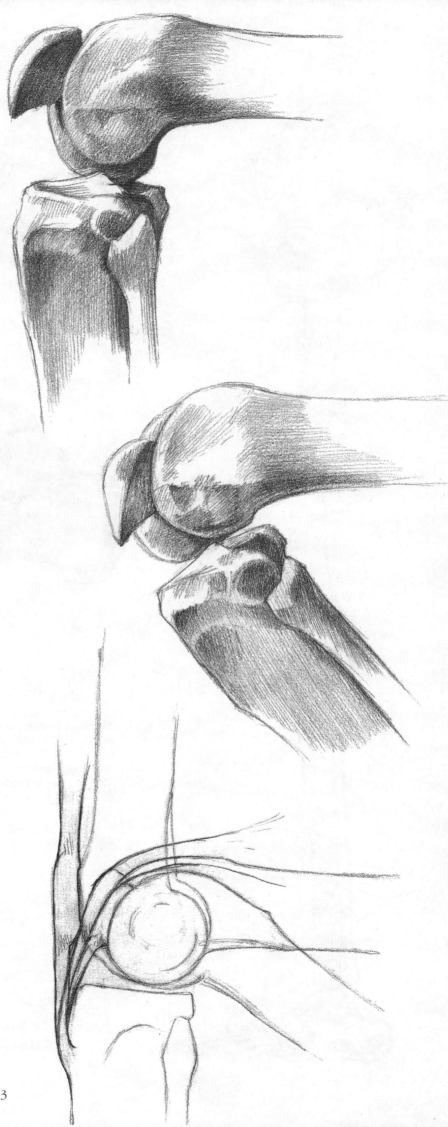

Fig. 78

Movement of the knee joint, lateral aspect

Viewed from the side, the thigh and lower leg are perpendicular
when the knee joint is extended. The C-shaped cartilages compen-
sate for incongruities in the articular surfaces of the femur and
tibia. The patella is located above the condyles of the femur.
During flexion the patella glides up and down on the articular
surface of the femur. The distance between the condyle of the tibia
and the patella remains constant. The tibia and the fibula do not
move relative to each other.

123

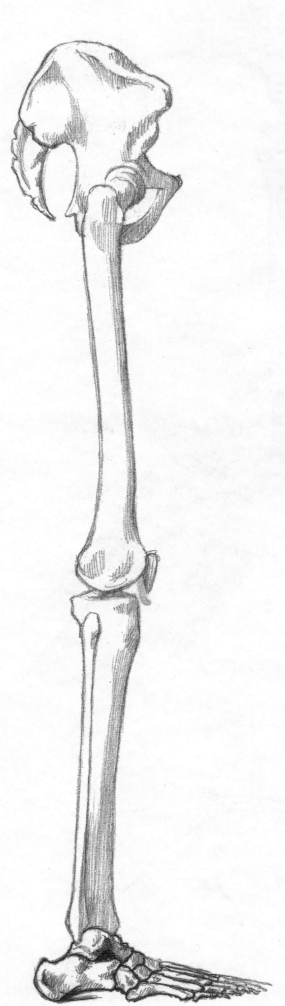

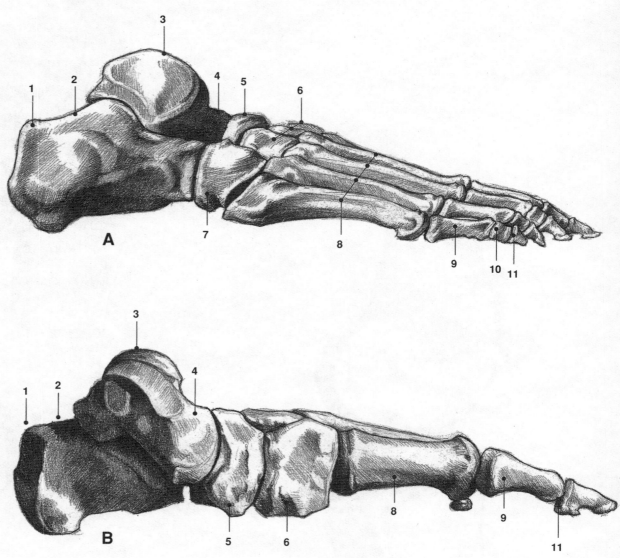

Fig. 79

The bones of the foot; lateral (A) and medial (B) aspects

The foot is composed of the bones of the tarsus (1–7), the metatarsus (8) and the phalanges (9–11). They bear the weight of the body and are correspondingly large. The big toe is twice as thick as the others and has only two phalanges.

1 Tuberosity of the calcaneum
2 Calcaneum

3 Articular surface of the talus
4 Body of the talus
5 Navicular bone
6 Cuneiform bones
7 Cuboid
8 Metatarsals
9 Proximal phalanx
10 Middle phalanx
11 Distal phalanx (nail bone)

Fig. 80

The phalangeal bones
of the IInd–IVth toes

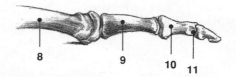

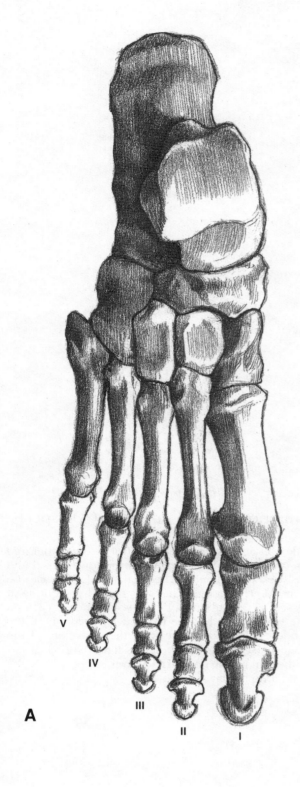

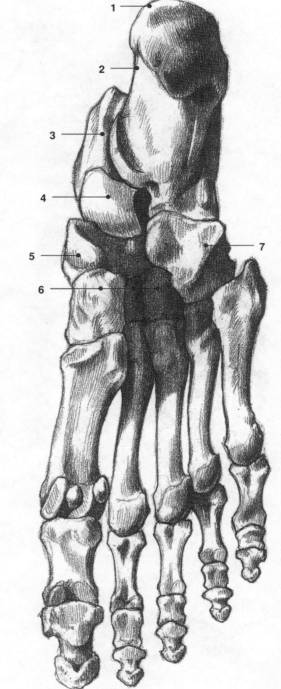

Fig. 81

The bones of the foot; dorsal (A) and plantar (B) aspects

1 Tuberosity of the calcaneum 5 Navicular bone
2 Calcaneum 6 Cuneiform bones
3 Talus 7 Cuboid
4 Body of the talus

Ist–Vth toes

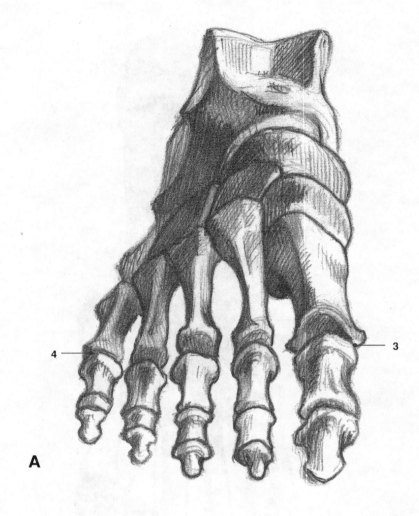

A

B

Fig. 82

The foot; anterior (A) and posterior (B) aspects

The extent of flexion and extension is greatest in the upper and lower (1) joints of the tarsus. Movements of the lower tarsal and metatarsal joints are rather limited. The phalangeal joints can be flexed and extended. The foot touches the ground posteriorly at the two processes of the tuberosity of the calcaneum (2) and anteriorly at the base of the big toe (3) and little toe (4). If the weight of the body is loaded on the foot, the convexity of the metatarsus (5) decreases. The foot behaves like a spring: it becomes flat and then arches again. This action is supported by the anterior tibial and long fibular muscles.

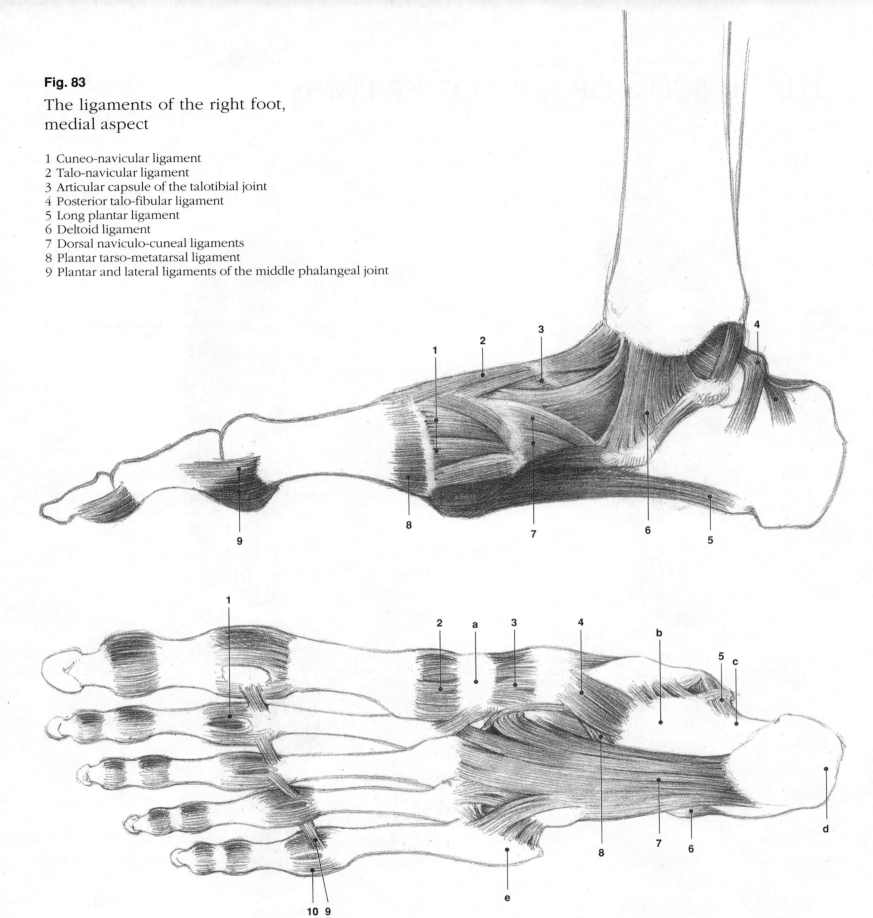

Fig. 83

The ligaments of the right foot, medial aspect

1 Cuneo-navicular ligament
2 Talo-navicular ligament
3 Articular capsule of the talotibial joint
4 Posterior talo-fibular ligament
5 Long plantar ligament
6 Deltoid ligament
7 Dorsal naviculo-cuneal ligaments
8 Plantar tarso-metatarsal ligament
9 Plantar and lateral ligaments of the middle phalangeal joint

Fig. 84

The ligaments of the foot, plantar aspect

1 Plantar ligaments of digiti IInd
2 Plantar tarso-metatarsal ligament
3 Cuneo-navicular ligament
4 Calcaneo-navicular ligament
5 Inner collateral ligament
6 Calcaneo-tibial ligament

7 Long plantar ligament
8 Calcaneo-cuboidal ligament
9 Deep transverse (interdigital) ligament
10 Collateral ligaments of the IInd digital joints

a) Medial cuneiform bone
b) Sustentaculum tali
c) Tendinous fossa
d) Calcanean tuber
e) Dorsal metatarsal tubercle of digiti Vth

THE MUSCLES OF THE LOWER LIMBS

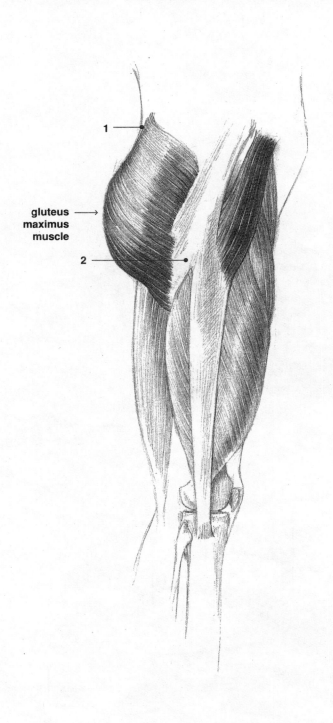

gluteus → maximus muscle

1

2

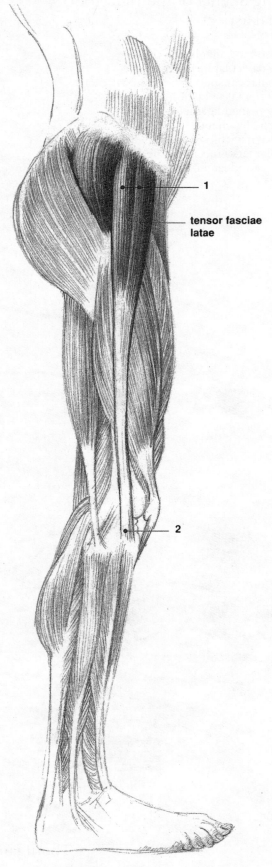

tensor fasciae latae

1

2

Fig. 85

The gluteal muscles

The gluteus maximus muscle *(96)*
Origin: on the ala and crest of the ilium, the sides of the sacrum and the coccygeal bones as a tendinous lamina. Covering the gluteus medius muscle, it is inserted into the fascia lata and the gluteal tuberosity of the femur. It swings the body forward by pulling the thigh backwards.

The tensor fasciae latae muscle *(95)*
Origin: on the anterior superior iliac spine. Its tendon joins the fascia lata and then inserts into the upper end of the fibula. Its function is to flex and abduct the hip joint.
1 Origin
2 Insertion

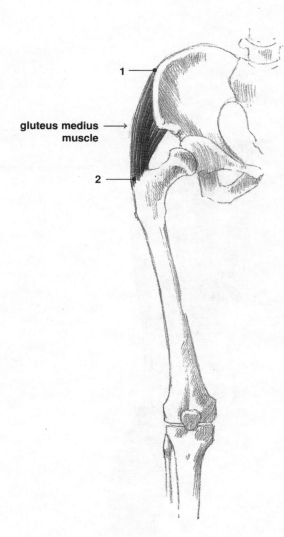

gluteus medius
muscle

1

2

The gluteus medius muscle *(97)*
Origin: on the ala of the ilium. Insertion: into the lateral surface of the greater trochanter. It abducts and rotates the thigh medially, and is very important in walking, when it tilts the pelvis to the supported side of the body. It also fixes the hip joint laterally.

1 Origin
2 Insertion

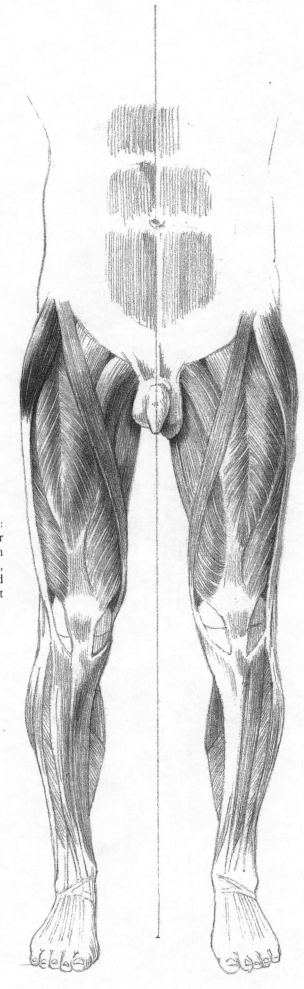

Fig. 86

The posterior gluteal muscles; lateral (A), medial (B) and posterior (C) aspects

The biceps femoris muscle *(106)*
Origins: the long head on the ischial tuberosity, the short one on the posterior surface of the femur. Insertion: into the head of the fibula. Function: it flexes the knee joint and slightly rotates the foot laterally.

The semitendinosus muscle *(107)*
Origin: on the ischial tuberosity. Insertion: into the medial surface of the proximal end of the tibia. Function: it flexes and rotates the knee joint medially.

The semimembranosus muscle *(108)*
Origin: on the ischial tuberosity. Insertion: into the medial condyle of the tibia. Function: it extends the knee joint and rotates the limb medially, pushing the trunk forward.

1 Origin
2 Insertion

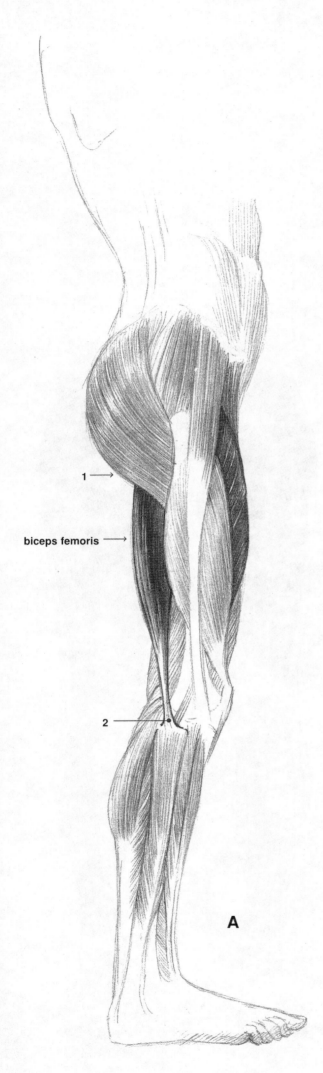

biceps femoris

A

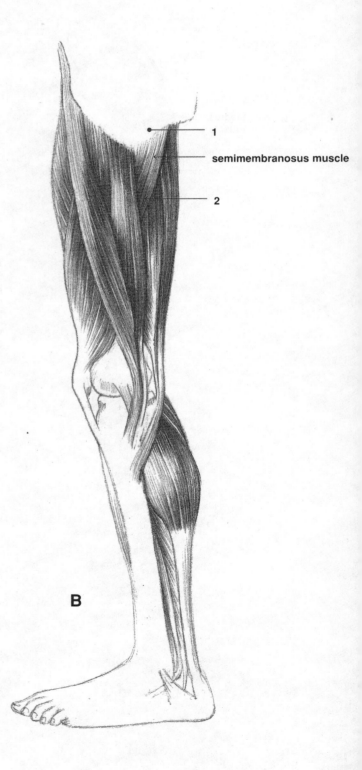

semimembranosus muscle

B

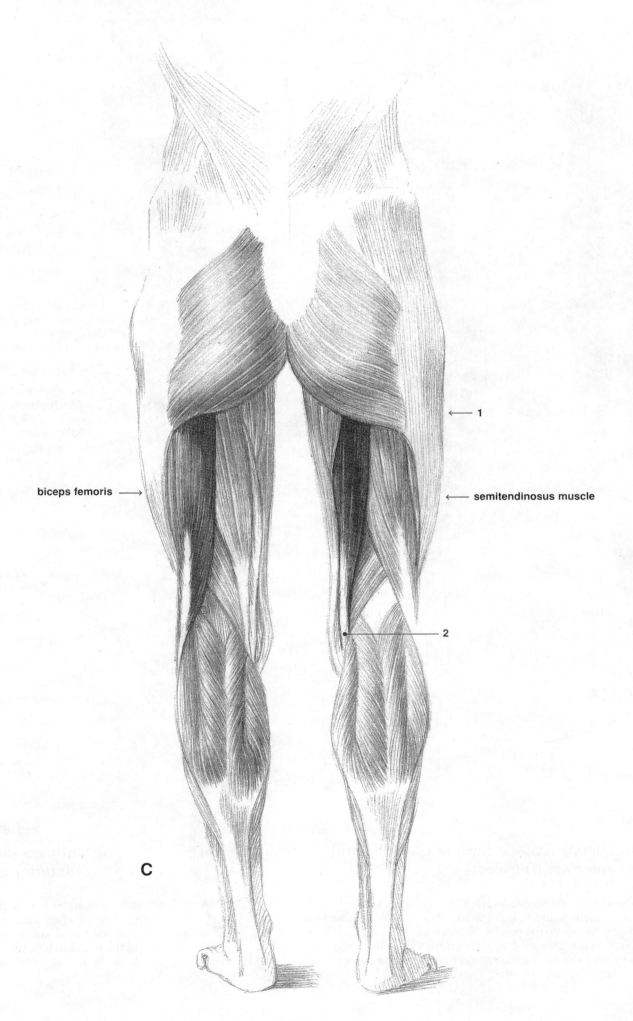

biceps femoris →

← semitendinosus muscle

← 1

• 2

C

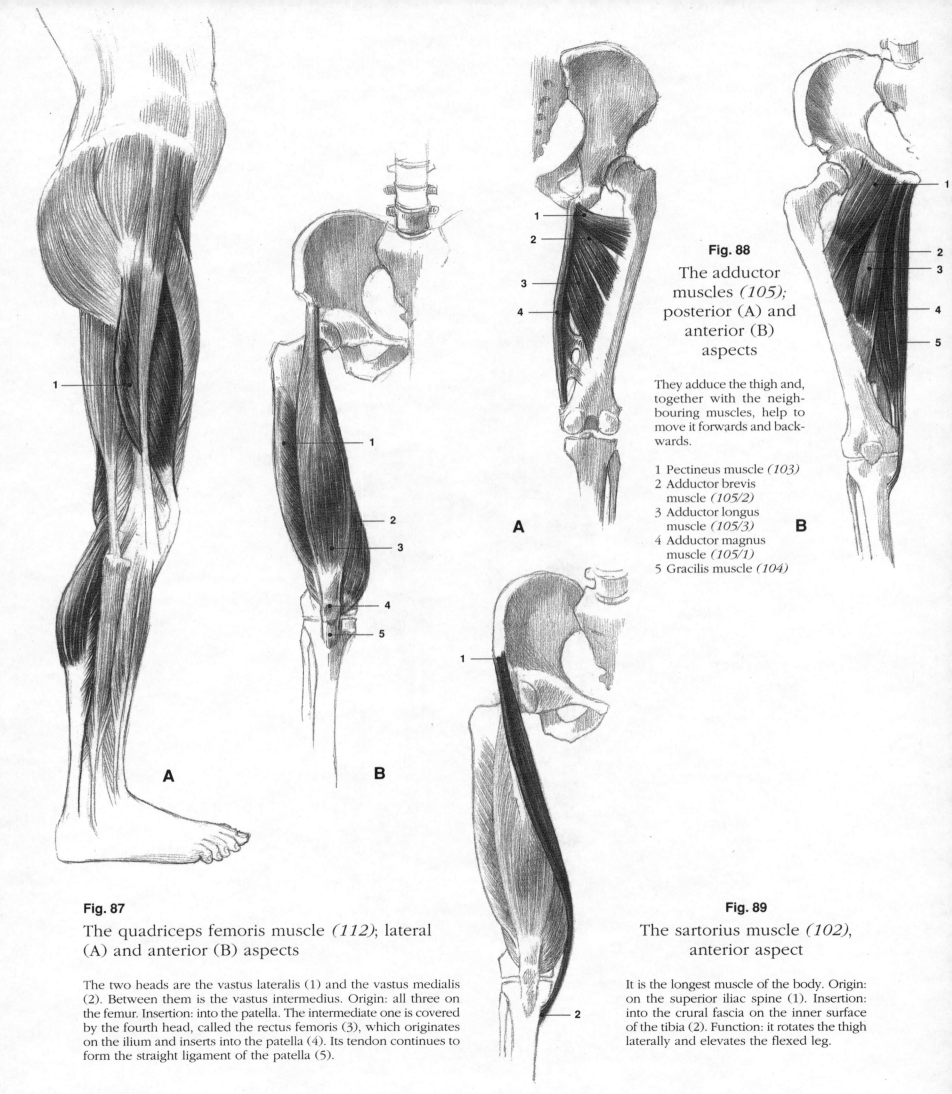

Fig. 88

The adductor muscles *(105)*; posterior (A) and anterior (B) aspects

They adduce the thigh and, together with the neighbouring muscles, help to move it forwards and backwards.

1 Pectineus muscle *(103)*
2 Adductor brevis muscle *(105/2)*
3 Adductor longus muscle *(105/3)*
4 Adductor magnus muscle *(105/1)*
5 Gracilis muscle *(104)*

A

B

Fig. 87

The quadriceps femoris muscle *(112)*; lateral (A) and anterior (B) aspects

The two heads are the vastus lateralis (1) and the vastus medialis (2). Between them is the vastus intermedius. Origin: all three on the femur. Insertion: into the patella. The intermediate one is covered by the fourth head, called the rectus femoris (3), which originates on the ilium and inserts into the patella (4). Its tendon continues to form the straight ligament of the patella (5).

Fig. 89

The sartorius muscle *(102)*, anterior aspect

It is the longest muscle of the body. Origin: on the superior iliac spine (1). Insertion: into the crural fascia on the inner surface of the tibia (2). Function: it rotates the thigh laterally and elevates the flexed leg.

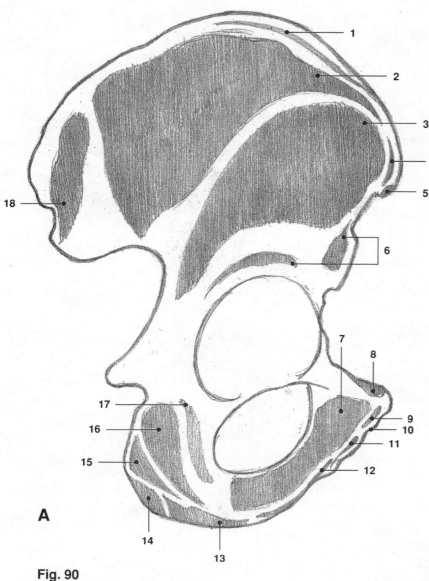

A

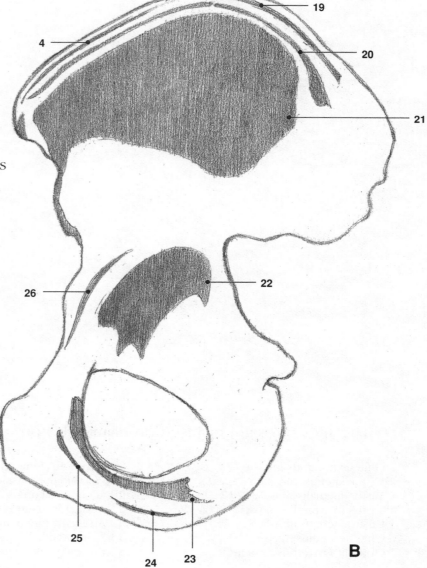

B

Fig. 90

The sites of origin or insertion of muscles
on the hipbone; lateral (A) and medial (B) aspects

1 Obliquus externus abdominis muscle *(36)*
2 Gluteus medius muscle *(97)*
3 Gluteus profundus muscle *(100)*
4 Tensor fasciae latae muscle *(95)*
5 Sartorius muscle *(102)*
6 Rectus femoris muscle *(112/1)*
7 Adductor longus muscle *(105/3)*
8 Pectineus muscle *(103)*
9 Rectus abdominis muscle *(39)*
10 Pyramidalis muscle *(42)*
11 Adductor brevis muscle *(105/2)*
12 Adductor parvus muscle *(105)*
13 Adductor magnus muscle *(105/1)*
14 Semitendinosus muscle *(107)*
15 Biceps femoris muscle *(106)*
16 Semimembranosus muscle *(108)*
17 Quadratus femoris muscle *(110)*
18 Gluteus maximus muscle *(96)*
19 Quadratus lumborum muscle *(94)*
20 Obliquus internus abdominis muscle *(37)*
21 Iliacus muscle *(92)*
22 Obturator internus muscle
23 Transversus perinei muscle
24 Levator ani muscle
25 Pectineus muscle *(103)*
26 Transversus abdominis muscle *(38)*

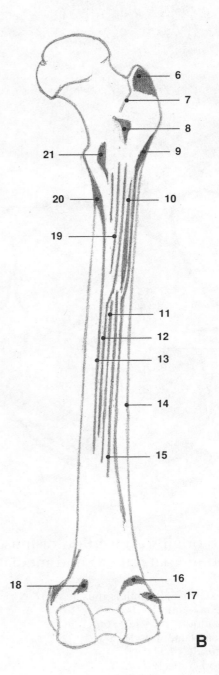

A

B

Fig. 91

The sites of origin or insertion of muscles on the femur; anterior (A) and posterior (B) aspects

1 Gluteus minimus muscle *(100)*
2 Vastus lateralis muscle *(112/4)*
3 Vastus medialis muscle *(112/2)*
4 Vastus intermedius muscle *(112/3)*
5 Gastrocnemius muscle *(115)*
6 Gluteus medius muscle *(97)*
7 Obturator externus muscle

8 Quadratus femoris muscle *(110)*
9 Psoas major muscle *(93)*
10 Gluteus maximus muscle *(96)*
11 Adductor magnus muscle *(105/1)*
12 Adductor longus muscle *(105/3)*
13 Vastus medialis muscle *(112/2)*
14 Biceps femoris muscle *(106)*

15 Vastus lateralis muscle *(112/4)*
16 Popliteus muscle *(113)*
17 Gastrocnemius muscle *(115)*
18 Adductor brevis muscle *(105/2)*
19 Pectineus muscle *(103)*
20 Iliacus muscle *(92)*
21 Psoas major muscle *(93)*

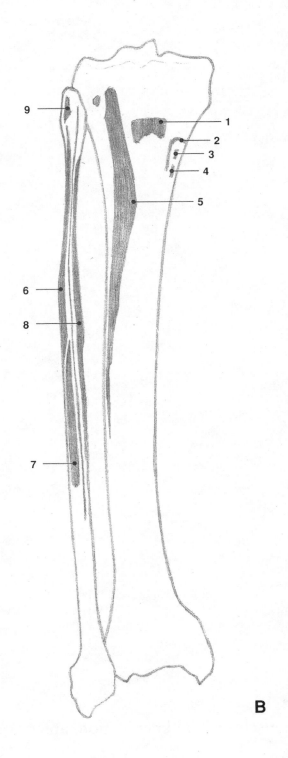

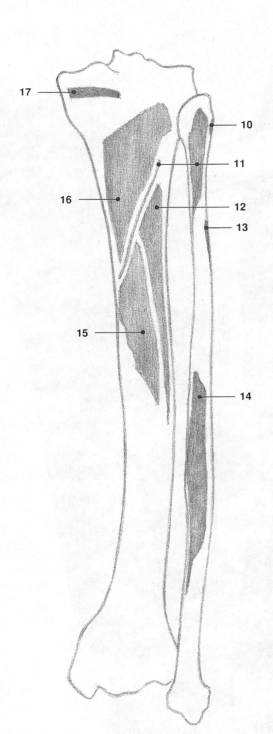

Fig. 92

The sites of origin or insertion of muscles on the tibia and fibula;
anterior (A) and posterior (B) aspects

1 Quadriceps femoris muscle *(112)*
2 Sartorius muscle *(102)*
3 Gracilis muscle *(104)*
4 Semitendinosus muscle *(107)*
5 Tibialis anterior muscle *(117)*
6 Extensor digitorum longus muscle *(118)*

7 Peroneus brevis muscle *(121/1)*
8 Tibialis posterior muscle *(126)*
9 Peroneus longus muscle *(121)*
10 Biceps femoris muscle *(106)*
11 Soleus muscle *(116)*
12 Tibialis posterior muscle *(126)*

13 Peroneus longus muscle *(121)*
14 Flexor digiti Ist muscle *(124/1)*
15 Flexor digitorum longus muscle *(125)*
16 Popliteus muscle *(113)*
17 Semimembranosus muscle *(108)*

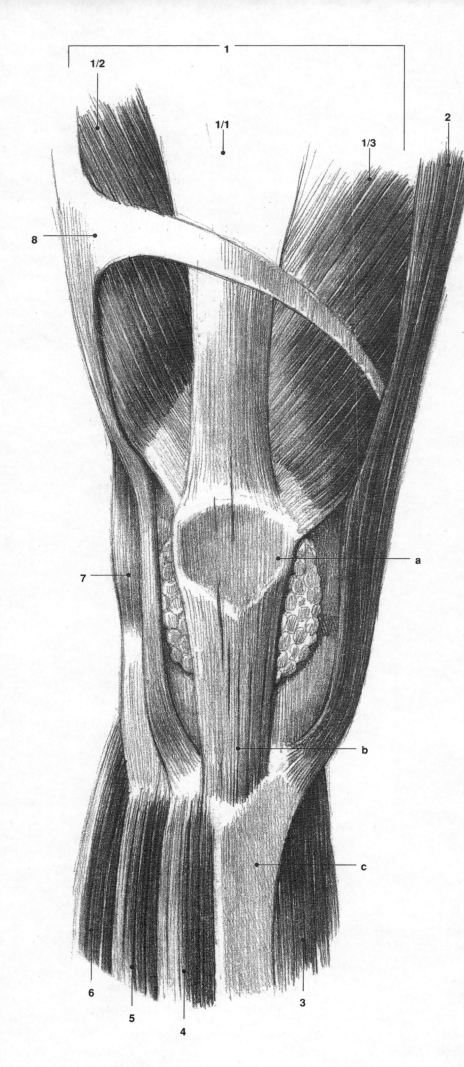

Fig. 93

The muscles of the knee region, anterior aspect

1 Quadriceps femoris muscle *(112)*
 1/1 Rectus femoris muscle *(112/1)*
 1/2 Vastus lateralis muscle *(112/4)*
 1/3 Vastus medialis muscle *(112/2)*
2 Sartorius muscle *(102)*
3 Gastrocnemius muscle *(115)*
4 Tibialis anterior muscle *(117)*
5 Extensor digitorum longus muscle *(118)*
6 Peroneus longus muscle *(121)*
7 Biceps femoris muscle *(106)*
8 Bundles of the fascia lata

a) Patella
b) Straight ligament of the patella
c) Tibial tuberosity

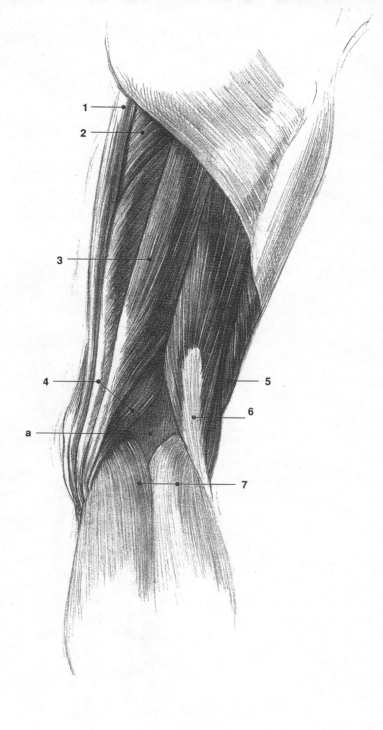

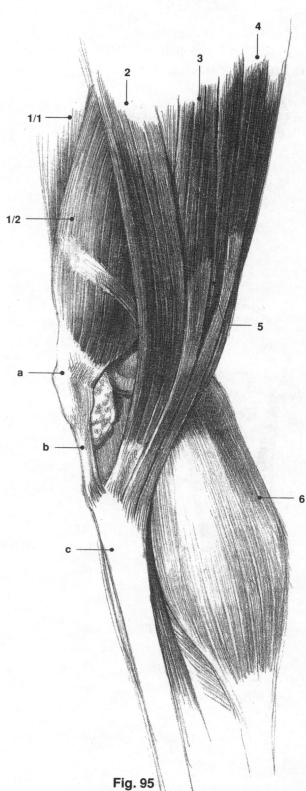

Fig. 94

The muscles of the knee
region, postero-medial aspect

1 Gracilis muscle *(104)*
2 Adductor magnus muscle *(105/1)*
3 Semitendinosus muscle *(107)*
4 Semimembranosus muscle *(108)*
5 Biceps femoris muscle, short head *(106)*
6 Biceps femoris muscle, long head *(106)*
7 Gastrocnemius muscle *(115)*

a) Popliteal fossa

Fig. 95

The muscles of the knee
region, medial aspect

1/1 Rectus femoris muscle *(112/1)*
1/2 Vastus medialis muscle *(112/2)*
2 Sartorius muscle *(102)*
3 Gracilis muscle *(104)*
4 Semitendinosus muscle *(107)*
5 Semimembranosus muscle *(108)*
6 Gastrocnemius muscle *(115)*

a) Patella
b) Straight ligament of the patella
c) Planum cutaneum tibiae

Fig. 96

The sartorius, gracilis and semitendinosus muscles

The sartorius (1), gracilis (2) and semi-tendinosus (3) muscles insert behind each other below the medial condyle of the tibia.

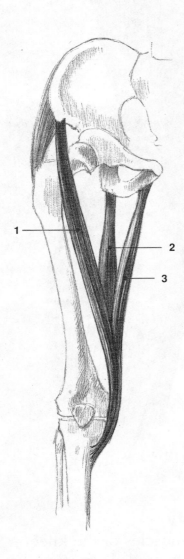

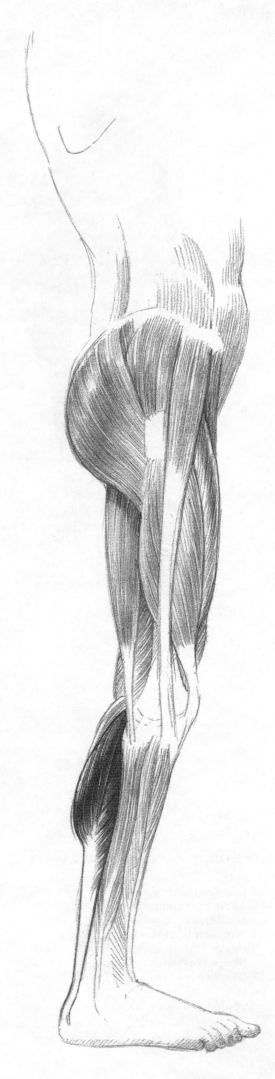

Fig. 97

The triceps surae muscle *(114)*, lateral aspect

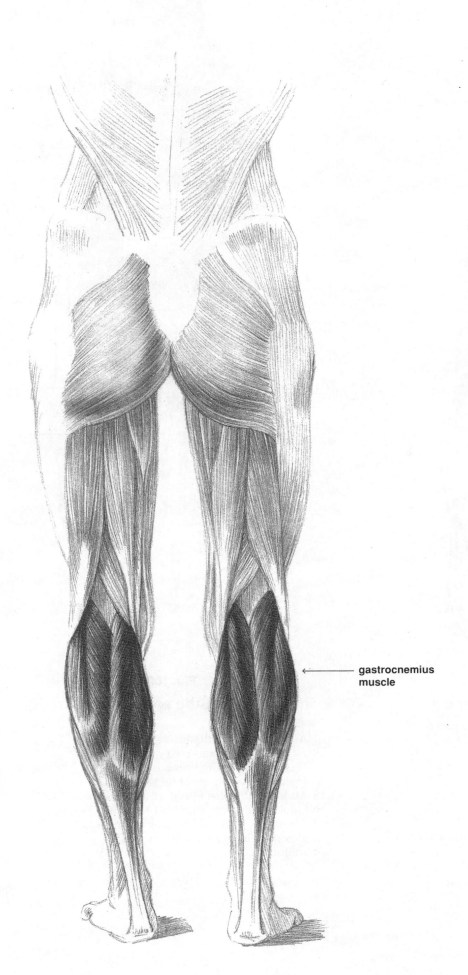

Fig. 98

The triceps surae
muscle *(114)*, posterior aspect

Origin: the two heads which form the
gastrocnemius muscle originate on the
medial and lateral condyles of the femur
(1) and the capsule of the knee joint. They
cover the third head, or soleus muscle,
which has its origin on the tibia and fibula.
The tendon of the three muscles is the
Achilles tendon (2), which inserts on the
tuberosity of the calcaneum (3). It extends
the tarsal joint.

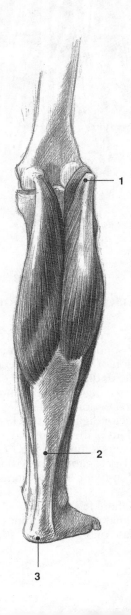

← **gastrocnemius
muscle**

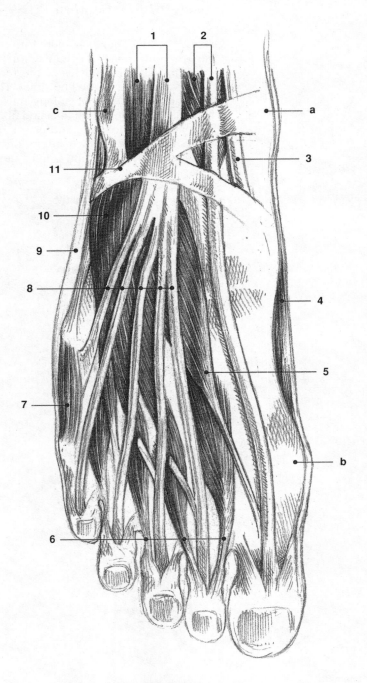

Fig. 99

The muscles of the foot, dorsal aspect

 1 Extensor digitorum longus muscle *(118)*
 2 Extensor digiti Ist longus muscle *(120)*
 3 Tendon of the tibialis anterior muscle *(117)*
 4 Abductor digiti Ist muscle *(127)*
 5 Extensor digiti Ist brevis muscle *(120)*
 6 Interossei dorsales muscles *(138/2)*
 7 Abductor digiti Vth muscle *(132)*
 8 Tendons of the extensor digitorum longus muscle *(118)*
 9 Peroneus tertius muscle *(119)*
10 Extensor digitorum brevis muscle *(118/1)*
11 Tendon-fixing anterior transverse tarsal ligaments

a) Medial ankle
b) Proximal phalangeal joint of the great toe
c) Lateral ankle

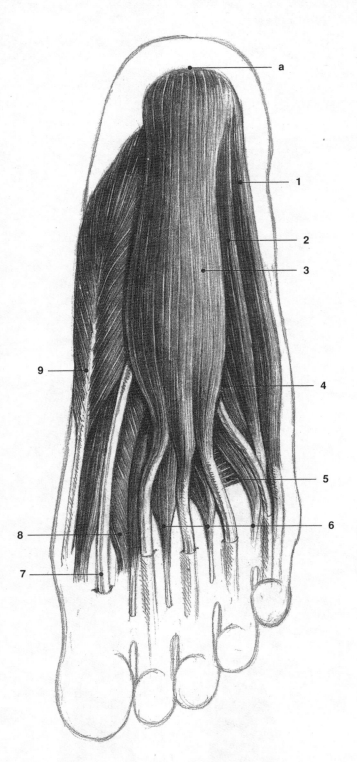

Fig. 100

The muscles of the sole, plantar aspect

 1 Abductor digiti Vth muscle *(131)*
 2 Flexor digiti Vth muscle *(133)*
 3 Flexores digitorum brevis muscle *(134)*
 4 Interosseus plantaris muscle *(137)*
 5 Abductor digiti Ist muscle, transverse head *(127)*
 6 Lumbricales digitorum IInd-Vth muscles *(136)*
 7 Tendon of adductor digiti Ist muscle *(128)*
 8 Flexor digiti Ist brevis muscle *(129)*
 9 Abductor digiti Ist muscle *(127)*

a) Calcaneum

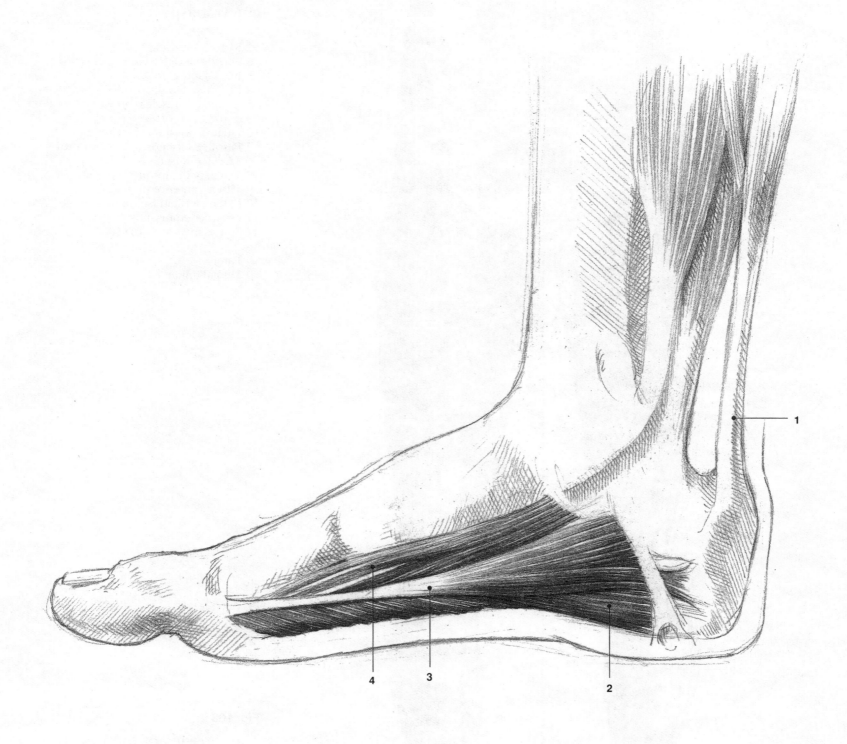

Fig. 101

The muscles of the right foot, medial aspect

1 Achilles tendon *(115)*
2 Flexor digitorum brevis muscle *(134)*
3 Abductor digiti Ist muscle *(127)*
4 Flexor digiti Ist brevis muscle *(129)*

141

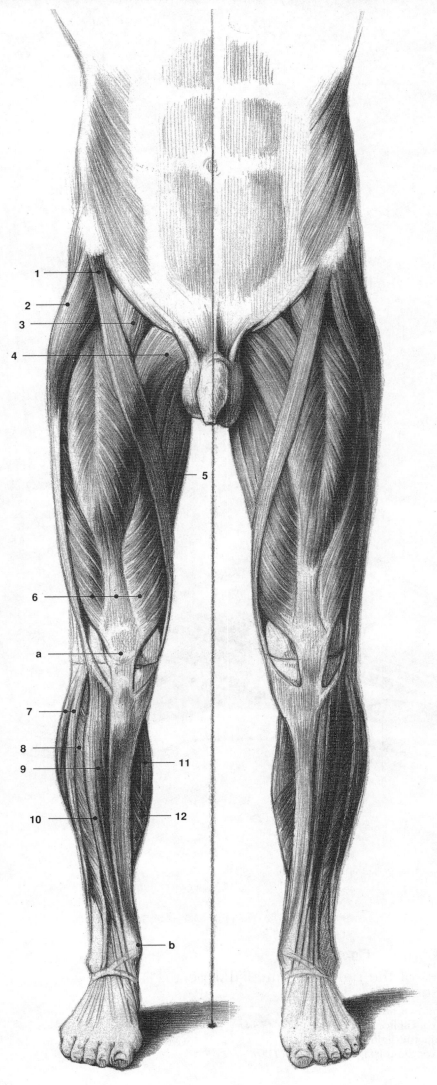

Fig. 102

The muscles of the lower limb, anterior aspect

1 Sartorius muscle *(102)*
2 Tensor fasciae latae muscle *(95)*
3 Iliacus muscle *(92)*
4 Pectineus muscle *(103)*
5 Adductor muscles (brevis and longus) of the thigh *(105)*
6 Quadriceps femoris muscle *(112)*
7 Peroneus longus *(121)* and brevis *(121/1)* muscles
8 Extensor digitorum longus muscle *(118)*
9 Tibialis anterior muscle *(117)*
10 Extensor digiti Ist longus muscle *(120)*
11 Gastrocnemius muscle *(115)*
12 Soleus muscle *(116)*

a) Patella
b) Medial ankle

Fig. 103

The muscles of the lower limb, posterior aspect

The gluteal, thigh and leg muscles are well separated and their contours are clearly visible under the skin.

1 Gluteus maximus muscle *(96)*
2 Sartorius muscle *(102)*
3 Semitendinosus muscle *(107)*
4 Biceps femoris muscle *(106)*
5 Semimembranosus muscle *(108)*
6 Gastrocnemius muscle *(115)*
7 Achilles tendon

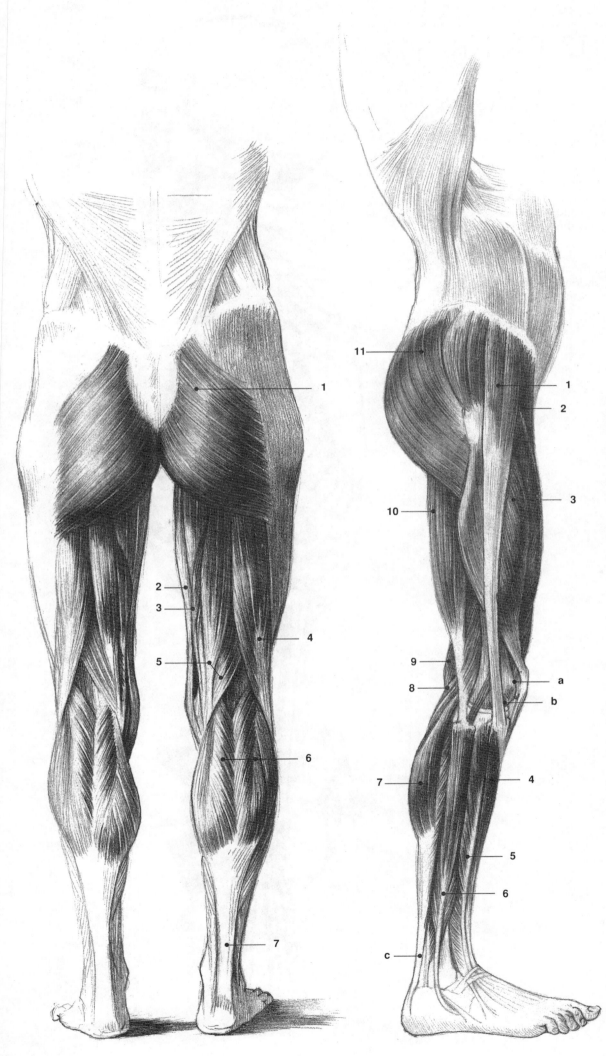

Fig. 104

The muscles of the lower limb, lateral aspect

The gluteus maximus muscle forms the buttocks, and together with the tensor fasciae latae muscle also defines the lateral contour of the pelvis. The shape of the thigh is determined anteriorly by the quadriceps femoris and posteriorly by the gluteal muscles. The medial surface of the tibia is covered only by skin. The anterior and lateral convexity of the lower leg is formed by the flexors of the foot and extensors of the toes, while the posterior convexity is created by the extensors of the foot and flexors of the toes.

1 Tensor fasciae latae muscle *(95)*
2 Sartorius muscle *(102)*
3 Quadriceps femoris muscle *(112)*
4 Extensor digitorum longus muscle *(118)*
5 Extensor digitorum lateralis muscle *(122)*
6 Peroneus longus *(121)* and brevis *(121/1)* muscles
7 Gastrocnemius muscle *(115)*
8 Semimembranosus muscle *(108)*
9 Semitendinosus muscle *(107)*
10 Biceps femoris muscle *(106)*
11 Gluteus maximus muscle *(96)*

a) Patellar joint
b) Tibial joint
c) Achilles tendon

THE BONES OF THE TRUNK

Fig. 105

The bones of the trunk; lateral (A)
and anterior (B) aspects

The bony structure of the trunk is composed of the vertebral column
(1), the ribs (2) and the sternum (3), complemented above and
below by the bones of the shoulder (4) and pelvic girdles (5).
Between the closed chest and the bony pelvis the abdominal re-
gion has a bony framework only at the back; laterally and anteriorly
it has a muscular wall. Anteriorly the clavicle, xiphoid process of
the sternum, costal arch, deltoideus muscles, thoracic muscles, an-
terior serrate muscle, borders of the rectus abdominis muscle and
anterior iliac spines can be seen through the skin. Posteriorly, the
contours of the trunk are formed by the scapular spine, trapezius
muscle, spinous processes of the thoracic and lumbar vertebrae
and the bulging gluteal muscles.

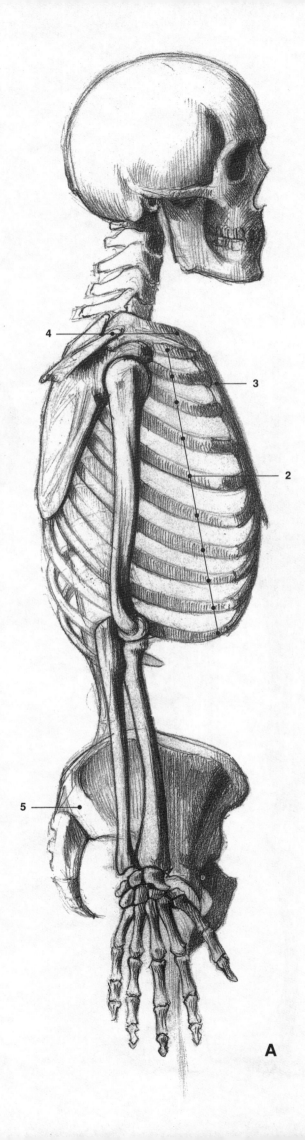

A

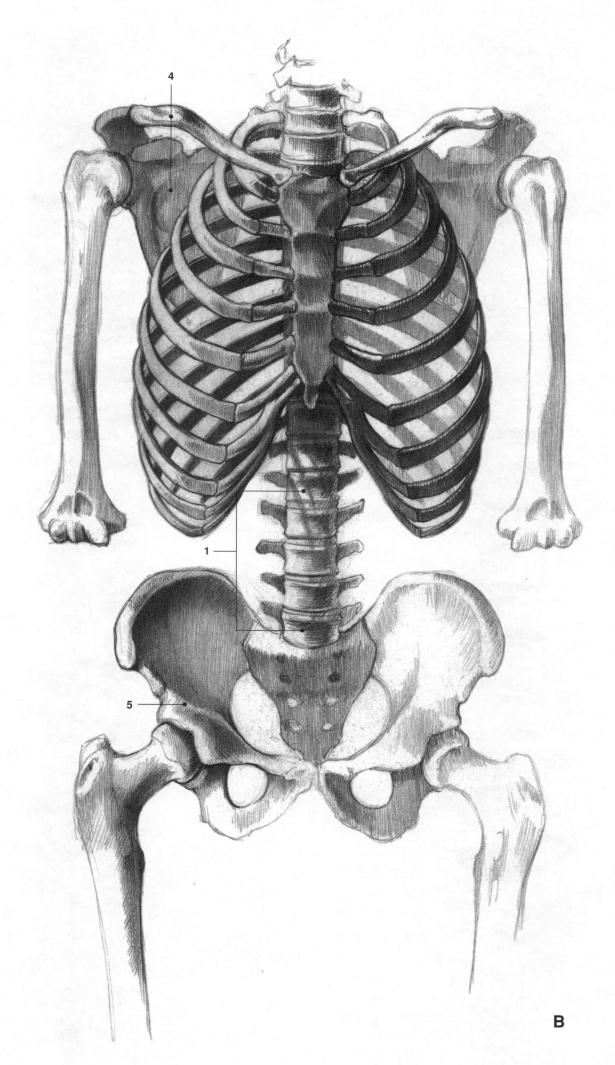

B

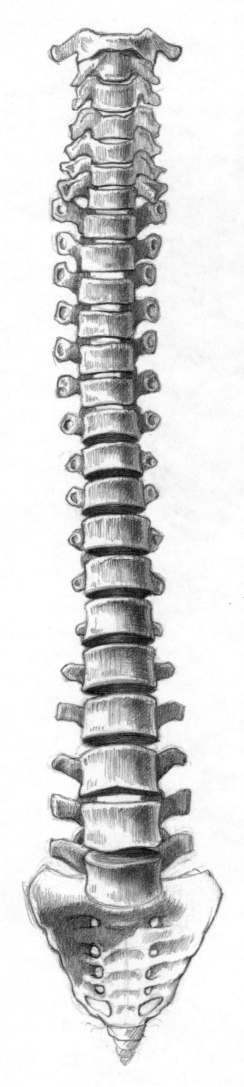

A B

Fig. 106

The vertebral column;
anterior (A), posterior (B)
and lateral (C) aspects

The vertebral column is in the median plane
of the body and consists of 32–33 verte-
brae (7 neck, 12 thoracic, 5 lumbar and 3–
4 coccygeal). The vertebrae account for
three quarters of its length and the
intervertebral cartilaginous discs account for
the remaining quarter. It is straight when
viewed anteriorly or posteriorly but from
the side three curves – cervical (a), tho-
racic (b) and lumbar (c) – can be seen.
The vertebral column has a cervical (1), a
thoracic (2), a lumbar (3), a sacral (4) and
a coccygeal (5) section.

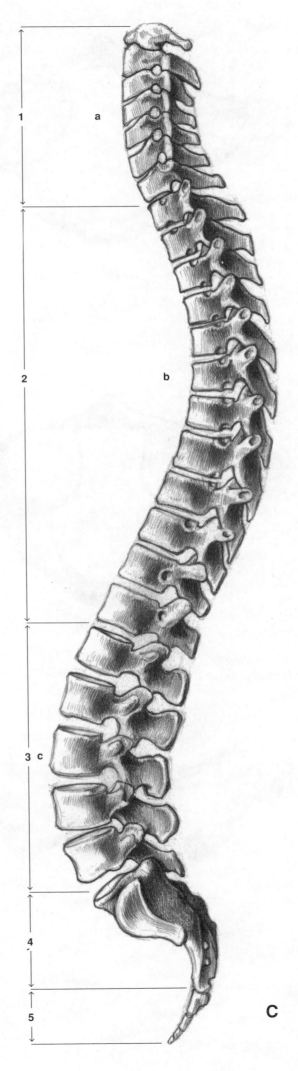

C

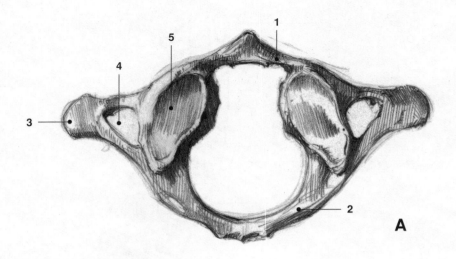

A

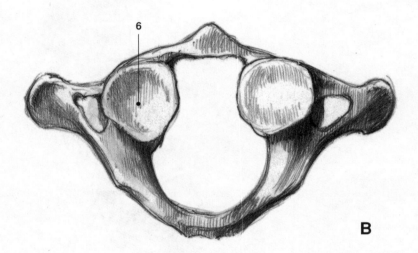

B

C

Fig. 107

The Ist cervical or atlas vertebra; superior (A), inferior (B) and posterior (C) aspects

1 Posterior arch
2 Anterior arch
3 Transverse process
4 Foramen of the transverse process
5 Superior articular fossa
6 Inferior articular surface

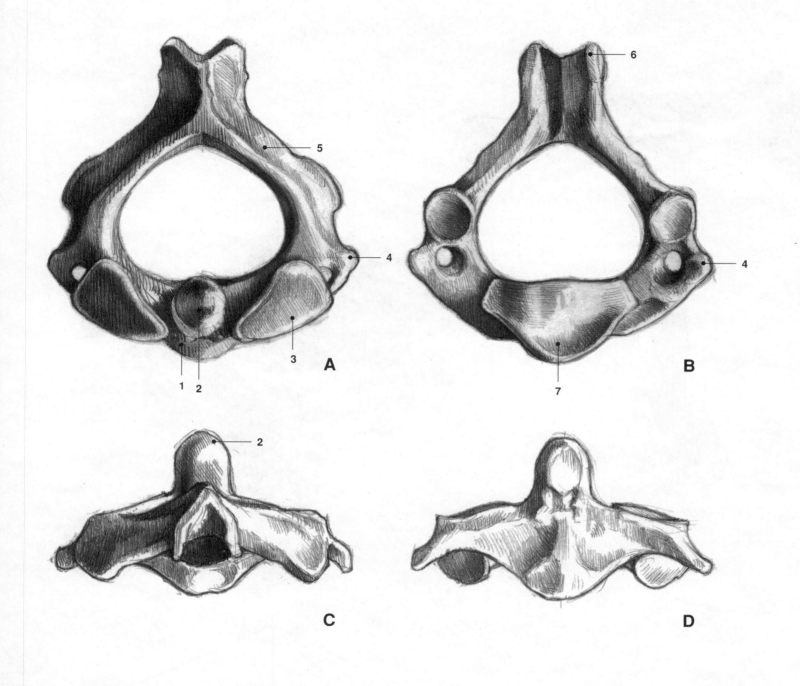
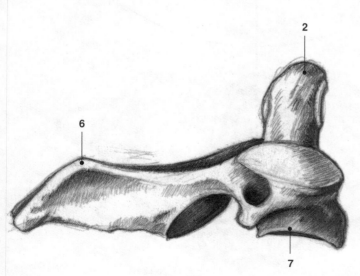

Fig. 108

The IInd cervical or axis
vertebra; superior (A), inferior (B),
posterior (C), anterior (D) and
lateral (E) aspects

1 Body
2 Odontoid process
3 Superior articular surface
4 Transverse process
5 Arch
6 Spinous process
7 Articular fossa

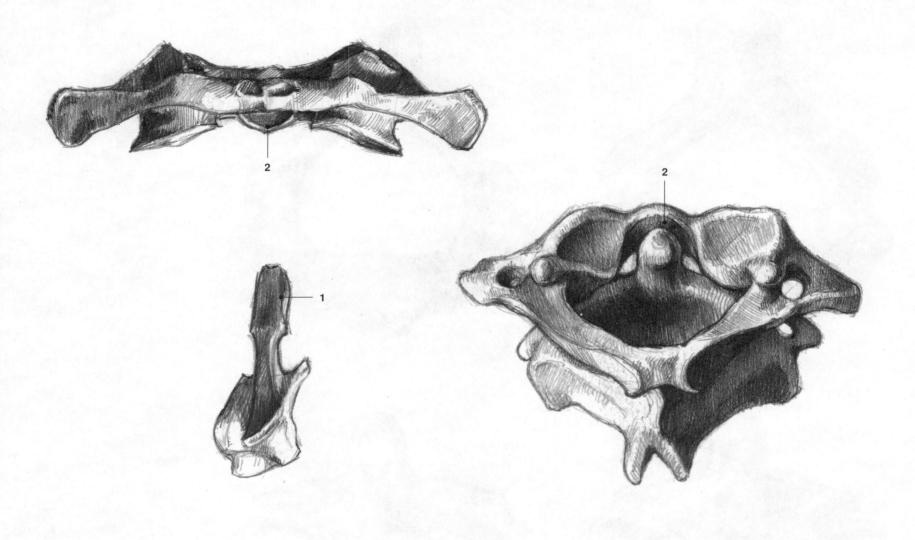

Fig. 109

The articulation between the
Ist and IInd cervical vertebrae

The odontoid process of the axis (1) rotates
in the odontoidal fossa of the atlas (2).

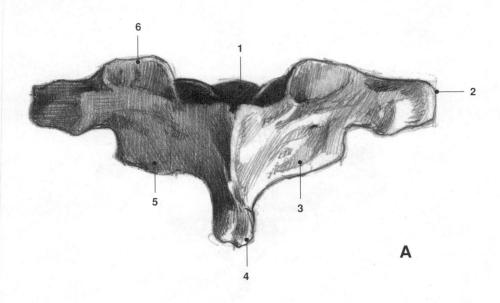

6

1

2

5

3

4

A

B

Fig. 110

The last or VIIth cervical
vertebra; posterior (A),
anterior (B) and
lateral (C) aspects

1 Body
2 Transverse process
3 Arch
4 Spinous process
5 Inferior articular process
6 Superior articular process
7 Inferior costal demi-facet

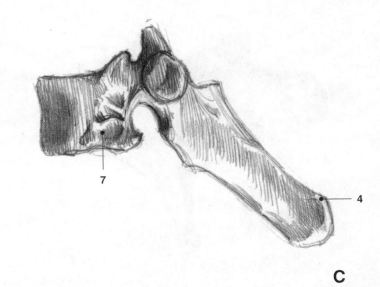

7

4

C

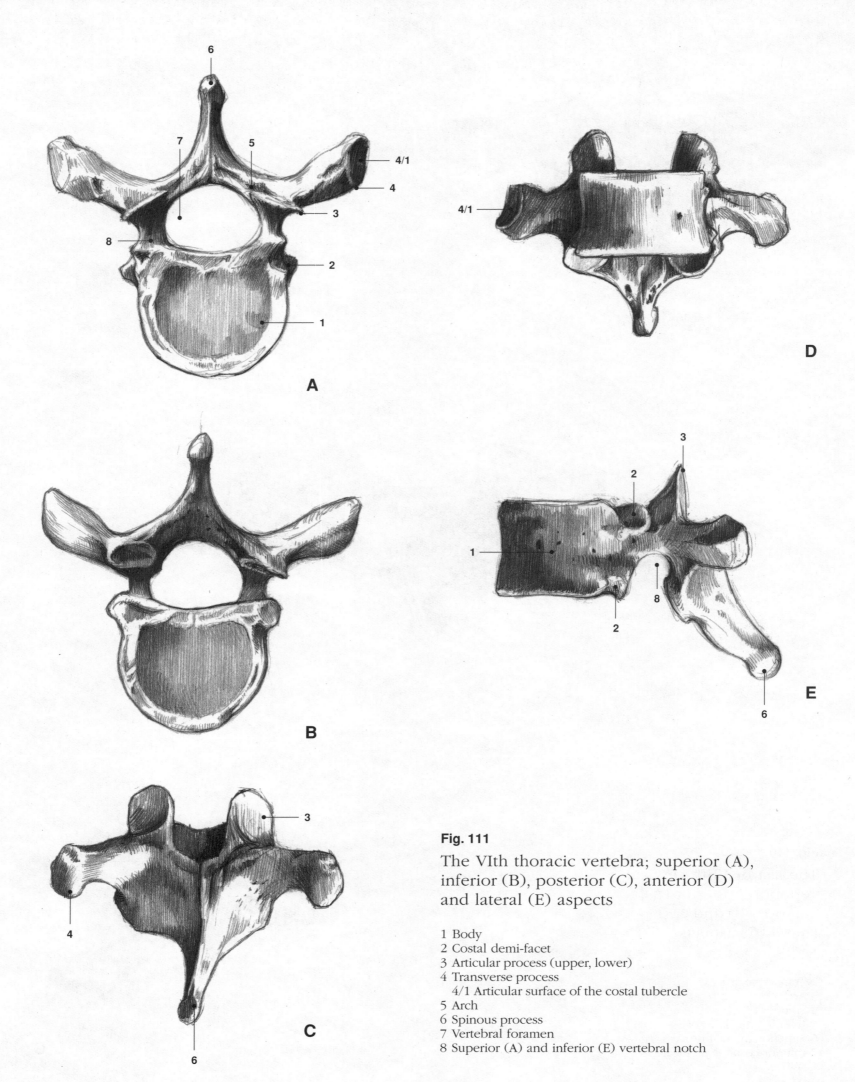

Fig. 111

The VIth thoracic vertebra; superior (A), inferior (B), posterior (C), anterior (D) and lateral (E) aspects

1 Body
2 Costal demi-facet
3 Articular process (upper, lower)
4 Transverse process
 4/1 Articular surface of the costal tubercle
5 Arch
6 Spinous process
7 Vertebral foramen
8 Superior (A) and inferior (E) vertebral notch

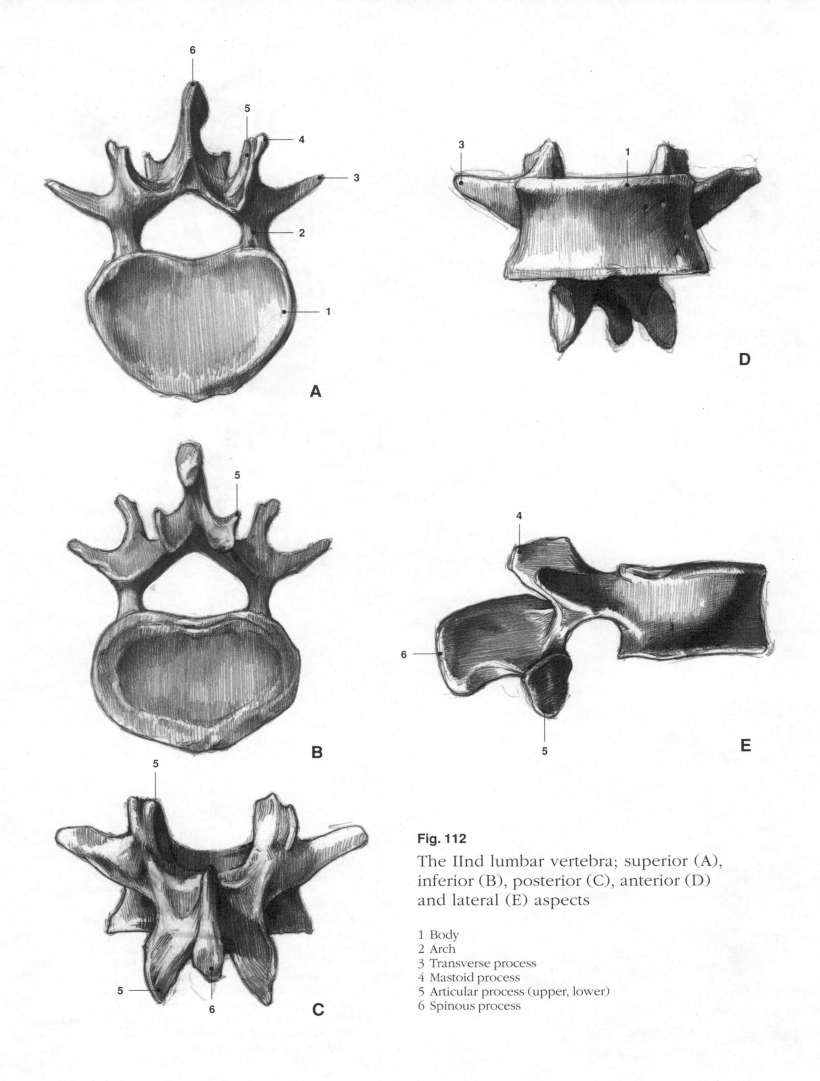

Fig. 112

The IInd lumbar vertebra; superior (A), inferior (B), posterior (C), anterior (D) and lateral (E) aspects

1 Body
2 Arch
3 Transverse process
4 Mastoid process
5 Articular process (upper, lower)
6 Spinous process

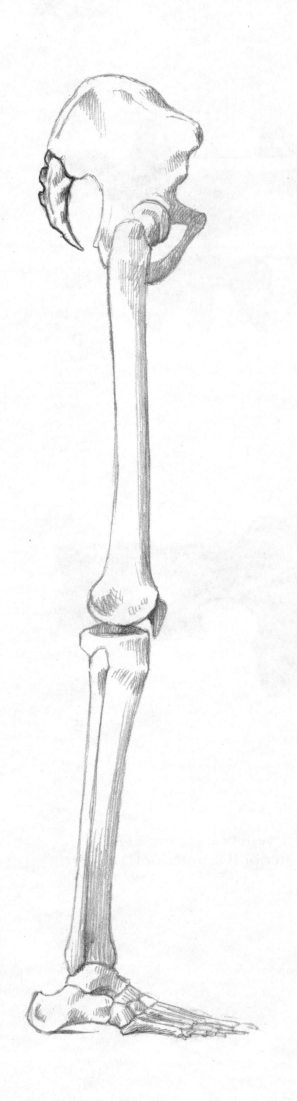

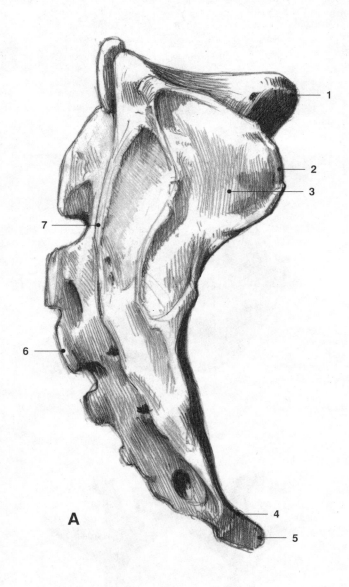

A

Fig. 113

The sacrum; lateral (A), anterior (B)
and posterior (C) aspects

The sacrum is an anteriorly concave, spade-shaped bone, which
constitutes the posterior section of the pelvic girdle. At the upper
border of the girdle is the promontory of the Ist sacral vertebra (1).
The rough auricular surface (3) on its lateral border forms a rigid
joint with the ala of the ilium (2). At its inferior border (4) the
coccygeal bone (5) is attached. On the posterior surface (C) the
fused spinous processes form the median sacral crest (6), the ar-
ticular processes form the lateral sacral crests (7) and the trans-
verse processes form the sacral tuberosities (8).
Through its superior (10) and inferior (9) foramina, branches of the
sacral nerves emerge from the spinal canal. In old age the sacrum
fuses with the coccygeal bone.

154

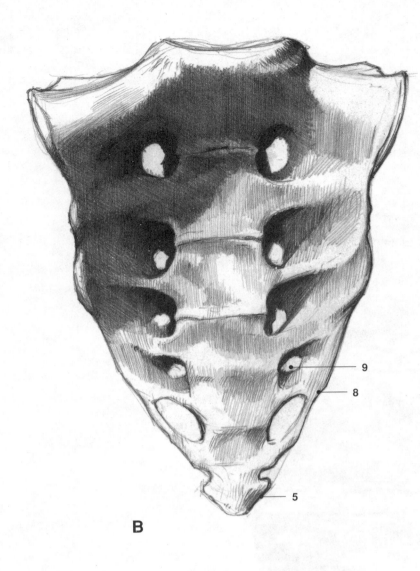

B

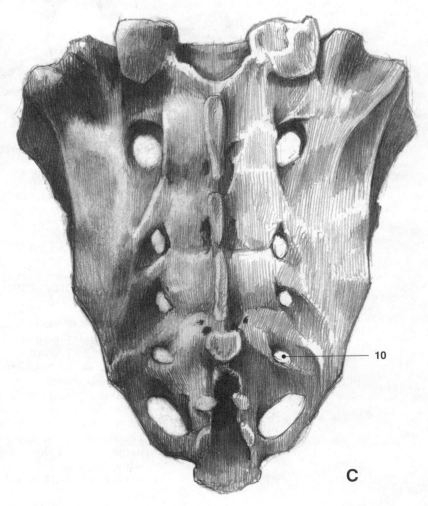

C

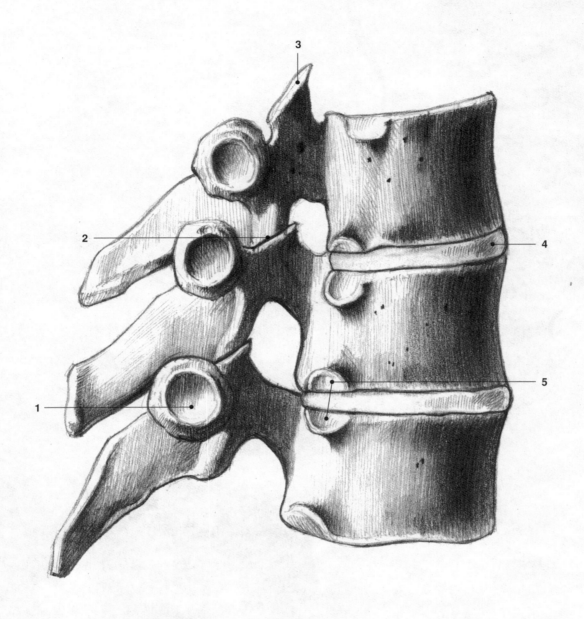

Fig. 114

The intervertebral joints

The bodies of the vertebrae are connected by cartilaginous discs (4), which have an outer ring of fibrous tissue, the annulus fibrosus, and a central mass of softer fibro-gelatinous tissue, the nucleus pulposus. In addition to the joints (2) formed by the articular processes (3), long and short ligaments also stabilize the vertebral column. The heads of the ribs articulate, with the demi-facets of the vertebral bodies (5), while their tubercles articulate with the transverse costal facets (1) of the transverse processes.

156

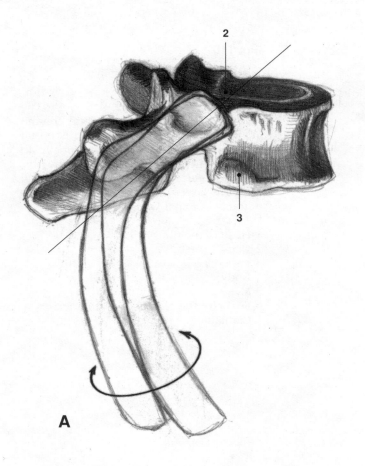

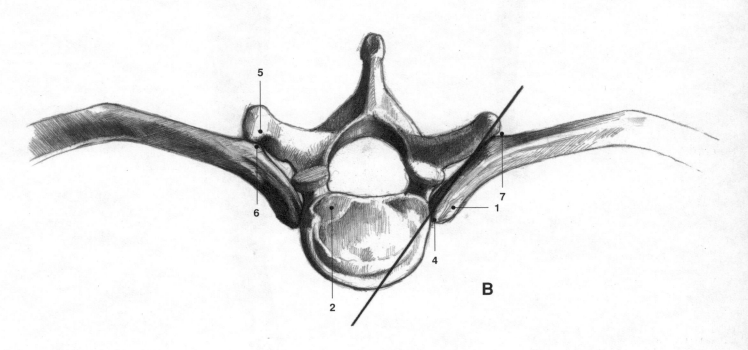

Fig. 115

Costovertebral articulation; lateral (A) and superior (B) aspects

The head of the rib (1) together with the superior (2) and inferior (3) articular demifacet of the vertebral body forms an articulation called the joint of the head of the rib (4). The tubercle of the rib (6) articulates with the transverse costal facet (5) of the corresponding vertebra. The axis of rotation of the joint (7) is a straight line.

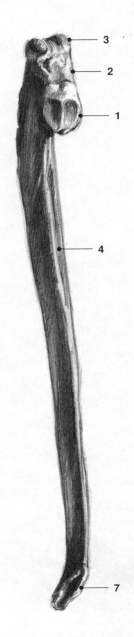

Ist rib, medial aspect

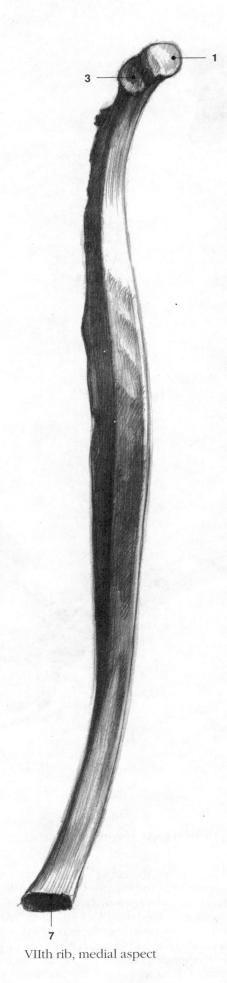

VIIth rib, medial aspect

Fig. 116

The ribs

The ribs are curved, long, flat bones. The two-thirds closer to the vertebral column are bone, the sternal one-third is costal cartilage. The upper 7 ribs are directly attached to the sternum and are the true ribs. The cartilages of ribs 8–10 form the costal arch. The last two or floating ribs end freely in the abdominal wall.

1 Head of the rib
2 Neck
3 Tubercle
4 Body
5 Muscular fossa of the body
6 Fossa for the blood vessel and nerve
7 Cartilaginous surface

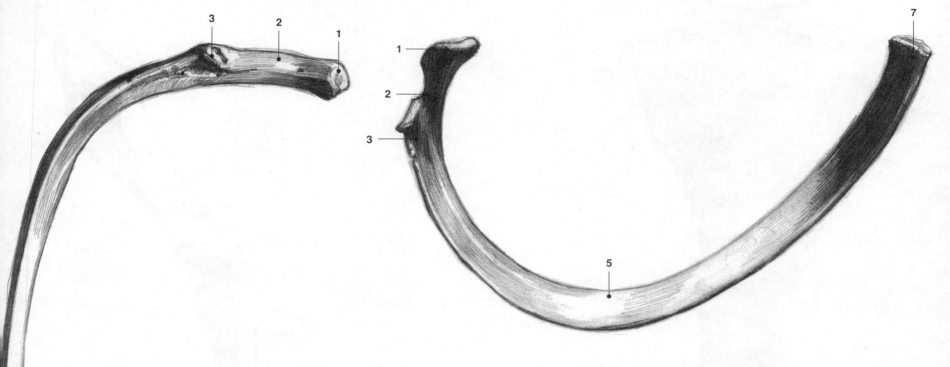

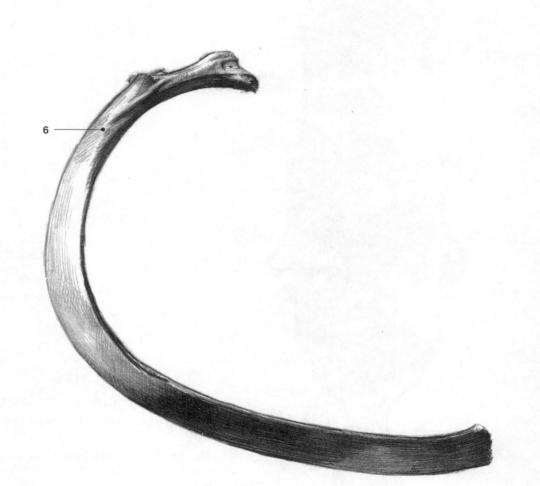

IInd rib, superior aspect

VIIth rib, inferior aspect

IInd rib, inferior aspect

159

Fig. 117

The sternum; anterior (A)
and lateral (B) aspects

The sternum is an anterio-posteriorly flat-
tened, cartilaginous bone consisting of sec-
tions called sternebrae.

1 Jugular notch
2 Clavicular noth
3 Notches for the costal cartilages
4 Sections (sternebrae)
5 Xiphoid process

160

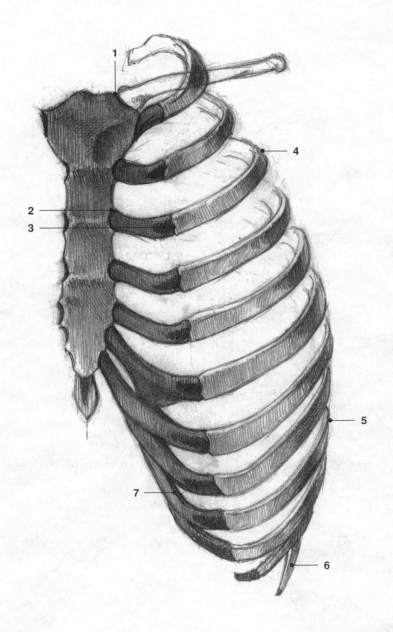

Fig. 118

The joints of the sternum,
anterior aspect

1 Sternoclavicular joint
2 Joint composed of the sternum
 and the costal cartilage
3 Joint formed by the cartilaginous
 and bony part of the rib
4 True rib
5 False rib
6 Floating rib
7 Costal arch

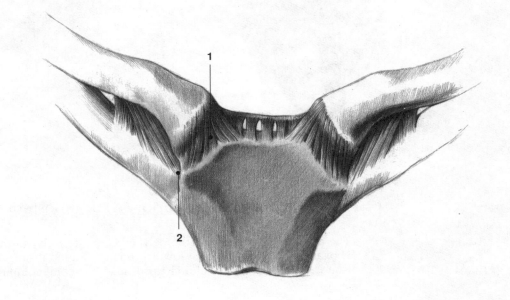

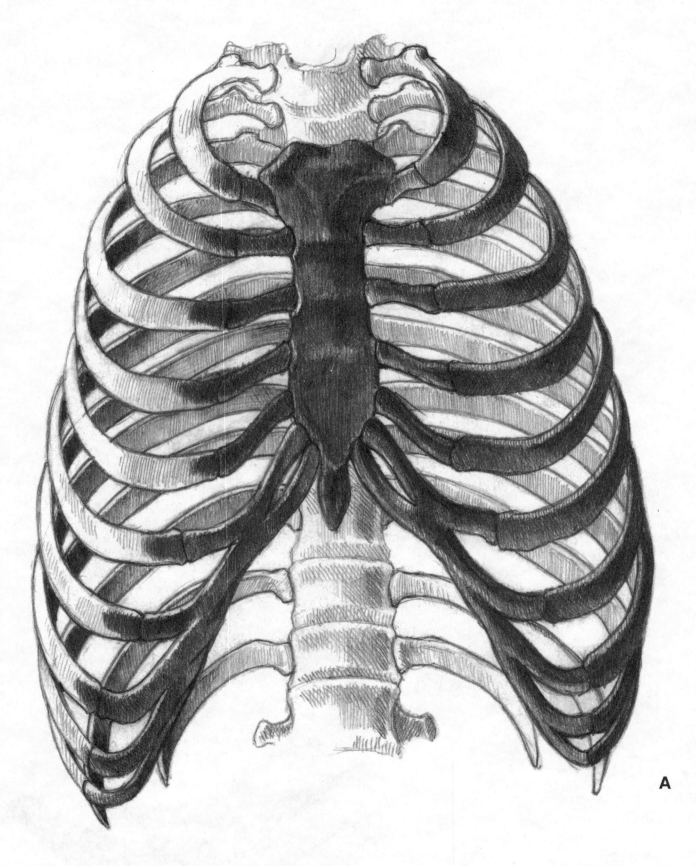

A

Fig. 119

The chest; anterior (A) and posterior (B) aspects

The chest broadens toward the pelvis and is oval in cross-section. The lower border (the last rib and the costal arch) rises an-teriorly during inspiration. During expir-ation it sinks and approximates to the ver-tebral column.

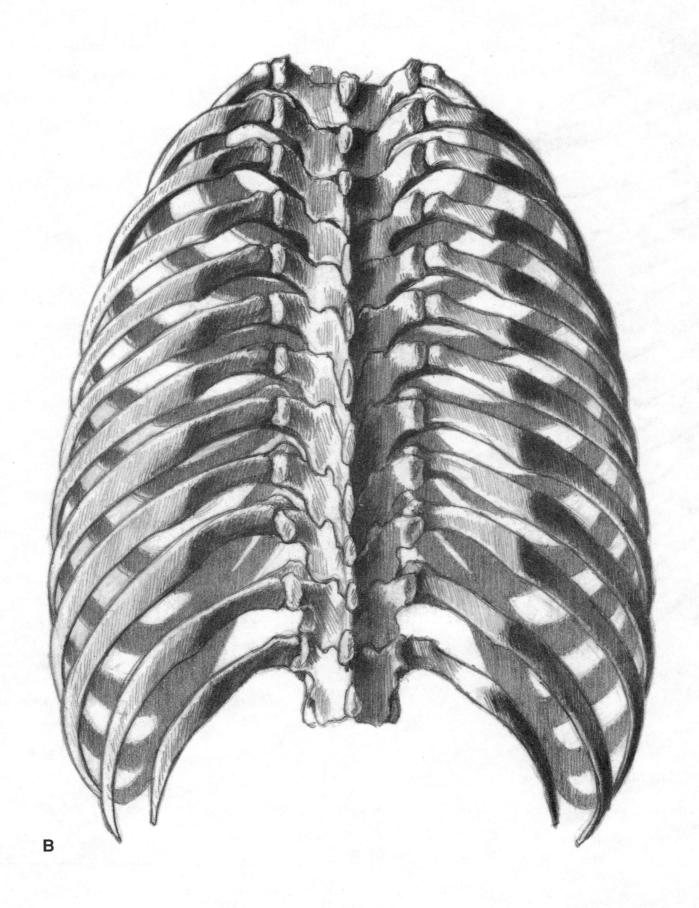

B

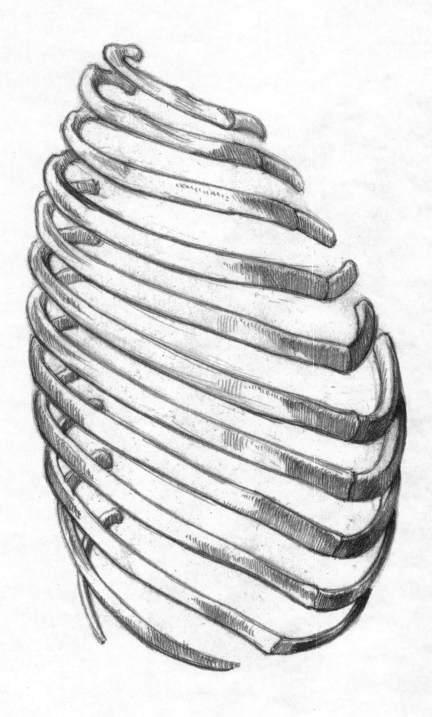

Fig. 120

The chest, lateral aspect

The chest is flattened both anteriorly and posteriorly, and laterally it is convex.

Fig. 121

Diameters of the chest

1 Median diameter
2 Transverse diameter

a) The axis of rotation of costovertebral joints

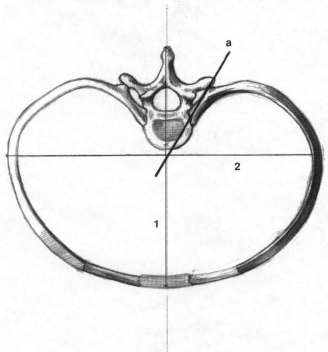

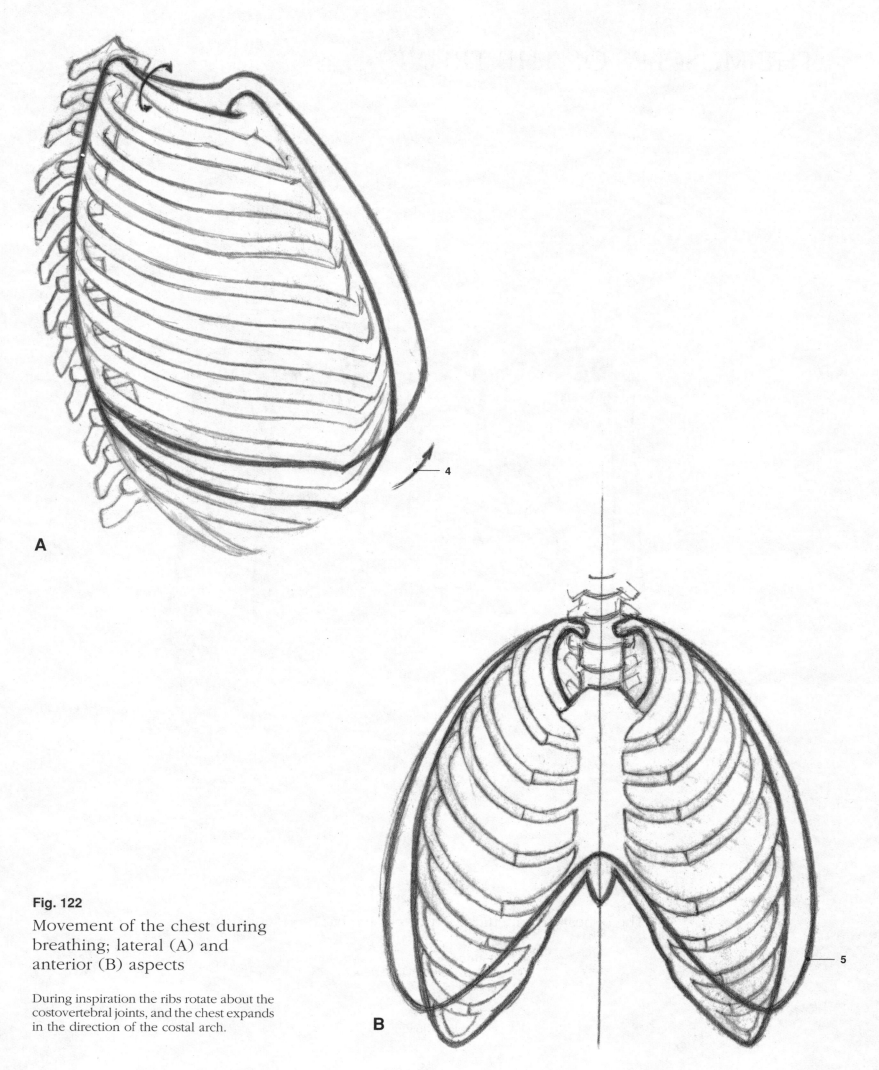

Fig. 122

Movement of the chest during
breathing; lateral (A) and
anterior (B) aspects

During inspiration the ribs rotate about the
costovertebral joints, and the chest expands
in the direction of the costal arch.

A

B

165

THE MUSCLES OF THE TRUNK

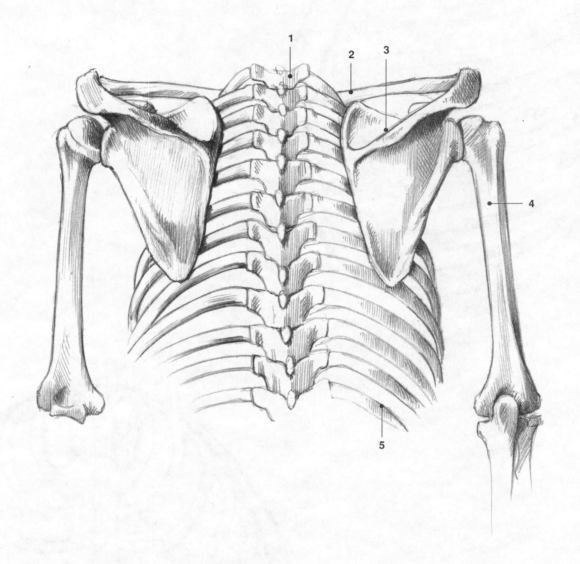

Fig. 123

The bones and superficial muscles of the back, posterior aspect

Bones
1 The Ist thoracic vertebra
2 Clavicle
3 Scapular spine
4 Humerus
5 The last (floating) rib

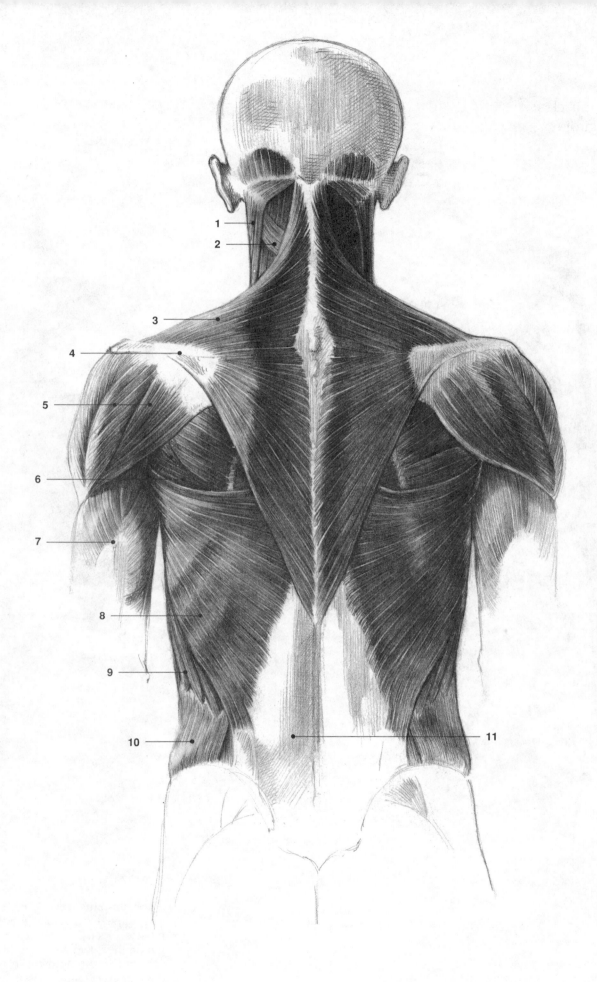

Muscles

1 Sternocleidomastoideus muscle *(6)*

2 Splenius muscle *(5)*

3 Trapezius muscle *(14)*

4 Aponeurosis above the scapular spine

5 The two bellies of the deltoideus muscle *(43)*

6 Teres major and teres minor muscles *(47, 46)*

7 Triceps brachii muscle *(52)*

8 Latissimus dorsi muscle *(16)*

9 Serratus anterior muscle *(18)*

10 Obliquus externus abdominis muscle *(36)*

11 Dorsolumbar fascia

Fig. 124

The bones and muscles
of the shoulder girdle

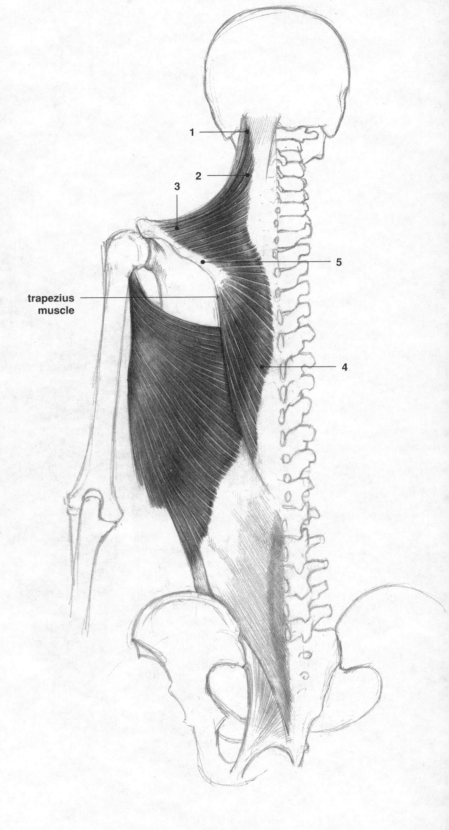

trapezius
muscle

The trapezius muscle *(14)*
The trapezius muscle is a flat triangular
muscle sheet. The cervical part has its ori-
gin on the occiput (1) and nuchal ligament
(2), and inserts into the clavicle (3). The
dorsal part originates on the spinous proc-
esses of the vertebrae (4) and inserts into
the scapular spine (5). It pulls the shoulder
joint in the direction of the vertebral col-
umn. The cervical part raises the shoulder,
while the dorsal part pulls the scapula
medially.

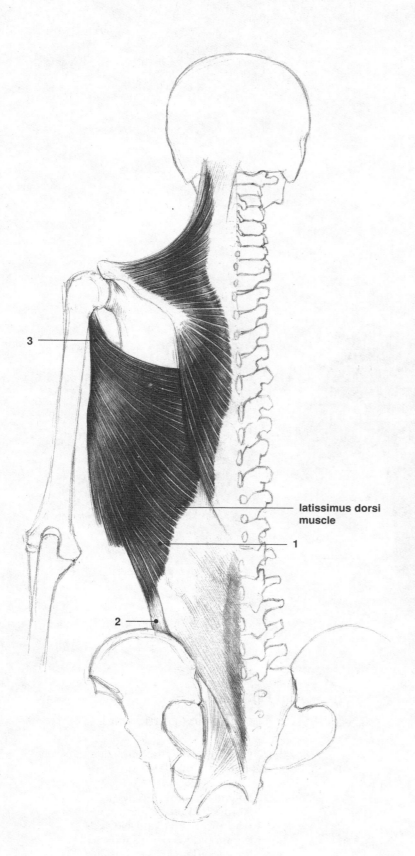

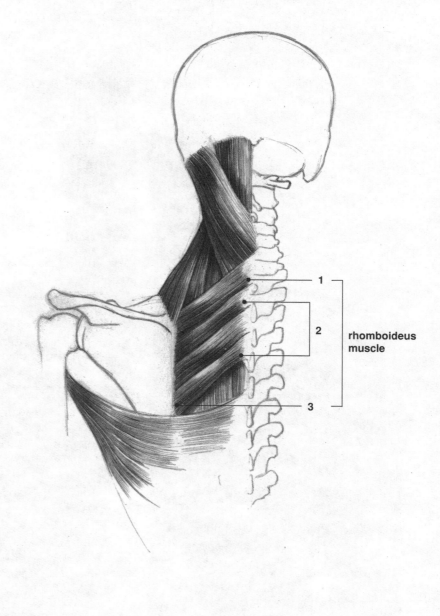

latissimus dorsi
muscle

1

rhomboideus
muscle

The latissimus dorsi muscle *(16)*
It is a broad muscle sheet, originating on
the six lower thoracic vertebrae, the lum-
bar vertebrae (1), and the ilium (2). It
covers the posterior and lateral walls of
the chest as well as the lower angle of
the scapula. It passes below the teres ma-
jor muscle to insert into the floor of the
intertubercular groove of the humerus (3).

The rhomboideus muscle *(17)*
It originates on the spinous processes of the
last two cervical (1), and the first four tho-
racic vertebrae (2) and inserts into the
medial border of the scapula (3). It adducts
the scapula towards the midline.

The bones are demonstrated in Fig. 123.

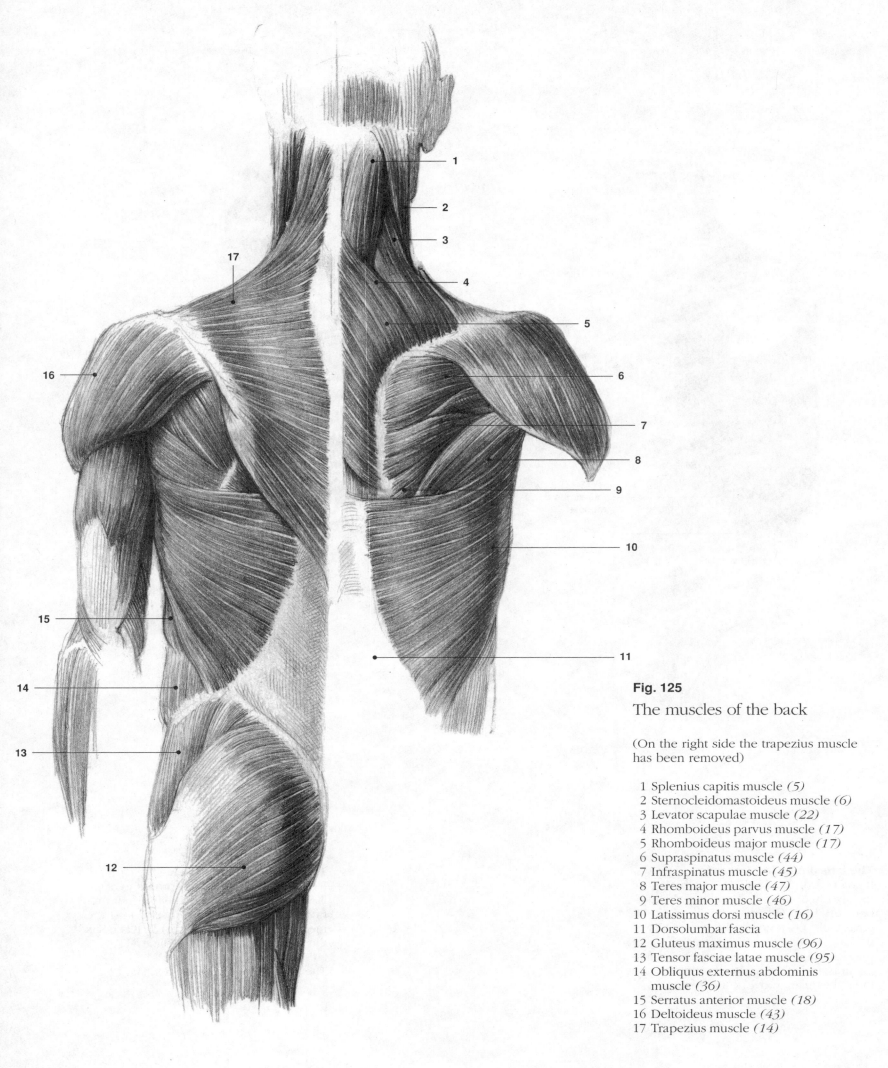

Fig. 125

The muscles of the back

(On the right side the trapezius muscle has been removed)

1 Splenius capitis muscle *(5)*
2 Sternocleidomastoideus muscle *(6)*
3 Levator scapulae muscle *(22)*
4 Rhomboideus parvus muscle *(17)*
5 Rhomboideus major muscle *(17)*
6 Supraspinatus muscle *(44)*
7 Infraspinatus muscle *(45)*
8 Teres major muscle *(47)*
9 Teres minor muscle *(46)*
10 Latissimus dorsi muscle *(16)*
11 Dorsolumbar fascia
12 Gluteus maximus muscle *(96)*
13 Tensor fasciae latae muscle *(95)*
14 Obliquus externus abdominis
muscle *(36)*
15 Serratus anterior muscle *(18)*
16 Deltoideus muscle *(43)*
17 Trapezius muscle *(14)*

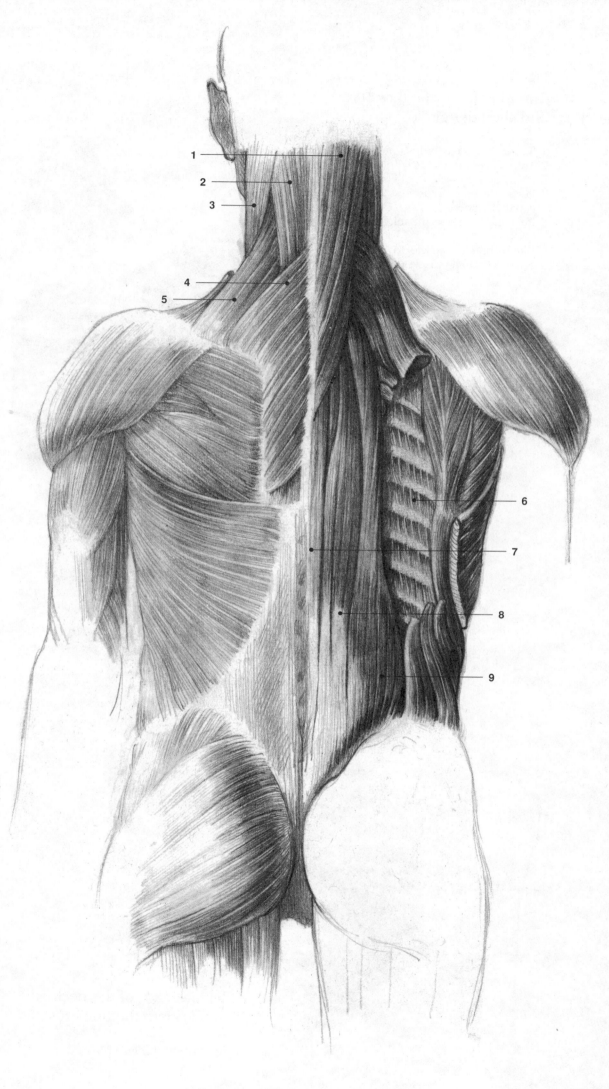

Fig. 126

The muscles of the neck and back

(On the left side the trapezius muscle and on the right side the scapula and its muscles have been removed)

1 Splenius capitis muscle *(5)*
2 Obliquus capitis superior muscle *(4)*
3 Sternocleidomastoideus muscle *(6)*
4 Rhomboideus parvus muscle *(17)*
5 Levator scapulae muscle *(22)*
6 Intercostalis externus muscle *(33)*
7 Transversospinalis muscle *(23)*
8 Longissimus dorsi muscle *(21)*
9 Iliocostalis lumborum muscle *(20/3)*

Fig. 127

The muscles of the thorax
and shoulder girdle

1 Sternocleidomastoideus muscle *(6)*
2 Trapezius muscle *(14)*
3 Deltoideus muscle *(43)*
4 Pectoralis major muscle,
 clavicular part *(27/1)*
5 Pectoralis major muscle, sternal part
 (27/1)
6 Biceps brachii muscle *(51)*
7 Triceps brachii muscle *(52)*

Fig. 128

The insertion of the pectoralis
muscles into the humerus

Explanation in Fig. 127.

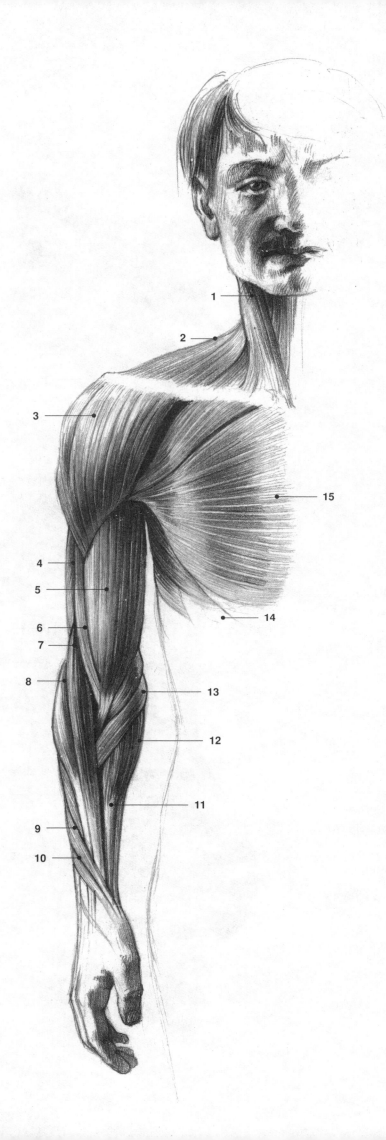

Fig. 129

The muscles of the shoulder girdle
and upper arm

1 Sternocleidomastoideus muscle *(6)*
2 Trapezius muscle *(14)*
3 Deltoideus muscle *(43)*
4 Triceps brachii muscle *(52)*
5 Biceps brachii muscle *(51)*
6 Brachialis muscle *(50)*
7 Brachioradialis muscle *(63)*
8 Extensor carpi radialis muscle *(64)*
9 Adductor digiti Ist muscle *(75)*
10 Extensor digiti Ist brevis muscle *(71)*
11 Palmaris longus muscle *(61)*
12 Flexor carpi radialis muscle *(56)*
13 Pronator teres muscle *(55)*
14 Oliquus externus abdominis muscle *(36)*
15 Pectoralis major muscle *(27/1)*

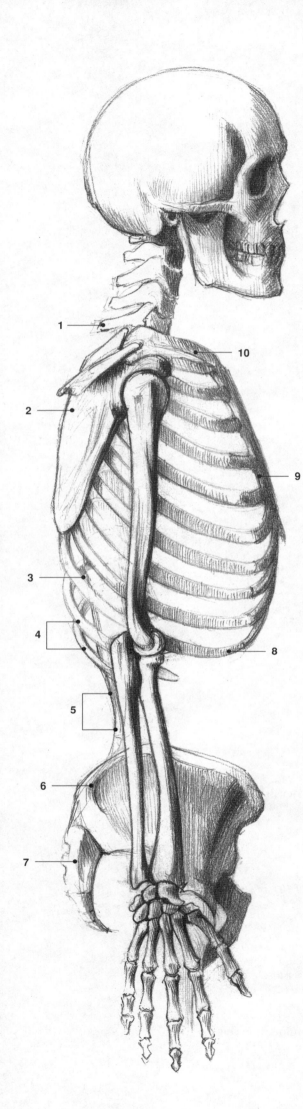

Fig. 130

The bones and muscles
of the trunk, lateral aspect

Bones
1 VIth cervical vertebra
2 Scapula
3 Xth rib
4 Floating ribs
5 Lumbar vertebrae
6 Ilium
7 Sacrum
8 Costal arch
9 Sternum
10 Clavicle

Muscles
1 Sternocleidomastoideus muscle *(6)*
2 Pectoralis major muscle *(27/1)*
3 Serratus anterior muscle *(18)*
4 Obliquus externus abdominis
 muscle *(36)*
5 Tensor fasciae latae muscle *(95)*
6 Trapezius muscle *(14)*
7 Deltoideus muscle *(43)*
8 Latissimus dorsi muscle *(16)*
9 Gluteus maximus muscle *(96)*

a) Clavicle
b) Mammary body
c) Nipple
d) Navel
e) Anterior iliac spine
f) Posterior iliac spine

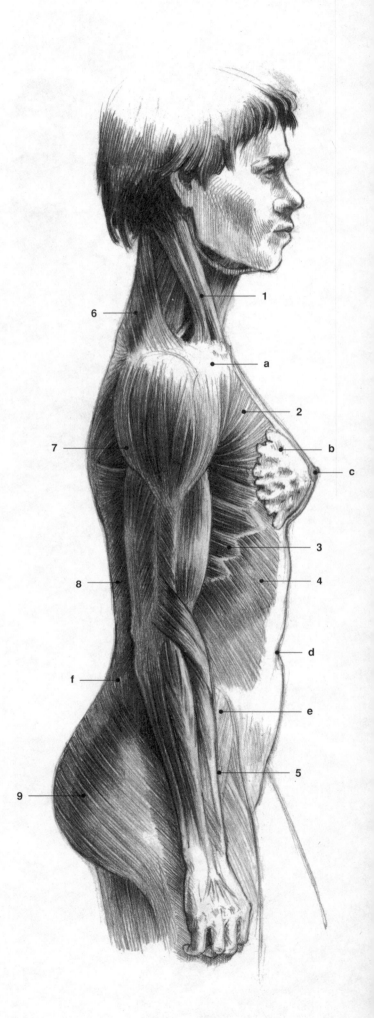

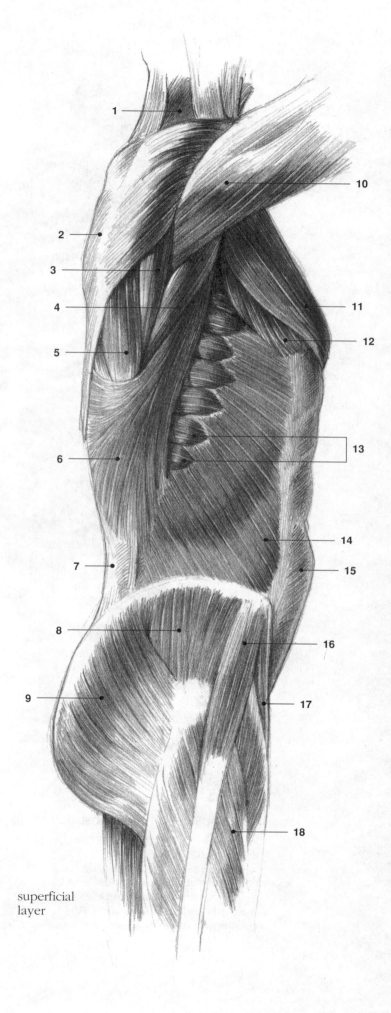

Fig. 131

The bones and superficial
muscles of the trunk,
lateral aspect

Muscles
1 Splenius capitis muscle *(5)*
2 Trapezius muscle *(14)*
3 Teres minor muscle *(46)*
4 Teres major muscle *(47)*
5 Supraspinatus muscle *(44)*
6 Latissimus dorsi muscle *(16)*
7 Dorsolumbar fascia
8 Gluteus medius muscle *(97)*
9 Gluteus maximus muscle *(96)*
10 Deltoideus muscle *(43)*
11 Pectoralis minor muscle *(31)*
12 Pectoralis major muscle *(27/1)*
13 Serratus anterior muscle *(18)*
14 Obliquus externus abdominis
 muscle *(36)*
15 Tendinous lamina of the obliquus
 externus abdominal muscle *(36)*
16 Tensor fasciae latae muscle *(95)*
17 Sartorius muscle *(102)*
18 Quadriceps femoris muscle *(112)*

The bones are demonstrated in Fig. 130.

superficial
layer

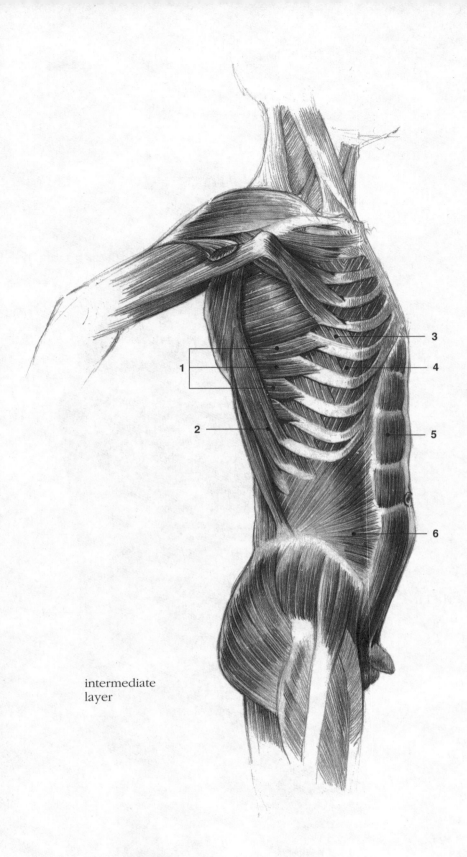

intermediate
layer

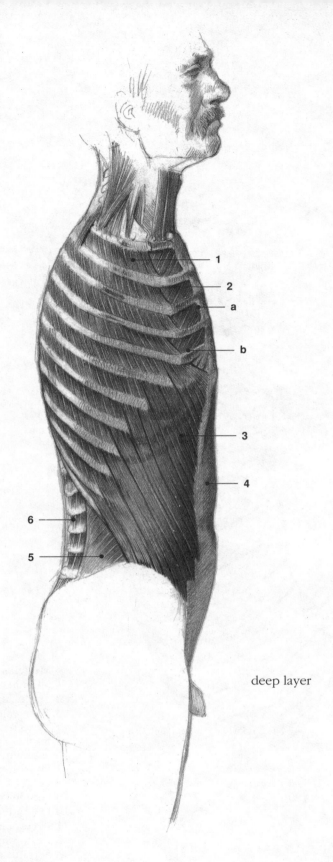

deep layer

Fig. 132

The muscles of the chest, lateral aspect

1 Serratus anterior muscle *(18)*
2 Latissimus dorsi muscle *(16)*
3 Intercostalis externus muscles *(33)*
4 Intercostalis internus muscles *(34)*
5 Rectus abdominis muscle *(39)*
6 Obliquus internus abdominis muscle *(37)*

Fig. 133

The muscles of the chest and abdomen,
lateral aspect

1 Intercostalis externus muscles *(33)*
2 Intercostalis internus muscles *(34)*
3 Obliquus externus abdominis muscle *(36)*
4 Vagina recti abdominis *(40)*
5 Obliquus internus abdominis muscle *(37)*
6 Transversospinalis muscles *(23)*

a) Sternum
b) Cartilage of the Vth rib

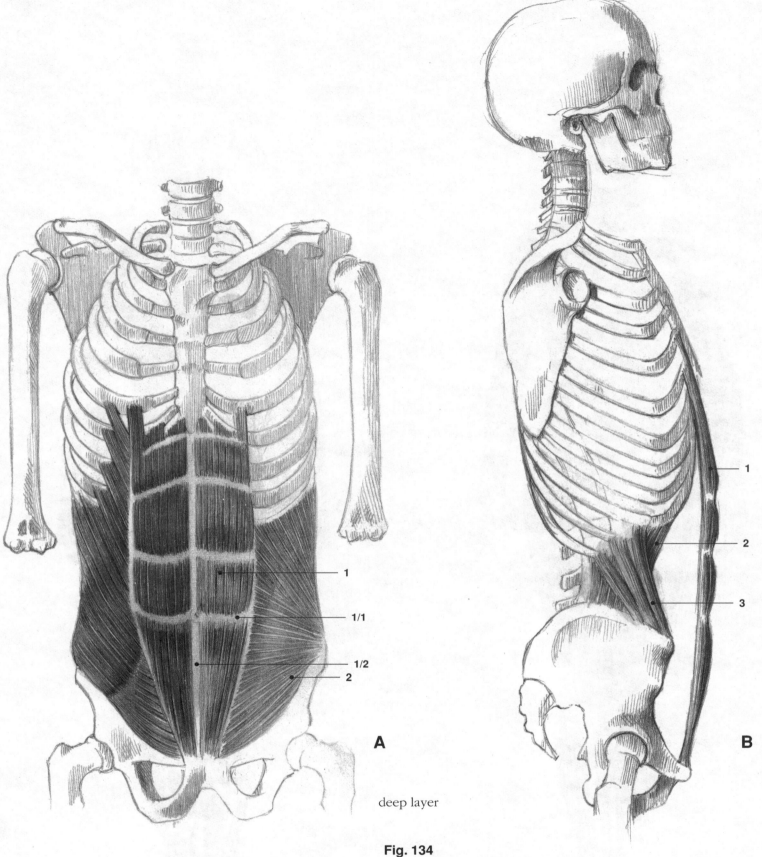

A

deep layer

B

Fig. 134

The muscles of the abdomen; anterior (A) and lateral (B) aspects

These muscles constitute the lateral and anterior walls of the abdomen. In a young, athletic person the edges and tendinous intersections of the rectus abdominis muscle and "linea alba" running along the midline of the abdomen can be distinguished under the skin. These muscles are bordered superiorly by the costal arch and inferiorly by the iliac crest. The four layers of abdominal muscles are superimposed and their fibres cross over each other.

1 Rectus abdominis muscle *(39)*
 1/1 Tendinous intersection
 1/2 "Linea alba" *(41)*
2 Obliquus internus abdominis muscle *(37)*
3 Quadratus lumborum muscle *(94)*

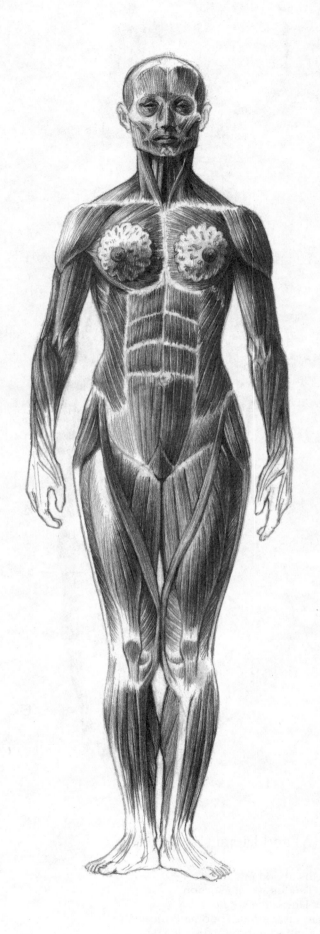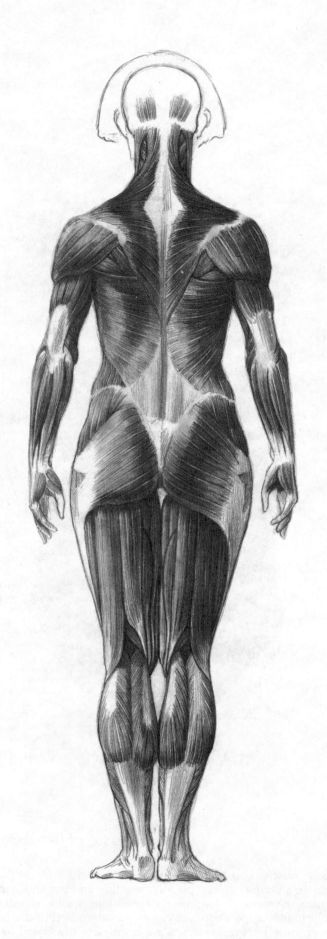

Fig. 135
The muscles of the human body

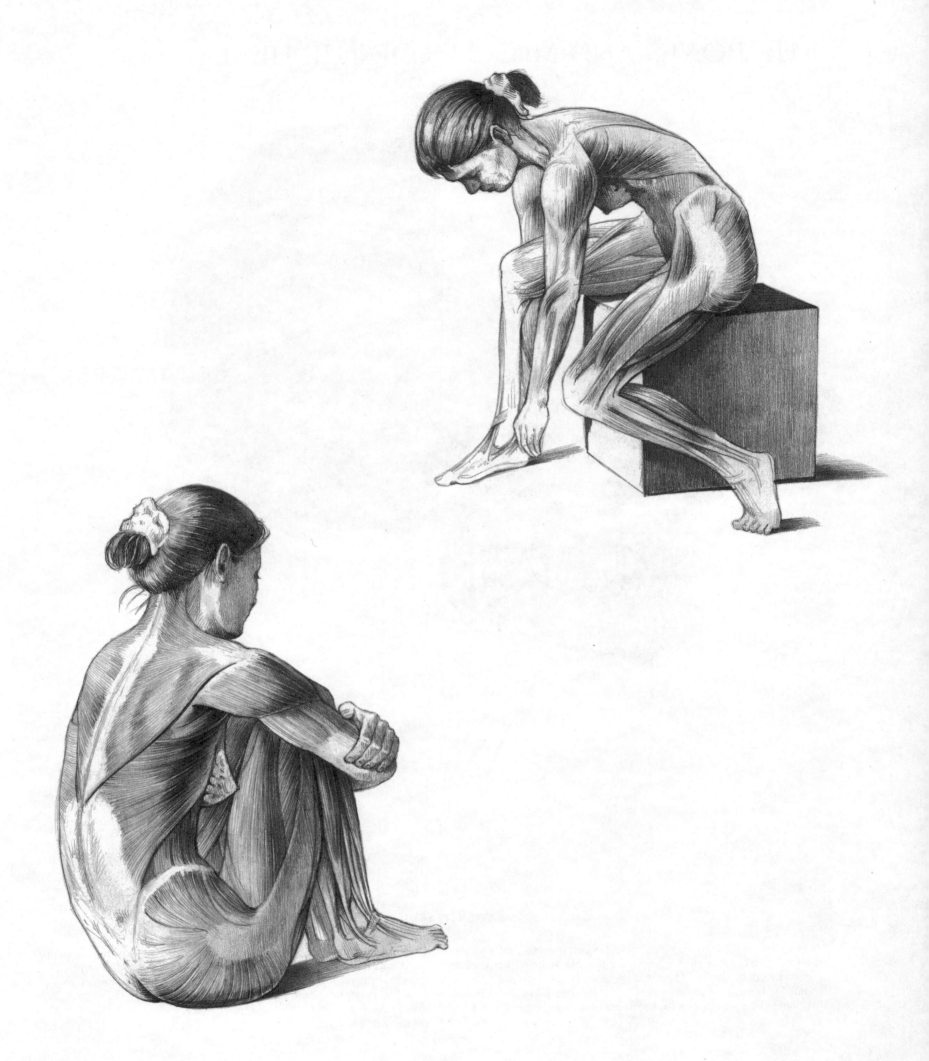

THE BONES AND MUSCLES OF THE HEAD

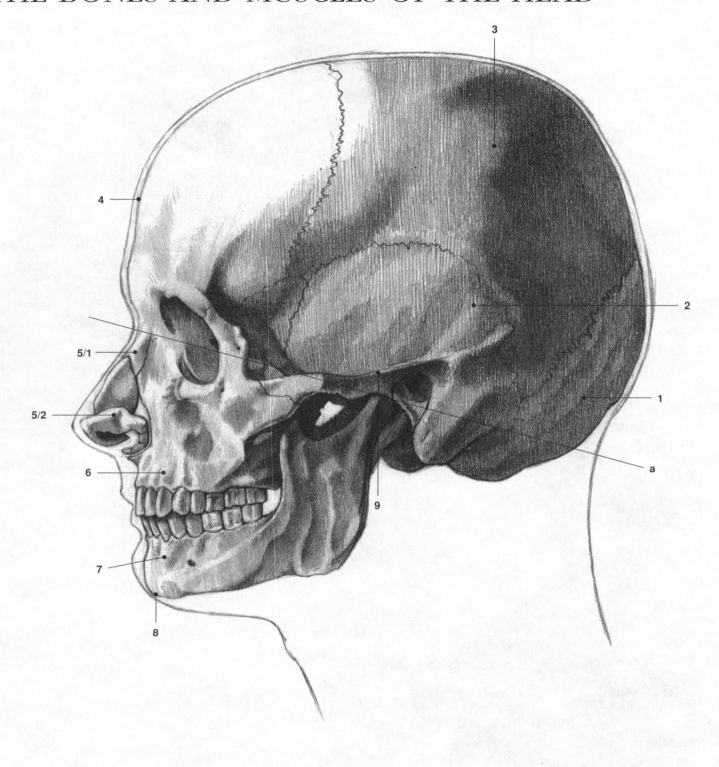

Fig. 136

The skull

The root of the nose, the axis of the orbit and the external auditory canal lie in an oblique plane (a). Above this plane the neurocranium is composed of the occipital (1), temporal (2), parietal (3) and frontal (4) bones, rigidly attached to each other by sutures. Below this plane the nasal bones (5/1) are small and their cartilages form the apex of the nose (5/2). The teeth are located in the maxillary (6) and mandibular (7) dental alveoli. The chin is defined by the mental protuberance (8). The temporal fossa is bordered laterally by the zygomatic arch (9).

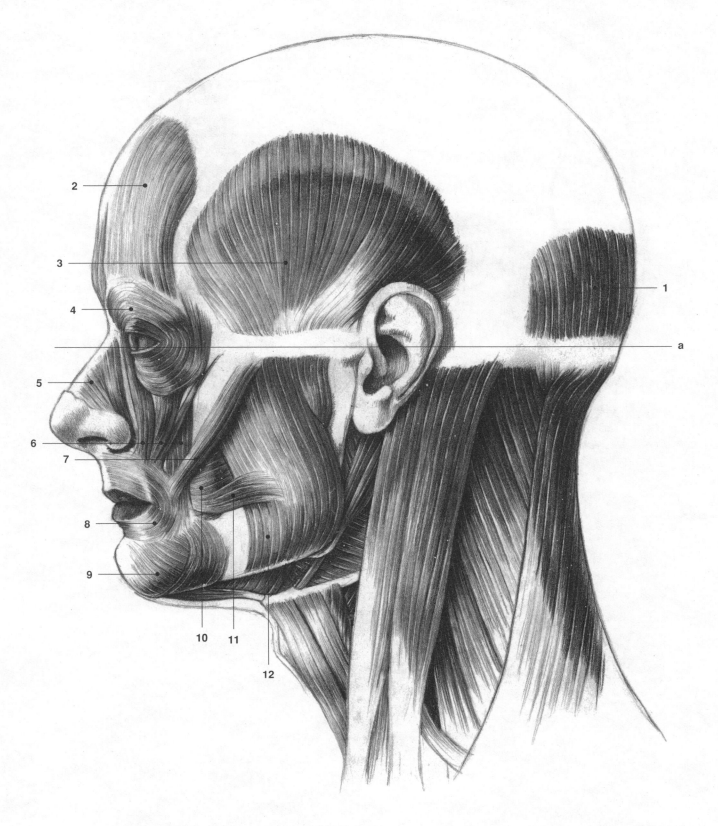

Fig. 137

The muscles of the head

The skull, the region of the eye and the nose are covered by flat muscles. The contours of the face are defined by muscles 6–12.

(a) horizontal plane

1 Occipitalis muscle *(139)*
2 Frontalis muscle *(140)*
3 Temporalis muscle *(179)*
4 Orbicularis oculi muscle *(155)*
5 Lateralis nasi muscle *(162)*
6 Levator labii superioris muscles *(168)*

7 Zygomaticus muscle *(174)*
8 Orbicularis oris muscle *(163)*
9 Mentalis muscle *(173)*
10 Buccinator muscle *(175)*
11 Risorius muscle *(167)*
12 Masseter muscle *(178)*

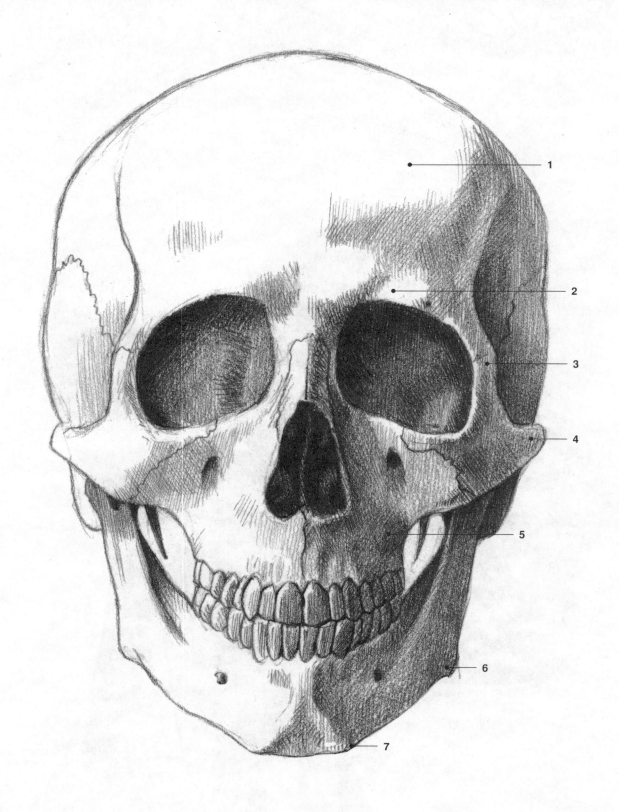

Fig. 138

The skull, anterior aspect

The bony structure of the forehead and face is comprised of the frontal bone (1), the supraorbital ridges (2), the borders of the orbit (3), the zygomatic arch (4), the maxilla (5), the angle of the mandible (6) and the mental protuberance (7). The shape of the neurocranium varies between races and individuals.

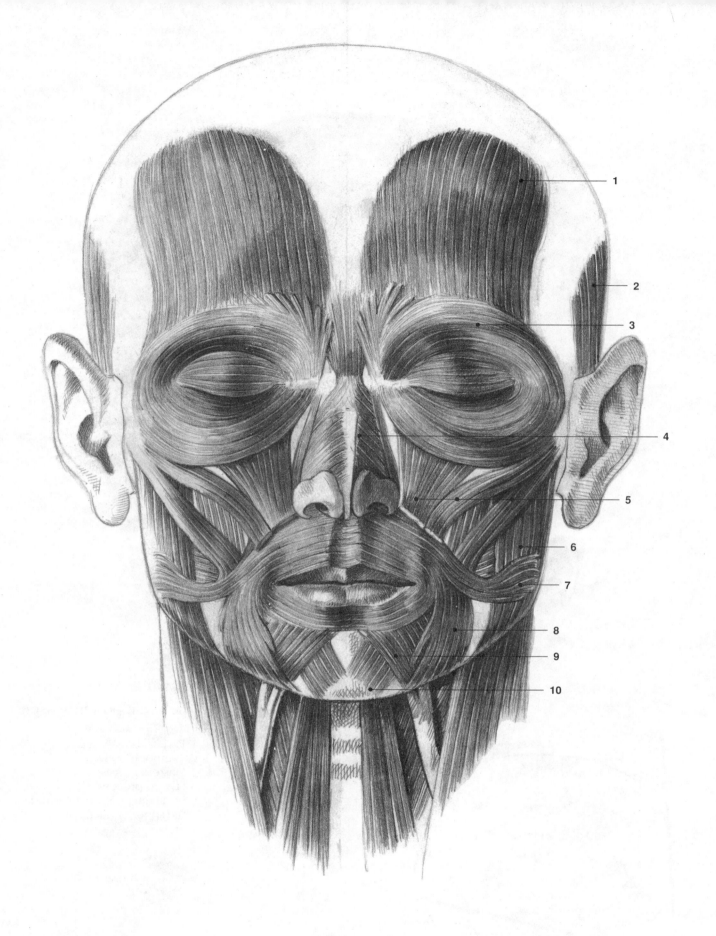

Fig. 139

The muscles of the head, anterior aspect

1 Frontalis muscle *(140)*
2 Temporalis muscle *(179)*
3 Orbicularis oculi muscle *(155)*
4 Transversus nasi muscle *(161)*
5 Levator labii superioris muscles *(168)*

6 Masseter muscle *(178)*
7 Risorius muscle *(167)*
8 Depressor anguli oris muscle *(170/1)*
9 Depressor labii inferioris muscle *(170)*
10 Mentalis muscle *(173)*

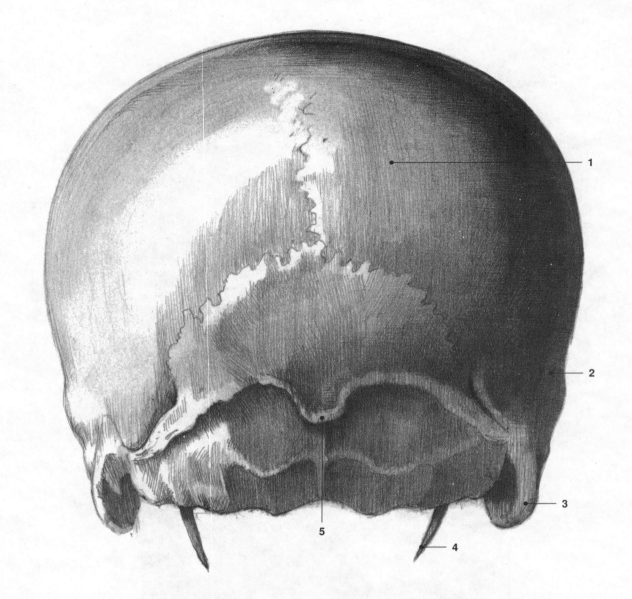

Fig. 140

The skull, posterior aspect

1 Parietal bone
2 Temporal bone
3 Mastoid process
4 Styloid process
5 Occipital protuberance and
 the superior nuchal line

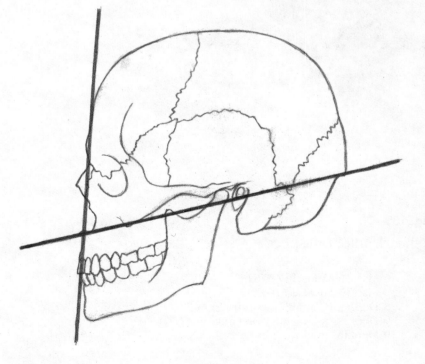

Fig. 141

The facial angle (Camper's angle)

The line connecting the base of the nostril and the forehead, and
the line connecting the base of the nostril and the external auditory
meatus, form an angle which is characteristic of the race and the
individual, so it is important from an artistic point of view.

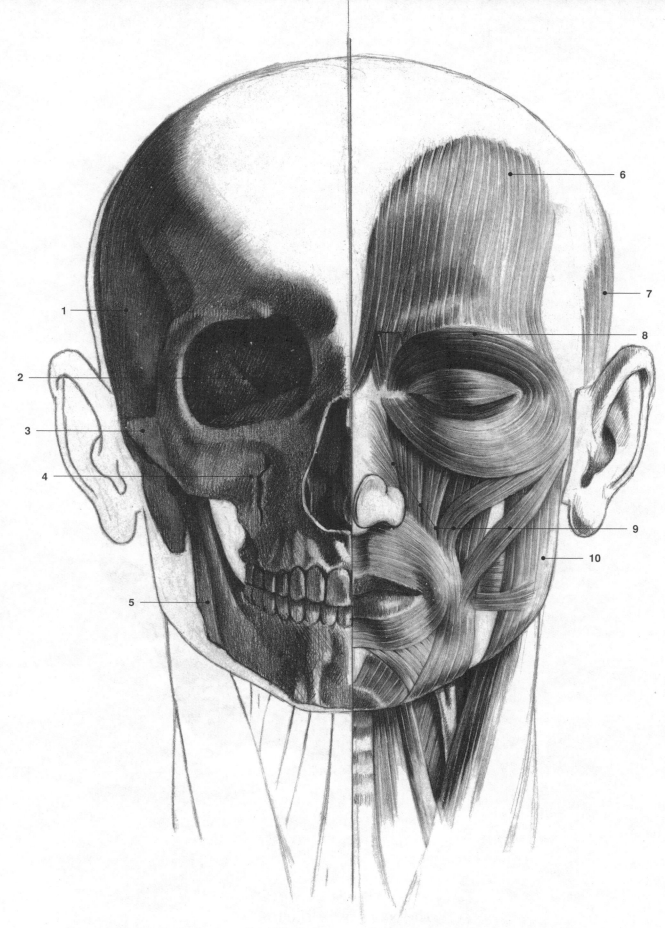

Fig. 142

The skull and muscles of the head, anterior aspect

From this view the shape of the head is determined by the frontal, superior and temporal (1) parts of the skull, as well as by the shape of the orbital (2), zygomatic (3), nasomaxillary (4) and mandibular (5) parts of the face.

The frontal bone is covered by the thin frontalis muscle (6), the temporal bone by the temporalis muscle (7) and the orbit is surrounded by the orbicularis oculi muscle (8). The muscles of the nose and the lips (9) are largely responsible for facial expression. Only the body and ramus of the mandible are covered by the masseter muscle (10).

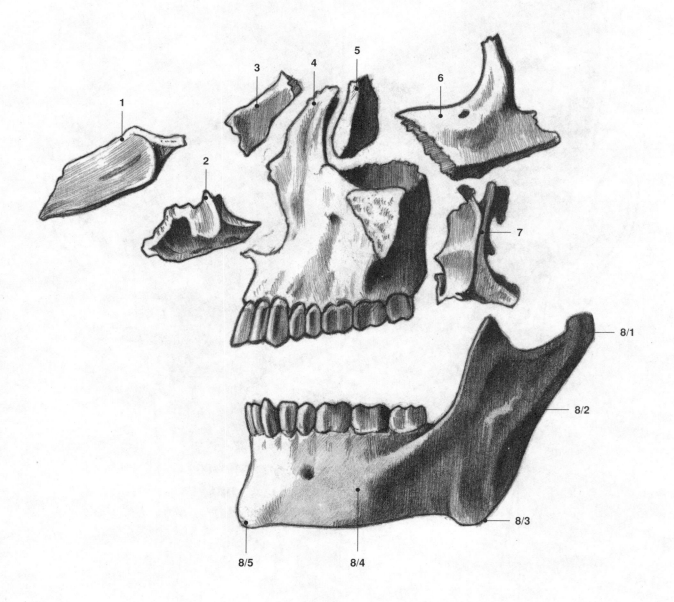

Fig. 143

The bones of the skull

The skull is composed of 22 (6 single and 8 paired) bones. With the exception of the mandible, these are rigidly attached to each other by sutures. These bones protect the brain, the oral cavity and the sense organs. Some incorporate air-filled sinuses into their structure.

Splanchnocranium

1 Nasal bone
2 Lacrimal bone
3 Vomer
4 Maxilla
5 Nasal septum
6 Palatine bone

7 Zygomatic bone
8 Mandible
 8/1 Articular process, condyle
 8/2 Ramus of the mandible
 8/3 Angle of the mandible
 8/4 Body of the mandible
 8/5 Mental protuberance

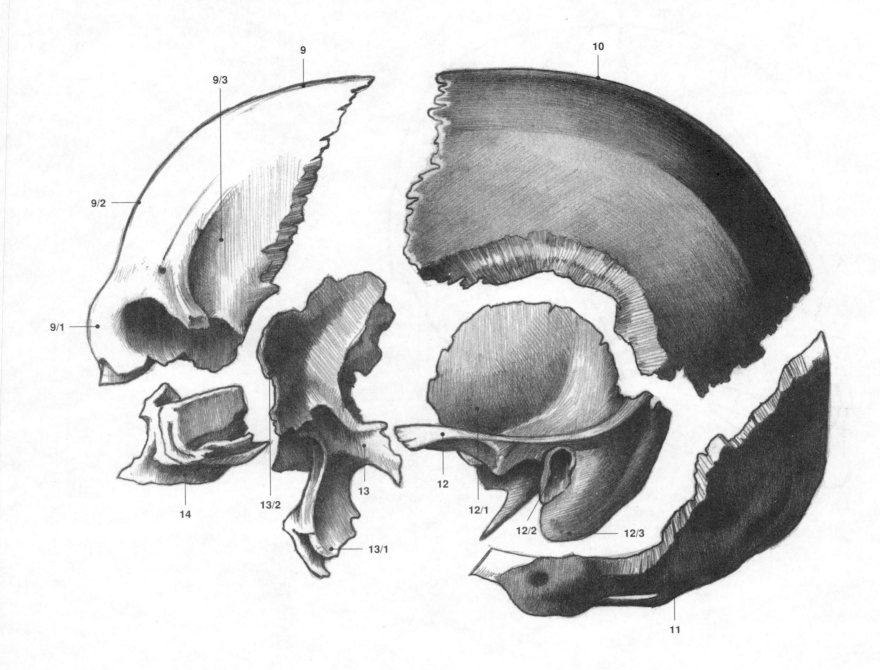

Neurocranium

9 Frontal bone
 9/1 Supraorbital ridge
 9/2 Frontal prominence
 9/3 Temporal part
10 Parietal bone
11 Occiput

12 Temporal bone
 12/1 Squama
 12/2 External auditory meatus
 12/3 Mastoid process
13 Body of the sphenoid bone
 13/1 Lesser wing of the sphenoid
 13/2 Greater wing of the sphenoid
14 Ethmoid bone

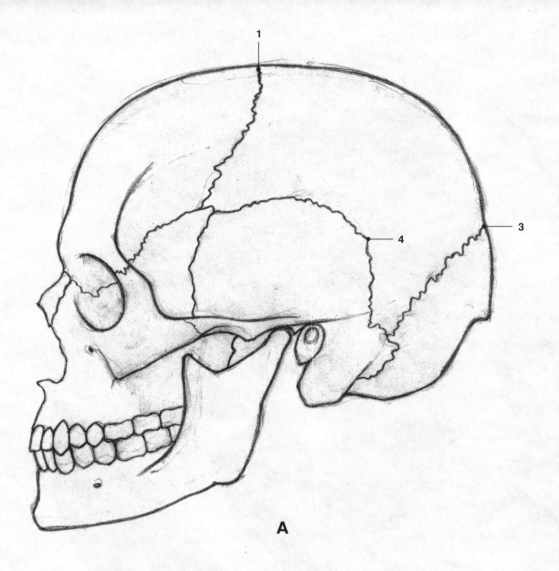

A

Fig. 144

The sutures of the skull; lateral (A) and superior (B) aspects

In childhood the bones are joined by connective tissue or cartilage. In adults the bones become united by true bony sutures.

1 Coronal suture
2 Sagittal suture
3 Lambdoid suture
4 Squamoid suture

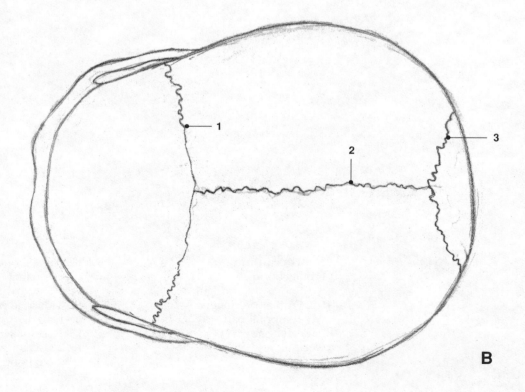

B

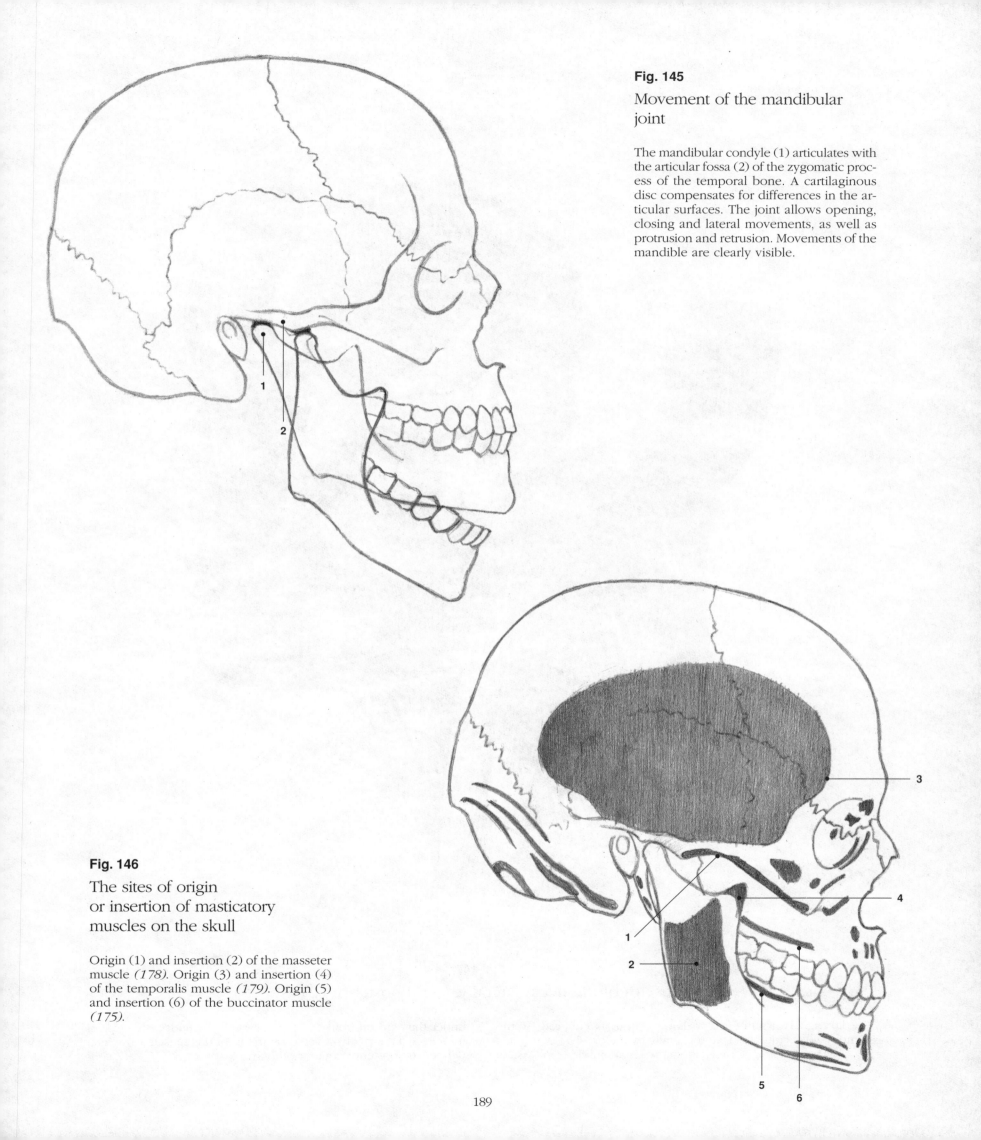

Fig. 145

Movement of the mandibular joint

The mandibular condyle (1) articulates with the articular fossa (2) of the zygomatic process of the temporal bone. A cartilaginous disc compensates for differences in the articular surfaces. The joint allows opening, closing and lateral movements, as well as protrusion and retrusion. Movements of the mandible are clearly visible.

Fig. 146

The sites of origin or insertion of masticatory muscles on the skull

Origin (1) and insertion (2) of the masseter muscle *(178)*. Origin (3) and insertion (4) of the temporalis muscle *(179)*. Origin (5) and insertion (6) of the buccinator muscle *(175)*.

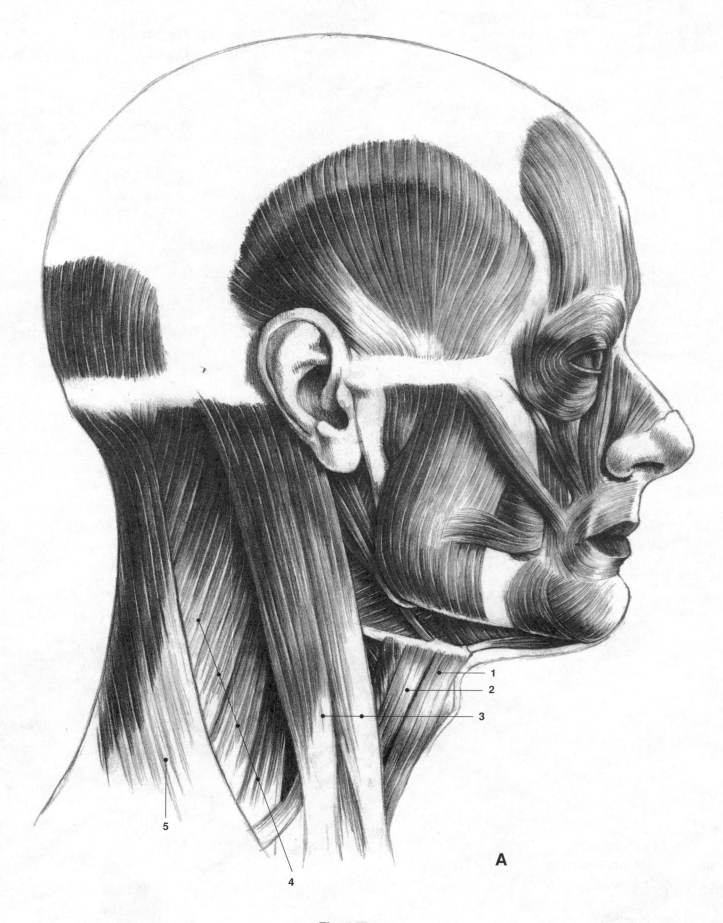

Fig. 147

The muscles of the neck; lateral (A) and posterior (B) aspects

The laryngeal prominence (Adam's apple) is covered by the sternohyoideus muscle (1) and laterally by the omohyoideus muscle (2). The digastric sternocleidomastoideus muscle (3) is visible under the skin on both sides of the neck. Behind it, the scaleni muscles (4) are partly covered by the trapezius muscle (5) which defines the posterior contour of the neck.

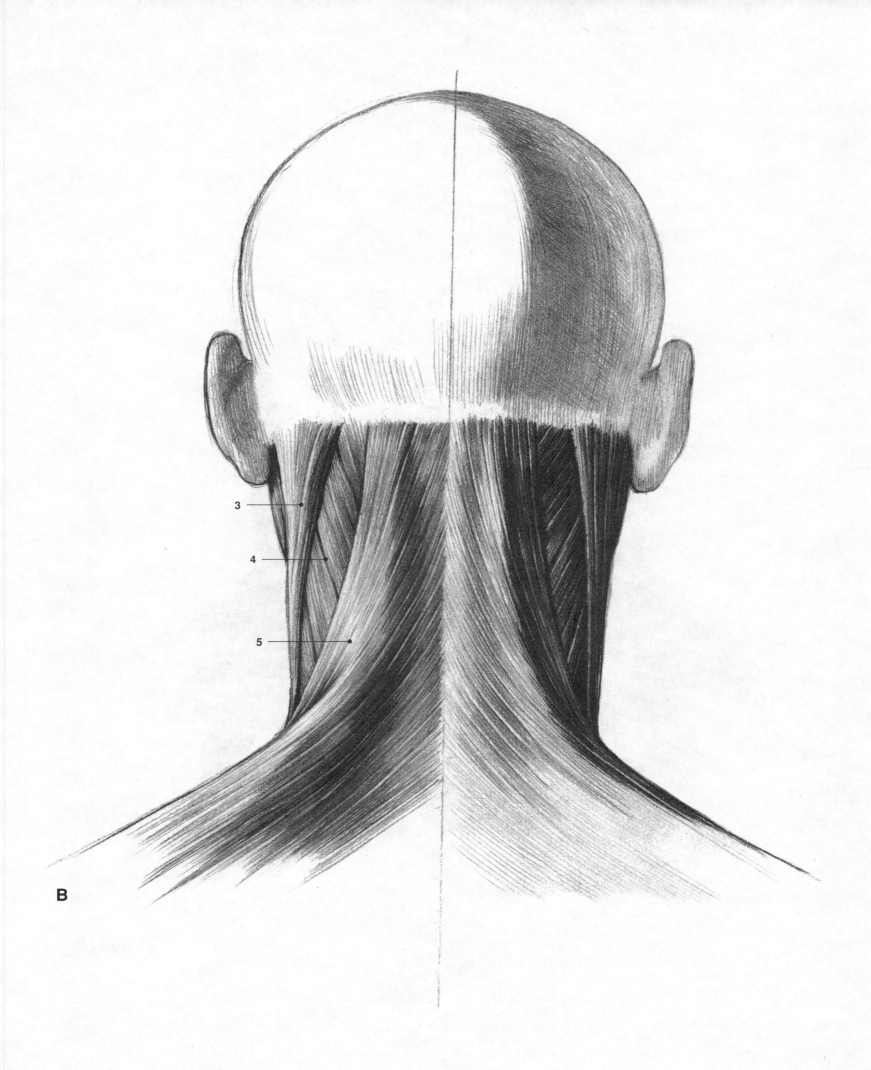

B

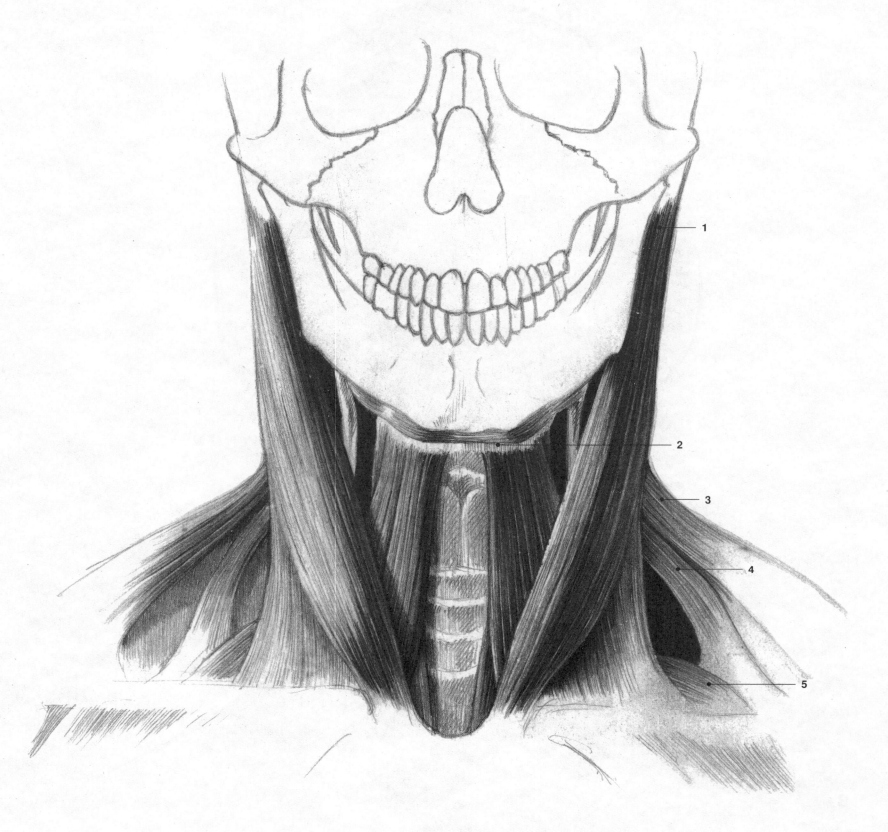

Fig. 148

The muscles of the neck, anterior aspect

1 Sternocleidomastoideus muscle *(6)*
2 Sternohyoideus muscle *(9)*
3 Trapezius muscle *(14)*
4 Levator scapulae muscle *(22)*
5 Scalenus muscle *(11)*

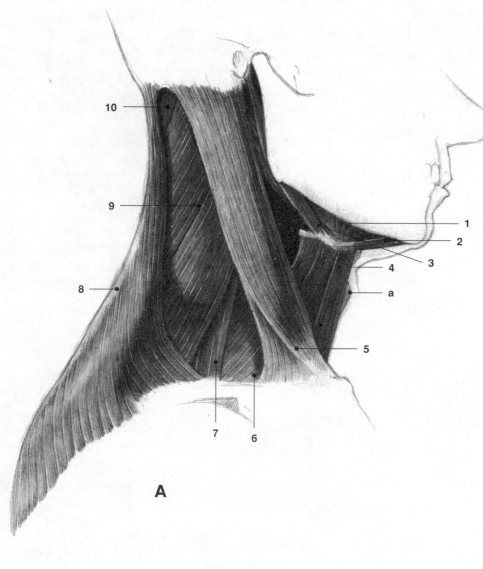

A

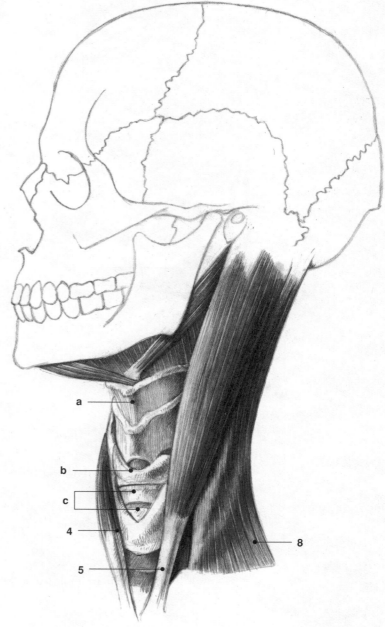

Fig. 149

The muscles of the neck; superficial (A) and deep (B) layers

1 Mylohyoideus muscle *(176)*
2 Biventer mandibulae muscle *(12)*
3 Stylohyoideus muscle *(13)*
4 Sternohyoideus muscle *(9)*
5 Sternocleidomastoideus muscle *(6)*
6 Omohyoideus muscle *(10)*
7 Scalenus anterior muscle *(11/1)*
8 Trapezius muscle *(14)*
9 Scalenus medius muscle *(11/2)*
10 Splenius capitis muscle *(5)*

a) Thyroid cartilage (Adam's apple)
b) Annular cartilage of the larynx
c) Annular cartilage of the laryngeal tube

B

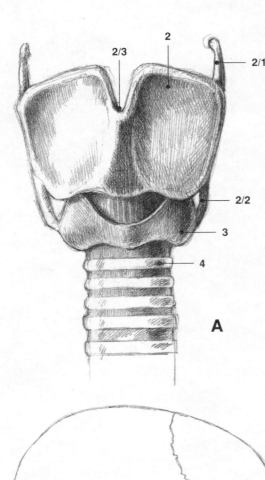

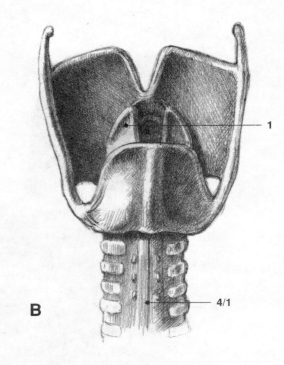

Fig. 150

The cartilaginous framework
of the larynx; anterior (A)
and posterior (B) aspects

1 Arytenoid cartilage
2 Thyroid cartilage
 2/1 Hyoid horn
 2/2 Annular cartilaginous horn
 2/3 Thyroid incisura
3 Annular cartilage of the larnyx
4 Annular cartilage of the laryngeal tube
 4/1 Membranous wall connecting the
 posterior endings of the annular
 cartilages

A

B

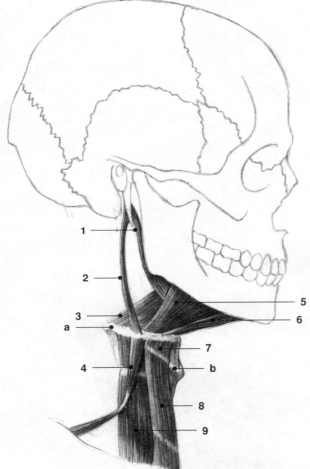

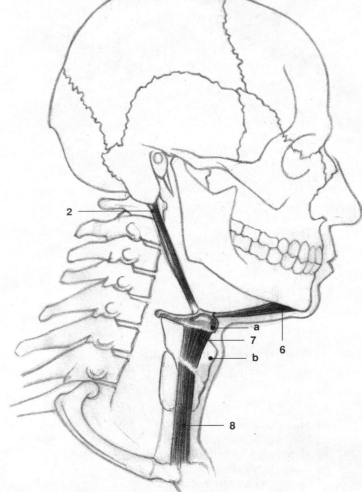

Fig. 151

The muscles of the larynx; superficial (A) and deep (B) layers

1 Styloglossus muscle *(13/2)*
2 Stylohyoideus muscle *(13/1)*
3 Constrictores pharyngis muscles
4 Sternohyoideus muscle *(9)*
5 Mylohyoideus muscle *(176)*
6 Digastricus mandibulae muscle *(12)*

7 Thyreohyoideus muscle *(13/3)*
8 Sternothyreoideus muscle *(8)*
9 Omohyoideus muscle *(10)*

a) Hyoid bone
b) "Adam's apple"

194

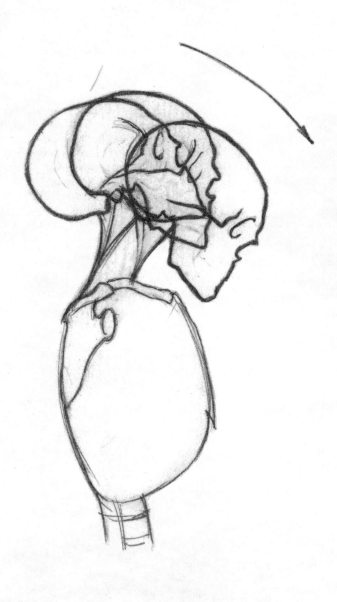

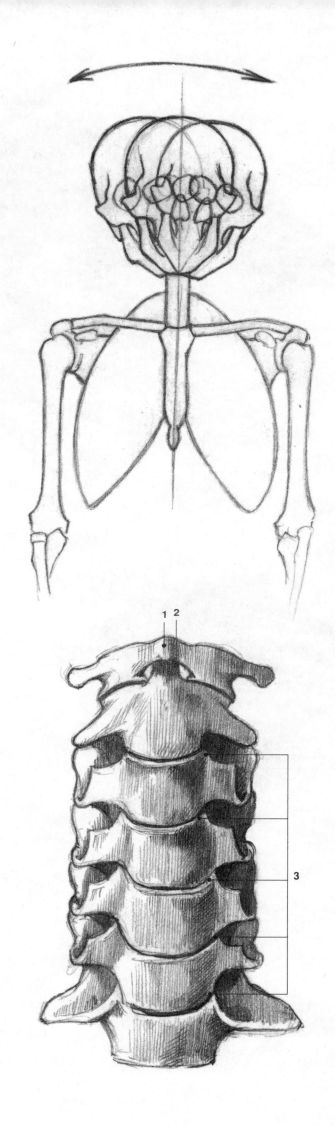

Fig. 152

Movement of the neck

The neck can be flexed and extended at the atlantooccipital joint (1). Lateral movements take place mainly at the atlantoaxial joint (2). The head can be rotated by synchronized movements of the joints between the cervical vertebrae (3).

Fig. 153

The eye

Through the cornea (1) the iris (2), which is responsible for the colour of the eye, can be seen with the black pupil in the center (3). In the open palpebral fissure the sclera appears white (4). The larger upper (5) and smaller lower (6) eyelids are wrinkled. On their inner margins (8) the tarsal glands open. On their outer margins (7) are the eyelashes. The outer canthus is pointed (9), the inner one is rounded (10).

Fig. 154

The muscles of the eye

1 Orbicularis oculi muscle *(155)*
 1/1 Palpebral part
 1/2 Orbital part
2 Corrugator supercilii muscle *(156)*
3 Levator labii superioris muscle (medial part) *(168)*
4 Levator labii superioris muscle (lateral part) *(168)*
5 Zygomaticus parvus muscle *(174)*
6 Frontalis muscle *(140)*
7 Procerus muscle *(140/1)*

Fig. 155

Studies of the eye

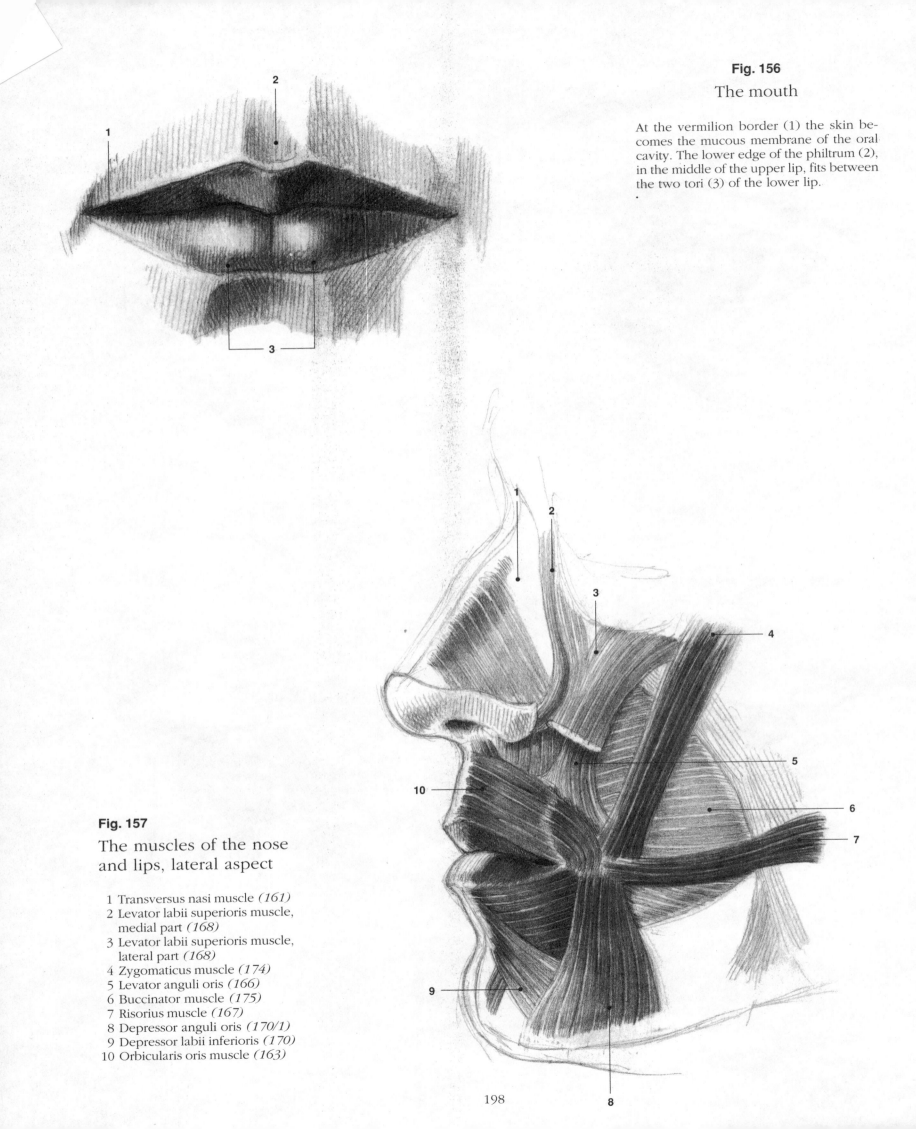

Fig. 156

The mouth

At the vermilion border (1) the skin becomes the mucous membrane of the oral cavity. The lower edge of the philtrum (2), in the middle of the upper lip, fits between the two tori (3) of the lower lip.

Fig. 157

The muscles of the nose and lips, lateral aspect

1 Transversus nasi muscle *(161)*
2 Levator labii superioris muscle, medial part *(168)*
3 Levator labii superioris muscle, lateral part *(168)*
4 Zygomaticus muscle *(174)*
5 Levator anguli oris *(166)*
6 Buccinator muscle *(175)*
7 Risorius muscle *(167)*
8 Depressor anguli oris *(170/1)*
9 Depressor labii inferioris *(170)*
10 Orbicularis oris muscle *(163)*

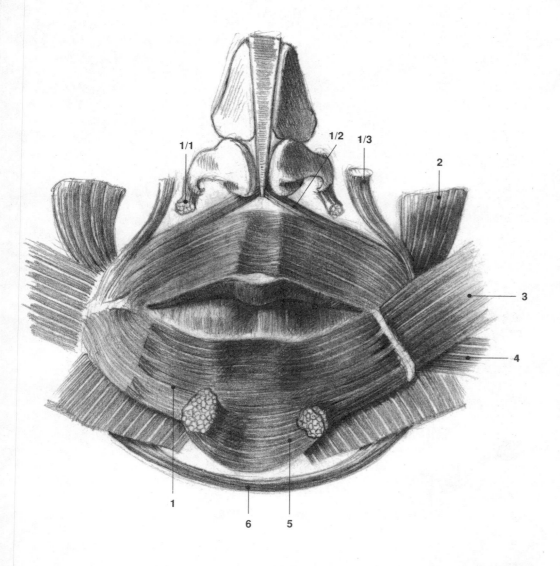

Fig. 158

The muscles of the lip, anterior aspect

1 Muscle bundles of the orbicularis oris muscle *(163)*
 originating on the
 1/1 Triangular cartilages
 1/2 Cartilaginous septum
 1/3 Maxilla
2 Levator anguli oris muscle *(166)*
3 Risorius muscle *(167)*
4 Depressor anguli oris muscle *(170/1)*
5 Mentalis muscle *(173)*
6 Transversus menti muscle *(173/1)*

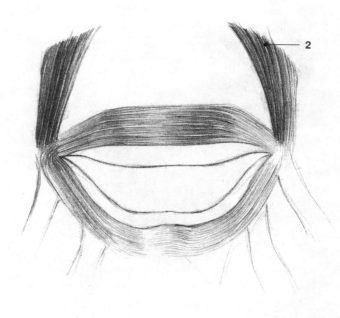

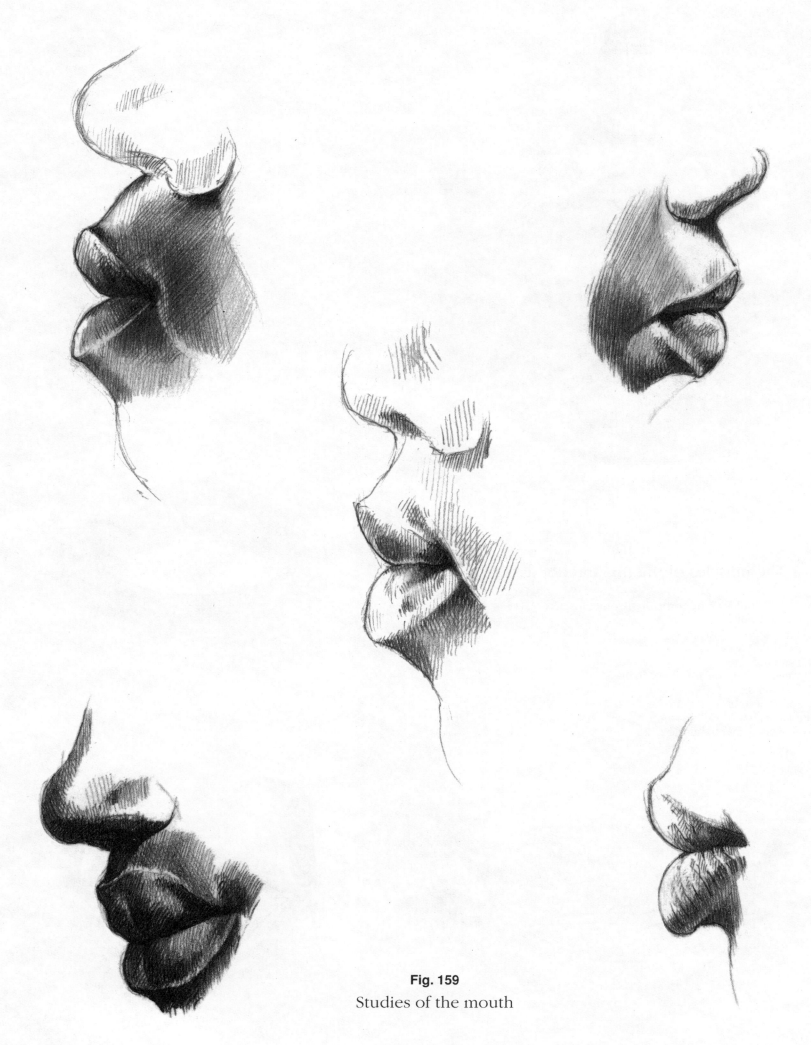

Fig. 159
Studies of the mouth

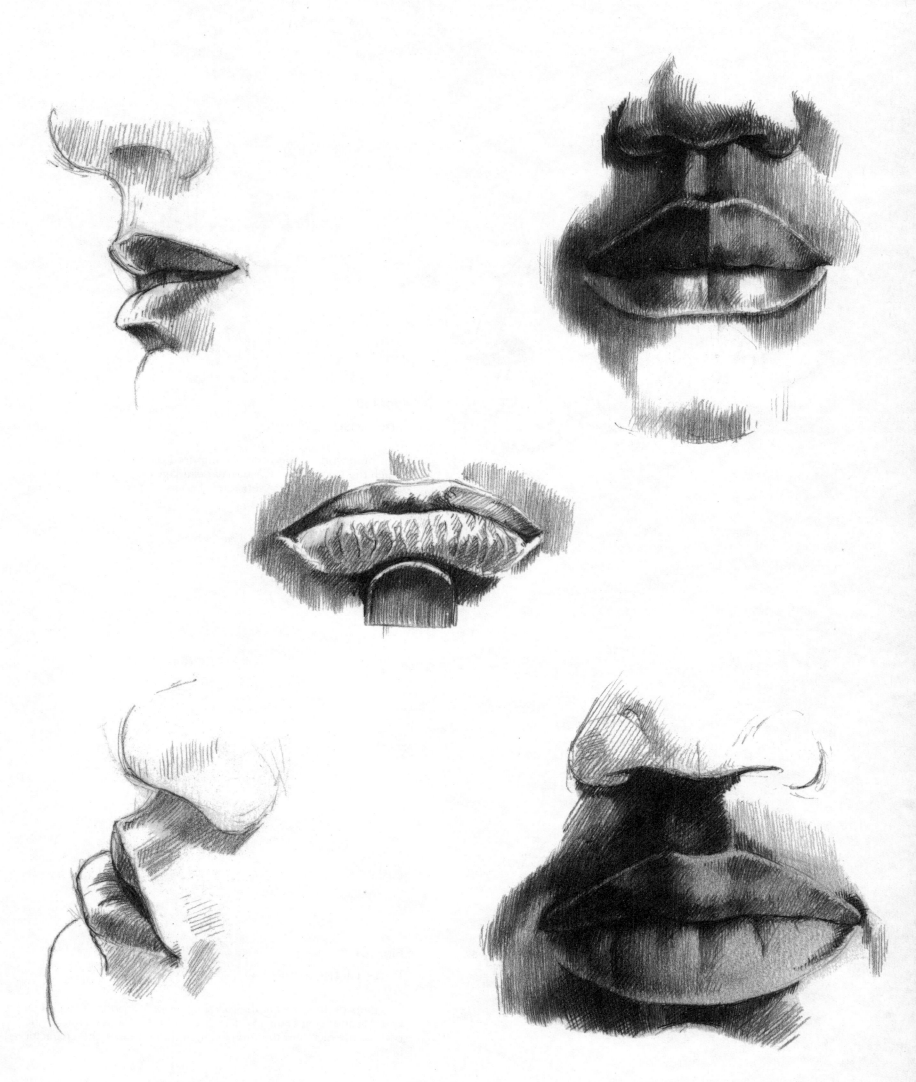

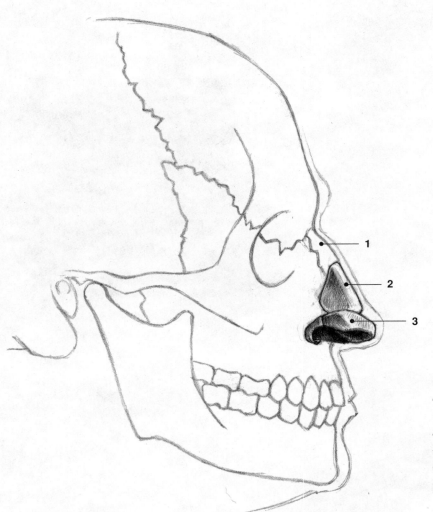

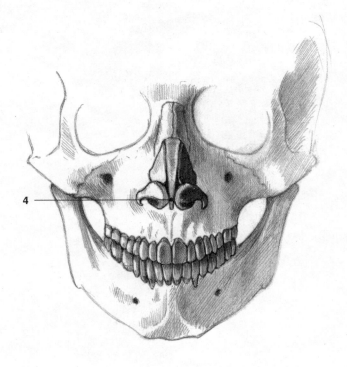

Fig. 160

The nose

The framework of the nose is comprised of the nasal bone (1) to which the lateral nasal (2) and alar cartilages (3) are attached. The cartilaginous septum (4) separates the nasal cavities of the left and right sides.

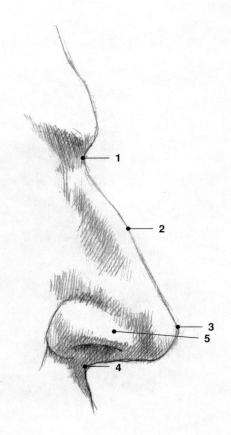

Fig. 161

Parts of the nose

The parts of the nose are the following: root (1), bridge (2), tip (3), base (4) and wing or ala (5). The shape of the nose is characteristic both of the race and the individual, and determines the character of the face.

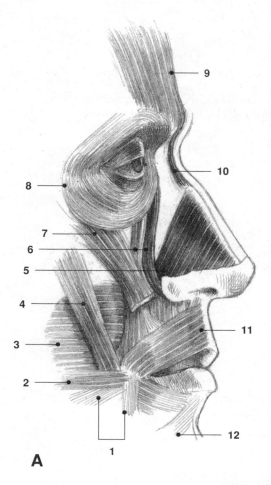

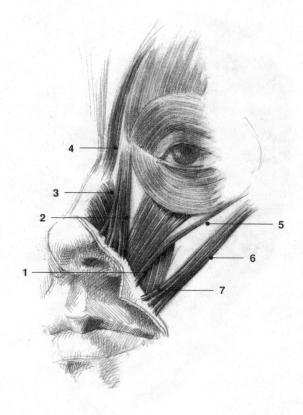

Fig. 162

The muscles of the nose
and lips; lateral (A)
and anterior (B) aspects

A

B

1 Depressor anguli oris muscle *(170/1)*
2 Risorius muscle *(167)*
3 Buccinator muscle *(175)*
4 Zygomaticus muscle *(174)*
5 Transversus nasi muscle *(161)*
6 Levator labii superioris muscle,
 medial part *(168)*
7 Levator labii superioris muscle,
 lateral part *(168)*
8 Orbicularis oculi muscle *(155)*
9 Frontalis muscle *(140)*
10 Depressor glabellae muscle
11 Orbicularis oris muscle *(163)*
12 Depressor labii inferioris muscle *(170)*

1 Levator labii superioris muscle *(168)*
2 Levator labii superioris muscle, medial
 part *(168)*
3 Transversus nasi muscle *(161)*
4 Depressor glabellae muscle
5 Zygomaticus parvus muscle *(174)*
6 Zygomaticus major muscle *(174)*
7 Levator anguli oris muscle *(166)*

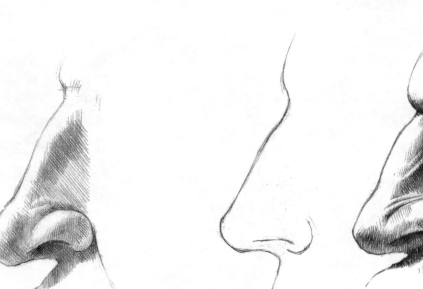

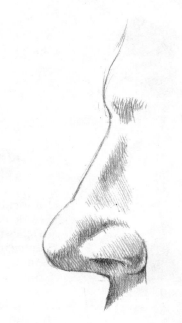

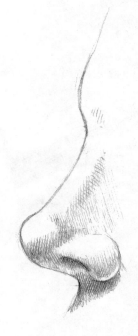

Fig. 163
Studies of the nose

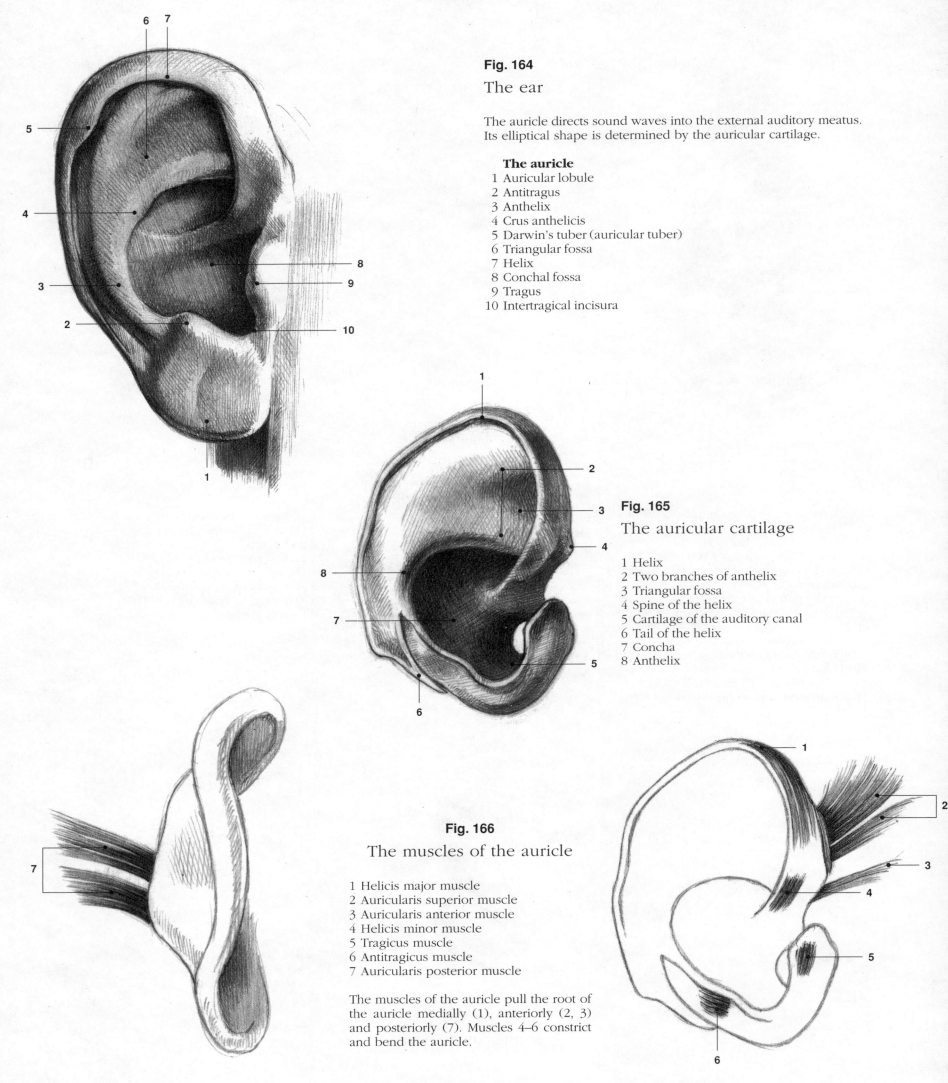

Fig. 164

The ear

The auricle directs sound waves into the external auditory meatus. Its elliptical shape is determined by the auricular cartilage.

The auricle
1 Auricular lobule
2 Antitragus
3 Anthelix
4 Crus anthelicis
5 Darwin's tuber (auricular tuber)
6 Triangular fossa
7 Helix
8 Conchal fossa
9 Tragus
10 Intertragical incisura

Fig. 165

The auricular cartilage

1 Helix
2 Two branches of anthelix
3 Triangular fossa
4 Spine of the helix
5 Cartilage of the auditory canal
6 Tail of the helix
7 Concha
8 Anthelix

Fig. 166

The muscles of the auricle

1 Helicis major muscle
2 Auricularis superior muscle
3 Auricularis anterior muscle
4 Helicis minor muscle
5 Tragicus muscle
6 Antitragicus muscle
7 Auricularis posterior muscle

The muscles of the auricle pull the root of the auricle medially (1), anteriorly (2, 3) and posteriorly (7). Muscles 4–6 constrict and bend the auricle.

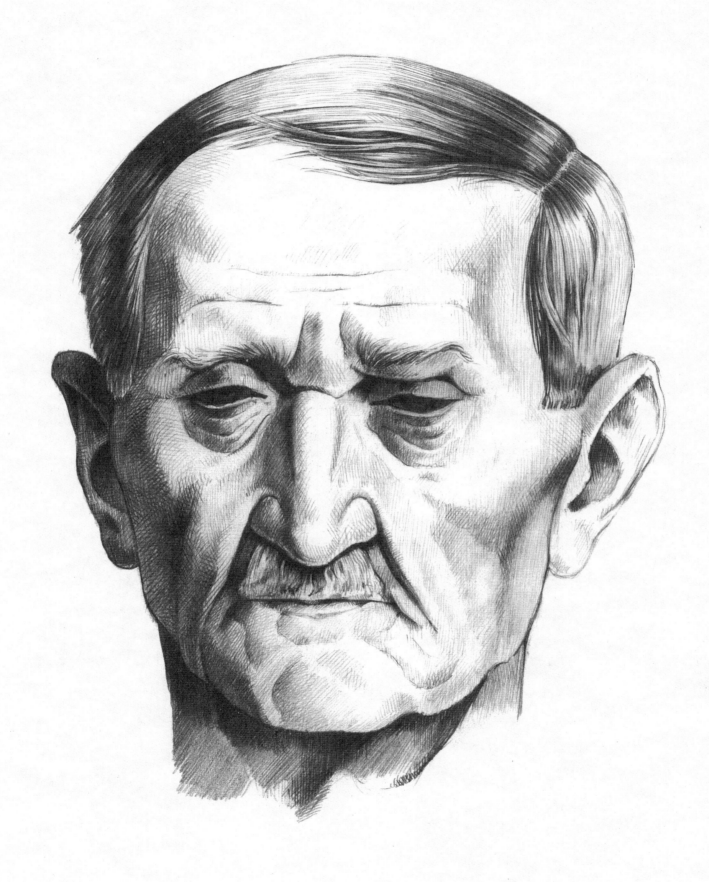

Fig. 167

Head study

ANIMAL ANATOMY

THE HORSE

The horse has played an important role throughout the cultural history of man. It was used extensively as a pack and draft animal, especially in agriculture and for transport. When ridden, the horse assisted in the transmission of news and was indispensible in wars. But as a result of technological advances its use as a utility animal has largely disappeared.

The horse is able to run fast and for long periods, and it can also jump high and far. Because the leg muscles are close to the body, only a short contraction and relatively little energy is needed for maximum movement of the slender and sinewy legs. The ligaments are arranged in such a way that the limbs are held in an angled position; therefore only forward and backward movements are possible. However, these are sufficient to enable the horse to take very long strides and run at high speed. Its anatomical structure makes it easy for the horse to stand, run and jump, but lying down and getting up are difficult. Horses avoid these movements and prefer to sleep standing up.

The most important gaits of horses are walking, trotting and galloping. When walking, a horse moves forward slowly by putting down one foot after the other in a crosswise manner. Three legs are in contact with the ground at all times. During trotting, the steps are taken faster so that two legs are in the air at the same time. When galloping, the horse jumps from the hindlegs onto the forelegs so that all four legs are in the air and the hooves touch the ground only briefly. Galloping is very energy-consuming because it involves extensive use of the trunk muscles. Because of their long strides – often up to 4 metres (13 ft) – race-horses can reach speeds of up to 60 km/h (38 mph).

The legs of the horse, which are designed for running, have short, strong bones in the upper forelegs and hindlegs. The two bones of the lower forelegs and hindlegs are fused together. It is impossible to overstretch the limbs. All the metatarsal bones, as well as the phalanges, have become smaller, apart from the third metatarsal bone which now predominates. The bones of the tip of the toes have spread out and are protected by hooves. Therefore horses are digitigrades and odd-toed ungulates.

Horses are exclusively herbivores; their teeth enable them to eat hard and woody plants. Their diet can therefore be very varied. With their strong incisors tough foliage can be bitten off. The food is ground thoroughly with large, wide molars. Important parts of the teeth, namely the dentine and dental cement, are worn away at a faster rate than the enamel. This leads to so-called enamel-folds which act like coarse rasps and facilitate the grinding of food. These enamel folds are also a clue to the age of the horse. In both the upper and the lower jaw there is a gap behind the incisors and the canines where the mouth piece of the snaffle can be inserted, to which reins can then be attached.

Chewed food is digested straight away in the stomach and small intestine, because horses do not chew the cud. Plant fibres are broken down by bacteria in the caecum and large intestine. Indigestible waste products are expelled in the fiber-rich droppings.

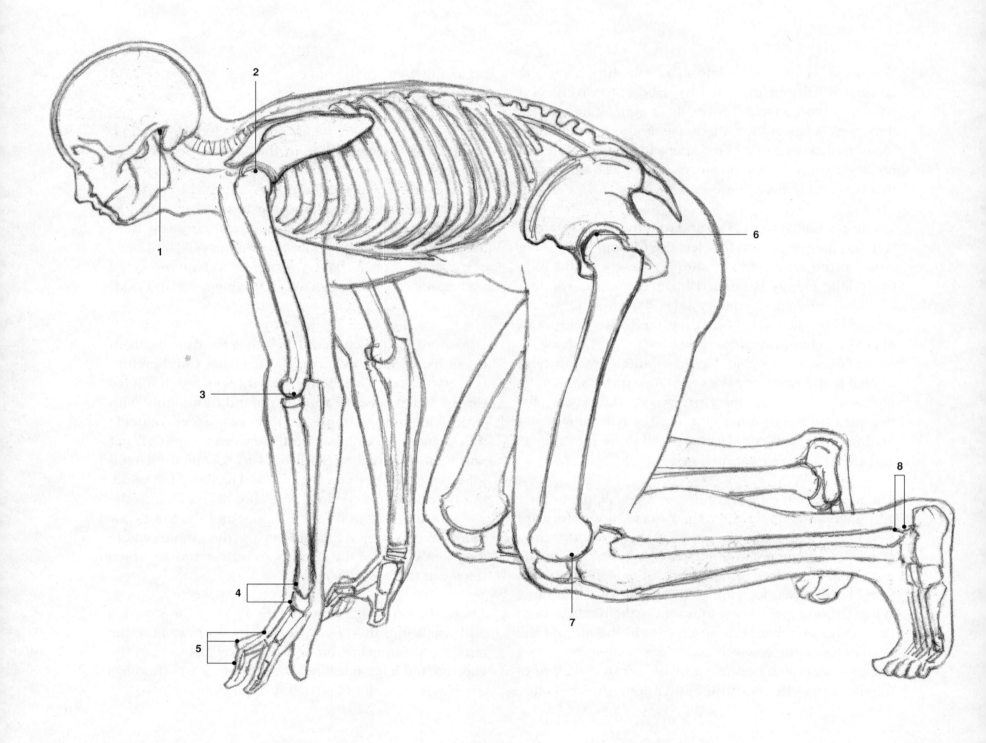

Fig. 1

The skeleton and the joints

We draw attention to the main morphological differences between man and animals. The spinal column of man is vertical, and the neck is short. In animals the vertebral column is horizontal and the neck is long. The neurocranium of man is bigger than the splanchnocranium (the proportion is 3:1), while in animals the splanchnocranium is longer and more fully developed (the pro-portion is 1:3). The human humerus and femur are long, while the hands and feet are short. The animals' humerus and femur are short and stand close to the trunk. The legs are long. The number of digits is re-duced and owing to this the joints of the limbs are located in different positions. The shape and the location of the muscles are similar in man and animals. See Figs. 1–4.

1 Mandibular joint
2 Shoulder joint
3 Elbow joint
4 Carpal joint
5 Phalangeal joints
6 Hip joint
7 Knee joint
8 Tarsal joint

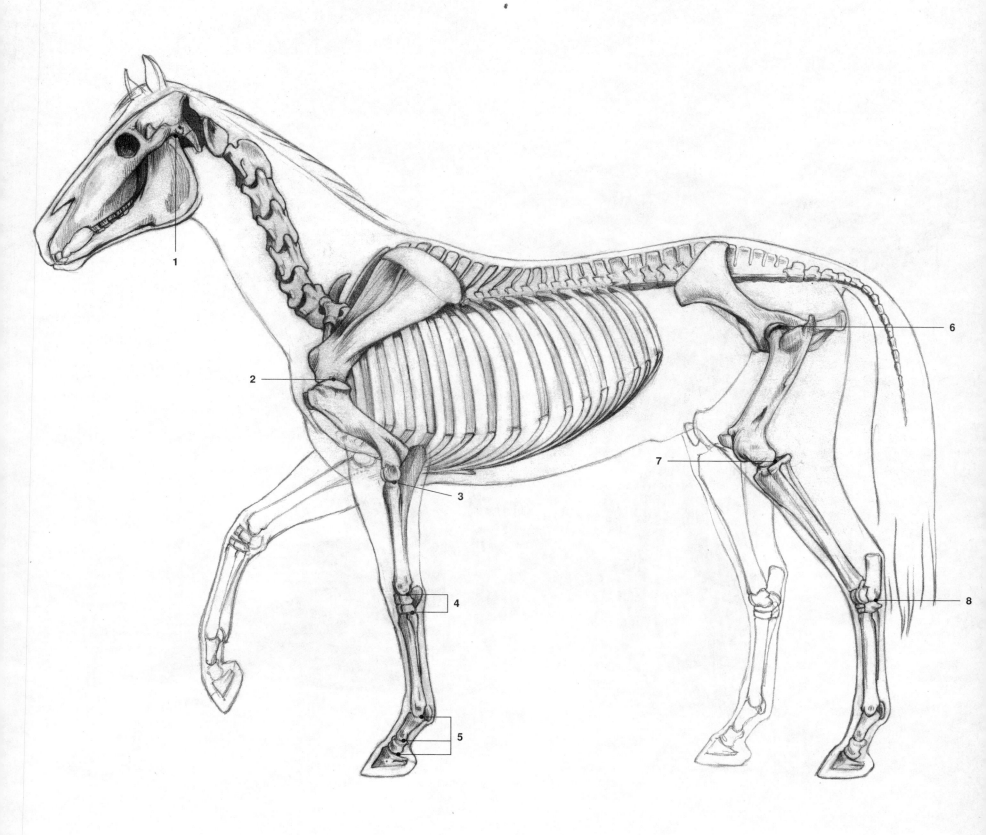

Fig. 2

The skeleton and joints

1 Mandibular joint 5 Phalangeal joints
2 Shoulder joint 6 Hip joint
3 Elbow joint 7 Stifle joint
4 Carpal joint 8 Tarsal joint

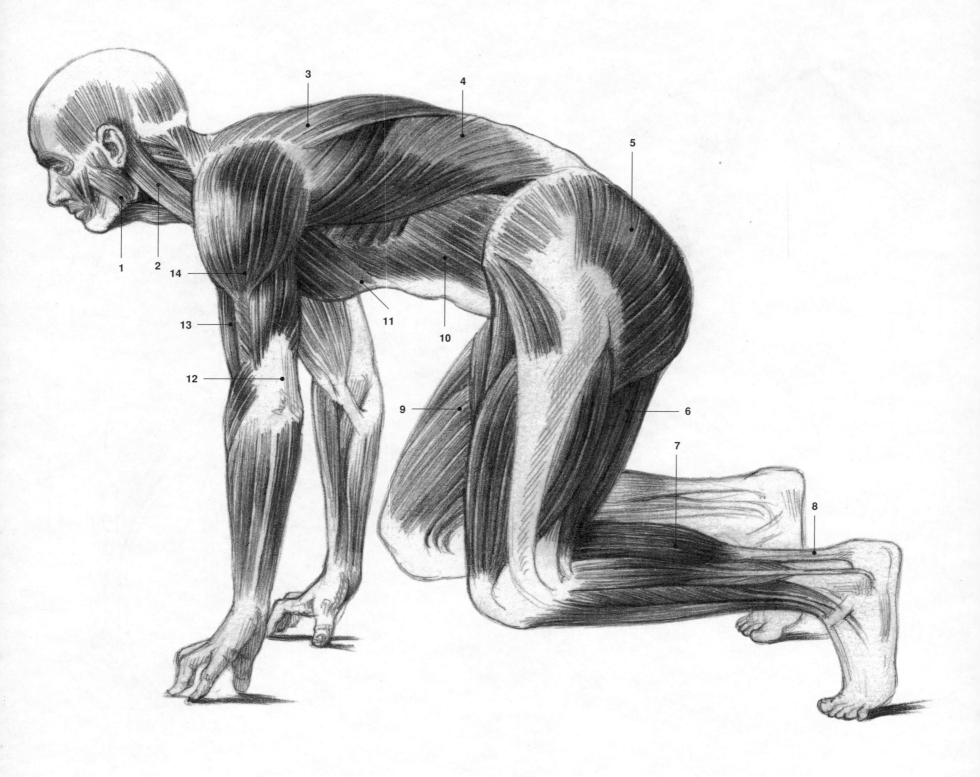

Fig. 3

The muscles

1 Masseter muscle *(178)*
2 Sternocleidomastoideus muscle *(6)*
3 Trapezius muscle *(14)*
4 Latissimus dorsi muscle *(16)*
5 Proximal muscles of the rump *(96–100)*
6 Biceps femoris muscle *(106)*
7 Triceps surae muscle *(114)*

8 Achilles tendon *(115)*
9 Quadriceps femoris muscle *(112)*
10 Obliquus externus abdominis muscle *(36)*
11 Pectoralis muscles *(27–30)*
12 Triceps brachii muscle *(52)*
13 Biceps brachii or brachialis (horse) muscle *(50–51)*
14 Deltoideus muscle *(43)*

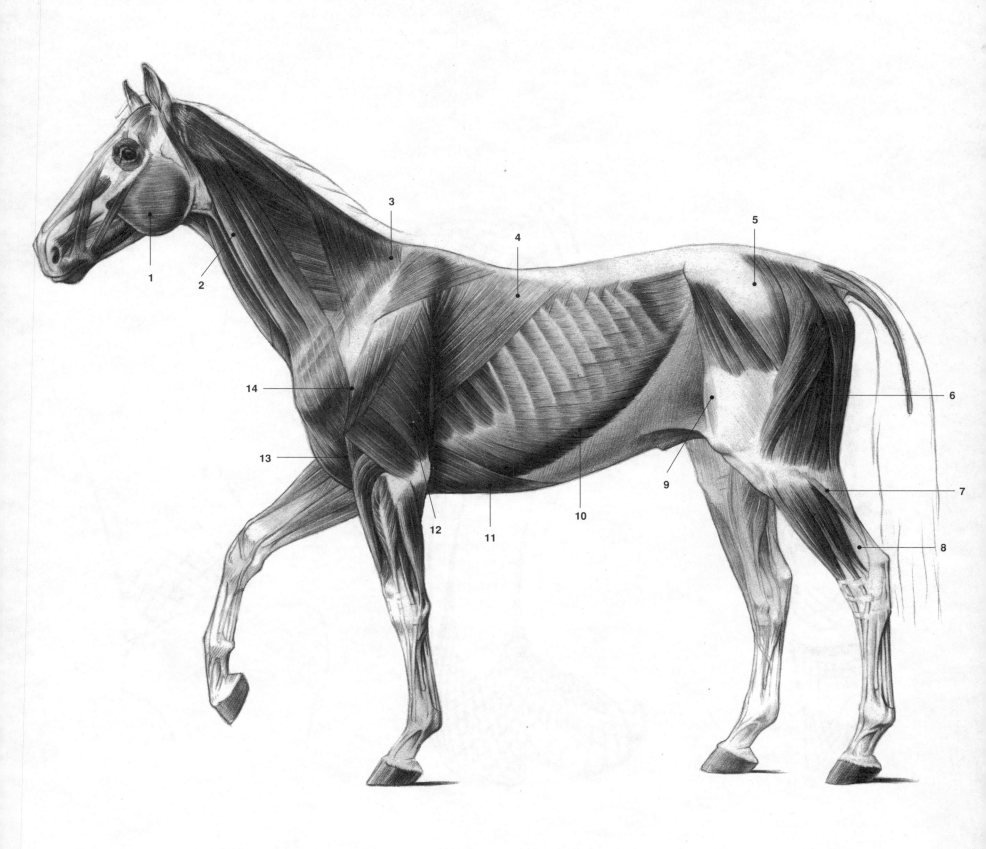

Fig. 4

The muscles

1 Masseter muscle *(178)*
2 Sternocleidomastoideus muscle *(6)*
3 Trapezius muscle *(14)*
4 Latissimus dorsi muscle *(16)*
5 Proximal muscles of the rump *(96–100)*
6 Biceps femoris muscle *(106)*
7 Triceps surae muscle *(114)*

8 Achilles tendon *(115)*
9 Quadriceps femoris muscle *(112)*
10 Obliquus externus abdominis muscle *(36)*
11 Pectoral muscles *(27–30)*
12 Triceps brachii muscle *(52)*
13 Biceps brachii or brachialis (horse) muscle *(50–51)*
14 Deltoideus muscle *(43)*

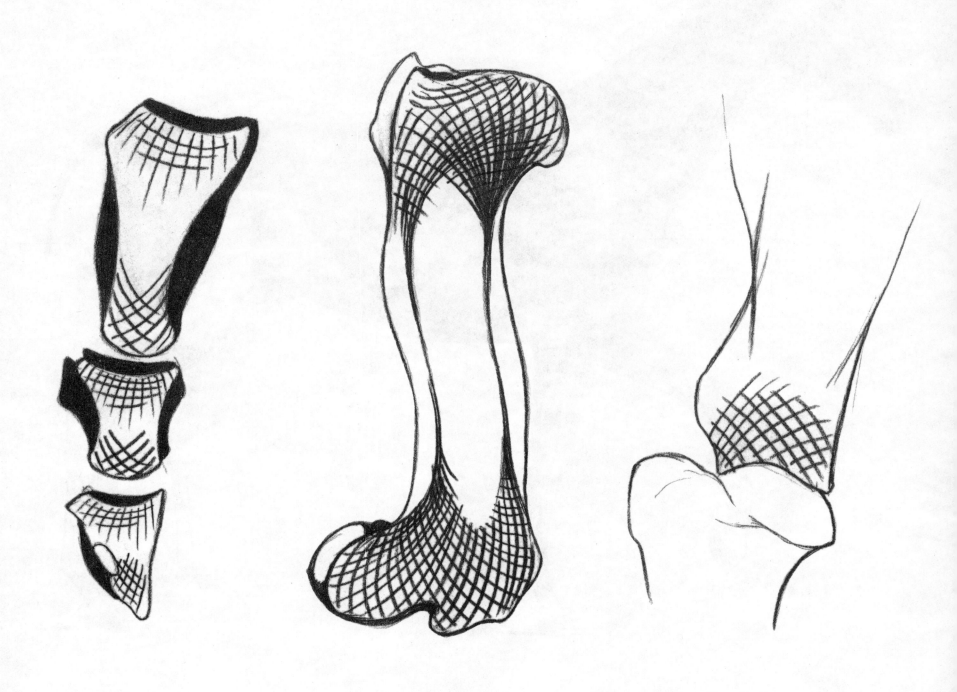

Fig. 5

The structure of bones

The bony plates of cancellous bone are arranged according to the tension curves.

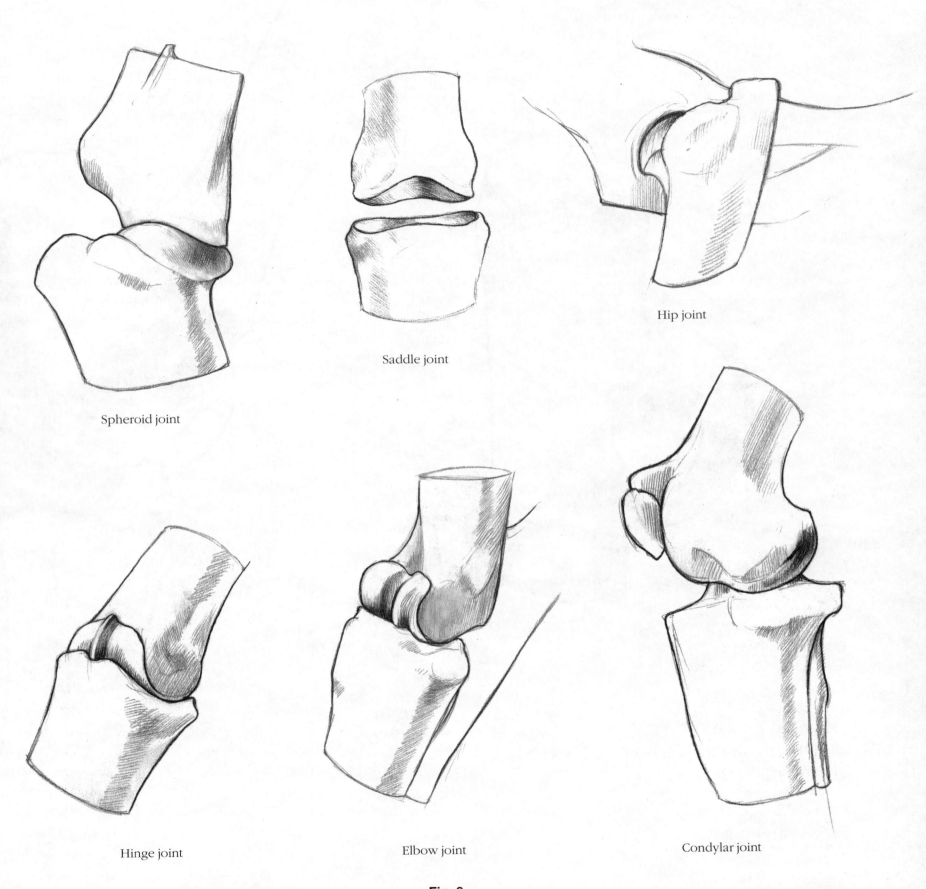

Spheroid joint

Saddle joint

Hip joint

Hinge joint

Elbow joint

Condylar joint

Fig. 6

Types of joint

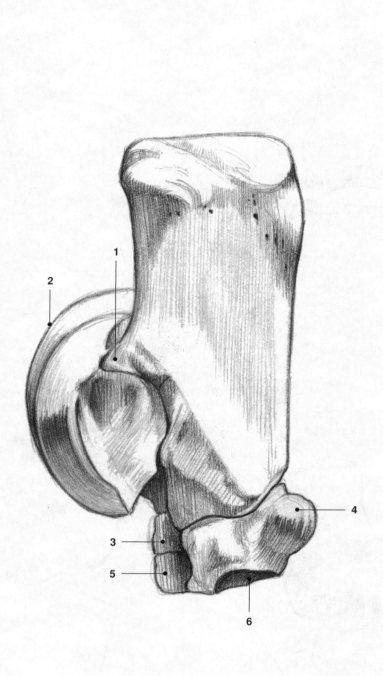

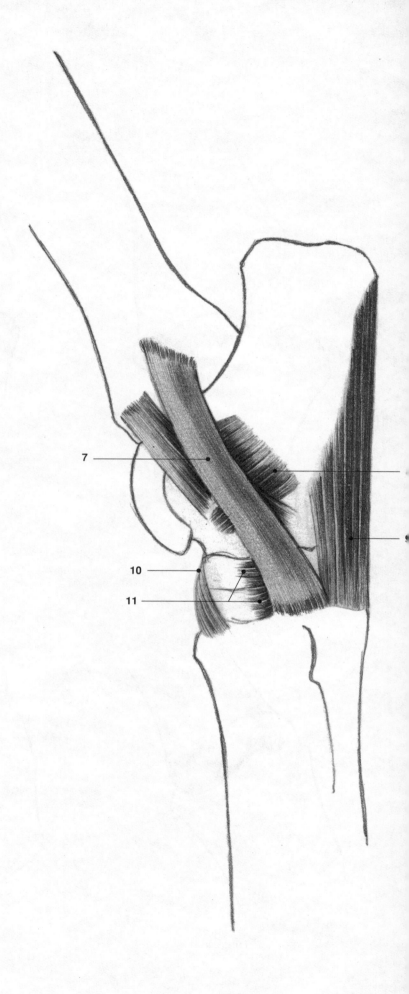

Fig. 7

The bones and the joints of the hock,
lateral aspect

1 Processus coracoideus
2 Trochlea tali
3 Central tarsal bone
4 IVth and Vth tarsal bones
5 IIIrd tarsal bone
6 Articular surface
7 Long collateral ligament
8 Talocalcanean ligament
9 Ligamentum plantare rectum
10 Ligamentum dorsale obliquum
11 Interosseus intertarsal ligaments

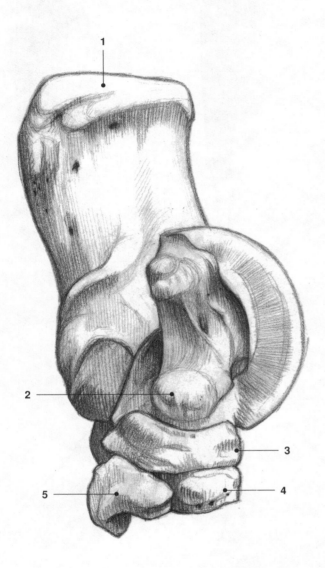

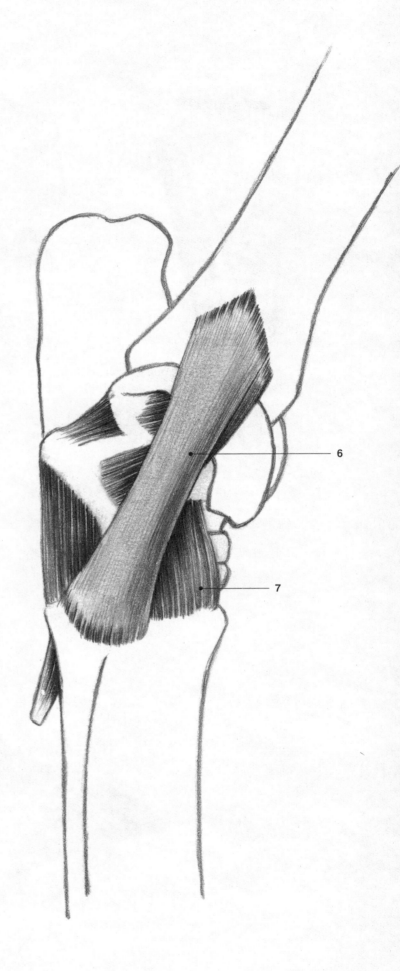

Fig. 8

The bones and joints
of the hock, medial aspect

1 Tuber calcanei
2 Body of talus
3 Central tarsal bone
4 IIIrd tarsal bones
5 Ist and IInd tarsal bones
6 Long collateral ligament
7 Dorsal oblique ligament

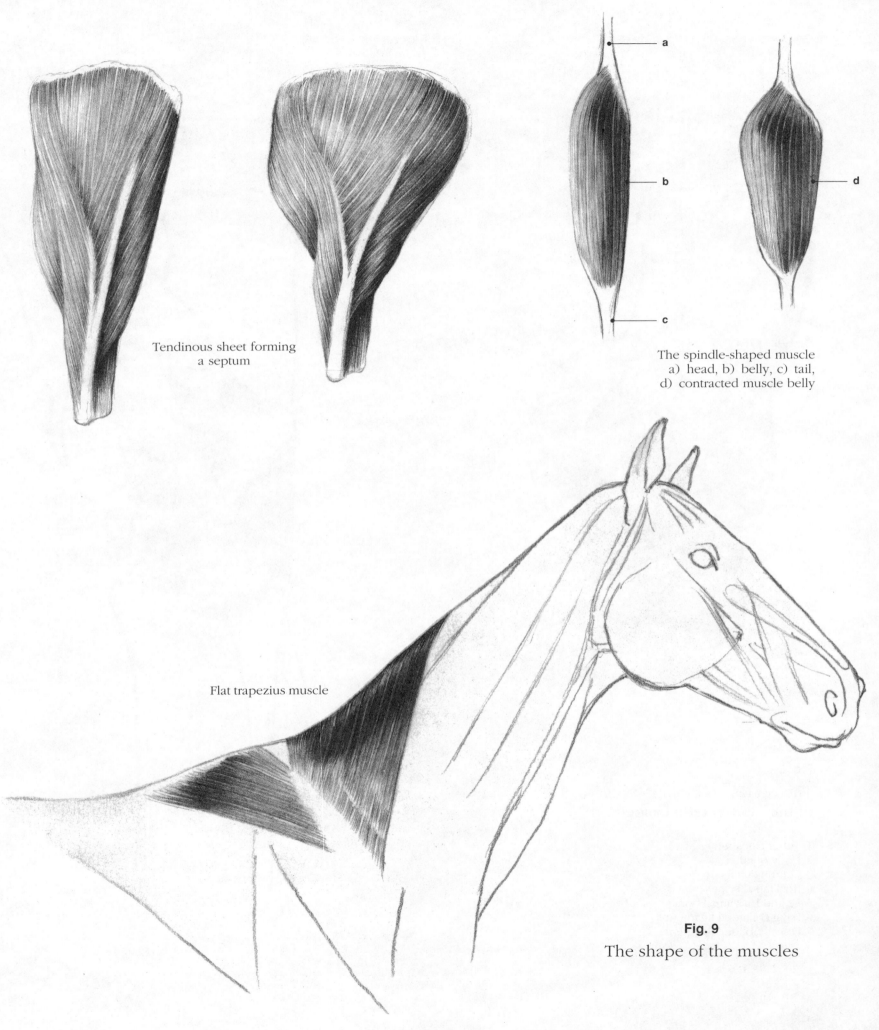

Tendinous sheet forming
a septum

The spindle-shaped muscle
a) head, b) belly, c) tail,
d) contracted muscle belly

Flat trapezius muscle

Fig. 9
The shape of the muscles

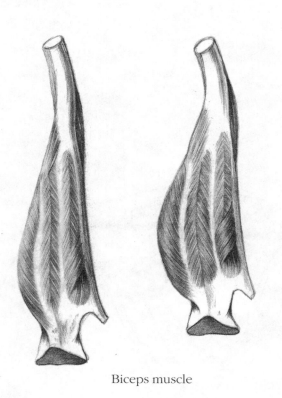

Biceps muscle

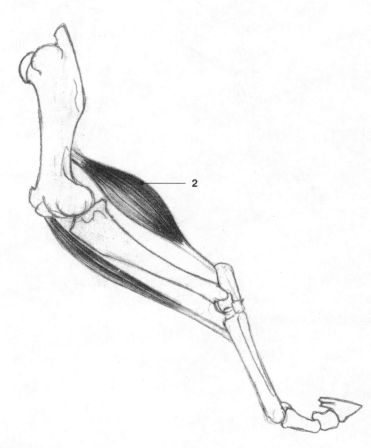

Serratus ventralis muscle

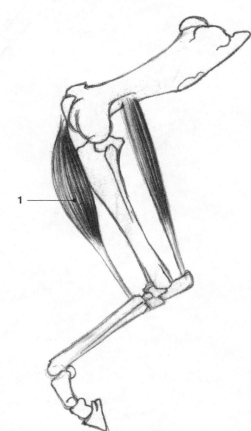

Fig. 10

The functioning of muscles

The bones are moved by the muscles which serve as single or double
levers. The end of the foot is abruptly lifted by the tibialis cranialis muscle
(1) while the gastrocnemius muscles (2) acting as levers, extend the tarsal
joint. By so doing the whole body is pushed forward.

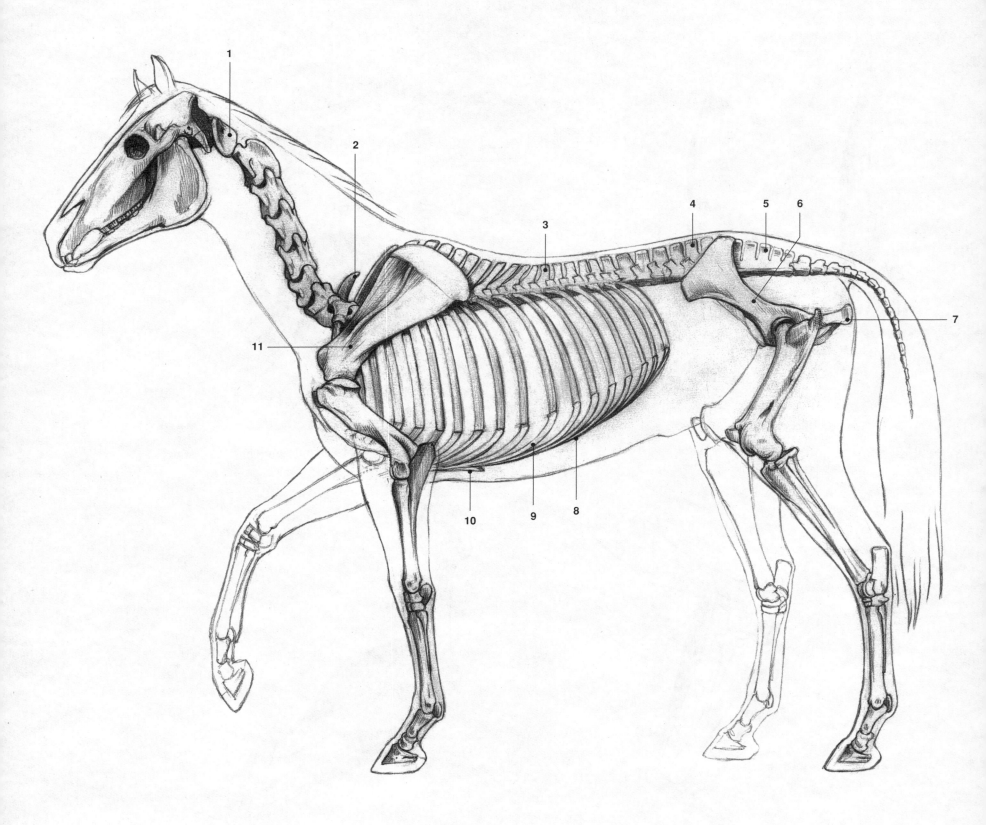

Fig. 11

The skeleton

1 IInd cervical vertebra
2 VIIth cervical vertebra
3 Xth thoracic vertebra
4 Vth lumbar vertebra
5 Sacrum
6 Hipbone

7 Ischium
8 Costal arch
9 Xth rib
10 Sternum
11 Shoulder blade

The bones of the head are demonstrated in Figs. 74 and 76, those of the limbs in Figs. 17, 27, 29, 54, respectively.

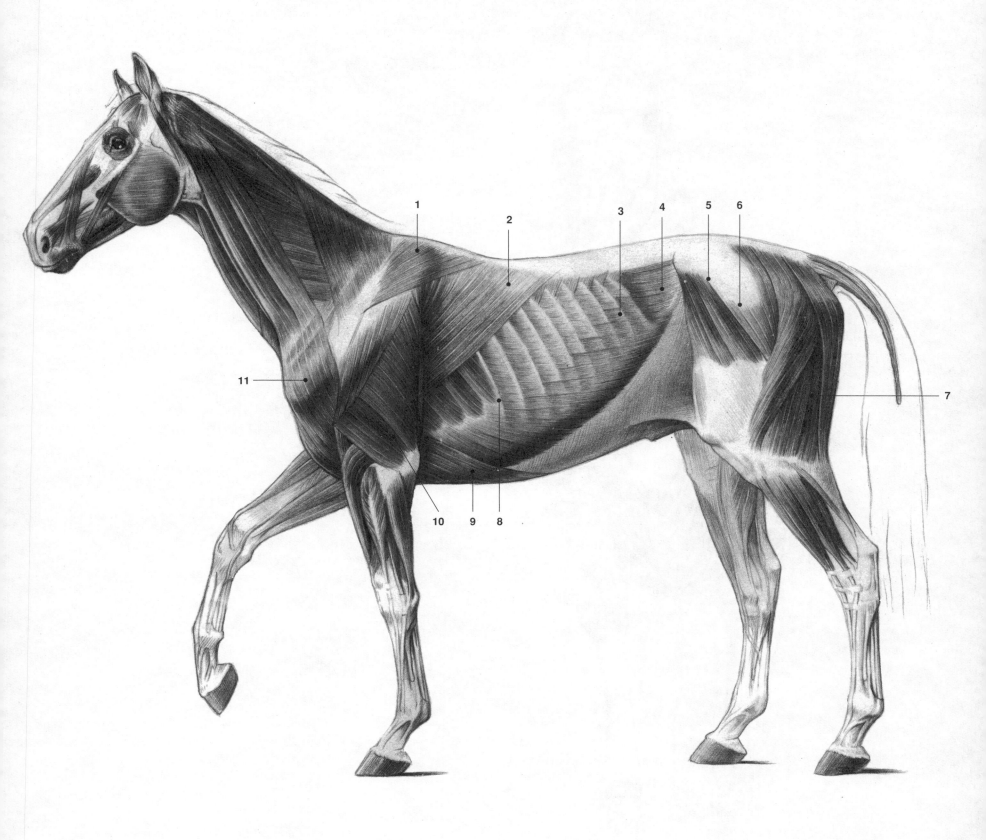

Fig. 12

The muscles

1 Trapezius muscle *(14)*
2 Latissimus dorsi muscle *(16)*
3 Obliquus externus abdominis muscle *(36)*
4 Obliquus internus abdominis muscle *(37)*
5 Tensor fasciae latae muscle *(95)*

6 Proximal muscles of the rump (96, 97)
7 Gluteus caudalis muscles (106–108)
8 Serratus ventralis muscle *(18)*
9 Pectoralis muscles *(27–32)*
10 Triceps brachii muscle *(52)*
11 Brachiocephalicus muscle *(6)*

The muscles of the head are demonstrated in Fig. 75, those of the neck in Figs. 31 and 52, those of the limbs in Figs. 26, 37, 60, 62, 64, 66, 67 and 68, respectively.

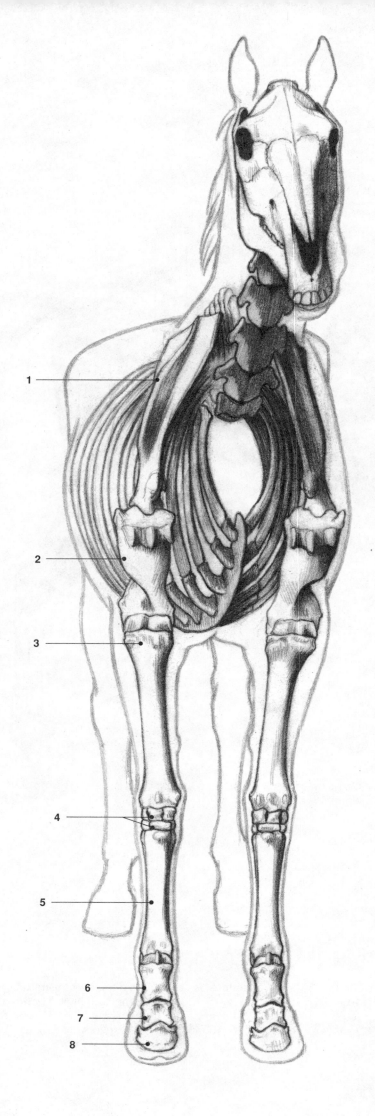

Fig. 13

The skeleton, cranial aspect

1 Spine of the shoulder blade
2 Humerus
3 Radius
4 Carpal bones
5 IIIrd metacarpal bone
6 Proximal phalanx
7 Middle phalanx
8 Distal phalanx
 (coffin bone)

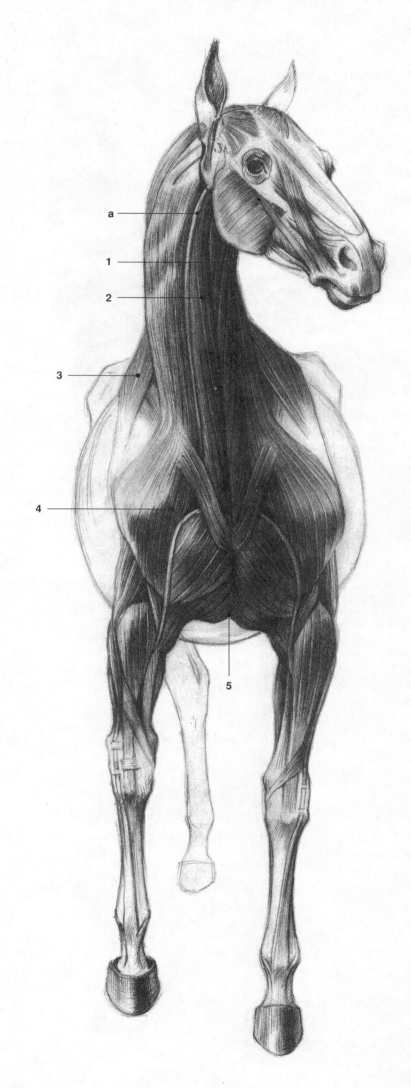

Fig. 14

The muscles, cranial aspect

1 Sternohyoideus muscle *(9)*
2 Sternocephalicus muscle *(7)*
3 Trapezius muscle *(14)*
4 Shoulder joint, covered by the brachiocephalicus muscle *(6)*
5 Sulcus pectoralis medianus bordered by the pectoral
 muscles *(27–30)*

a) Jugular groove with the jugular vein

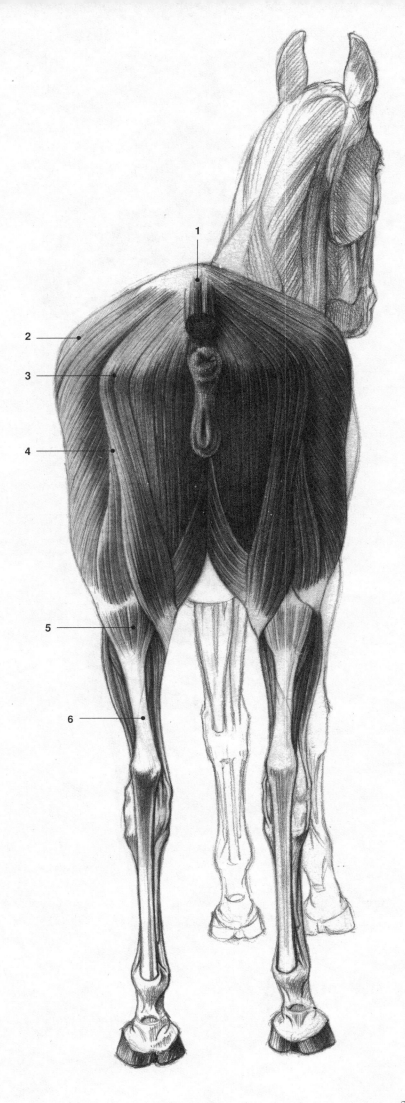

Fig. 15

The horse and its muscles at rest,
caudal aspect

The muscles of the hip and thigh form the rounded shape of the
rump, in the dorso-medial part of which the sacrum (1) protrudes.
The coxal tubers (2), and ischial tubers (3) are clearly visible. On
the thigh the ischial groove (4), the gastrocnemius muscle (5) and
its Achilles tendon (6) protrude.

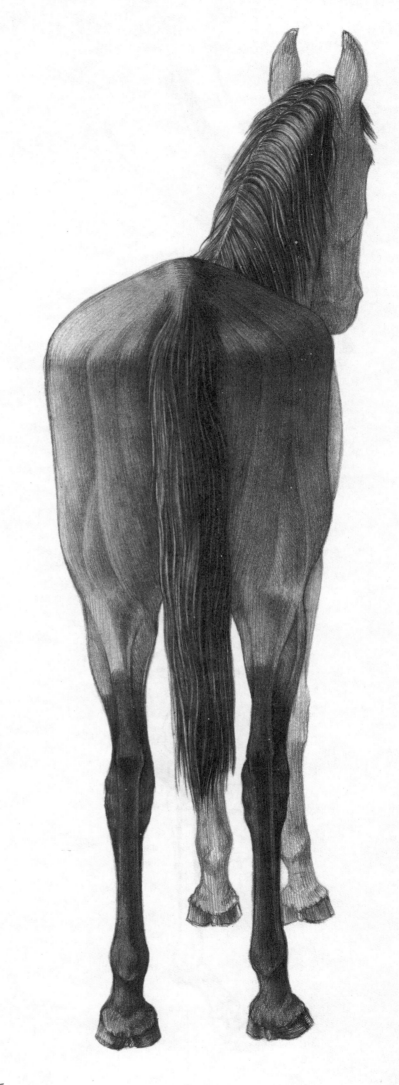

Fig. 16

The horse at rest,
caudal aspect

The contours of the muscles visibly
protrude under the skin.

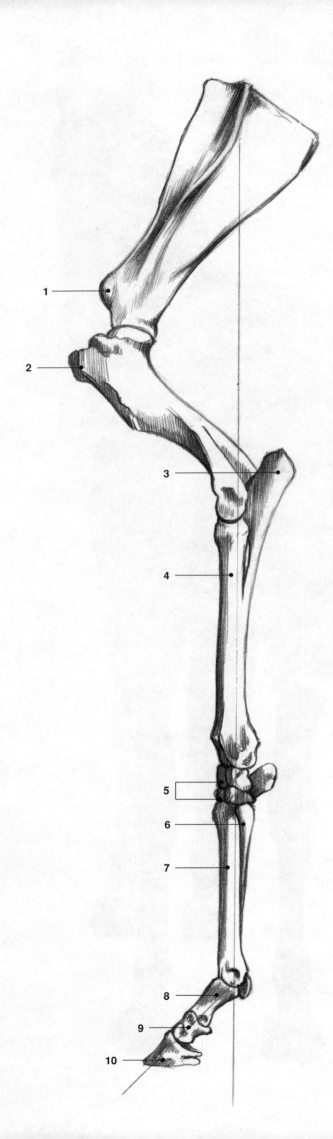

Fig. 17

The bones of the thoracic limb, lateral aspect

1 Shoulder blade
2 Humerus
3 Olecranon
4 Radius
5 Carpal bones
6 IVth metacarpal bone
7 IIIrd metacarpal bone
8 Proximal phalanx
9 Middle phalanx
10 Distal phalanx

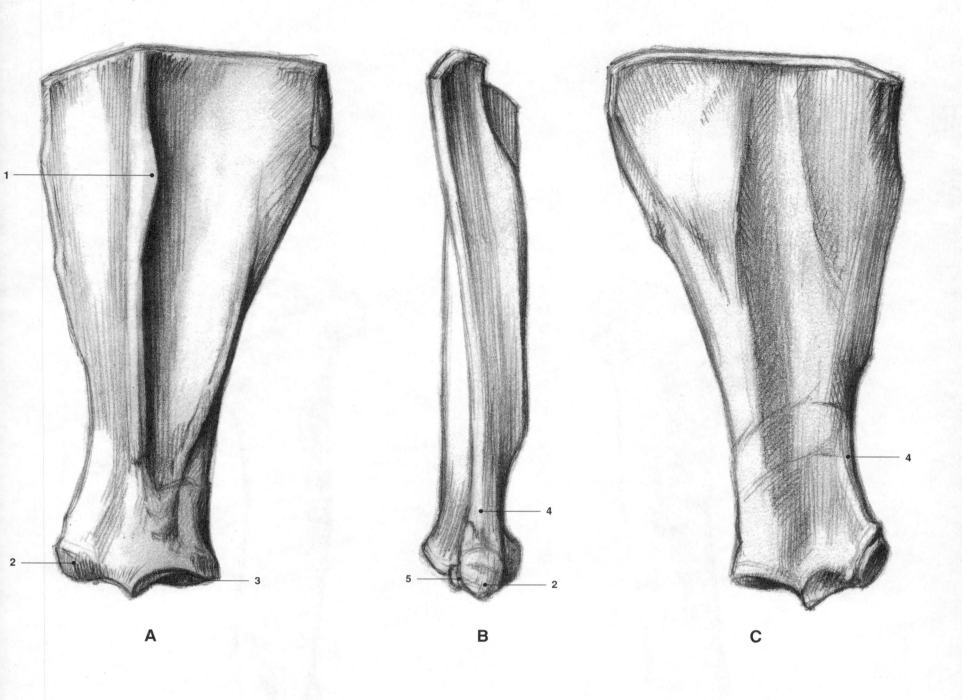

A

B

C

Fig. 18

The shoulder blade; lateral (A), cranial (B),
medial (C) and dorsal (D) aspects

1 Spine of the shoulder blade
2 Tuberculum supraglenoidale
3 Cavitas glenoidalis
4 Neck of the shoulder blade
5 Coracoid process

D

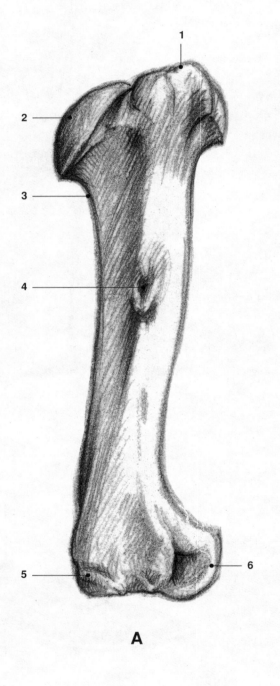

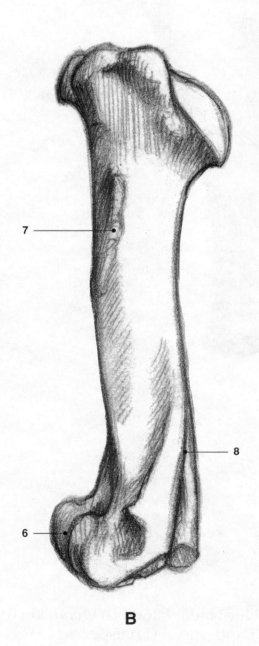

A

B

Fig. 19

The humerus; medial (A), lateral (B), cranial (C), distal (D), proximal (E) and caudal (F) aspects

1 Tubercle of the humerus
2 Head of the humerus
3 Neck of the humerus
4 Tuberosity of the teres major muscle

5 Medial epicondyle
6 Condyle (trochlea) of the humerus
7 Deltoid tuberosity
8 Fossa olecrani

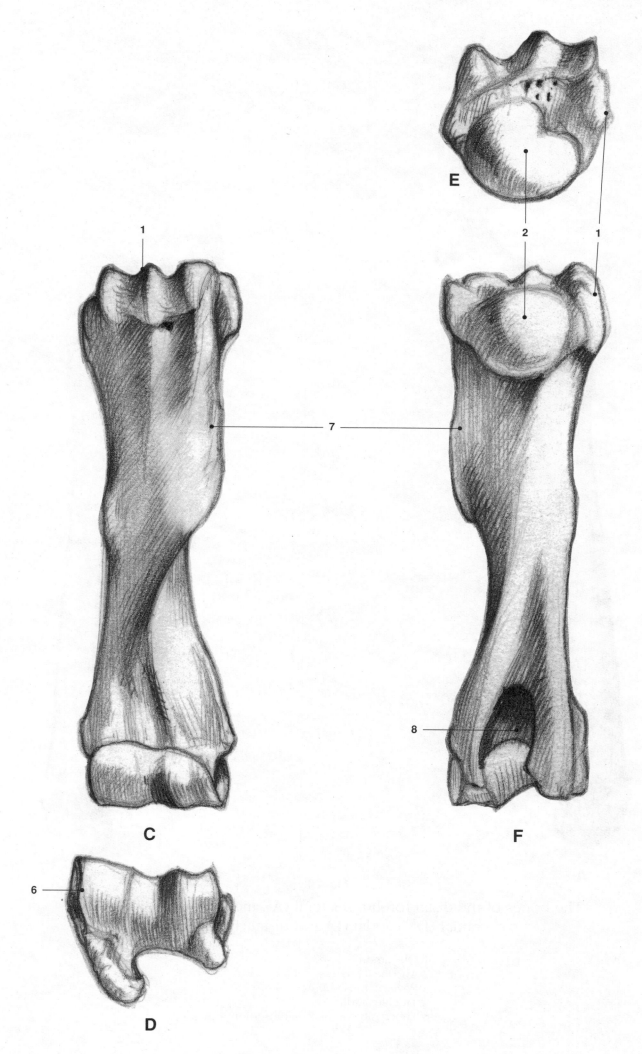

C

D

E

F

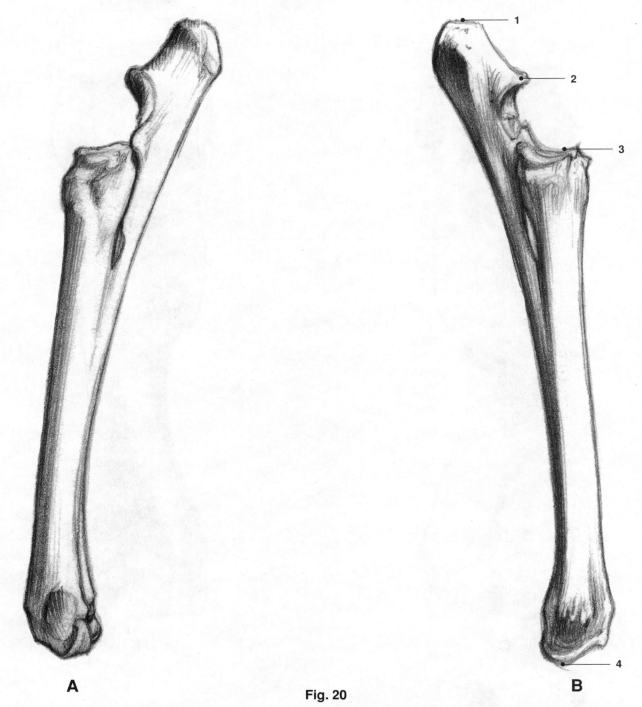

Fig. 20

The bones of the distal forelimb; lateral (A), medial (B), proximal (C),
cranial (D), caudal (E) and distal (F) aspects

1 Olecranon
2 Anconeal process
3 Fovea capitis radii
4 Trochlea radii
5 Tuberosity for muscular insertion

230

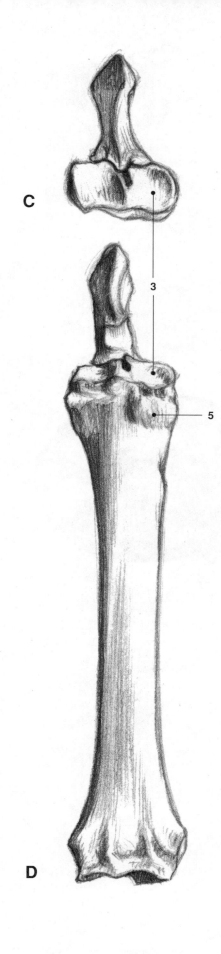

C

D

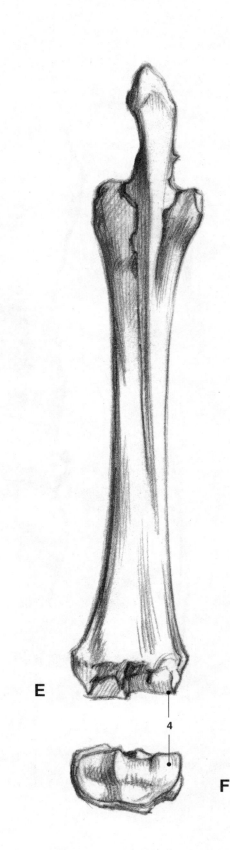

E

F

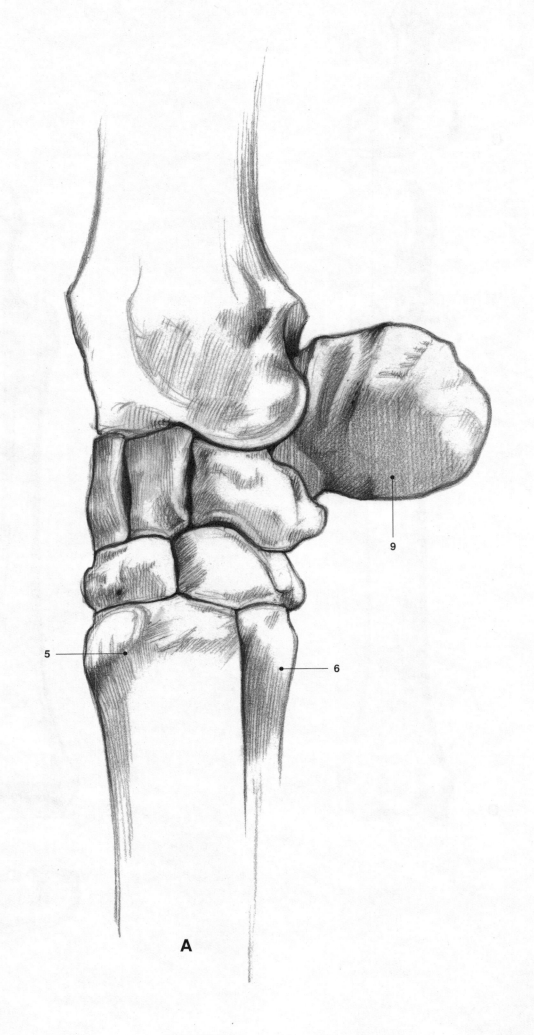

A

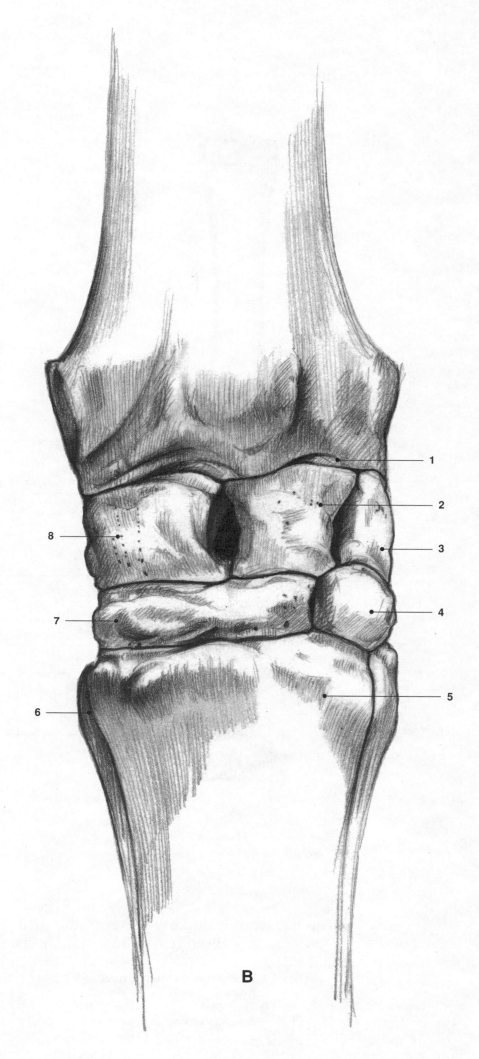

Fig. 21

The carpal bones; lateral (A)
and dorsal (B) aspects

1 Trochlea radii
2 Intermedial carpal bone
3 Ulnar carpal bone
4 IVth and Vth carpal bones
5 Epiphysis of the IIIrd metacarpal bone
6 Splint bone
7 Third carpal bone (lower row)
8 Radial carpal bone
9 Accessorial carpal bone

B

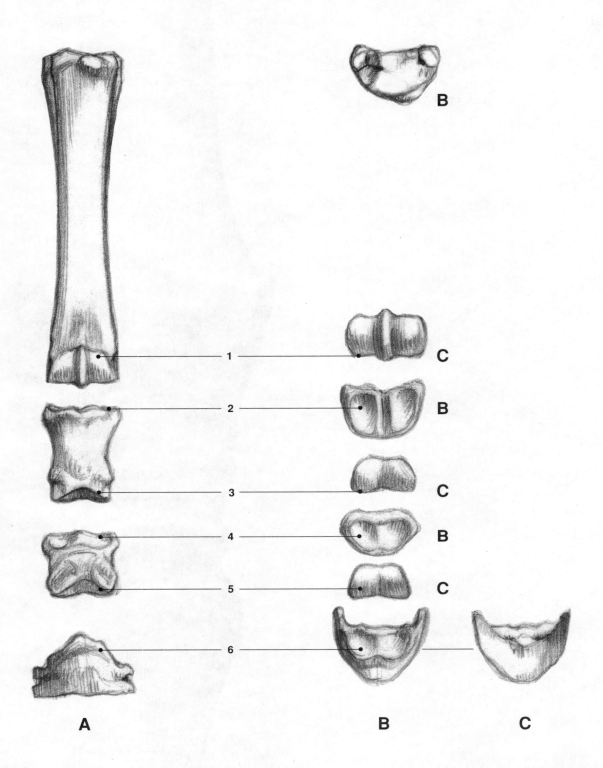

Fig. 22

The metacarpus and the bones of the IIIrd digit; dorsal (A), proximal (B), distal (C), palmar (D) and lateral (E) aspects

1 Trochlea of the metacarpus
2 Articular groove of the pastern
3 The distal trochlea of the pastern
4 Articular groove of the coronet
5 The trochlea of the coronet
6 Distal phalanx
7 IInd and IVth splint bones
8 Sesamoid bones

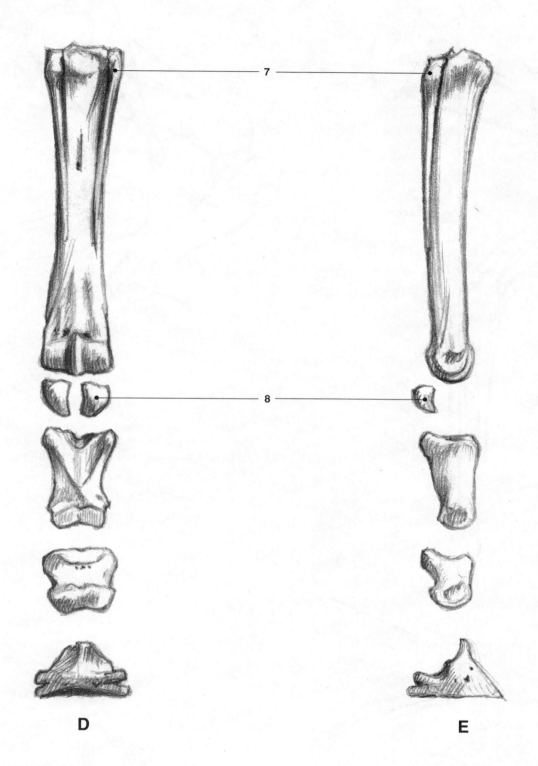

7

8

D

E

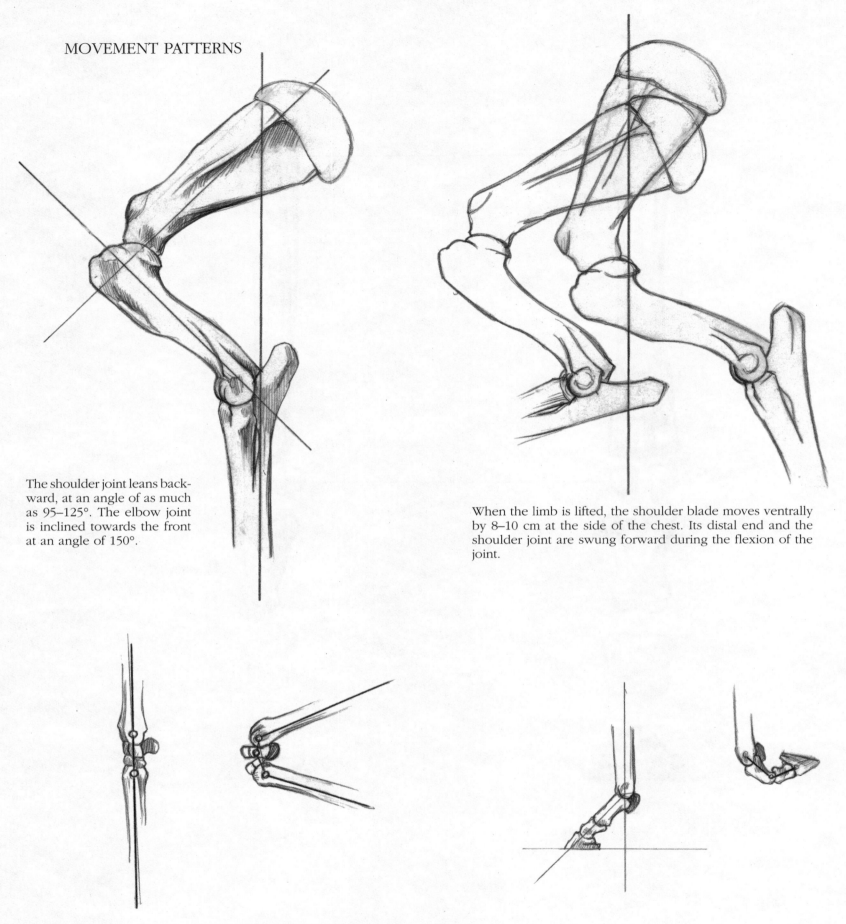

The shoulder joint leans backward, at an angle of as much as 95–125°. The elbow joint is inclined towards the front at an angle of 150°.

When the limb is lifted, the shoulder blade moves ventrally by 8–10 cm at the side of the chest. Its distal end and the shoulder joint are swung forward during the flexion of the joint.

The carpal joint functions as a ginglymus, during flexion only the two upper joints are flexed.

The phalangeal joints can be flexed to a great extent.

Fig. 23

The movements of the shoulder, elbow, carpal and phalangeal joints

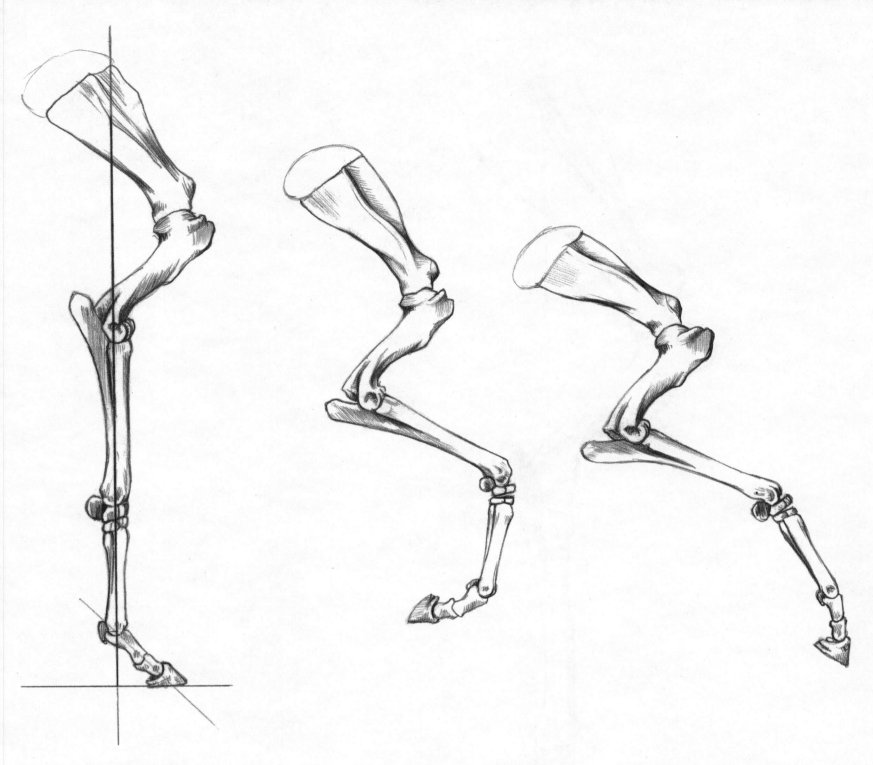

In a standing position the perpendicular line from the fulcrum of the shoulder blade to the ground passes through the elbow joint, to the point of the pastern joint, and coincides with the axis of the thoracic limb. The pastern joint is in an over-extended position. The axis of the phalanges forms an angle of 45° with the ground.

During elevation of the limb, flexion of the joints starts with flexion of the shoulder joint, followed by the elbow and pedal joints.

During forward movement of the limb this happens in reverse order; first the pedal joint is extended and lastly the shoulder joint.

Fig. 24

The stepping movement of the thoracic limb during walking

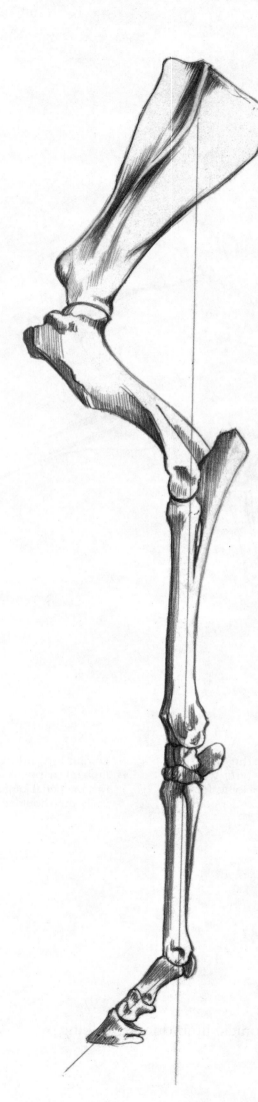

Fig. 25

The bones of the thoracic limb, lateral aspect

Demonstration see Fig. 17.

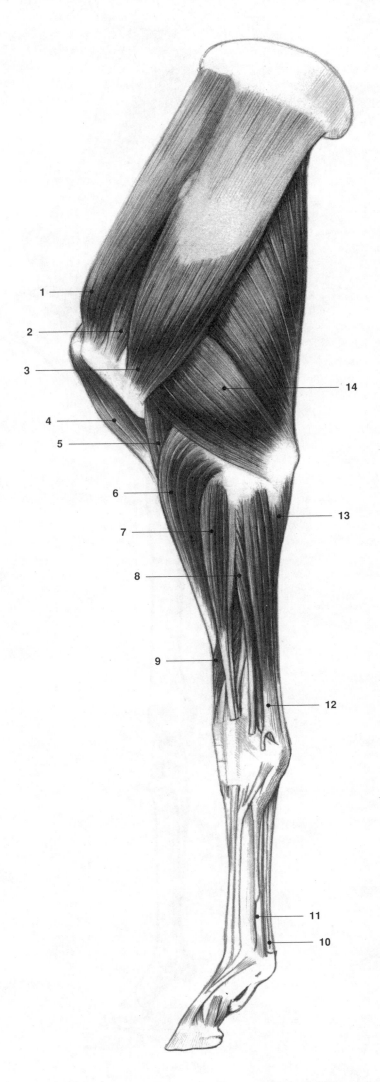

Fig. 26

The muscles of the thoracic limb,
lateral aspect

1 Supraspinatus muscle *(44)*
2 Infraspinatus muscle *(45)*
3 Deltoideus muscle *(43)*
4 Biceps brachii muscle *(51)*
5 Brachialis muscle *(50)*
6 Extensor carpi radialis muscle *(64)*
7 Extensor digitorum communis muscle *(66)*
8 Extensor digitorum lateralis muscle *(67)*
9 Abductor pollicis longus muscle *(70)*
10 Flexor digitorum superficialis muscle *(58)*
11 Interosseus medius muscle *(88)*
12 Extensor carpi ulnaris muscle *(65)*
13 Flexor digitorum profundus muscle *(59)*
14 Triceps brachii muscle *(52)*

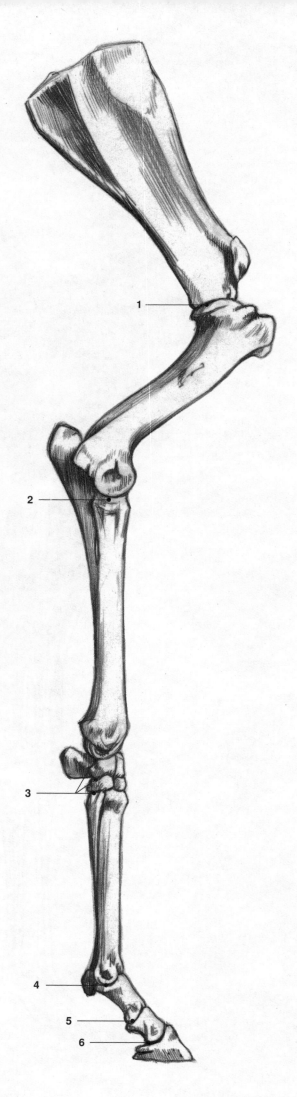

Fig. 27

The bones and joints
of the thoracic limb,
medial aspect

1 Shoulder joint
2 Elbow joint
3 Carpal joint
4 Fetlock joint
5 Pastern joint
6 Pedal joint

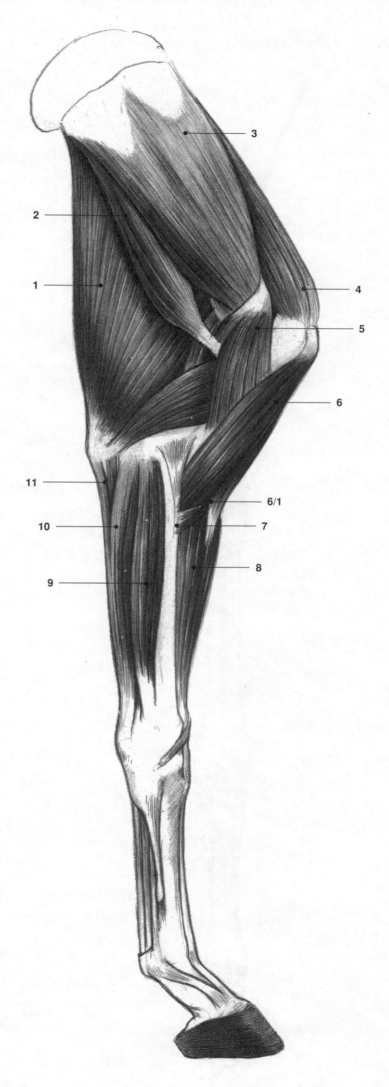

Fig. 28

The muscles of the thoracic limb,
medial aspect

1 Triceps brachii muscle *(52)*
2 Teres major muscle *(47)*
3 Subscapularis muscle *(48)*
4 Subclavius muscle *(32)*
5 Coracobrachialis muscle *(49)*
6 Biceps brachii muscle *(51)*
 6/1 Its lacertus fibrosus portion
 to the extensor carpi radialis muscle
7 Brachialis muscle *(50)*
8 Extensor carpi radialis muscle *(64)*
9 Flexor carpi radialis muscle *(56)*
10 Flexor carpi ulnaris muscle *(57)*
11 Flexor digitorum profundus muscle *(59)*

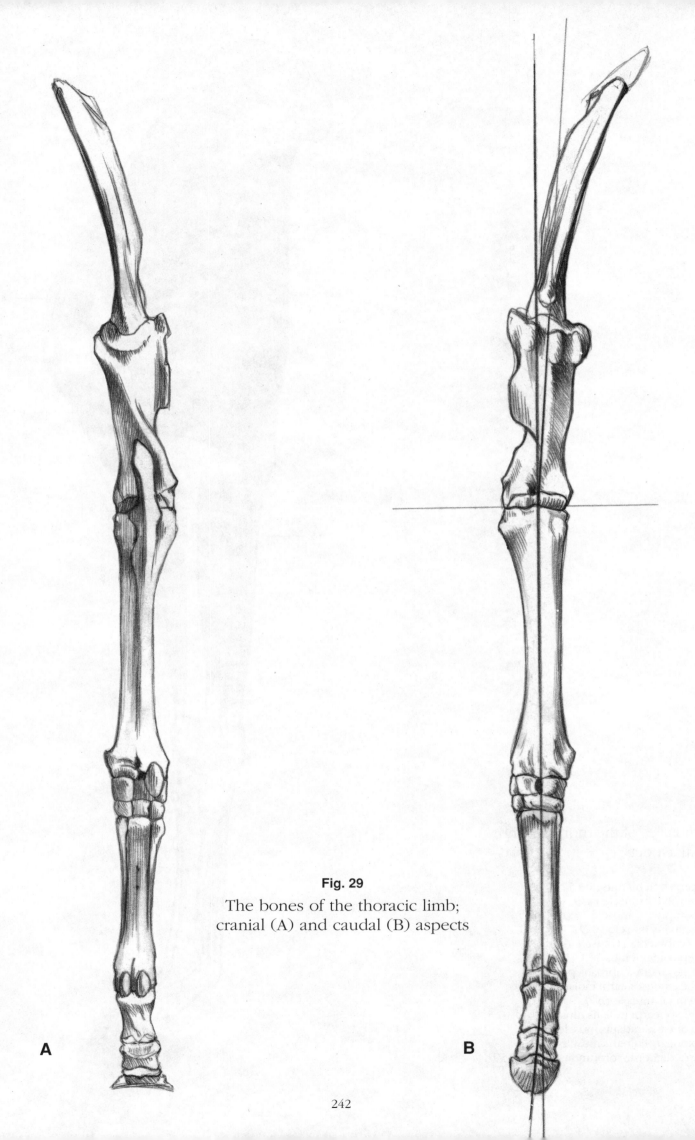

Fig. 29
The bones of the thoracic limb;
cranial (A) and caudal (B) aspects

A

B

Fig. 30

The muscles of the thoracic limb, cranial aspect

1 Biceps brachii muscle *(51)*
 1/1 Its lacertus fibrosus portion
 to the extensor carpi radialis muscle
2 Deltoideus muscle *(43)*
3 Brachialis muscle *(50)*
4 Extensor carpi radialis muscle *(64)*
5 Extensor digitorum communis muscle *(66)*
6 Abductor pollicis longus muscle *(70)*

Fig. 31

The muscles of the neck and shoulder,
lateral (A) aspect,
the muscles of the shoulder,
cranial (B) aspect

 1 Obliquus capitis muscle *(4)*
 2 Splenius muscle *(5)*
 3 Serratus ventralis muscle *(18)*
 4 Trapezius muscle *(14)*
 5 Sternohyoideus muscle *(9)*
 6 Sternocephalicus muscle *(7)*
 7 Brachiocephalicus muscle *(6)*
 8 Cutaneus colli muscle *(2)*
 9 Subclavius muscle *(32)*
10 Brachialis muscle *(50)*
11 Latissimus dorsi muscle *(16)*
12 Triceps brachii muscle *(52)*
13 Deltoideus muscle *(43)*
14 Pectoralis muscles *(27–32)*

 a) Jugular groove

The muscles of the head are demonstrated in Figs. 75 and 77,
those of the thoracic limb in Figs. 28–30, respectively.

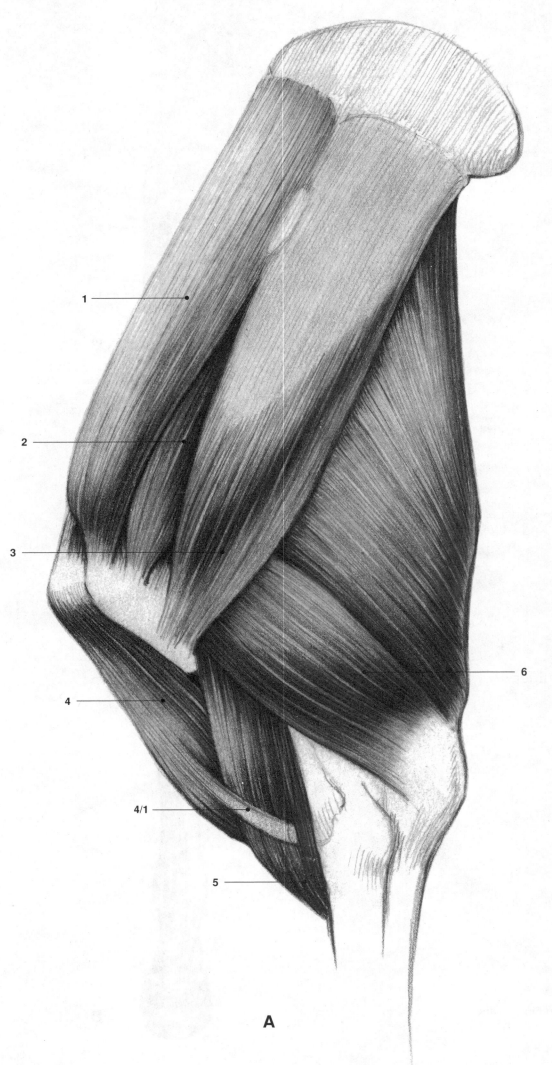

Fig. 32

The muscles of the shoulder
and elbow joints;
lateral (A) and medial (B) aspects
(superficial layer)

1 Supraspinatus muscle *(44)*
2 Infraspinatus muscle *(45)*
3 Deltoideus muscle *(43)*
4 Biceps brachii muscle *(51)*
 4/1 Its lacertus fibrosus portion
 to the extensor carpi radialis
5 Brachialis muscle *(50)*
6 Triceps brachii muscle *(52)*
7 Teres major muscle *(47)*
8 Subscapularis muscle *(48)*
9 Subclavius muscle *(32)*
10 Coracobrachialis muscle *(49)*

A

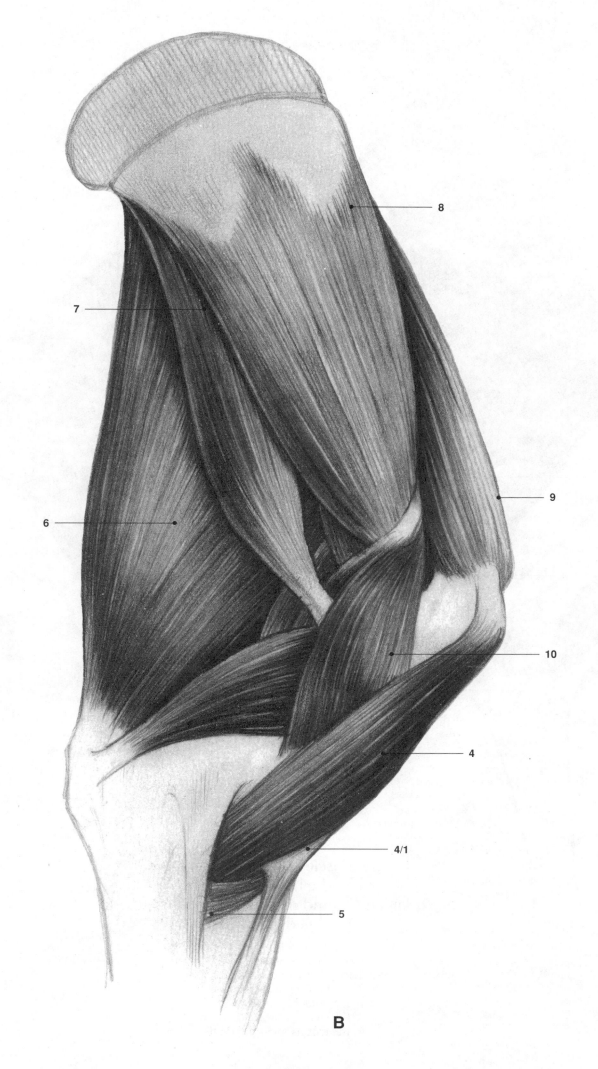

B

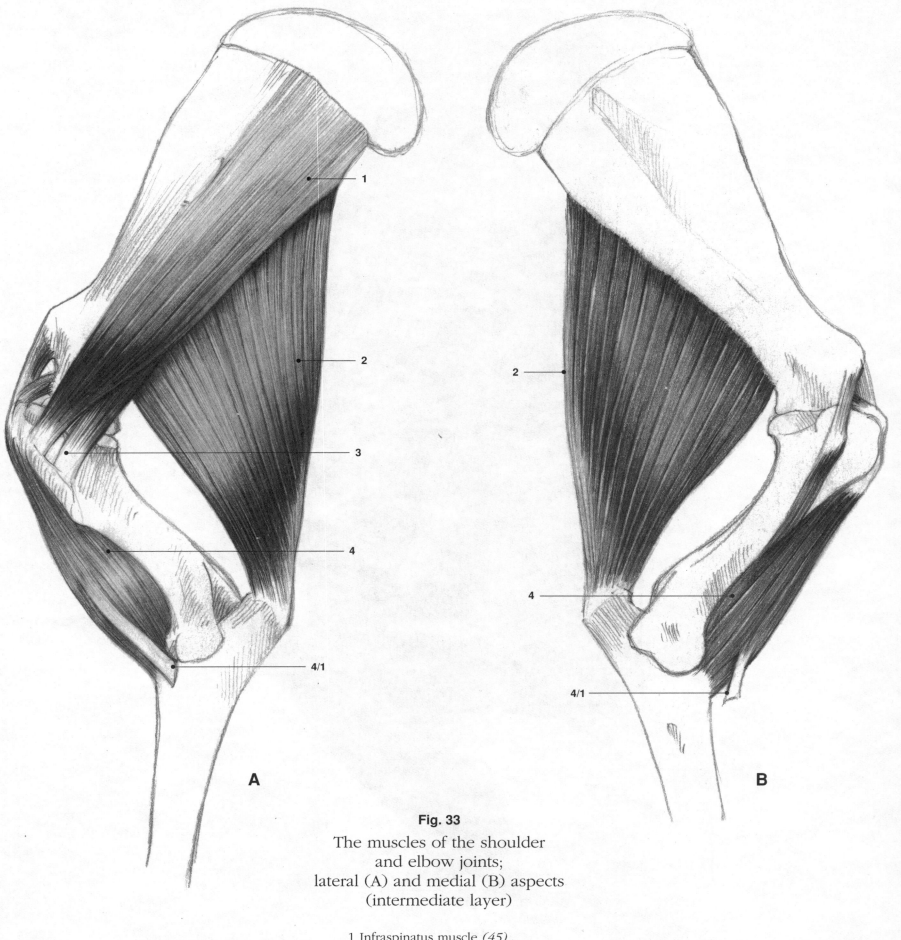

Fig. 33

The muscles of the shoulder
and elbow joints;
lateral (A) and medial (B) aspects
(intermediate layer)

1 Infraspinatus muscle *(45)*
2 Triceps brachii muscle *(52)*
3 Teres minor muscle *(46)*
4 Biceps brachii muscle *(51)*
 4/1 Lacertus fibrosus portion
 to the extensor carpi radialis

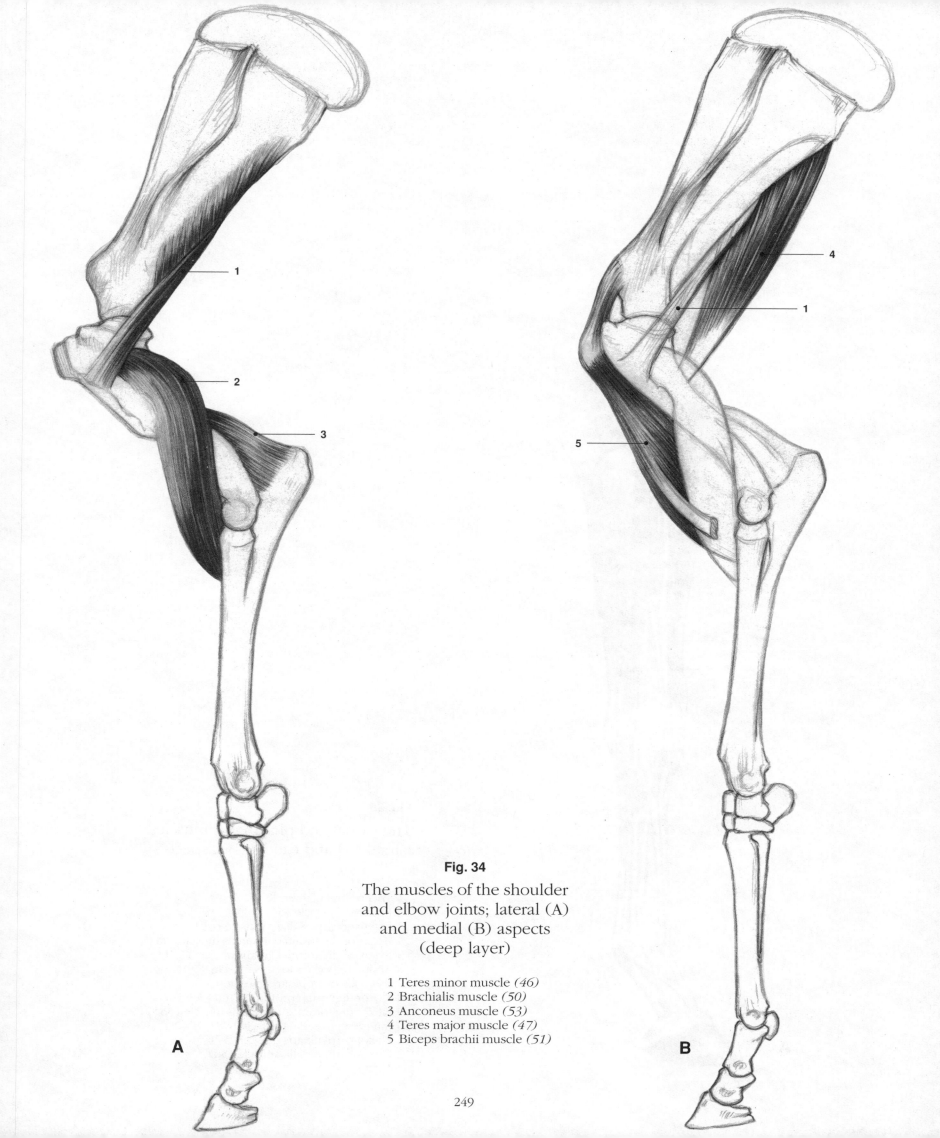

Fig. 34

The muscles of the shoulder
and elbow joints; lateral (A)
and medial (B) aspects
(deep layer)

1 Teres minor muscle *(46)*
2 Brachialis muscle *(50)*
3 Anconeus muscle *(53)*
4 Teres major muscle *(47)*
5 Biceps brachii muscle *(51)*

A

B

249

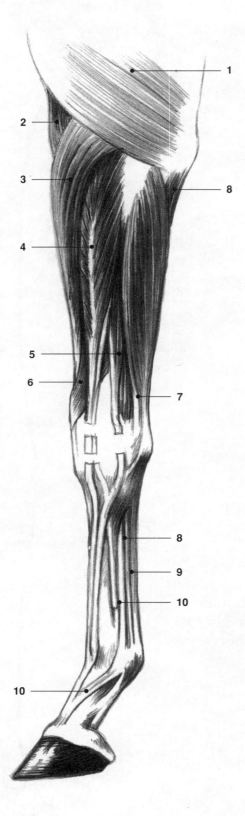

Fig. 35

The carpal and phalangeal muscles;
lateral (A) and caudal (B) aspects

1 Triceps brachii muscle *(52)*
2 Brachialis muscle *(50)*
3 Extensor carpi radialis muscle *(64)*
4 Extensor digitorum communis muscle *(66)*
5 Extensor digitorum lateralis muscle *(67)*
6 Abductor pollicis longus muscle *(70)*
7 Extensor carpi ulnaris muscle *(65)*
8 Flexor digitorum profundus muscle *(59)*
9 Flexor digitorum superficialis muscle *(58)*
10 Interosseus medius muscle *(88)*
11 Flexor carpi ulnaris muscle *(57)*
12 Flexor carpi radialis muscle *(56)*

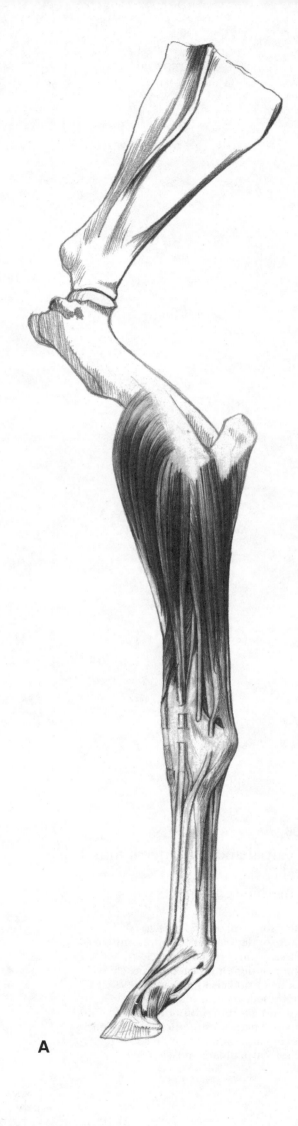

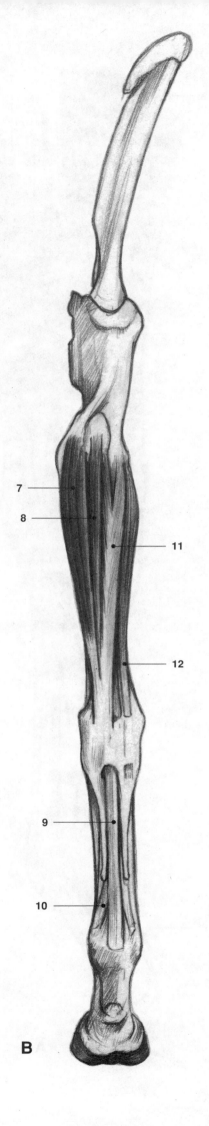

A

B

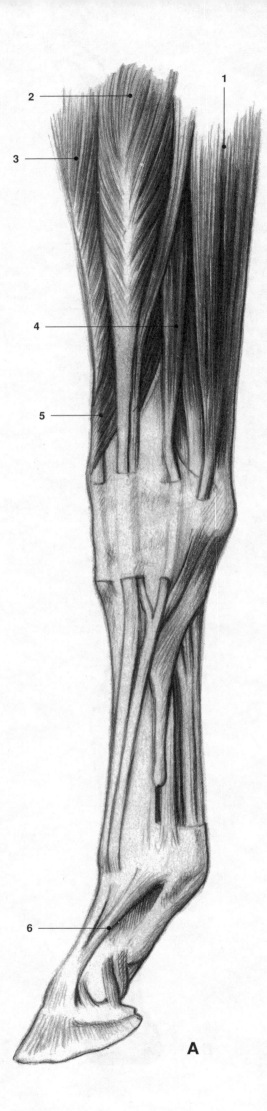

Fig. 36

The carpal and phalangeal muscles;
lateral (A), cranial (B)
and medial (C) aspects

1 Extensor carpi ulnaris muscle *(65)*
2 Extensor digitorum communis muscle *(66)*
3 Extensor carpi radialis muscle *(64)*
4 Extensor digitorum lateralis muscle *(67)*
5 Abductor pollicis longus muscle *(70)*
6 Interosseus medius muscle *(88)*
7 Flexor digitorum profundus muscle *(59)*
8 Flexor digitorum superficialis muscle *(58)*
9 Flexor carpi radialis muscle *(56)*
10 Flexor carpi ulnaris muscle *(57)*

A

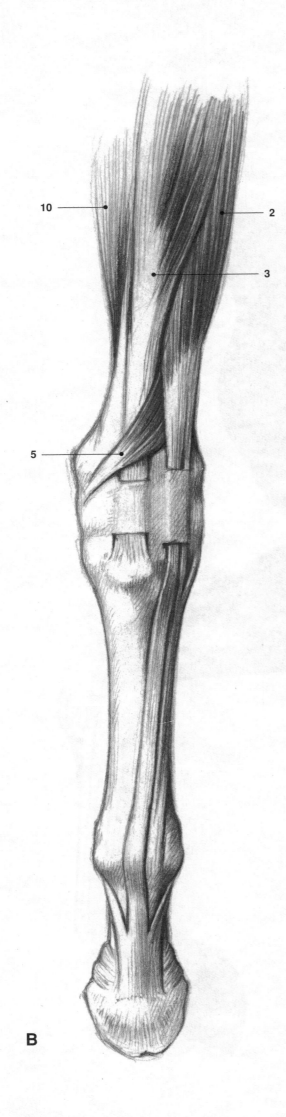

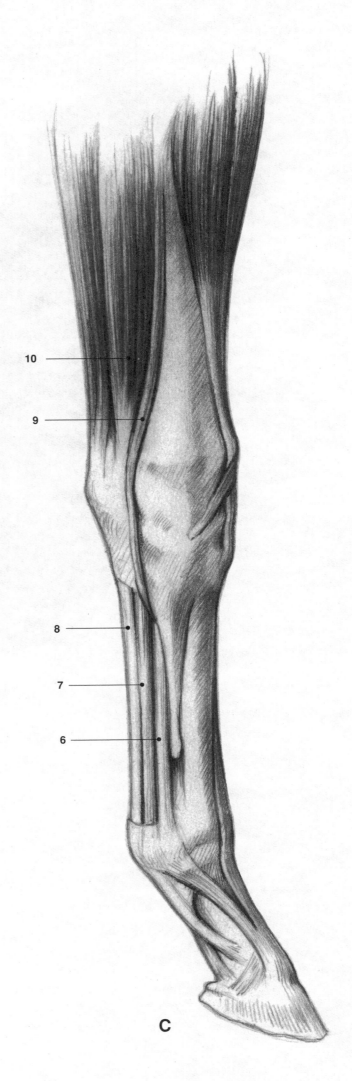

B

C

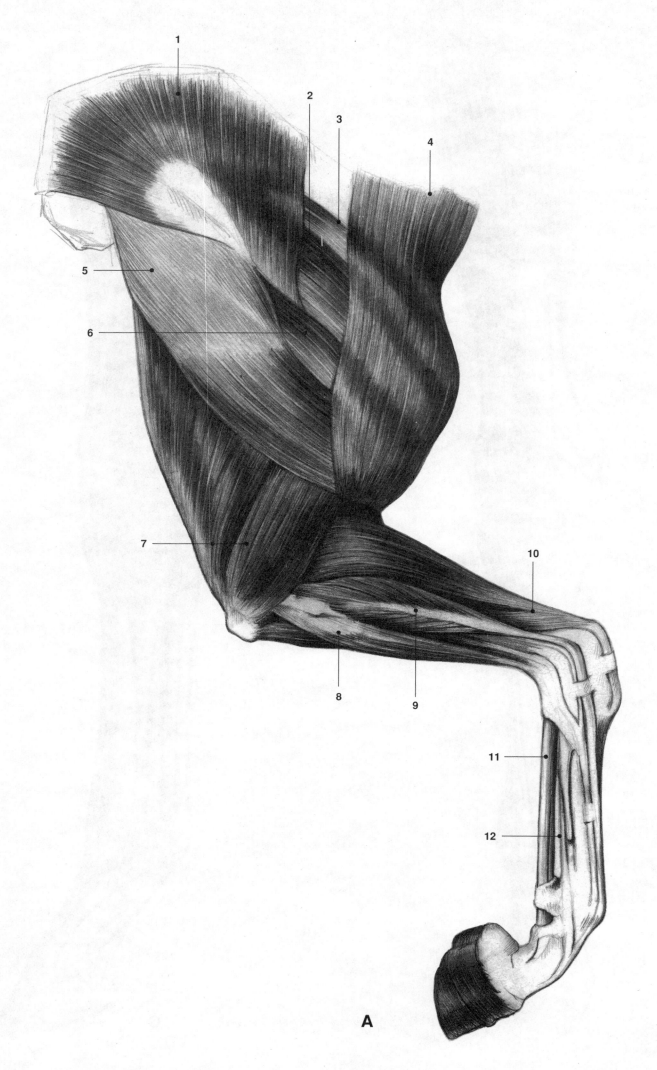

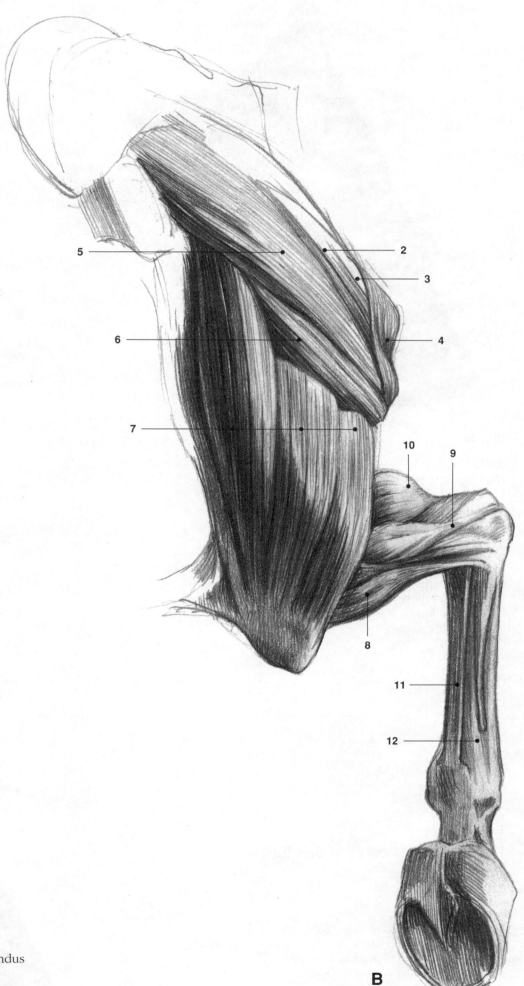

Fig. 37

The muscles of the thoracic limb
during elevation;
lateral (A) and caudal (B) aspects

1 Trapezius muscle *(14)*
2 Supraspinatus muscle *(44)*
3 Subclavius muscle *(32)*
4 Brachiocephalicus muscle *(6)*
5 Deltoideus muscle *(43)*
6 Infraspinatus muscle *(45)*
7 Triceps brachii muscle *(52)*
8 Extensor carpi ulnaris muscle *(65)*
9 Extensor digitorum communis muscle *(66)*
10 Extensor carpi radialis muscle *(64)*
11 Common tendon of the flexor digitorum profundus
 and superficialis muscle *(58–59)*
12 Interosseus medius muscle *(88)*

B

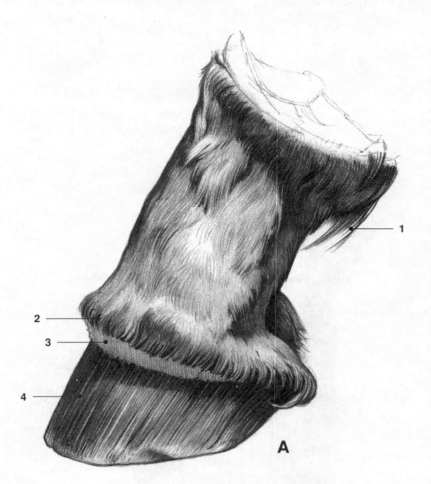

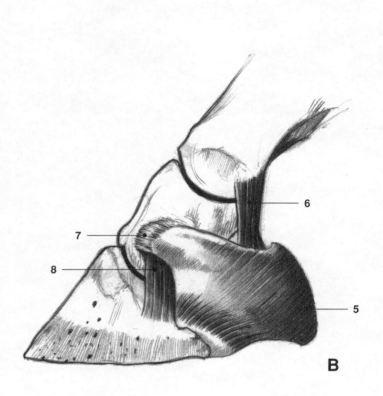

A

B

Fig. 38

The digit without hoof corium (A),
the ligaments of hoof cartilage (B)

1 Feathers
2 Perioplic corium
3 Coronary corium
4 Corium of the wall
5 Hoof cartilage
6 Lateral ligament chondrocompedalis
7 Dorsal ligament of the hoof cartilage
8 Collateral ligament of the pedal joint

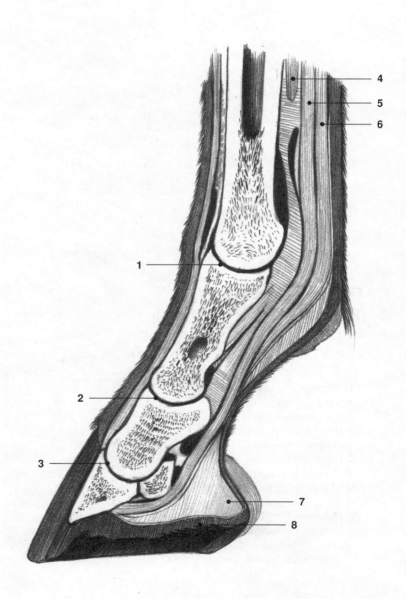

Fig. 39

Longitudinal section of the digit

1 Fetlock joint
2 Pastern joint
3 Pedal joint
4 Interosseus medius muscle *(88)*
5 Flexor digitorum profundus muscle *(59)*
6 Flexor digitorum superficialis muscle *(58)*
7 Hypodermis (digital cushion)
8 Horny frog (epidermis cunei)

lateral

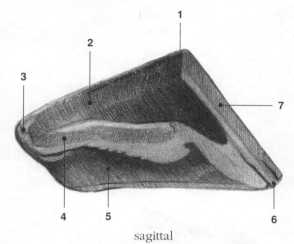

sagittal

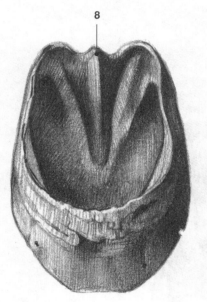

proximal

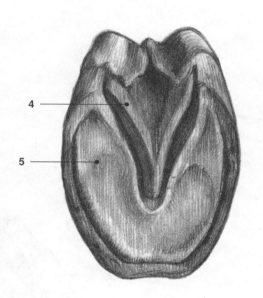

distal

dorsal

palmar

Fig. 40

Different aspects
of the hoof

1 Periople
2 Horn of the coronet
3 Bulbar cushion
4 Horny frog (epidermis cunei,
 cuneus corneus)
5 Horn of the sole
6 Unpigmented horny lamellae
 of the connecting layer
7 Horny wall
8 Crest of the frog (spina cunei)

Fig. 41

The position
of the thoracic limbs
on landing

At the moment of landing the whole left
limb is fully extended.

Fig. 42

The position
of the thoracic limbs
during grazing

During grazing the horse stretches
and lowers its neck. The extended limbs
are characteristic.

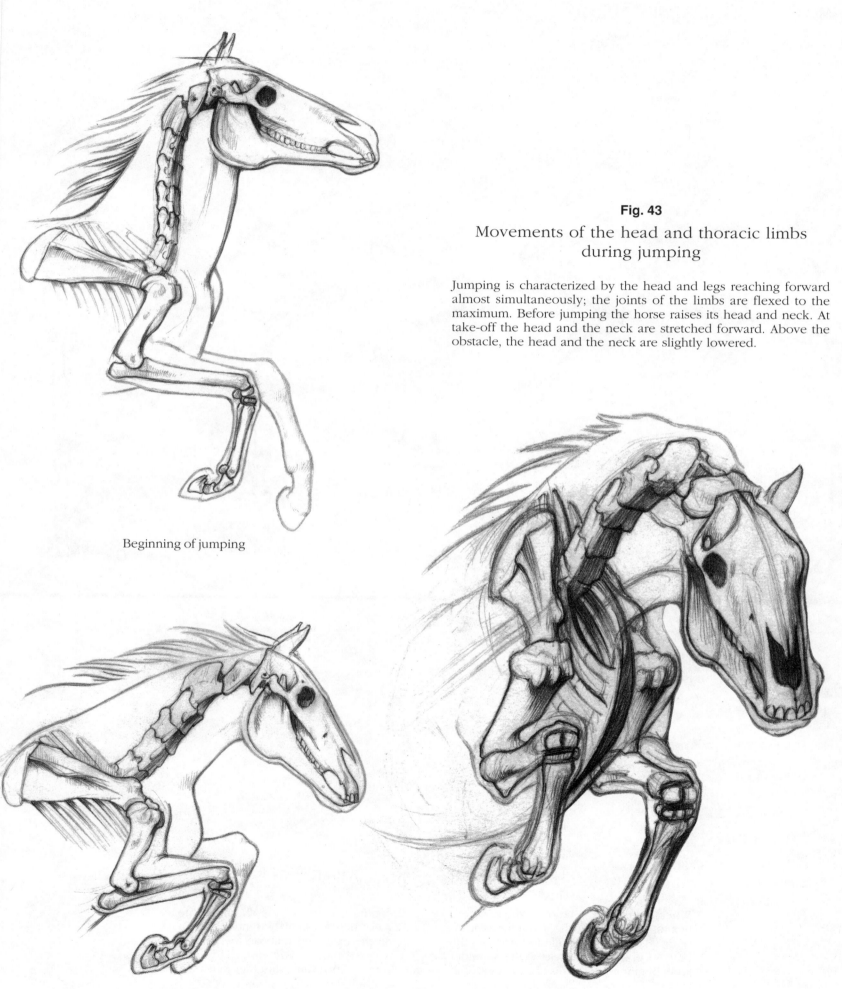

Fig. 43

Movements of the head and thoracic limbs during jumping

Jumping is characterized by the head and legs reaching forward almost simultaneously; the joints of the limbs are flexed to the maximum. Before jumping the horse raises its head and neck. At take-off the head and the neck are stretched forward. Above the obstacle, the head and the neck are slightly lowered.

Beginning of jumping

Take-off

Above the obstacle

259

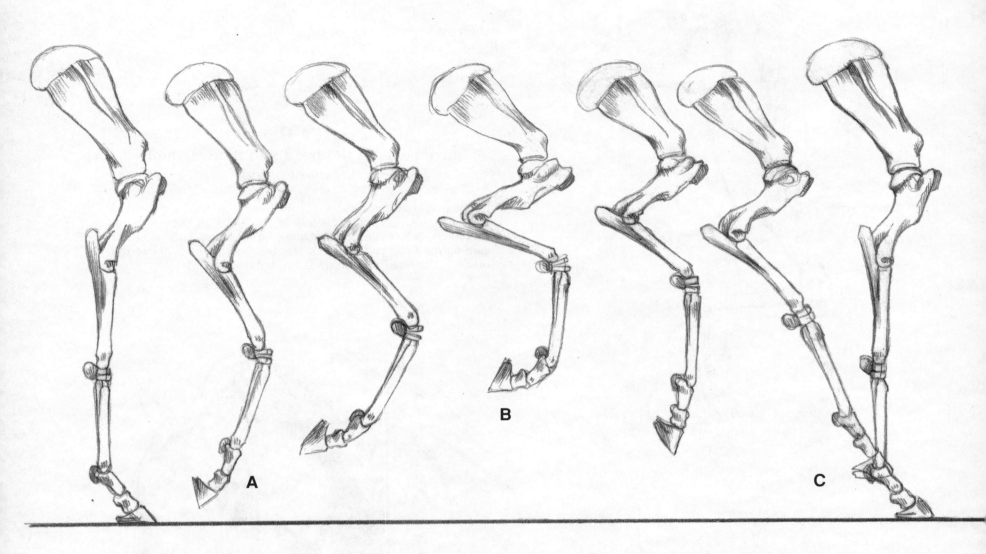

Fig. 44

Phases of walking, thoracic limb

When lifting the forelimb (A) the joints are flexed, beginning at the shoulder joint. At point (B) the limb is pulled forward by the brachiocephalicus muscle of the shoulder joint. Beginning at the distal end of the limb and continuing toward the shoulder, the joints are then gradually extended. When placing the extended limb on the ground (C), forward motion is continued by extending the elbow and shoulder joints.

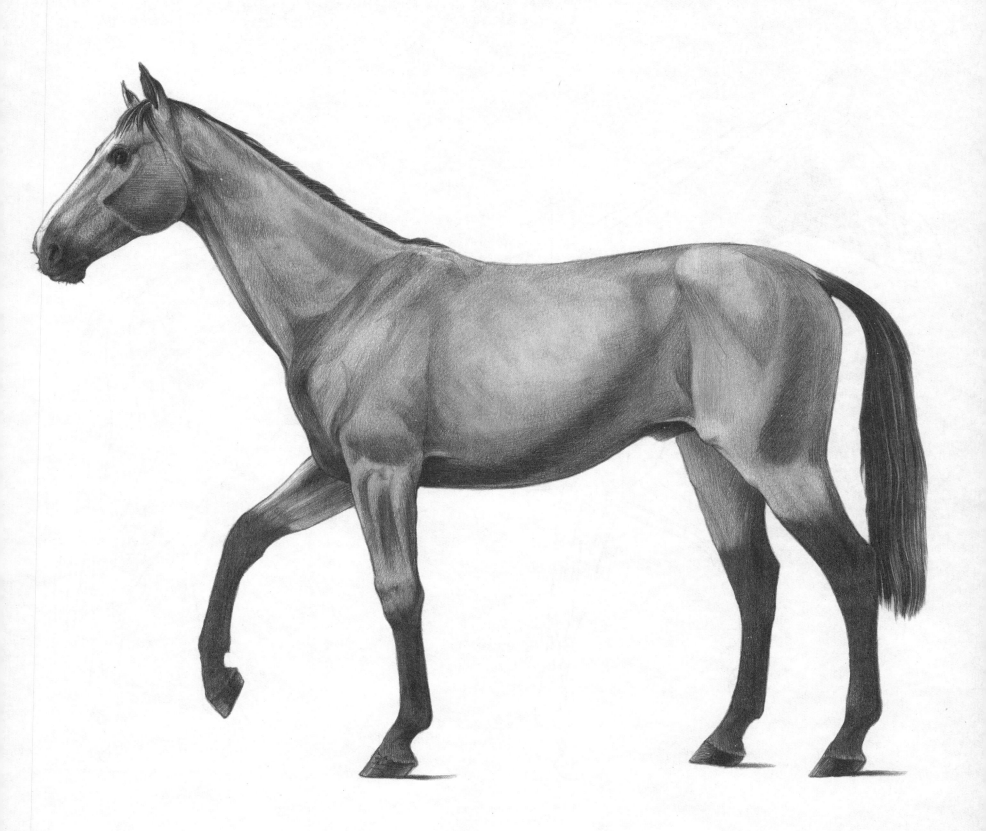

Fig. 45
Walking slowly

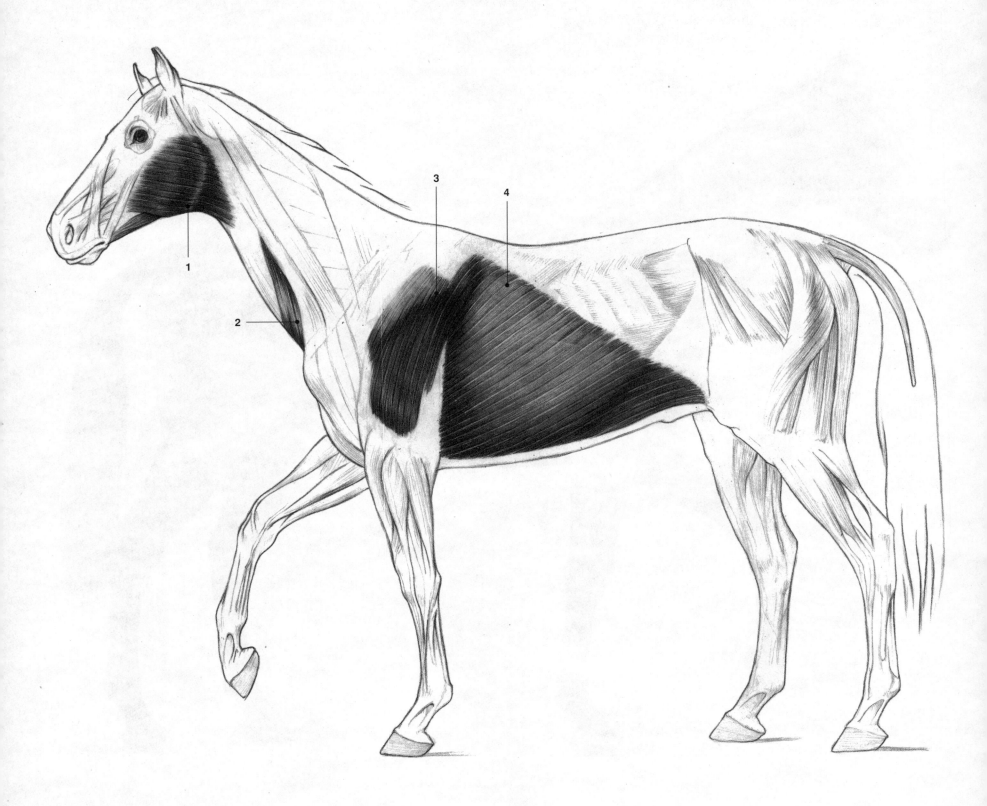

Fig. 46

The cutaneous muscles

1 Cutaneus faciei muscle *(1)*
2 Cutaneus colli muscle *(2)*
3 Cutaneus omobrachialis muscle *(25)*
4 Cutaneus maximus muscle *(26)*

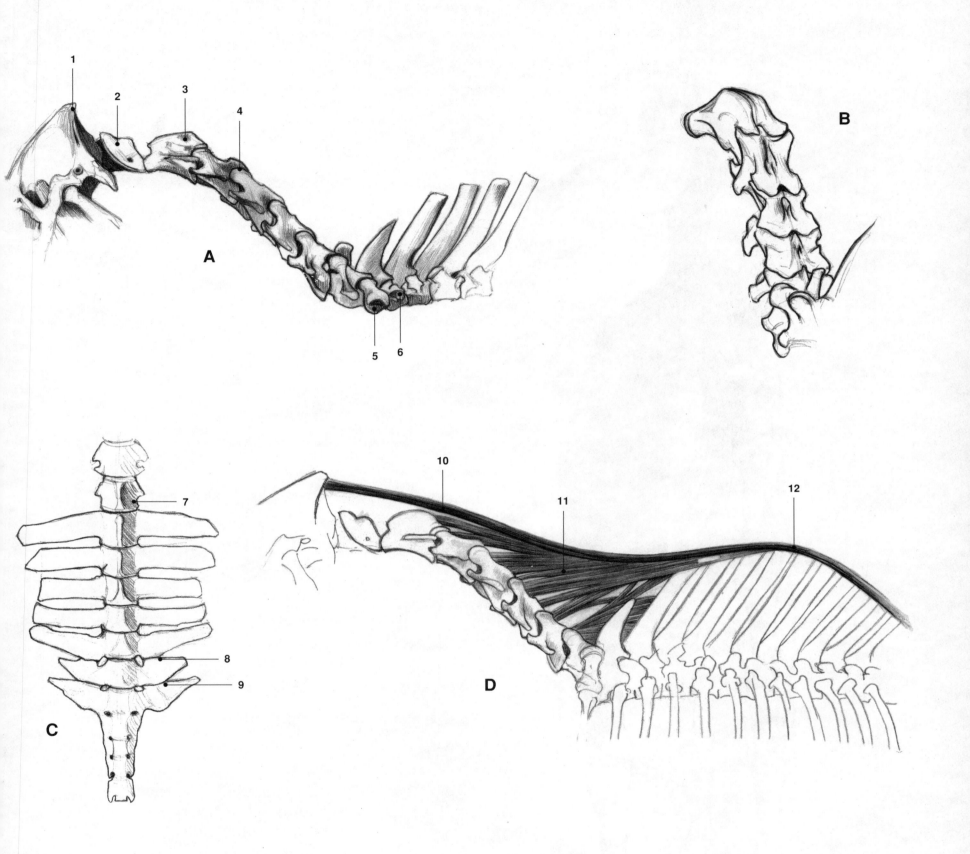

Fig. 47

The vertebral column; cervical (A, B), lumbo-sacral sections (C) and the nuchal ligament (D)

1 Crista nuchae
2 Ist cervical vertebra (atlas)
3 IInd cervical vertebra (axis)
4 Plane joints formed by the articular
　processes

5 Facies articularis capituli costae
6 Facies articularis tuberculi costae
7 XVIIIth thoracic vertebra
8 Joints of transverse processes
　of the Vth and VIth lumbar vertebrae

9 The wing and articulation
　of the os sacrum
10 Funicular part of the nuchal ligament
11 Laminated part of the nuchal ligament
12 Supraspinous ligament

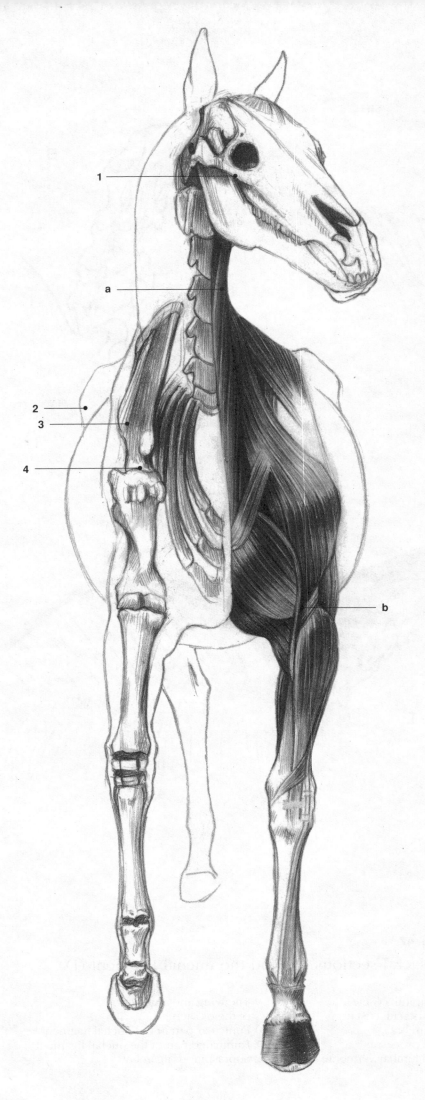

Fig. 48

The skeleton
and muscles
of the walking horse,
cranial aspect

Parts of bones, muscles and vessels are
clearly visible under the skin.

1 Facial crest
2 Tuber coxae laterale
3 Spina scapulae
4 Shoulder joint

a) Jugular groove with the jugular vein
b) Lateral groove with the subcutaneous
 vena cephalica

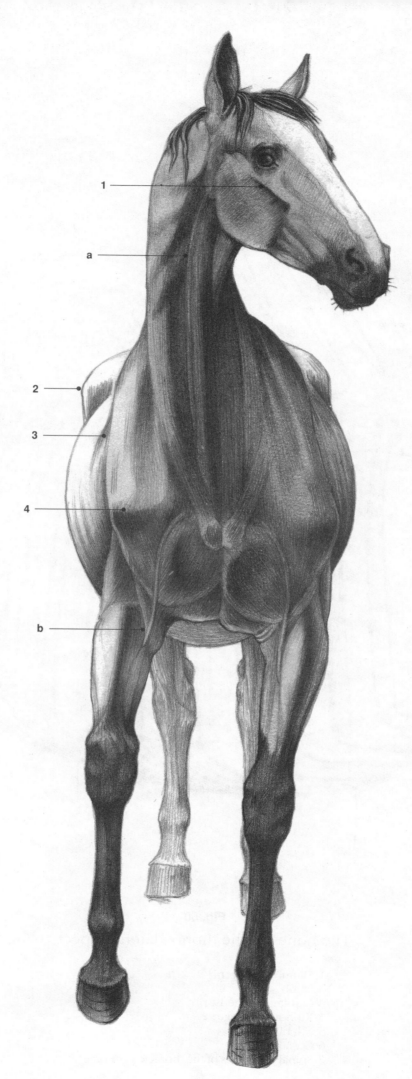

Fig. 49

Horse walking

The contours of the muscles are clearly visible under the skin.

Explanation see Fig. 48.

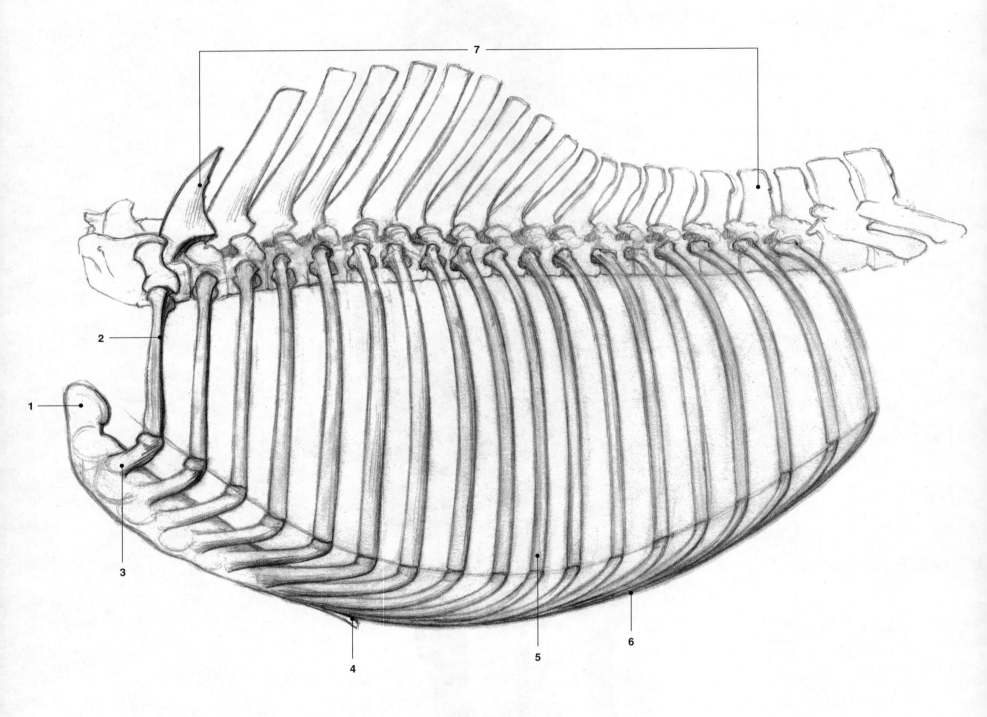

Fig. 50

The bones of the thorax, lateral aspect

1 Manubrium sterni
2 Ist rib
3 Cartilage of the Ist rib
4 Xiphoid cartilage
5 Xth rib
6 Costal arch
7 Spinal processes of the thoracic vertebrae

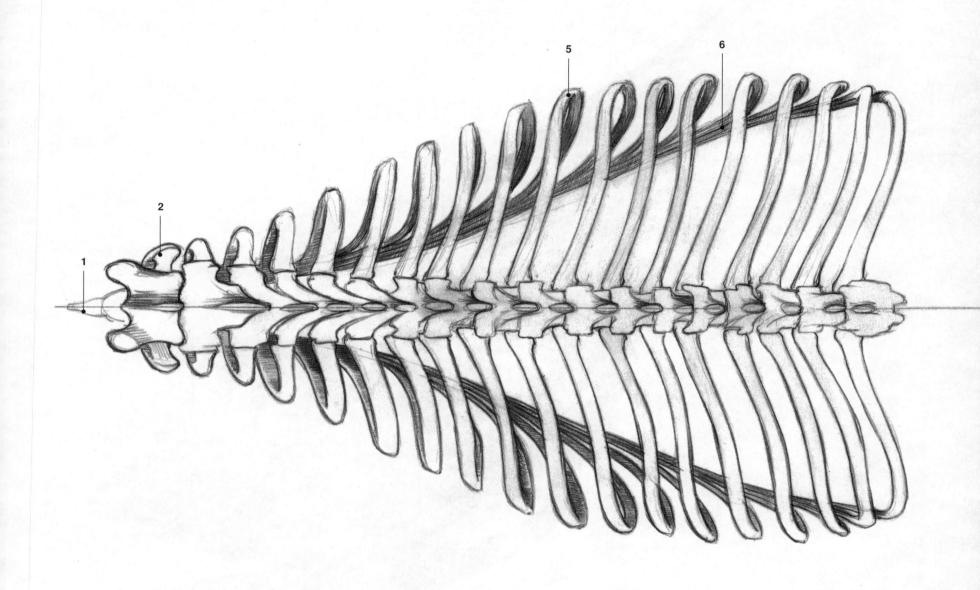

Fig. 51

The bones of the thorax, dorsal aspect

Explanation see Fig. 50.

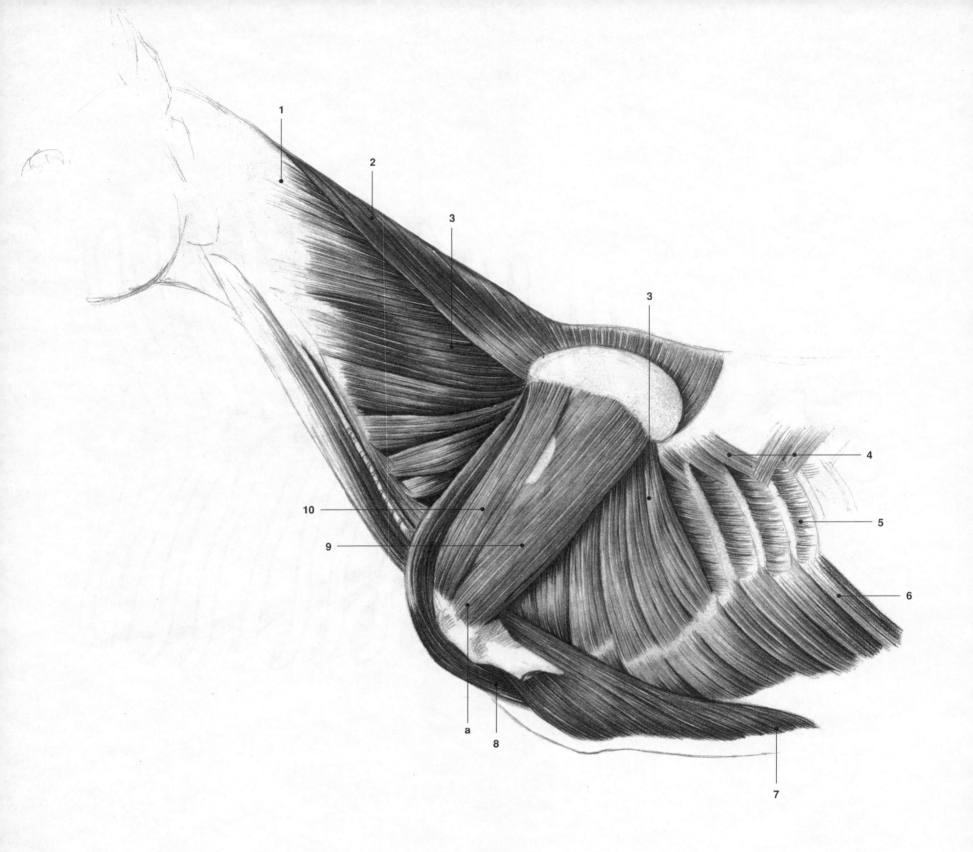

Fig. 52

The muscles of the neck and the trunk, lateral aspect
(middle layer)

1 Splenius muscle *(5)*
2 Rhomboideus muscle *(17)*
3 Serratus ventralis muscle *(18)*
4 Serratus dorsalis muscle *(19)*
5 Intercostalis externus
 muscle *(33)*

6 Obliquus externus abdominis
 muscle *(36)*
7 Pectoralis profundus muscle *(30)*
8 Subclavius muscle *(32)*
9 Infraspinatus muscle *(45)*
10 Suprasprinatus muscle *(44)*

a) Shoulder joint

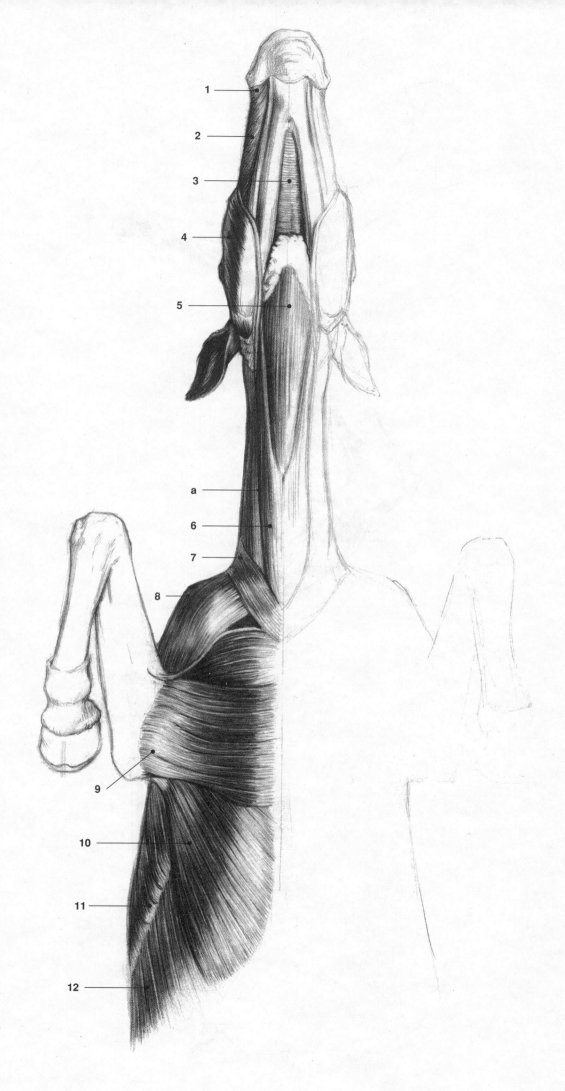

Fig. 53

The muscles of the head,
neck and thorax,
ventral aspect

1 Orbicularis oris muscle *(163)*
2 Buccinator muscle *(175)*
3 Mylohyoideus muscle *(176)*
4 Masseter muscle *(178)*
5 Sternohyoideus muscle *(9)*
6 Sternomastoideus muscle *(6)*
7 Cutaneus colli muscle *(2)*
8 Brachiocephalicus muscle *(6/1)*
9 Pectoralis transversus muscle *(28)*
10 Pectoralis profundus muscle *(30)*
11 Serratus ventralis muscle *(18)*
12 Obliquus externus abdominis muscle *(36)*

a) Jugular groove

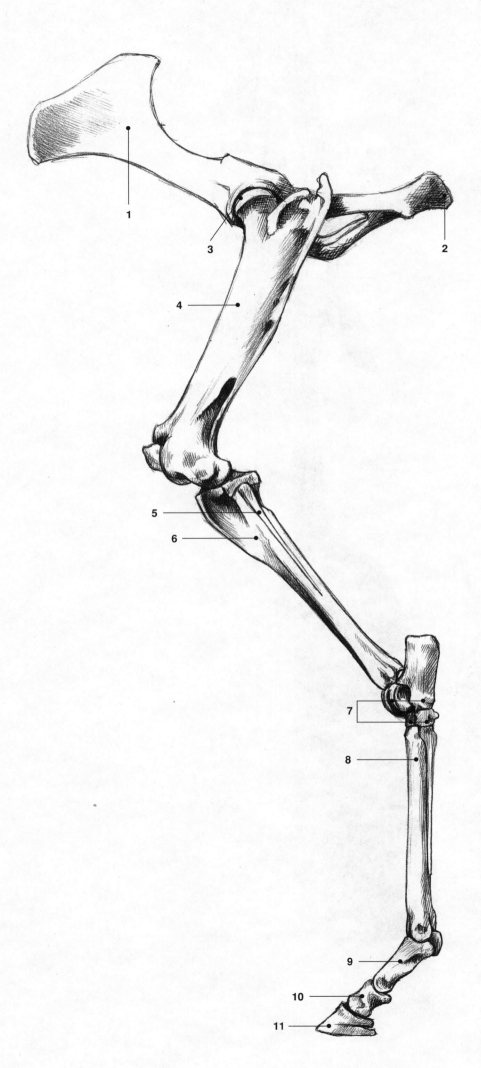

Fig. 54

The bones of the pelvic limb, lateral aspect

1 Ilium
2 Ischium
3 Acetabulum
4 Femur
5 Fibula
6 Tibia
7 Tarsal bones
8 IIIrd metatarsal bone
9 Proximal phalanx (pastern)
10 Middle phalanx (coronet)
11 Distal phalanx (coffin bone)

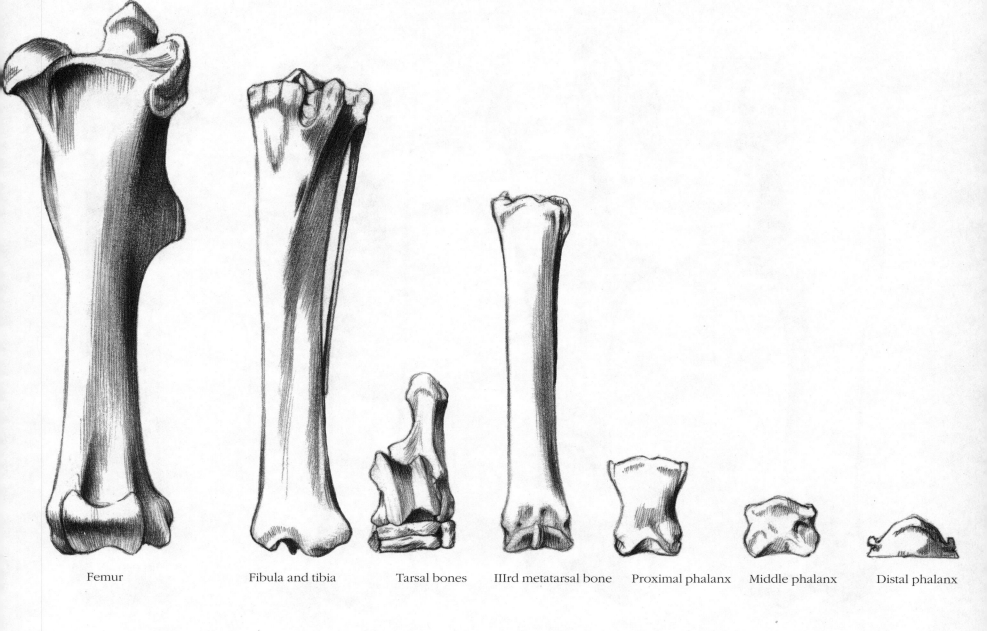

Femur Fibula and tibia Tarsal bones IIIrd metatarsal bone Proximal phalanx Middle phalanx Distal phalanx

Fig. 55

The bones of the pelvic limb, cranial aspect

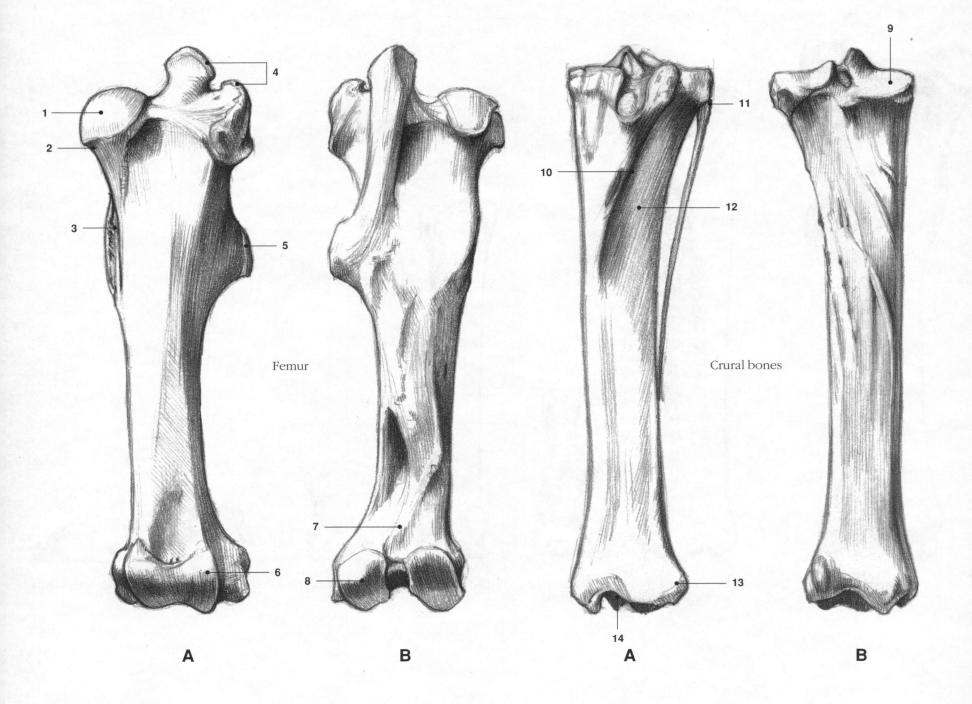

Femur

Crural bones

A B A B

Fig. 56

The femur and crural bones;
cranial (A) and caudal (B) aspects

1 Head (caput)
2 Neck (collum)
3 Trochanter minor
4 Trochanter major
5 Trochanter tertius
6 Trochlea
7 Facies poplitea

8 Condylus
9 Articular surface of tibia
10 Crista tibiae
11 Caput fibulae
12 Sulcus muscularis (muscular groove)
13 Malleolus lateralis (external ankle)
14 Cochlea-shaped articular surface

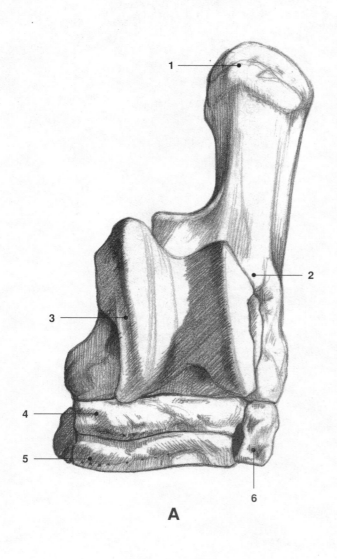

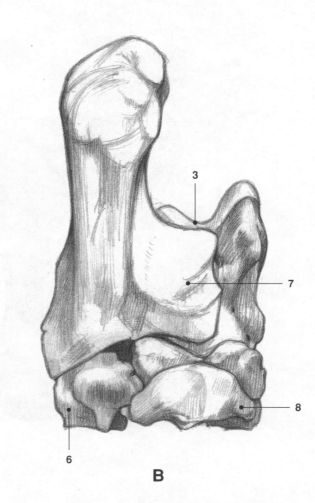

Tarsal bones

A

B

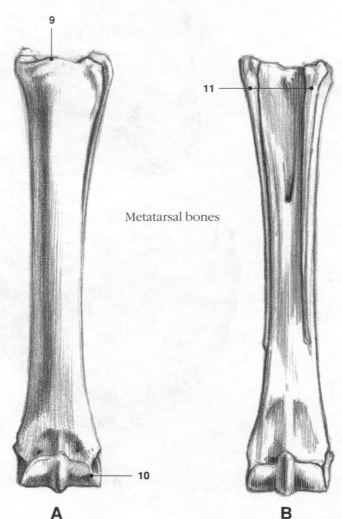

Metatarsal bones

A

B

Fig. 57

The tarsal and metatarsal bones;
dorsal (A) and plantar (B) aspects

1 Tuber calcanei (calcanean tuber)
2 Processus coracoideus
3 Trochlea tali
4 Central tarsal bones
5 IIIrd tarsal bone
6 IVth and Vth tarsal bones
7 Sustentaculum tali
8 Ist and IInd tarsal bones
9 Articular surface of
 the IIIrd metatarsal bone
10 Articular trochlea of
 the IIIrd metatarsal bone
11 Medial and lateral splint bones

273

Proximal phalanx (pastern)

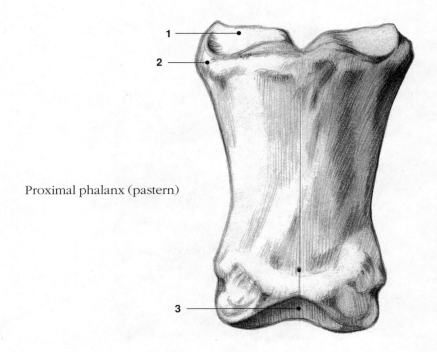

Middle phalanx (coronet)

Distal phalanx

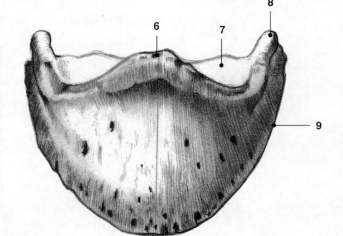

A

Fig. 58

The bones of the IIIrd digit; dorsal (A) and plantar (B) aspects

1 Metatarso-phalangeal articular surface of the pastern
2 Protuberance for the ligament
3 Articular trochlea
4 Tuberosity of flexoria (flexoreal tuber)
5 Solear surface of the distal phalanx
6 Processus extensorius (extensoreal process) of the distal phalanx
7 Articular surface
8 Plantar processes
9 Margo solearis

274

Proximal phalanx (pastern)

Sesamoid bones

B

4 ——

Middle phalanx (coronet)

Distal phalanx (coffin bone)

5 ——

B

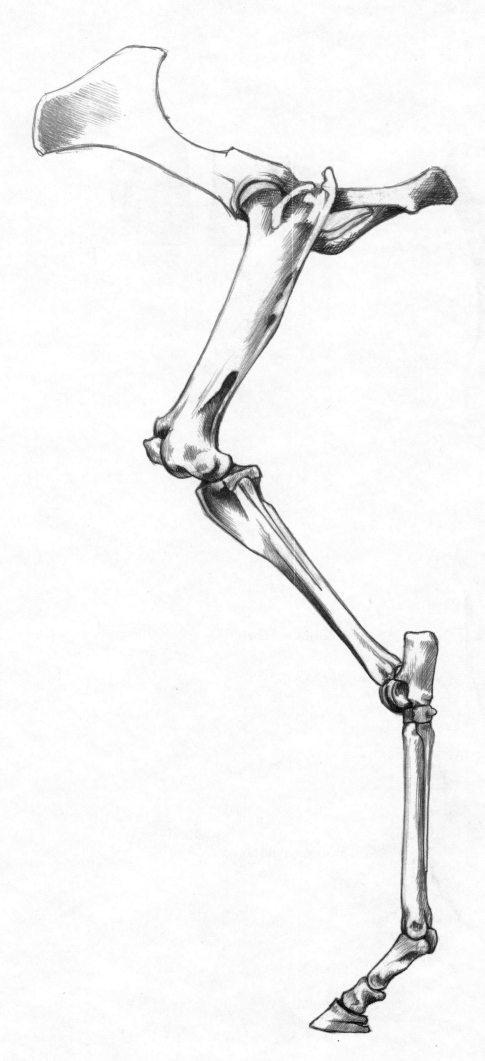

Fig. 59

The bones of the pelvic limb,
lateral aspect

Demonstration of bones see Fig. 54.

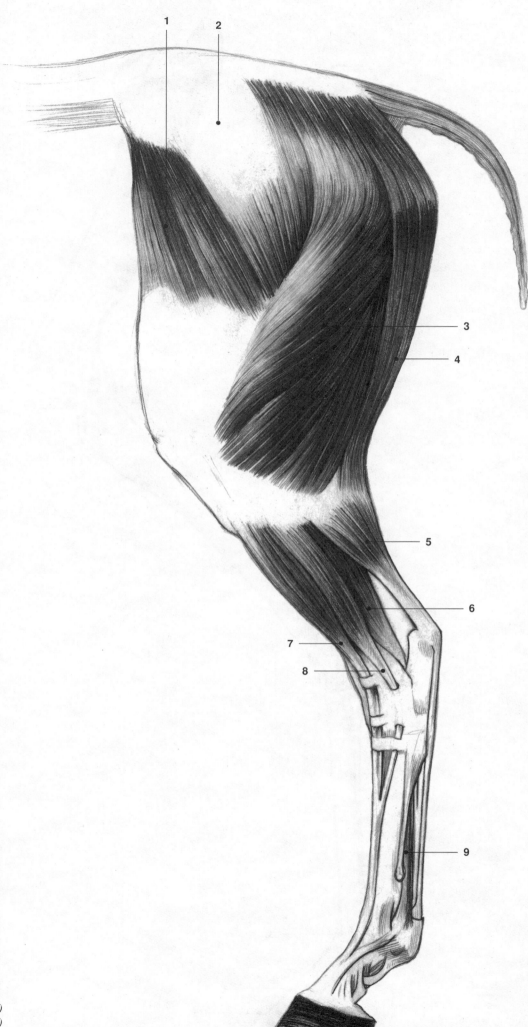

Fig. 60

The muscles of the pelvic limb,
lateral aspect

1 Tensor fasciae latae muscle *(95)*
2 Gluteus superficialis muscle *(96)*
3 Biceps femoris muscle *(106)*
4 Semitendinosus muscle *(107)*
5 Gastrocnemius muscle *(115)*
6 Tibialis caudalis muscle *(126)*
7 Extensor digitorum longus muscle *(118)*
8 Extensor digitorum lateralis muscle *(122)*
9 Interosseus medius muscle *(137)*

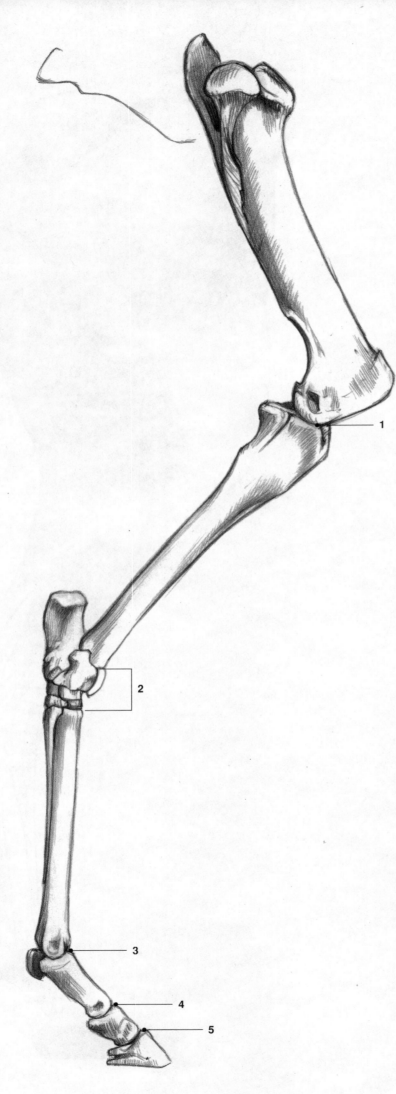

Fig. 61

The bones and joints
of the pelvic limb,
medial aspect

1 Stifle joint
2 Tarsal joint
3 Fetlock joint
4 Pastern joint
5 Pedal joint

Demonstration of bones see Fig. 54.

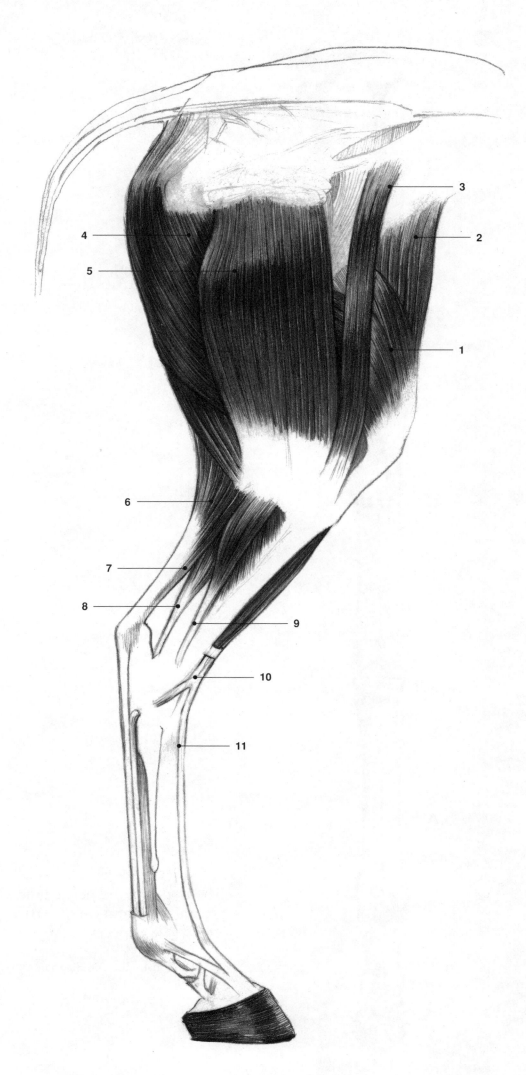

Fig. 62

The muscles of the pelvic limb,
medial aspect

1 Quadriceps femoris muscle *(112)*
2 Tensor fasciae latae muscle *(95)*
3 Sartorius muscle *(102)*
4 Semimembranosus muscle *(108)*
5 Gracilis muscle *(104)*
6 Gastrocnemius muscle *(115)*
7 Flexor digitorum superficialis muscle *(123)*
8 Tibialis caudalis muscle *(126)*
9 Flexor digitorum longus muscle *(125)*
10 Tibialis cranialis muscle *(117)*
11 Tendon of the extensor digitorum
 longus muscle *(118)*

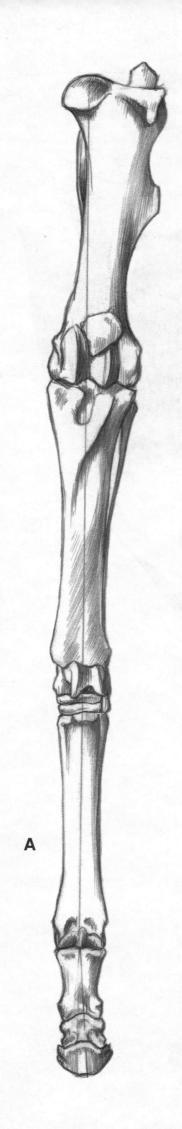

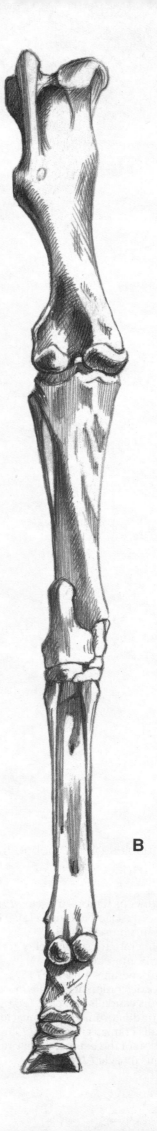

A

B

Fig. 63

The bones of the pelvic limb; cranial (A) and caudal (B) aspects

Demonstration see Fig. 54.

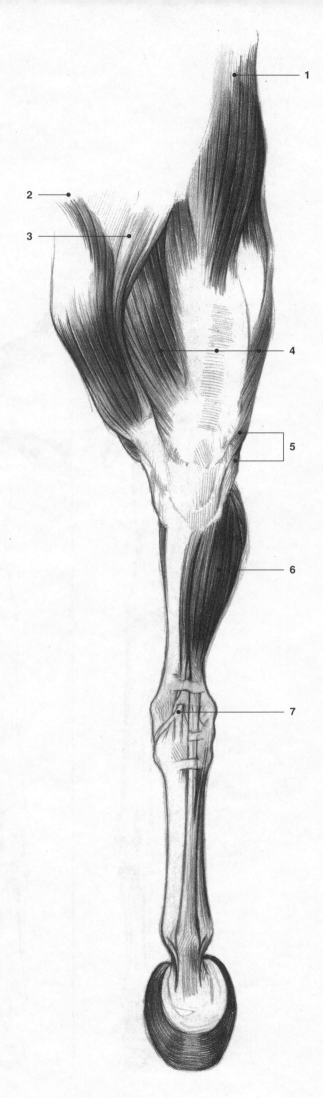

Fig. 64

The muscles of the pelvic limb,
cranial aspect

1 Tensor fasciae latae muscle *(95)*
2 Gracilis muscle *(104)*
3 Sartorius muscle *(102)*
4 Quadriceps femoris muscle *(112)*
5 Biceps femoris muscle *(106)*
6 Extensor digitorum longus muscle *(118)*
7 Tendon of the tibialis cranialis muscle *(117)*

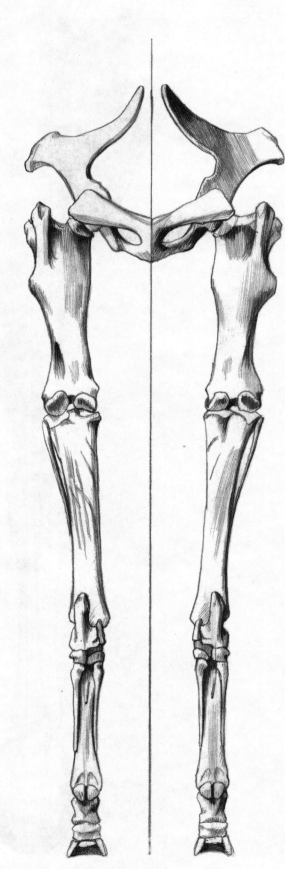

Fig. 65

The bones of the rump
and pelvic limb, caudal aspect

Demonstration see Fig. 54.

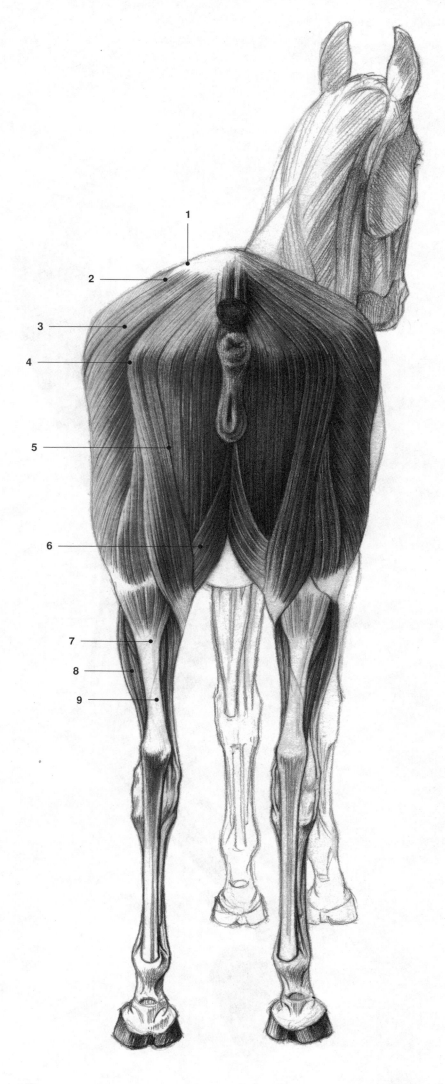

Fig. 66

The muscles of the rump
and pelvic limb, caudal aspect

1 Tuber sacrale
2 Gluteus superficialis muscle *(96)*
3 Biceps femoris muscle *(106)*
4 Semitendinosus muscle *(107)*
5 Semimembranosus muscle *(108)*
6 Gracilis muscle *(104)*
7 Gastrocnemius muscle *(114)*
8 Tibialis cranialis muscle *(117)*
9 Achilles tendon *(114)*

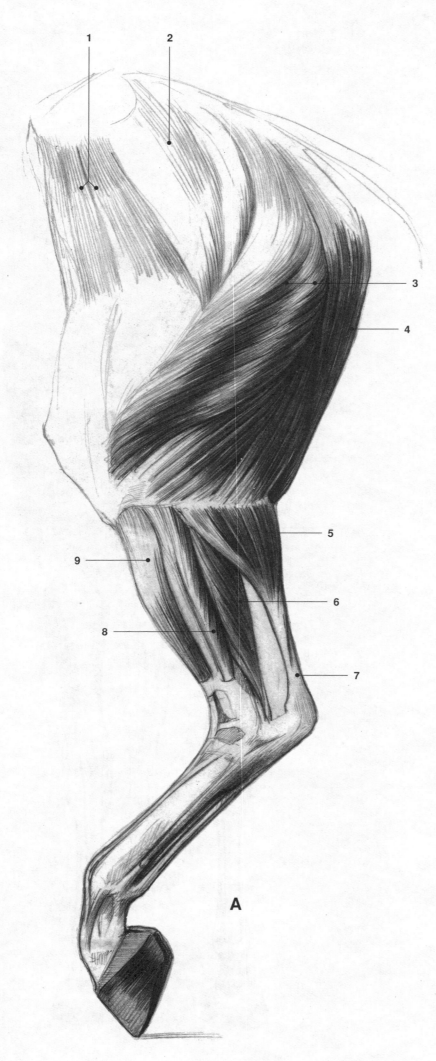

Fig. 67

The pelvic limb
at the beginning
of a step; lateral (A),
caudo-lateral (B)
and caudo-medial (C) aspects

1 Tensor fasciae latae muscle *(95)*
2 Gluteus medius muscle *(97)*
3 Biceps femoris muscle *(106)*
4 Semitendinosus muscle *(107)*
5 Gastrocnemius muscle *(115)*
6 Flexor digitorum profundus muscle *(124)*
7 Flexor digitorum superficialis
 muscle *(123)*
8 Extensor digitorum lateralis muscle *(122)*
9 Extensor digitorum longus muscle *(118)*

A

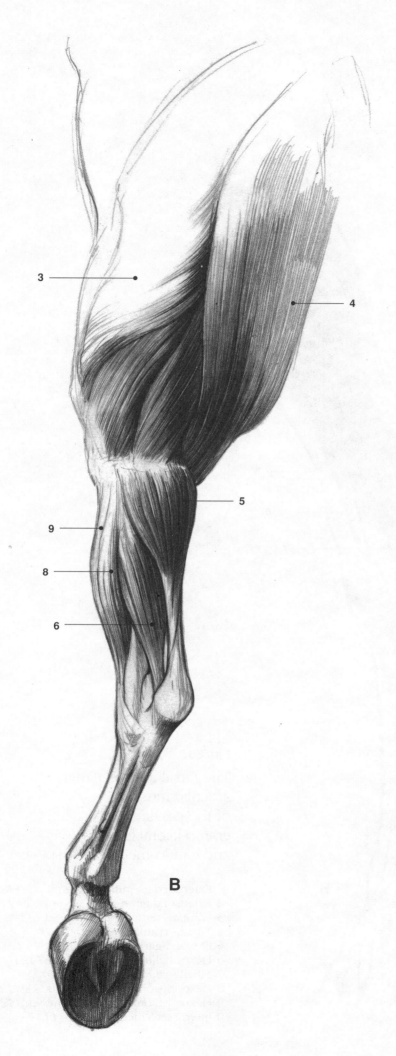

3

4

5

9

8

6

B

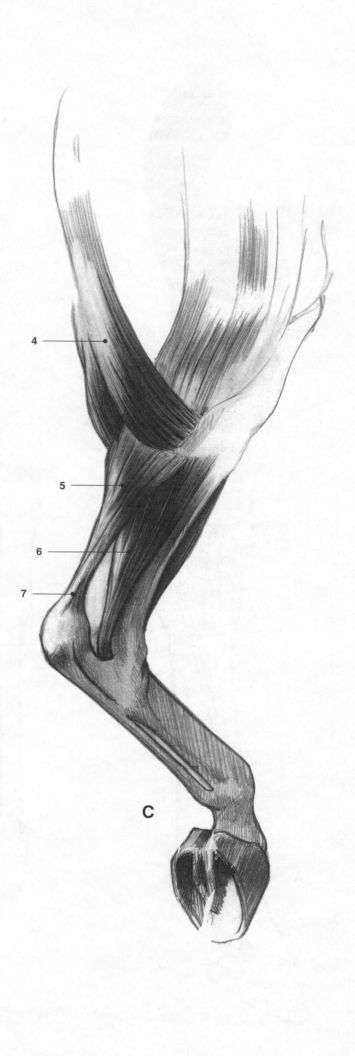

4

5

6

7

C

285

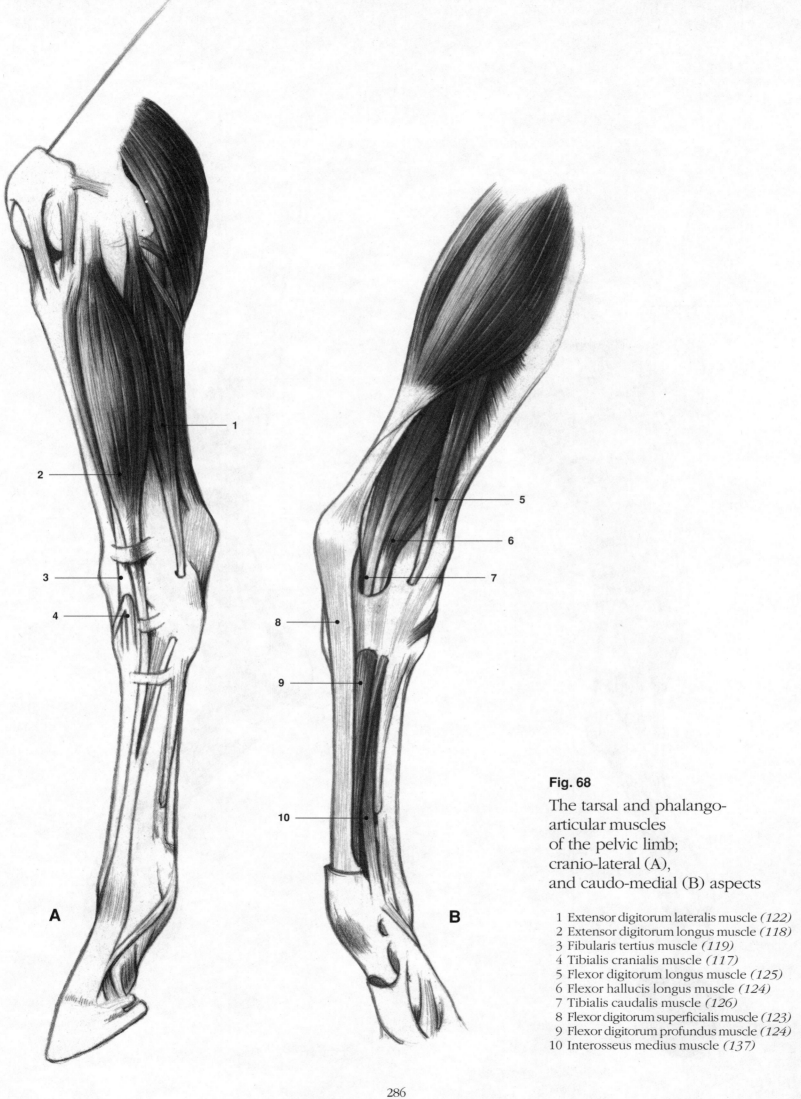

Fig. 68

The tarsal and phalango-
articular muscles
of the pelvic limb;
cranio-lateral (A),
and caudo-medial (B) aspects

1 Extensor digitorum lateralis muscle *(122)*
2 Extensor digitorum longus muscle *(118)*
3 Fibularis tertius muscle *(119)*
4 Tibialis cranialis muscle *(117)*
5 Flexor digitorum longus muscle *(125)*
6 Flexor hallucis longus muscle *(124)*
7 Tibialis caudalis muscle *(126)*
8 Flexor digitorum superficialis muscle *(123)*
9 Flexor digitorum profundus muscle *(124)*
10 Interosseus medius muscle *(137)*

Flag-like carriage of the tail

Medium high attachment of the tail

High attachment of the tail

Elevated tail

Elevated carriage of the tail

Carriage of the tail during running

Fig. 69

The tail

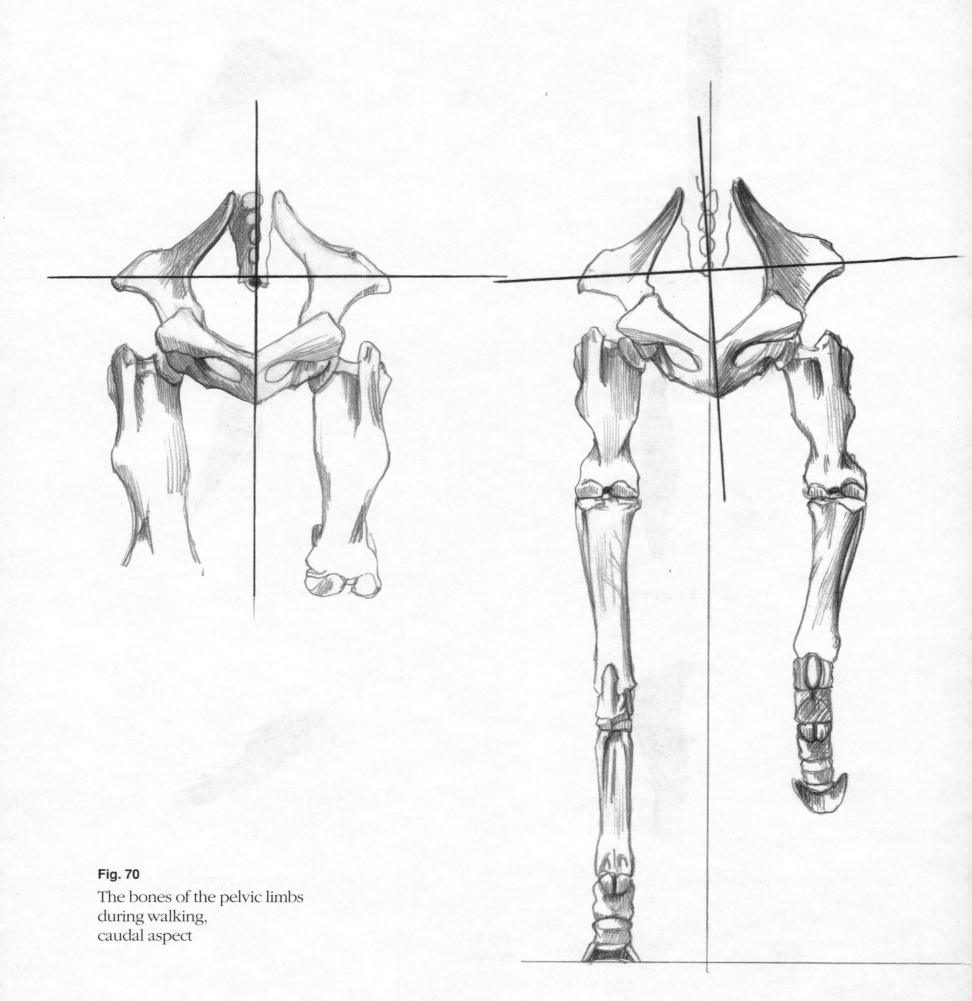

Fig. 70

The bones of the pelvic limbs
during walking,
caudal aspect

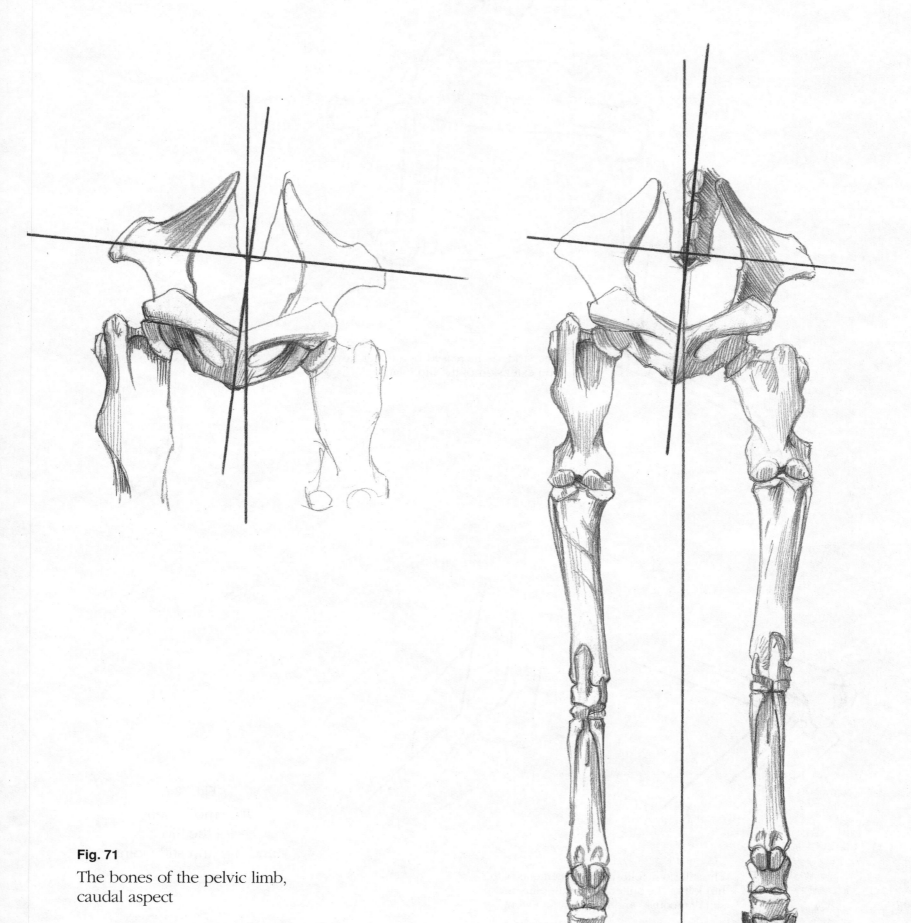

Fig. 71

The bones of the pelvic limb,
caudal aspect

When the standing (resting) animal lifts one pelvic limb,
the pelvis becomes inclined to the vertical.

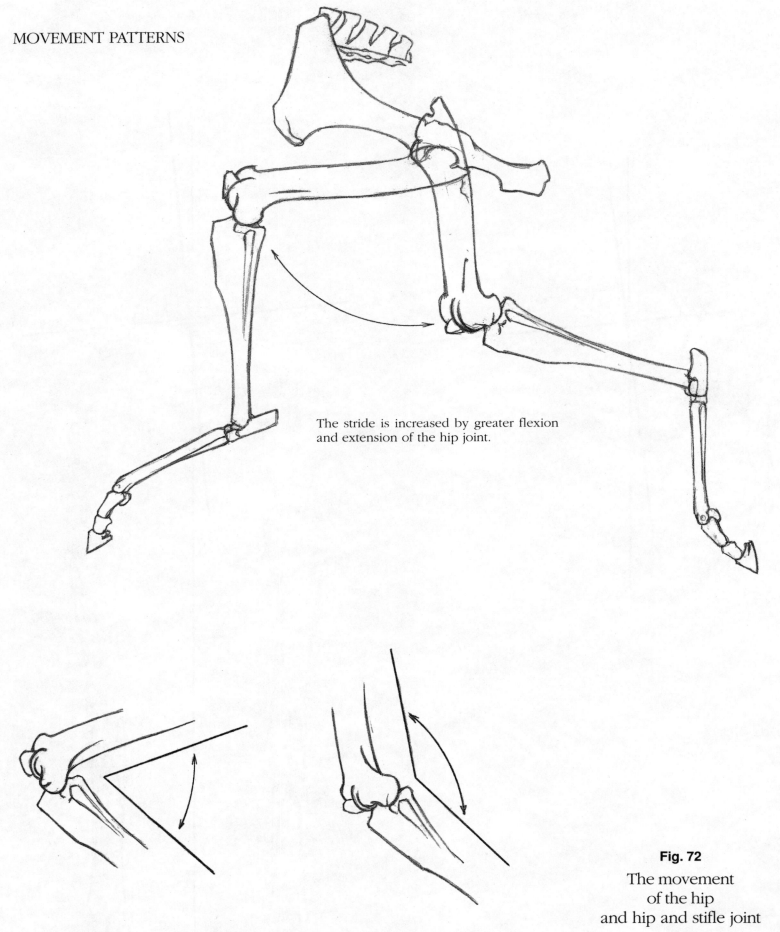

The stride is increased by greater flexion and extension of the hip joint.

Fig. 72

The movement of the hip and hip and stifle joint

The stifle joint follows the movements of the hip joint. The stifle and tarsal joints move simultaneously and to the same extent.

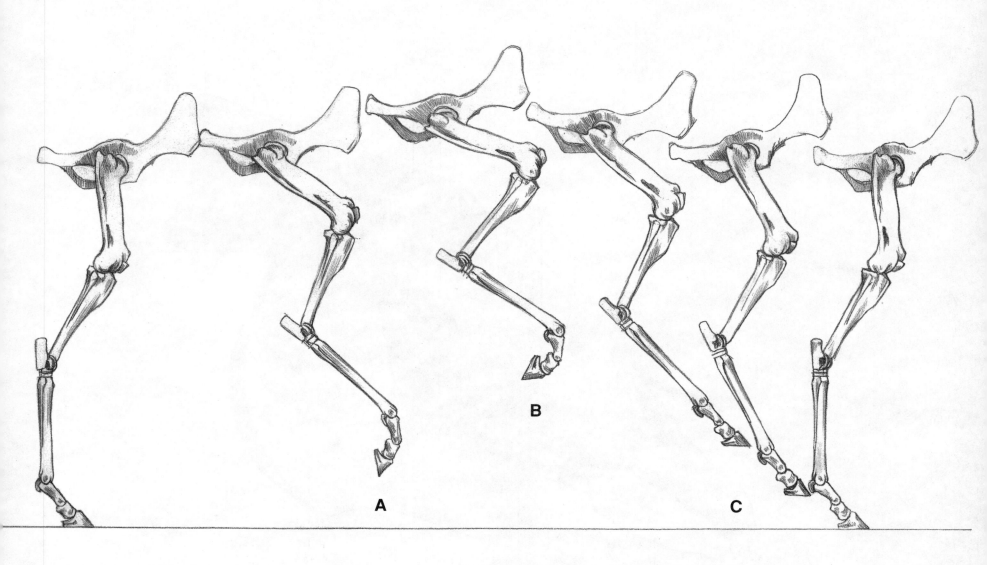

Fig. 73

Phases of walking, pelvic limb

During lifting of the hindlimb (A), the joints flex starting from the hip joint. The last movement is very intensive flexion of the pedal joint (B). In the meantime the whole limb is pulled up and swung forward by the lumbar muscles. When placing the foot on the ground the extension of the joints begins at the pedal joint (C).

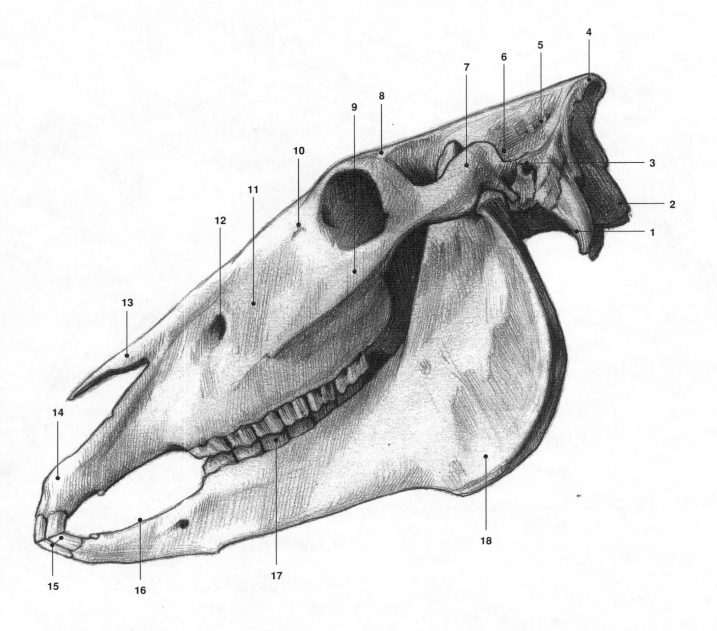

Fig. 74

The skull

1 Paracondylar process
2 Occipital condyle
3 Meatus acusticus externus
4 Nuchal crest
5 Parietal bone
6 Fossa temporalis
7 Zygomatic arch
8 Frontal bone
9 Zygomatic bone with the facial crest
10 Lacrimal bone with the orbit behind it
11 Maxilla
12 Infraorbital hole
13 Nasal bone
14 Incisival bone
15 Incisor teeth
16 Margo interalveolaris
17 Molar teeth
18 Mandibular angle

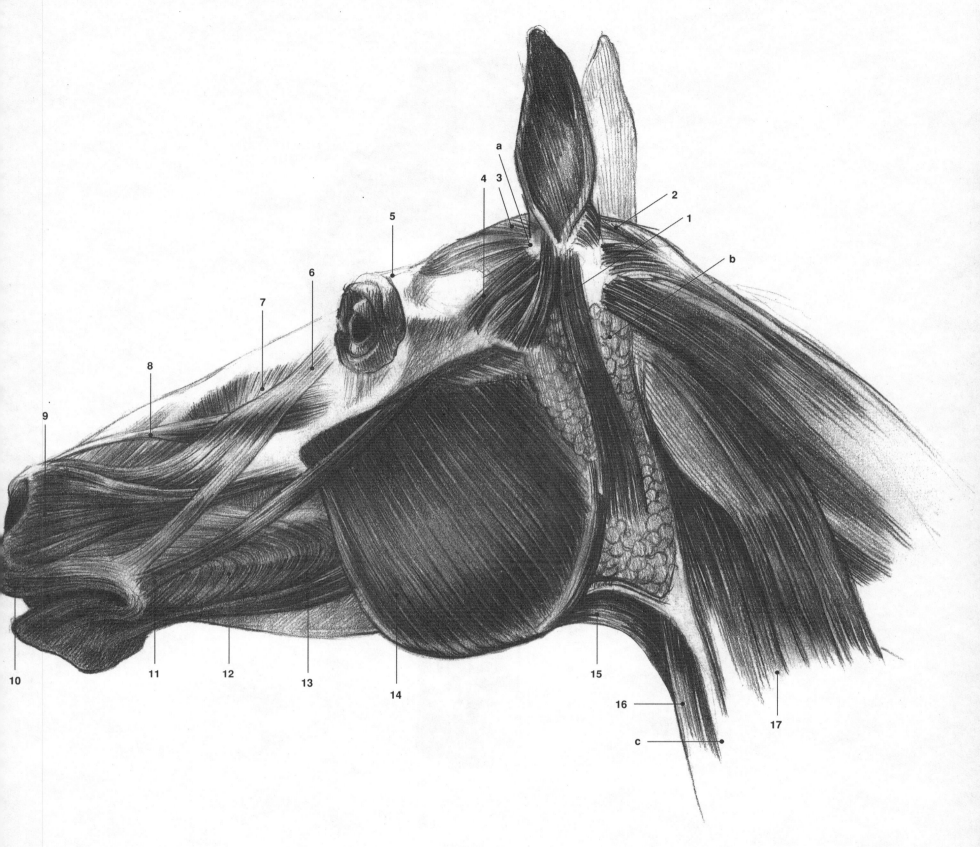

Fig. 75

The muscles of the head

1 Parotideoauricularis muscle *(150)*
2 Cervicoauricularis superficialis
 muscle *(149)*
3 Interscutularis muscles *(145–147)*
4 Pars temporalis of the frontoscutularis
 muscle *(141)*
5 Levator anguli medialis muscle *(157)*
6 Levator nasolabialis muscle *(164)*

7 Lateralis nasi muscle *(162)*
8 Levator labii maxillaris muscle *(168)*
9 Caninus muscle *(165)*
10 Orbicularis oris muscle *(163)*
11 Zygomaticus muscle *(174)*
12 Buccalis muscle *(175)*
13 Depressor labii mandibularis
 muscle *(170)*

14 Masseter muscle *(178)*
15 Sternohyoideus muscle *(9)*
16 Sternomandibularis muscle *(7)*
17 Brachiocephalicus muscle *(6)*

a) Ear scutular cartilage
b) Parotid gland
c) Jugular vein

293

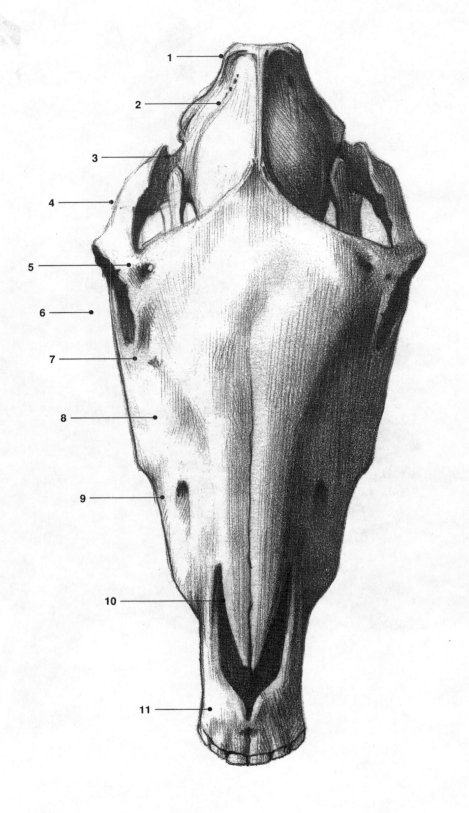

Fig. 76

The skull, dorsal aspect

1 Nuchal crest
2 Parietal bone
3 Temporal fossa
4 Zygomatic arch
5 Frontal bone
6 Zygomatic bone
7 Lacrimal bone
8 Maxilla
9 Infraorbital hole
10 Nasal bone
11 Incisival bone

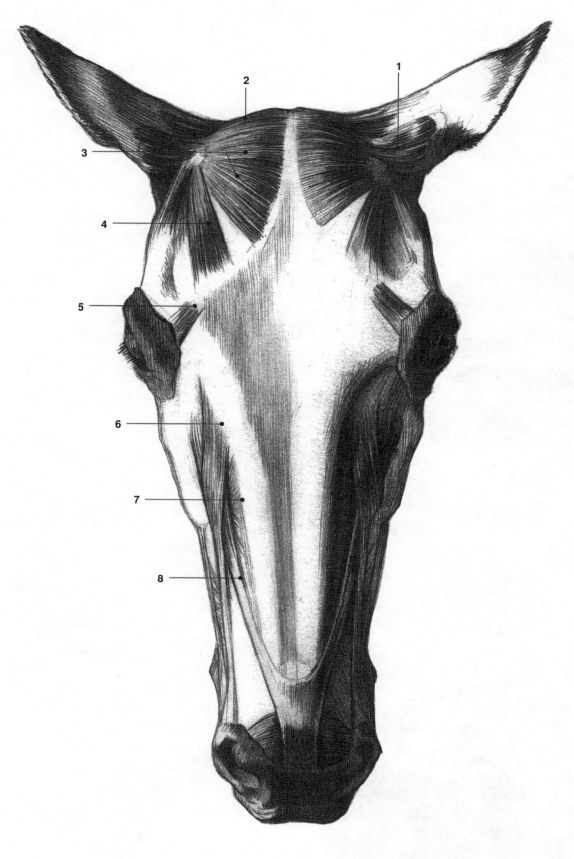

Fig. 77

The muscles of the head, dorsal aspect

1 Scutuloauricularis muscle *(144)*
2 Cervicoauricularis superficialis muscle *(149)*
3 Interscutularis muscle *(145–147)*
4 Frontoscutularis muscles *(141)*
5 Levator anguli medialis muscle *(157)*
6 Levator nasolabialis muscle *(164)*
7 Lateralis nasi muscle *(162)*
8 Levator labii maxillaris muscle *(168)*

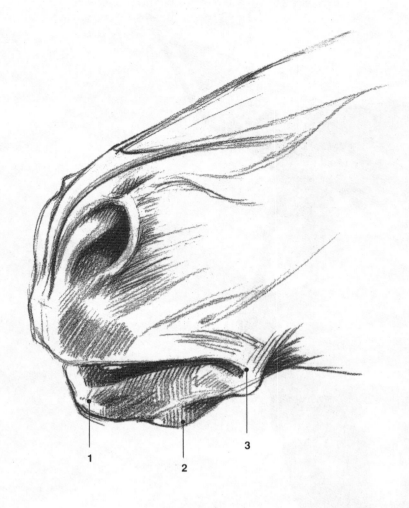

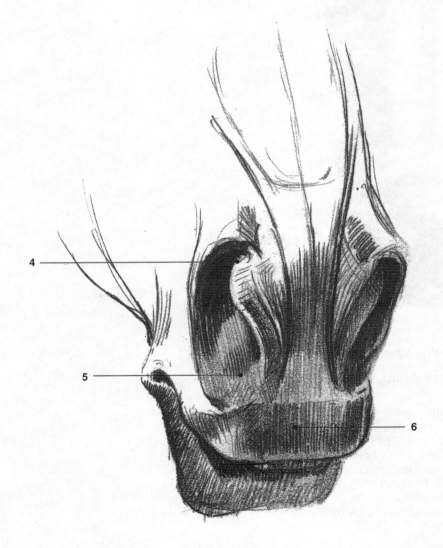

Fig. 78

The lips and nose

1 Lower lip
2 Mental point
3 Angle of mouth
4 False nostril (diverticulum)
5 True nostril
6 Nasolabial region

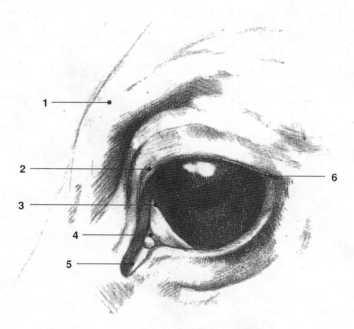

Left eye, lateral aspect

Left eye, caudal aspect

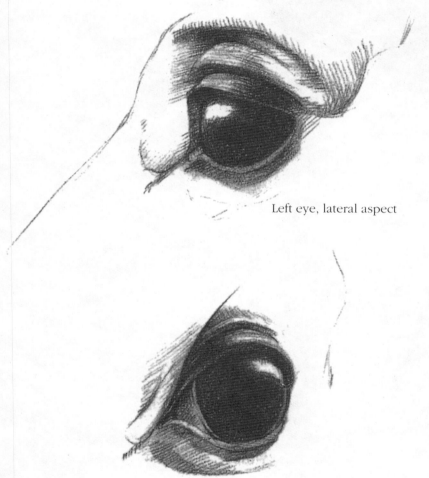

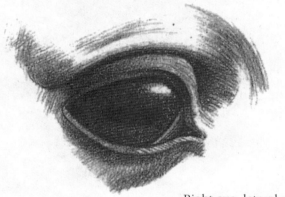

Left eye, lateral aspect

Right eye, lateral aspect

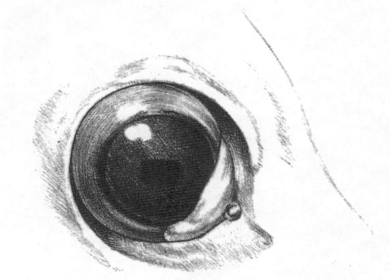

Left eye, cranial aspect

Right eye (wide open), lateral aspect

Fig. 79

The eye

1 Supraorbital region
2 Eyelash border of the upper eyelid
3 IIIrd eyelid

4 Lacrimal caruncle
5 Medial angle of the eye
6 Lateral angle of the eye

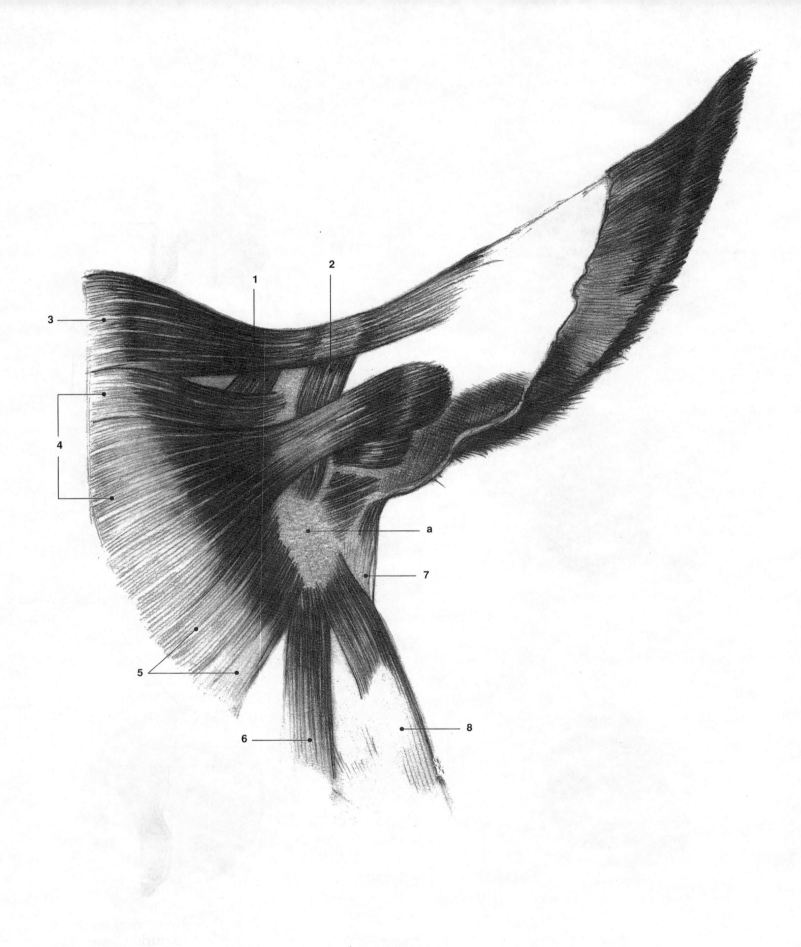

Fig. 80

The muscles of the ear, cranial aspect

1 Rotator auris longus muscle *(153)*
2 Scutuloauricularis muscle *(144)*
3 Cervicoauricularis superficialis
 muscle *(149)*

4 Inter- and parietoauricularis
 muscles *(146, 147)*
5 Frontoscutularis muscle (medial part) *(141)*
6 Parietoscutularis muscle (lateral part) *(145)*

7 Parotideoauricularis muscle *(150)*
8 Zygomaticoscutularis muscle *(142)*

a) Scutular cartilage

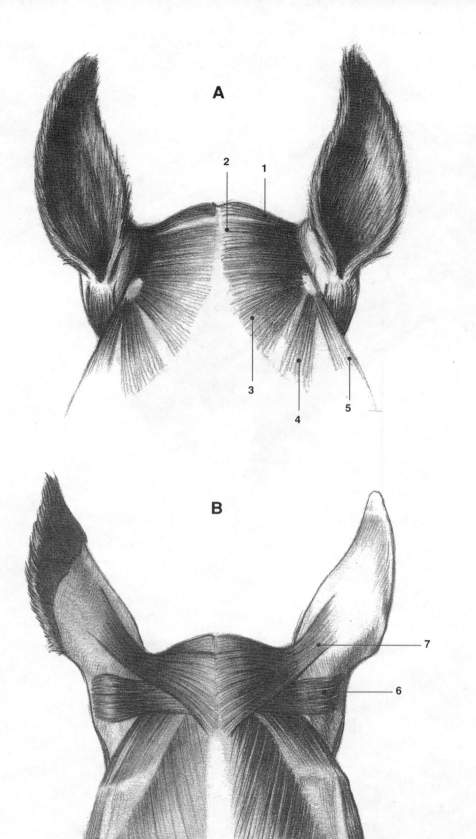

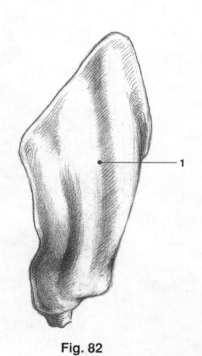

Fig. 81

The muscles of the ear; cranial (A) and caudal (B) aspects

1 Cervicoauricularis muscles *(149)*
2 Inter- and frontoauricularis
 muscles *(146, 147)*
3 Parietoscutularis muscle *(145)*

4 Frontoscutularis muscle *(141)*
5 Zygomaticoscutularis muscle *(142)*
6 Cervicoauricularis profundus muscle *(149)*
7 Cervicoauricularis superficialis muscle *(149)*

Fig. 82

The auricular cartilage;
cranial (A) and caudal (B) aspects

1 Caudal surface of the auricular cartilage
2 Cavity of the auricular cartilage
3 Rostral margin of the auricular cartilage
4 Caudal margin of the auricular cartilage
5 Apex of the auricular cartilage
6 External chondrous auditory canal

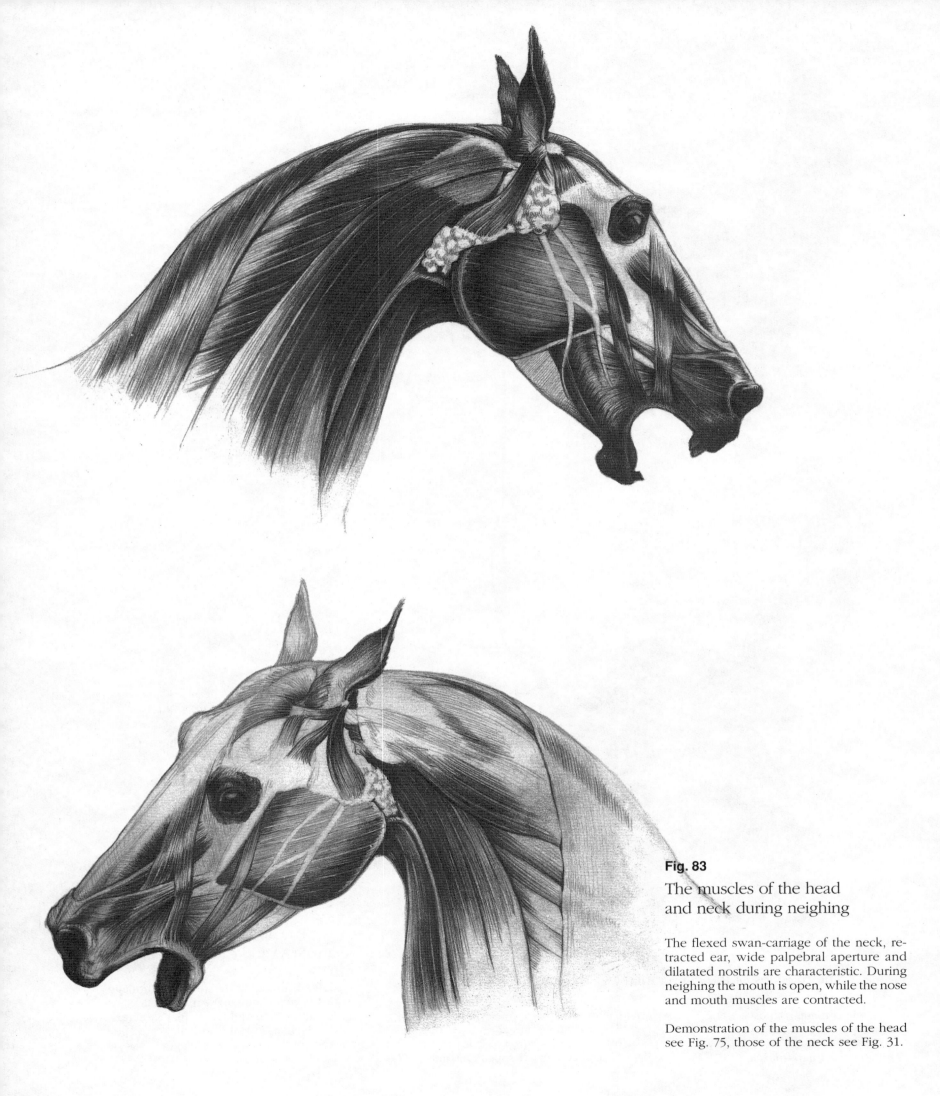

Fig. 83

The muscles of the head
and neck during neighing

The flexed swan-carriage of the neck, re-
tracted ear, wide palpebral aperture and
dilatated nostrils are characteristic. During
neighing the mouth is open, while the nose
and mouth muscles are contracted.

Demonstration of the muscles of the head
see Fig. 75, those of the neck see Fig. 31.

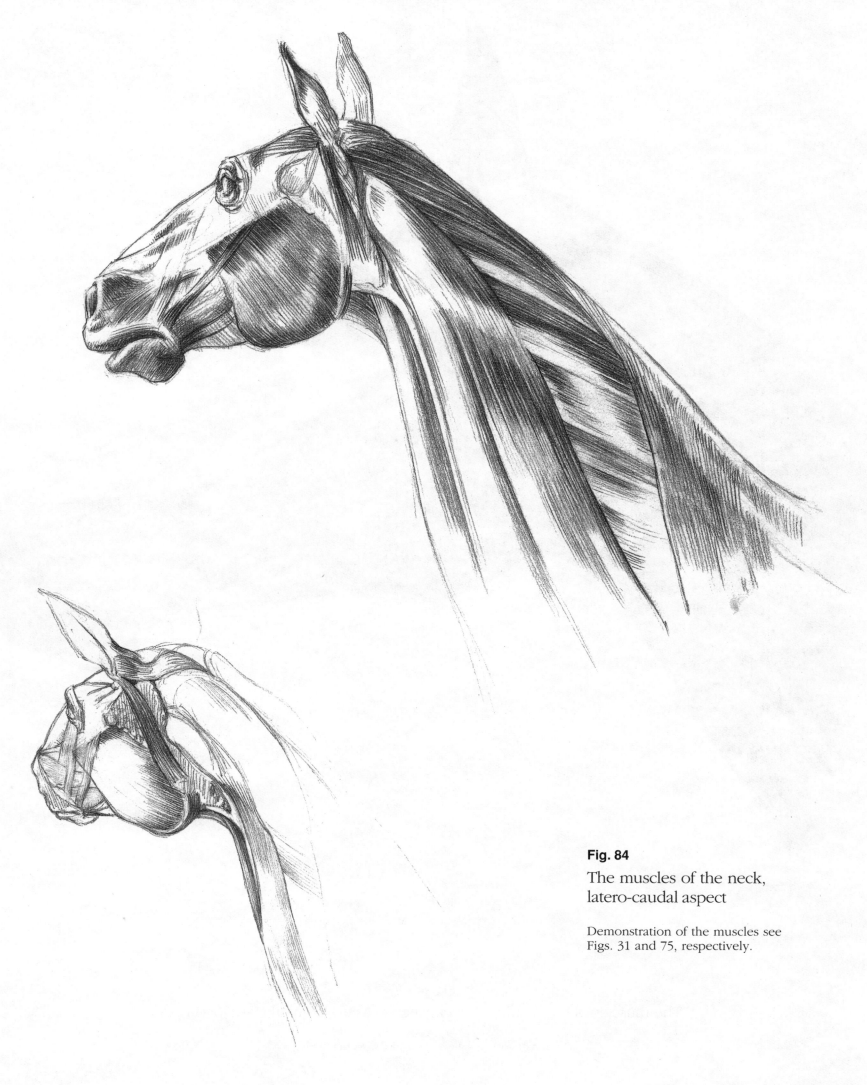

Fig. 84

The muscles of the neck,
latero-caudal aspect

Demonstration of the muscles see
Figs. 31 and 75, respectively.

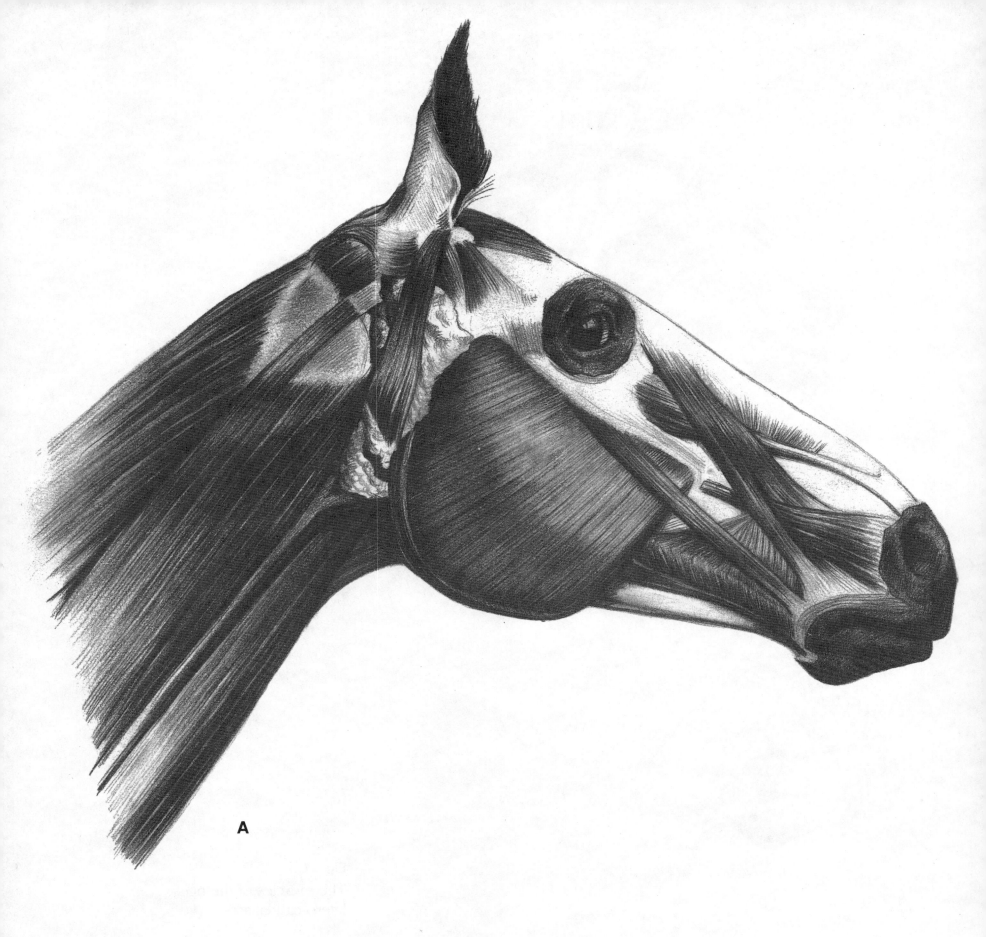

A

Fig. 85

The muscles of the head and neck; lateral (A) and ventral (B) aspects

Demonstration see Figs. 31 and 53, respectively.

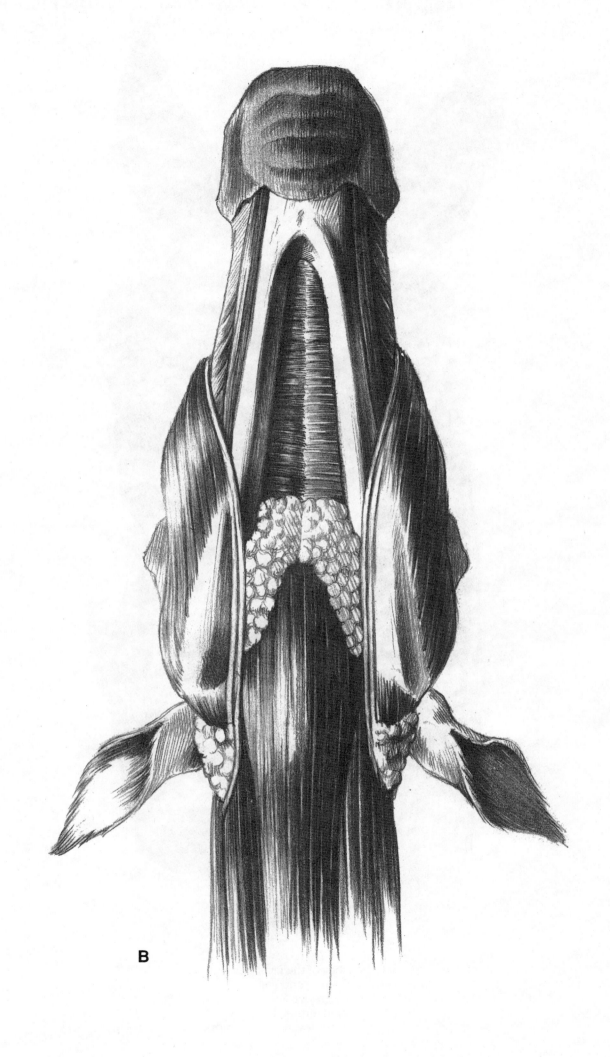

B

303

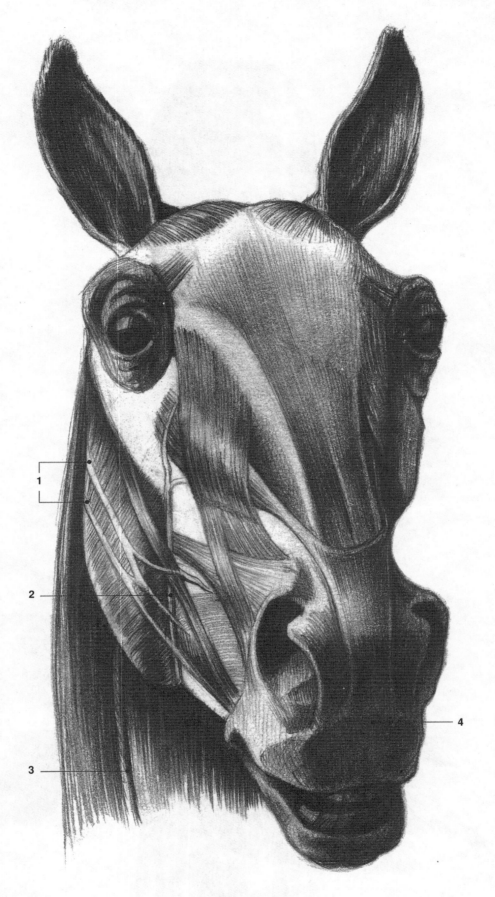

Fig. 86

The head

1 Branches of the facial nerve
2 Facial artery and vein
3 Jugular groove and vein
4 Common terminal tendon
 of the two levators of the upper lip

304

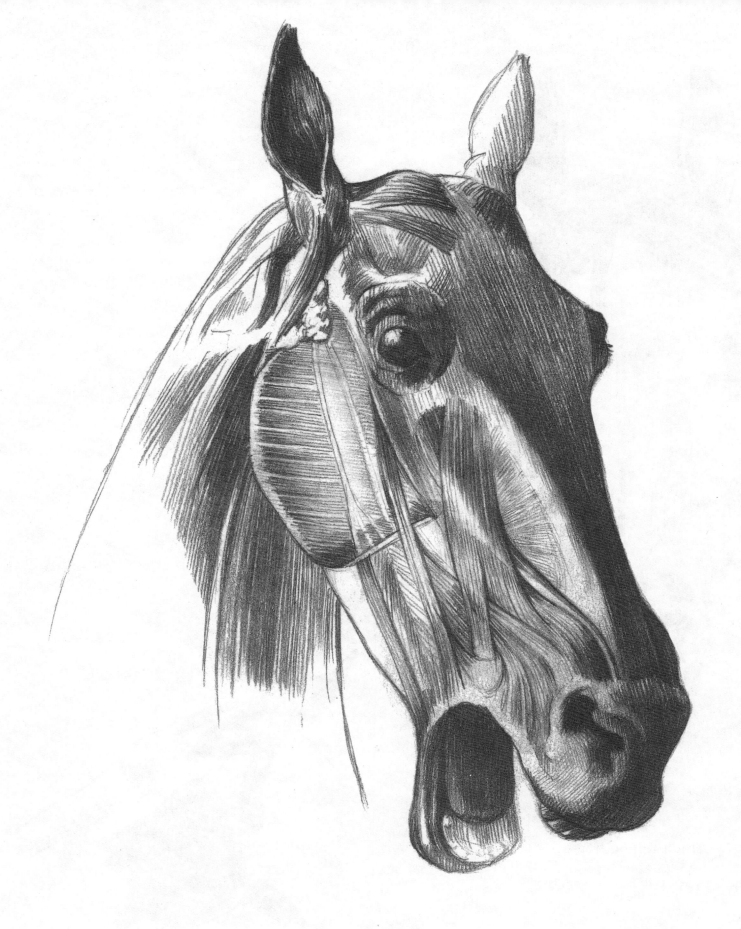

Fig. 87

The head during neighing

The muscles are demonstrated in Figs. 31 and 75.

Fig. 88

The listening horse

The horse reacts to familiar sounds only
with the ears.

Fig. 89

The watching horse

Ear carriage before kicking out.

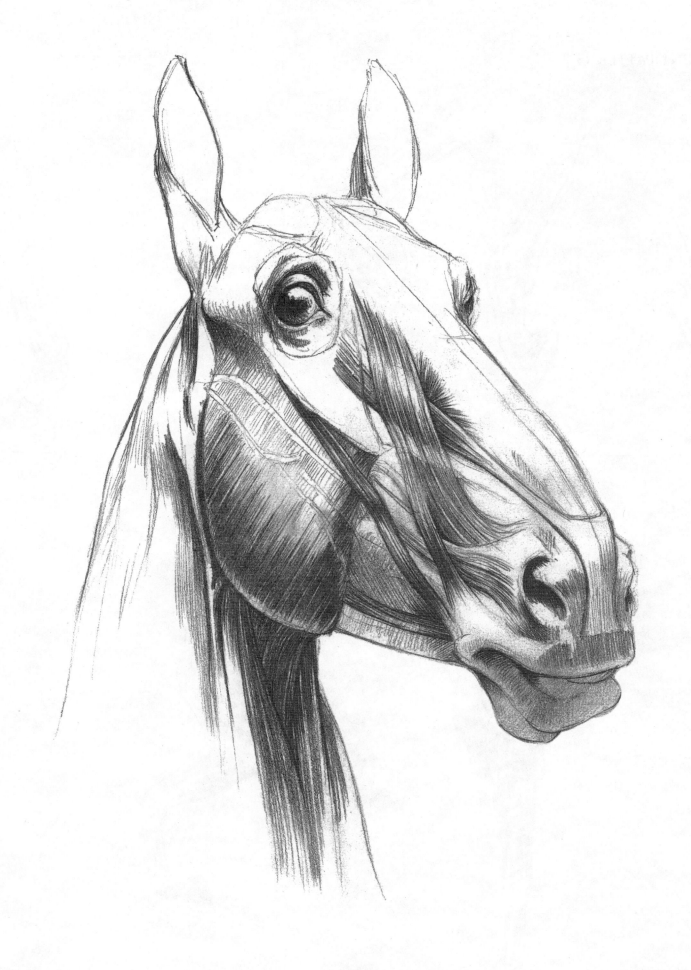

Fig. 90

An expression of alarm

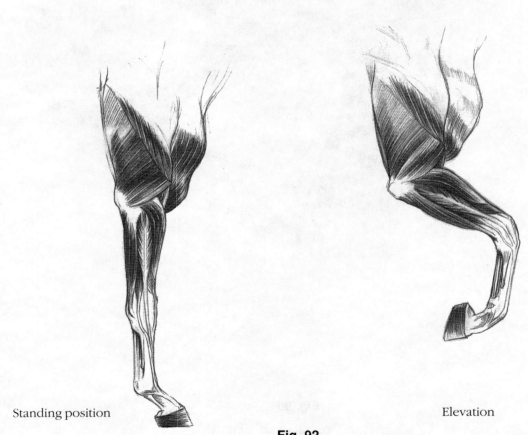

Pushing off Elevation Forward movement Placement Taking the weight

Fig. 91

Phases of walking, thoracic limb

Standing position Elevation

Fig. 92

Elements of walking, thoracic limb

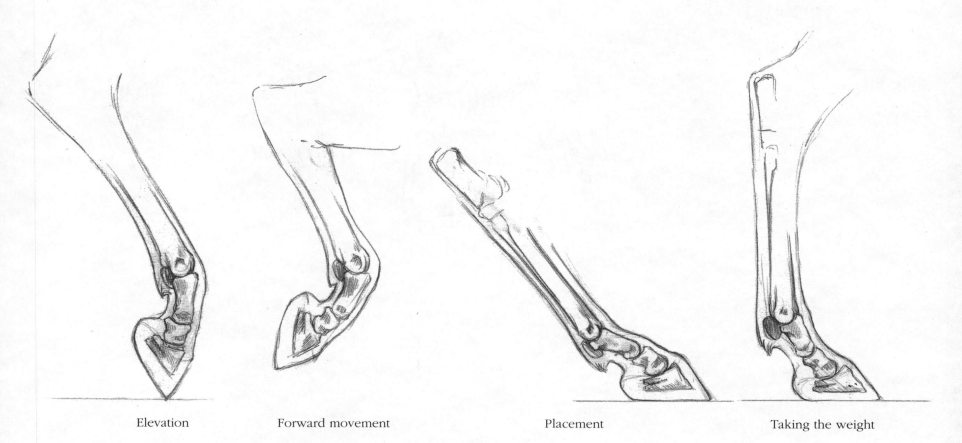

Elevation Forward movement Placement Taking the weight

Fig. 93

Phases of walking, pelvic limb

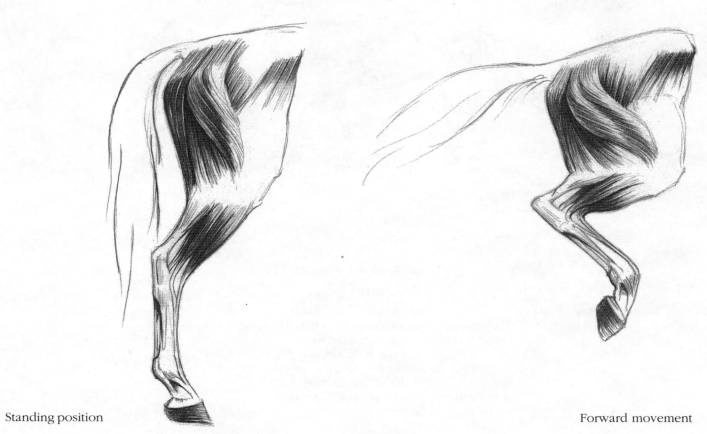

Standing position Forward movement

Fig. 94

Elements of walking, pelvic limb

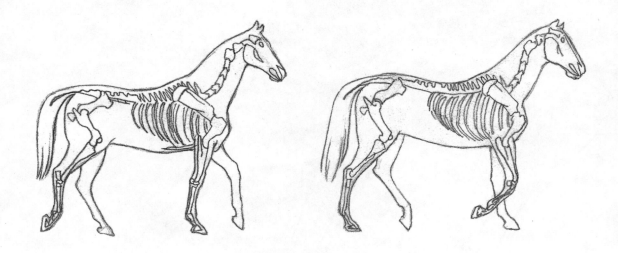

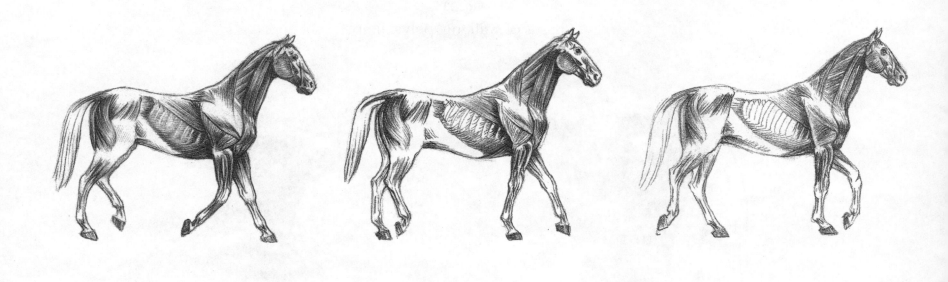

Fig. 95

Walking

The impulse for locomotion starts from the pelvic limb, which precedes the ipsilateral thoracic limb by some half a stride. The tail always swings in the direction of the supporting limb. When pulling a heavy burden, the head nods at the time of elevation of the thoracic limb and turns towards the opposite direction.

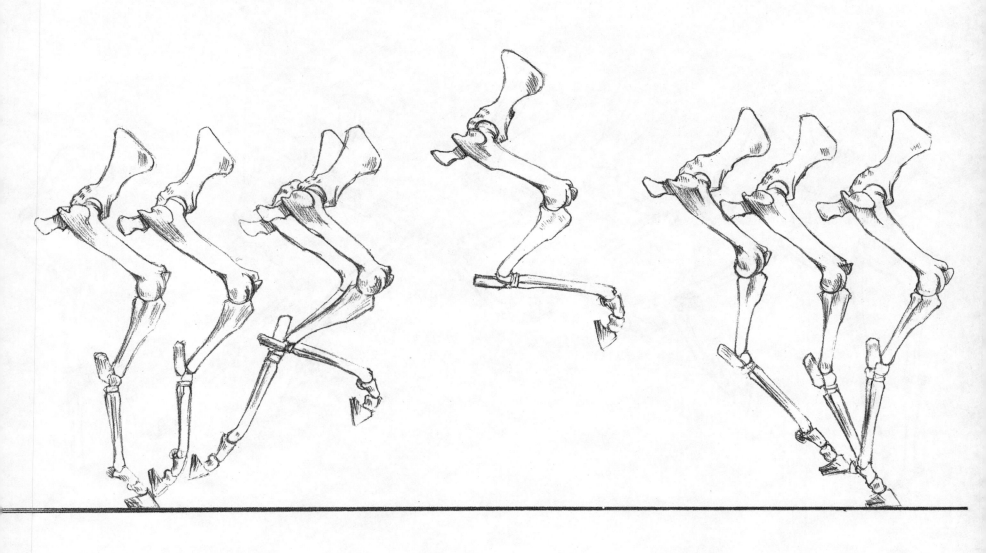

Fig. 96

Phases of galloping, pelvic limb

For explanation see the introductory text.

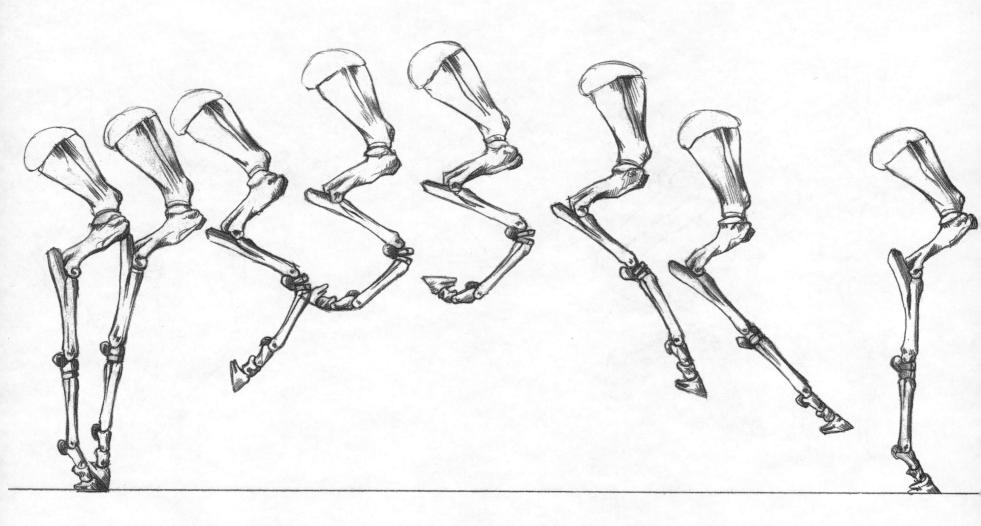

Fig. 97

The movement of the thoracic limb during jumping

During jumping, the whole limb is elevated together
with the trunk. The joints are flexed to the maximum
and the animal flies through in the air.

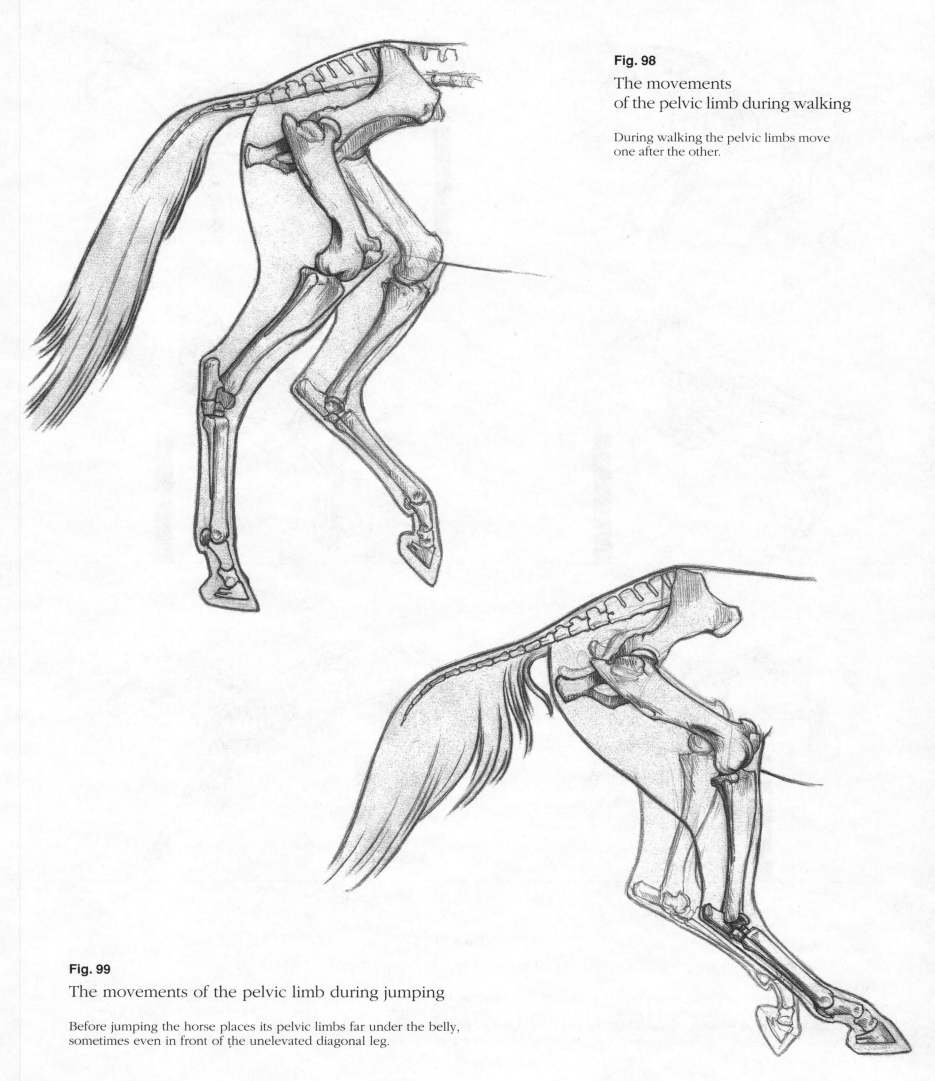

Fig. 98

The movements
of the pelvic limb during walking

During walking the pelvic limbs move
one after the other.

Fig. 99

The movements of the pelvic limb during jumping

Before jumping the horse places its pelvic limbs far under the belly,
sometimes even in front of the unelevated diagonal leg.

313

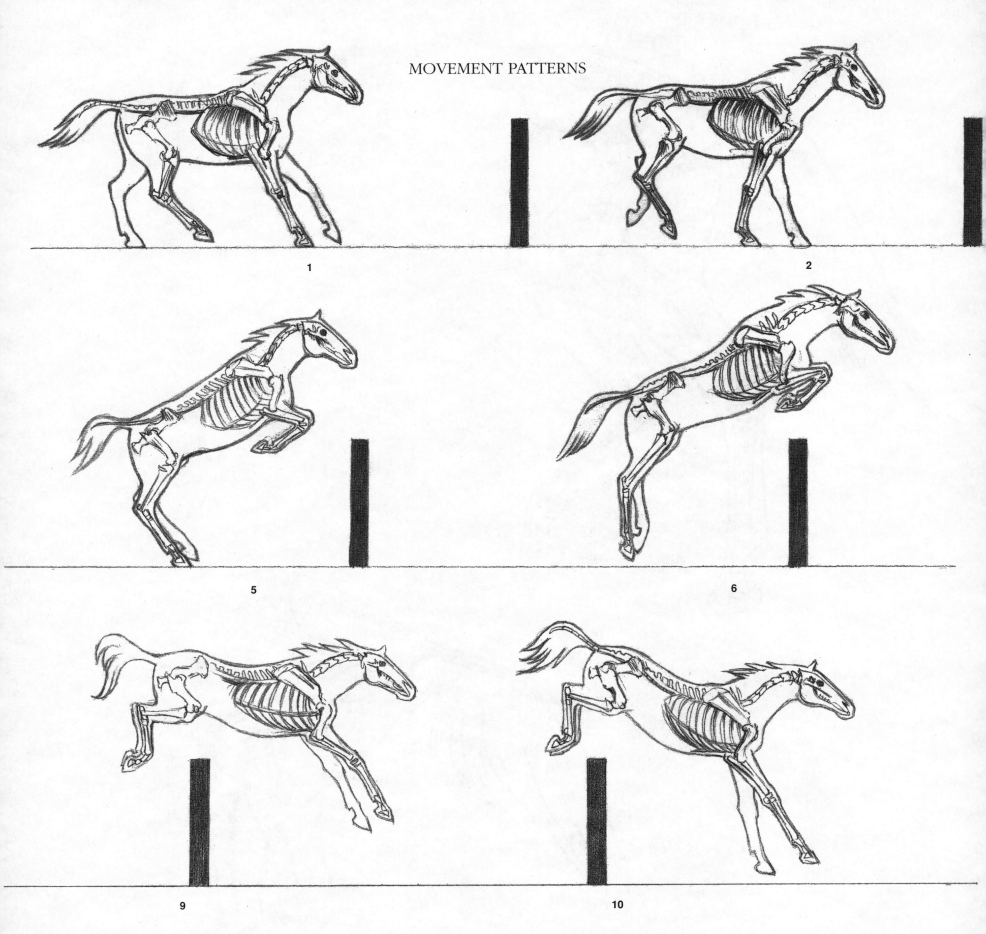

Fig. 100

Phases of obstacle jumping

In preparation for jumping the obstacle, the galloping horse raises its head and neck, then swings one of its pelvic limbs under its trunk. It pushes itself off from the ground with both hind limbs. The pelvic limbs, by intense contraction of the muscles of the back and the rump, raise the trunk and push it forward with the thoracic limb joints flexed. The joints of the pelvic limbs are then fully extended. As soon as the front half of the body has passed over the obstacle the head and neck are stretched for-

314

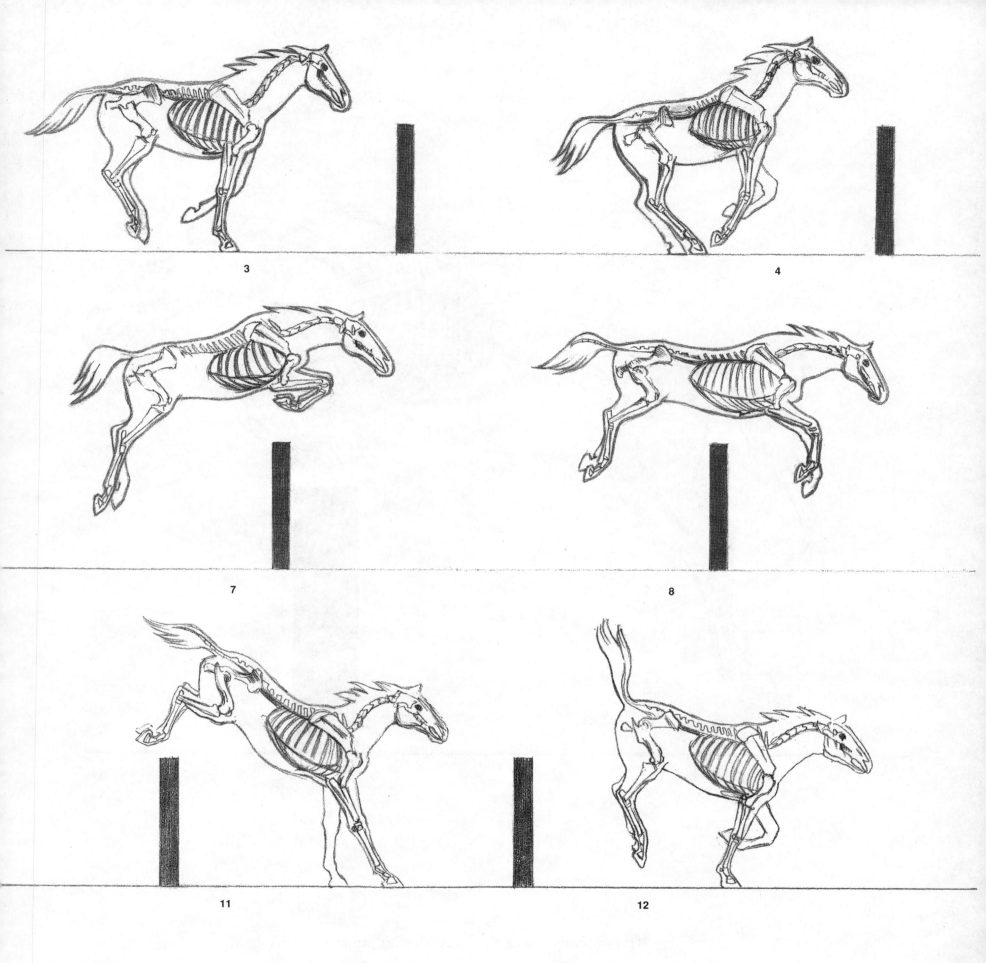

3

4

7

8

11

12

ward, the trunk falls, the thoracic limbs are stretched forward and the pelvic limbs are flexed. On touching the ground the horse reduces its speed by lifting the head and neck. Trained horses estimate the height of the obstacle properly before jumping.

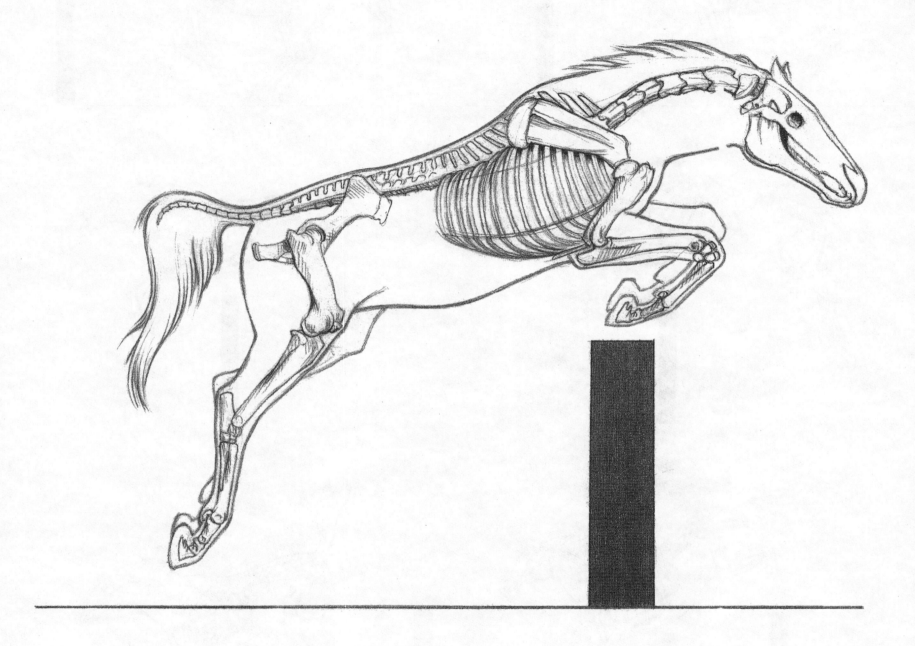

Fig. 101

The movements of the head during jumping

Above the obstacle the head is lowered and stretched forward.
On landing the head and neck are raised again.

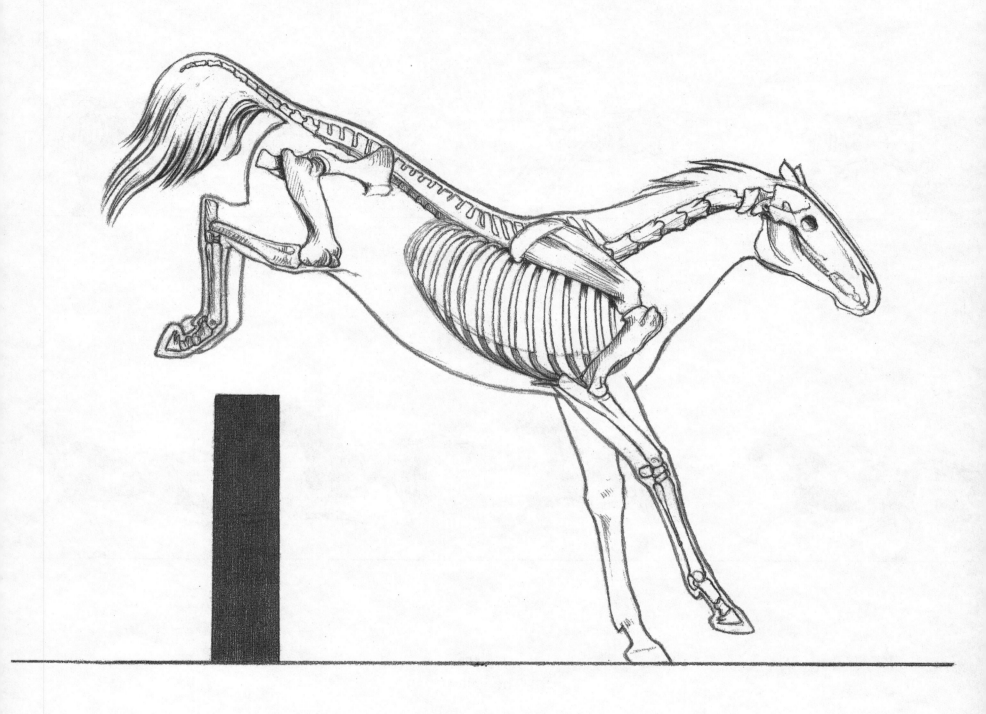

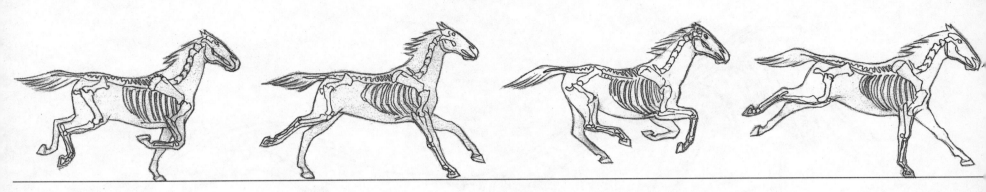

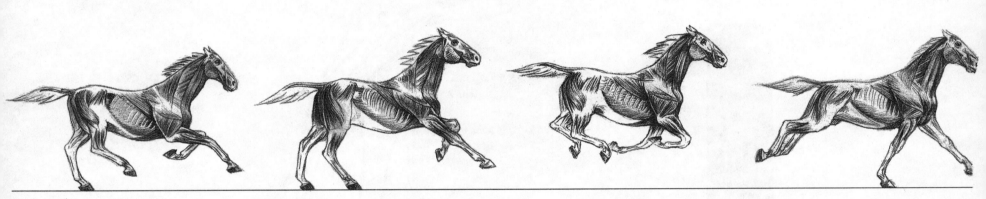

Fig. 102

The gallop

This kind of locomotion consists of consecutive jumps.

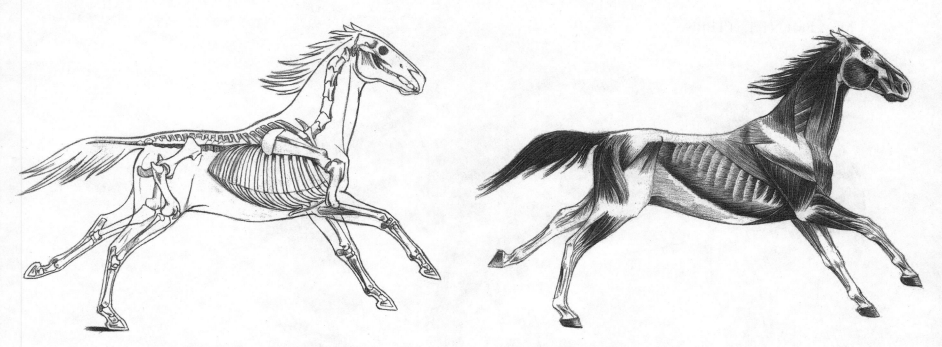

The horse is galloping to the right. The right thoracic limb is one phase in front of the left one.

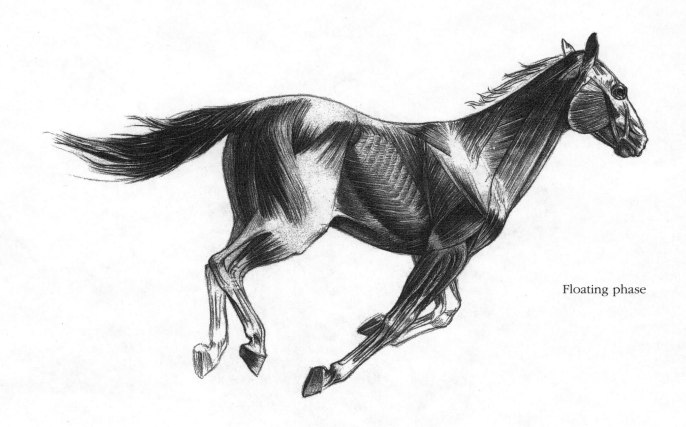

Floating phase

Fig. 103

The race gallop (carrier)

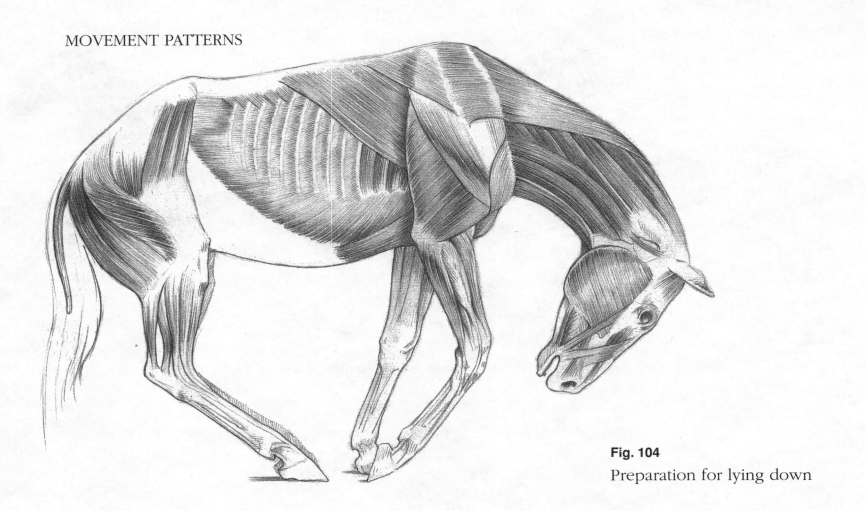

Fig. 104
Preparation for lying down

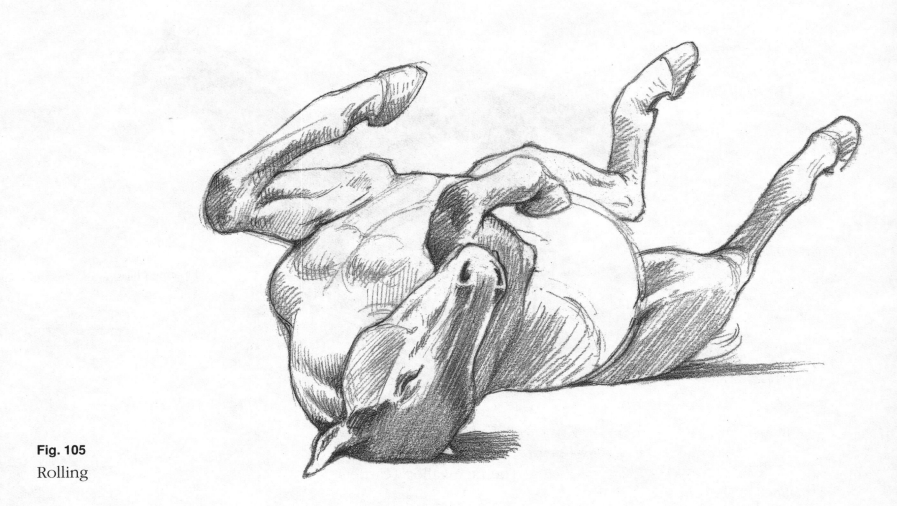

Fig. 105
Rolling

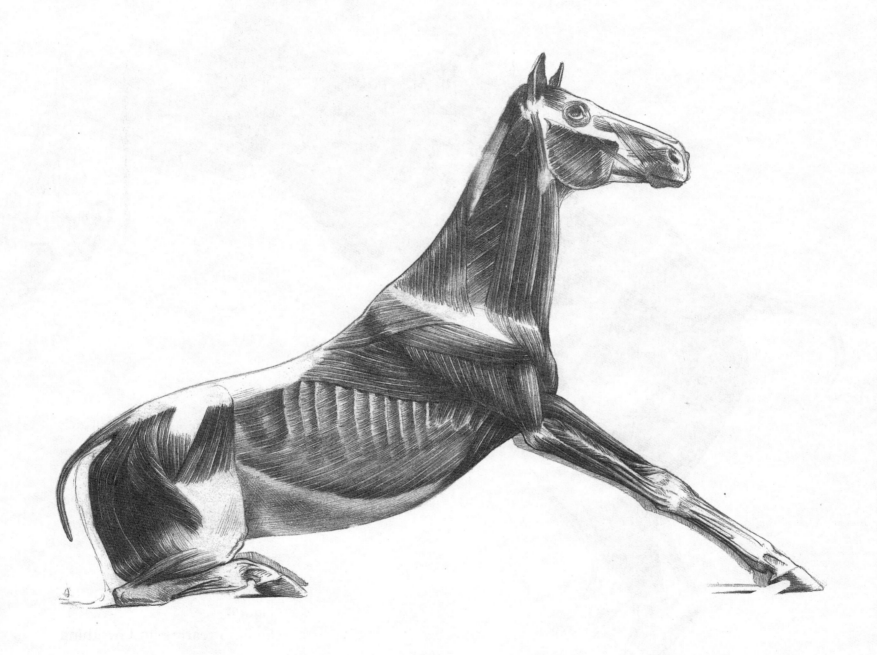

Fig. 106

Standing up

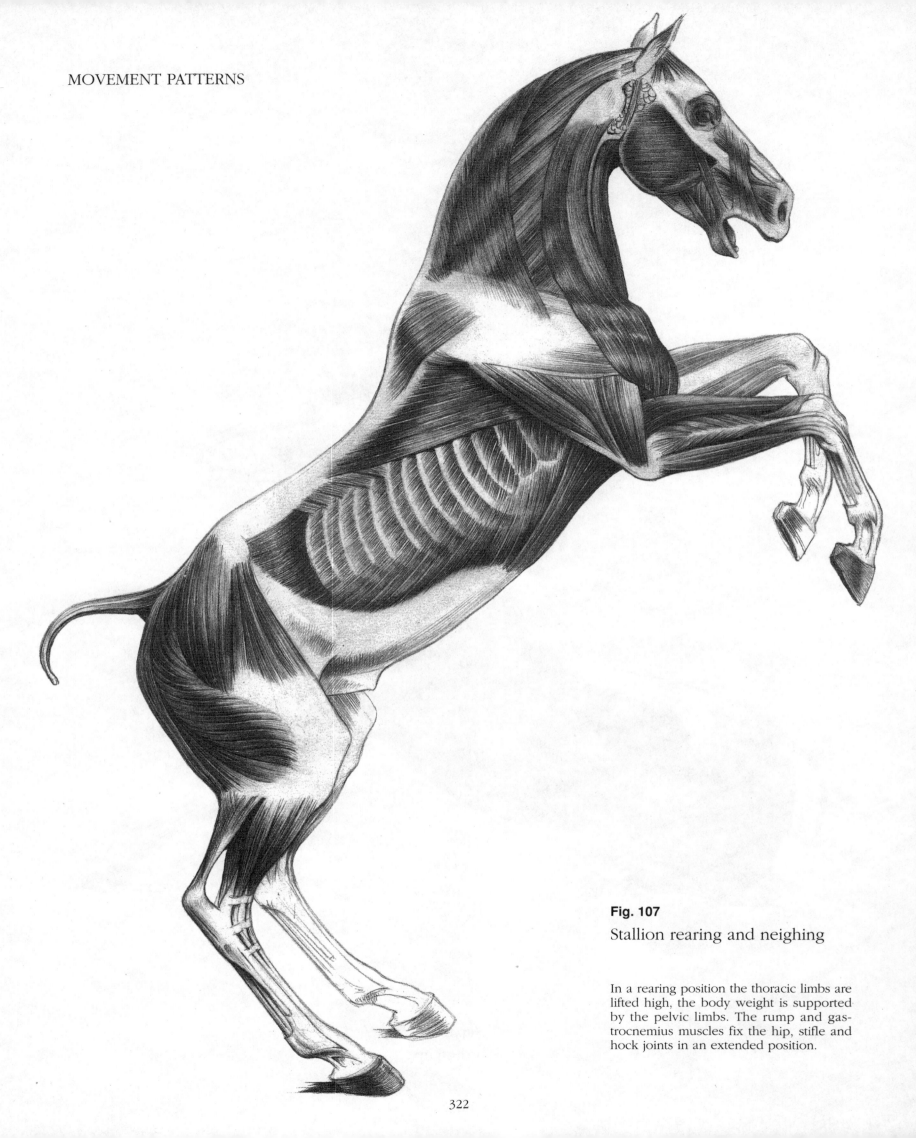

Fig. 107

Stallion rearing and neighing

In a rearing position the thoracic limbs are lifted high, the body weight is supported by the pelvic limbs. The rump and gastrocnemius muscles fix the hip, stifle and hock joints in an extended position.

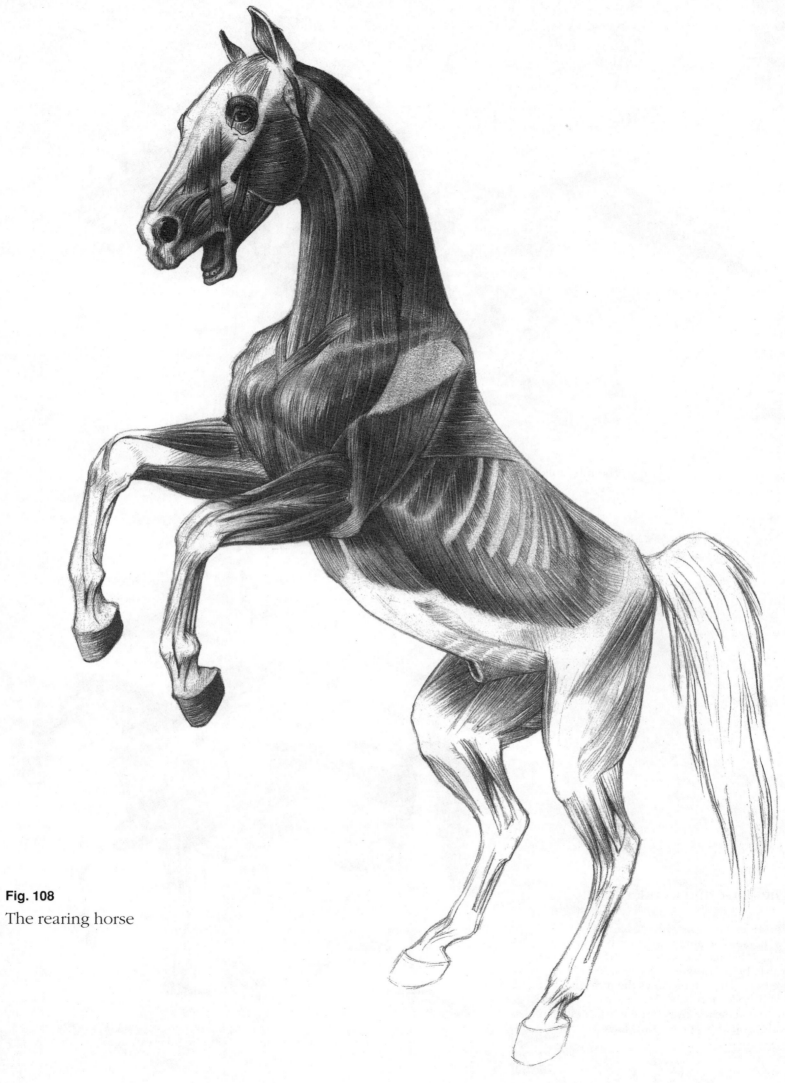

Fig. 108
The rearing horse

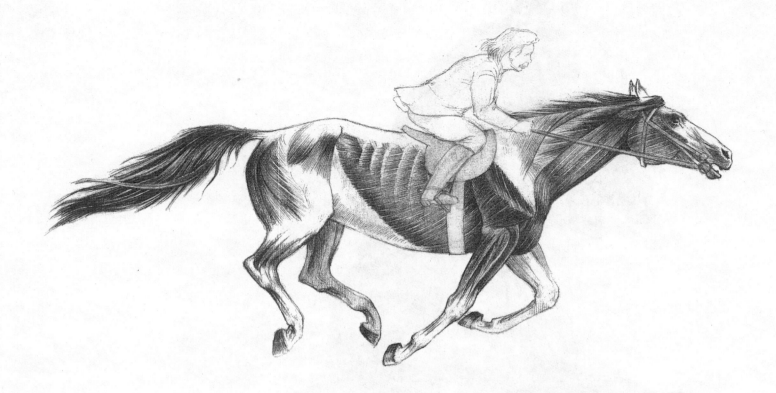

The rider follows the movements of the horse (race gallop).

Fig. 109

The horse and its rider

The rider is in permanent harmony with the horse. The animal's center of gravity is located behind the sternum, and shifts forwards by 4 cm when the head and neck are bent. The rider follows the movements of his horse and is held in the saddle only by his balanced position; he grasps neither with his hands nor with his legs.

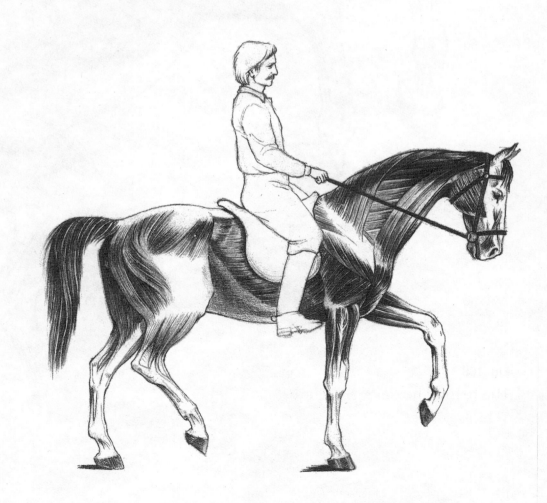

Keeping balance during walking (regular carriage).

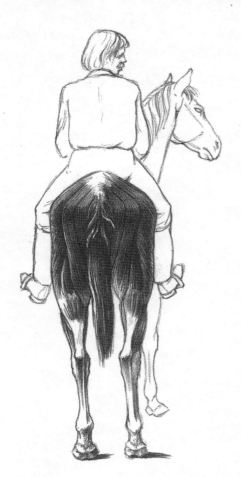

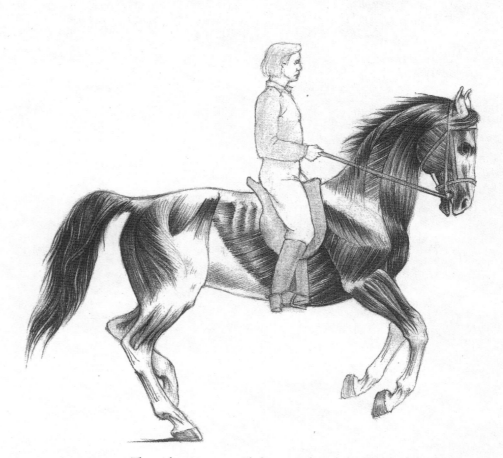

In all phases of locomotion the rider has to keep his balance (symmetrical sitting position).

The rider can control the speed and direction of the horse.

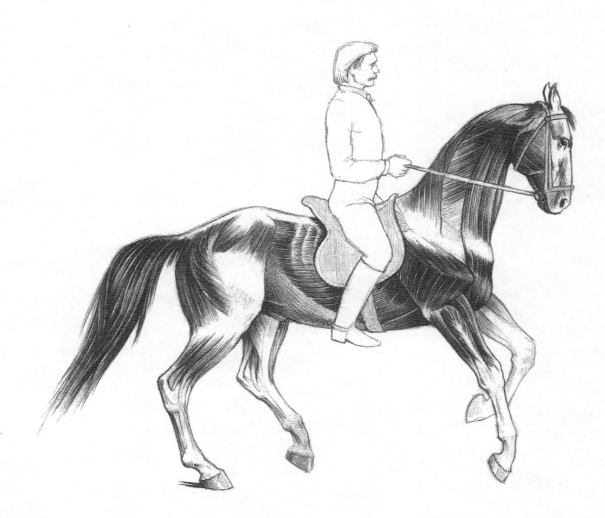

Stepping is achieved using the reins and the rider's legs.

THE DOG

The dog, domesticated more than 10,000 years ago, is considered the earliest pet of man, who finds it particularly interesting because of its acute sense of smell and hearing, its stamina and its loyalty. These qualities are used for guarding, hunting, leading the blind, pulling sleds, and tracking.

It is certain that the dog is descended from the wolf. This origin is more visible in its behaviour than in its anatomy. Only a few of the more than 400 breeds of dogs have similarities with the wolf. The body length of the various breeds alone varies from 75–90 cm (30–35 ins) for a Great Dane, to 15–20 cm (6–8 ins) for a Chihuahua. The corresponding withers heights are 72–92 cm (28–36 ins) and 15–23 cm (6–9 ins). The different colours of the coat do not suggest a common ancestor. But their behaviour exhibits many similarities, with very few differences between individual breeds. All – from the wolf down to the smallest lap-dog – show a very strong territorial behaviour: marking the territory with urine, as well as a snarling and gnashing of teeth when a stranger enters their marked area.

Wolves live in packs of between five and eight animals who each have a defined place in a strict hierarchy. Every pack has a leader, especially during hunting. Pet dogs also need company – their bond to man replaces life in a pack. Man is therefore regarded and accepted as a pack member. Dogs who return to a life in the wild gang together like their relative, the wolf. Like all social animals, dogs express their moods by the position of the ears, posture, position of the tail, and various sounds.

Stamina and endurance are the fundamental requirements for hunting. A dog pursues its prey until totally exhausted, then grabs it with the incisors and shakes it until it is dead. Dogs are digitigrades and are built for running; they can run fast and for a long periods. Greyhounds can reach speeds of 100 km/h (65 mph). Strong claws, which do not retract, prevent dogs from slipping on the ground.

Capturing and tearing up prey require highly specialized teeth. The incisors are elongated, slightly curved and very strong. The prey is torn apart with powerful molars that interlock like scissors and the flesh is swallowed almost unchewed. With the largest molars even bones can be broken, and the incisors are able to scrape the last morsels of meat off bones. Despite this highly specialised dentition dogs are also able to eat plant food, which they grind with the rather flat molars at the back of their mouths.

The dog has a highly developed sense of hearing, on which it depends for locating and catching its prey. Most breeds have a long nose with a large nasal cavity with a turbinate bone consisting of fine lamellae. Through the numerous convolutions of these lamellae the surface of the olfactory membrane is enlarged considerably. The olfactory membrane of the dog measures 85 cm² (33 in²), compared with the cat's, which measures only about 20 cm² (8 in²), and man's, which measures between 2.5 and 5 cm² (between 1 and 2 in²). This figure determines the acuity of the sense of smell.

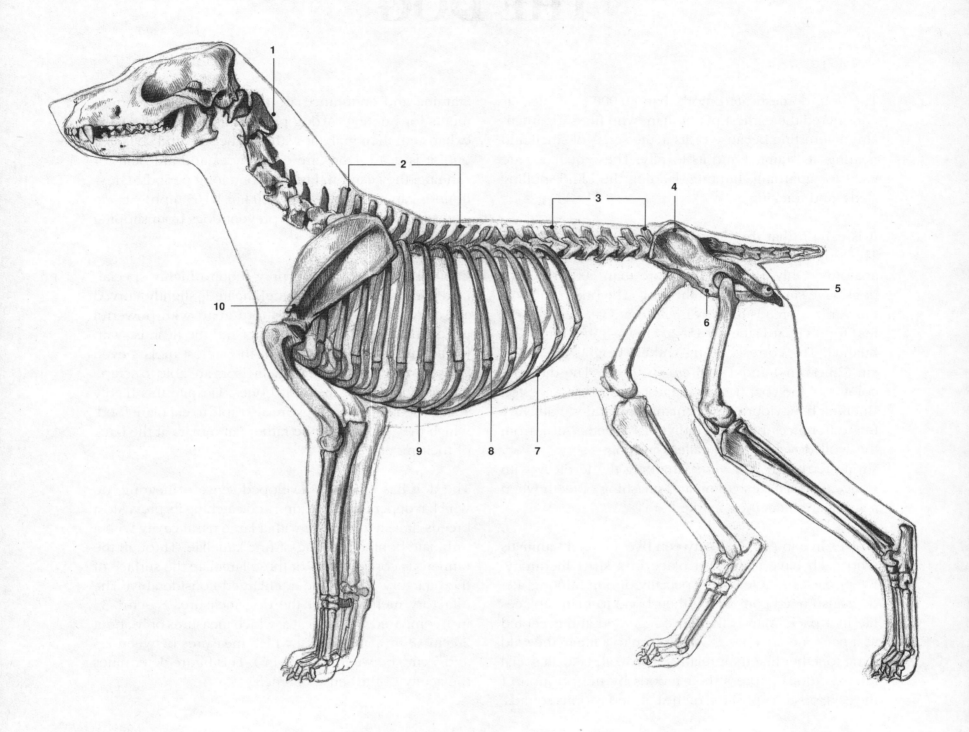

Fig. 1

The skeleton

The shape and size of the skull, trunk and the limbs varies greatly according to the breed. The vertebrae are short, their processes are small. The ribs are well arched, so that the chest is wide. The sternum is cylindrical and thin. The shoulder blade is wide and shovel-shaped. The humerus and femur are thin, their bodies are curved. The pelvis is small. The bones of the lower foreleg and the crus are long. The animal walks on four digits.

1 The spine of the IInd cervical
 vertebra is high
2 The spines of the Ist–VIth thoracic
 vertebrae form the base of the withers
3 Lumbar vertebrae
4 Vertical wing of the hipbone
5 Ischium
6 Pubic bone

7 Costal arch
8 VIIIth rib
9 Sternum
10 Shoulder blade

The bones of the skull are demonstrated in Fig. 22, those of the limbs in Figs. 5, 7, 11 and 16, respectively.

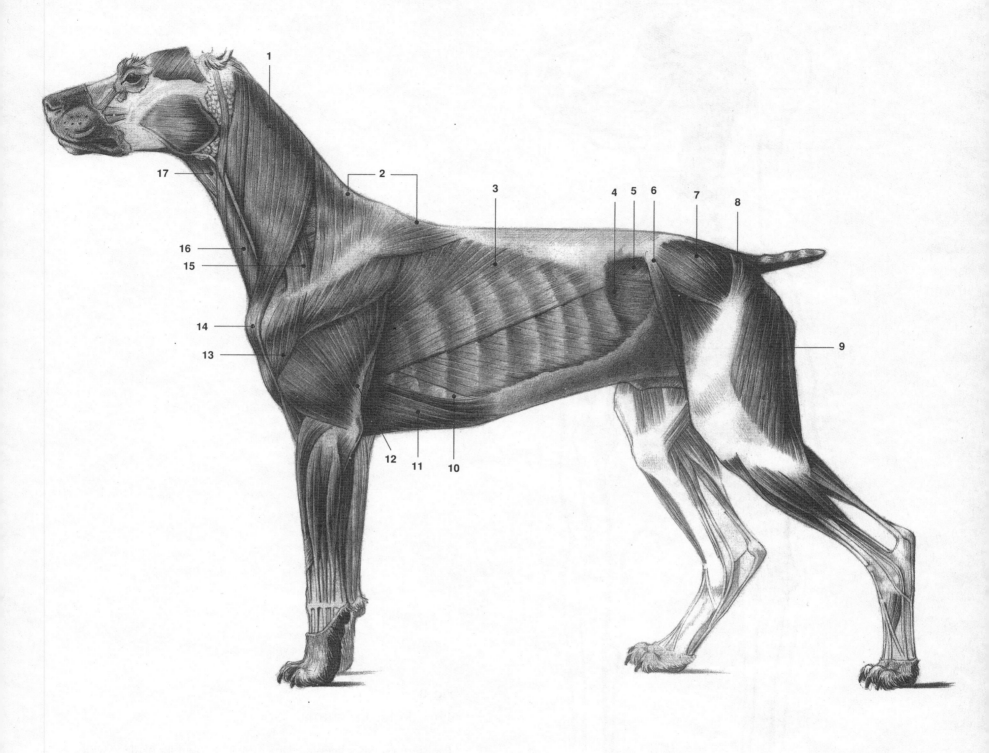

Fig. 2

The muscles

The masticatory muscles – particularly the temporal muscle – are massive. The greater part of the neck is covered by the brachiocephalicus muscle. The muscles of the pectoral girdle which fix the limbs to the thorax are strong. The superficial muscles of the rump are small but solid. The muscles of the thighs are large and allow great flexibility of the hind limb.

1 Brachiocephalicus muscle *(6)*
2 Trapezius muscle *(14)*
3 Latissimus dorsi muscle *(16)*
4 Obliquus externus abdominis muscle *(36)*
5 Obliquus internus abdominis muscle *(37)*
6 Sartorius muscle *(102)*
7 Gluteus medius muscle *(97)*
8 Gluteus superficialis muscle *(96)*
9 Biceps femoris muscle *(106)*
10 Intercostalis externus muscle *(33)*

11 Pectoralis profundus muscle *(30)*
12 Triceps brachii muscle *(52)*
13 Deltoideus muscle *(43)*
14 Clavicular tendinous septum
15 Omotransversarius muscle *(15)*
16 Sternocephalicus muscle *(7)*
17 Sternohyoideus muscle *(9)*

The muscles of the head are demonstrated in Figs. 23, 25, those of the limbs in Figs. 4, 6, 8, 9, 11, 13, 17 and 19.

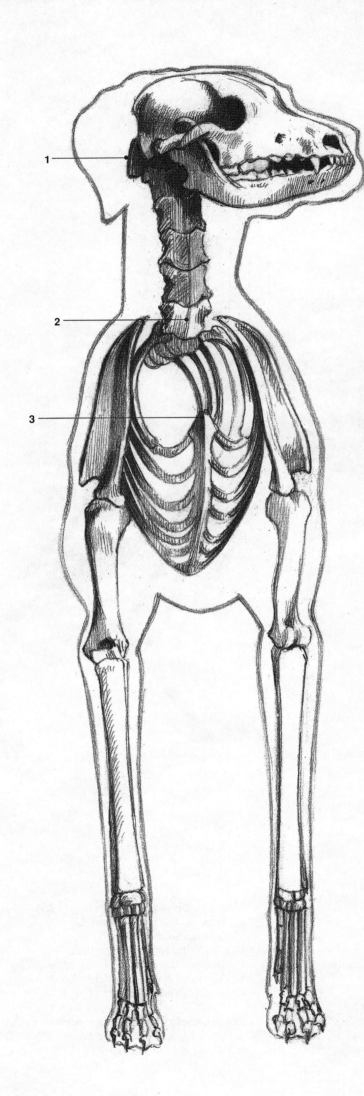

Fig. 3

The skeleton, cranial aspect

The sternum has a keel-like structure. The shoulder blade is wide, the humerus is short, the bones of the lower foreleg are long.

1 IInd cervical vertebra
2 VIIth cervical vertebra
3 Cylindrical body of the sternum
 with the costal cartilages which are forming joints

The bones of the thoracic limb are demonstrated in Figs. 5 and 7.

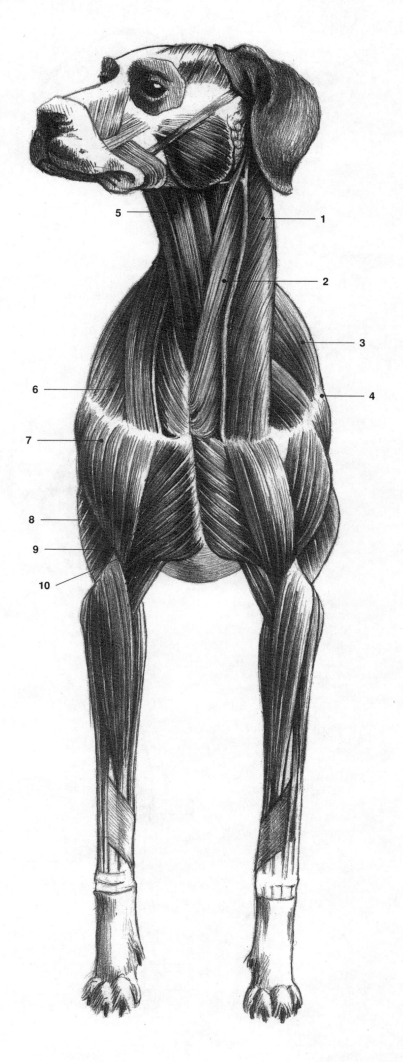

Fig. 4

The muscles, cranial aspect

The cervical muscles are well developed, their boundaries are marked by sharp grooves. The shoulder and pectoral muscles are bulky.

 1 Brachiocephalicus muscle *(6)*
 2 Sternocephalicus muscle *(7)*
 3 Trapezius muscle *(14)*
 4 Tendinous sheet above the spine of the shoulder blade
 5 Sternohyoideus and sternothyreoideus muscles *(8, 9)*
 6 Omotransversarius muscle *(15)*
 7 Deltoideus muscle *(43)*
 8 Cleidobrachialis muscle *(6)*
 9 Triceps brachii muscle *(52)*
10 Pectoralis superficialis muscle *(27)*

The muscles of the thoracic limb are demonstrated
in Figs. 6, 8 and 9.

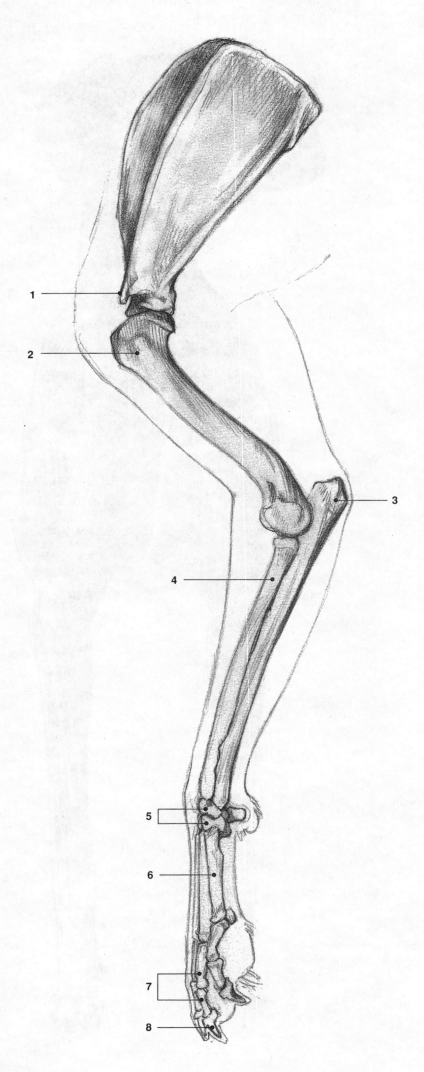

Fig. 5

The bones of the thoracic limb, lateral aspect

The shoulder blade is wide, being slightly curved posteriorly. The lower foreleg is long, the ulna and the radius cross and are flexibly attached to each other. The seven carpal bones are arranged in two rows. There are five cylindrical metocarpiens bones, the IIIrd and IVth being longer. The second phalanx of the first digit is missing. The IIIrd and IVth digits are the longest and most developed. The third phalanx is hook-shaped and pointed.

1 Spine of the shoulder blade
2 Muscular condyle of the humerus
3 Process of the ulna
4 Radius
5 Carpal bones
6 Metacarpal bone
7 Proximal and middle phalangeal bones
8 Claw bone

Fig. 6

The muscles
of the thoracic limb,
lateral aspect

The muscles of the shoulder and elbow joints are well developed. The muscles of the forelimb can move the leg in several directions. Most of the limb muscles are spindle-shaped, well separated from each other and the intermuscular grooves are deep.

1 Trapezius muscle *(14)*
2 Omotransversarius muscle *(15)*
3 Supraspinatus muscle *(44)*
4 Brachiocephalicus muscle *(6)*
5 Triceps brachii muscle *(52)*
6 Brachialis muscle *(50)*
7 Brachioradialis muscle *(63)*
8 Extensor carpi radialis muscle *(64)*
9 Extensor digitorum communis muscle *(66)*
10 Extensor digitorum lateralis muscle *(67)*
11 Abductor digiti Ist longus muscle *(70)*
12 Extensor carpi ulnaris muscle *(65)*
13 Flexor carpi ulnaris muscle *(57)*

a) Olecranon
b) Carpal cushion
c) Transverse tendon-fixing ligament of the carpus

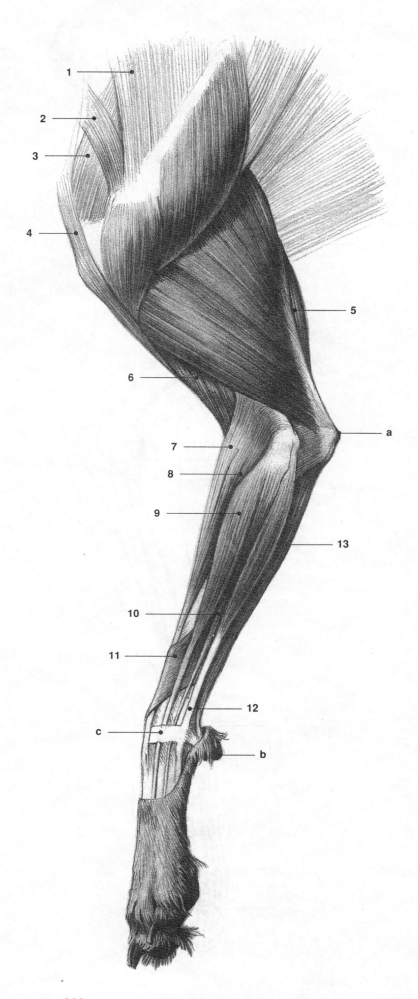

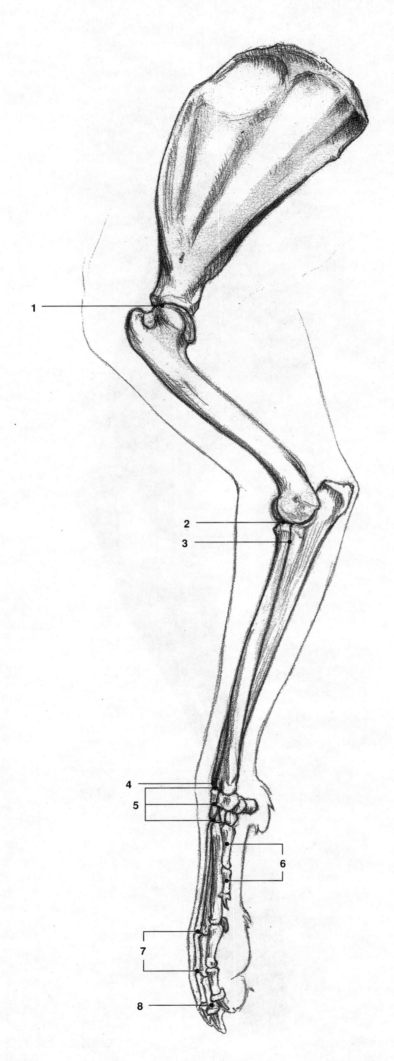

Fig. 7

The bones and the joints
of the thoracic limb,
medial aspect

1 Shoulder joint
2 Elbow joint
3 Proximal radio-ulnar joint
4 Distal radio-ulnar joint
5 Joints of the carpal bones
6 Bones of the Ist finger
7 Proximal and middle phalangeal joints
8 Claw joint

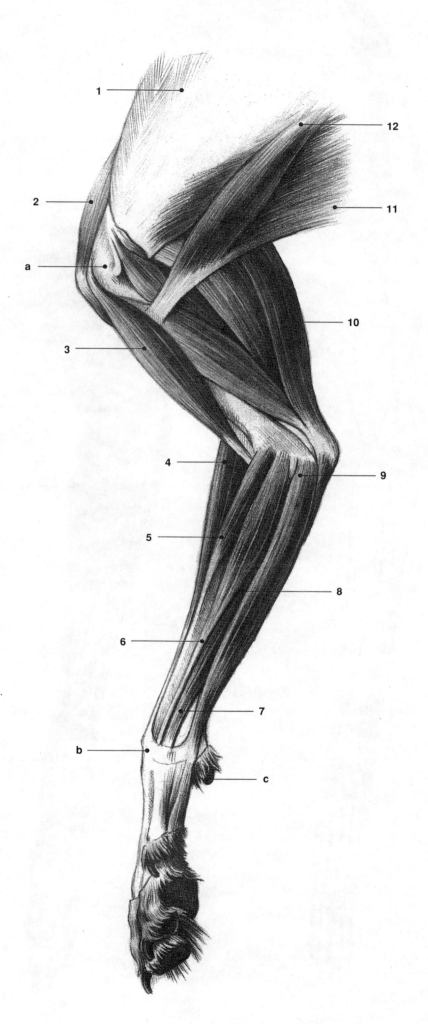

Fig. 8

The muscles
of the thoracic limb,
medial aspect

1 Subscapularis muscle *(48)*
2 Brachiocephalicus muscle *(6)*
3 Biceps brachii muscle *(51)*
4 Extensor carpi radialis muscle *(64)*
5 Pronator teres muscle *(55)*
6 Flexor carpi radialis muscle *(56)*
7 Flexor digitorum profundus muscle *(59)*
8 Flexor digitorum superficialis muscle *(58)*
9 Flexor carpi ulnaris muscle *(57)*
10 Triceps brachii muscle *(52)*
11 Latissimus dorsi muscle *(16)*
12 Teres major muscle *(47)*

a) Shoulder joint
b) Transverse tendon-fixing ligament
 of the carpus
c) Carpal cushion

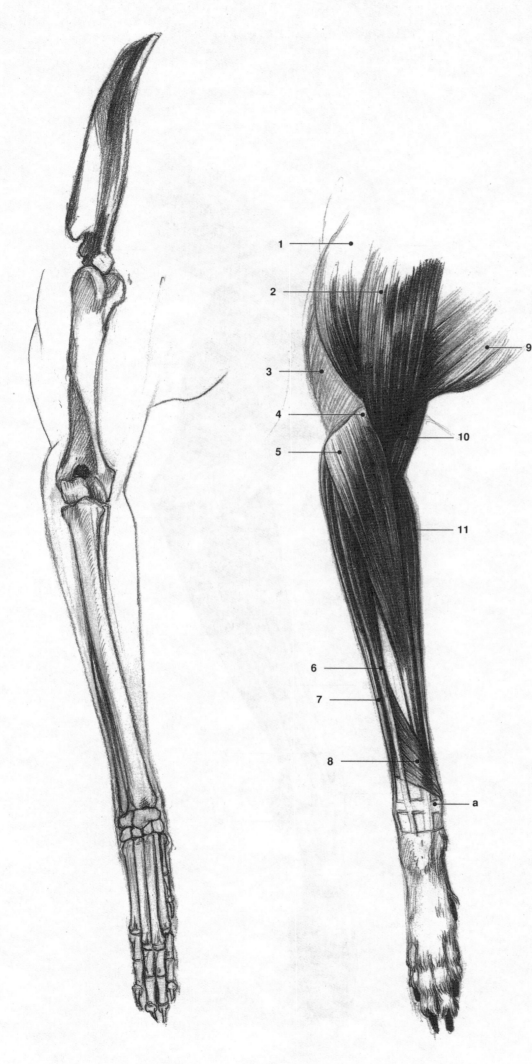

Fig. 9

The bones and the muscles
of the thoracic limb,
cranial aspect

1 Deltoideus muscle *(43)*
2 Brachiocephalicus muscle *(6)*
3 Triceps brachii muscle *(52)*
4 Brachioradialis muscle *(63)*
5 Extensor carpi radialis muscle *(64)*
6 Extensor digitorum communis
 muscle *(66)*
7 Extensor digitorum lateralis muscle *(67)*
8 Abductor digiti Ist muscle *(70)*
9 Pectoralis superficialis muscle *(27)*
10 Brachialis muscle *(50)*
11 Pronator teres and flexor carpi radialis
 muscle *(55, 56)*

a) Transverse tendon-fixing ligament
 of the carpus

The bones are demonstrated
in Figs. 5 and 7.

Fig. 10

The phalangeal bones

1 Proximal phalanx
2 Middle phalanx
3 Dorsal ligament of the claw
4 Groove of the claw bone
5 Tip of the claw bone
6 Claw joint

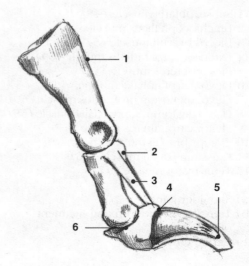

336

Fig. 11

The bones, the joints and the muscles of the (raised) pelvic limb, caudal aspect

As the sacrum is composed of only 3 sacral vertebrae, the pelvis is short, and the sacro-iliac joint is almost vertical. Behind the condyle of the femur are sesamoid bones named Vesalius' bones. The tibia is S-shaped. The five metatarsal bones are arranged in such a way that they bulge cranially. The Ist digit is rudimentary having only two phalanges.

The thigh is flattened medio-laterally. On the caudo-lateral surface the ischial groove forms a wide fossa above the gastrocnemius muscle.

Joints
1 Hip joint
2 Stifle joint
3 Tarsal joint
4 Phalangeal joints

Muscles
1 Biceps femoris muscle *(106)*
2 Semitendinosus muscle *(107)*
3 Semimembranosus muscle *(108)*
4 Gracilis muscle *(104)*
5 Sartorius muscle *(102)*
6 Triceps surae muscle *(114)*
7 Tendons of the digital flexors *(123–126)*

a) Ischial groove
b) Calcanean tuberosity

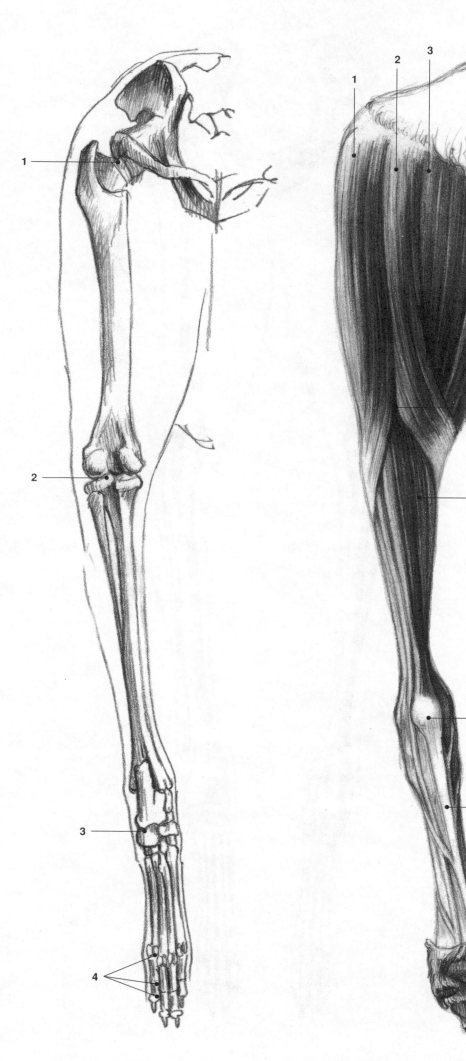

337

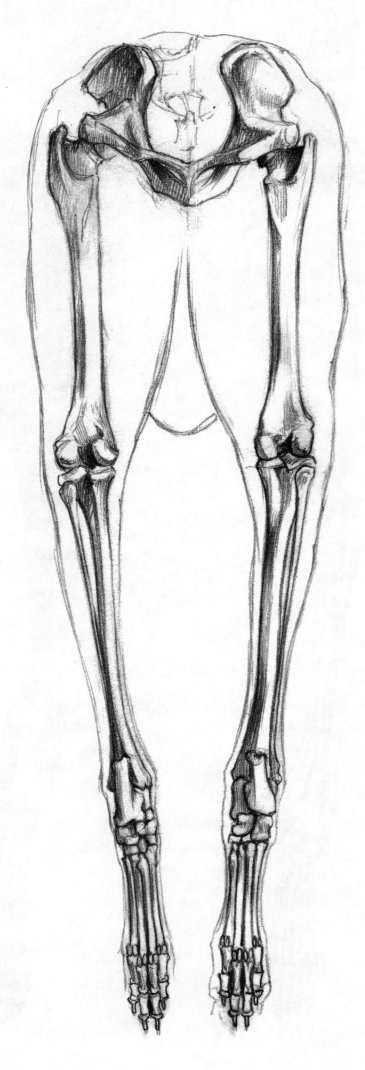

Fig. 12

The bones
of the (raised) pelvic limbs
with extended toes,
caudal aspect

The bones of the pelvic limb are
demonstrated in Figs. 11 and 16.

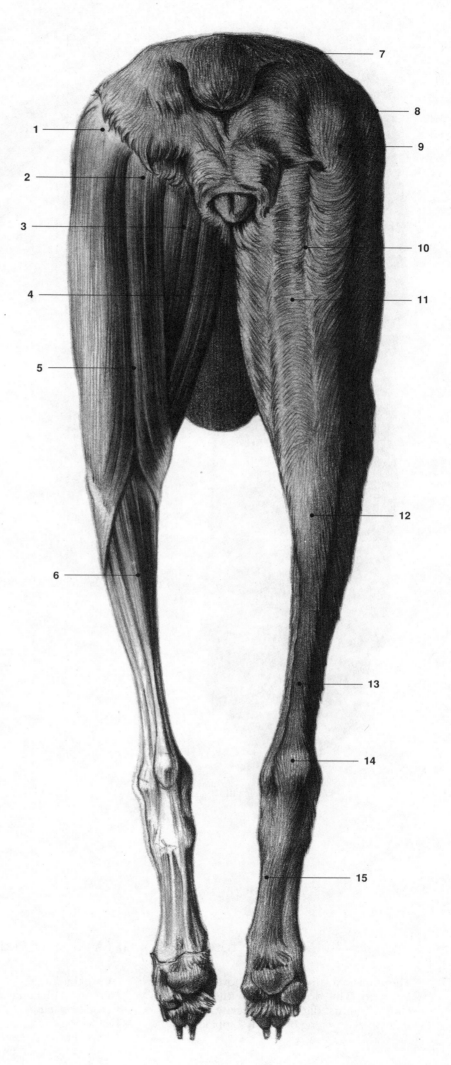

Fig. 13

The pelvis of the bitch,
pelvic limbs with extended
toes, caudal aspect,
skin removed
on the left side

The muscles of the rump bulge slightly on
both sides of the sacrum. The thigh is long
and well muscled; the intermuscular groove
is deep, the tibia is directed slightly medi-
ally. The tarsus is angular and is covered
only by tendons.

1 Biceps femoris muscle *(106)*
2 Semitendinosus muscle *(107)*
3 Semimembranosus muscle *(108)*
4 Gracilis muscle *(104)*
5 Ischial groove
6 Gastrocnemius muscle *(115)*
7 Tuber coxae
8 Hip joint
9 Pin bone
10 Ischial groove
11 Contour of the semitendinous
 muscle *(107)*
12 Contour of the gastrocnemius
 muscle *(115)*
13 Contour of the Achilles tendon
14 Calcanean tuberosity
15 Contours of the tendons
 of digital flexors *(123–126)*

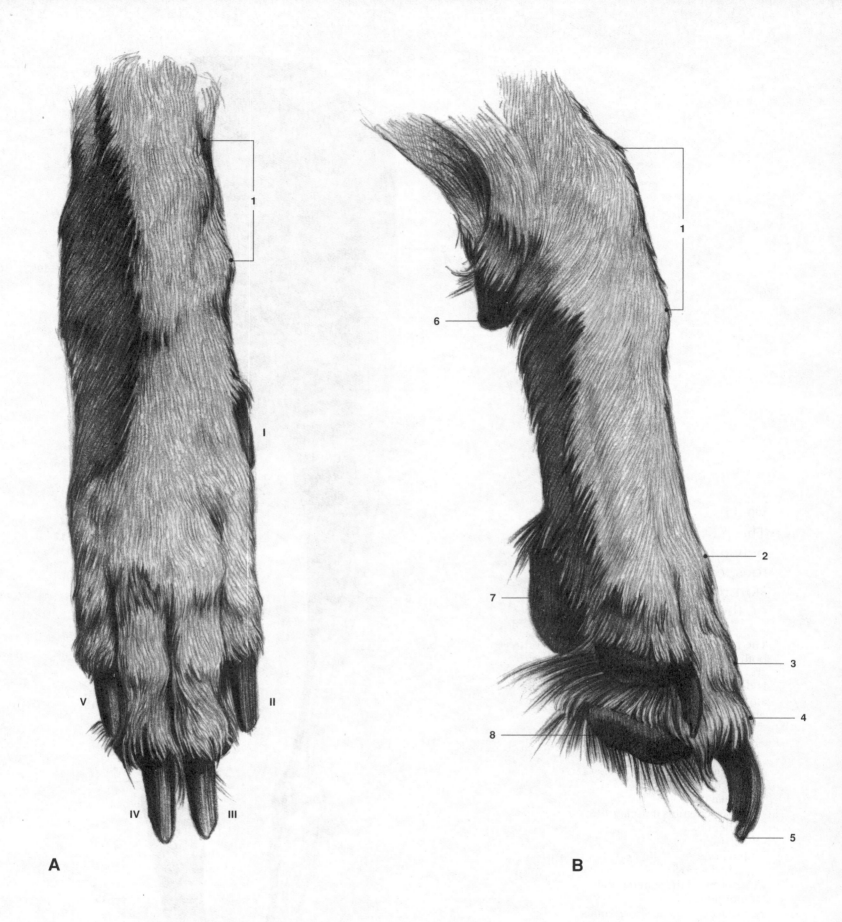

Fig. 14

The forefoot; dorsal (A) and lateral (B) aspects

The four toes (IInd–Vth) are normally developed. The dog cannot withdraw its claws. The first digit, the dewclaw, is rudimentary, consisting of only two phalanges.

1 Carpal joint
2 Proximal phalangeal joint
3 Distal phalangeal joint
4 Claw joint
5 Claw horn

6 Carpal pad
7 Palmar pad
8 Phalangeal pads

I-V Toes

340

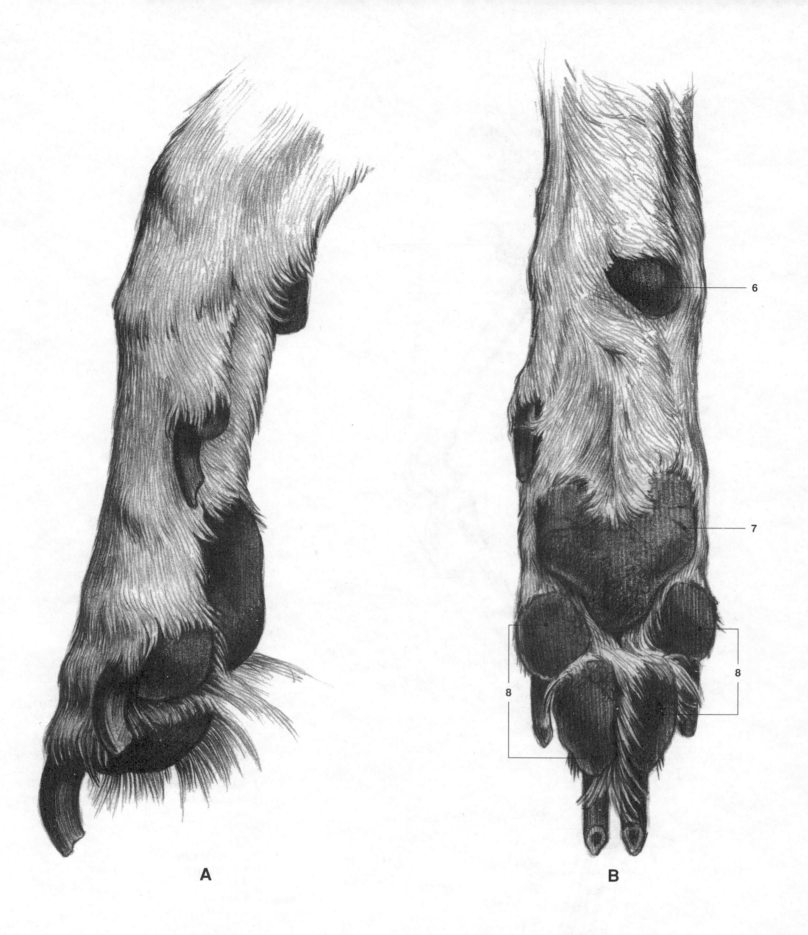

Fig. 15

The forefoot; medial (A) and palmar (B) aspects

Explanation see Fig. 14.

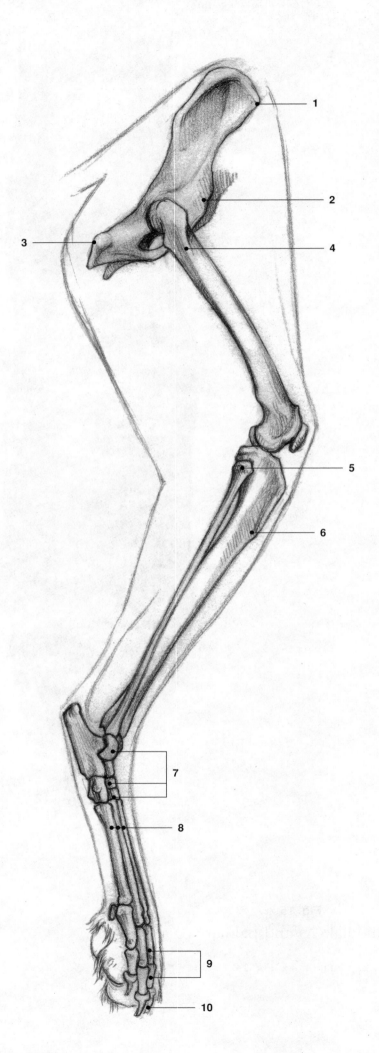

Fig. 16

The bones of the pelvic limb, lateral aspect

The pelvis is inclined downward, the femur is long and protrudes forward slightly. The fibula is thinner and crosses the tibia. The metatarsal bones are longer and slimmer than the metacarpals.

1 Hipbone
2 Pubic bone
3 Ischium
4 Femur
5 Fibula
6 Tibial crest
7 Tarsal bones
8 Metatarsal bones
9 Proximal and middle phalanges
10 Claw bone

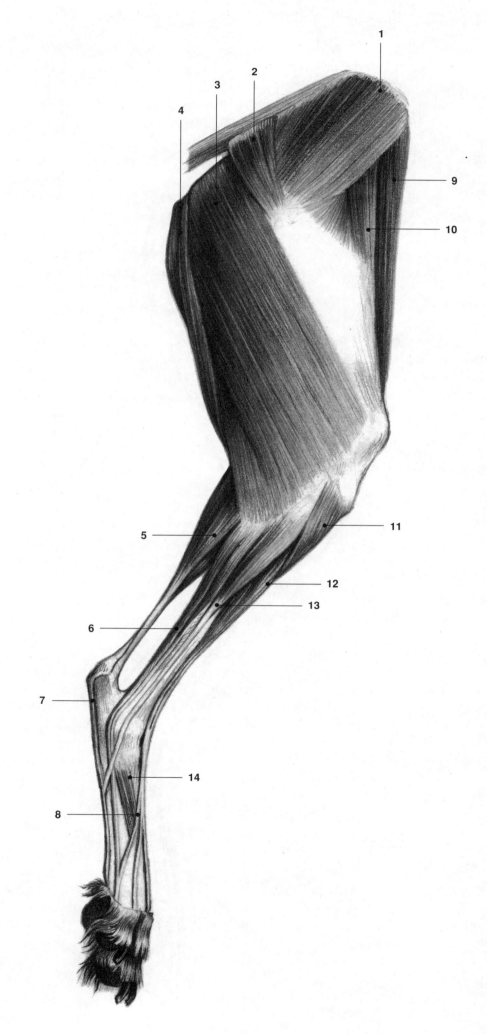

Fig. 17

The muscles of the pelvic limb, lateral aspect

The tuber coxae, hip joint, patella and the bones of the leg are clearly visible. The muscles on the caudal surface of the rump, as well as those of the tarsus and leg, are strong.

 1 Gluteus medius muscle *(97)*
 2 Gluteus superficialis muscle *(96)*
 3 Biceps femoris muscle *(106)*
 4 Semitendinosus muscle *(107)*
 5 Triceps surae muscle *(114)*
 6 Flexor hallucis longus muscle *(124)*
 7 Flexor digitorum superficialis muscle *(123)*
 8 Extensor digitorum lateralis muscle *(122)*
 9 Sartorius muscle *(102)*
10 Tensor fasciae latae muscle *(95)*
11 Tibialis cranialis muscle *(117)*
12 Extensor digitorum longus muscle *(118)*
13 Peroneus longus muscle *(121)*
14 Extensor digitorum brevis muscle *(118)*

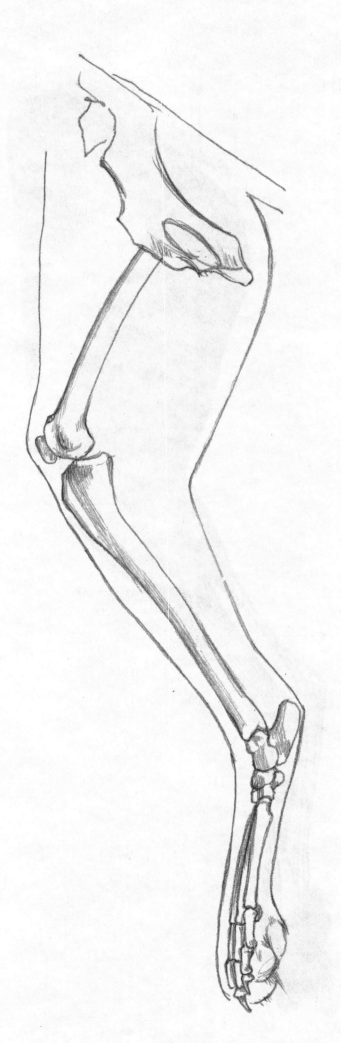

Fig. 18

The bones of the pelvic limb,
medial aspect

The bones are demonstrated in Fig. 16.

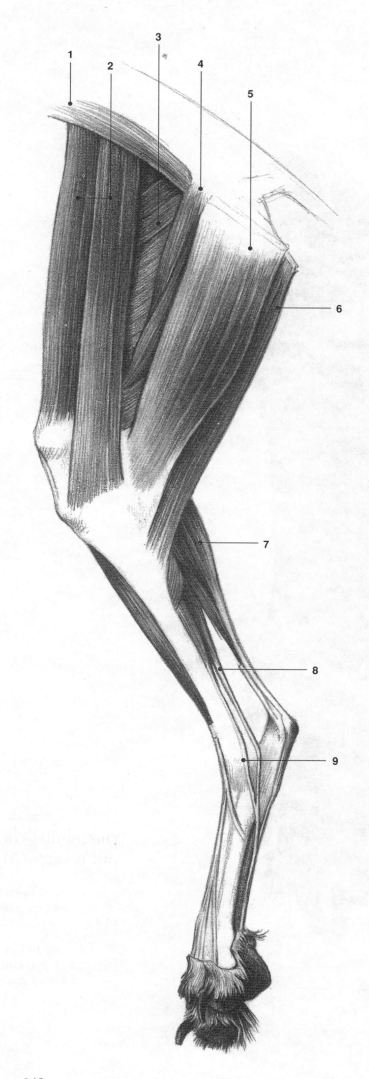

Fig. 19

The muscles of the pelvic limb,
medial aspect

1 Psoas minor muscle *(91)*
2 Sartorius muscle *(102)*
3 Adductor muscle *(105)*
4 Pectineus muscle *(103)*
5 Gracilis muscle *(104)*
6 Semitendinosus muscle *(107)*
7 Triceps surae muscle *(114)*
8 Flexor hallucis longus muscle *(124)*
9 Flexor digitorum longus muscle *(125)*

A

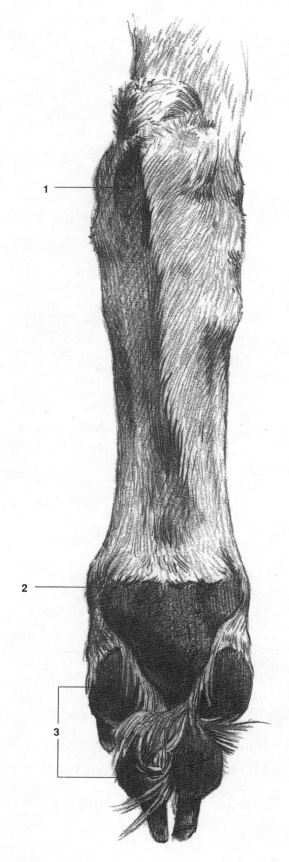

B

Fig. 20

The hindleg; dorsal (A)
and plantar (B) aspects

On the metatarsal bones the tendons of the
digital flexors and extensors protrude un-
der the skin.

1 Tarsal pad
2 Plantar pad
3 Phalangeal pads

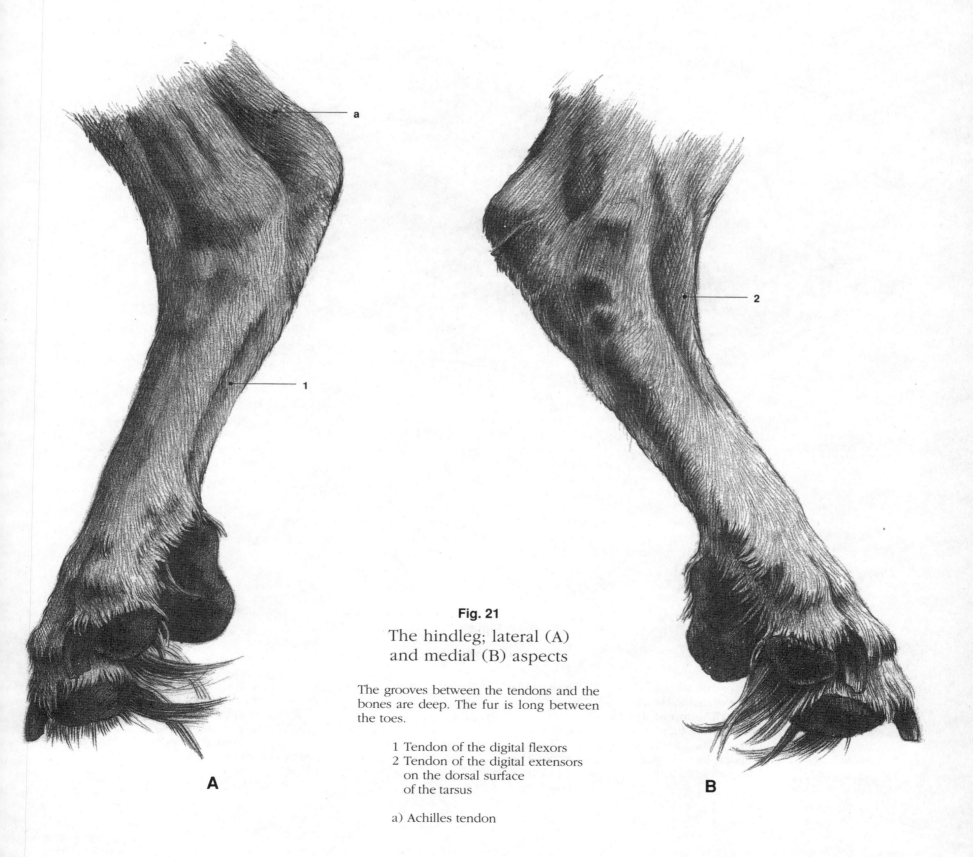

Fig. 21

The hindleg; lateral (A)
and medial (B) aspects

The grooves between the tendons and the
bones are deep. The fur is long between
the toes.

1 Tendon of the digital flexors
2 Tendon of the digital extensors
on the dorsal surface
of the tarsus

a) Achilles tendon

A

B

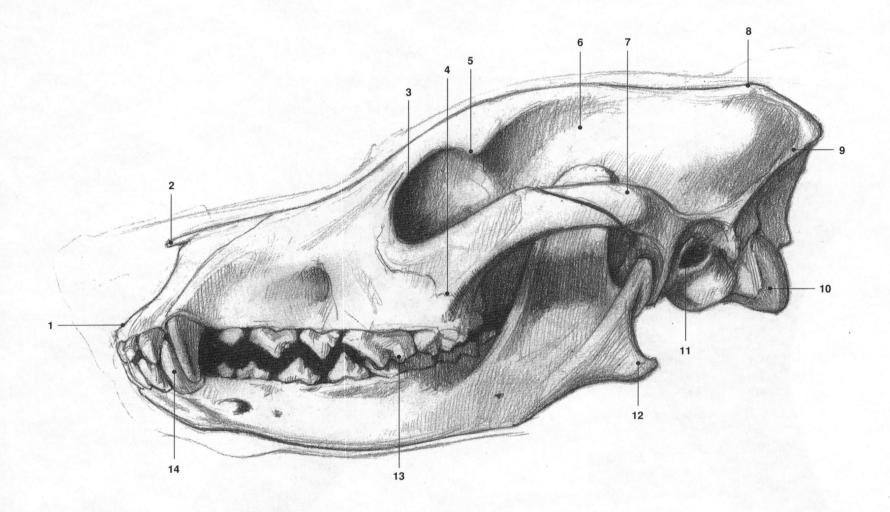

Fig. 22

The skull

The proportion of the face and the neurocranium is 2:1, but there are remarkable differences between breeds. The top of the skull is rounded, in the midline there is a longitudinal crest ending in the transverse nuchal crest. The temporal fossa is large, the zygomatic arch protrudes, the orbit is open caudally.

1 Incisive bone with the incisor teeth
2 Nasal bone
3 Orbit
4 Facial crest
5 Zygomatic process of the frontal bone
6 Temporal fossa
7 Zygomatic arch
8 Median osseous crest

9 Nuchal crest
10 Condyle of the occipital bone,
 it forms a joint with
 the Ist vertebra
11 External osseous auditory canal
12 Muscular process of the mandible
13 Tearing teeth
14 Canine teeth

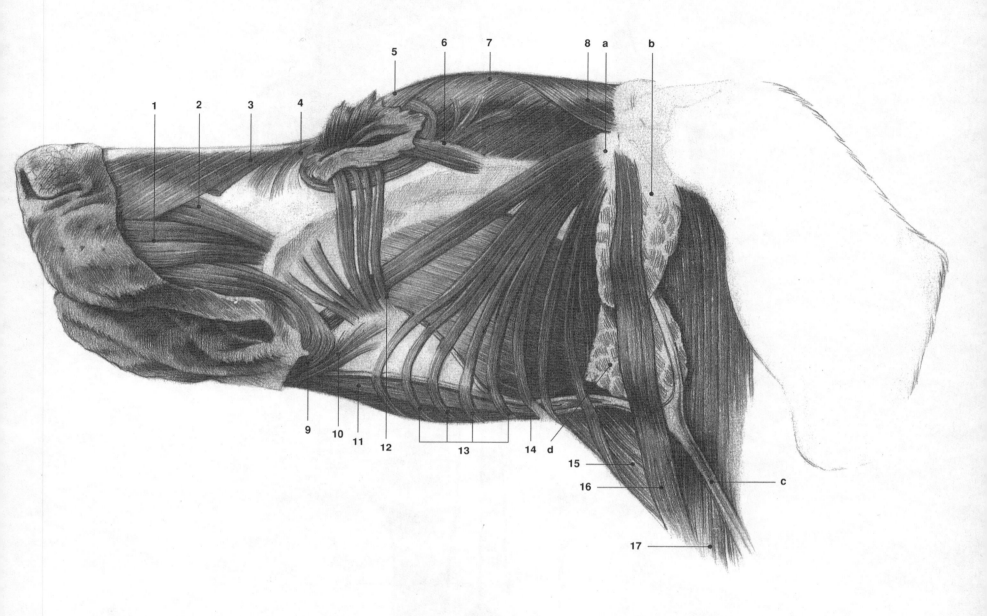

Fig. 23

The muscles of the head
(superficial layer)

The region below the masseter and the orbit is covered by fan-shaped muscles. These muscles elevate and fold the skin, and move the nose, lips and ears.

1 Caninus muscle *(166)*
2 Levator labii maxillaris muscle *(168)*
3 Levator nasolabialis muscle *(164)*
4 Lateralis nasi muscle *(162)*

5 Levator anguli oculi medialis muscle *(157)*
6 Retractor anguli oculi lateralis muscle *(158)*
7 Temporalis muscle *(179)*
8 Frontoscutularis muscle *(141)*
9 Orbicularis oris muscle *(163)*
10 Zygomaticus muscle (levator
 of the labial angle) *(174)*
11 Depressor labii mandibularis
 muscle *(170)*
12 Malaris muscle *(159)*

13 Zygomatic cutaneous muscle *(174)*
14 Masseter muscle *(178)*
15 Sternohyoideus muscle *(9)*
16 Parotideo-auricularis muscle *(150)*
17 Sternocephalicus muscle *(7)*

a) Scutiform cartilage
b) Parotid gland
c) Jugular vein and groove
d) Mandibular gland

349

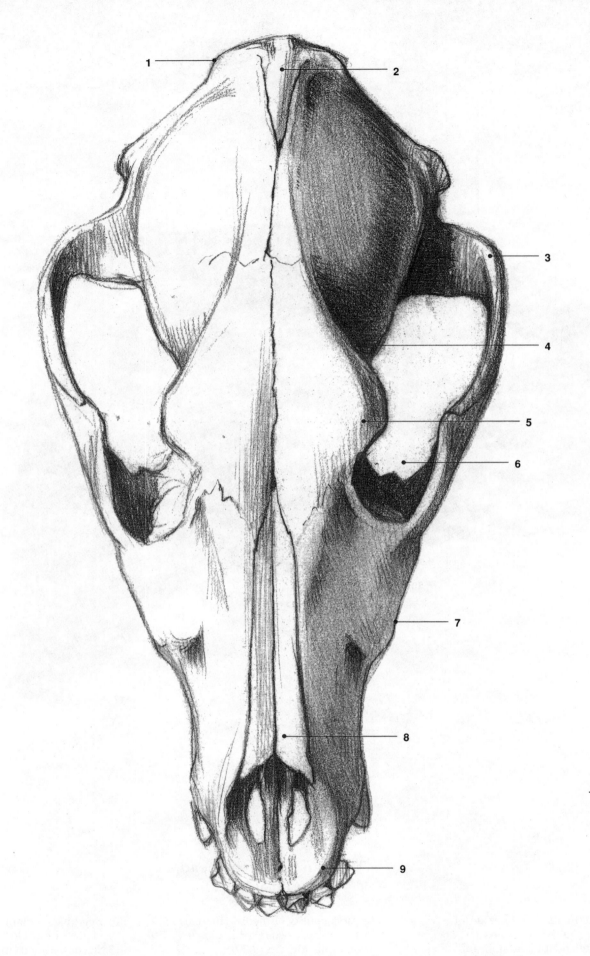

Fig. 24

The skull, dorsal aspect

1 Nuchal crest
2 Median osseous crest
3 Zygomatic arch
4 Temporal fossa
5 Zygomatic process of the frontal bone
6 Orbit
7 Facial crest
8 Nasal bone
9 Incisive bone with the incisor teeth

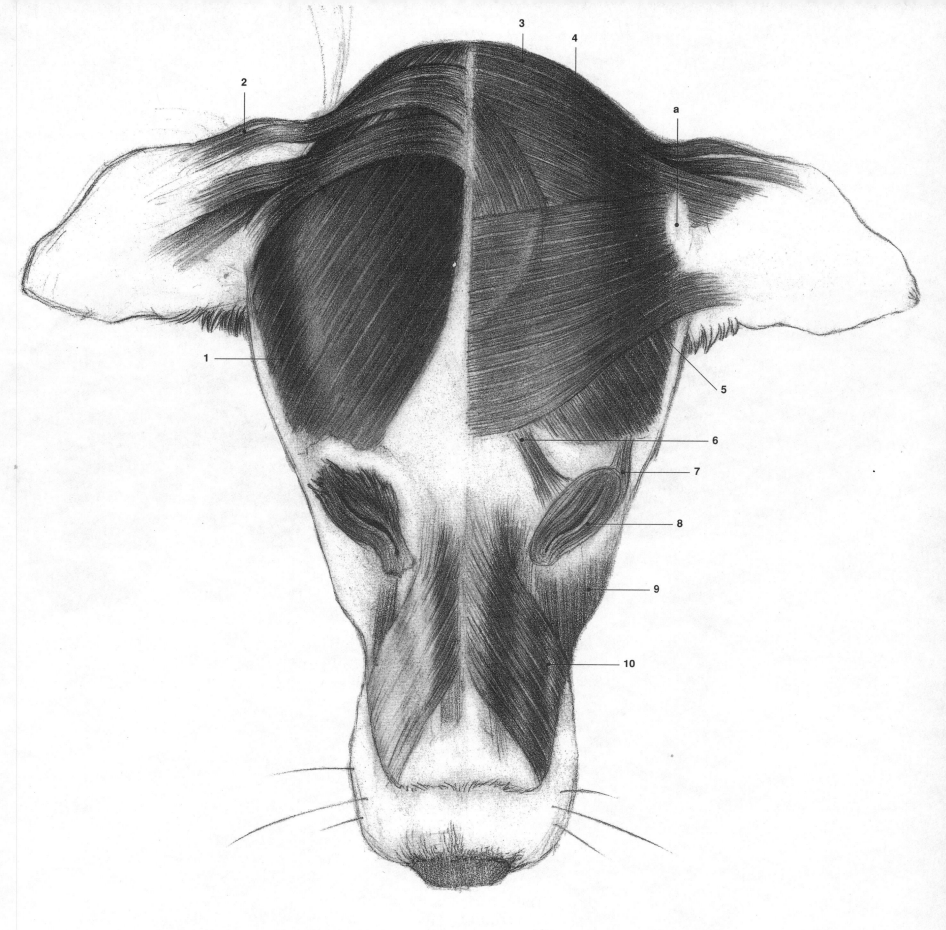

Fig. 25

The muscles of the skull, dorsal aspect

1 Temporalis muscle *(179)*
2 Cervicoauricularis superficialis muscle *(149)*
3 Cervicoauricularis profundus muscle *(149)*

4 Parietoauricularis muscle *(147)*
5 Frontoscutularis and frontoauricularis muscle *(141)*
6 Levator anguli oculi medialis muscle *(157)*
7 Retractor anguli oculi lateralis muscle *(158)*

8 Orbicularis oculi muscle *(155)*
9 Malaris muscle *(159)*
10 Levator nasolabialis muscle *(164)*

a) Scutiform cartilage

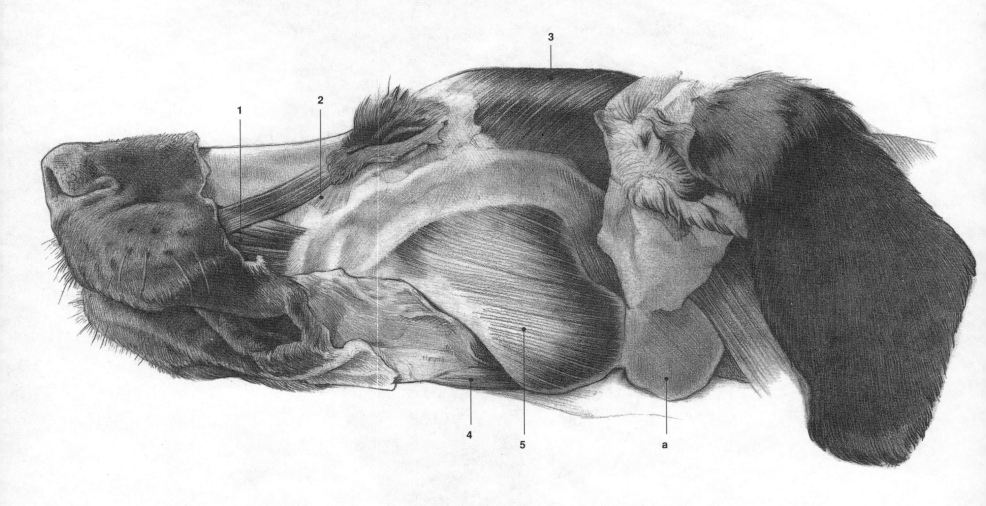

Fig. 26

The muscles of the head
(middle layer)

The zygomatic arch protrudes on both sides, covering the huge temporal muscle which fills up the temporal fossa. The base of the ear is covered by the parotid gland, below this and behind the mandible the round submandibular gland is in contact with the mandibular angle. The lips are loose, the mouth is large.

1 Caninus muscle *(166)*
2 Malaris muscle *(159)*
3 Temporalis muscle *(179)*
4 Depressor labii mandibularis muscle *(170)*
5 Masseter muscle *(178)*

a) Mandibular gland

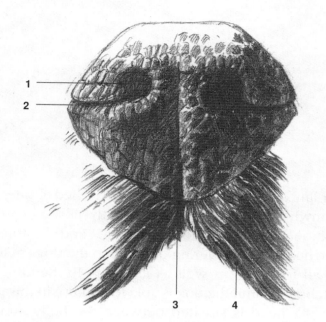

Fig. 27

The nasal plane, cranial aspect

There is a notch in the middle of the upper lip. The labial groove situated in the middle of the nasal plane extends between the nostrils. The nostril is comma-shaped. The skin of the nose is usually black.

1 True nostril
2 False nostril
3 Labial groove
4 Upper lip

Fig. 28

The nose; cranio-lateral (A) and lateral (B) aspects

The dog sits down in a characteristic manner, preceded by flexing and collecting the hindlimbs under the trunk. By bending its back, the rump, the base of the tail, the hip and thigh are brought into contact with the ground. In the sitting position, the weight of the body is taken on the two extended, parallel forelegs and the pin bones, hocks and pasterns of the hindlegs.

When lying down, first the hindlegs and then the forelegs are flexed. The trunk is then lowered onto all four limbs. The dog's hindlegs are stretched to one side, meanwhile the head and the slightly raised chest are positioned between the elbow joints and the forelegs stretched forward. During deep sleep the dog stretches out all four legs as well as its body. By bending the vertebral column the dog is able to curl up, in this position the head is situated between the belly and the hindlimbs. Occasionally, however, it adopts positions entirely different from these.

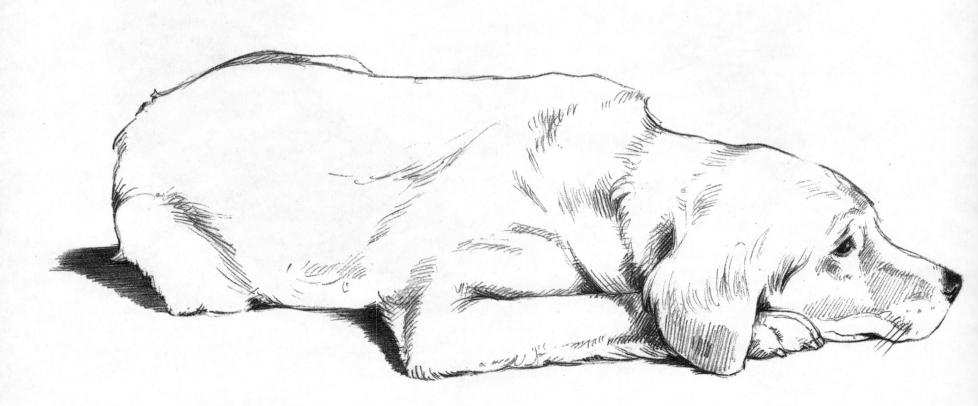

Fig. 29

Lying dog

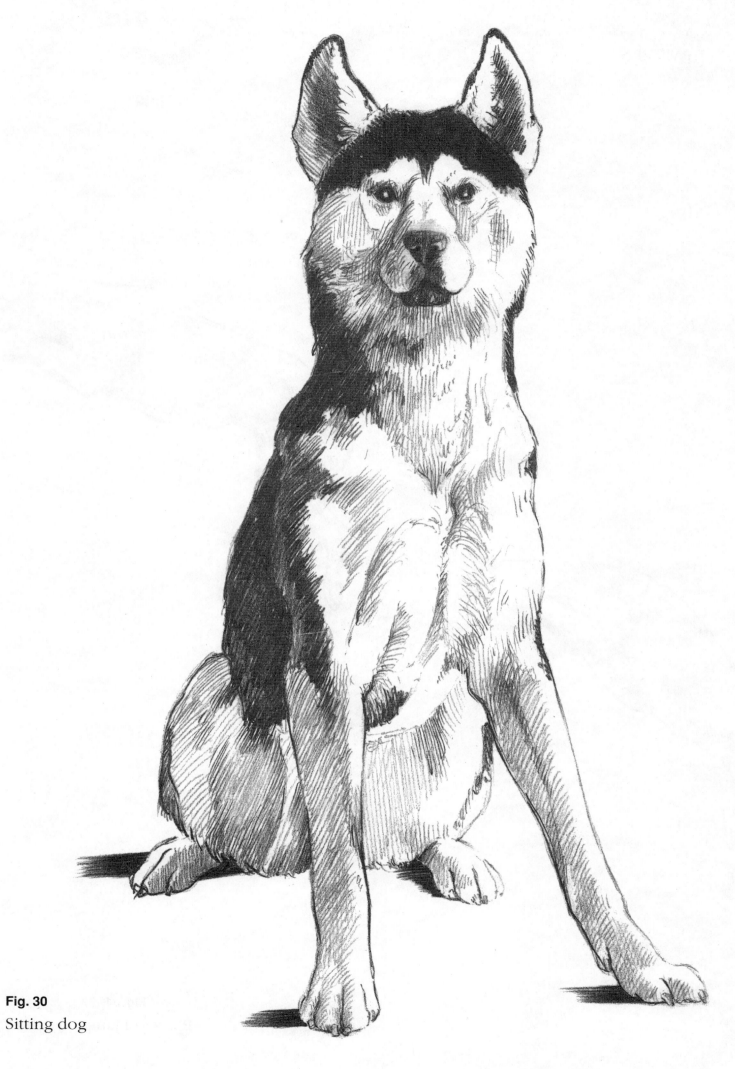

Fig. 30

Sitting dog

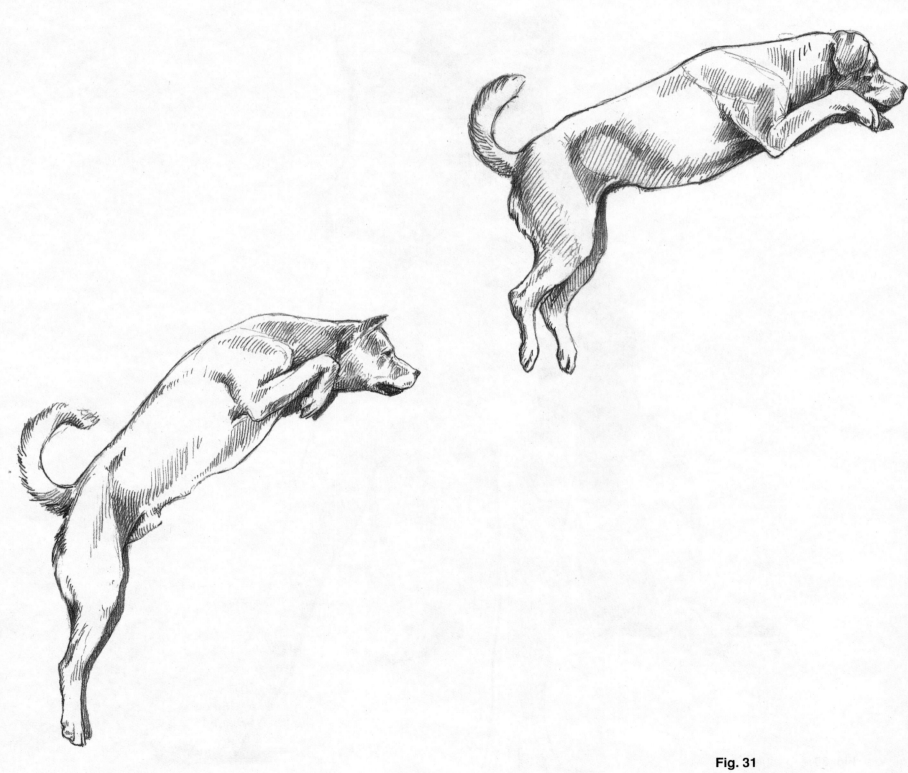

Fig. 31
Phases of jumping

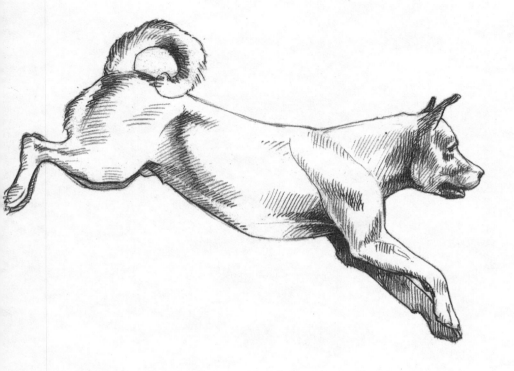

The dog walks in the same way as the horse. A trotting dog lifts its diagonally opposite limbs together but the synchronization is incomplete; the forelimb touches the ground prior to the diagonal hindlimb, and the foreleg is lifted slightly before the hindleg. This is called dog trotting and is the characteristic trot of gundogs.

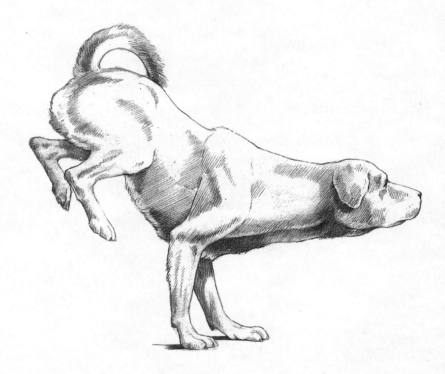

357

THE CAT

The cat is a member of the felidae family, which was originally domesticated in the Near East and North Africa. In ancient Egypt cats were kept to rid grain stores of rats and mice. They played such an important role that a goddess of cats was revered, and some cats were embalmed after death.

The cat is still kept as a hunter of mice, but in the Western world this function is becoming less important. The cat is gaining in popularity as a pet and as a companion because it can also be kept in a small flat. Cats do not form groups, but are solitary animals; they form only loose bonds with humans although they always return to their owners.

The domestic cat has a relatively small body (up to 30 cm/12 ins high and 80 cm/32 ins long), with a flexible spine and a narrow chest and pelvis. Its movements are smooth and agile. The cat is also a very skilled climber. Prey is stalked in a crouching position. Because cats are digitigrades and walk on pads they are capable of running fast and jumping high. If they jump from a height or have a fall they are able to turn in the air, using their tail as a balance, so that they always land on their paws. Even if a cat falls from several metres, it is rarely injured. Cats are not very fond of walking as this involves the use of numerous muscle groups and quickly tires the animal.

Cats are excellently equipped for hunting at night and can locate their prey in total darkness. Their external ears are funnel-shaped and can individually turn in almost any direction. With their acute sense of hearing cats are particularly able to detect high-pitched sounds from mice and other rodents, and locate the direction of the sound. Even in poor light they are able to see well, due to the fact that light is reflected by a mirror-like surface at the back of the eye. In daylight the pupils narrow down to a vertical slit; in the dark they widen to a circle in order to let in more light. In complete darkness the tactile hairs round the eyes, ears, upper lip, cheeks and chin aid a cat's orientation. They sense each stream of air and each touch. The sense of smell is also very keen and used for orientation.

On their soft paws cats can approach prey virtually silently, because their claws can be retracted. The prey is stalked and grabbed with the paws; the sickle-shaped, pointed claws are extended by a reflex action and dug into the prey. Smaller animals, like birds and mice, are killed with a bite to the neck or by biting off their heads. Cats often play with their prey before killing it. Catching and killing prey are learnt at an early age, when the mother brings live mice for her kittens to play with.

Especially noticeable in the cats' dentition are the sabre-like canine teeth with which prey are caught and killed. The molars interlock like scissor blades and cut the flesh. Cats barely chew their food, but swallow it whole or in pieces. The feline digestive system is, therefore, very efficient.

When a cat is in danger, it flees up a tree or to another high place. When it is alarmed or is cornered, it hunches its back, raises fur and tail, and hisses, showing its teeth; clearly a threatening gesture. When fighting, a cat scratches with its paws and also bites.

Cats are ready to mate in a three-weekly cycle; this is also termed being on heat. Nine weeks after successful mating between two and eight blind and helpless kittens are born, which have to be suckled for 4–5 weeks. Cats are fully grown after about one year. Females are sexually mature at the age of five months, and males after six to eight months.

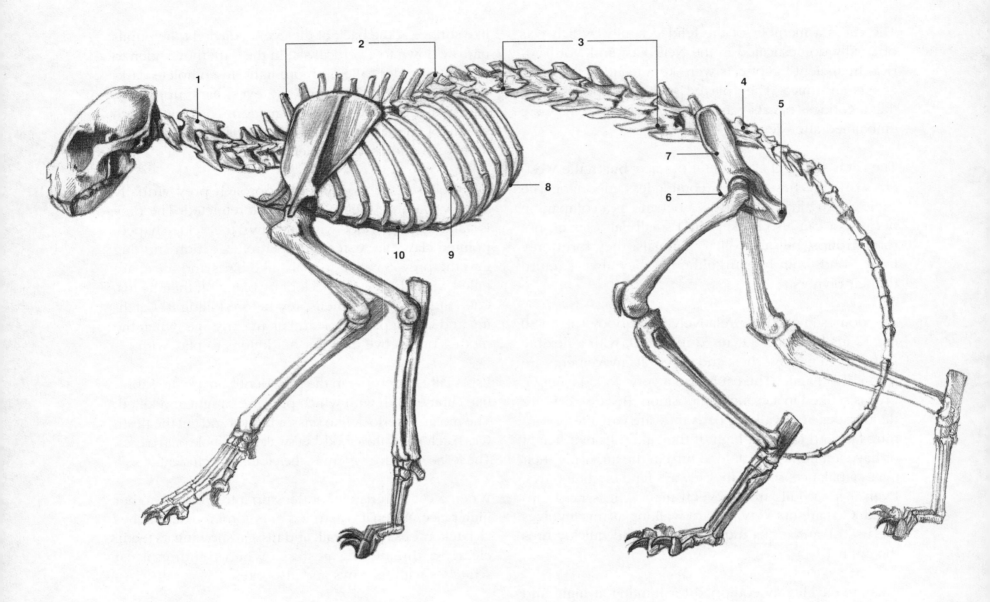

Fig. 1

The skeleton

1 IInd cervical vertebra
2 Spines of the thoracic vertebrae
3 Transverse processes
 of the lumbar vertebrae
4 Sacrum

5 Ischial bone
6 Pubic bone
7 Hip bone
8 Costal arch
9 VIIIth real rib

10 Sternum

The bones of the skull are demonstrated in Fig. 10, those of the limbs in Figs. 5, 6 and 8.

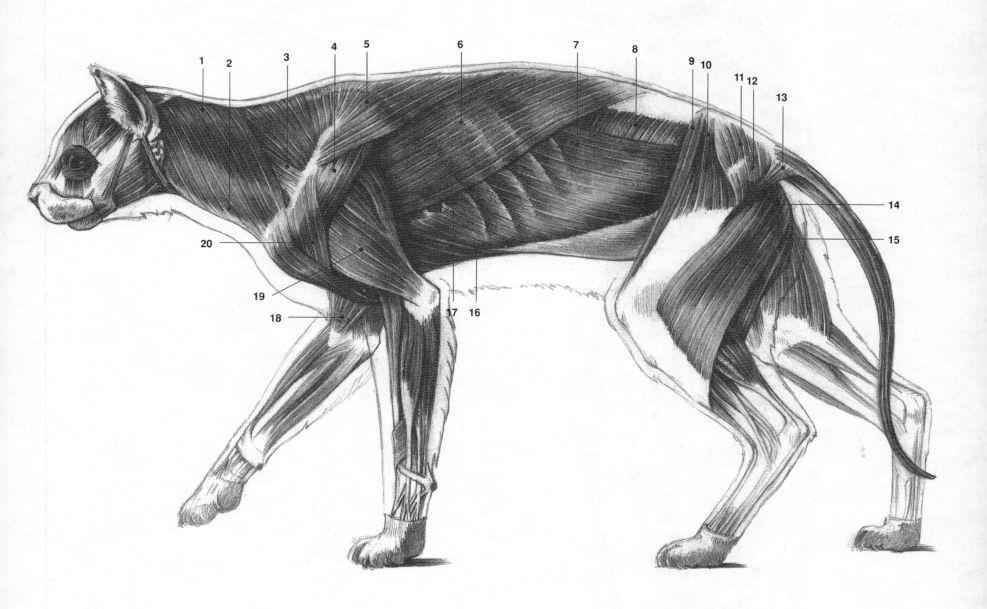

Fig. 2

The muscles

1 Brachiocephalicus muscle *(6)*
2 Sternocephalicus muscle *(7)*
3 Omotransversarius muscle *(15)*
4 Infraspinatus muscle *(45)*
5 Trapezius muscle *(14)*
6 Latissimus dorsi muscle *(16)*
7 External oblique abdominal muscle *(36)*
8 Internal oblique abdominal muscle *(37)*

9 Sartorius muscle *(102)*
10 Tensor fasciae latae muscle *(95)*
11 Gluteus medius muscle *(97)*
12 Gluteus superficialis muscle *(96)*
13 Caudofemoralis muscle *(98)*
14 Biceps femoris muscle *(106)*
15 Semitendinosus muscle *(107)*
16 Pectoralis profundus muscle *(30)*

17 Serratus ventralis muscle *(18)*
18 Pectoralis descendens muscle *(29)*
19 Triceps brachii muscle *(52)*
20 Deltoideus muscle *(43)*

The muscles of the head are demonstrated
in Fig. 11, those of the limbs in Figs. 7
and 9, respectively.

361

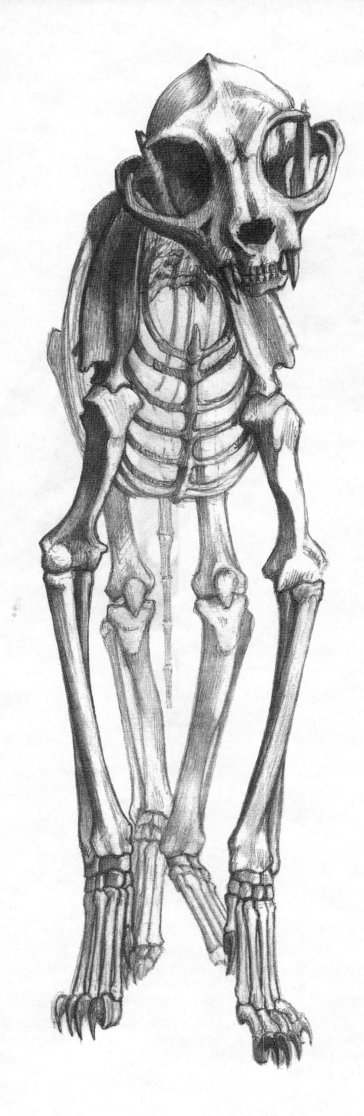

Fig. 3

The skeleton, cranial aspect

The chest points downward and forward; it is egg-shaped, the ribs are thin, the sternum is cylindrical. The spine of the shoulder blade ends in a process above the shoulder joint

The bones of the skull are demonstrated in Fig. 10, those of the thoracic limbs in Figs. 5 and 6.

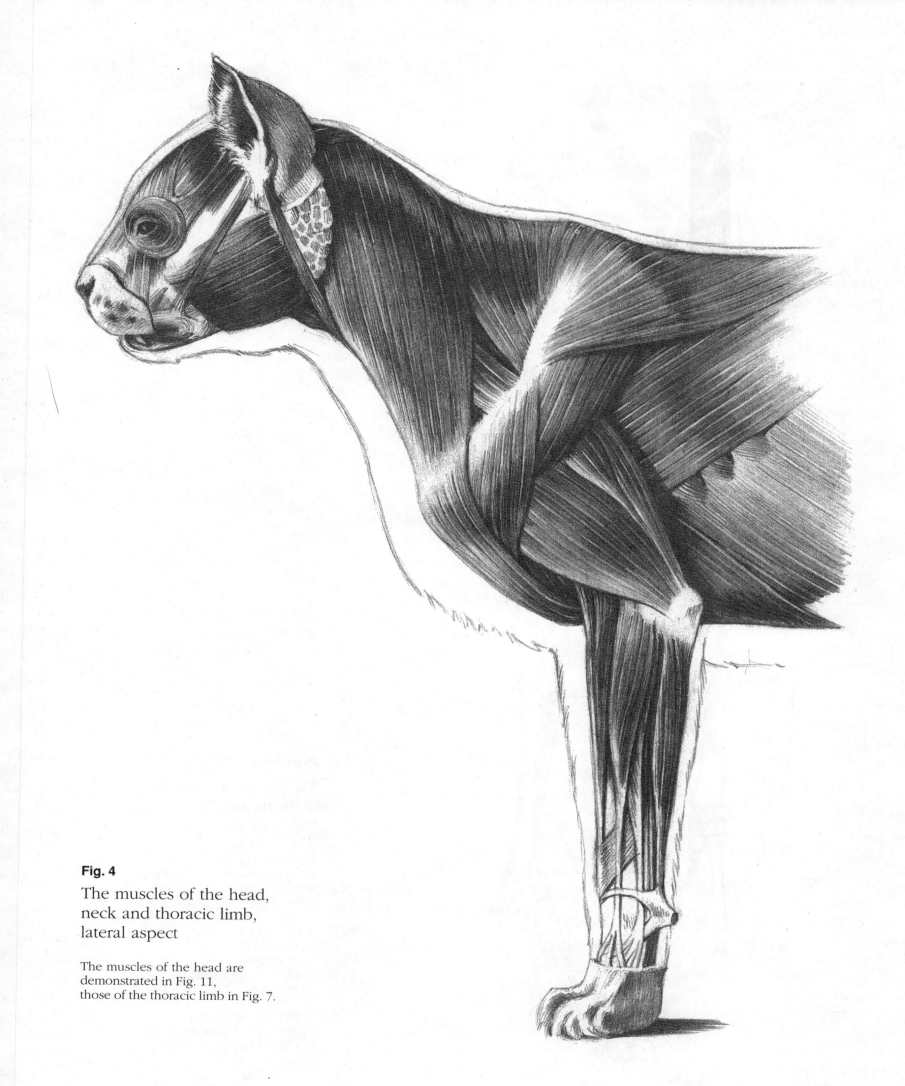

Fig. 4

The muscles of the head,
neck and thoracic limb,
lateral aspect

The muscles of the head are
demonstrated in Fig. 11,
those of the thoracic limb in Fig. 7.

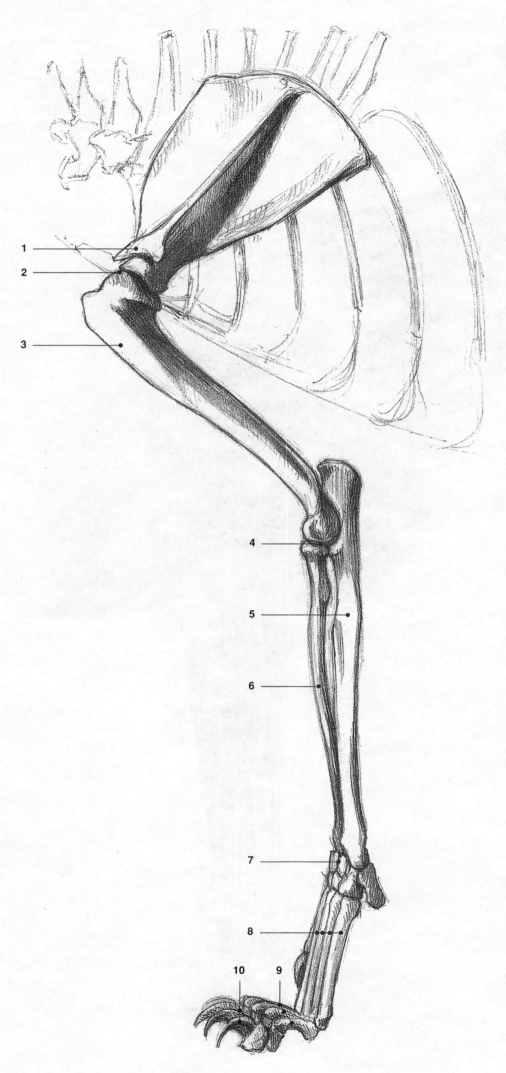

Fig. 5

The bones and joints
of the thoracic limb,
lateral aspect

The bones of the foreleg are long, their
processes are short, the tuberosities are
small and blunt.

1 Process of the spine of the shoulder blade
2 Shoulder joint
3 Humerus
4 Elbow joint
5 Ulna
6 Radius
7 Carpal joint
8 Metacarpal bones
9 Proximal phalangeal bone
10 Claw bone

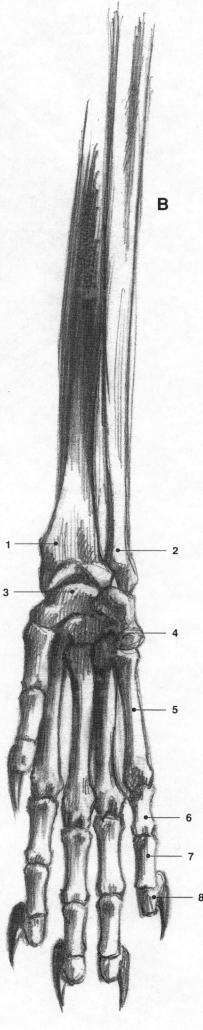

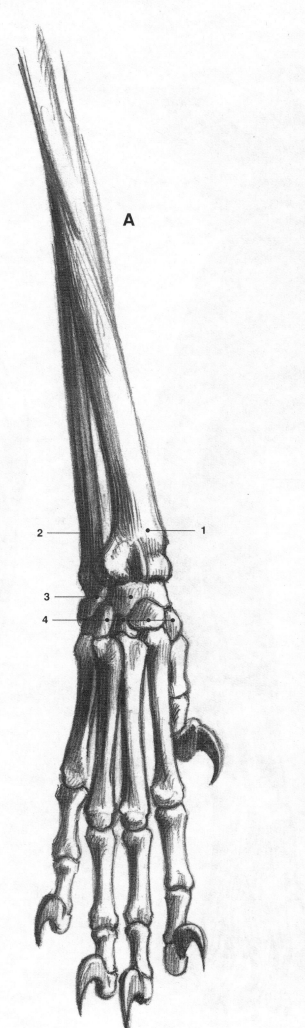

Fig. 6

The bones of the thoracic foot; dorsal (A) and palmar (B) aspects

The carpal and metacarpal bones are domed towards the dorsal surface of the limb. In the proximal row of carpal bones the medial and intermediate bones are united. The first digit consists of only two phalanges.

1 Radius
2 Ulna
3 Proximal row of carpal bones
4 Distal row of carpal bones
5 Metacarpal bone
6 Proximal phalanx
7 Middle phalanx
8 Distal phalanx with claw

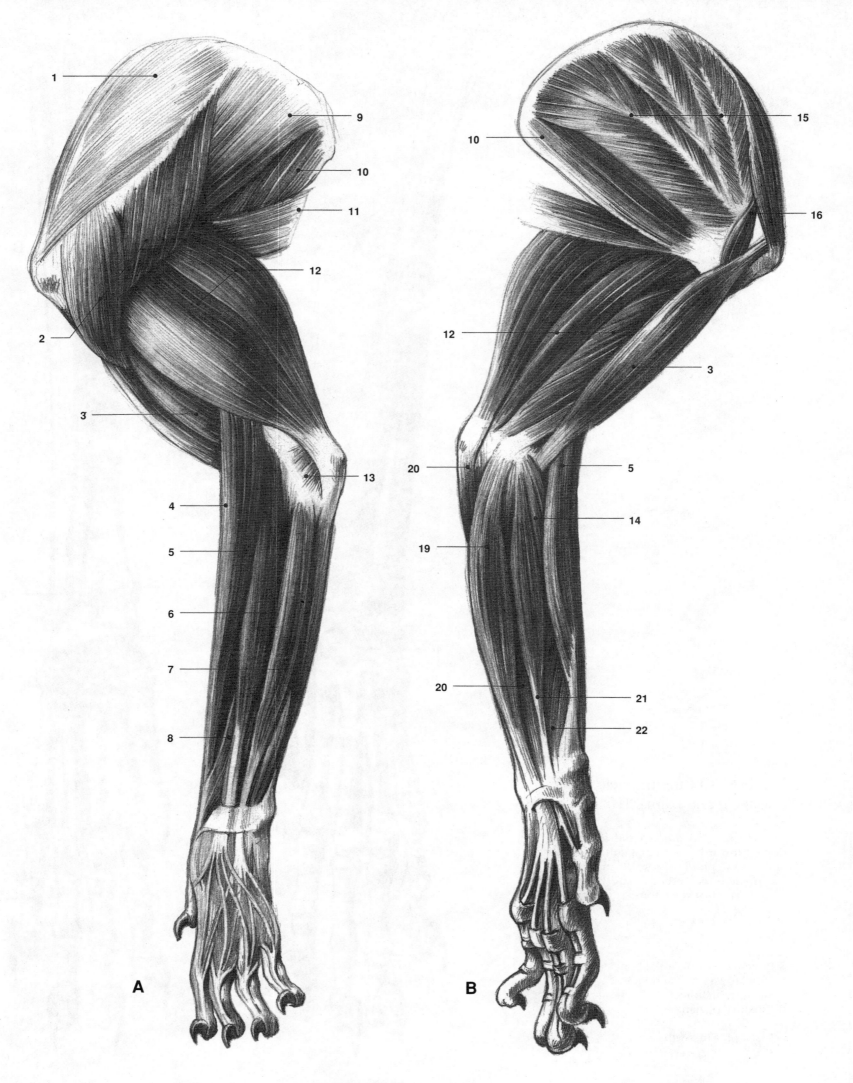

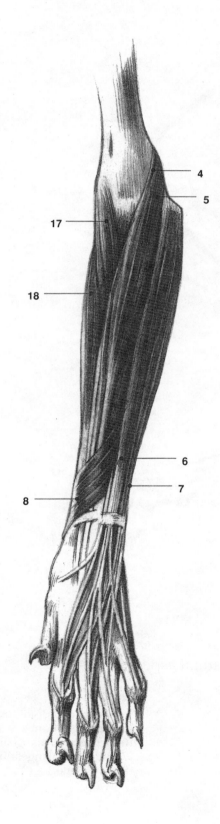

C

Fig. 7

The muscles of the thoracic limb;
lateral (A), medial (B)
and cranial (C) aspects

1 Supraspinatus muscle *(44)*
2 Deltoideus muscle *(43)*
3 Biceps brachii muscle *(51)*
4 Brachioradialis muscle *(63)*
5 Extensor carpi radialis muscle *(64)*
6 Extensor digitorum communis muscle *(66)*
7 Extensor digitorum lateralis muscle *(67)*
8 Abductor digiti Ist muscle *(70)*
9 Infraspinatus muscle *(45)*
10 Teres major muscle *(47)*
11 Latissimus dorsi muscle *(16)*
12 Triceps brachii muscle *(52)*
13 Anconeus muscle *(53)*
14 Flexor carpi radialis muscle *(56)*
15 Subscapularis muscle *(48)*
16 Coracobrachialis muscle *(49)*
17 Pronator teres muscle *(55)*
18 Flexor carpi ulnaris muscle *(57)*
19 Flexor digitorum superficialis muscle *(58)*
20 Flexor digitorum profundus muscle *(59)*
21 Flexor digiti Ist longus muscle *(74)*
22 Adductor digiti Ist muscle *(75)*

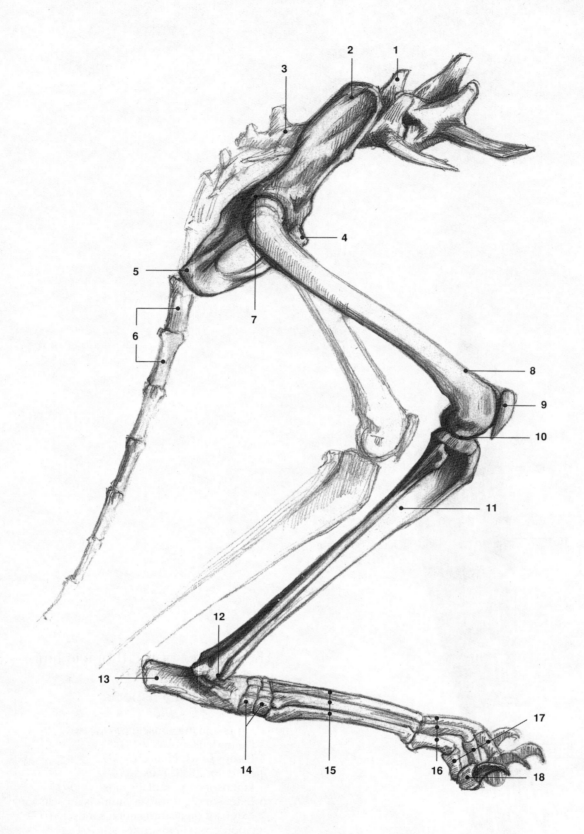

Fig. 8

The bones of the pelvic limb, lateral aspect

1 Last lumbar vertebra
2 Hip bone
3 Sacrum
4 Pubic bone
5 Ischial bone
6 Coccygeal vertebrae

7 Hip joint
8 Femur
9 Patella
10 Stifle joint
11 Tibia
12 Distal tibio-fibular joint

13 Calcaneus
14 Middle and distal row of tarsal bones
15 Metatarsal bones
16 Proximal phalangeal bone
17 Middle phalangeal bone
18 Claw bone

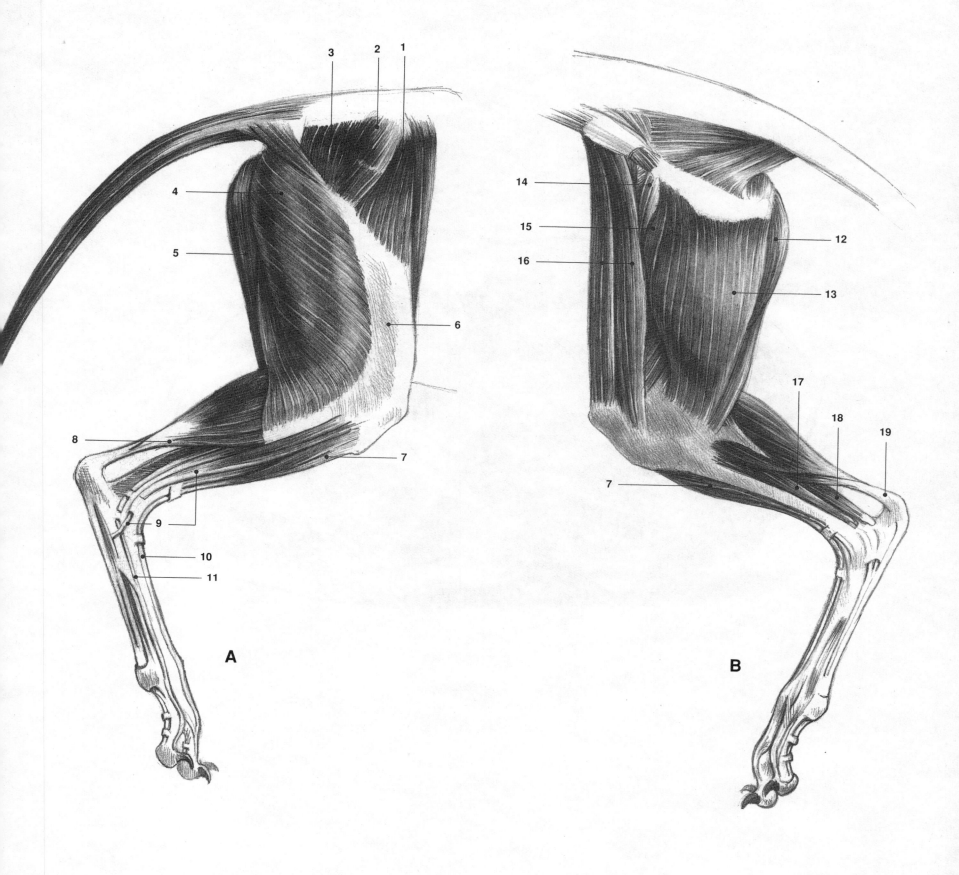

Fig. 9

The muscles of the pelvic limb; lateral (A) and medial (B) aspects

1 Tensor fasciae latae muscle *(95)*
2 Gluteus medius muscle *(97)*
3 Gluteus superficialis muscle *(96)*
4 Biceps femoris muscle *(106)*
5 Semitendinosus muscle *(107)*
6 Quadriceps femoris muscle *(112)*
7 Tibialis cranialis muscle *(117)*

8 Triceps surae muscle *(114)*
9 Peroneus longus muscle *(121)*
10 Extensor digitorum longus muscle *(118)*
11 Extensor digitorum lateralis
 muscle *(122)*
12 Semimembranosus muscle *(108)*
13 Gracilis muscle *(104)*

14 Pectineus muscle *(103)*
15 Adductor muscle *(105)*
16 Sartorius muscle *(102)*
17 Flexor digitorum longus muscle *(125)*
18 Flexor hallucis longus muscle *(124)*
19 Flexor digitorum superficialis
 muscle *(123)*

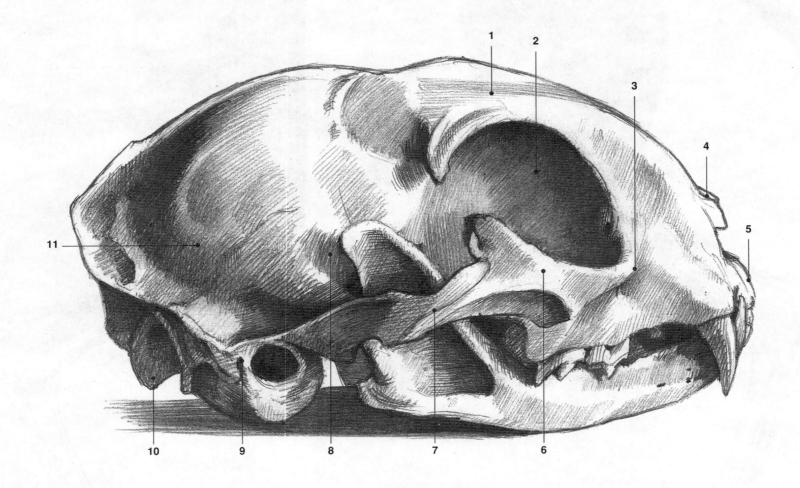

Fig. 10

The skull

1 Frontal bone
2 Orbit
3 Maxilla
4 Nasal bone
5 Incisive bone
6 Zygomatic bone

7 Zygomatic arch
8 Temporal bone
9 Petrous bone
10 Occipital condyle
11 Parietal bone

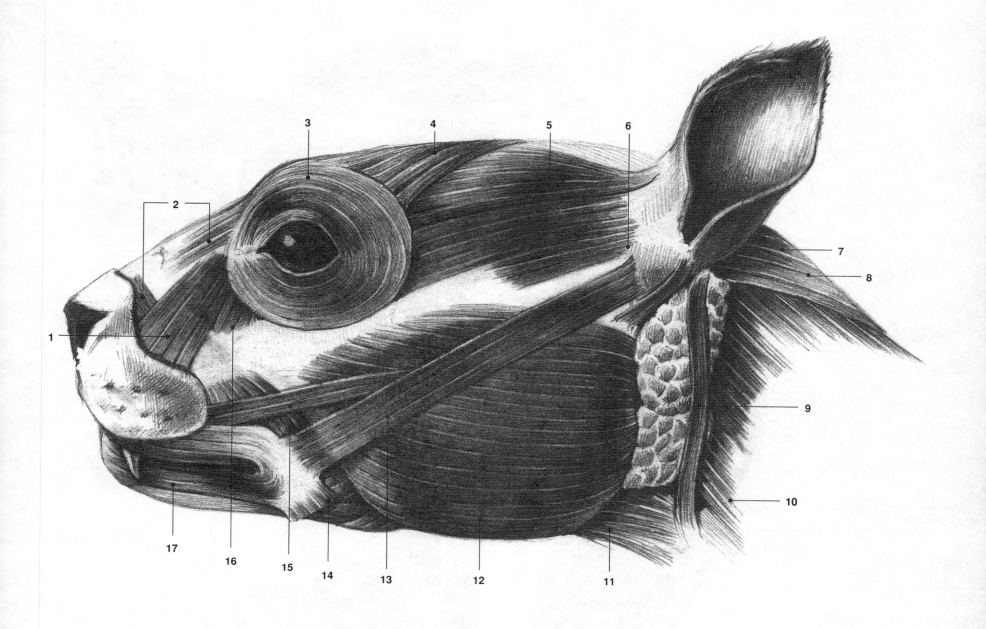

Fig. 11

The muscles of the head

1 Levator nasolabialis muscle *(164)*
2 Dorsalis and lateralis nasi muscles *(162)*
3 Orbicularis oculi muscle *(155)*
4 Levator palpebrae superioris muscle *(156)*
5 Frontoscutularis muscle *(141)*
6 Zygomaticoscutularis muscle *(142)*

7 Cervicoauricularis profundus muscle *(149)*
8 Cervicoauricularis superficialis muscle *(149)*
9 Parotideoauricularis muscle *(150)*
10 Brachiocephalicus muscle *(6)*
11 Sternohyoideus muscle *(9)*
12 Masseter muscle *(178)*

13 Zygomaticus muscle *(174)*
14 Depressor labii mandibularis muscle *(170)*
15 Depressor labii maxillaris muscle *(169)*
16 Malaris muscle *(159)* (depressor of the lower eyelid)
17 Orbicularis oris muscle *(163)*

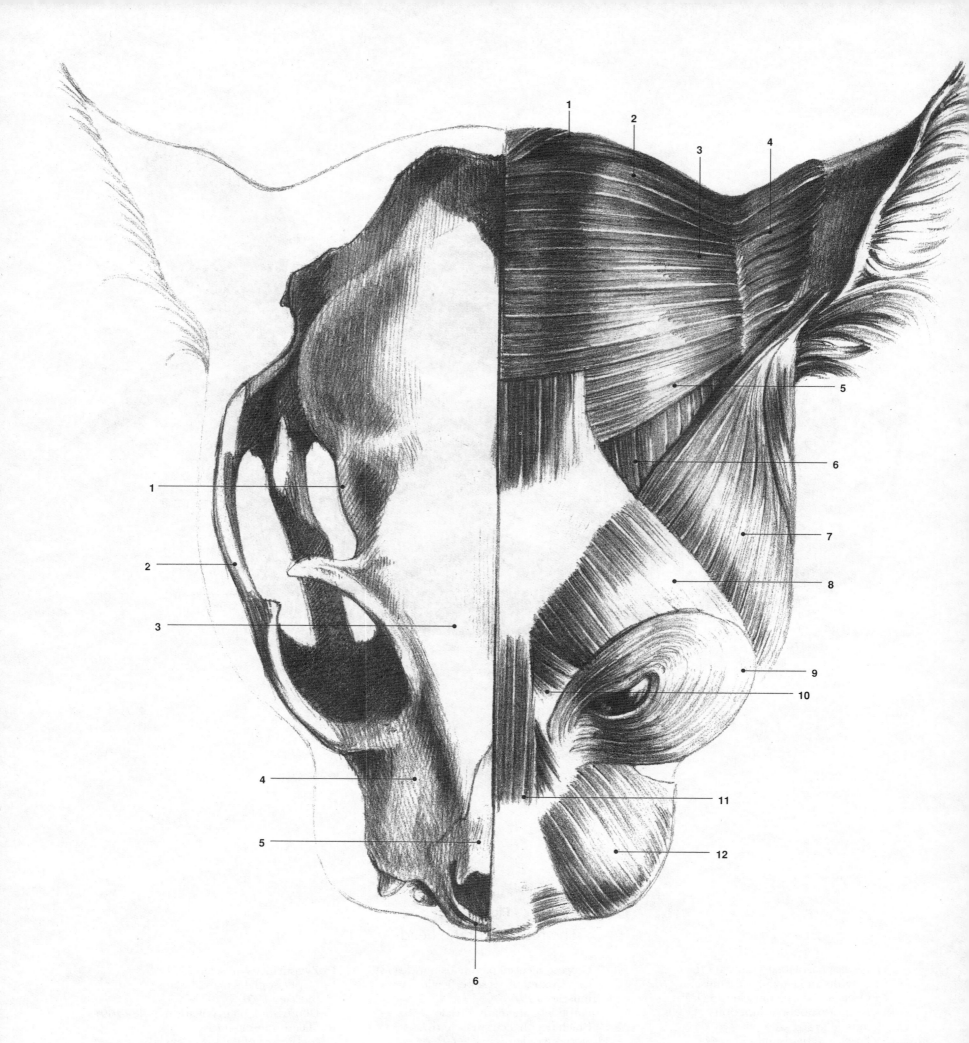

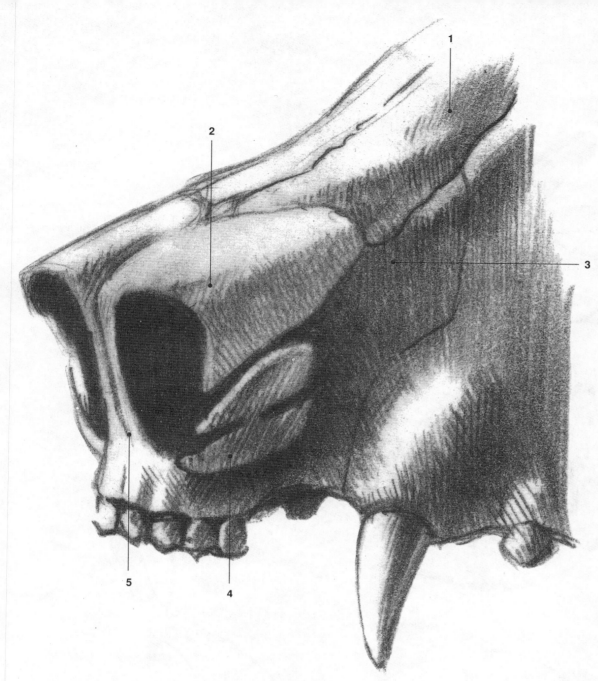

Fig. 13

The cartilages of the nose

1 Nasal bone
2 Dorsal parietal cartilage
3 Ventral parietal cartilage
4 Accessory nasal cartilage
5 Cartilage of the nasal septum

Fig. 12

The skull and the muscles of the head, dorsal aspect

Bones
1 Temporal bone
2 Zygomatic arch
3 Frontal bone
4 Maxilla
5 Nasal bone
6 Inscisive bone

Muscles
1 Cervicoauricularis profundus muscle *(149)*
2 Cervicoauricularis superficialis muscle *(149)*
3 Interscutularis muscle *(146)*
4 Scutuloauricularis profundus muscle *(144)*
5 Parietoscutularis muscle *(145)*
6 Temporalis muscle *(170)*

7 Zygomaticoauricularis muscle *(143)*
8 Levator palpebrae superioris muscle *(156)*
9 Orbicularis oculi muscle *(163)*
10 Levator of the medial eye angle *(157)*
11 Dorsalis nasi muscle *(162)*
12 Levator nasolabialis muscle *(164)*

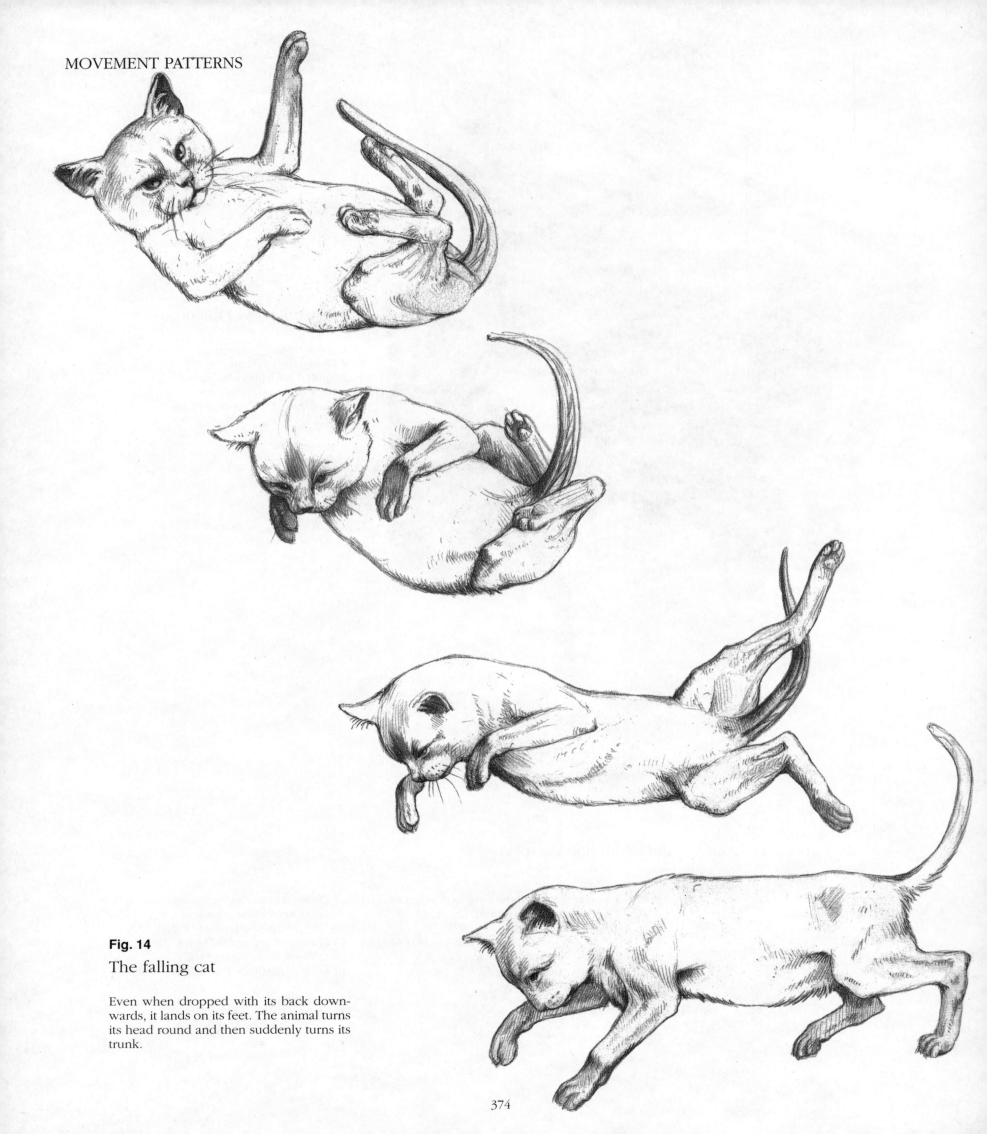

Fig. 14

The falling cat

Even when dropped with its back downwards, it lands on its feet. The animal turns its head round and then suddenly turns its trunk.

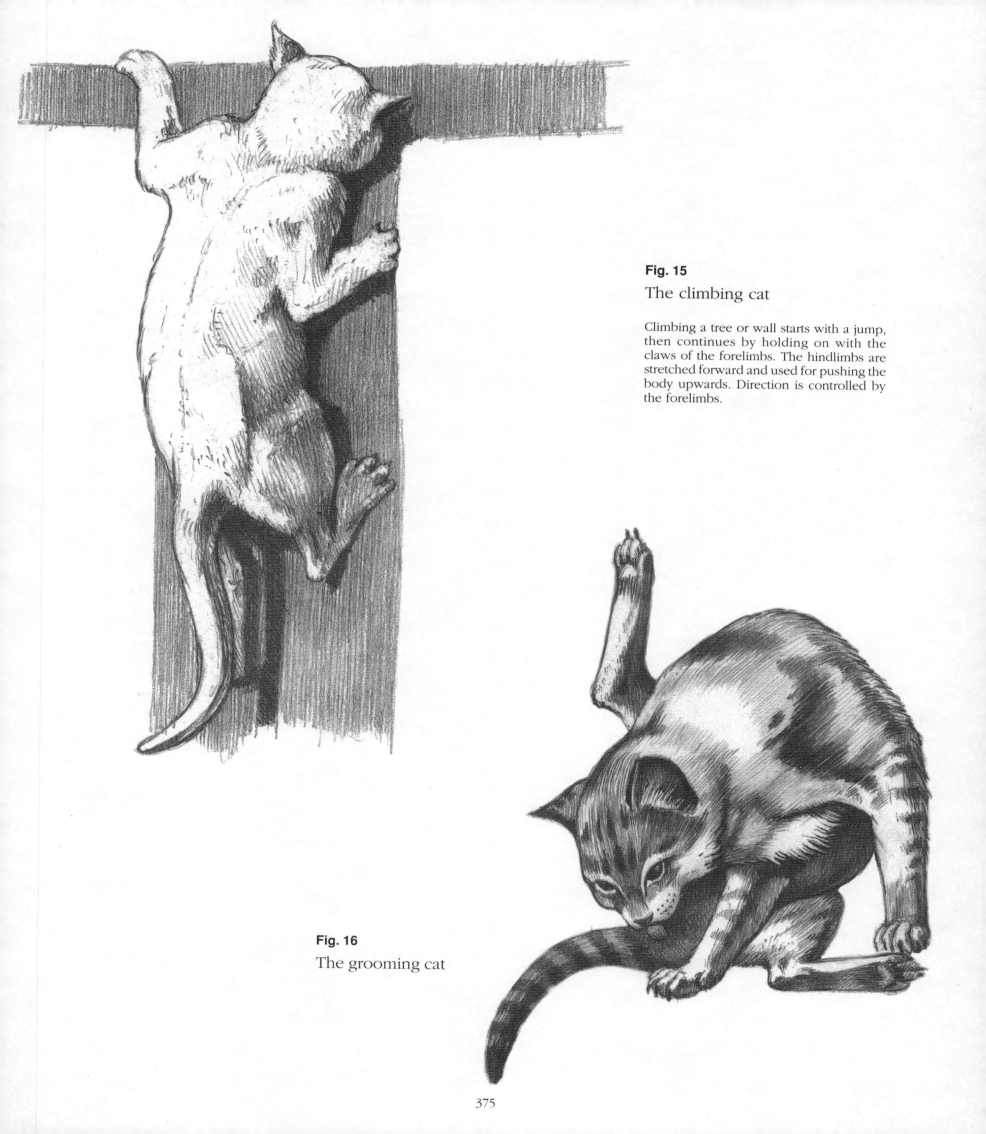

Fig. 15

The climbing cat

Climbing a tree or wall starts with a jump, then continues by holding on with the claws of the forelimbs. The hindlimbs are stretched forward and used for pushing the body upwards. Direction is controlled by the forelimbs.

Fig. 16

The grooming cat

THE PIG

About 7000 years ago the Asian wild pig (Sus scrofa vittatus) was domesticated, and the ancestor of the domestic pig was born. Today's domestic pig (Sus scrofa scrofa), is probably a cross between the Asian and the Central European wild pig. Domestication altered their appearance: their bodies became longer and rounder, their bristles sparser and lighter, the ears grew slightly larger, the tails curled, and the fatty layers under the skin thickened. But domestic pigs retain many characteristics of their wild ancestors: they love wallowing in mud, digging up the ground and building sleeping quarters. If released into the wild, they soon revert to their original behaviour.

Pigs reared for meat are ready for slaughter at the age of 5–8 months, when they weigh around 100 kg/220 lbs. Domesticated pigs are bred for meat, bacon, lard, and their skin. Because they eat carrion as well as faecal matter, and because they can transfer parasites (e.g. trichinella) to humans, many religions consider them impure and forbid the consumption of their meat.

The anatomy of a wild pig is adapted to a woodland life. A small, strong body, slightly flattened at the sides, enables them to forage and seek shelter in the undergrowth. With their wedge-shaped heads and trunk-like, elongated snouts, pigs turn up the ground to look for food which they locate with their acute sense of smell and touch. The end of the snout is especially sensitive.

Wild pigs are omnivores; they eat plant matter (fruit, especially acorns and beechnuts, roots, tubers, and toadstools) as well as animals (insect larvae, worms, slugs, mice, and carrion). Their teeth reflect their eating habits: their incisors, which are proclined, can pick up even tiny morsels, like worms or larvae. The four premolars have pointed ridges and are used for tearing meat. Plant food is ground with smooth-ridged molars. Powerful, long canines point upwards and are used for rooting up the ground and as weapons. The canine teeth of a fully grown wild boar are so long that they protrude outside the mouth. The domesticated pig also has distinctive canines, but they are considerably shorter than those of the wild pig.

The massive head is borne on a short, muscular neck. Because of the relatively restricted mobility of the neck pigs cannot clean their whole body with their snout. Therefore, in order to get rid of annoying parasites they roll in mud puddles and rub against trees. In summer the mud baths are also a means of keeping cool.

Pigs are even-toed ungulates; they walk on the third and fourth toes of their short legs. The second and fourth toes have regressed to become secondary claws. Pigs can move easily on soggy ground and are able to gallop at great speed.

Older wild boars are solitary animals, only joining the sows for mating. A sow gives birth to her litter of piglets in a sort of nest, which consists of a hollow in the ground lined with branches, grass, leaves, and moss. Usually several sows and their offspring live together in a group.

Wild pigs are active at dusk and at night; during the day they rest in hollows in the ground. Pigs have an excellent sense of hearing and always try to avoid danger. If they feel threatened they suddenly start running and take flight. They only ever attack if they are cornered or if they have to defend their young. They communicate with each other with a great variety of sounds (grunting, squealing, shrieking, and snorting).

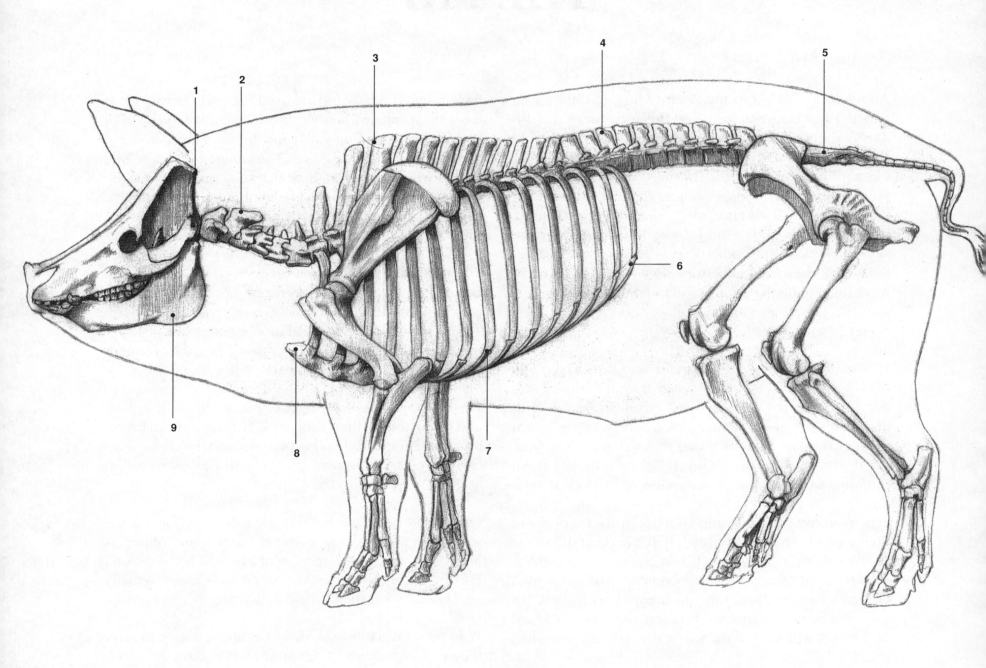

Fig. 1

The skeleton

The cervical part of the vertebral column is short and slightly arched, the dorso-lumbar portion is straight. The shoulder blade is broad, the pelvis bones are massive. The bony framework of the chest is composed of 14–16 ribs and a flat sternum.

1 Occipital crest
2 Second cervical vertebra
3 IIIrd thoracic vertebra
4 Ist lumbar vertebra
5 Sacrum
6 Costal arch

7 VIIIth or last real rib
8 Sternum
9 Mandible

The bones of the limbs are demonstrated in Figs. 5 and 9.

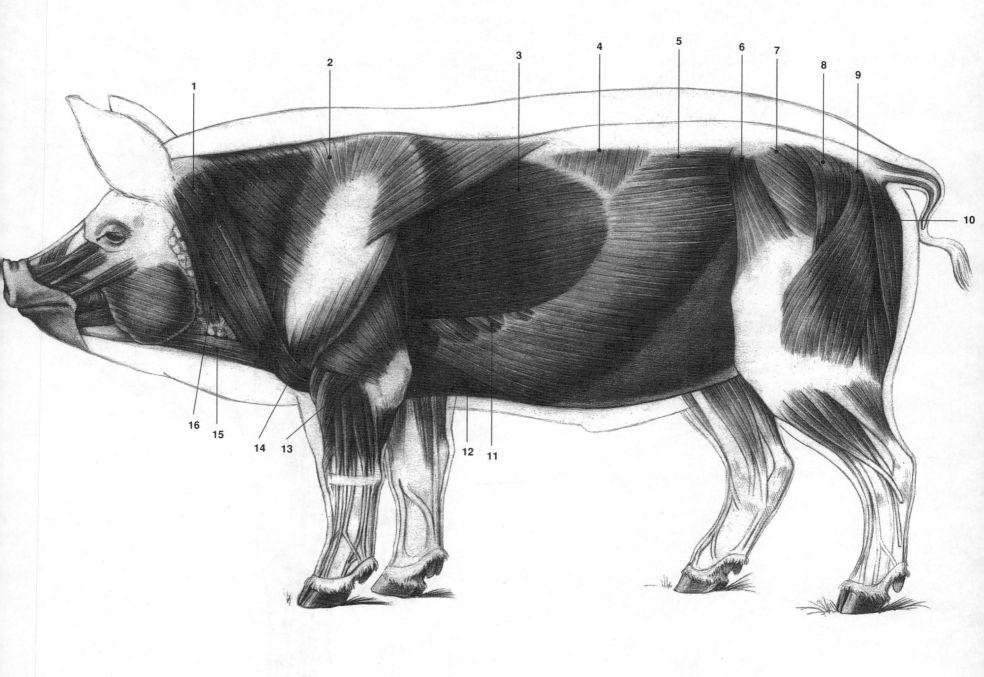

Fig. 2

The muscles

1 Brachiocephalicus muscle *(6)*
2 Trapezius muscle *(14)*
3 Latissimus dorsi muscle *(16)*
4 Serratus dorsalis muscle *(19)*
5 Obliquus externus abdominis muscle *(36)*
6 Tensor fasciae latae muscle *(95)*

7 Gluteus medius muscle *(97)*
8 Gluteus superficialis muscle *(96)*
9 Biceps femoris muscle *(106)*
10 Semitendinosus muscle *(107)*
11 Serratus ventralis muscle *(18)*
12 Pectoralis profundus muscle *(30)*
13 Triceps brachii muscle *(52)*

14 Deltoideus muscle *(43)*
15 Sternohyoideus muscle *(9)*
16 Parotideoauricularis muscle *(150)*

The muscles of the head are demonstrated in Fig. 14, those of the limbs in Figs. 6 and 11, respectively.

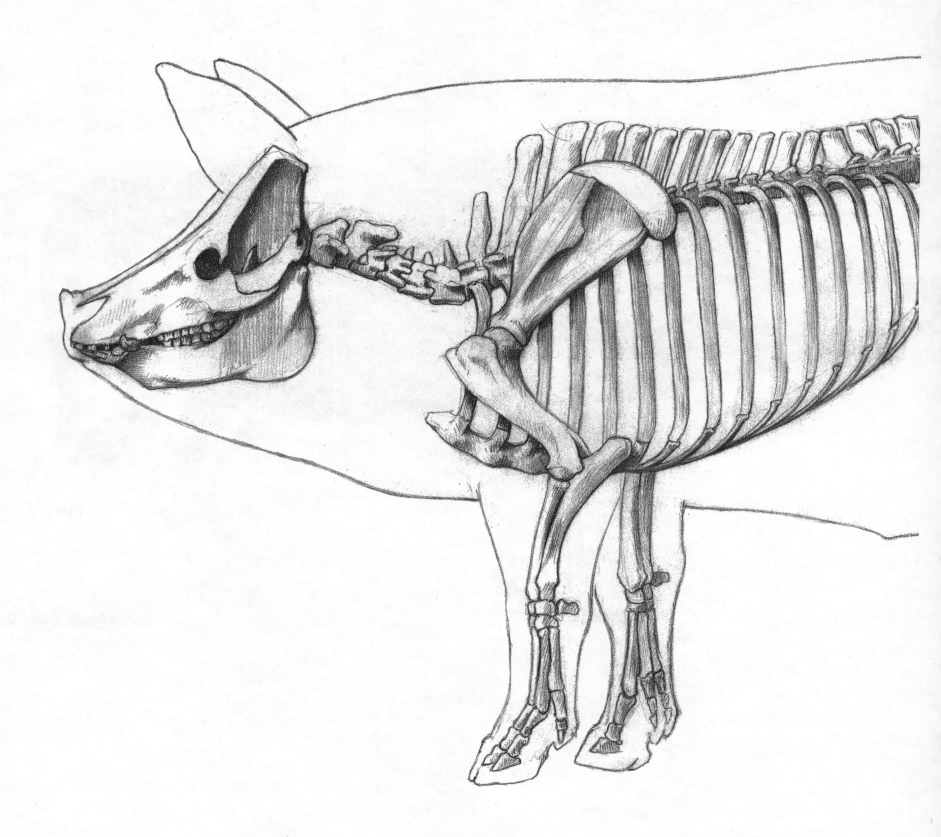

Fig. 3

The bones of the head, the neck and the thoracic girdle

The bones are demonstrated in Fig. 1.

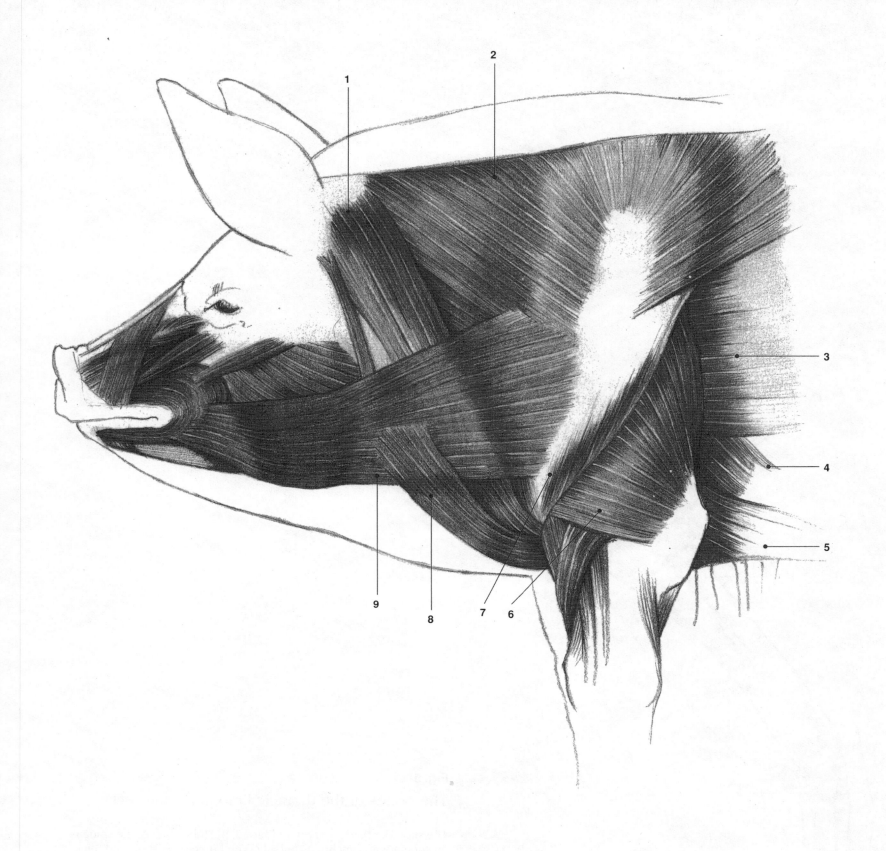

Fig. 4

The superficial muscles of the head, the neck and the thoracic girdle

The muscles of the nose are tendinous toward the snout, the masticatory muscles of the buccal region are thick and strong. The dorsal edge of the neck is straight, the lower border bulges slightly. The breast is well muscled, the shoulder is wide.

1 Brachiocephalicus muscle *(6/1)*
2 Trapezius muscle *(14)*
3 Latissimus dorsi muscle *(16)*
4 Serratus ventralis muscle *(18)*
5 Pectoralis profundus muscle *(30)*
6 Triceps brachii muscle *(52)*
7 Deltoideus muscle *(43)*

8 Cutaneus colli muscle *(2)*
9 Cutaneus faciei muscle *(1)*

The muscles of the head are demonstrated in Fig. 14.

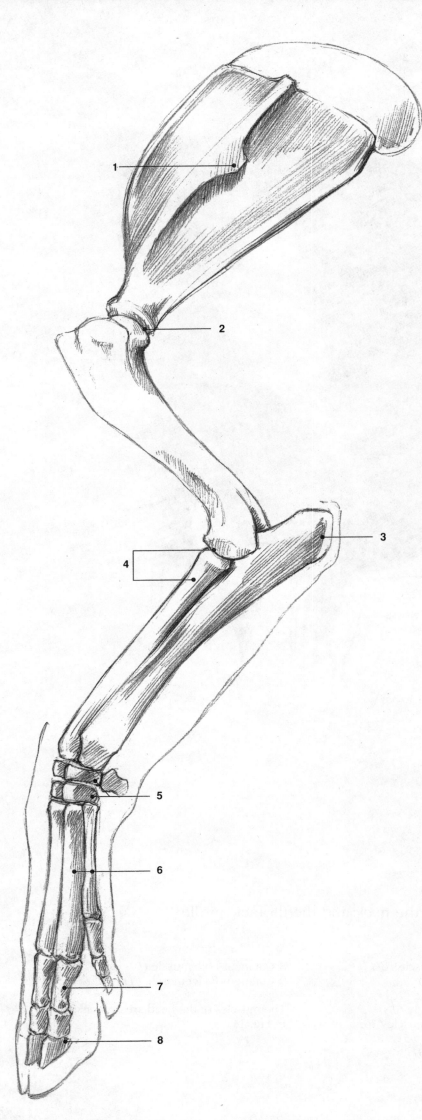

Fig. 5

The bones of the thoracic limb, lateral aspect

The shoulder blade is short and broad, the tuberosity of the spine is protuberant and inclined caudally. The humerus is short and thick. Of the bones of the lower limb the ulna is thicker, the elbow process is long. Four digits have developed; the IIIrd and IVth are used for walking, the IInd and the Vth are rudimentary dewclaws; they do not reach the ground.

1 Spine of the shoulder blade
2 The head of the humerus forming the shoulder joint with the articular groove of the shoulder blade
3 Process of the ulna
4 Radius, elbow joint
5 Bones and joints of the carpus
6 IVth and Vth metacarpal bones
7 Proximal phalanx
8 Distal phalanx

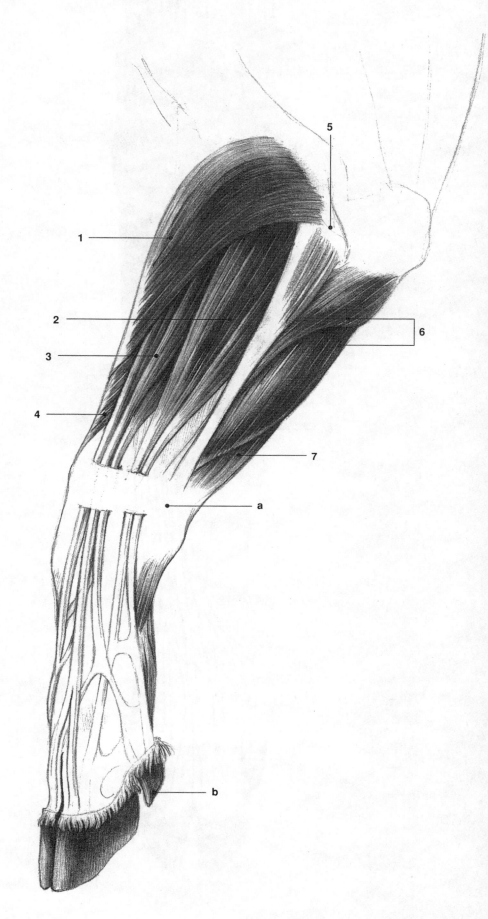

Fig. 6

The muscles of the thoracic limb, lateral aspect

The upper two-thirds of the lower limb are surrounded by spindle-shaped muscle-bellies. The bellies on the palmar surface of the metacarpus thicken this region.

1 Extensor carpi radialis muscle *(64)*
2 Extensor digitorum lateralis muscle *(67)*
3 Extensor digitorum communis muscle *(66)*
4 Abductor digiti Ist muscle *(70)*
5 Extensor carpi ulnaris muscle *(65)*
6 Flexor digitorum profundus muscle *(59)*
7 Flexor carpi ulnaris muscle *(57)*

a) Transverse ligament of the carpus
b) Dewclaw

383

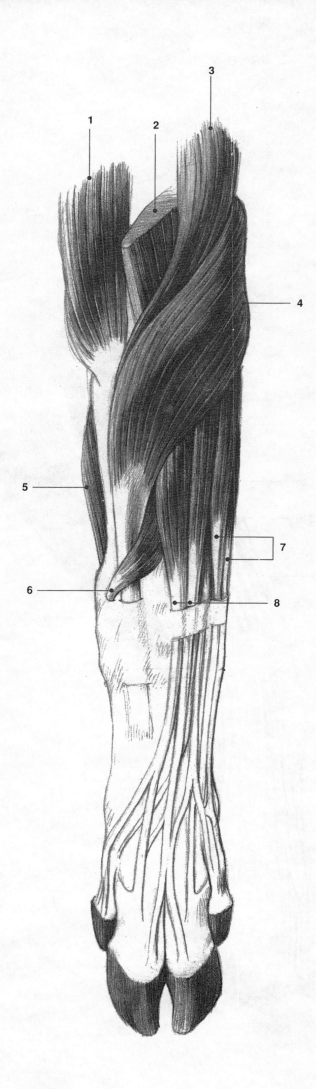

Fig. 7

The muscles of the thoracic
limb, cranial aspect

1 Biceps brachii muscle *(51)*
2 Brachiocephalicus muscle *(6)*
3 Brachialis muscle *(50)*
4 Extensor carpi radialis muscle *(64)*
5 Flexor carpi radialis muscle *(56)*
6 Abductor digiti Ist muscle *(70)*
7 Extensor digitorum lateralis muscle *(67)*
8 Extensor digitorum communis muscle *(66)*

Fig. 8

The muscles of the thoracic limb, palmar aspect

The lower limb is well muscled on the palmar surface. The flat palmar surface of the metacarpus is broadened by the rudimentary IInd and Vth digits. The thick tendons of the flexors pass over it. In the pastern and coronet regions the main digits and rudimentary ones are fixed to each other by the interdigital ligaments.

1 Flexor carpi ulnaris muscle *(57)*
2 Flexor digitorum profundus muscle *(59)*
3 Extensor carpi ulnaris muscle *(65)*
4 Flexor digitorum superficialis muscle *(58)*
5 Flexor carpi radialis muscle *(56)*
6 Abductor digiti IInd muscle *(78)*
7 Flexor digiti IInd muscle *(79)*

a) Transverse ligaments of the carpus
b) Dewclaw
c) Digital cushion

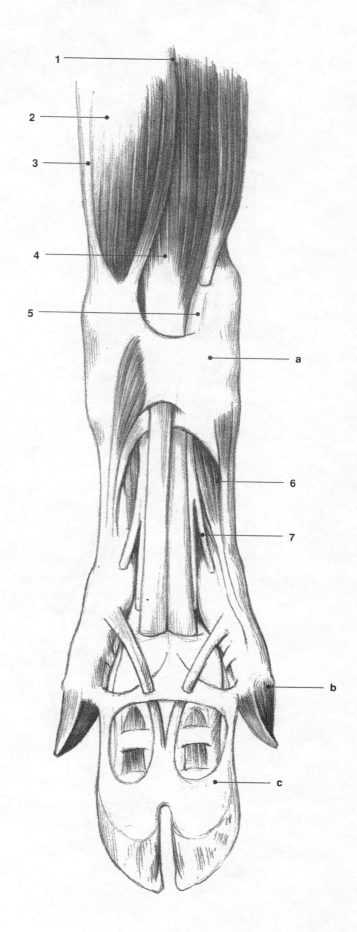

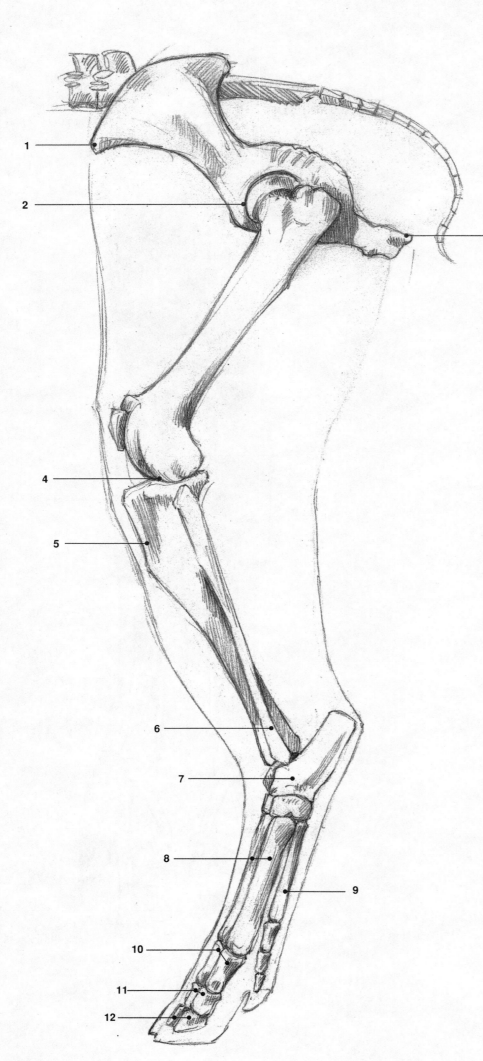

Fig. 9

The bones of the pelvic limb, lateral aspect

The pelvis is short, the hipbone is massive, the ischial tuber is high, the acetabulum is large. The tibia and fibula cross each other. The limb is short.

 1 Tuber coxae
 2 Hip joint
 3 Ischiatic tuber
 4 Stifle joint
 5 Tibia
 6 Fibula
 7 Calcaneus
 8 IIIrd and IVth metatarsal bones
 9 Vth metatarsal bone
10 Proximal phalangeal bones
 of the main digits
11 Middle phalangeal bones
12 Distal phalanges

Fig. 10

The muscles of the pelvis
and the thigh, lateral aspect

The dorsal and caudal muscles of the rump
are large and massive, the rump bulges,
the thigh is bulky.

1 Tensor fasciae latae muscle *(95)*
2 Gluteus medius muscle *(97)*
3 Gluteus superficialis muscle *(96)*
4 Coccygeus lateralis muscle *(180)*
5 Semitendinosus muscle *(107)*
6 Gluteobiceps muscle *(99)*
7 Gastrocnemius muscle *(115)*
8 Tibialis cranialis muscle *(117)*
9 Peroneus tertius muscle *(119)*

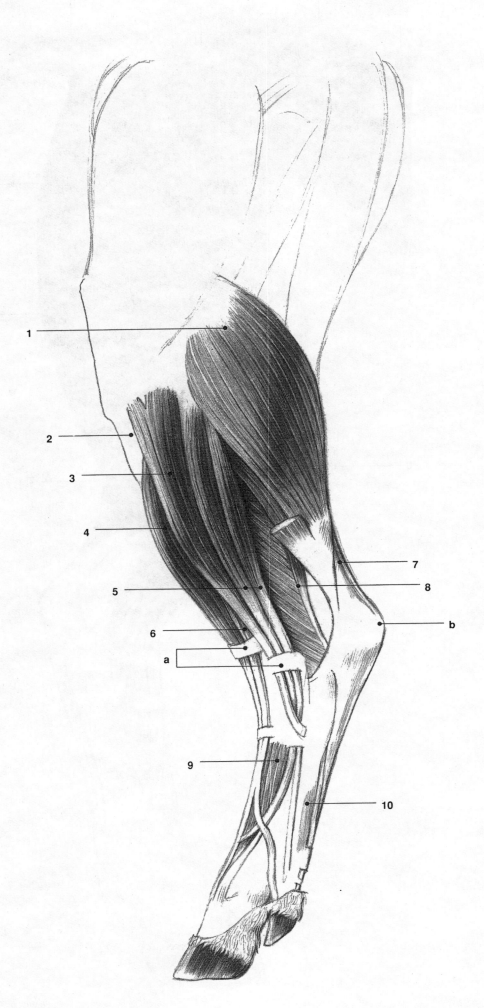

Fig. 11

The muscles of the pelvic limb, lateral aspect

1 Gastrocnemius muscle *(115)*
2 Tibialis cranialis muscle *(117)*
3 Peroneus longus muscle *(121)*
4 Peroneus tertius muscle *(119)*
5 Extensor digitorum lateralis muscle *(122)*
6 Extensor digitorum longus muscle *(120)*
7 Flexor digitorum superficialis muscle *(123)*
8 Flexor digitorum profundus muscles *(124)*
9 Extensor digitorum brevis muscle *(118/1)*
10 Abductor digiti Vth muscle *(132)*

a) Transversal ligament of the tarsus
b) Calcanean tuber

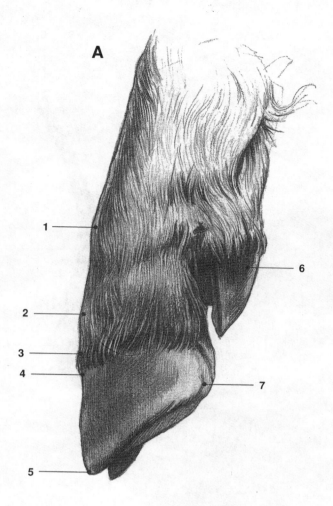

A

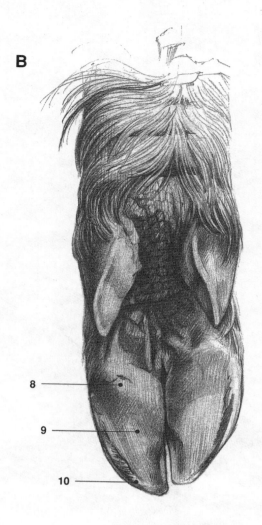

B

C

Fig. 12

The phalanges; lateral (A),
palmar (B) and dorsal (C)
aspects

The structure of the main and rudimentary
digits is identical, but the latter are smaller
in size.

 1 Region of the fetlock joints
 2 Region of the pastern joints
 3 Periople
 4 Coronet region
 5 The tip of the horny wall
 6 Dewclaws
 7 Palmar/plantar border of the horny wall
 8 Digital cushion
 9 Sole
10 Border of the sole

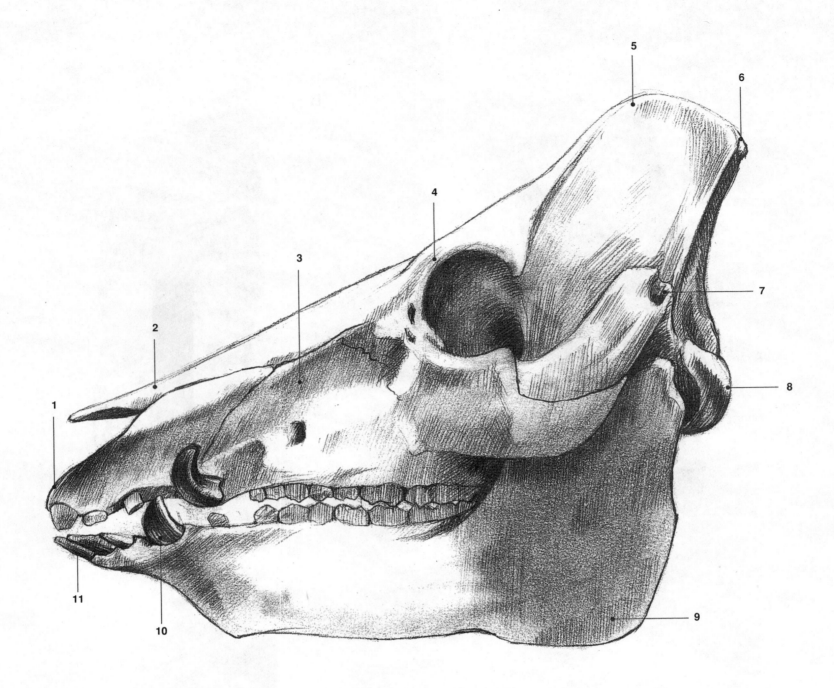

Fig. 13

The skull

The skull is cone-shaped. The nose is long and pointed, but its shape may be different depending on the breed. The os incisivum and the mandible are strong and massive. The tusk is bent cranio-laterally, it grows permanently, as it is worn away. The zygomatic arch is broad and strong, the bony orbit is open at its caudal margin. The fossa temporalis is bordered dorsally by the frontal bone and caudally by the crests of the occiput. The body of the mandible is massive, its base is straight and it forms a rectangle with the mandibular ramus.

1 Os incisivum
2 Nasal bone
3 Maxilla with the fossa lacrimalis

4 Orbit
5 Temporal crest (linea temporalis)
6 Nuchal crest
7 Cone-shaped occipital bone with the meatus acusticus externus
8 Condylus occipitalis
9 The angle of the mandible
10 Tusk
11 Incisor teeth

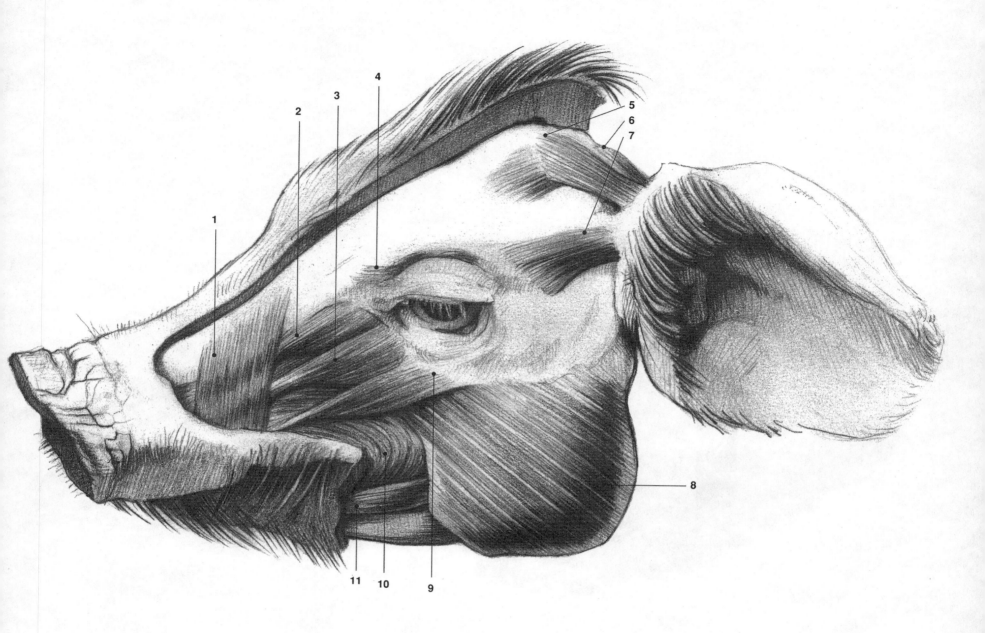

Fig. 14

The muscles of the head

1 Levator nasolabialis muscle *(164)*
2 Levator labii superioris muscle *(168)*
3 Caninus muscle (165)
4 Levator anguli oculi medialis muscle (157)

5 Parietoauricularis muscle *(147)*
6 Cervicoauricularis muscle *(149)*
7 Zygomaticoauricularis muscle *(143)*
8 Masseter muscle *(178)*

9 Depressor labii maxillaris muscle *(169)*
10 Orbicularis oris muscle *(163)*
11 Depressor labii mandibularis
 muscle *(170)*

Fig. 15

The head

The tip of the nose ends in the snout. The lower lip is small, pointed and stiff. The ear is large and pointed. The eyebrow and the hair of the face are long. The skin is thick, the fat layer becoming thicker posteriorly.

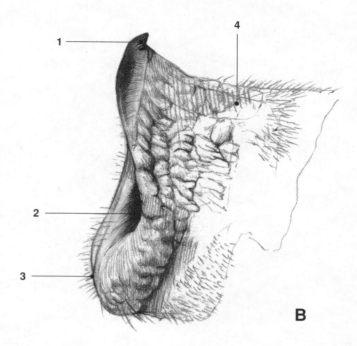

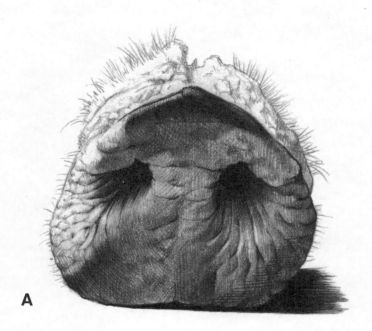

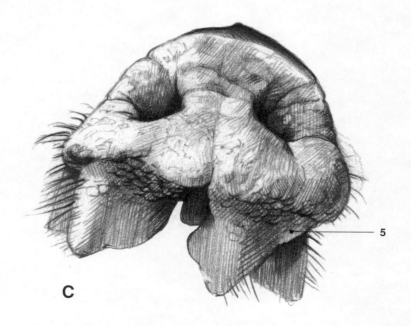

Fig. 16

The rostrum; frontal (A), lateral (B) and ventral (C) aspects

The mobile rostrum is a muscular organ; it has a bony base and its shape can be changed. From the front it is oval and is bordered by the snout, which has tactile hairs at its edge. Its lower border is broken in the midline by the labial groove. The round nostrils can be constricted and closed. The skin is thick and hairless with fine radial grooves.

1 Rostrum
2 Nostril
3 Labial groove
4 The rostral process continuing in the back of the nose
5 Upper lip continuing in the rostrum

THE APE

Apes form an order with many species; they all have hands and feet with five digits. The order of apes can be divided into two sub-orders: Strepsirhini (lemurs) and haplorhini (apes in the strict sense). The haplorhini are again divided into New World or broad-nosed monkeys and Old World or narrow-nosed apes. Members of the latter are gibbons, primates and man.

The family of primates (Pongidae) includes orang-utans, gorillas, chimpanzees, and dwarf chimpanzees. These are the mammals that show most similarities with the stature and behaviour of man. They are able to stand and sit upright for a considerable time, but most walk on all fours. Standing upright is very strenuous for them because the spine is not S-shaped like man's, but has only a slight curve. Compared to man they have a much deeper and wider chest, wider jaws and longer forearm, metacarpus and finger bones. Their arms are so long that they reach below the knees when standing upright. In man, by contrast, the arms end a long way above the knees. The legs are considerably shorter than the arms, so that the body is almost upright when the ape stands on all fours.

Apes are not only agile climbers, they can also run fast and jump far. Gibbons, for instance, can jump a distance of 12 metres (40 ft). Apes walk on the soles of their feet and the knuckles of their hands which are bent into fists. The main weight of the body is taken by the hind limbs, which therefore play a major role in moving around, the arms being used mainly for support. The big toes are hinged like thumbs. Apes are therefore able to grip with their feet – an important requirement when climbing.

Apes use their arms for running and swinging, as well as gripping and preparing food. This is unique in the animal kingdom and is only made possible by having hands with five fingers and a hinged thumb.

Like man, primates have an omnivore dentition, with 32 teeth. The large, powerful canine teeth are used for holding prey and in defence. Large incisors are able to bite off big chunks or nibble small pieces. The premolars are well suited to tearing meat, and the wide molars are used for grinding plant food.

The senses of primates are adapted to life in the forest. Their acute sense of hearing enables them to detect danger early, before it can be seen. With their excellent sense of smell they check the quality of food and identify other members of their group. Forward pointing eyes enhance their vision, which is especially important for climbing, although this position of the eyes does restrict the field of vision to a degree.

All primates live mainly in forests. Gorillas and chimpanzees especially roam through large woodland areas in search of food. Unlike gorillas, chimpanzees live mainly on the ground. They only climb trees to find food, escape from enemies, and sleep. They are omnivores and eat fruit, roots, leaves, buds, and animals. Not only do they catch small prey, but often hunt in groups and catch larger mammals like baboons.

Chimpanzees live in groups with a strict hierarchy. Each group consists of several males, as well as females with their young. The hierarchy is determined by fighting. Therefore the largest and most experienced animal is usually the leader. They communicate with a multitude of sounds and gestures and are capable of many facial expressions. All members develop individual relationships with other members of the group, which are expressed in mutual grooming, for instance.

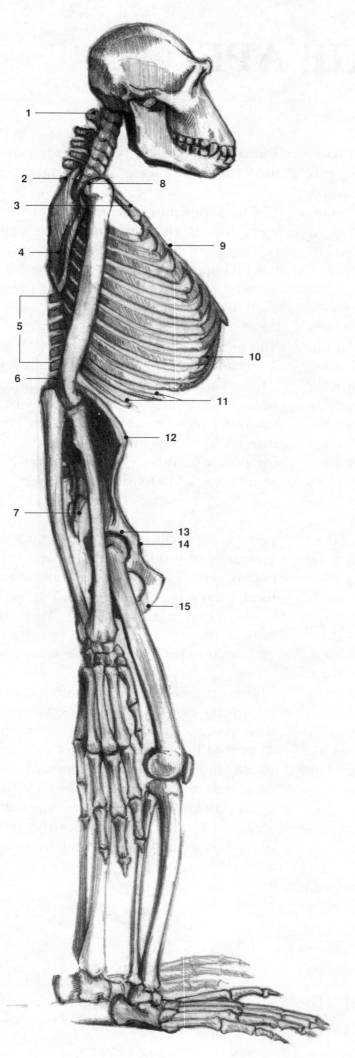

Fig. 1

The skeleton

1 IInd cervical vertebra
2 VIIth cervical vertebra
3 Clavicle
4 Shoulder blade
5 Spinous processes
 of the thoracic vertebra
6 Lumbar vertebrae
7 Sacrum
8 Shoulder joint
9 Sternum
10 Costal arch
11 Floating ribs
12 Outer iliac spine
13 Hip joint
14 Pubis
15 Ischium

The bones of the skull are demonstrated
in Fig. 11, those of the limbs
in Figs. 5, 7 and 9.

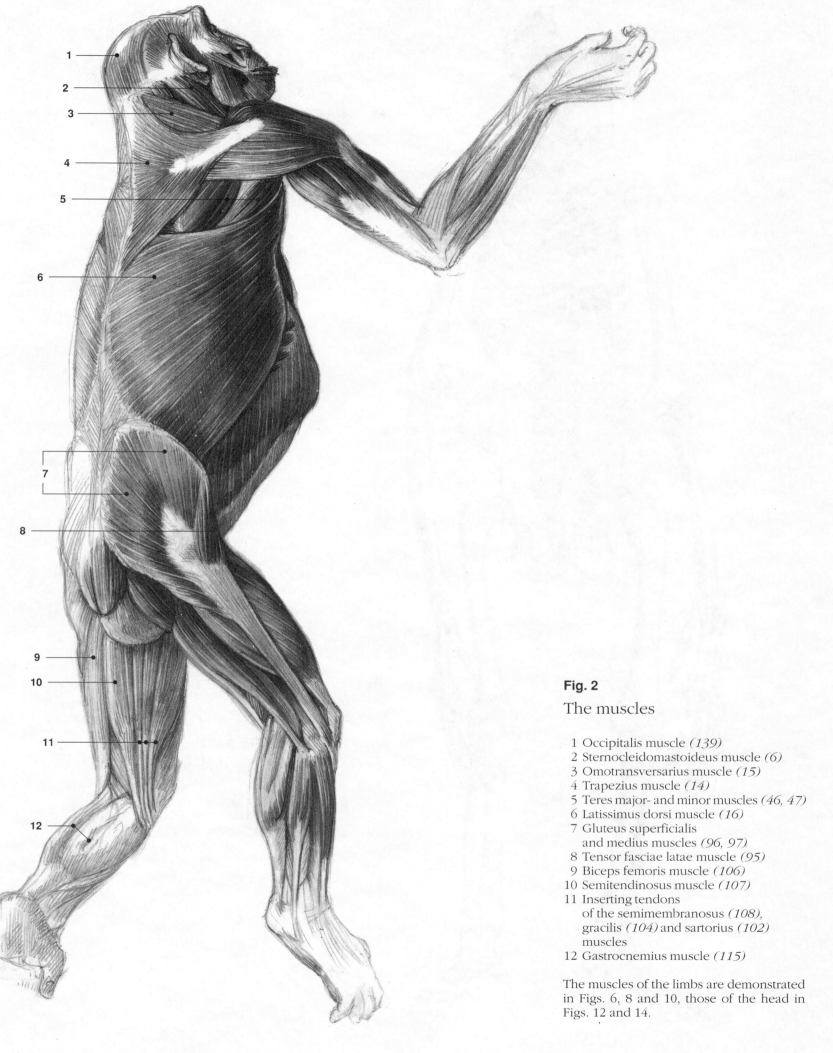

Fig. 2

The muscles

1 Occipitalis muscle *(139)*
2 Sternocleidomastoideus muscle *(6)*
3 Omotransversarius muscle *(15)*
4 Trapezius muscle *(14)*
5 Teres major- and minor muscles *(46, 47)*
6 Latissimus dorsi muscle *(16)*
7 Gluteus superficialis
 and medius muscles *(96, 97)*
8 Tensor fasciae latae muscle *(95)*
9 Biceps femoris muscle *(106)*
10 Semitendinosus muscle *(107)*
11 Inserting tendons
 of the semimembranosus *(108)*,
 gracilis *(104)* and sartorius *(102)*
 muscles
12 Gastrocnemius muscle *(115)*

The muscles of the limbs are demonstrated
in Figs. 6, 8 and 10, those of the head in
Figs. 12 and 14.

Fig. 3

The skeleton

1 Clavicle
2 Lumbar vertebrae
3 Sacrum

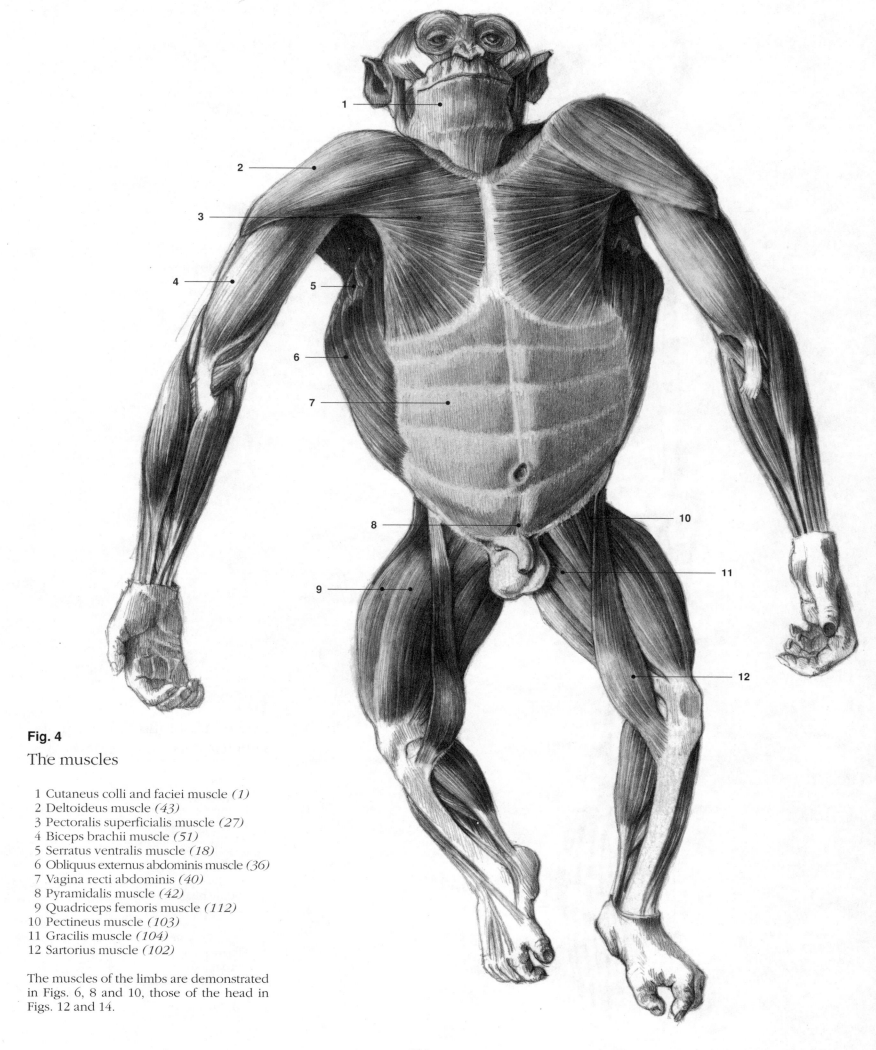

Fig. 4

The muscles

 1 Cutaneus colli and faciei muscle *(1)*
 2 Deltoideus muscle *(43)*
 3 Pectoralis superficialis muscle *(27)*
 4 Biceps brachii muscle *(51)*
 5 Serratus ventralis muscle *(18)*
 6 Obliquus externus abdominis muscle *(36)*
 7 Vagina recti abdominis *(40)*
 8 Pyramidalis muscle *(42)*
 9 Quadriceps femoris muscle *(112)*
10 Pectineus muscle *(103)*
11 Gracilis muscle *(104)*
12 Sartorius muscle *(102)*

The muscles of the limbs are demonstrated in Figs. 6, 8 and 10, those of the head in Figs. 12 and 14.

Fig. 5

The bones of the thoracic limb, lateral aspect

 1 Clavicle
 2 Scapula
 3 Humerus
 4 Ulna
 5 Radius
 6 Carpus
 7 Metacarpal bone
 8 Proximal phalangeal bone
 9 Middle phalangeal bone
10 Claw bone

a) Shoulder joint
b) Elbow joint
c) Carpal joint
d) Proximal phalangeal joint

Ist–Vth fingers

Fig. 6

The muscles of the thoracic
limb,
lateral aspect

1 Trapezius muscle *(14)*
2 Deltoideus muscle *(43)*
3 Brachialis muscle *(50)*
4 Biceps brachii muscle *(51)*
5 Triceps brachii muscle *(52)*
6 Brachioradialis muscle *(63)*
7 Flexor carpi ulnaris muscle *(57)*
8 Extensor carpi ulnaris muscle *(65)*
9 Extensor digitorum communis
 muscle *(66)*
10 Extensor digiti Vth proprius muscle *(84)*
11 Extensor carpi radialis muscle *(64)*
12 Flexor digiti Ist muscle *(74)*
13 Abductor digiti Ist longus muscle *(70)*
14 Abductor digiti Ist brevis muscle *(70)*

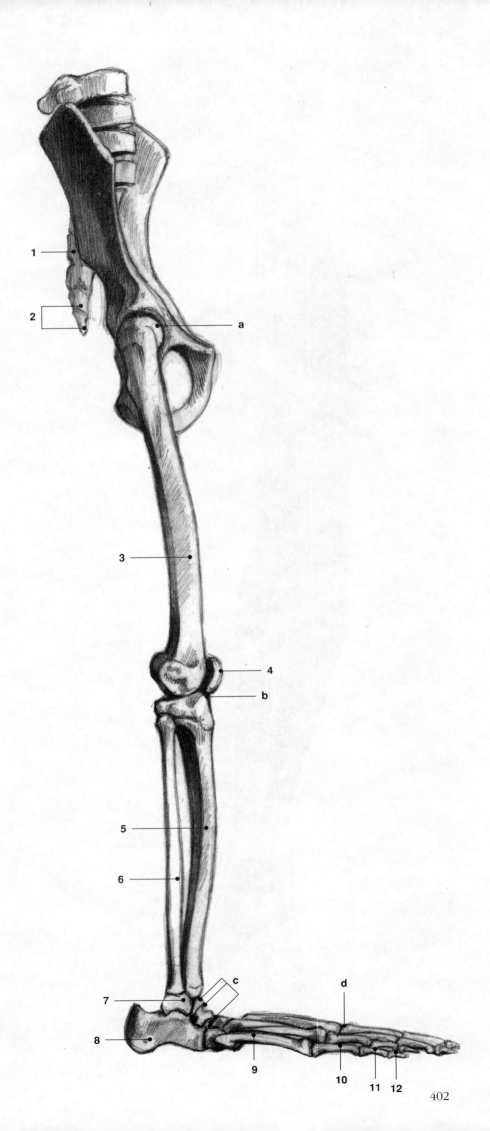

Fig. 7

The bones of the pelvic limb,
lateral aspect

1 Sacrum
2 Coccygeal vertebrae
3 Femur
4 Patella
5 Tibia
6 Fibula
7 Talus
8 Calcaneus
9 Metatarsal bone
10 Proximal phalangeal bone
11 Middle phalangeal bone
12 Claw bone

a) Hip joint
b) Knee joint
c) Tarsal joint
d) Proximal phalangeal joint

402

Fig. 8

The muscles of the pelvic limb,
lateral aspect

1 Tensor fasciae latae muscle *(95)*
2 Gluteus medius muscle *(97)*
3 Gluteus superficialis muscle *(96)*
4 Semitendinosus muscle *(107)*
5 Biceps femoris muscle *(106)*
6 Quadriceps femoris muscle *(112)*
7 Tibialis cranialis muscle *(117)*
8 Triceps surae muscle *(114)*
9 Peroneus longus muscle *(121)*
10 Peroneus brevis muscle *(121)*
11 Extensor digitorum longus muscle *(118)*
12 Extensor digiti Ist longus muscle *(120)*
13 Flexor digitorum longus muscle *(125)*

403

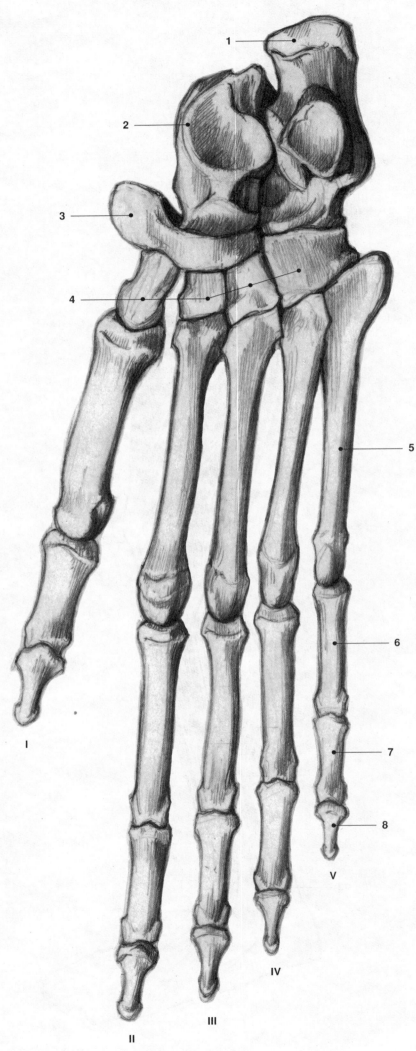

I
II
III
IV
V

Fig. 9

The bones of the foot,
anterior aspect

1 Calcaneus
2 Talus
3 Navicular bone
4 Lower row of the tarsal bones
5 Metatarsal bone
6 Proximal phalangeal bone
7 Middle phalangeal bone
8 Claw bone

Ist–Vth fingers

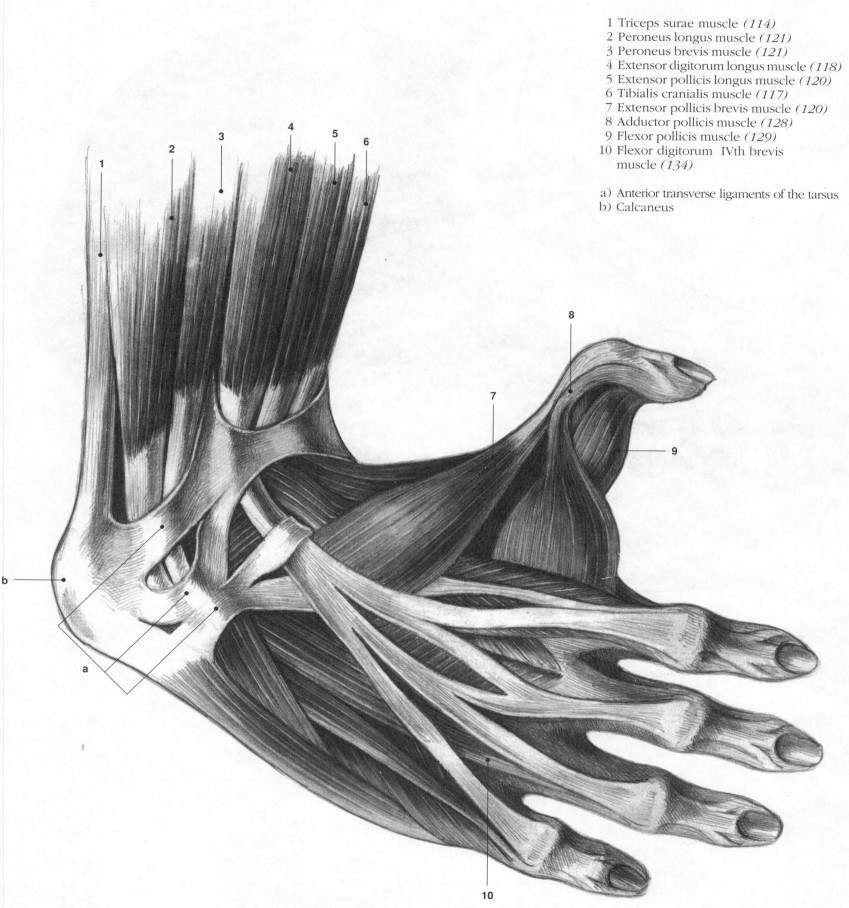

Fig. 10

The muscles of the foot,
lateral aspect

1 Triceps surae muscle *(114)*
2 Peroneus longus muscle *(121)*
3 Peroneus brevis muscle *(121)*
4 Extensor digitorum longus muscle *(118)*
5 Extensor pollicis longus muscle *(120)*
6 Tibialis cranialis muscle *(117)*
7 Extensor pollicis brevis muscle *(120)*
8 Adductor pollicis muscle *(128)*
9 Flexor pollicis muscle *(129)*
10 Flexor digitorum IVth brevis
 muscle *(134)*

a) Anterior transverse ligaments of the tarsus
b) Calcaneus

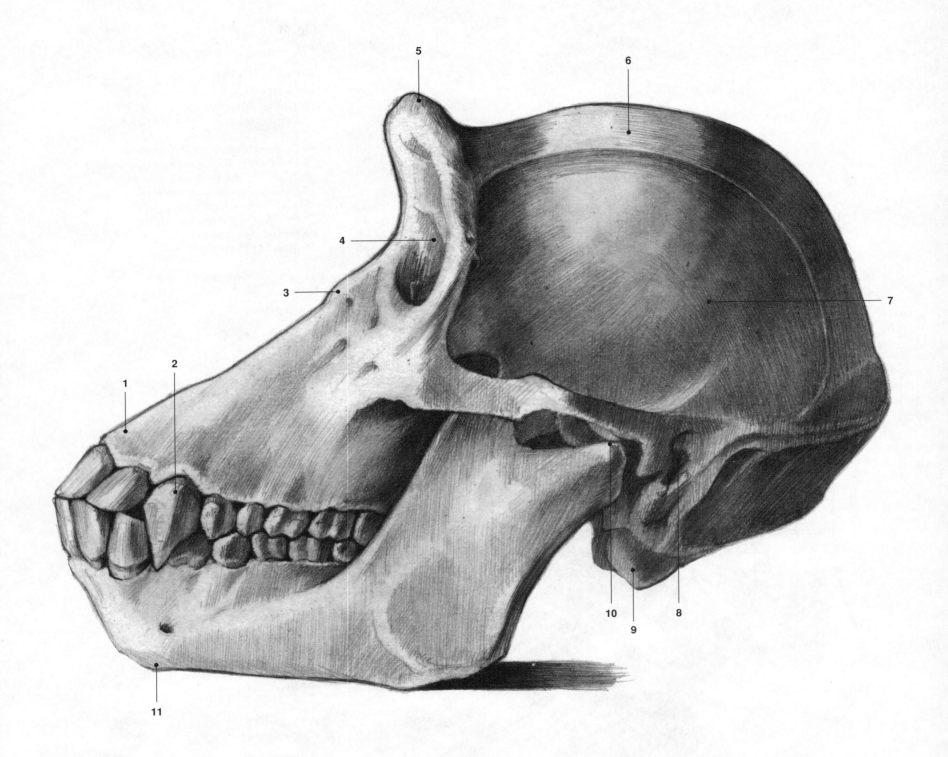

Fig. 11

The skull, lateral aspect

1 Incisive bone
2 Canine tooth
3 Nasal bone
4 Orbit
5 Upper orbital crest
6 Frontal bone
7 Parietal bone, temporal fossa
8 External osseous auditory duct
9 Occipital condyle
10 Mandibular joint
11 Mandible

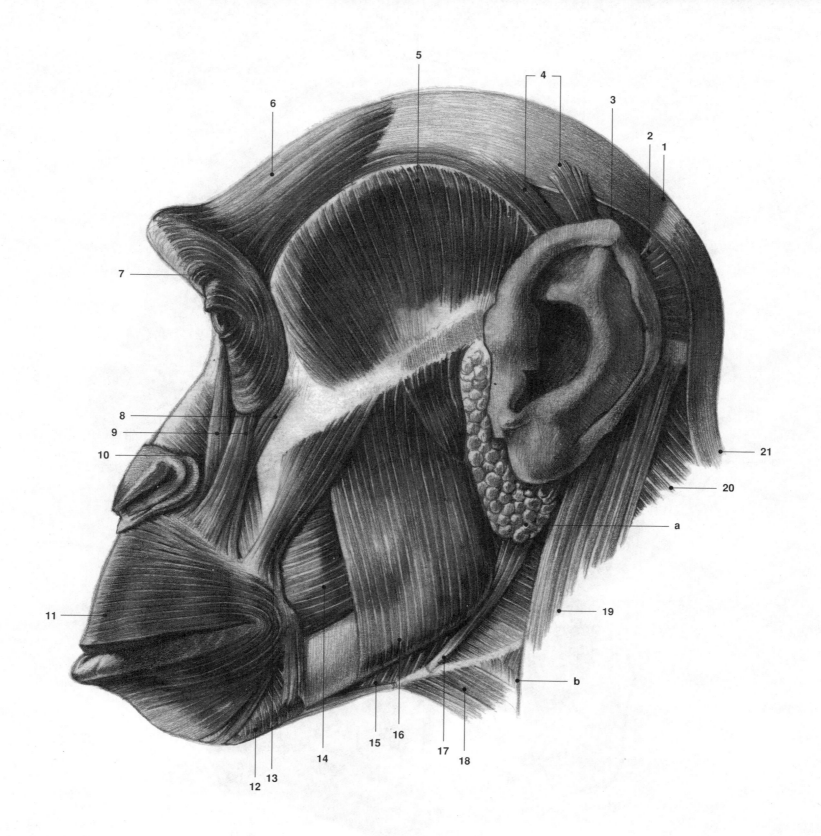

Fig. 12

The muscles of the head, lateral aspect

1 Occipitofrontalis muscle *(139)*
2 Cervicoauricularis superficialis
 muscle *(149)*
3 Interscutularis muscle *(146)*
4 Frontoscutularis muscles *(141)*
5 Temporalis muscle *(179)*
6 Frontalis muscle *(140)*
7 Orbicularis oculi muscle *(155)*
8 Maxillar part of levator labii
 superioris muscle *(168)*

9 Lacrimal part (outer and inner)
 of musculus levator labii superioris
 alaeqe nasi muscle *(168/1)*
10 Lateralis nasi muscle *(162)*
11 Orbicularis oris muscle *(163)*
12 Mentalis muscle *(173)*
13 Zygomaticus muscle *(174)*
14 Buccinator muscle *(175)*
15 Transversus mandibulae muscle *(177)*
16 Masseter muscle *(178)*

17 Digastricus muscle *(12)*
18 Sternohyoideus muscle *(9)*
19 Sternocleidomastoideus muscle *(6)*
20 Splenius capitis et cervicis muscle *(5)*
21 Trapezius muscle *(14)*

a) Parotid gland
b) Jugular fossa

407

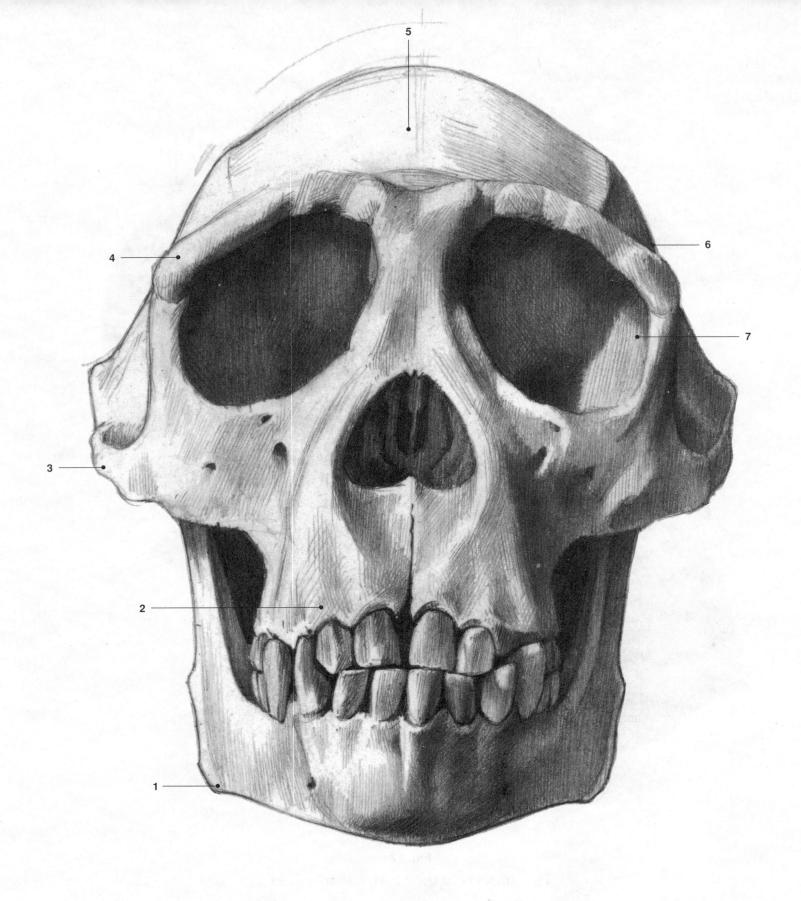

Fig. 13

The skull, anterior aspect

1 Mandible
2 Incisive bone
3 Zygomatic arch
4 Upper orbital crest
5 Frontal bone
6 Temporal fossa
7 Orbit

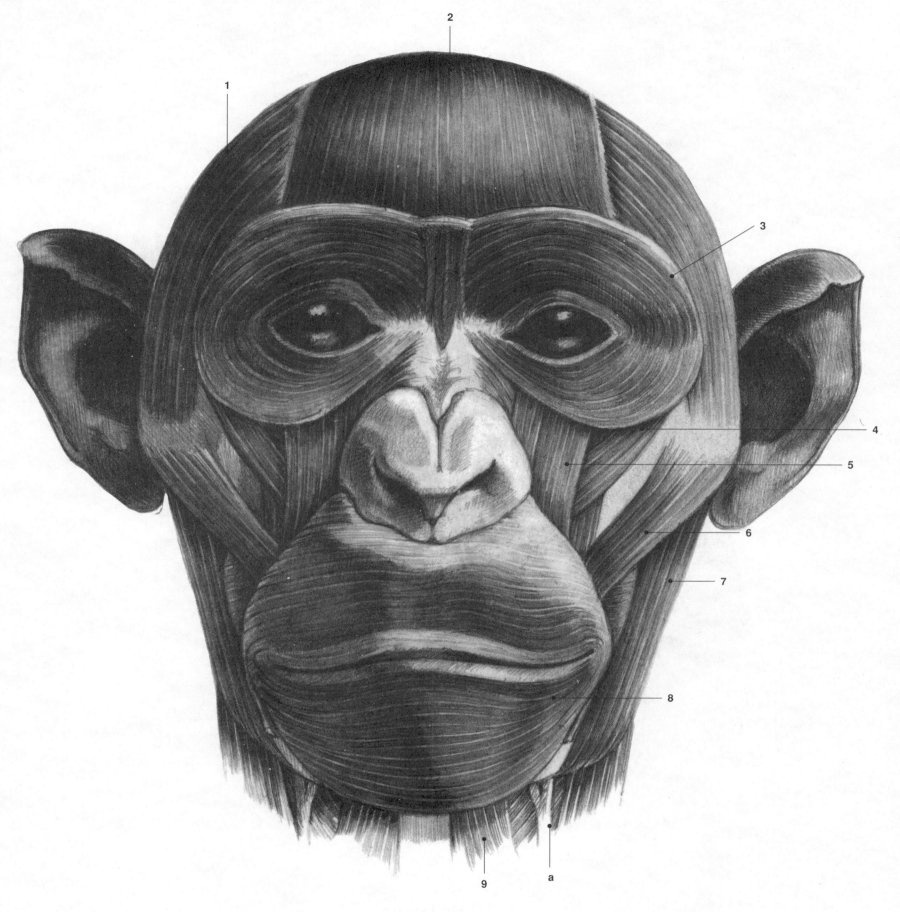

Fig. 14

The muscles of the head, anterior aspect

1 Temporalis muscle *(179)*
2 Frontalis muscle *(140)*
3 Orbicularis oculi muscle *(155)*
4 Maxillar part of levator labii superioris muscle *(168)*

5 Lacrimal part (outer and inner) of levator labii superioris alaeque nasi muscle *(168/1)*
6 Zygomaticus muscle *(174)*
7 Masseter muscle *(178)*

8 Orbicularis oris muscle *(163)*
9 Sternohyoideus muscle *(9)*

a) Jugular fossa and jugular vein

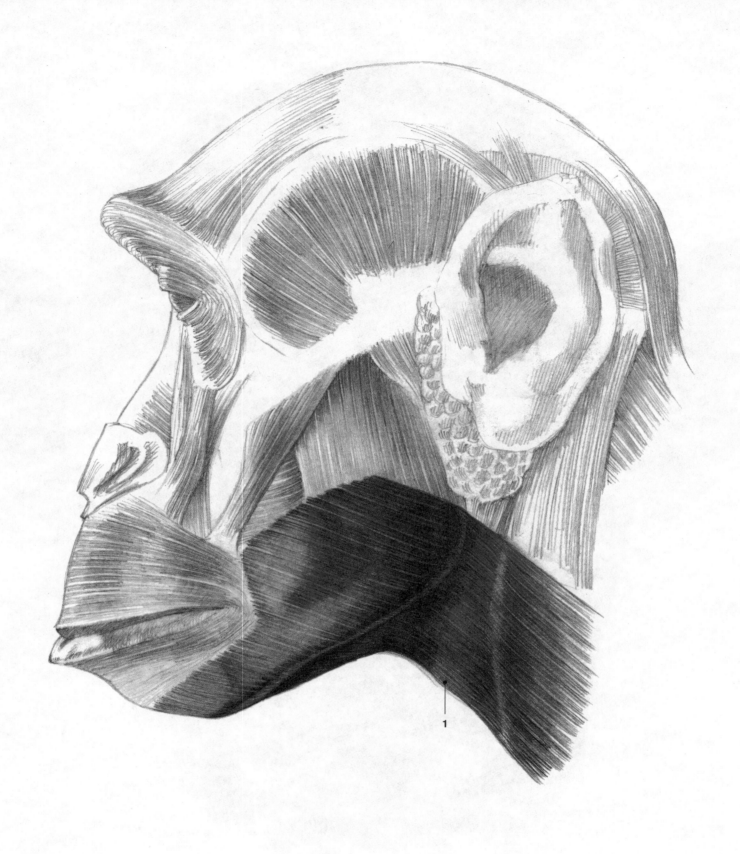

Fig. 15

The muscles of the head, lateral aspect

1 Cutaneus faciei muscle *(1)*

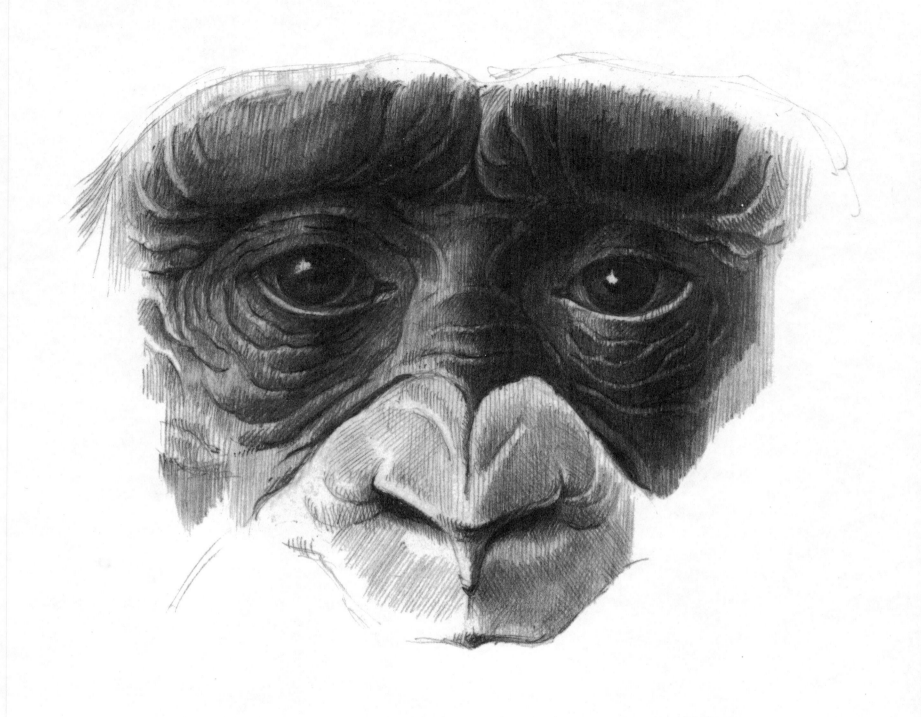

Fig. 16

The face

The eyebrow is emerging forward and up-
ward (*nasus prominens*). The bridge of the
nose is saddle-like. The eyelids are wrin-
kled, the nose is flat, the wings of the nose
are protruding laterally, the nostril is trans-
verse slit-like.

THE SHEEP

The domestic sheep is one of the oldest and most widely distributed animals of economic importance. Because of its versatility and modest requirements it can be kept even in barren regions. Sheep are driven to their pasture in flocks which range from small ones to big ones of several hundred animals. One shepherd and one sheepdog are enough to keep even large flocks under control because of the sheep's docile temperament and herd instinct.

Sheep supply man with wool, meat, milk, and sheepskins. In heathland they are also utilised for "land cultivation"; they eat both grass and saplings, preventing these heathlands from reverting to woodland.

The domestic sheep is probably descended from the moufflon, as well as other species of wild sheep. The first domestic sheep were bred ten thousand years ago. Today's breeds have been specially bred for the production of milk, meat or wool. To obtain wool sheep are shorn early in the year. This is also beneficial for the animals, as they would otherwise suffer from the summer heat in their natural thick coats. Not just the fleece, but whole skins are utilised. Fine, black, curly Persian lamb skins come from animals that are only three to eight days old.

Just like goats and cattle, sheep are perissodactyls and digitigrades, their toe and foot bones are reduced to two per foot. Sheep are of medium size. Compared to their big bodies, they have short, very thin legs which, like the head, are covered with short hair.

Sheep are ruminants. They pull up grass, which is their main diet. The grass is gripped by incisors, which only grow in the lower jaw, and a horny layer in the upper jaw. It is swallowed without being chewed and collects in the first stomach, the rumen. It is eaten quickly and in large amounts. The sheep then retreat to a quiet place to ruminate and digest their food. Plant material that has been swallowed and has travelled to the rumen is fermented with the aid of micro-organisms, releasing fatty acids; most of these enter the blood stream directly from the rumen. In the reticulum the remaining plant material is formed into small balls which are returned to the mouth. Here they are ground between wide molars. The resulting food pulp travels to the reticulum once more where most of the water is removed.

In the last stomach, the abomasum, the micro-organisms contained in the food pulp are killed off with hydrochloric acid, and the last phase of digestion can begin. In the extremely long small intestine special enzymes dissolve the remaining food pulp, and the released nutrients can be absorbed into the bloodstream. Indigestible plant fibres are expelled as droppings.

Apart from their horns and hooves sheep are defenceless. They rely on detecting enemies early, having a very good sense of hearing, vision and smell. If they hear unusual sounds they raise their heads to try and spot any possible danger with their eyes. If the danger turns out to be real, the whole flock starts to flee. If that is not possible the animals huddle together, and each tries to reach the centre of the flock. In this way the lambs are protected. Only ewes with their young and rams fight as a last resort. Rams fight by charging each other and clashing their heads and horns. These collisions are also a means of assessing the opponent's strength.

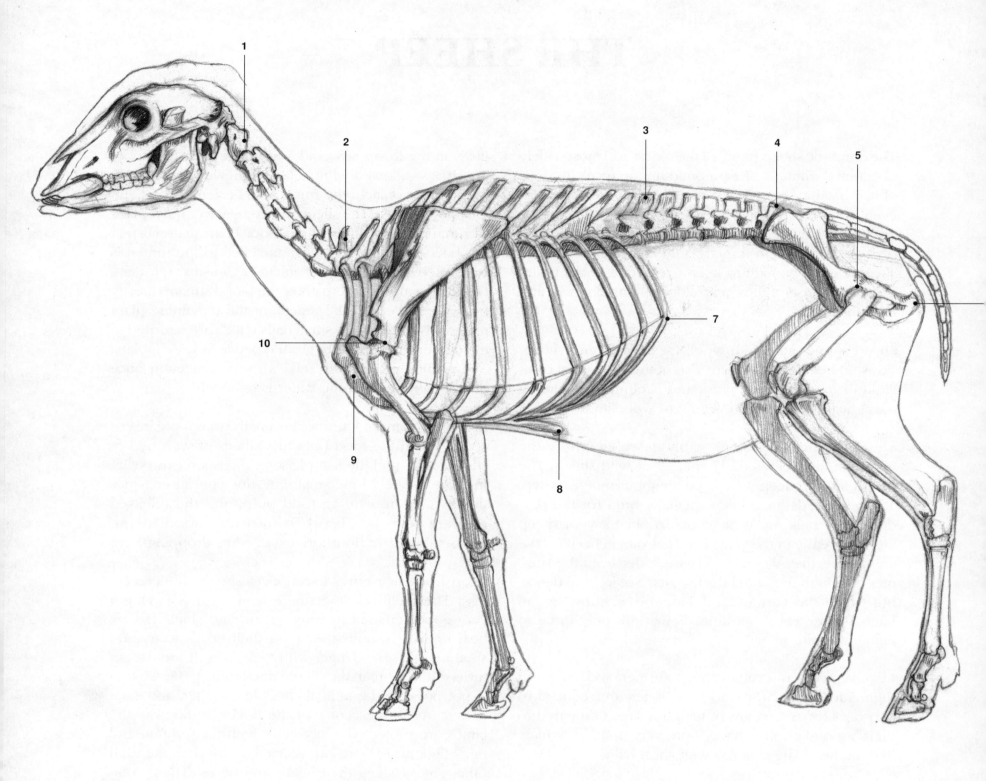

Fig. 1

The skeleton

The skeleton is similar to that of cattle. The head is relatively smaller, the forehead bulges, the neck is lower in front of the withers, and bent at its base. The vertebral column is straight, the ribs are flat and broad; the thorax is flattened on the side, and broadens towards the costal arch.

1 Ist cervical vertebra (atlas)
2 VIIth cervical vertebra
3 Ist lumbar vertebra
4 Sacrum
5 Hip joint
6 Ischial tuber
7 Costal arch, the knee of the rib

8 Xiphoidal cartilage of the sternum
9 Sternum
10 Shoulder joint

The bones of the limbs are demonstrated in Figs. 5 and 10, those of the head in Fig. 16.

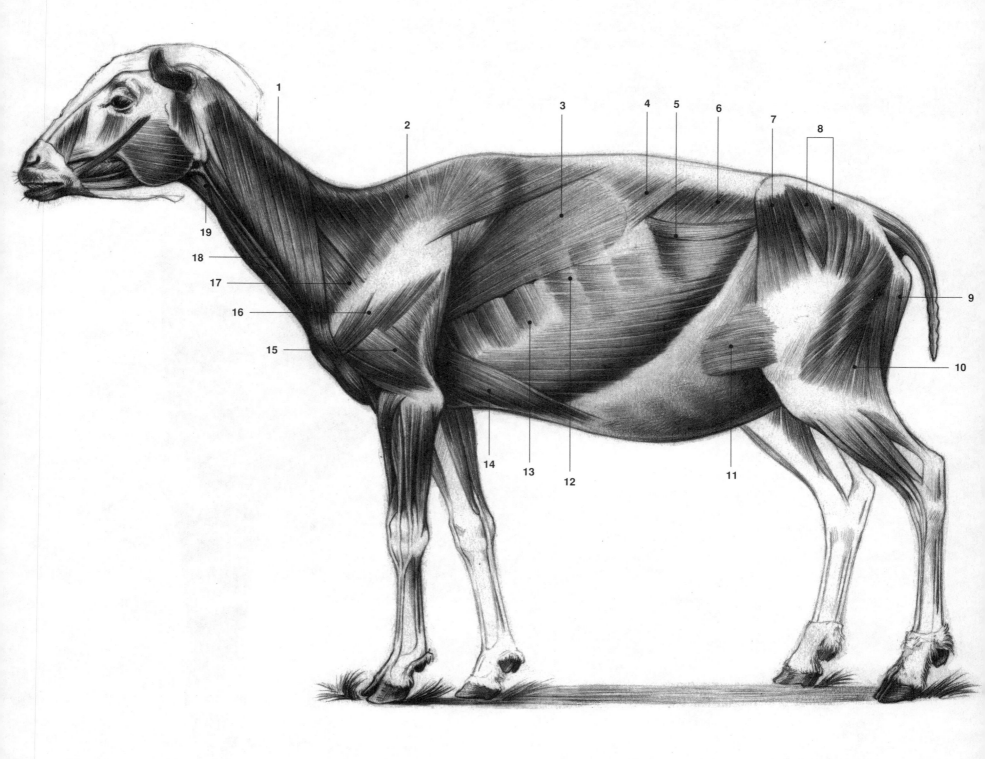

Fig. 2

The muscles, lateral aspect

The facial and buccal muscles are strong, the masticatory ones are big. The neck is thin, the sternocephalicus is a thin layer of muscle. The shoulder blade is poorly muscled, its covering muscles such as the trapezius are thin, its cervical portion broad. The muscles of the elbow, hip and stifle joints are massive and big. The muscles covering the sides of the thorax and those of the abdominal wall are thin, only the pectoral muscles are thick.

1 Brachiocephalicus muscle *(6)*
2 Trapezius muscle *(14)*
3 Latissimus dorsi muscle *(16)*
4 Serratus dorsalis muscle *(19)*
5 Obliquus externus abdominis muscle *(36)*
6 Obliquus internus abdominis muscle *(37)*
7 Tensor fasciae latae muscle *(95)*
8 Gluteus proximalis muscles *(96–98)*
9 Semitendinosus muscle *(107)*
10 Gluteobiceps muscle *(99)*
11 Cutaneus plicae lateris muscle *(26/1)*

12 Intercostalis externus muscle *(33)*
13 Serratus ventralis muscle *(18)*
14 Pectoralis profundus muscle *(30)*
15 Triceps brachii muscle *(52)*
16 Deltoideus muscle *(43)*
17 Omotransversarius muscle *(15)*
18 Sternocephalicus muscle *(7)*
19 Sternohyoideus muscle *(9)*

The muscles of the head are demonstrated in Fig. 17, those of the limbs in Figs. 3, 4, 7, 8, 11, 13 and 14, respectively.

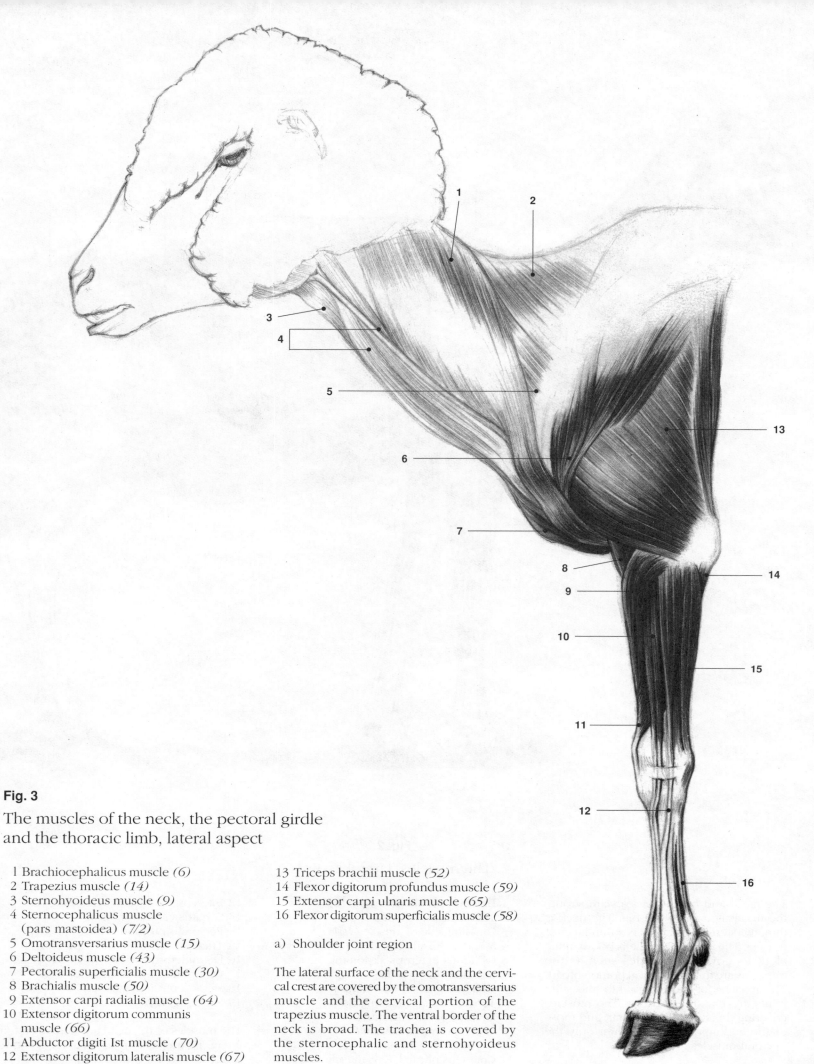

Fig. 3

The muscles of the neck, the pectoral girdle
and the thoracic limb, lateral aspect

1 Brachiocephalicus muscle *(6)*
2 Trapezius muscle *(14)*
3 Sternohyoideus muscle *(9)*
4 Sternocephalicus muscle
 (pars mastoidea) *(7/2)*
5 Omotransversarius muscle *(15)*
6 Deltoideus muscle *(43)*
7 Pectoralis superficialis muscle *(30)*
8 Brachialis muscle *(50)*
9 Extensor carpi radialis muscle *(64)*
10 Extensor digitorum communis
 muscle *(66)*
11 Abductor digiti Ist muscle *(70)*
12 Extensor digitorum lateralis muscle *(67)*

13 Triceps brachii muscle *(52)*
14 Flexor digitorum profundus muscle *(59)*
15 Extensor carpi ulnaris muscle *(65)*
16 Flexor digitorum superficialis muscle *(58)*

a) Shoulder joint region

The lateral surface of the neck and the cervi-
cal crest are covered by the omotransversarius
muscle and the cervical portion of the
trapezius muscle. The ventral border of the
neck is broad. The trachea is covered by
the sternocephalic and sternohyoideus
muscles.

416

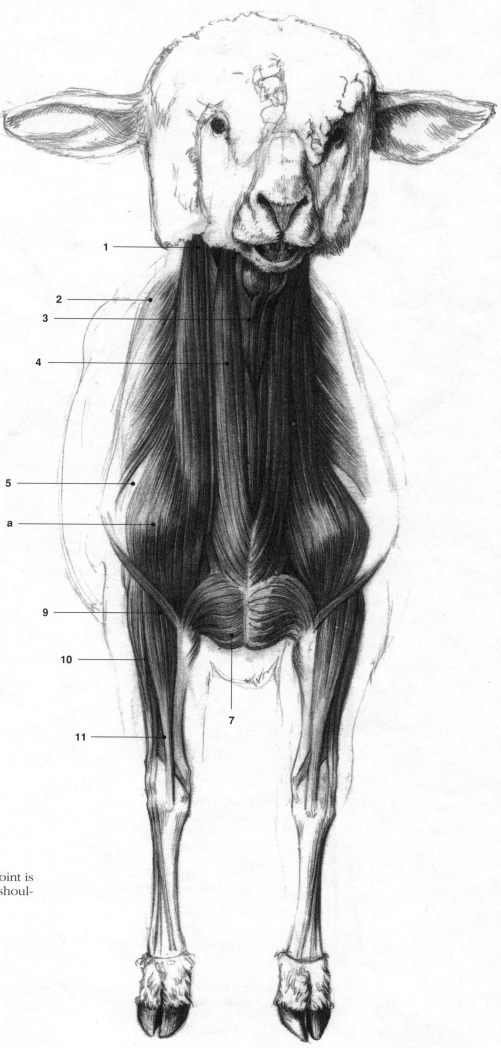

Fig. 4

The muscles of the neck,
the thorax and the forelimb,
cranial aspect

The muscles of the breast are well developed, the shoulder joint is clearly visible because of the lean and flat musculature of the shoulder blade.

Explanation see Fig. 3.

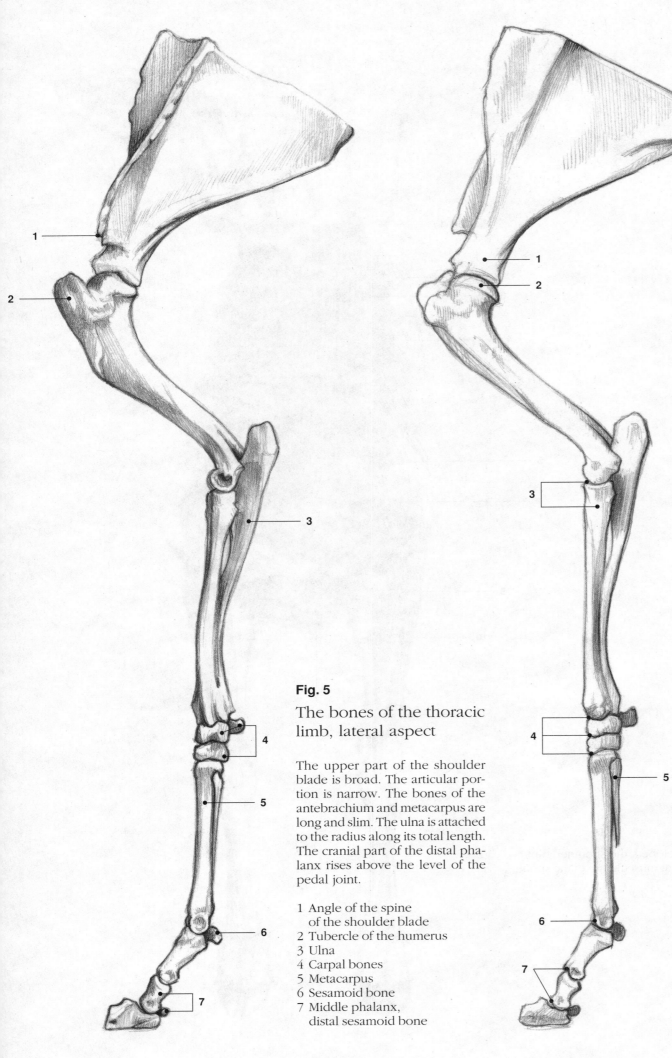

Fig. 5

The bones of the thoracic limb, lateral aspect

The upper part of the shoulder blade is broad. The articular portion is narrow. The bones of the antebrachium and metacarpus are long and slim. The ulna is attached to the radius along its total length. The cranial part of the distal phalanx rises above the level of the pedal joint.

1 Angle of the spine
 of the shoulder blade
2 Tubercle of the humerus
3 Ulna
4 Carpal bones
5 Metacarpus
6 Sesamoid bone
7 Middle phalanx,
 distal sesamoid bone

Fig. 6

The bones and the joints of the thoracic limb, medial aspect

The medial, relatively large surface of the radius is located directly under the skin. The olecranean tuber protrudes, the carpal and fetlock joints are massive.

1 Shoulder neck
2 Shoulder joint
3 Radius and elbow joint
4 Carpal joints
5 Medial splint bone
6 Fetlock joint
7 Pastern joint and pedal joint

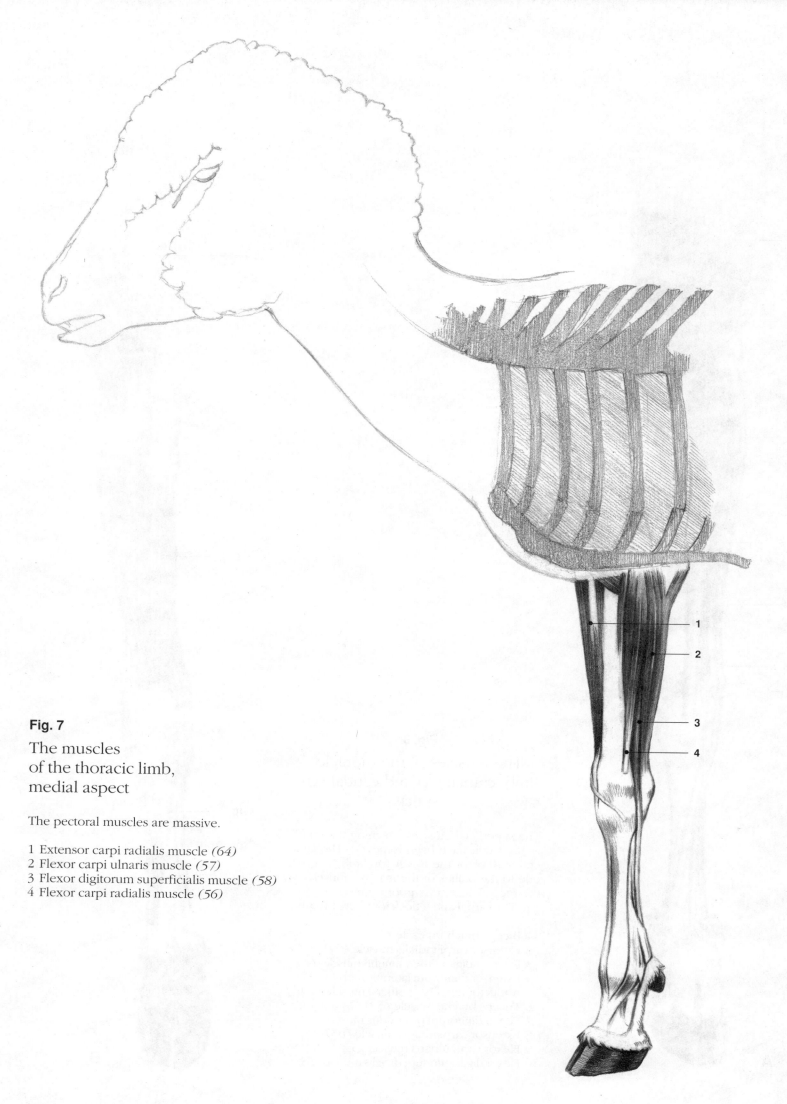

Fig. 7

The muscles
of the thoracic limb,
medial aspect

The pectoral muscles are massive.

1 Extensor carpi radialis muscle *(64)*
2 Flexor carpi ulnaris muscle *(57)*
3 Flexor digitorum superficialis muscle *(58)*
4 Flexor carpi radialis muscle *(56)*

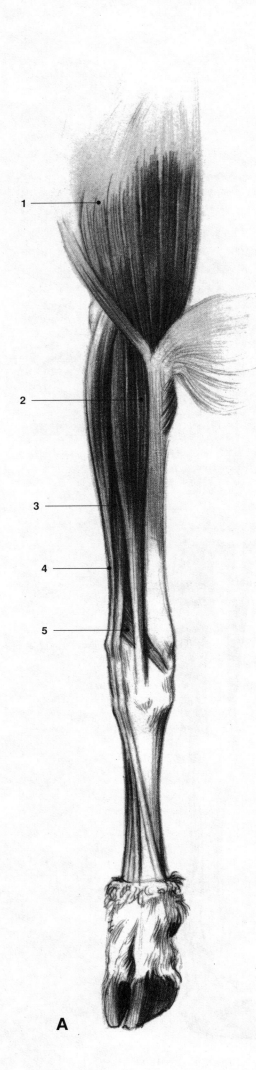

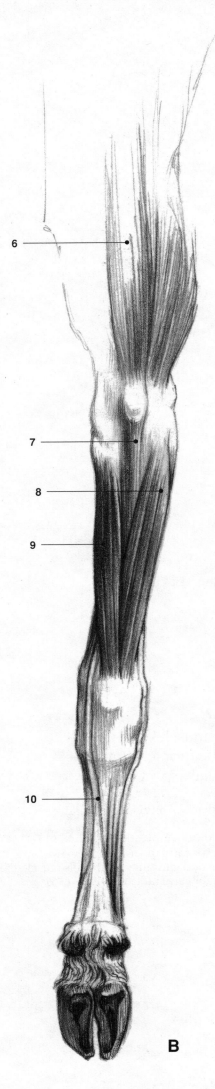

Fig. 8

The muscles of the thoracic
limb; cranial (A) and caudal (B)
aspects

The superficial muscles attaching the limb
to the trunk have been removed. The lat-
eral surface of the lower forelimb bulges
due to the bellies of the massive muscles,
the medial surface is poorly muscled and
flat. The carpal and fetlock joints are broad.

1 Biceps brachii muscle *(51)*
2 Extensor carpi radialis muscle *(64)*
3 Extensor digitorum communis muscle *(66)*
4 Extensor digitorum lateralis muscle *(67)*
5 Abductor digiti Ist (pollicis) muscle *(70)*
6 Triceps brachii muscle *(52)*
7 Flexor digitorum profundus muscle *(59)*
8 Extensor carpi ulnaris muscle *(65)*
9 Flexor capri ulnaris muscle *(57)*
10 Flexor digitorum superficialis muscle *(58)*

A

B

420

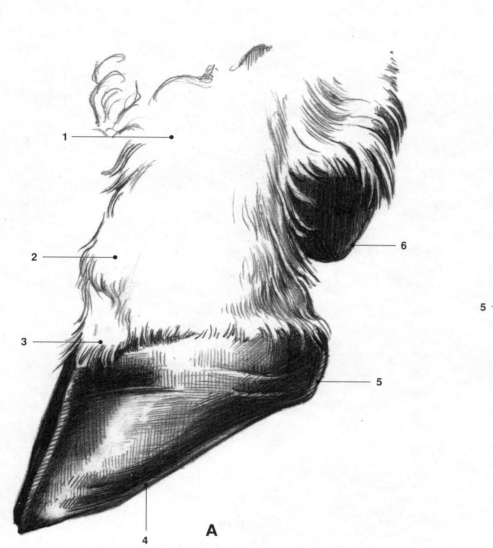

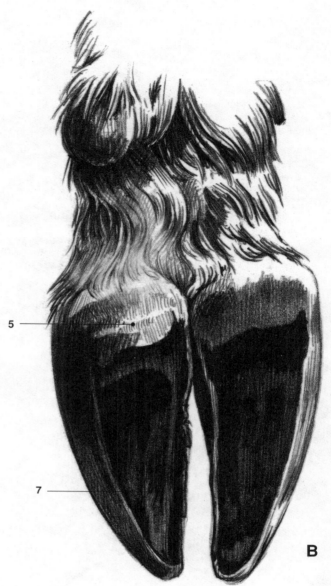

Fig. 9

The digits and the hoof of the thoracic limb; lateral (A) and palmar (B) aspects

Behind the massive fetlock joint the dew-claws are located. The fetlock and pastern regions are narrow, the distal phalanx is boat-shaped.

1 Region of the fetlock joint
2 Region of the pastern joint
3 Coronet region
4 Solear border of the parietal horn

5 Digital cushion
6 Dewclaw
7 Sole

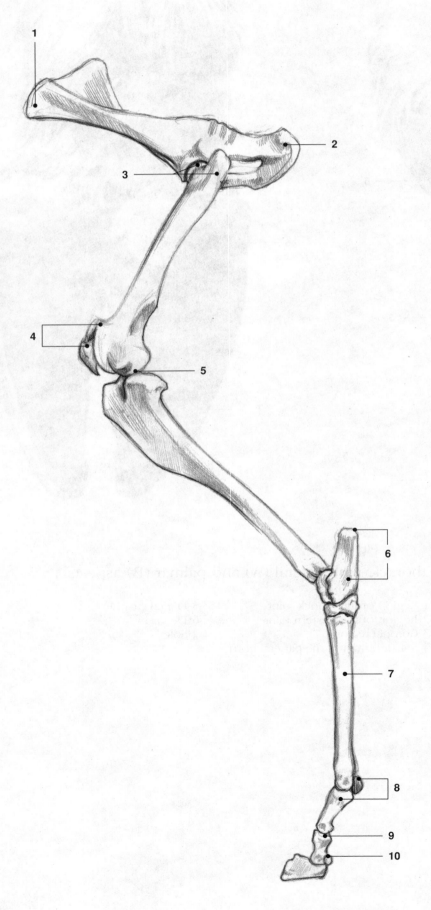

Fig. 10

The bones and the joints of the pelvic limb, lateral aspect

The bones of the pelvis are massive. The hipbone inclines forward. The femur is slim, the tibia and the metatarsus are long, the angle of the axis of the phalanges is steep, the forward opening angle of the hipbone is 90–120°, the backward opening angle of the stifle joint is 140–155°, the forward opening angle of the tarsal joint is 150–160°. The digital axis forms an angle of 55° with the ground.

1 Tuber coxae
2 Ischial tuber
3 Head of the femur and trochanter major
4 Trochlea of the femur and the patella
5 Intercondylar tubercle of the tibia
6 Calcaneus and its tubercle
7 IIIrd–IVth metatarsal bones
8 Sesamoid bones and the proximal phalanx
9 Middle phalanx
10 Distal sesamoid bone

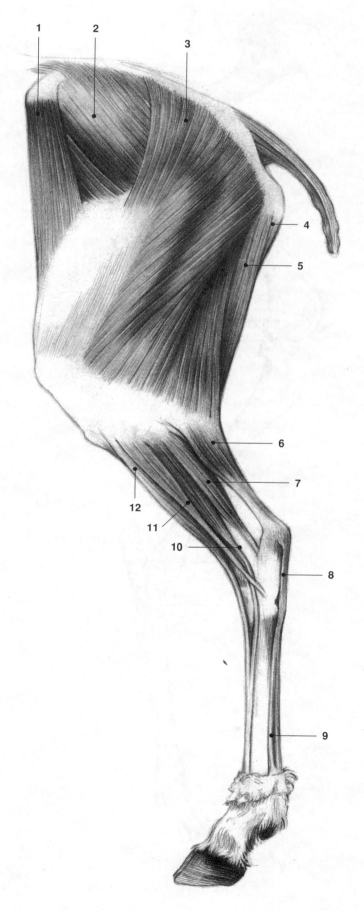

Fig. 11

The muscles of the rump and the pelvic limb, lateral aspect

The medial surface of the tibia lies directly under the skin, on its dorsal surface are the flexors of the tarsal joint, while on the plantar surface of the tibia the digital flexors can be seen. The tendons of the musculus triceps surae (extensor of the tarsal joint) and of the superficial digital flexor, originate on the tibia and are inserted on the calcanean tuber.

1 Tensor fasciae latae muscle *(95)*
2 Gluteus medius muscle *(97)*
3 Gluteobiceps muscle *(99)*
4 Semimembranosus muscle *(108)*
5 Semitendinosus muscle *(107)*
6 Triceps surae muscle *(114)*
7 Flexor digitorum profundus muscles *(124–126)*
8 Flexor digitorum superficialis muscle *(123)*
9 Interosseus medius muscle *(137)*
10 Extensor digitorum lateralis muscle *(122)*
11 Peroneus longus muscle *(121)*
12 Extensor digitorum longus muscle *(118)*

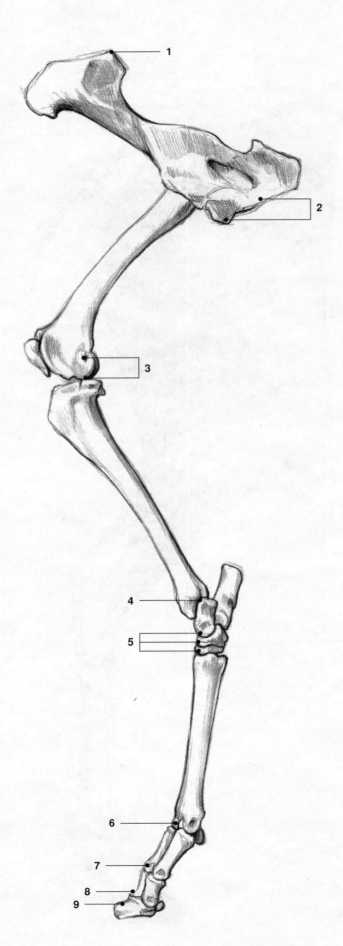

Fig. 12

The bones and the joints of the pelvic limb, medial aspect

1 Tuber sacrale
2 Ischial arch
3 Condyle and the femoro-tibial joint
4 Cochlea and the talocrural joint
5 Tarsal joints
6 Fetlock joint
7 Pastern joint
8 Pedal joint
9 Distal phalanx

Fig. 13

The muscles of the pelvic limb,
medial aspect

1 Triceps surae muscle *(114)*
2 Tibialis cranialis muscle *(117)*
3 Flexor digitorum profundus
 muscles *(124, 126)*
4 Flexor digitorum superficialis muscle *(123)*
5 Extensor digitorum longus muscle *(118)*
6 Interosseus medius muscle *(137)*

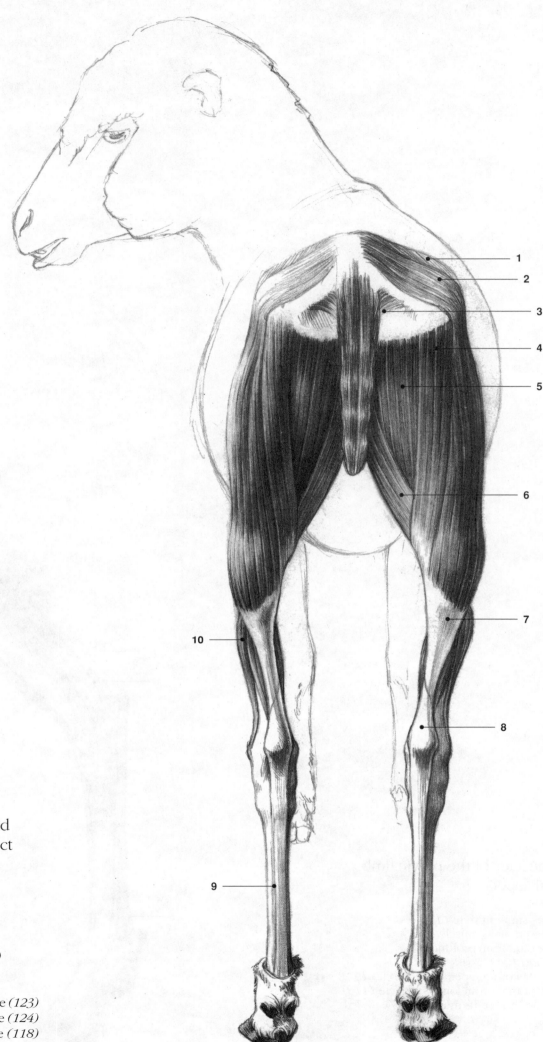

Fig. 14

The muscles of the rump and
the pelvic limb, caudal aspect

1 Gluteus medius muscle *(97)*
2 Gluteobiceps muscle *(99)*
3 Long lateral abductor of the tail
 coccygeus lateralis muscle *(180)*
4 Semitendinosus muscle *(107)*
5 Semimembranosus muscle *(108)*
6 Gracilis muscle *(104)*
7 Triceps surae muscle *(114)*
8 Flexor digitorum superficialis muscle *(123)*
9 Flexor digitorum profundus muscle *(124)*
10 Extensor digitorum longus muscle *(118)*

426

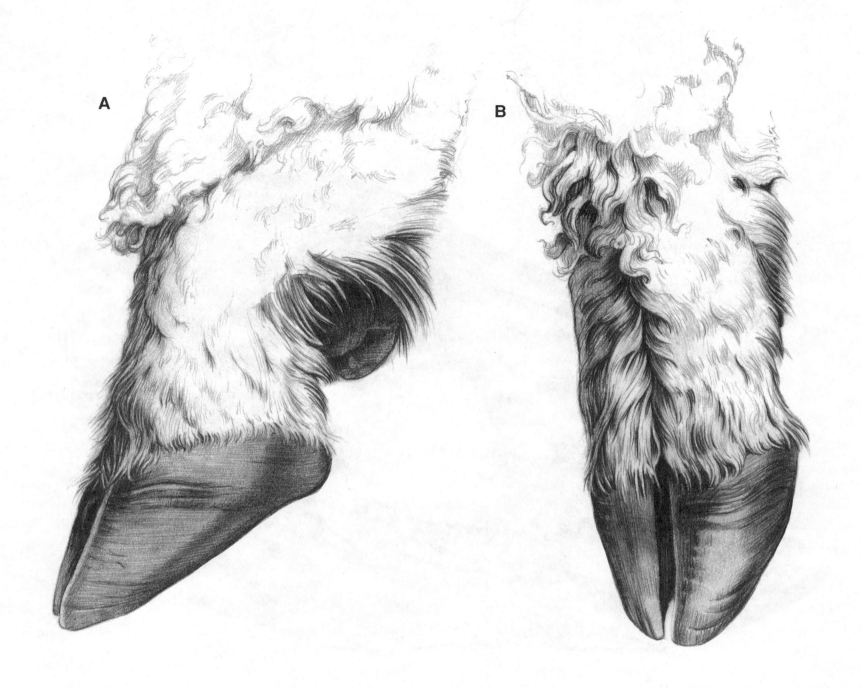

Fig. 15
The hindfoot; lateral (A) and dorsal (B) aspects

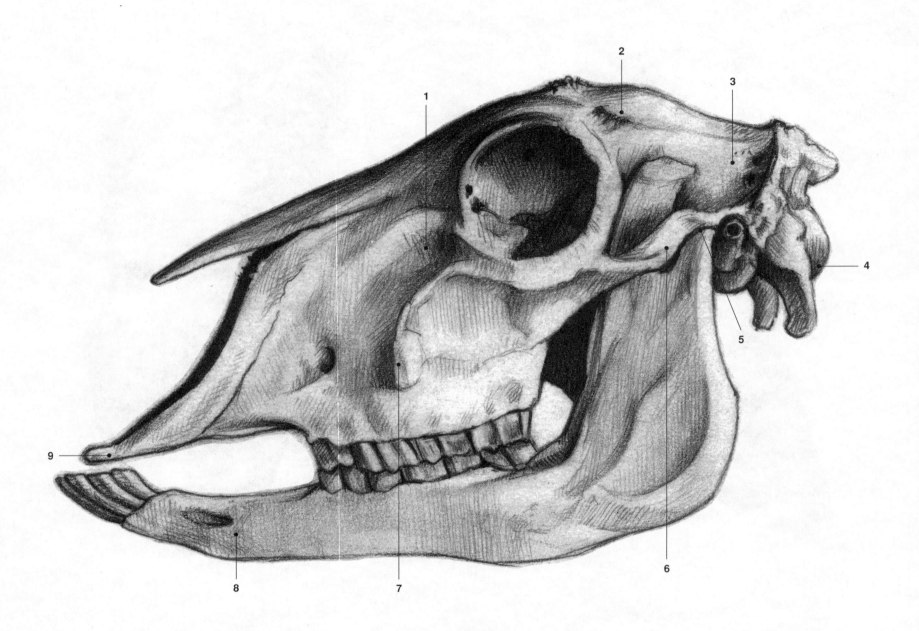

Fig. 16

The skull

The cranio-frontal region of the skull shows a convex profile. The orbit and the fossa temporalis are big. On the lacrimal bone a deep lacrimal fossa can be seen. The zygomatic arch and the facial crest are narrow. The proportion of the neurocranium and the facial region is 1:2.5. The high nose is flattened on the side, the mandible is massive.

1 Fossa lacrimalis
2 Frontal bone
3 Parietal bone and fossa temporalis
4 Occipital bone
5 Mandibular joint
6 Zygomatic arch
7 Facial crest ending on the maxilla
8 Mandible
9 Incisive bone

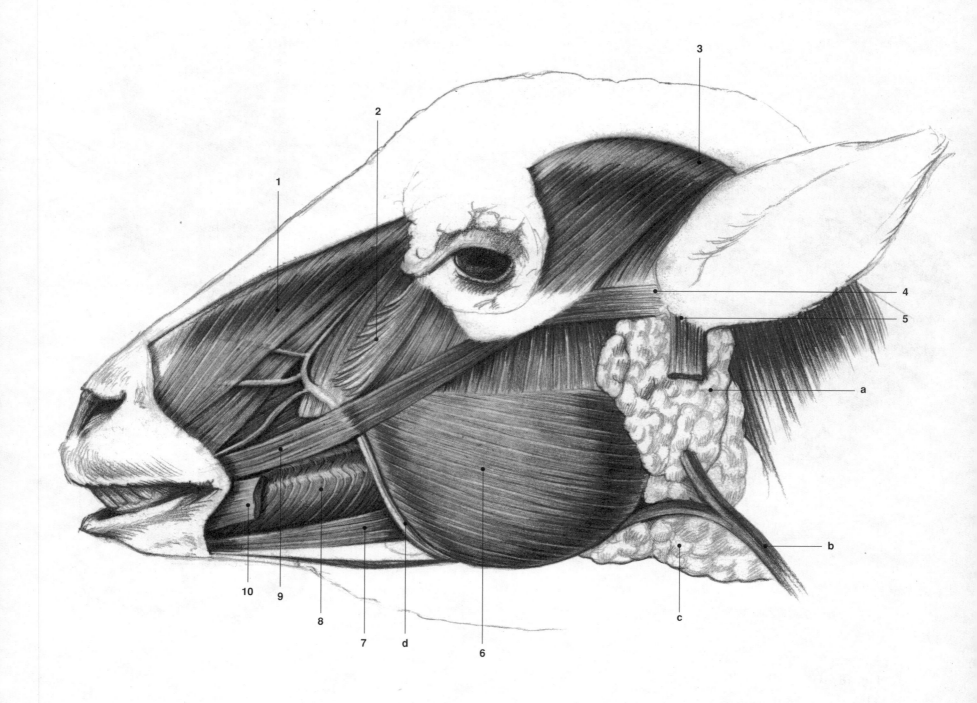

Fig. 17

The muscles of the head

The muscles of the face are well developed, broad and flat. The buccal and masticatory muscles are massive.

1 Levator nasolabialis muscle *(164)*
2 Malaris muscle *(159)*
3 Temporalis muscle *(179)*

4 Zygomatico auricularis muscle *(143)*
5 Depressor muscle of the ear *(150)*
6 Masseter muscle *(178)*
7 Depressor labii mandibularis muscle *(170)*
8 Buccalis muscle *(175)*
9 Zygomaticus muscle *(174)*
10 Depressor anguli oris muscle *(170/1)*

a) Parotid gland
b) Jugular vein
c) Mandibular gland
d) Facial artery and vein

429

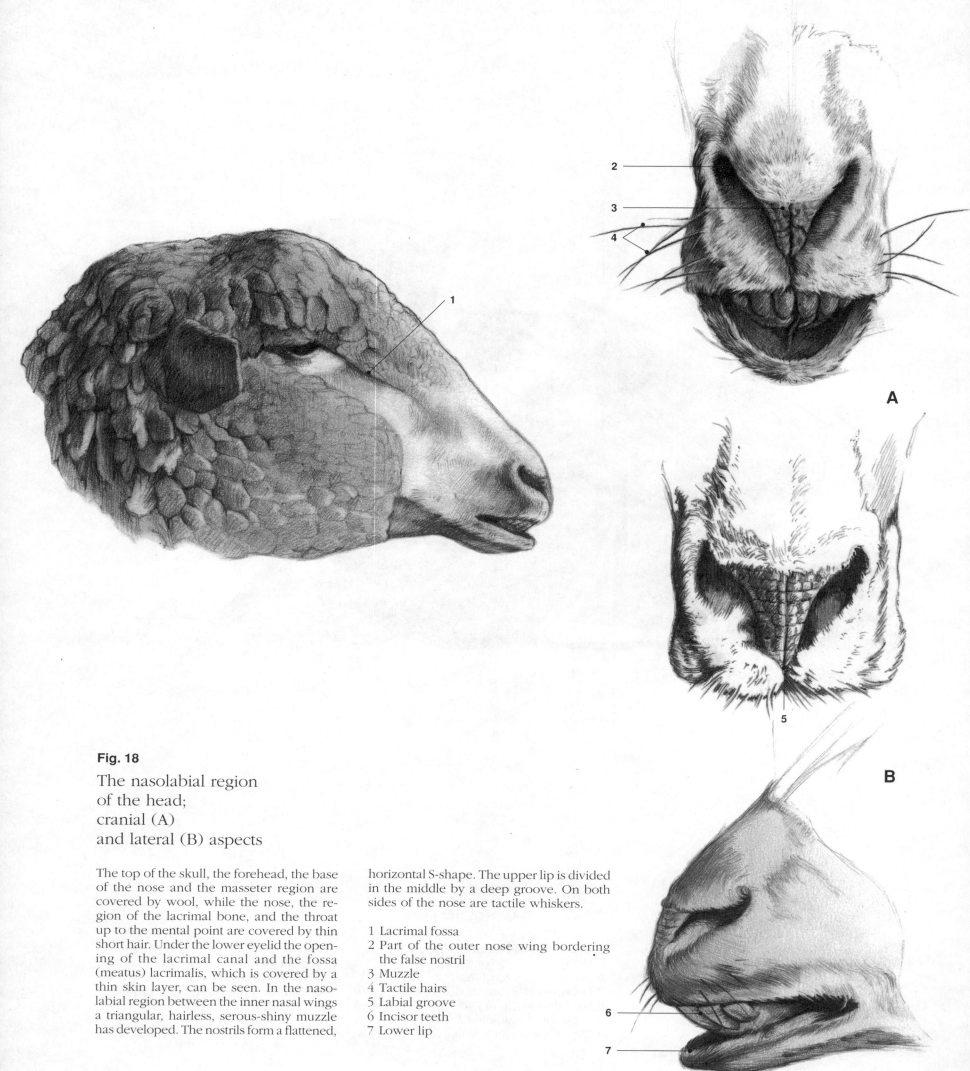

Fig. 18

The nasolabial region
of the head;
cranial (A)
and lateral (B) aspects

The top of the skull, the forehead, the base of the nose and the masseter region are covered by wool, while the nose, the region of the lacrimal bone, and the throat up to the mental point are covered by thin short hair. Under the lower eyelid the opening of the lacrimal canal and the fossa (meatus) lacrimalis, which is covered by a thin skin layer, can be seen. In the nasolabial region between the inner nasal wings a triangular, hairless, serous-shiny muzzle has developed. The nostrils form a flattened,

horizontal S-shape. The upper lip is divided in the middle by a deep groove. On both sides of the nose are tactile whiskers.

1 Lacrimal fossa
2 Part of the outer nose wing bordering the false nostril
3 Muzzle
4 Tactile hairs
5 Labial groove
6 Incisor teeth
7 Lower lip

430

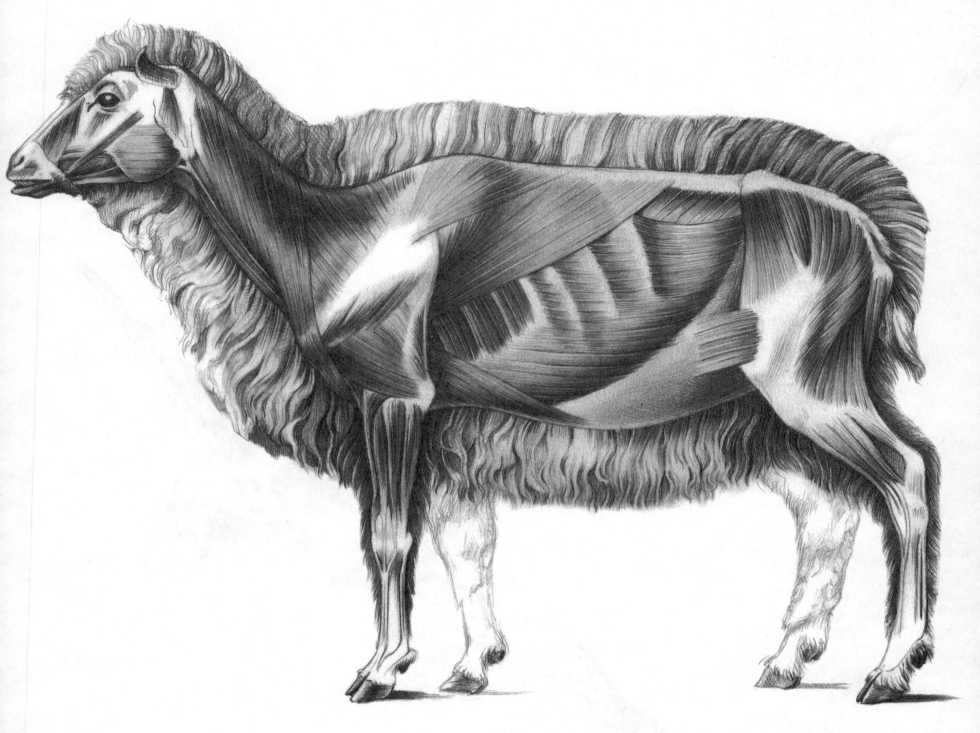

Fig. 19

The muscles, the skin and the fleece

The body – except the nose, face, lips, ears, fingers, armpit and the medial surface of the thighs – is covered by wool or hair of nearly equal length. The quality of the wool depends upon the individual breed. The merino has fine wool, while the Hungarian racka has long, coarse fibres in the fleece. In certain regions (face, ears, distal part of the legs and in the inguinal region) there is fine hair instead of wool. Over loose, thick subcutaneous tissue the skin can be elevated into deep folds.

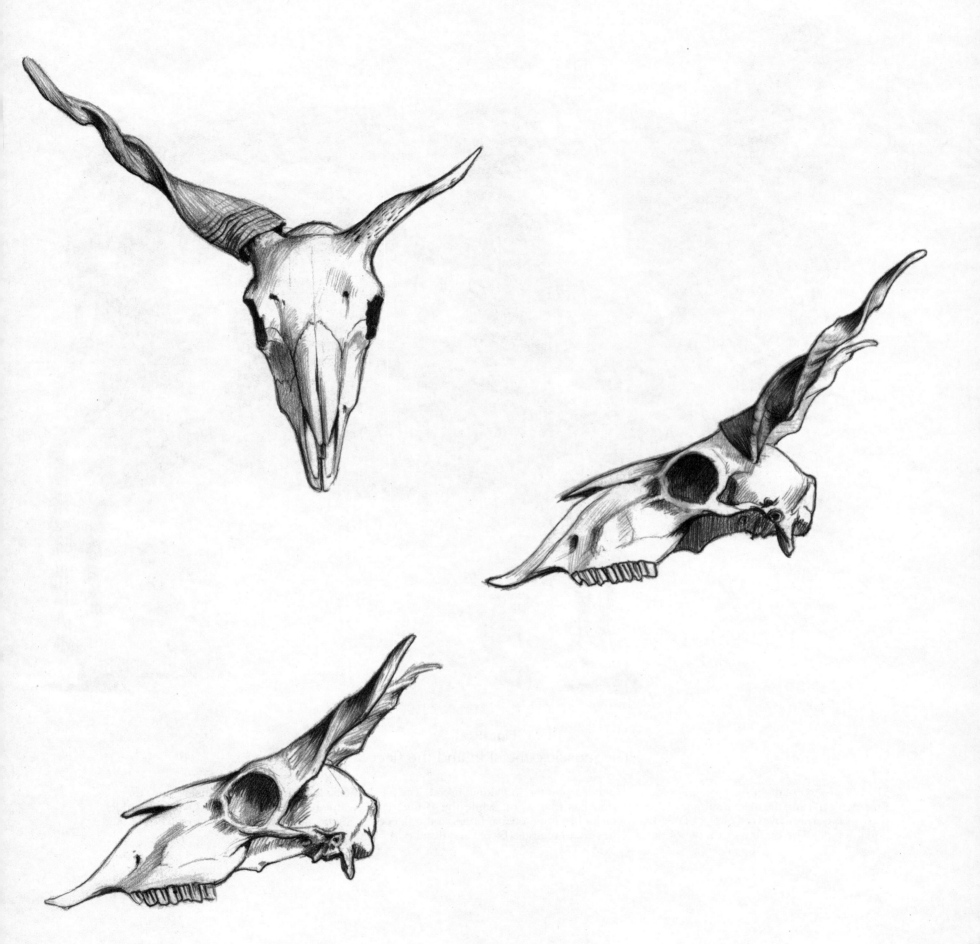

Fig. 20
The twirled horn of the racka sheep

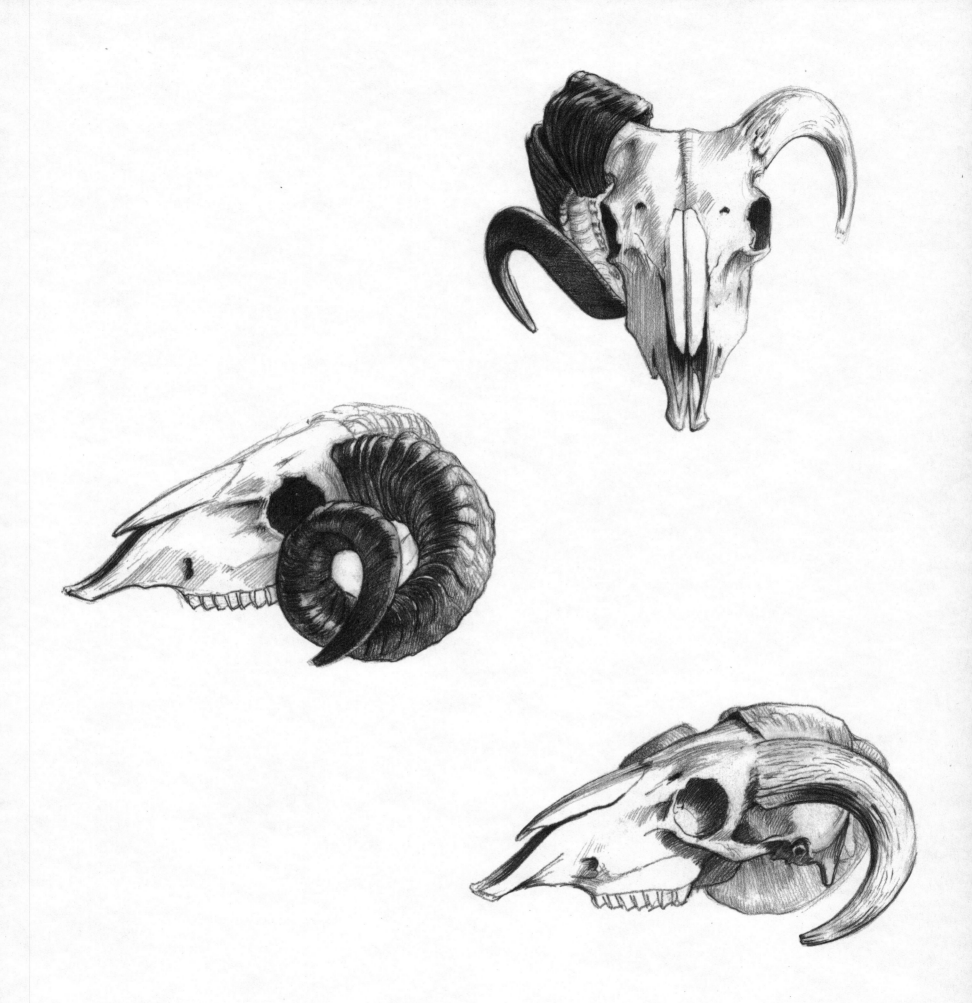

Fig. 21

The helix-shaped horn of the merino sheep

THE BEAR

The brown bear is the largest terrestrial predator. All seven species of bear (brown bear, Himalayan black bear, American black bear, Polar bear, Himalayan bear, Malay bear, spectacled bear) have a heavy build with an extremely muscular body and a large head.

Fully grown bears are solitary animals and avoid contact with other members of the species outside the breeding season. If two bears meet they will almost certainly fight. Brown bears need large woodland territories of about 3000 ha (7500 acres) per animal. Polar bears, on the other hand, have no fixed territories and wander around the vast Arctic drift ice.

Bears express their moods primarily with their posture and with sounds. The ears and tail, because of their small size, do not play a large part in this emotional behaviour. Posture is especially important in threatening displays, when bears stand on their hind legs, paws raised and teeth displayed whilst growling and snarling.

The nose is the bear's most important sense organ, and bears have an excellent sense of smell. In order to view their surroundings and to detect smells they often stand on their hind legs.

When hunting or fleeing, bears are able to gallop and reach a speed of up to 40 km/h (25 mph), despite their large size. They walk on the soles of their feet, which have thick pads. The soles of polar bears' feet are covered with thick fur to protect them against the cold. The claws, which cannot be retracted, are useful for climbing. Young bears are especially agile, climbing into trees as a means of escaping enemies. The bodies of polar bears are adapted to their lifestyle, with webs between their toes and a very smooth coat which is ideal for swimming – they can swim at up to 10 km/h (6 mph).

Brown bears are omnivores and eat roots, berries, mushrooms, worms, snails, insects and their larvae, birds' eggs and fish, as well as small and large mammals. Their teeth are adapted to their diet. The canine teeth are used for catching prey. Some of the molars are used for tearing food, others have smooth, broad ridges which are ideal for grinding plants.

Bears use their large wide paws for obtaining food. They gather ants and ant larvae from anthills which they have broken up, and honey from the hives of wild bees. Their thick, warm coat is a welcome protection against formic acid, which is released by ants, and insect bites. Unlike the omniverous brown bears, polar bears eat mainly seals which are caught on the drift ice.

In winter when snow and ice make food almost unobtainable, brown bears retreat into natural caves where they hibernate. They line their winter lodgings with fir branches, leaves and hay, and go to sleep for the winter, only waking for short periods. During hibernation their body temperature and respiration rate drop. Grizzly bears dig caves which reach deep into the earth. Although polar bears are well adapted to their hard life in the arctic they retreat into snow-caves, which they dig when the weather is particularly bad.

Bear cubs are usually born in a cave during the period when food is scarce. The female typically gives birth to two or three cubs, which are totally helpless. They leave their cave with their mother in spring. By the time the young bears are one to three years old they either leave their mother voluntarily or are chased away by her. Females are sexually mature at the age of two years, but males can take up to six years to reach sexual maturity.

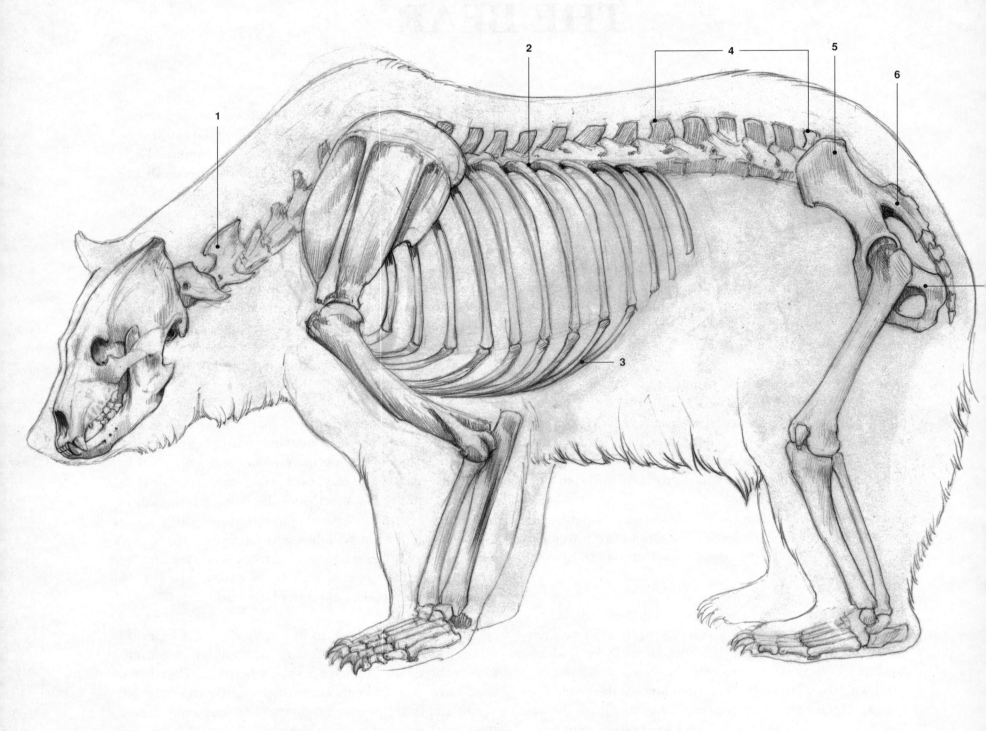

Fig. 1

The skeleton

The cervical part of the vertebral column is short. The dorso-lumbar portion is straight or slightly bent. The spinous processes of the thoracic vertebrae are short. The ribs are narrow, the body of the sternum is rounded. The rump is steep; the sacrum and the pelvis are bent downward. The cranial part of the pelvis (located in front of the hip joint) and the hipbone are long, the ischial bone is short.

1 IInd cervical vertebra (axis)
2 VIIIth rib
3 Costal arch

4 Lumbar vertebrae
5 Wing of the hipbone
6 Sacrum
7 Pin bone

The bones of the skull are demonstrated in Fig. 7, those of the limbs in Figs. 3 and 5.

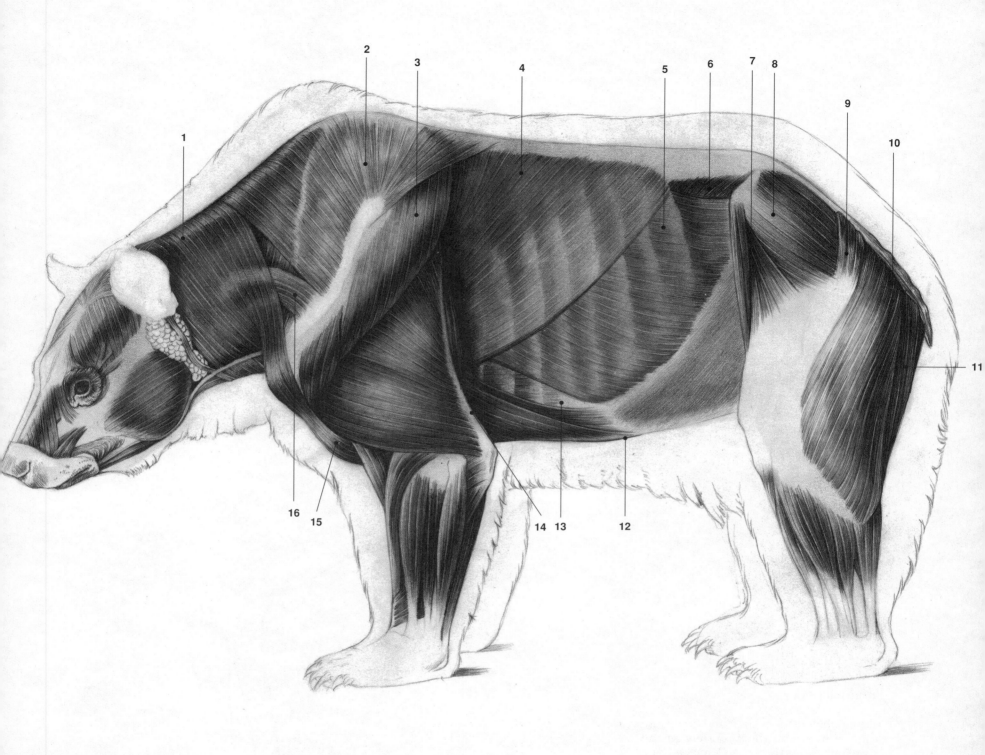

Fig. 2

The muscles

The bear's trunk and neck are short. The strongest group of muscles is in the shoulder region. The masticatory, arm and thigh muscles are large and strong.

1 Sternocephalicus muscle *(7)*
2 Trapezius muscle *(14)*
3 Deltoideus muscle *(43)*
4 Latissimus dorsi muscle *(16)*

5 Obliquus externus abdominis muscle *(36)*
6 Obliquus internus abdominis muscle *(37)*
7 Tensor fasciae latae muscle *(95)*
8 Gluteus medius muscle *(97)*
9 Gluteus superficialis muscle *(96)*
10 Biceps femoris muscle *(106)*
11 Semitendinosus muscle *(107)*

12 Pectoralis profundus muscle *(30)*
13 Intercostalis externus muscle *(33)*
14 Triceps brachii muscle *(52)*
15 Brachiocephalicus muscle *(6)*
16 Omotransversarius muscle *(15)*

The muscles of the head are demonstrated in Fig. 8, those of the limbs in Figs. 4 and 6, respectively.

437

Fig. 3

The bones of the shoulder and the thoracic limb, lateral aspect

The shoulder blade is short and broad, the spine is high and thick, ending in the acromion process (processus hamatus). The body of the humerus is long and arched. In the foreleg the ulna is more developed than the radius. Some of the carpal bones touch the ground (plantigrade). The five metacarpal bones and the phalanges are short.

1 The caudal edge of the shoulder blade is incized
2 Deltoid tuberosity of the humerus
3 Ulna
4 Radius
5 Carpal bones
6 Claw bone
7 Middle phalanx
8 Proximal phalanx
9 Metacarpal bone

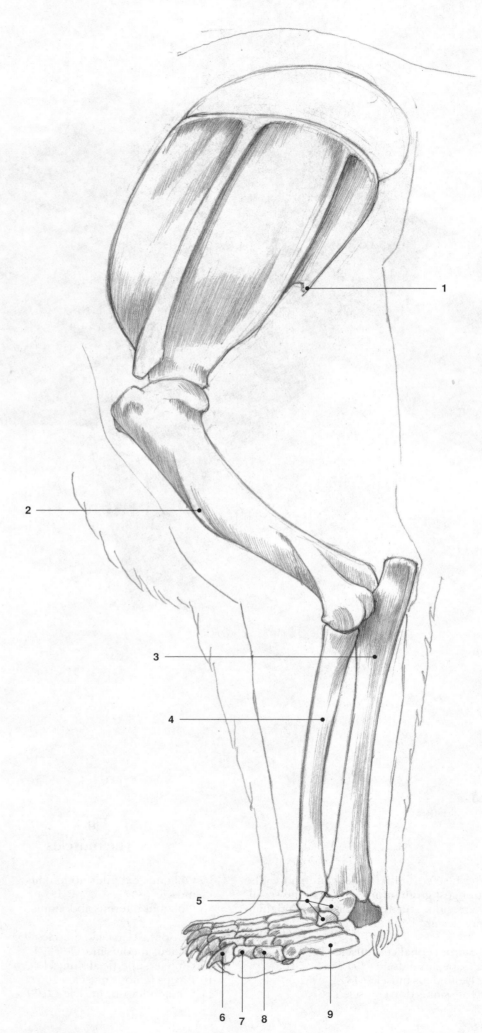

Fig. 4

The muscles of the shoulder and the thoracic limb, lateral aspect

The limb is robust as far as the carpus, it is covered by muscles; the muscles of the shoulder girdle, the shoulder and elbow are particularly bulky. The many movements of the paw (walking, catching, hitting) are produced by different rotatory muscles of the forearm.

1 Brachialis muscle *(50)*
2 Extensor carpi radialis muscle *(64)*
3 Extensor digitorum communis muscle *(66)*
4 Abductor digiti Ist longus muscle *(70)*
5 Flexor digitorum profundus muscle *(59)*
6 Flexor carpi ulnaris muscle *(57)*
7 Extensor carpi ulnaris muscle *(65)*
8 Extensor digitorum lateralis muscle *(67)*

a) Olecranon

The muscles of the shoulder and elbow joints are demonstrated in Fig. 2.

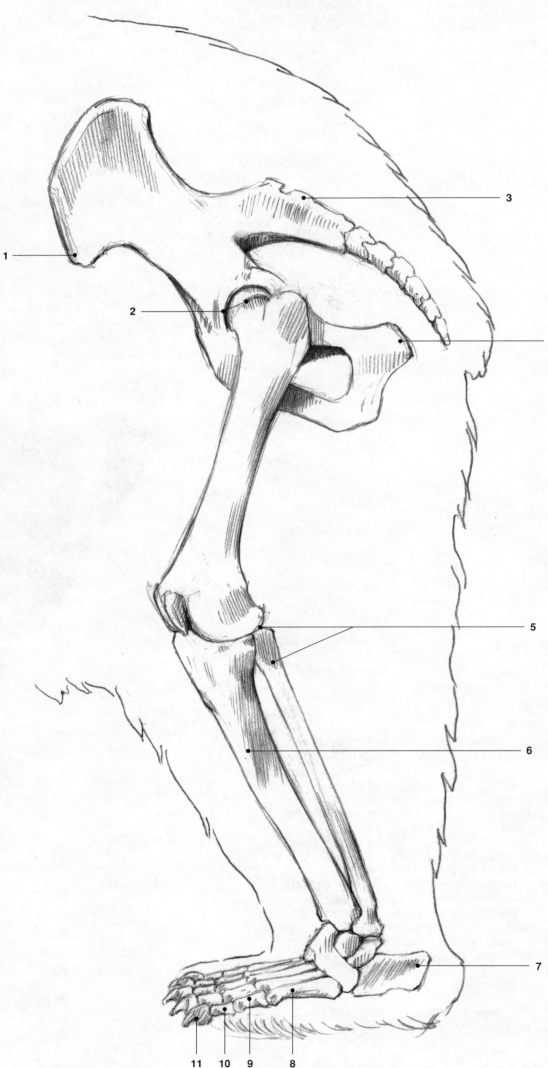

Fig. 5

The bones of the pelvic limb, lateral aspect

The pelvis is robust and thick, the sacrum attached to it is dorsally arched (convex). The main framework of the limb is composed of the femur and the bones of the crus. The tubercle of the hock bone is directed backward.

The sole is formed by the tarsal, metatarsal and phalangeal bones.

1 Tuber coxae
2 Head of the femur, hip joint
3 Sacrum
4 Pin bone
5 Fibula, stifle joint
6 Tibia
7 Calcanean bone
8 Metatarsal bone
9 Proximal phalanx
10 Middle phalanx
11 Claw bone

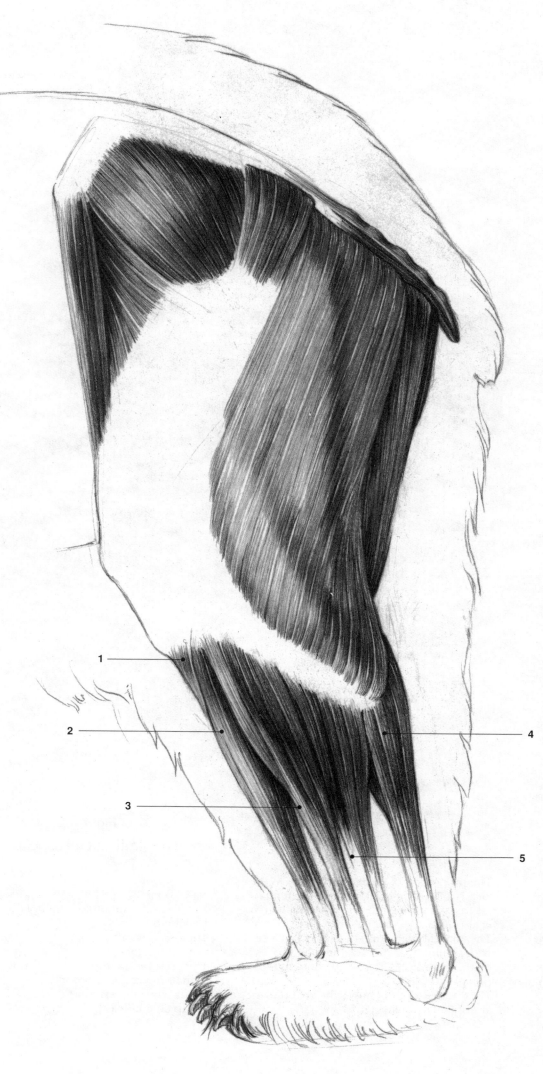

Fig. 6

The muscles of the pelvic limb, lateral aspect

The musculature of the pelvis consists of short robust muscles. The thigh is long and laterally flattened. The crus is well muscled.

1 Tibialis cranialis muscle *(117)*
2 Peroneus tertius muscle *(119)*
3 Extensor digitorum longus muscle *(118)*
4 Gastrocnemius muscle *(115)*
5 Extensor digitorum lateralis muscle *(122)*

The muscles of the hip and the stifle joints are demonstrated in Fig. 2.

441

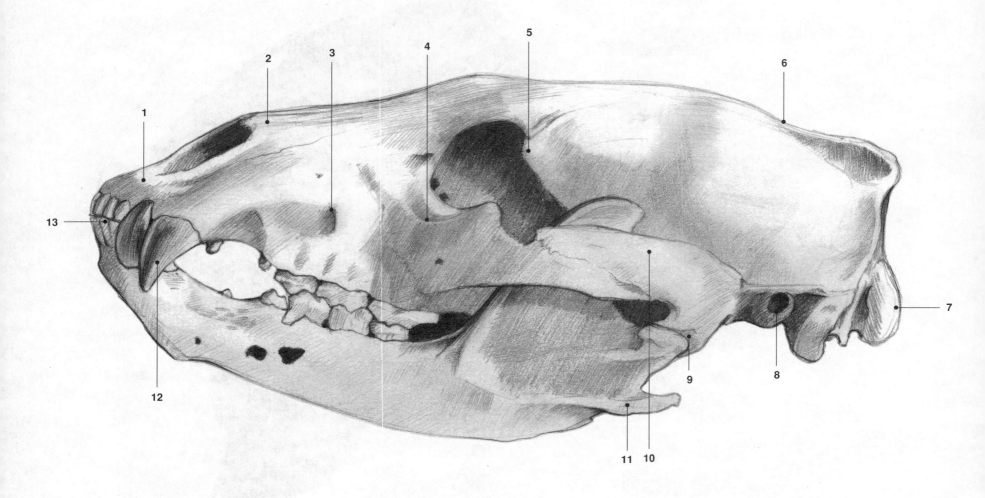

Fig. 7

The skull, lateral aspect

The proportion of the neurocranium to the face is 1:1.2. The orbit is small, the temporal fossa is elongated, the zygomatic arch is also laterally curved.

The mandibular ramus is short but very wide, a muscular process (angular process of the mandible) rises from its angle; it points caudally.

The canine tooth is huge, the real molars are of laniary character.

1 Incisive bone
2 Nasal bone
3 Maxilla with the infraorbital hole
4 Facial crest
5 The osseous orbit is open toward the rear
6 The crest on the top of the head is high at the caudal portion (crista sagittalis externa)
7 Occipital condyle

8 External osseous auditory canal
9 Mandibular joint
10 Zygomatic arch
11 Muscular process of the mandibular angle
12 Canine teeth
13 Incisor teeth

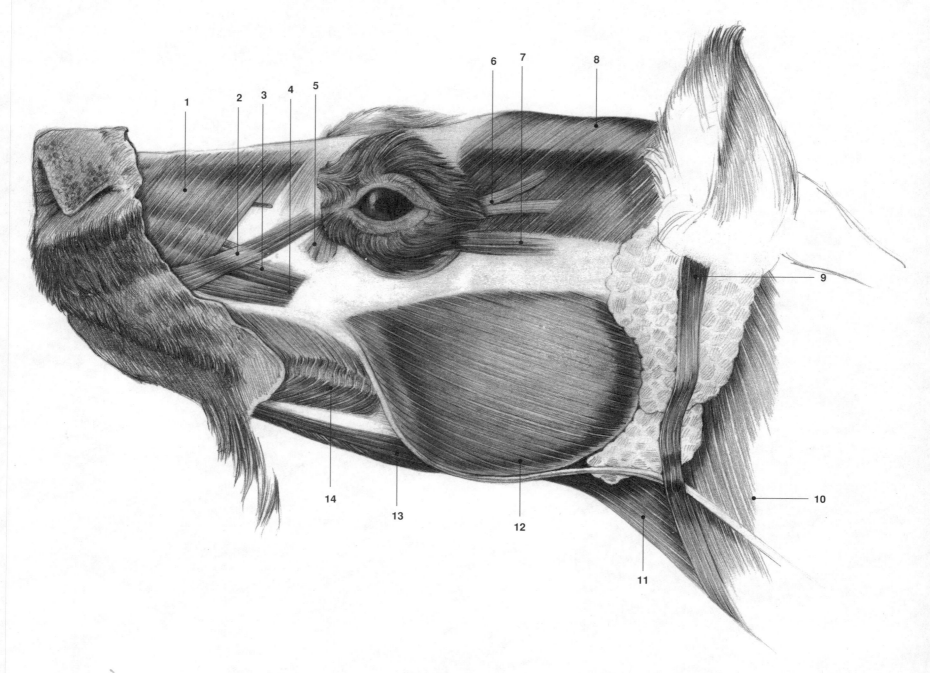

Fig. 8

The muscles of the head, lateral aspect

The adductor (biting) muscles of the mandible are well developed.

1 Levator nasolabialis muscle *(164)*
2 Zygomatic muscle *(174)*
3 Levator labii maxillaris muscle *(168)*

4 Caninus muscle *(165)*
5 Malaris muscle *(159)*
6 Levator palpebrae superioris muscle *(156)*
7 Retractor anguli oculi lateralis muscle *(158)*
8 Temporalis muscle *(179)*
9 Parotideoauricularis muscle *(150)*

10 Sternocephalicus muscle *(7)*
11 Sternohyoideus muscle *(9)*
12 Masseter muscle *(178)*
13 Depressor labii mandibularis muscle *(170)*
14 Buccalis muscle *(175)*

THE DEER

The most common European species of deer are fallow deer, red deer, and roe deer. Their main distinguishing features are antlers, which grow from the head of the males; these antlers are hormonally controlled and grow from the bony pedicle, which is an extension of the frontal bone.

Antlers consist of bone; during growth they are covered by a skin that is supplied with blood, covered with hair, and called antler velvet. As time goes on the blood supply to the antler velvet decreases until it dies. The animal then feels the urge to get rid of this skin; during shedding the stag rubs its antlers on shrubs and trees, and the velvet comes off in pieces. The antlers are lost in spring or late autumn, depending on the species. The size of the antlers depends on the age, social rank and size of the animal. All antlers, even the largest, regrow each year to their full size. Antlers serve as weapons not so much in competition for food, but rather in contests for the leadership of a herd. Males rarely try to injure or even kill members of the same species; the size and splendour of the antlers are a means of impressing opponents. If the opponent fails to take notice the contest begins. Each pushes its adversary back with its antlers, trying to force the other party to retreat or expose its flank, the most vulnerable part of the body. Usually one stag flees before injuries occur, and the victor gains possession of the females over which he has fought.

All deer are paired ungulates. If they sense danger they flee at very high speed on long, slim legs. Red deer in particular rely on stamina and speed to escape. They reach a speed of 76 km/h (48 mph) and can jump a distance of 11 metres (36 ft). Roe and fallow deer tend to flee into nearby undergrowth where they can move around easily thanks to their small size. Roe deer often crouch when danger threatens and remain very still, so that the enemy does not notice them.

Because of their acute sense of smell and hearing deer can perceive danger early. They lift their head high in order to assess the threat visually. Their funnel-shaped external ears are very noticeable, covered both outside and inside with dense hair. They can be moved individually in either direction. This enables the animals to locate the direction of sounds.

Deer are herbivores and have the typical digestive system of ruminants. They live off grass, herbs, buds, tender leaves, and other juicy plant parts.

Red deer (Cervus elaphus) belong to the largest deer species of Central Europe. When fully grown they can reach a length of 265 cm (9 ft) and weigh up to 340 kg (750 lbs). They need a habitat with extensive woodland and a dense growth of trees. During the rut in the autumn the antlers, which can have up to 24 points depending on the age of the stag, are fully developed.

Fallow deer also live in wooded regions. They are very shy animals who flee quckly, with long jumps and an erect tail, as soon as they sense danger. On their foreheads they bear palmated antlers which start to grow in the winter of their first year.

Roe deer live in many wooded areas which are not densely populated. They do not need woodland, but merely the cover of shrubs and trees, which provide sufficient protection for them to feel safe during the day. They are active at dusk and are able to find sufficient food in fields, meadows, and along hedgerows.

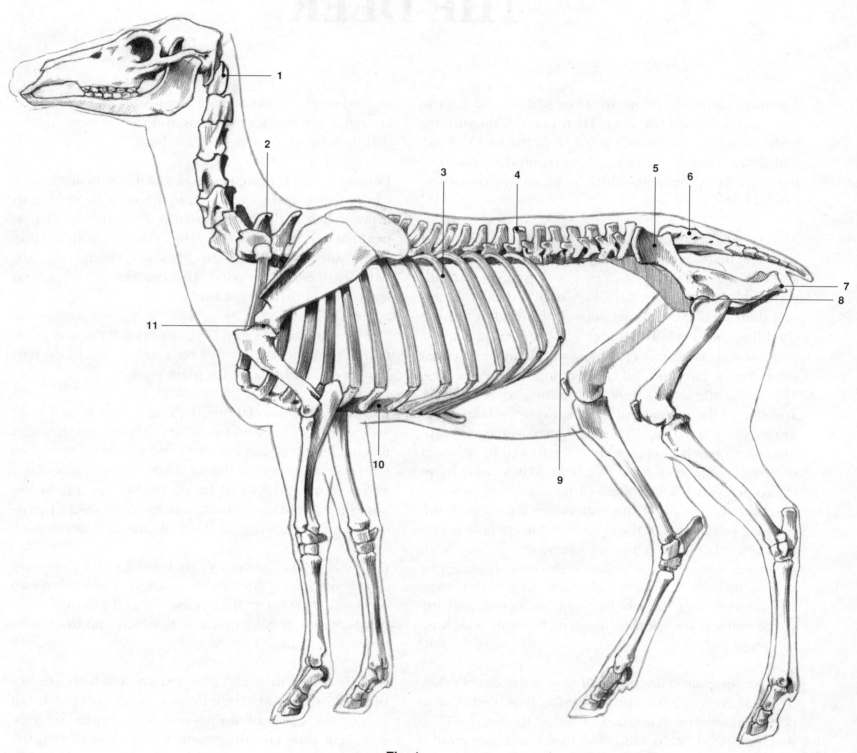

Fig. 1

The skeleton

The skeleton of the deer is constructed of long, thin, but firm and elastic bones. The dorso-lumbar portion of the vertebral column is straight. The base of the cervical part turns sharply upwards, so that the standing animal holds its head high. The chest is deep and flattened; it has 12 pairs of ribs. The limbs and particularly the metacarpal and metatarsal bones are long.

1 Ist cervical vertebra (atlas)
2 VIIth cervical vertebra
3 VIIIth rib
4 Last thoracic vertebra
5 Hipbone
6 Sacrum
7 Ischial tuberosity
8 Hip joint
9 Costal arch
10 Sternum
11 Shoulder joint

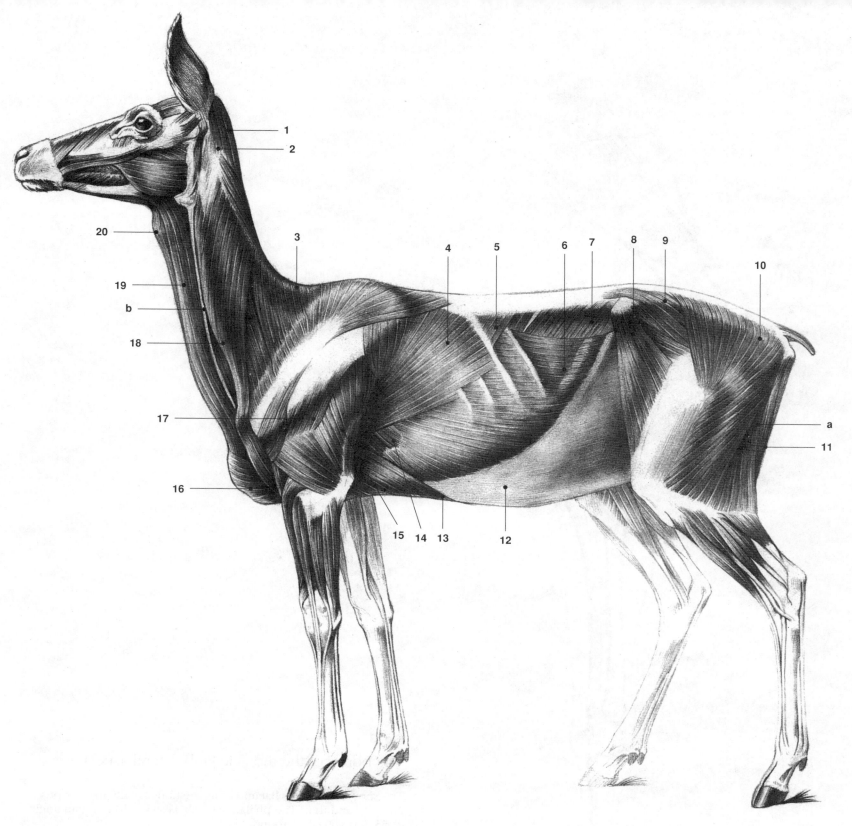

Fig. 2

The muscles

The superficial muscles are well developed, and distinctly separate from each other. The sides of the chest and abdomen are formed by flat, tendinous, lamellar muscles. The musculature of the breast, shoulder, arm and thigh consists of strong and bulky groups of muscles. The bones of the lower foreleg and crus are covered by tendinous, spindle-shaped muscles.

1 Rectus capitis dorsalis muscle *(3)*
2 Obliquus capitis caudalis muscle *(4)*
3 Trapezius muscle *(14)*
4 Latissimus dorsi muscle *(16)*
5 Serratus dorsalis muscle, caudal part *(19)*
6 Obliquus externus abdominis muscle *(36)*
7 Obliquus internus abdominis muscle *(37)*
8 Tensor fasciae latae muscle *(95)*
9 Gluteus medius muscle *(97)*
10 Gluteobiceps muscle *(99)*
11 Semitendinosus muscle *(107)*

12 Vagina recti abdominis muscle *(40)*
13 Musculus pectoralis ascendens *(30)*
14 Serratus ventralis muscle, pectoral part *(18)*
15 Triceps brachii muscle *(52)*
16 Pectoralis descendens muscle *(29)*
17 Deltoideus muscle *(43)*
18 Brachiocephalicus muscle *(6)*
19 Sternomandibularis muscle *(7)*
20 Sternohyoideus muscle *(9)*

a) Ischial groove
b) Jugular groove with the jugular vein

447

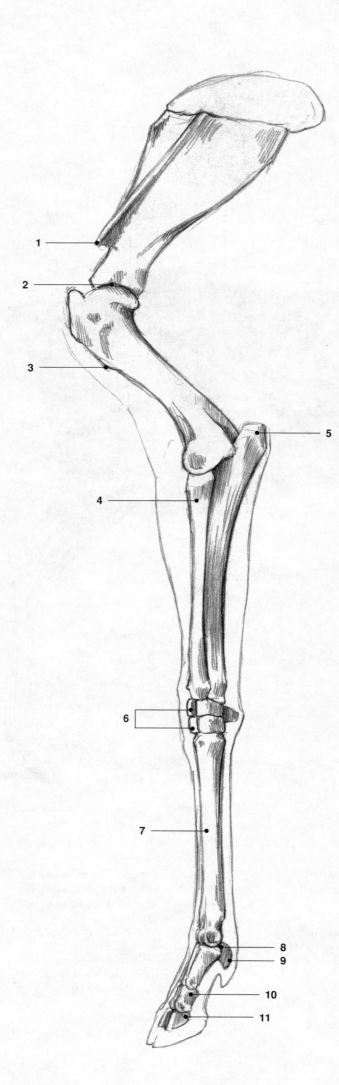

Fig. 3

The bones of the thoracic limb, lateral aspect

The shoulder blade is flat and long, the bones of the metacarpus are long and thin. The phalangeal axis is steep, forming an angle of 55–60° with the ground.

1 Acromion of the scapular spine
2 Shoulder joint
3 Deltoid tuberosity of the humerus
4 Radius
5 The olecranon is relatively short
6 Two rows of the carpal bones
7 The IIIrd and IVth metacarpal bone are united
8 Fetlock joint
9 Sesamoid bone
10 Pastern joint
11 Pedal joint

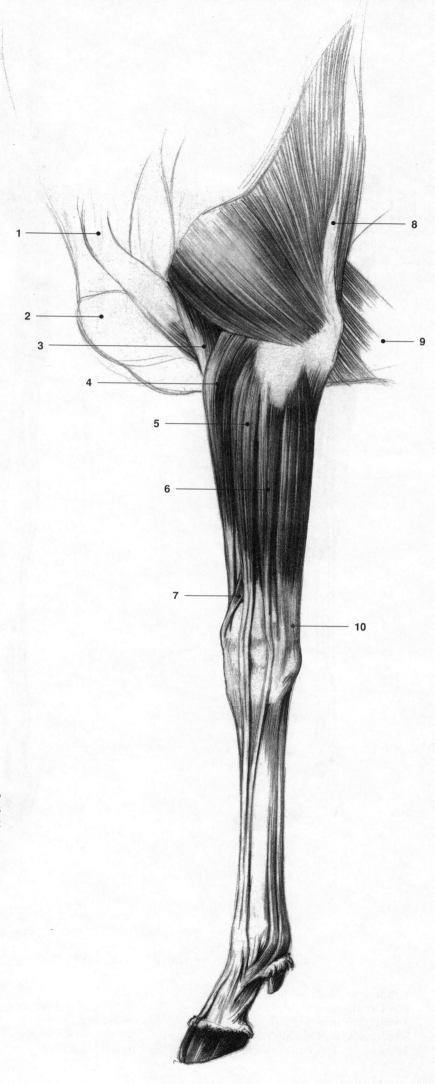

Fig. 4

The muscles of the thoracic limb, lateral aspect

The extensor muscle of the elbow joint is enormously developed, to help jumping and locomotion. The spindle-shaped muscle bellies of the metacarpus and the phalanges continue in a long tendon at the lower third of the foreleg. The carpus and leg are thin, covered only by tendons. The contours of the muscles and tendons are easily distinguished. The tendons of the flexors pass over the surface of the metacarpiens bones; they are palpable under the skin.

 1 Brachiocephalicus muscle *(6)*
 2 Pectoralis descendens muscle *(29)*
 3 Brachialis muscle *(50)*
 4 Extensor carpi radialis muscle *(64)*
 5 Extensor digiti IIIrd muscle *(66)*
 6 Extensor digiti IVth muscle *(67)*
 7 Abductor digiti Ist muscle *(70)*
 8 Triceps brachii muscle *(52)*
 9 Pectoralis profundus muscle *(30)*
10 Extensor carpi ulnaris muscle *(65)*

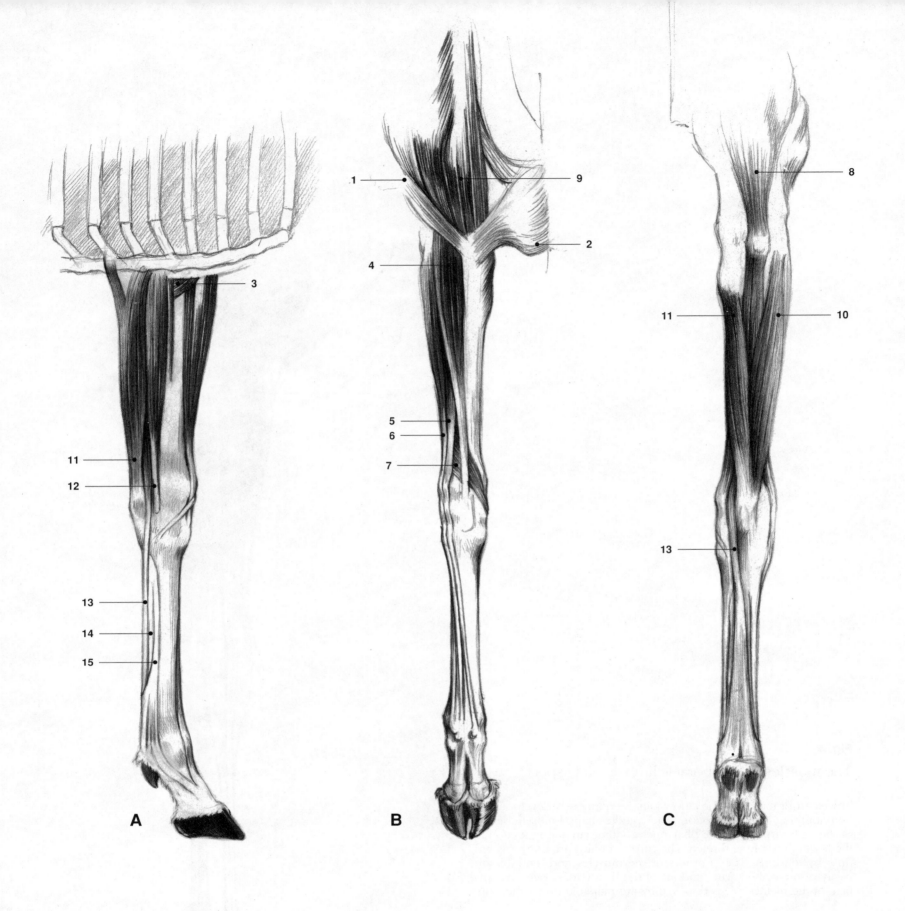

Fig. 5

The muscles of the thoracic limb; medial (A), cranial (B) and caudal (C) aspects

1 Brachiocephalicus muscle *(6)*
2 Pectoralis superficialis muscle *(29)*
3 Brachialis muscle *(50)*
4 Extensor carpi radialis muscle *(64)*
5 Extensor digiti IIIrd muscle *(66)*

6 Extensor digiti IVth muscle *(67)*
7 Abductor digiti Ist muscle *(70)*
8 Triceps brachii muscle *(52)*
9 Biceps brachii muscle *(51)*
10 Extensor carpi ulnaris muscle *(65)*

11 Flexor carpi ulnaris muscle *(57)*
12 Flexor carpi radialis muscle *(56)*
13 Flexor digitorum superficialis muscle *(58)*
14 Flexor digitorum profundus muscle *(59)*
15 Interosseus medius muscle *(88)*

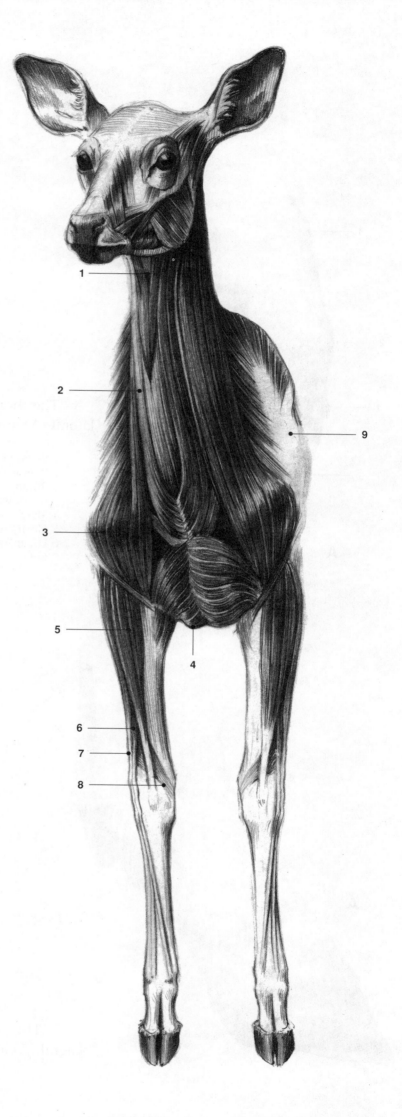

Fig. 6

The muscles of the hind,
cranial aspect

The slim and laterally flattened neck is covered by flat muscles. The
breast is wide and the enormously developed breast muscles pro-
trude. The shoulders appear as conical bulges on each side.

1 Sternohyoideus muscle *(9)*
2 Sternocephalicus muscle *(7)*
3 Brachiocephalicus muscle *(6/1)*
4 Pectoralis descendens muscle *(29)*
5 Extensor carpi radialis muscle *(64)*
6 Extensor digitorum IIIrd muscle *(66)*
7 Extensor digitorum IVth muscle *(67)*
8 Abductor digiti Ist muscle *(70)*
9 Trapezius muscle *(14)*

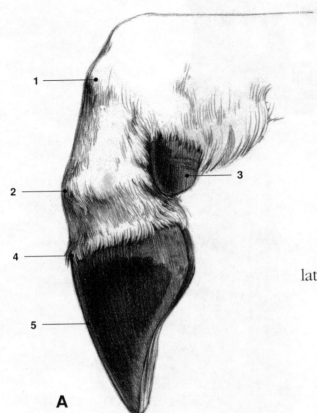

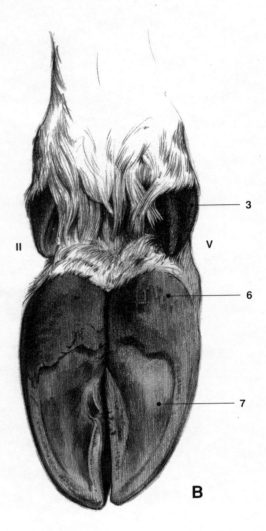

Fig. 7

The thoracic phalanges;
lateral (A) and palmar (B) aspects

1 Region of the fetlock joint
2 Region of the pastern joint
3 Rudimentary IInd and Vth digits;
 the dewclaws
4 Margo coronalis
5 Horny wall
6 Digital cushion
7 Sole

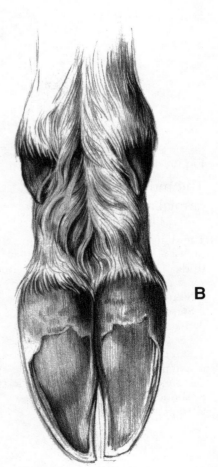

Fig. 8

The pelvic phalanges;
lateral (A) and plantar (B) aspects

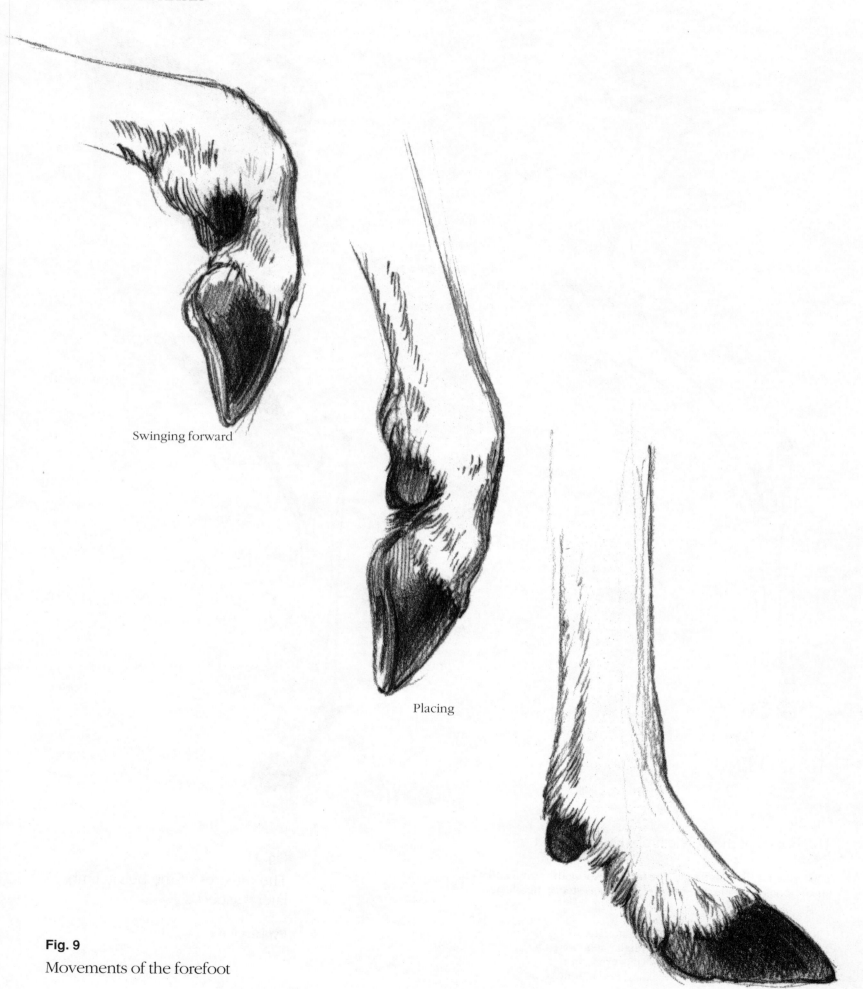

Swinging forward

Placing

Fig. 9

Movements of the forefoot

Taking the body weight

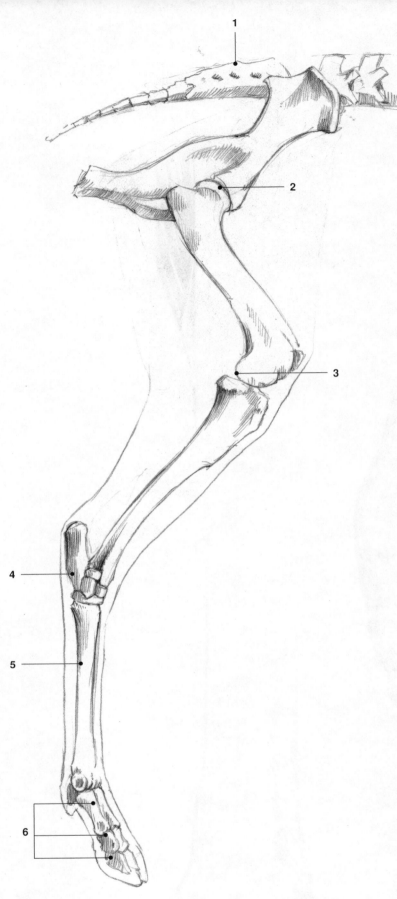

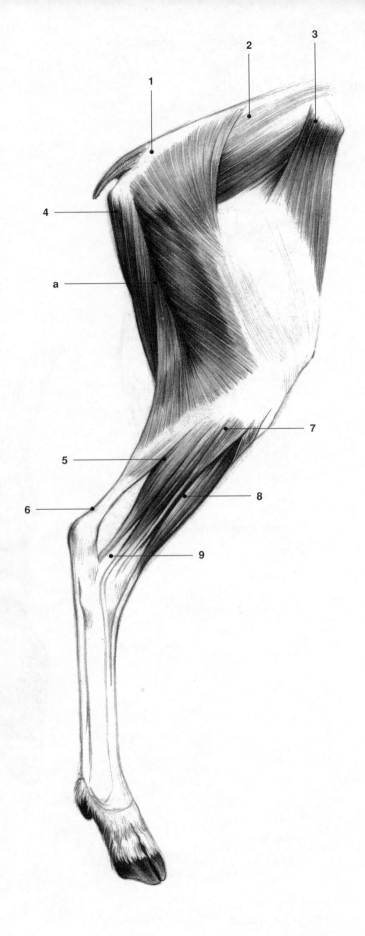

Fig. 10

The bones of the pelvic limb, lateral aspect

The pelvis is relatively small. The femur is short, the crural and metatarsal bones are long, the phalangeal axis is steep, the olecranon is long.

1 Sacrum
2 Hip joint
3 Stifle joint
4 Calcaneus
5 Metatarsus
6 Phalangeal bones
 (pastern, coronet
 and pedal bones)

Fig. 11

The muscles of the pelvic limb, lateral aspect

Explanation see Fig. 12.

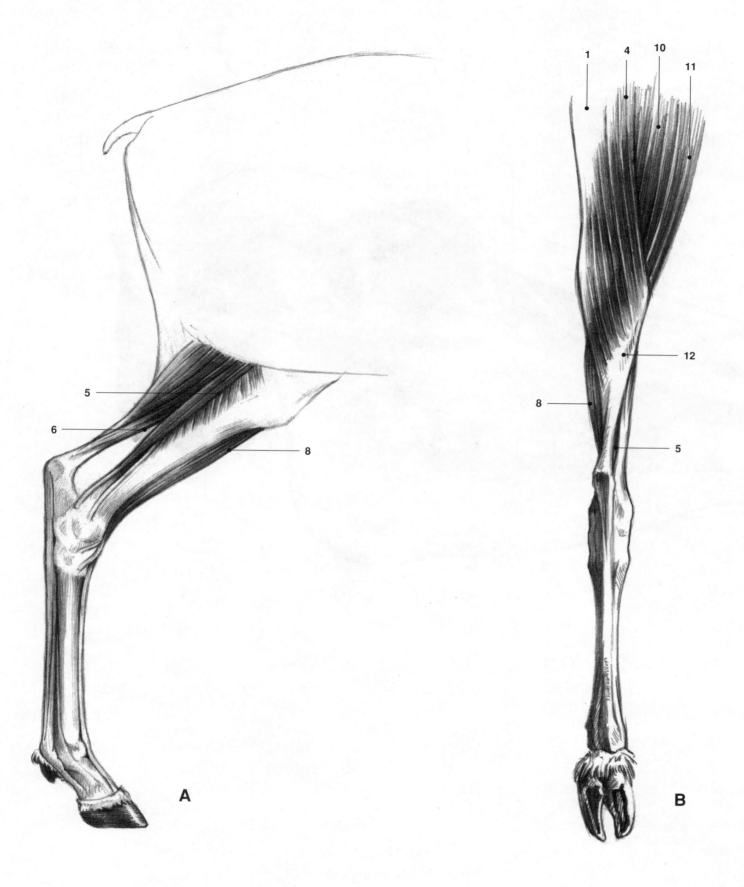

Fig. 12

The muscles of the pelvic limb; medial (A) and caudal (B) aspects

1 Gluteobiceps femoris muscle *(99)*
2 Gluteus medius muscle *(97)*
3 Tensor fasciae latae muscle *(95)*
4 Semitendinosus muscle *(107)*
5 Flexor digitorum profundus muscle *(124)*

6 Flexor digitorum superficialis muscle *(123)*
7 Peroneus longus muscle *(121)*
8 Extensor digitorum longus muscle *(118)*
9 Extensor digitorum lateralis muscle
 (or extensor of the IVth digit) *(122)*

10 Semimembranosus muscle *(108)*
11 Gracilis muscle *(104)*
12 Triceps surae muscle *(114)*

a) Ischial groove

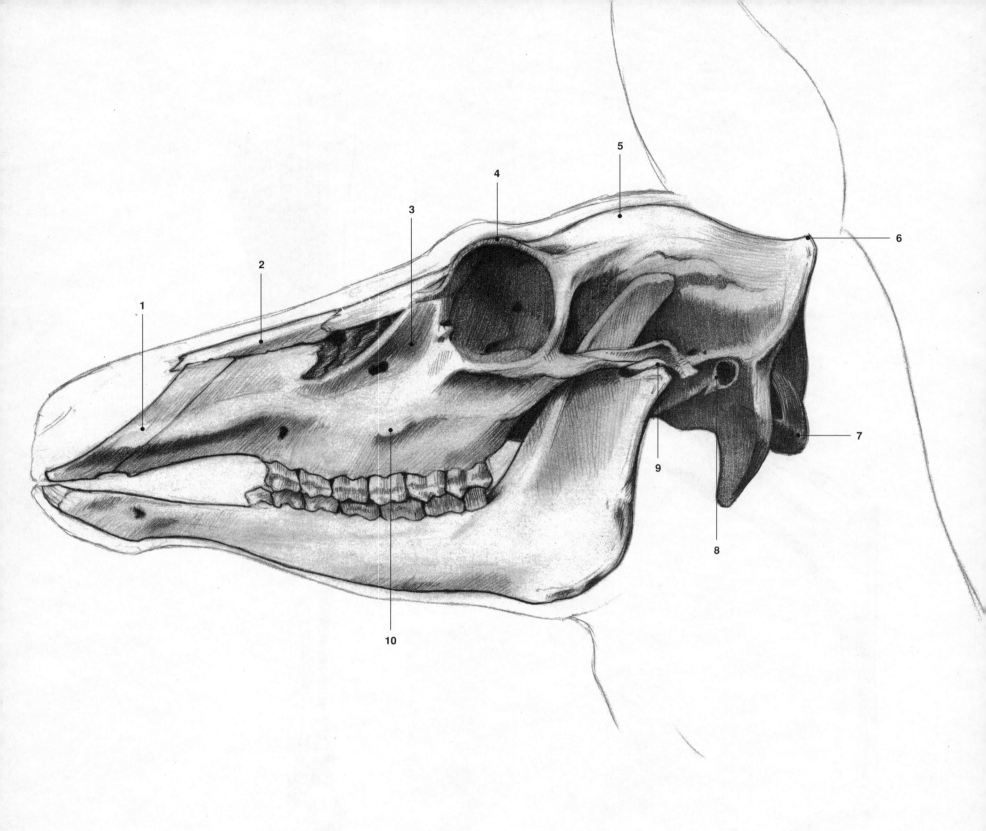

Fig. 13

The skull, lateral aspect

The facial part of the skull is long, its proportion to the neurocranium being 3:1. The nose and mandible are long and straight. The dentition of the deer is selenodont. The orbit is domed toward the forehead. Below the orbit there is a deep lacrimal fossa on the lacrimal bone. The dorsal part of the cranial cavity bulges slightly, the occipital crest is sharp.

1 Incisive bone
2 Nasal bone
3 Lacrimal fossa

4 Orbit
5 Dome of the skull
6 Nuchal crest
7 Occipital condyle
8 External auditory canal
9 Mandibular joint
10 Facial tuber of the maxilla

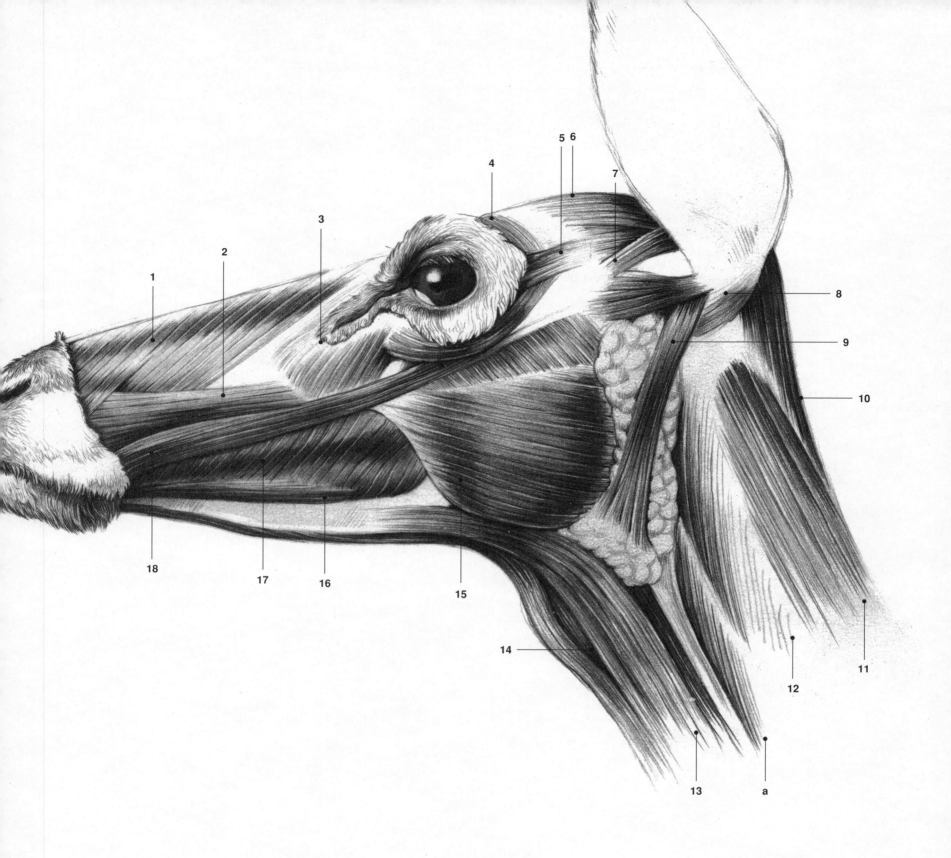

Fig. 14

The muscles of the head and the neck

The facial region is almost fully covered by lamellar muscles. The muscles of the mouth and the masticatory muscles are thick.

1 Levator nasolabialis muscle *(164)*
2 Caninus muscle *(165)*
3 Malaris muscle
 (depressor of the lower eyelid) *(159)*
4 Orbicularis oculi muscle *(155)*

5 Retractor anguli lateralis muscle *(158)*
6 Temporal muscle *(179)*
7 Forward pulling muscles
 of the ear *(141–144)*
8 Rotatory muscle of the ear *(153)*
9 Depressor muscle of the ear *(150)*
10 Rectus capitis dorsalis muscle *(3)*
11 Splenius muscle *(5)*
12 Brachiocephalicus muscle *(6)*

13 Sternomandibular muscle *(7)*
14 Sternohyoideus muscle *(9)*
15 Masseter muscle *(178)*
16 Depressor of the lower lip *(170)*
17 Buccalis muscle *(175)*
18 Zygomaticus muscle *(174)*

a) Jugular groove with the jugular vein

THE COW

The ancestor of the 8,000 breeds of cattle that can be found on all continents today is probably the aurochs. It lived in large herds in woodland and ate mainly grass, leaves, and buds. These were quickly eaten in clearings and then ruminated and digested in sheltered under-growth – a behaviour still seen in today's cattle. Cave-paintings from the stone age prove that these animals were hunted by our ancestors.

About 9,000 years ago the first domesticated cattle were bred. An emphasis on different features during breed-ing meant that different breeds exhibit different specific characteristics.

Man utilises nearly all parts of cattle, not only the milk, meat, fat, and offal, but also the skin, bones, horns, and hair. These produce, for instance, leather, glue, gela-tine, buttons, and felt. In addition, cattle used to play an important role as draft and pack animals.

Whereas cows are usually docile, oxen (castrated young males) and especially bulls can be very aggressive. That is why the long, pointed and dangerous horns were bred out of most breeds so that both sexes now have only short, blunt horns.

Domestic cattle are large animals with a wither height of 150–160 cm (5 feet) and little mobility, especially in the trunk. It is difficult for them to reach all parts of the body with their mouths and hooves for cleaning. That is why the long tufted tail is useful for getting rid of irritating insects.

Cattle are digitigrades and walk on the tips of their third and fourth toes which are protected by hooves. The first, second and fifth toes have largely degenerated.

Because the paired hooves are slightly spread outwards they prevent the legs from sinking into damp ground. Like horses cattle walk, trot and gallop, but their large body and restricted mobility makes them look rather plump, compared with other hooved animals.

Cattle are typical ruminants and have four stomachs. The largest of these, the rumen, holds 150–200 litres (300–400 pints). This size is necessary in order to con-sume grass in a short time and large quantities, in order to be ruminated later and digested when the animal is resting. The grass is pulled up with the very strong tongue and then collected in the rumen, which contains micro-organisms which are able to utilise cellulose, the main ingredient of plants. Because the enzymes contained in the digestive juices of higher mammals cannot digest cellulose, these micro-organisms indirectly enable cows to digest grass and convert plant material that could not otherwise be digested.

After pre-digestive processing of the plant fibres has taken place in the rumen, the food travels to the reticulum. Here water is extracted from the food pulp, which is then brought back into the mouth in small balls and ruminated. The ruminated food is then swal-lowed and travels, via the reticular groove, into the omasum. Then, in the abomasum, the micro-organisms contained in the digestive pulp are killed, and the nutri-ents absorbed from the intestine into the bloodstream.

Lactation is common to all female mammals, and in the case of the cow this milk production is economically utilised. There are special milk breeds whose milk pro-duction is much higher than the quantity required for suckling.

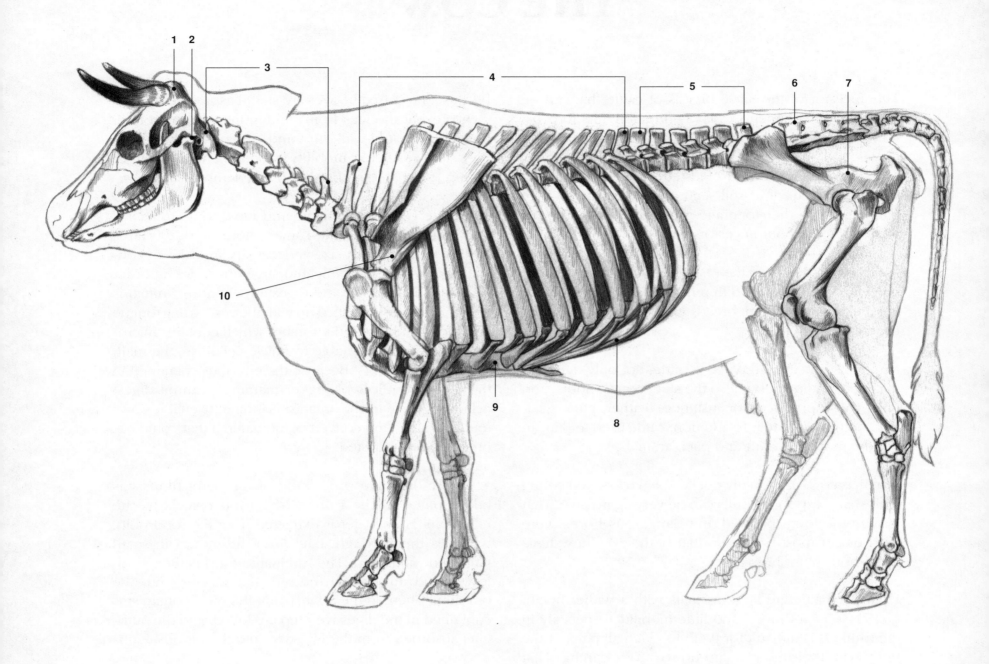

Fig. 1

The skeleton

The large size and coarse structure of the skeleton, large skull, massive and long limb bones are characteristic. The vertebral column consists of 7 cervical, 13 thoracic and 6 lumbar vertebrae, an arched sacrum and 18–23 coccygeal vertebrae.

1 Cornual process of the frontal bone
2 Mandibular joint
3 Cervical vertebrae
4 Thoracic vertebrae with long spinous processes
5 Lumbar vertebrae
6 Sacrum
7 Pelvic bone
8 Costal arch
9 Sternum.
10 Shoulder blade

The bones of the skull are demonstrated in Fig. 24, those of the limbs in Figs. 3, 5, 10 and 12.

460

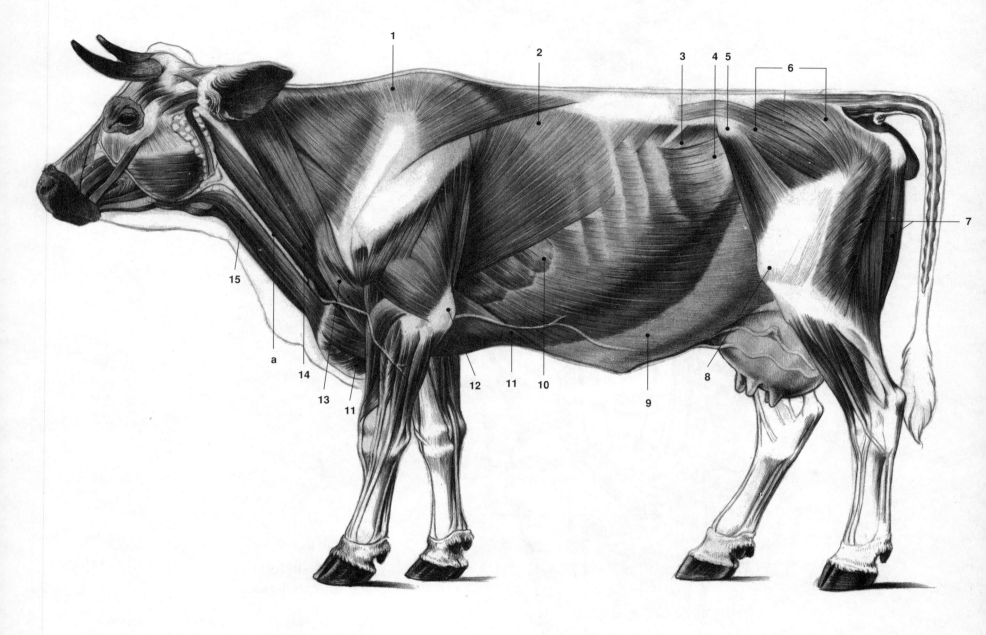

Fig. 2

The muscles

The musculature of the neck is well developed, the jugular groove is deep, the muscles of the trunk are flat. Because of the less developed muscles in the hind quarters the rump is flat.

1 Trapezius muscle *(14)*
2 Latissimus dorsi muscle *(16)*
3 Obliquus internus abdominis muscle *(37)*
4 Obliquus externus abdominis muscle *(36)*

5 Tensor fasciae latae muscle *(95)*
6 Gluteus proximalis muscles *(96–101)*
7 Gluteus caudalis muscles *(106–108)*
8 Stifle joint
9 Yellow abdominal fascia
 (tunica flava abdominis)
10 Serratus ventralis muscle *(18)*
11 Pectoralis muscles *(27–32)*
12 Tuber olecrani with the
 triceps brachii muscle *(52)*

13 Brachiocephalicus muscle *(6)*
14 Cleidomastoideus and
 cleidotransversarius muscle *(6)*
15 Sternomandibularis muscle *(7)*

a) Jugular groove and vein

The muscles of the head are demonstrated in Fig. 25, those of the limbs in Figs. 4, 6 and 15.

461

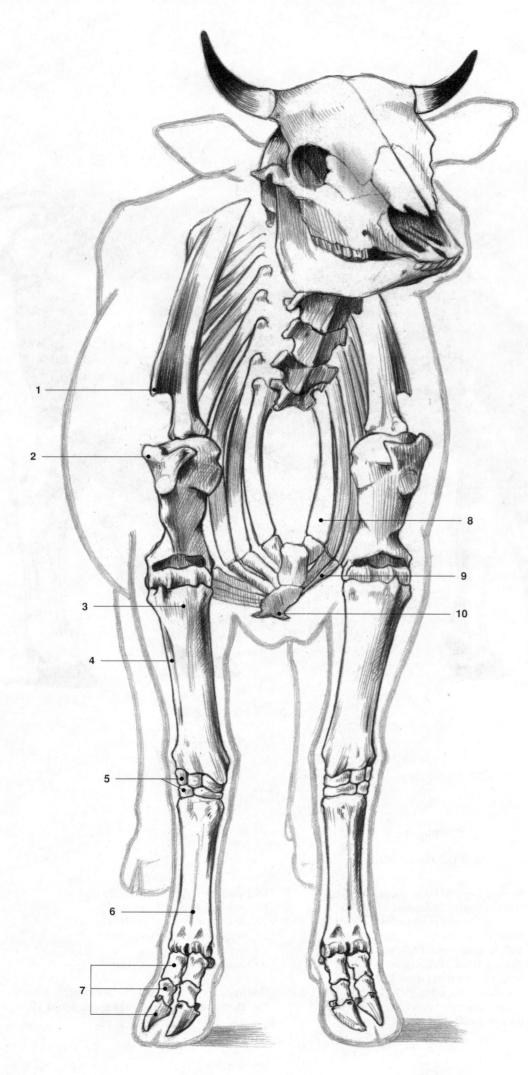

Fig. 3

The skeleton,
cranial aspect

The cranial part of the thorax is narrow, being flattened at the sides. The ribs are long becoming more rounded towards the rear. The caudial part of the thorax is wide, its caudal cross-section is round. The spine of the shoulder blade forms a process at the lower end. The tuberosities of the humerus are large. The IIIrd and IVth digits face slightly outward.

1 Spina scapulae
2 Tubercle of the humerus
3 Head of the radius
4 Ulna
5 Carpal bones
6 Metacarpus
7 Proximal, middle and distal
 phalangeal bones
8 Ist rib
9 Cartilages of the ribs
10 Sternum

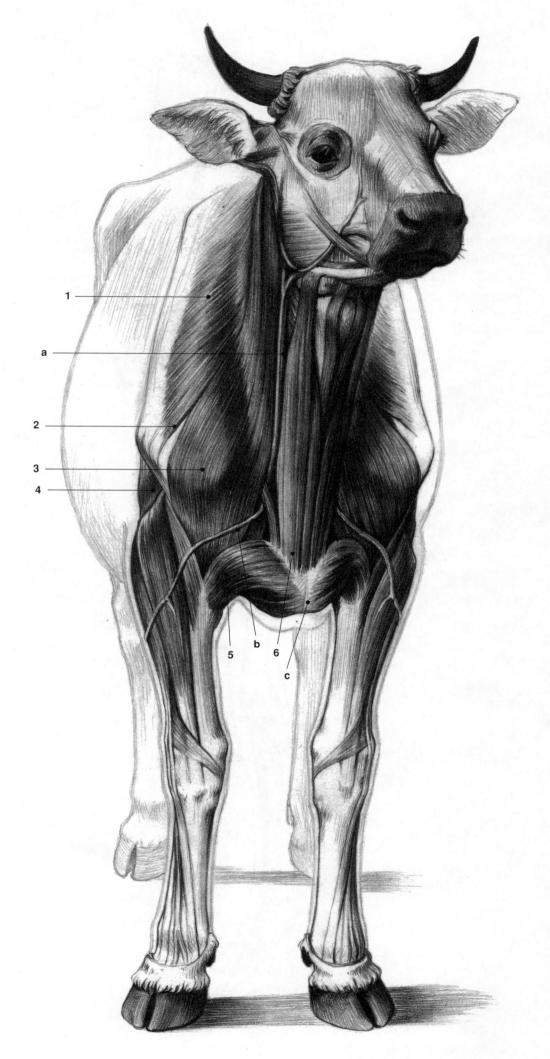

Fig. 4

The muscles, cranial aspect

The neck is flattened at the side, the jugular groove is deep, the thick jugular vein can be seen. The shoulder is less muscled than that of the horse. The extensor muscles of the carpal and phalangeal joints are located on the lateral and dorsal antebrachial surface, while the flexors are situated on the palmar surface and continue in tendons starting at the carpus.

1 Trapezius muscle *(14)*
2 Omotransversarius muscle *(15)*
3 Brachiocephalicus muscle *(6)*
4 Triceps brachii muscle *(52)*
5 Pectoralis superficialis muscle *(27)*
6 Sternomandibularis muscle *(7)*

a) Jugular groove
b) Cephalic vein
c) Middle pectoral groove

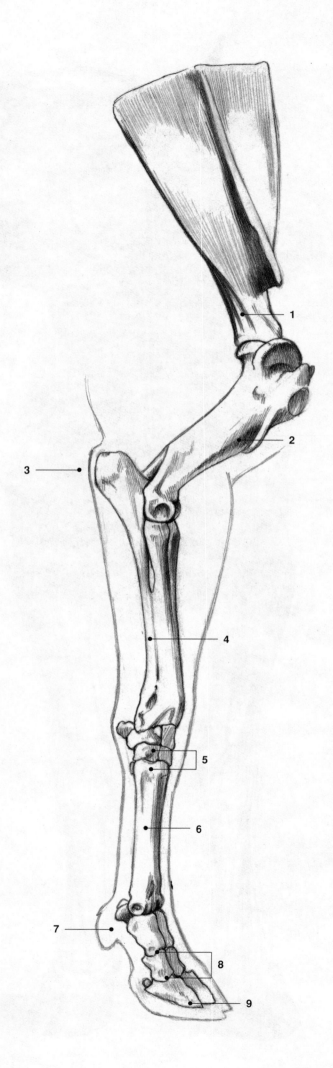

Fig. 5

The bones of the thoracic limb, lateral aspect

The bones of the limbs are massive and long, the ulna has an ossified attachment to the radius. The IIIrd and IVth digits are fully developed, the IInd and Vth are rudimentary dewcaws. The distal phalanx is boat-shaped.

1 Neck of the shoulder blade
2 Deltoid tuberosity
3 Olecranean tuber
4 Radius
5 Carpal bones
6 Metacarpus
7 Sesamoid bone
8 Proximal and middle phalanges
9 Distal phalanx

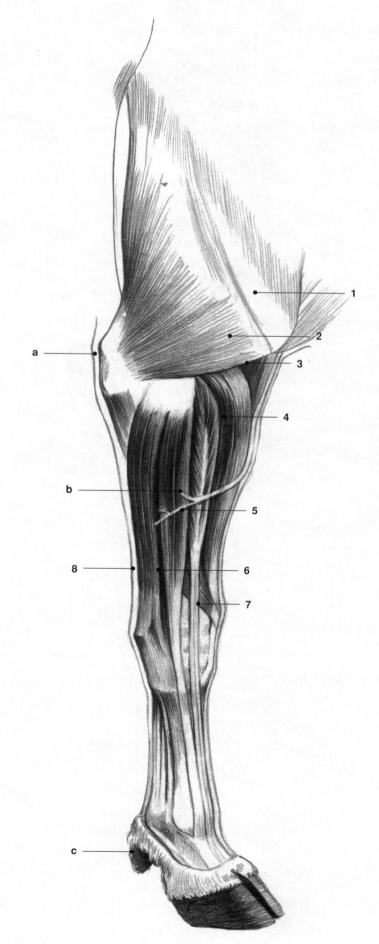

Fig. 6

The muscles of the thoracic limb, lateral aspect

The shoulder blade is attached to the neck and thorax by flat muscles, and to the sternum by large muscles. The shoulder blade moves along a sagittal plane parallel to the thorax. The shoulder joint is moved by strong, bulky muscles.

1 Deltoideus muscle *(43)*
2 Triceps brachii muscle *(52)*
3 Brachialis muscle *(50)*
4 Extensor carpi radialis muscle *(64)*
5 Extensor digitorum
 communis muscle *(66)*
6 Extensor digitorum lateralis muscle *(67)*
7 Abductor pollicis longus muscle *(70)*
8 Extensor carpi ulnaris muscle *(65)*

a) Olecranean tuber
b) Vena cephalica (cutanea antebrachii)
c) Dewclaw

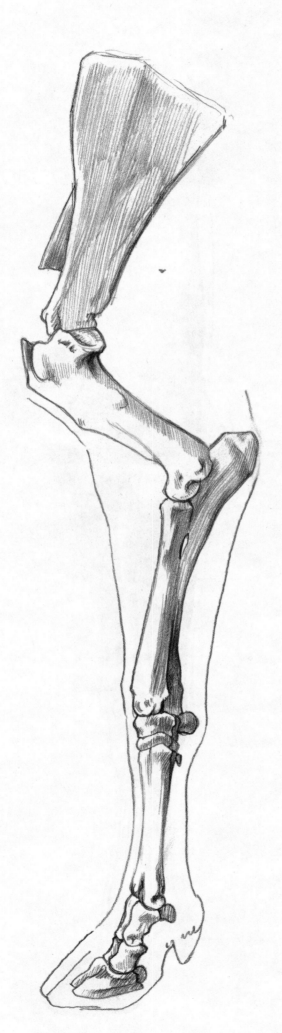

Fig. 7

The bones of the thoracic limb, medial aspect

The bones are demonstrated in Fig. 5.

466

Fig. 8

The muscles of the thoracic
limb, medial aspect

1 Brachialis muscle *(50)*
2 Extensor carpi radialis muscle *(64)*
3 Flexor carpi ulnaris muscle *(57)*
4 Flexor carpi radialis muscle *(56)*
5 Flexor digitorum superficialis
 muscle *(58)*
6 Flexor digitorum profundus muscle *(59)*
7 Interosseus medius muscle *(88)*

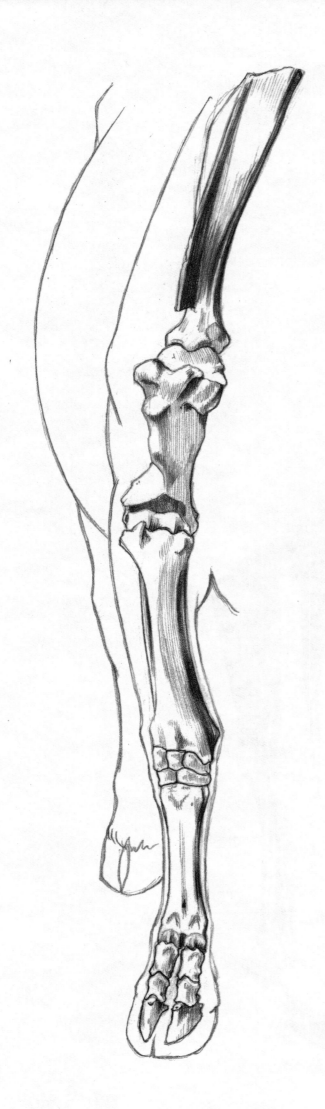
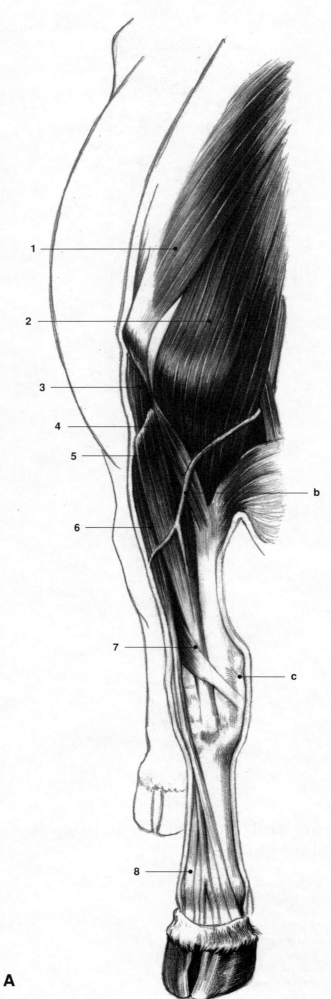

A

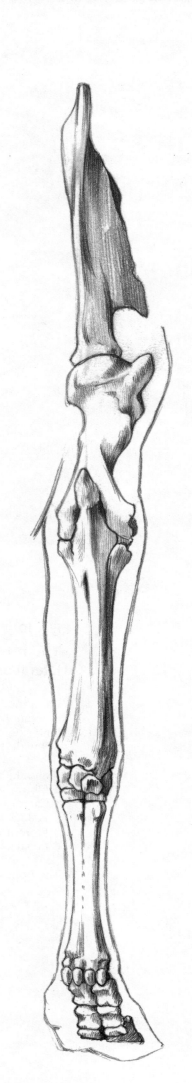

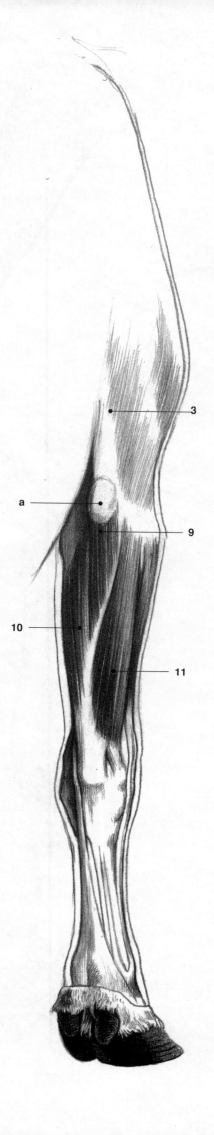

Fig. 9

The bones and muscles of the thoracic limb; cranial (A) and caudal (B) aspects

1 Deltoideus muscle *(43)*
2 Brachiocephalicus muscle *(6/1)*
3 Triceps brachii muscle *(52)*
4 Brachialis muscle *(50)*
5 Extensor carpi radialis muscle *(64)*
6 Extensor digitorum communis muscle *(66)*
7 Abductor pollicis longus muscle *(70)*
8 Extensor digitorum lateralis muscle *(67)*
9 Flexor digitorum profundus muscle *(59)*
10 Flexor carpi ulnaris muscle *(57)*
11 Extensor carpi ulnaris muscle *(65)*

a) Olecranean tuber
b) Vena cephalica (cutanea antebrachii)
c) Carpal joint

The bones are demonstrated in Fig. 5.

B

469

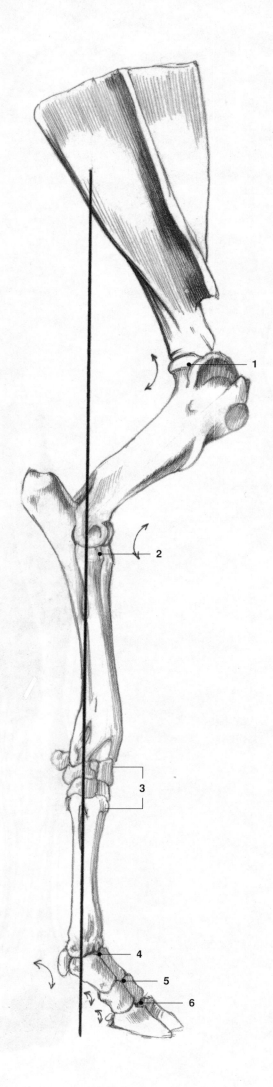

Fig. 10

The posture and joints of the thoracic limb, lateral aspect

From the lateral aspect, the perpendicular drawn from the center of rotation of the shoulder blade passes along the axes of the lower limb, the carpus and the metacarpus. It forms an angle of about 40° with the shoulder blade.

1 Shoulder joint
2 Elbow joint
3 Carpal joint
4 Fetlock joint
5 Pastern joint
6 Pedal joint

The bones are demonstrated in Figs. 3 and 5.

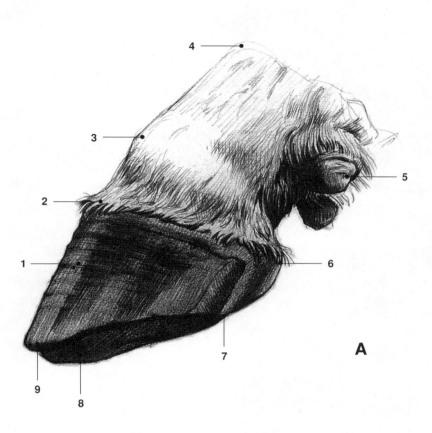

A

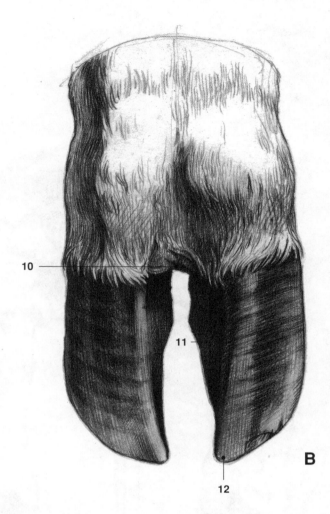

B

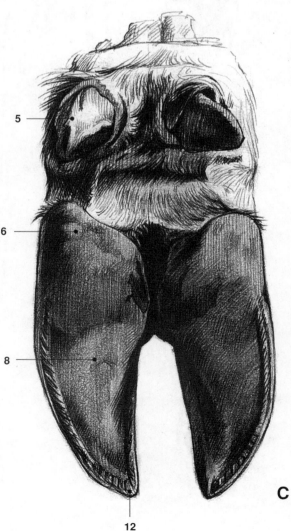

C

Fig. 11

The hoof of the thoracic limb; lateral (A), dorsal (B) and palmar (C) aspects

The hooves are the distal phalanges of the IIIrd and IVth digits. Their structure is similar to that of the horse, they are symmetrical formations covered by the hoof capsules. The IInd and Vth digits are rudimentary, forming the dewclaws.

 1 Paries lateralis and dorsalis
 2 Periople (epidermis limbi)
 3 Coronet region
 4 Pastern region
 5 Dewclaw
 6 Digital cushion
 7 Paries abaxio-palmaris
 8 Sole
 9 Margo solearis
10 Paries interdigitalis
11 Interdigital skinfold
12 Apex of the hoof horn

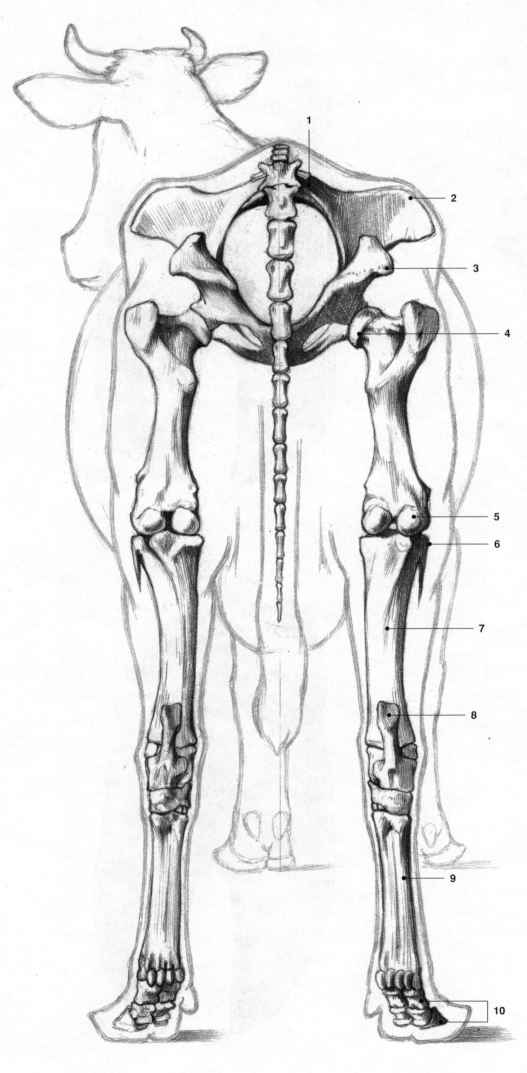

Fig. 12

The bones of the pelvic limb, caudal aspect

The rump is at the same level as the lumbar region, or higher. The pelvis is high and oval. The hipbone forms an angle of 45° with the horizontal. The hipbone and the femur form an angle of 90–100°. In the stifle joint, the femur and the crural bones form an angle of 120–150°. The crural and metatarsal bones form an angle of 145°. The phalangeal axis meets the ground in an angle of 50–55°.

1 Tuber sacrale
2 Tuber coxae
3 Ischiatic tuber
4 Head of the femur
5 Condyles of the femur
6 Head of the fibula
7 Tibia
8 Calcanean tuber
9 IIIrd and IVth metatarsal bone
10 Phalanges

472

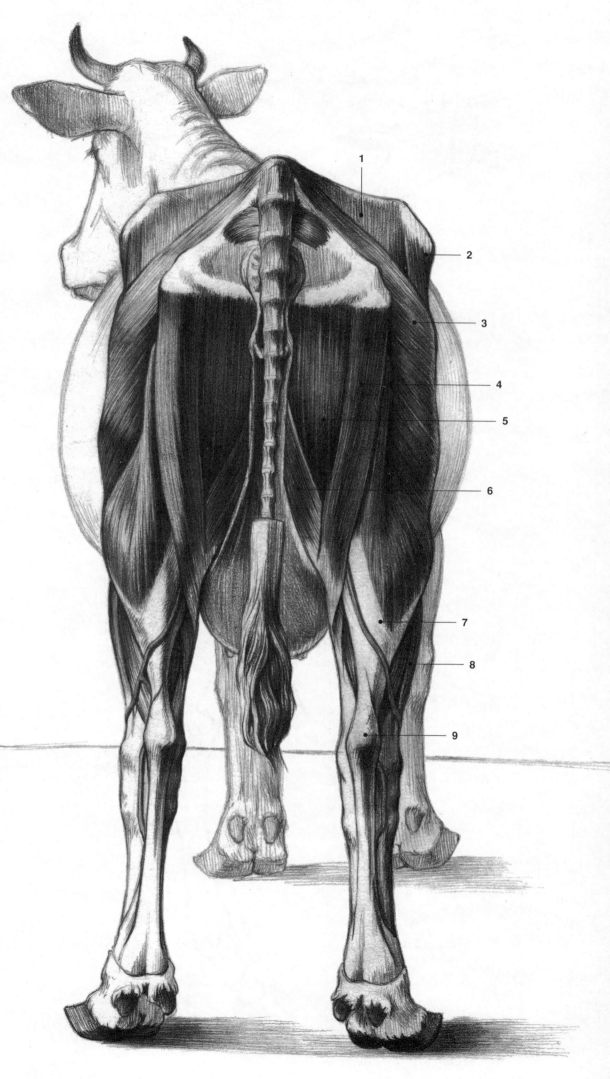

Fig. 13

The muscles of the pelvic limb, caudal aspect

The bull's thigh is relatively round, while the cow's is flat. The pelvis is bordered cranially by the tuber coxae and caudally by the tuberosities of the ischiatic bone. The two sides of the anal orifice covered by the tail are bordered by the anal foveae. The anterior border of the hipbone, the iliac crest also protrudes.

The contours of the thigh are formed by the muscles. In the crus, the spindle-shaped gastrocnemius muscle protrudes, its tendon – the Achilles tendon – is inserted on the calcanean tuber. The distal third of the crus and the foot are covered mainly by tendons. Due to the thick skin the contours of the tendons are hardly visible.

1 Gluteus medius muscle *(97)*
2 Tensor fasciae latae muscle *(95)*
3 Gluteobiceps femoris muscle *(99)*
4 Semitendinosus muscle *(107)*
5 Semimembranosus muscle *(108)*
6 Gracilis muscle *(104)*
7 Triceps surae muscle *(114)*
8 Tibialis cranialis muscle *(117)*
9 Flexor digitorum superficialis muscle *(123)*

473

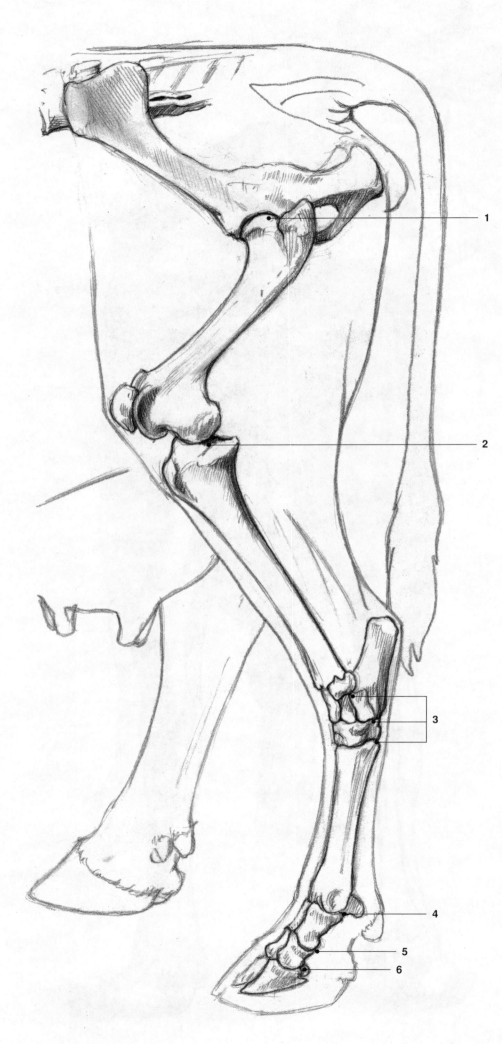

Fig. 14

The bones of the pelvic limb,
lateral aspect

The bones of the limb are long and massive, the tibia and the fibula form a synostosis.
The metatarsus and the proximal and middle phalanges are longer than those of the thoracic limb.

1 Hip joint
2 Stifle joint
3 Tarsal joint
4 Fetlock joint
5 Pastern joint
6 Pedal joint

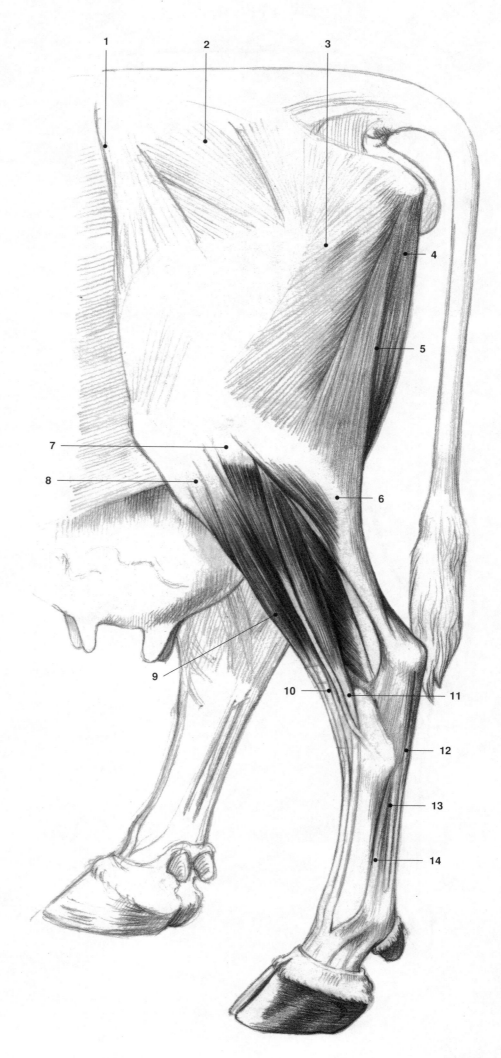

Fig. 15

The muscles of the pelvic limb,
lateral aspect

The muscles of the rump are flat. The thigh
and the crus of the bull are particularly well
muscled. The bones of the crus are cov-
ered craniolaterally by the flexor muscles
of the tarsus and by the digital extensors;
the plantar surface is covered by the ex-
tensors of the tarsal joint and the flexors of
the phalanges.

 1 Tensor fasciae latae muscle *(95)*
 2 Gluteus medius muscle *(97)*
 3 Gluteobiceps muscle *(99)*
 4 Semitendinosus muscle *(107)*
 5 Ischial groove
 6 Triceps surae muscle *(114)*
 7 Peroneus longus muscle *(121)*
 8 Tibialis cranialis muscle *(117)*
 9 Peroneus tertius muscle *(119)*
10 Extensor digitorum longus muscle *(118)*
11 Extensor digitorum lateralis muscle *(122)*
12 Tendon of the flexor digitorum
 superficialis muscle *(123)*
13 Tendon of the flexor digitorum
 profundi muscles *(124–126)*
14 Interosseus medius muscle *(137)*

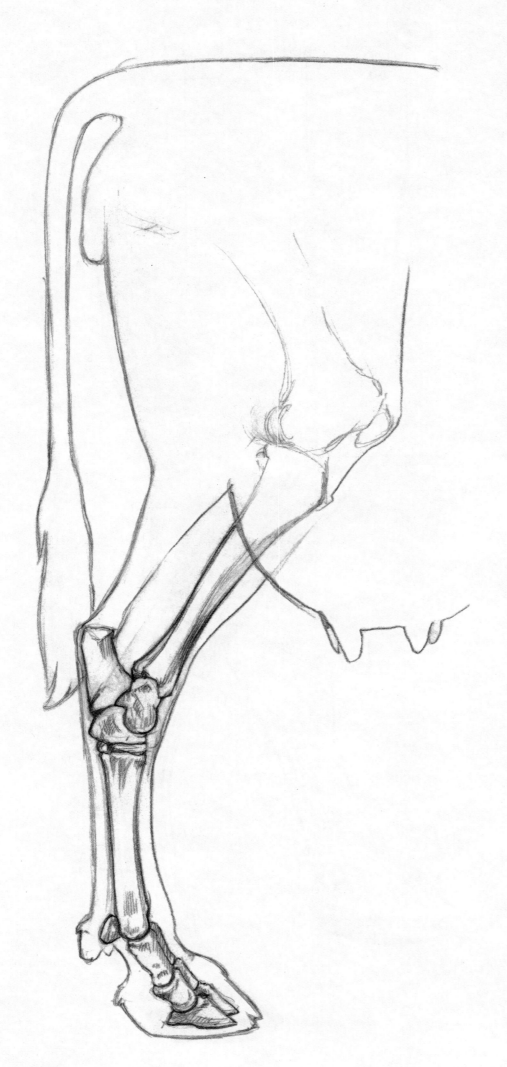

Fig. 16

The bones of the pelvic limb, medial aspect

The bones are demonstrated in Figs. 12 and 14.

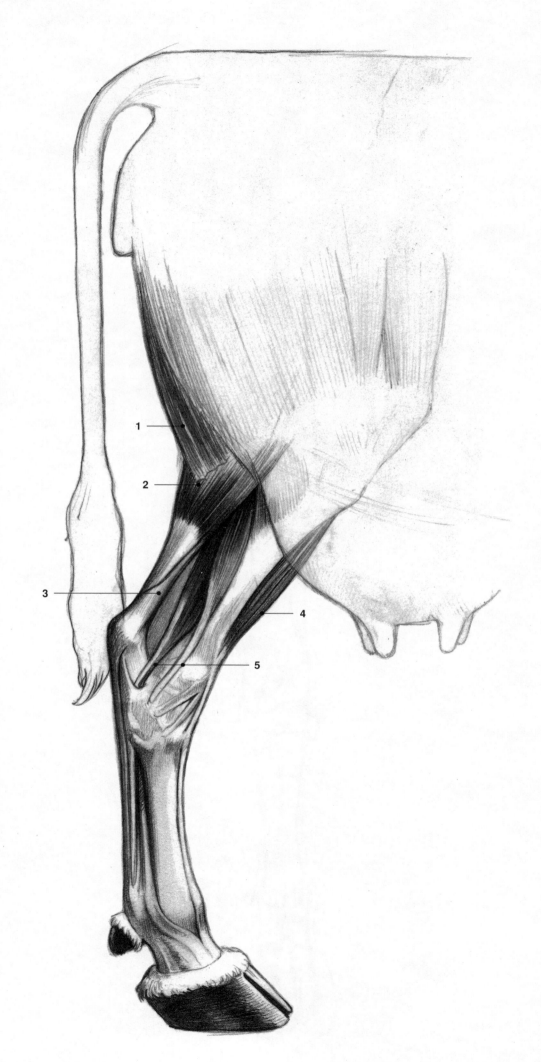

Fig. 17

The muscles of the pelvic limb, medial aspect

The medial surface of the tibia is covered only by skin and fascia. Above the tarsal joint, between the extensors of the tarsal joint and the digital flexors lying on the tibia, there is a deep muscular fossa. The tendons of the digital extensors protrude slightly on the dorsal surface of the metatarsus, while on the plantar surface the tendons of the digital flexors protrude.

1 Semitendinosus muscle *(107)*
2 Triceps surae muscle *(114)*
3 Flexor digitorum superficialis muscle *(123)*
4 Extensor digitorum longus muscle *(118)*
5 Flexor digitorum profundus muscles *(124–126)*

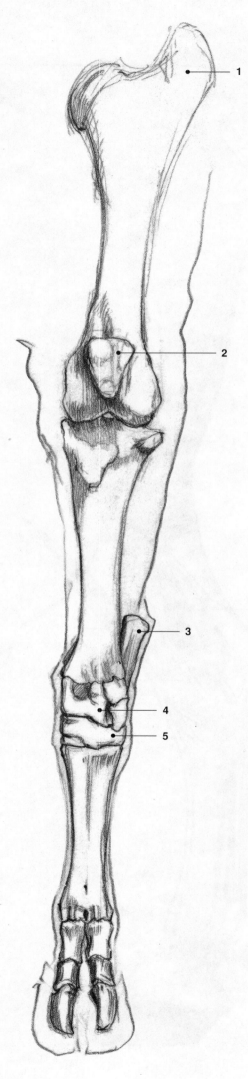

Fig. 18

The bones and joints
of the pelvic limb,
cranial aspect

In the stifle joint the trochlea of the femur
slides under the fixed patella. The talus has
trochleae on both its proximal and distal
surfaces, and both of them form hinge
joints.

1 Big trochanter of the femur
2 Patella
3 Calcanean tuber
4 Talus
5 Centroquartale bone

Fig. 19

The muscles of the pelvic limb, cranial aspect

The spindle-shaped muscles covering the dorsal and lateral surfaces of the tibia continue in tendons above the tarsus and are surrounded by tendon sheaths – fixed by three transverse ligaments, they pass over the tarsal joint.

1 Gluteobiceps muscle *(99)*
2 Tibialis cranialis muscle *(117)*
3 Peroneus tertius muscle *(119)*
4 Peroneus longus muscle *(121)*
5 Extensor digitorum lateralis muscle *(122)*
6 Extensor digitorum longus muscle *(118)*

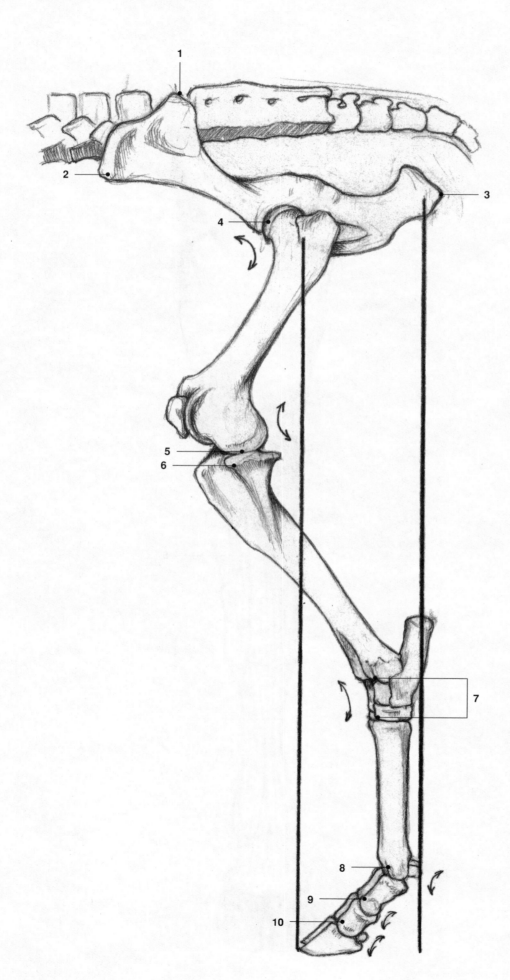

Fig. 20

The posture and the joints
of the pelvic limb, lateral aspect

In normal posture a vertical line drawn from
the ischiatic tuber is parallel with the axes
of the tarsus and the metatarsus. The per-
pendicular line originating in the hip joint
reaches the ground at the tips of the distal
phalanges. From the caudal aspect, the
thigh and the crus are close to each other,
the tarsus and the metatarsus are always in
the perpendicular plane.

1 Tuber sacrale
2 Tuber coxae
3 Ischiatic tuber
4 Hip joint
5 Femorotibial joint
6 Proximal tibio-fibular joint
7 Tarsal joint
8 Fetlock joint
9 Pastern joint
10 Pedal joint

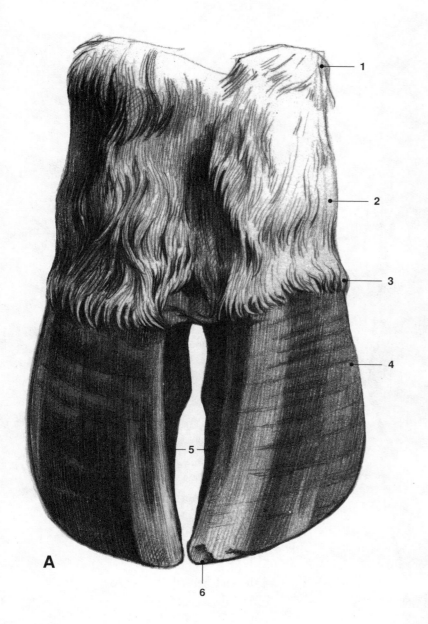
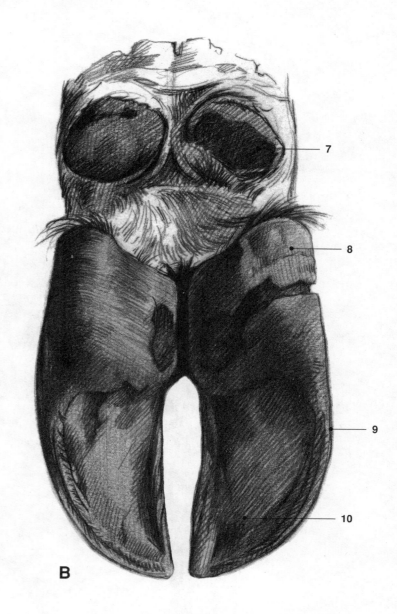

Fig. 21

The phalanges of the hoof; dorsal (A) and plantar (B) aspects

1 Pastern region
2 Coronet region
3 Limbus
4 External surface of the paries corneus
5 Axial part of the paries corneus
6 Apex of the paries corneus
7 Dewclaw
8 Digital cushion
9 Distal border of the paries corneus
10 Horny sole

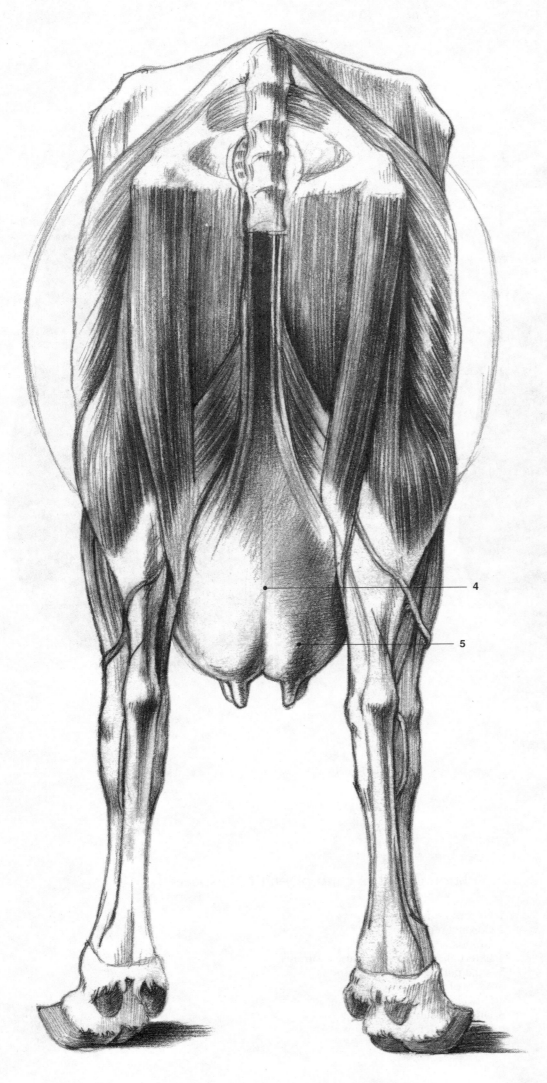

— 4

— 5

Fig. 22

The udder of the cow,
caudal aspect

The shape, measurements and proportions
of the udder, and its attachment to the
ventro-caudal walls of the belly and the
pelvis vary considerably.
Two udder-halves – right and left – are dis-
tinguished, each consisting of a front and
rear quarter. Each quarter is an independ-
ent milk gland. The cavities of a quarter
form a milk basin which is continued in a
teat canal and orifice with a lumen of about
1 mm. The teats are around 10 cm in length.

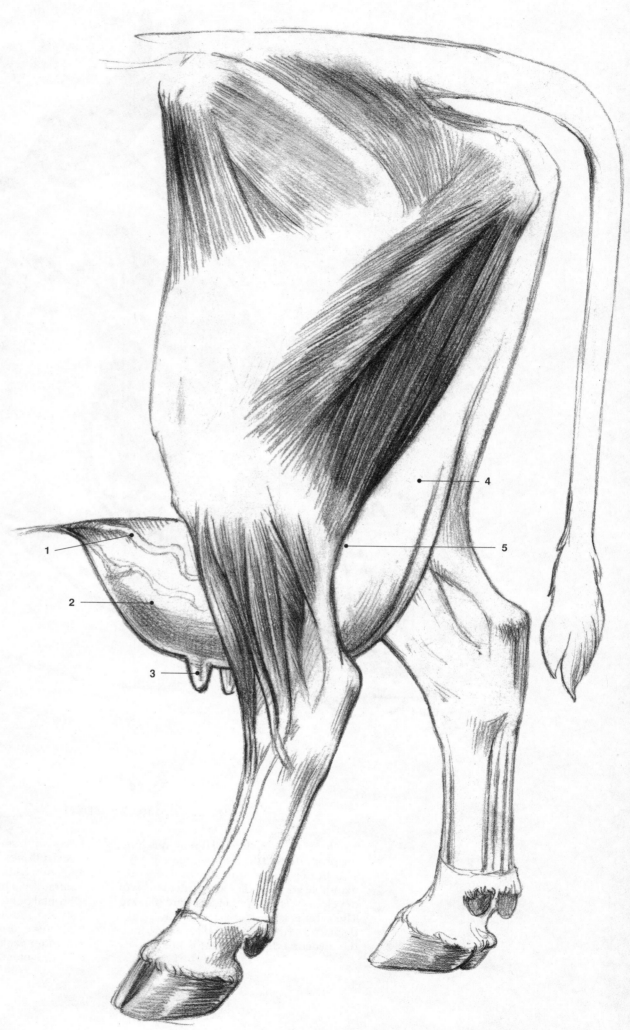

Fig. 23

The udder of the cow, lateral aspect

The well proportioned and well developed udder, in lateral aspect, is not entirely covered by the thigh.

The front teats have a broader base, the rear ones are longer. The skin of the udder is covered with fine hair; it is tense when the udder is full. The subcutaneous udder veins are clearly visible, they protrude under the skin. The thick subcutaneous vein (vena subcutana abdominis) arising from the cranial region and to the costal arch is named the milk vessel.

1 Milk vein
2 Left cranial udder quarter
3 Teat
4 Milk mirror with the groove separating the udder-halves
5 Left/right rear quarter

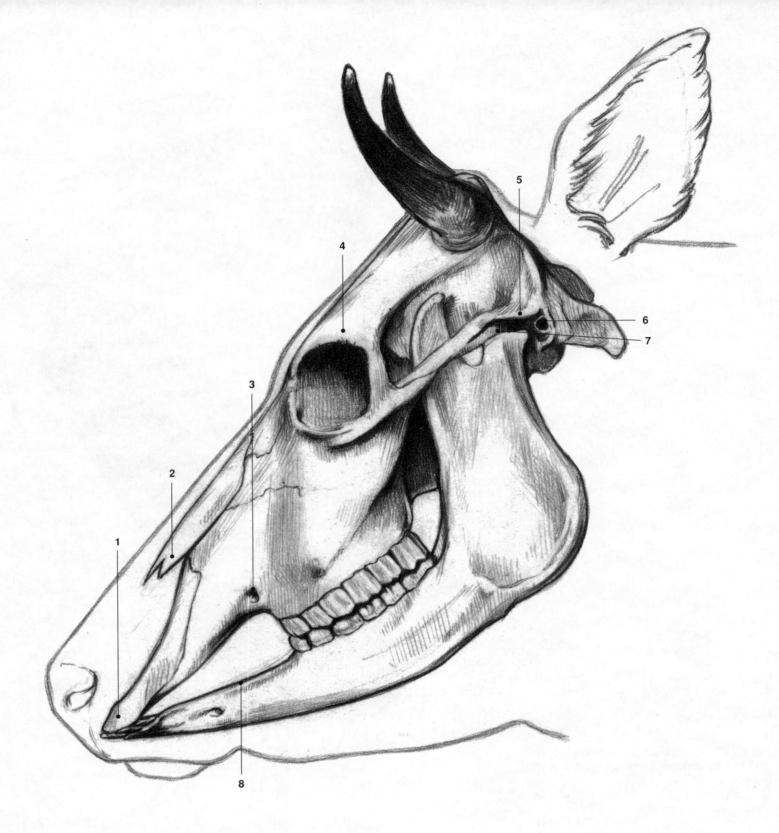

Fig. 24

The skull, lateral aspect

The head is large, the facial region is long; the proportion to the neurocranium is 1.8:1. The bones containing the molars – the mandible and maxilla – are particularly well developed. The upper incisors are missing. The orbit is large, the supraorbital fossa is displaced to the side. The body of the mandible is curved, the occiput is high.

1 Incisive bone
2 Nasal bone
3 Maxilla with the infraorbital hole
4 Frontal bone
5 Zygomatic arch
6 Meatus acusticus externus
7 Mandibular joint
8 Margo interalveolaris

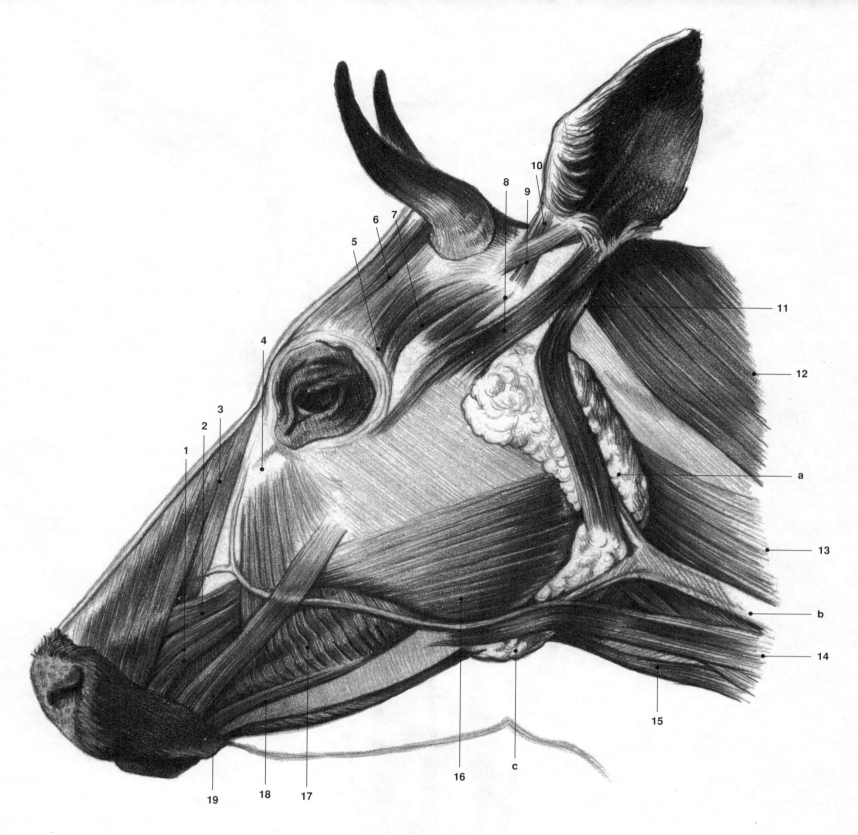

Fig. 25

The muscles of the head, lateral aspect

The muscles of the ear are flat and band-like. The buccal muscles are thick, the masticatory ones well developed. Owing to the thick skin, the contours of the muscles are not very conspicuous.

1 Caninus muscle *(165)*
2 Levator labii maxillaris muscle *(168)*
3 Levator nasolabialis muscle *(164)*
4 Malaris muscle *(159)*
5 Retractor anguli oculi lateralis muscle *(158)*

6 Frontalis muscle *(140)*
7 Temporalis muscle *(179)*
8 Frontoscutularis and zygomaticoauricularis muscles *(141, 142)*
9 Parietoauricularis muscle *(147)*
10 Scutuloauricularis muscle *(144)*
11 Parotideoauricularis muscle *(150)*
12 Cleidotransversarius muscle *(6/2)*
13 Sternocleidomastoideus muscle *(6/3)*
14 Sternomandibularis muscle *(7/1)*
15 Sternohyoideus muscle *(9)*

16 Masseter muscle *(178)*
17 Buccalis muscle *(175/1)*
18 Depressor labii mandibularis muscle *(170)*
19 Zygomaticus muscle *(174)*

a) Parotid gland
b) Jugular groove and jugular vein
c) Mandibular gland

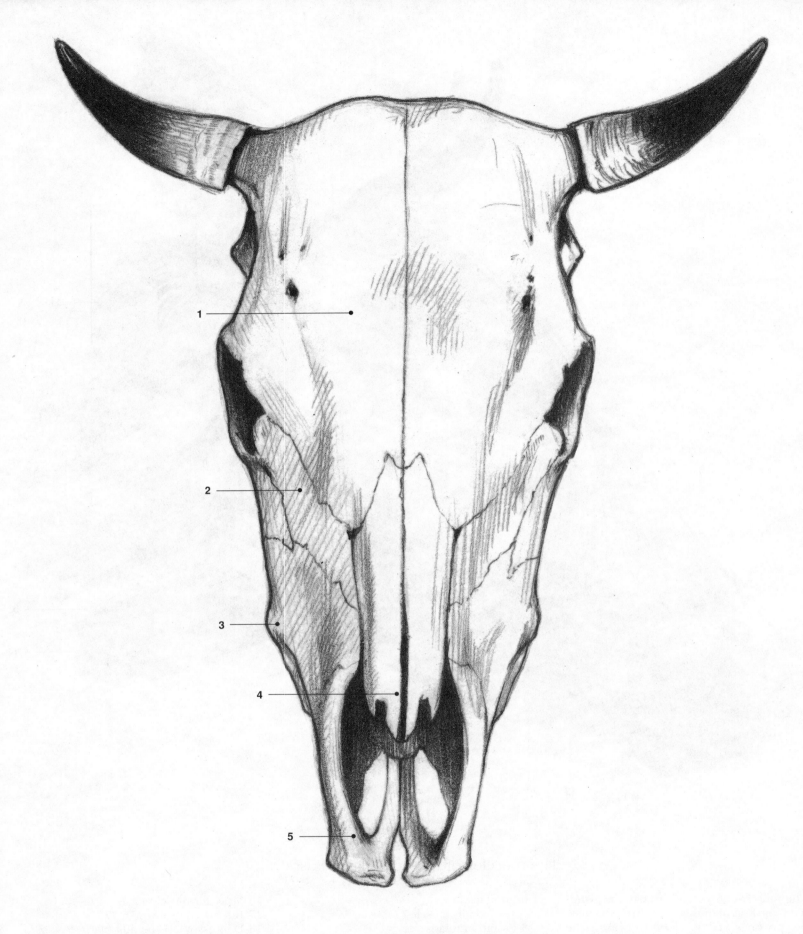

Fig. 26

The skull, dorsal aspect

The skull is broad and flat from the occiput to the supraorbital region. The occipital crest (crista nuchae) is slightly convex, cornual processes arise on its two sides, the temporal region is arched. The occipital condyles are large. The tympanic part of the petrous bone forms a large osseous bulla.

The two mandibular rows of molars and premolars are narrower than the maxillary rows.

1 Frontal bone
2 Lacrimal bone
3 Maxilla with the facial tuber
4 Nasal bone
5 Incisive bone

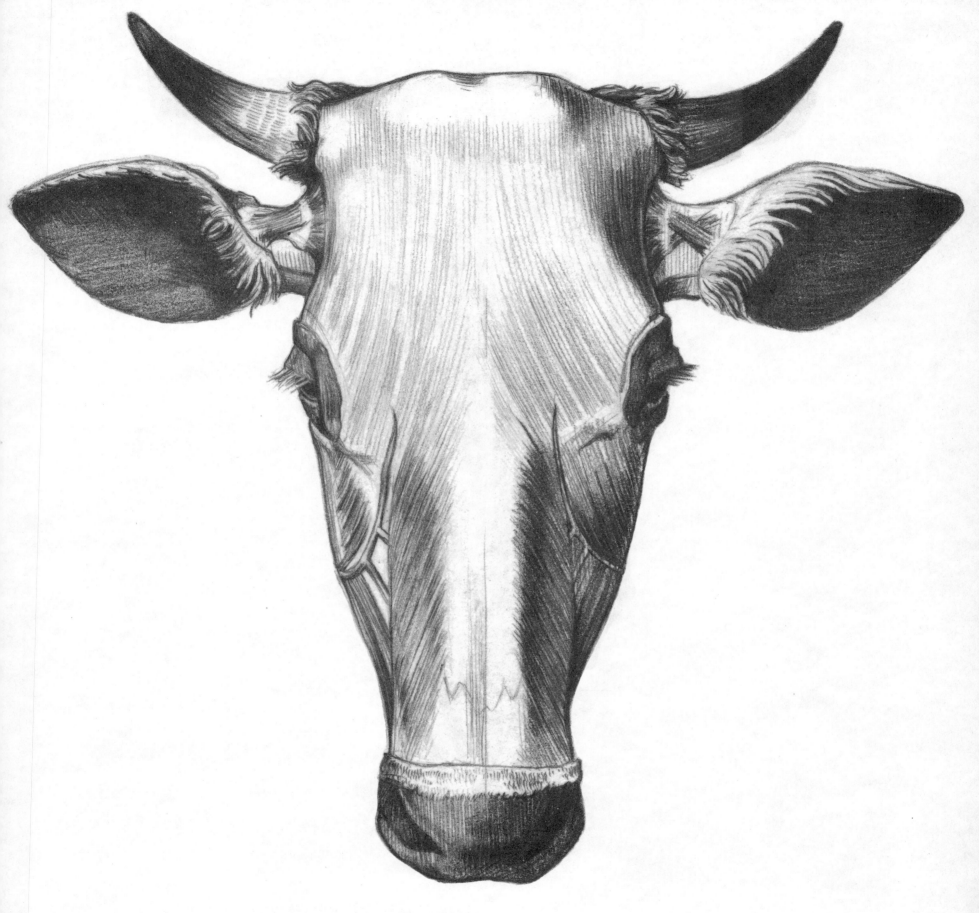

Fig. 27

The muscles of the head, dorsal aspect

The muscles are demonstrated in Fig. 25.

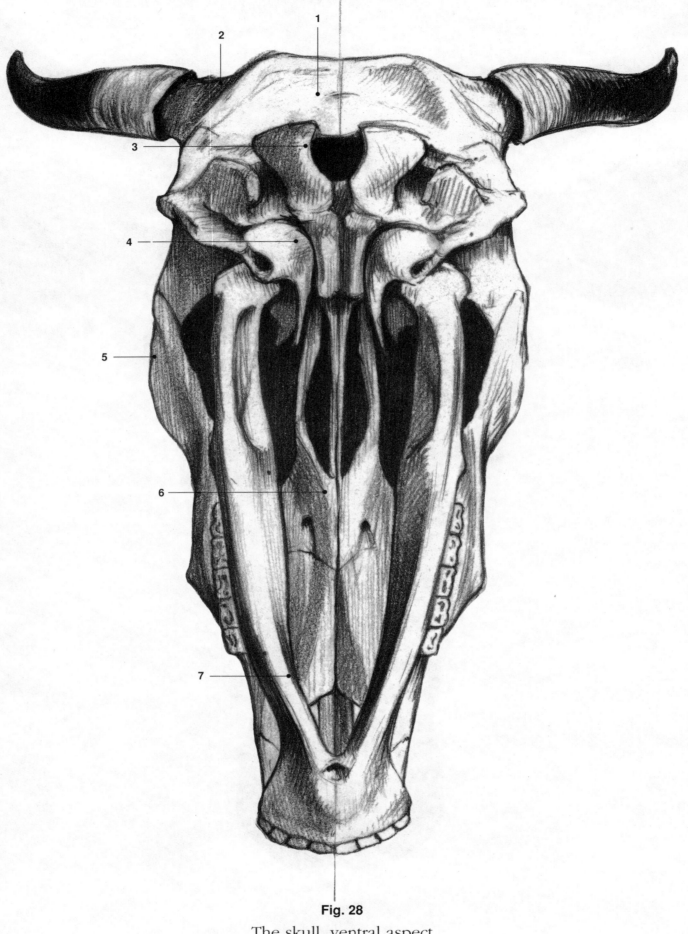

Fig. 28

The skull, ventral aspect

1 Parietal bone (occiput) 5 Zygomatic arch
2 Cornual process 6 Palatine bone
3 Occipital condyle 7 Mandible
4 Bulla tympanica

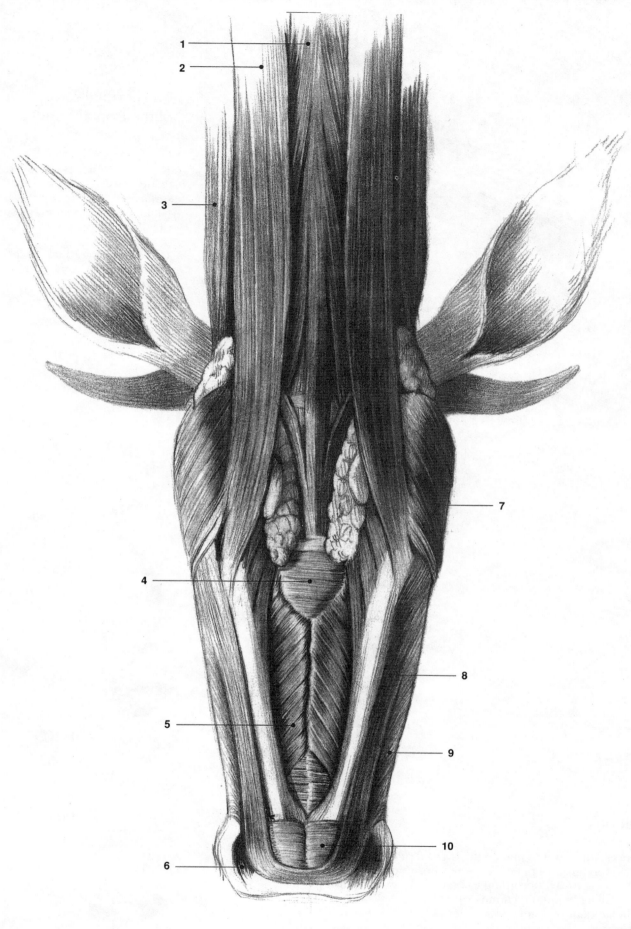

Fig. 29

The muscles of head, ventral aspect

1 Sternohyoideus muscle *(9)*
2 Sternomandibularis muscle *(7/1)*
3 Cleidomastoideus muscle *(7/2)*
4 Transversus mandibulae muscle *(177)*
5 Mylohyoideus muscle *(176)*

6 Orbicularis oris muscle *(163)*
7 Masseter muscle *(178)*
8 Depressor labii mandibularis muscle *(170)*
9 Buccalis muscle *(175/1)*
10 Mentalis muscle *(173)*

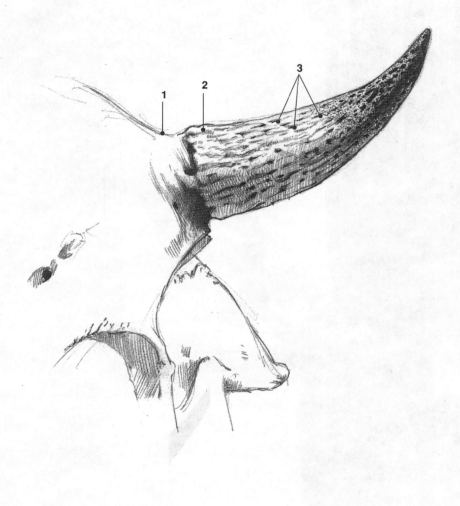

Fig. 30

The cornual process of the frontal bone, cranial aspect

The cornual process is covered by a horny tissue and has a neck at the base. On the surface, it has a spongy osseous structure with numerous openings of tiny ducts and canals for blood vessels.

1 Neck of the cornual process
2 Crown of the cornual process
3 Openings of the nutritive canals on the body and tip

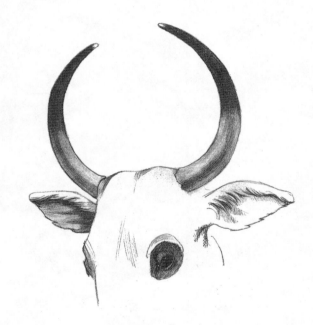

Horn (large)

Fig. 31

Horn formations

The horn is a modified skin structure on the cornual process of the frontal bone. Its keratinized epithelium is the horny capsule; its color, size and direction vary according to breed, age and sex. Its base is broad, the length and direction is variable.

According to the amount of pigment the color of the horn may be white, yellowish-brown, brown or black. There are circular grooves called year-rings on it, which are produced by poor nutrition periods, pregnancies or chronic disease, but these can be used neither for accurate determination of age nor for estimation of the number of pregnancies. The horny capsule is produced by the corium papillae closely attached to the periosteum. The corium forms a crown around the base of the horny process.

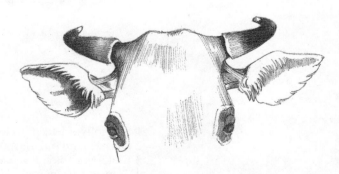

Horn (small)

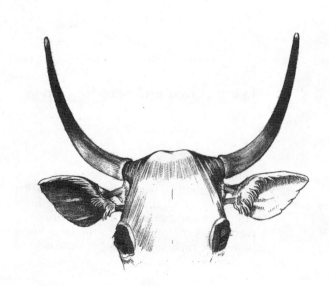

Tabular

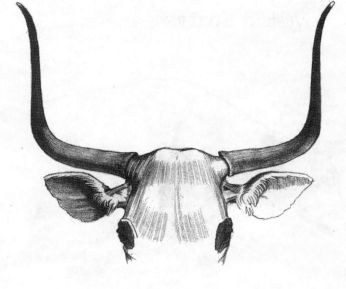

Shako

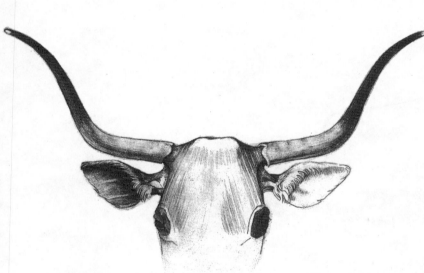

Twiggy

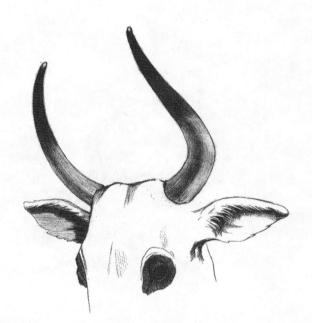

Fork-shaped (big)

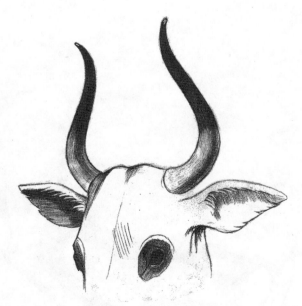

Lyre-shaped

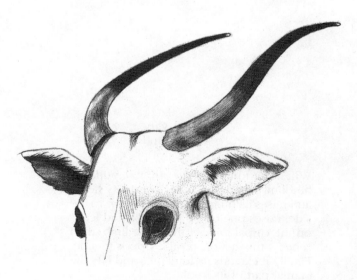

Goat horn

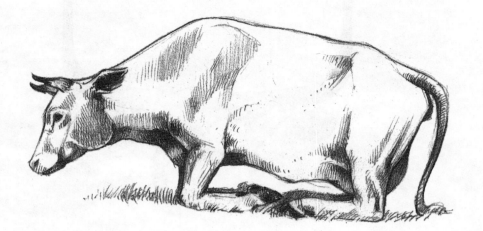

Fig. 32

Lying down and standing up

In preparation for lying down the animal first lowers its head, then flexes the forelimbs one after another and descends onto the carpal joints. Then it places the hind limbs under the belly and shifts onto the side of its thigh.

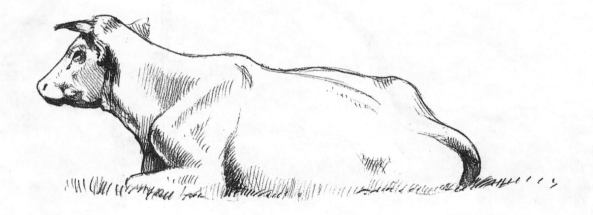

The lying animal rests in a half-elevated position on the sternum, the belly and the side of the thigh. The head is held upright.

When standing up the animal pulls its hindlimbs under its belly, nods its head, and raises its rump. After this it leans to the side, raises one of the forelimbs and leans on the carpal joint of the same limb, then repeats this action on the opposite side. Finally it extends its forelimbs and lifts the cranial part of its trunk.

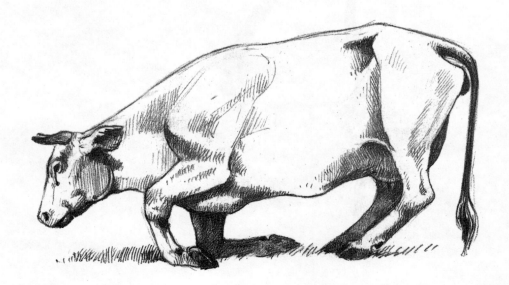

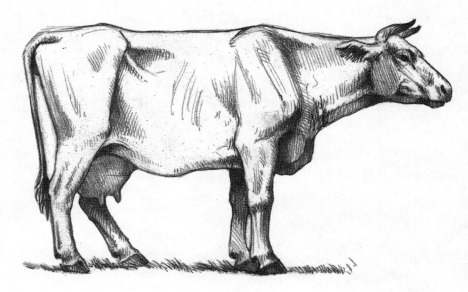

Standing

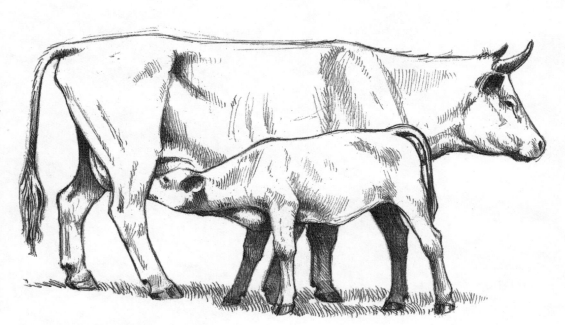

Suckling

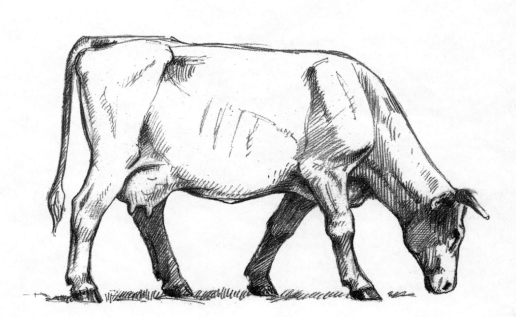

Grazing

493

THE CAMEL

Apart from the large African camels, the camel family also includes South American llamas. Camels were domesticated thousands of years ago and have been kept as domestic animals ever since. In hot and arid regions they make excellent animals for riding and carrying goods. Apart from meat, fat, skins and wool, they also provide milk (about 5 litres/10 pints per day for the Bactrian camel and about 20 litres/40 pints per day for the dromedary). In hot climates they are used for the long-distance transport of goods to this day. In the past a desert-crossing would have been impossible without camels. Large, two-humped camels can still be found in the wild, where they live in herds.

Camels are paired ungulates. The nails are present at the front of the sole of the foot. These soles are large and pliable, so camels are unlikely to sink into the soft sand. They walk on their third and fourth phalanx. All the other toes have degenerated.

Camels have a slender yet well built body. On their backs they carry one hump (dromedary) or two (Bactrian camel). These humps are fat-reserves used as energy and water supplies. As the stored fat is used up the humps begin to shrink and lean to one side. These reserves enable camels to live for weeks without taking in food and water. They can endure loss of body water better than any other mammal; even if the loss is as high as 40% of body weight they will come to no harm. They also produce very acid urine and very hard faeces. Because camels only begin to sweat at 40°C their water loss remains low, even in high desert temperatures.

Camels are well adapted to life in deserts and steppes; their nostrils can be closed, which is useful during sandstorms. Those parts of the body that come into contact with the ground during rest, like the chest, elbows, knees and soles of the feet are protected with a layer of callus. Their dense, yellow-reddish to reddish coat, with its insulating properties, protects them during the cold nights against hypothermia and during the day against overheating. Their outer ears and eyes are protected by long hairs which shield them against sand during storms.

Camels are herbivores, eating tough, thorny bushes which they can easily masticate with their specially adapted teeth. Plant material is ground between wide molars, the lower jaw making circular movements which are so typical of camels. The incisors in the lower jaw protrude a lot. In the upper jaw the incisors are missing, except for small ones at the sides. Alongside each canine in the upper jaw are an incisor and a molar, built like canines, and alongside each canine in the lower jaw is a molar also built like a canine. These teeth are used only for fighting.

Although camels re-chew their food they do not belong to the true ruminants (like, for instance, cattle), because there are significant differences in the construction of their bodies and the way their stomachs function.

With their long legs camels are, like horses, built for running. When they move they amble; the two legs on one side of the body move forwards together, making the body lean to one side and resulting in a typical swaying movement.

The rather small head is borne on a long, narrow, curved neck. The neck vertebrae are large and strong, enabling them to pick up food from the ground and to reach fruit, leaves and buds high up in trees. They can also see, hear and smell danger from far away.

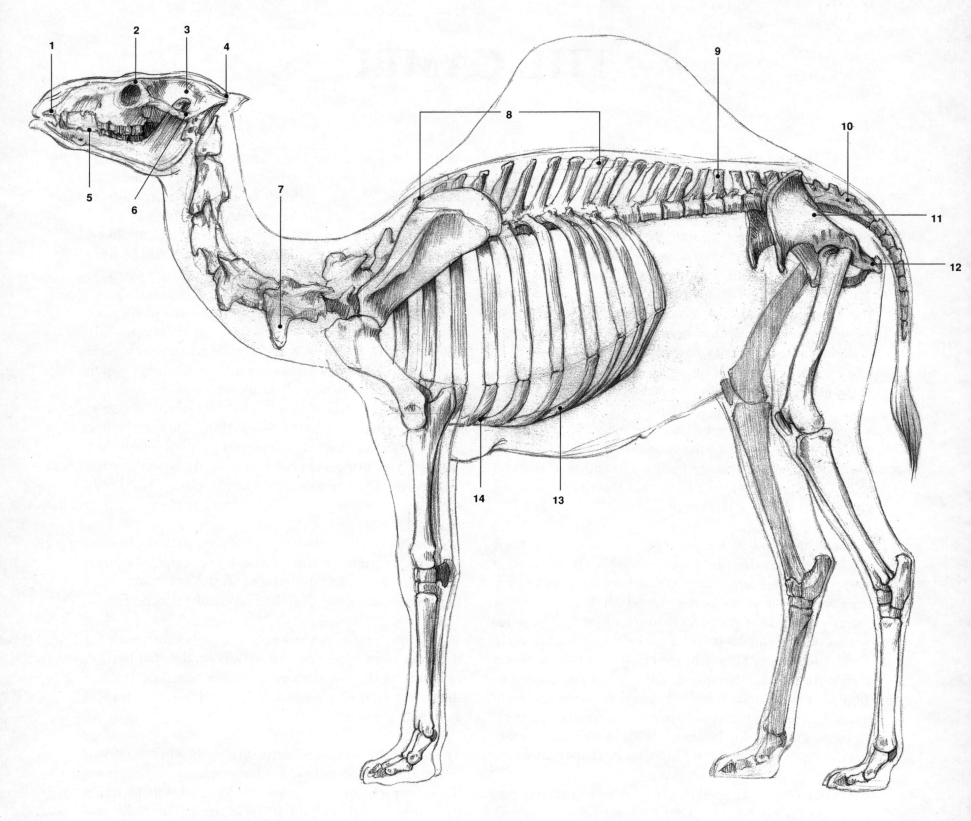

Fig. 1

The skeleton

The skull is strongly developed. The neck portion of the vertebral column is upturned, and the animal carries its head high. The back and the loin are convex, the vertebrae have long spinous processes.

1 Incisive bone
2 Supraorbital region, orbit
3 Temporal fossa
4 Nuchal crest

5 Margo interalveolaris
6 Zygomatic arch
7 The transverse processes of the cervical vertebrae are gradually lengthening to the Vth vertebra
8 Spinous processes of the thoracic vertebrae
9 The spinous process of the Vth lumbar vertebra is vertical (vertebra anticlinalis)
10 Sacrum

11 The wing of the hip bone is big, the lateral and medial coxal tubers are pointed
12 The ischial bone and its tuber are small
13 Costal arch
14 Sternum

The bones of the limbs are demonstrated in Figs. 3 and 5.

496

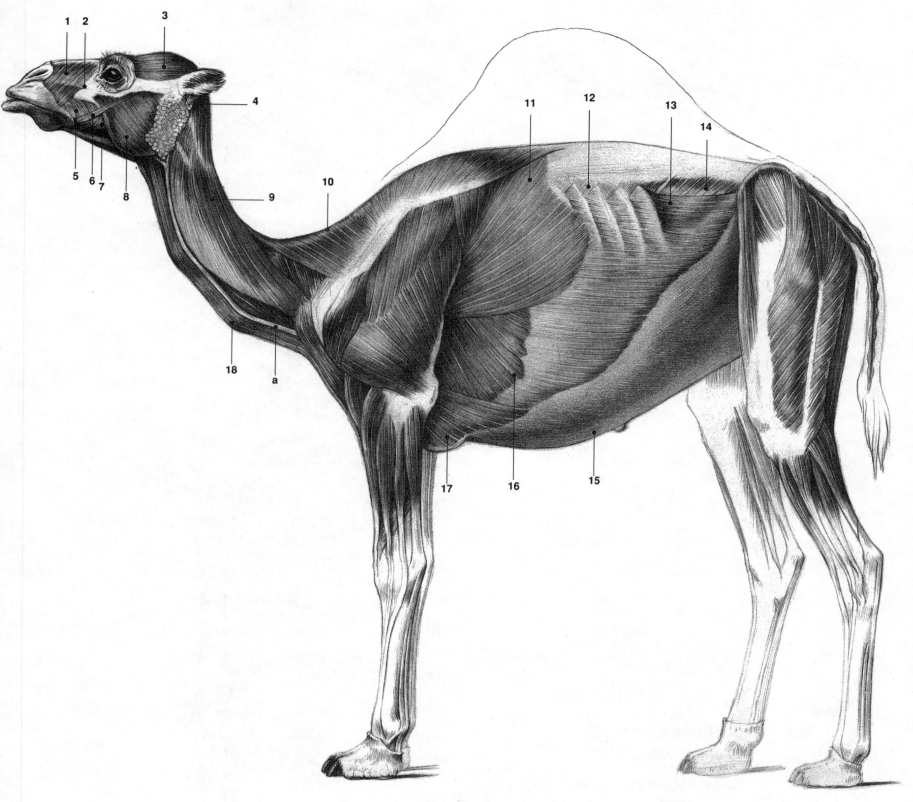

Fig. 2

The muscles

The superficial muscles of the camel are thin and lamellar, only the muscles of the thoracic girdle, arm and thighs are bulky. The neck is flattened on the sides. The rump is steep, the thigh is flattened and columnar, the feet are slender and tendinous.

1 Levator nasolabialis muscle *(164)*
2 Caninus muscle *(165)*
3 Temporalis muscle *(179)*
4 Rectus capitis dorsalis muscle *(3)*

5 Orbicularis oris muscle *(163)*
6 Zygomaticus muscle *(174)*
7 Buccalis muscle *(175/1)*
8 Masseter muscle *(178)*
9 Brachiocephalicus muscle *(6)*
10 Trapezius muscle *(14)*
11 Latissimus dorsi muscle *(16)*
12 Serratus dorsalis muscle *(19)*
13 Obliquus abdominis externus muscle *(36)*
14 Obliquus abdominis internus muscle *(37)*

15 Vagina recti abdominis *(40)*
16 Serratus ventralis muscle, thoracic part *(18)*
17 Pectoralis profundus muscle *(30)*
18 Sternocephalic *(7)* and sternohyoid muscles *(9)*

a) Jugular vein

The muscles of the limbs are demonstrated in Figs. 4. and 6.

497

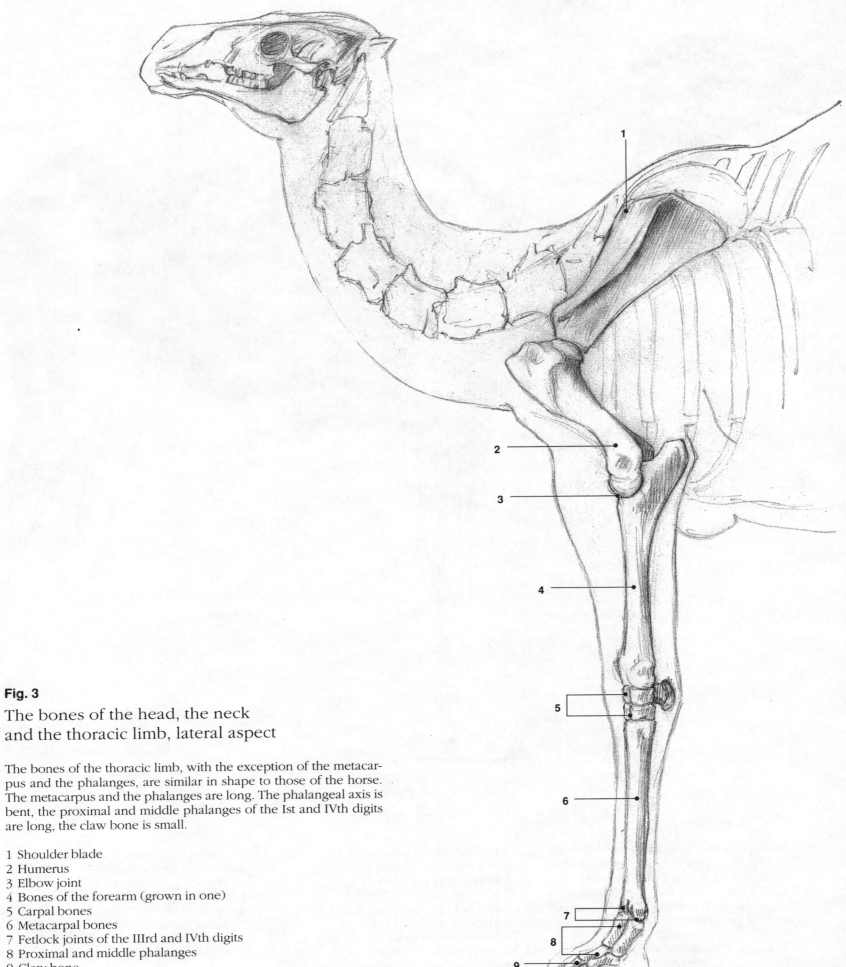

Fig. 3

The bones of the head, the neck and the thoracic limb, lateral aspect

The bones of the thoracic limb, with the exception of the metacarpus and the phalanges, are similar in shape to those of the horse. The metacarpus and the phalanges are long. The phalangeal axis is bent, the proximal and middle phalanges of the Ist and IVth digits are long, the claw bone is small.

1 Shoulder blade
2 Humerus
3 Elbow joint
4 Bones of the forearm (grown in one)
5 Carpal bones
6 Metacarpal bones
7 Fetlock joints of the IIIrd and IVth digits
8 Proximal and middle phalanges
9 Claw bone

The bones of the skull and the neck are demonstrated in Fig. 1.

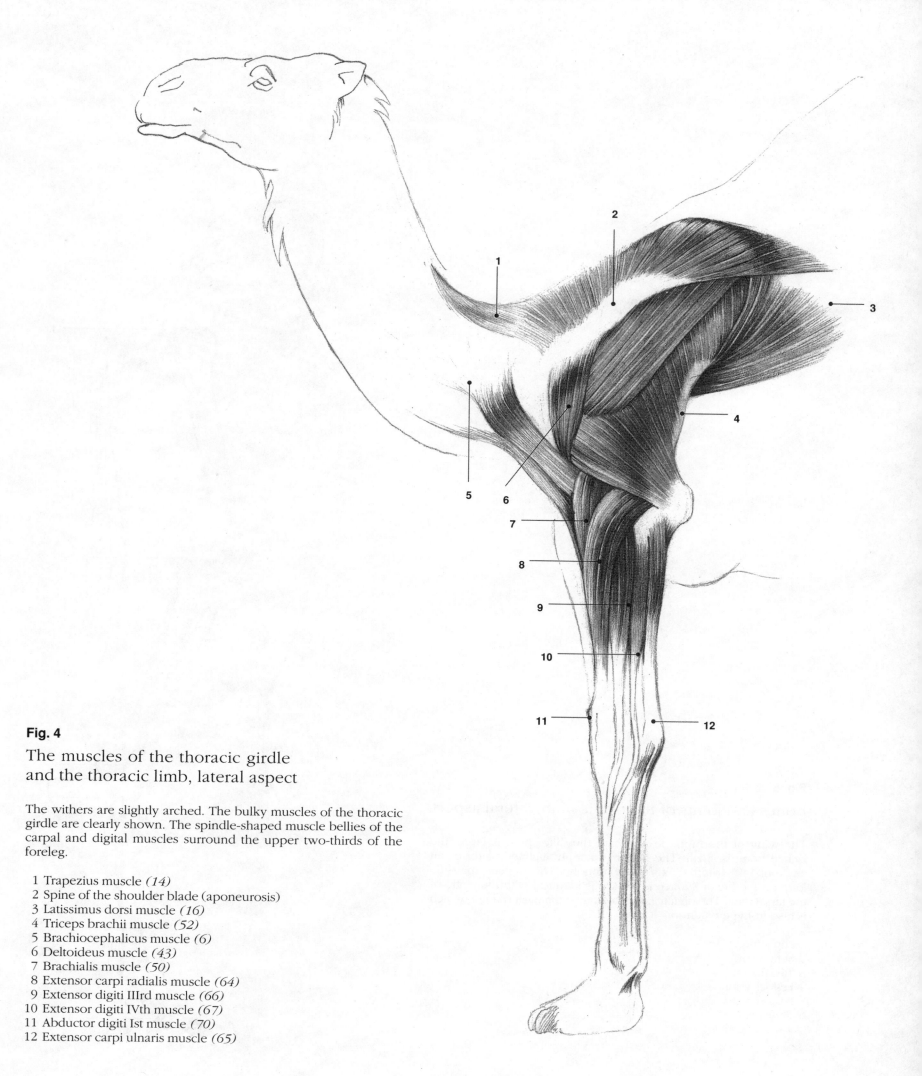

Fig. 4

The muscles of the thoracic girdle
and the thoracic limb, lateral aspect

The withers are slightly arched. The bulky muscles of the thoracic
girdle are clearly shown. The spindle-shaped muscle bellies of the
carpal and digital muscles surround the upper two-thirds of the
foreleg.

 1 Trapezius muscle *(14)*
 2 Spine of the shoulder blade (aponeurosis)
 3 Latissimus dorsi muscle *(16)*
 4 Triceps brachii muscle *(52)*
 5 Brachiocephalicus muscle *(6)*
 6 Deltoideus muscle *(43)*
 7 Brachialis muscle *(50)*
 8 Extensor carpi radialis muscle *(64)*
 9 Extensor digiti IIIrd muscle *(66)*
10 Extensor digiti IVth muscle *(67)*
11 Abductor digiti Ist muscle *(70)*
12 Extensor carpi ulnaris muscle *(65)*

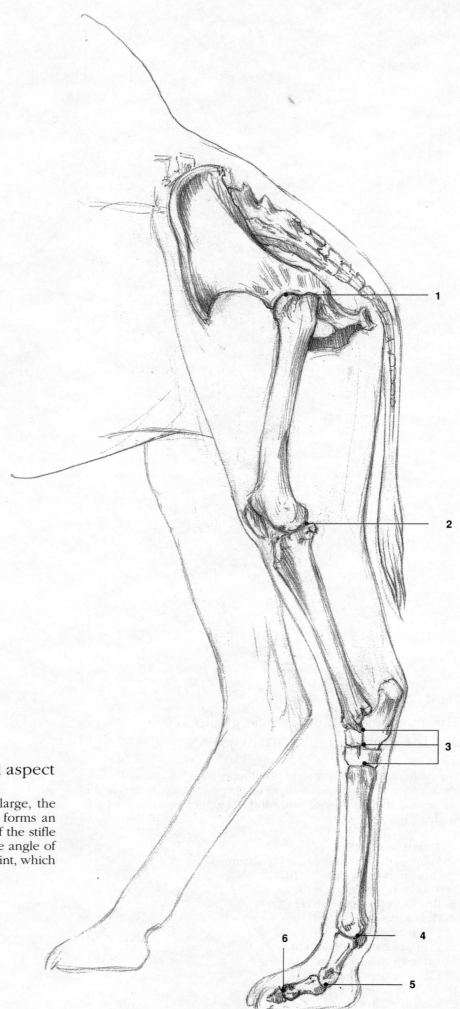

Fig. 5

Bones and joints of the pelvic limb, lateral aspect

The wing of the hipbone is broad, the iliac spine is large, the ischial bone is small. The femur is steeply inclined, it forms an angle of 140° with the axis of the hipbone. The angle of the stifle joint on the flexor surface is 180°, it is identical with the angle of the tarsal joint. The digital axis is broken at the pastern joint, which is also in hyperextension.

1 Hip joint
2 Stifle joint
3 Tarsal joint
4 Fetlock joint
5 Pastern joint
6 Claw joint

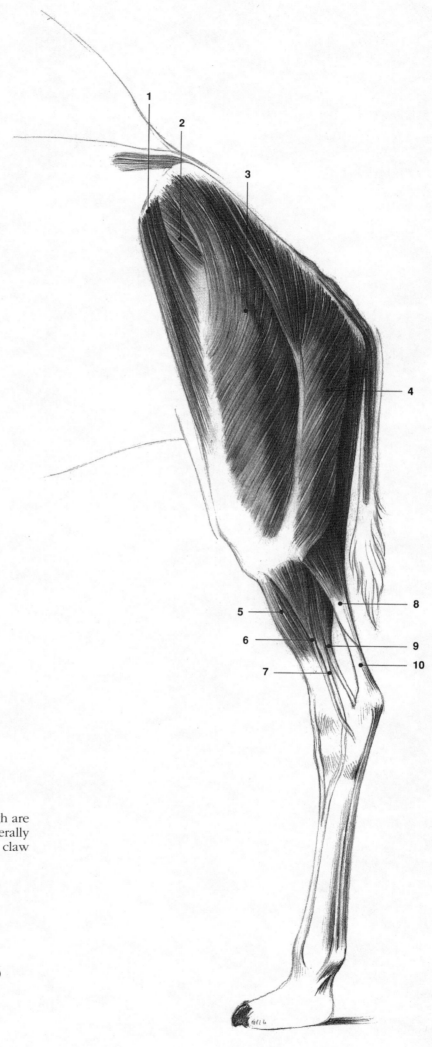

Fig. 6

The muscles of the pelvic limb, lateral aspect

The thigh is steep. The upper and caudal muscles of the thigh are long and narrow. Both the thigh and the crus are long and laterally flattened. The camel is digitigrad, it walks on its pastern and claw joints.

1 Tensor fasciae latae muscle *(95)*
2 Gluteus medius muscle *(97)*
3 Gluteobiceps muscle *(99)*
4 Caudofemoralis muscle *(98)*
5 Extensor digitorum longus muscle *(118)*
6 Peroneus longus muscle *(121)*
7 Digitalis lateralis muscle or extensor of the IVth digit *(122)*
8 Triceps surae muscle *(114)*
9 Flexor digitorum longus muscle *(125)*
10 Flexor digitorum superficialis muscle *(123)*

THE LION

Like their tame and much smaller relatives, domestic cats, lions belong to the felidae family. Lions are the largest free-living animals of the African and Southwest Asian steppes. In ancient times the lion, regarded as a symbol of power, strength and independence, was kept in zoos and used in fights against gladiators.

The yellow-brown colored coat of young males and all lionesses camouflages them very well in the grassy steppes and semi-desert. Especially impressive are the huge, mainly dark brown manes around the heads, necks and chests of older males; these animals can weigh up to 250 kg (550 lbs). Lions are the only wild cats who live in groups consisting of 10–15 females, one to three grown up males and several young animals. As soon as the males reach sexual maturity they fight for leadership of the pride. Older males, who have been expelled from their prides after losing a fight, live on as solitary animals. Sexually mature male lions often gang together in "bachelor" groups.

The real hunters and providers of a pride are the lionesses. They hunt mainly in a group and share the prey. The strategy of the group consists of silent stalking, selecting the prey and isolating it, followed by a short chase. In order to stalk, lionesses need the protection of vegetation or darkness. Because the hunt largely depends on environmental circumstances, i.e. the seasons or the time of day, they are mainly active at dusk and at night. Their senses, like those of the cat, are adapted to these conditions. Lions do not hunt regularly, but only when they are hungry. Otherwise they rest and groom each other, which is one way of expressing the strong social bonds inside the group. Because lions hunt mainly large prey, like gnus, zebras, and antelopes, a single kill can satisfy them for days. Digesting a large meal can take up to 100 hours. A well-fed lion is a reluctant hunter.

Lions are digitigrade, like all cats and are therefore ideally equipped for silent stalking and a fast chase. However, their intended prey, mostly hoofed animals like gazelles, can usually run even faster and longer. Approaching the prey without being noticed is absolutely vital for success, so that it can be caught in a short, fast sprint before reaching its top speed. At first the attackers stalk it very slowly with short steps, whilst other members of the group encircle the whole herd in a wide arc, in order to chase the prey towards the attackers. Once close enough they approach the intended victim with a few long jumps and strike with their strong paws and claws, killing it with one bite into the throat or neck. The teeth of lions, with their strong canines, are typical of a carnivore. These canines are used to hold the prey down and occlude the carotid artery. The captured animal collapses. The flesh is pulled apart and torn with strong molars, and the incisors used to gnaw the last remnants off the bones.

Despite the close social bonds the young are born away from the pride. After a pregnancy lasting for more than 100 days, the lioness gives birth to her young, which are suckled for 6–7 months. At birth the young weigh 1100–1500 g (2.5–3.5 lbs) and are at first totally helpless. After about 30 days they leave their hidden birthplace and soon start to eat solid food in addition to their mother's milk. 6–8 weeks after birth the lioness joins her pride again, together with her offspring. From now on the other lionesses also participate in the upbringing of the youngsters.

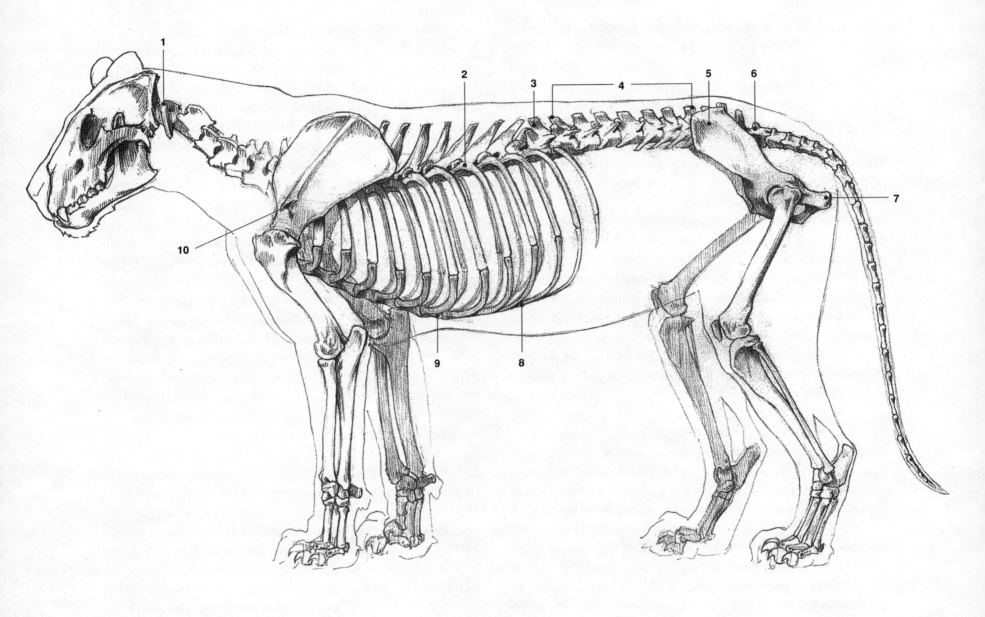

Fig. 1

The skeleton

The lion is a carnivorous animal. The back and the neck are straight. The chest is wide and rounded, the shoulder blade is wide and short, the pelvis is relatively small, the fore- and hindfeet are short. All five fingers are fully developed. The lion is a digitigrade animal.

1 Ist cervical vertebra
2 VIIIth or last real rib
3 XIIth thoracic vertebra
4 Lumbar vertebrae
5 Hipbone
6 Sacrum
7 Ischial bone

8 Costal arch
9 Sternum
10 Shoulder blade

The bones of the skull are demonstrated in Fig. 11, those of the limbs in Figs. 3, 7 and 10, respectively.

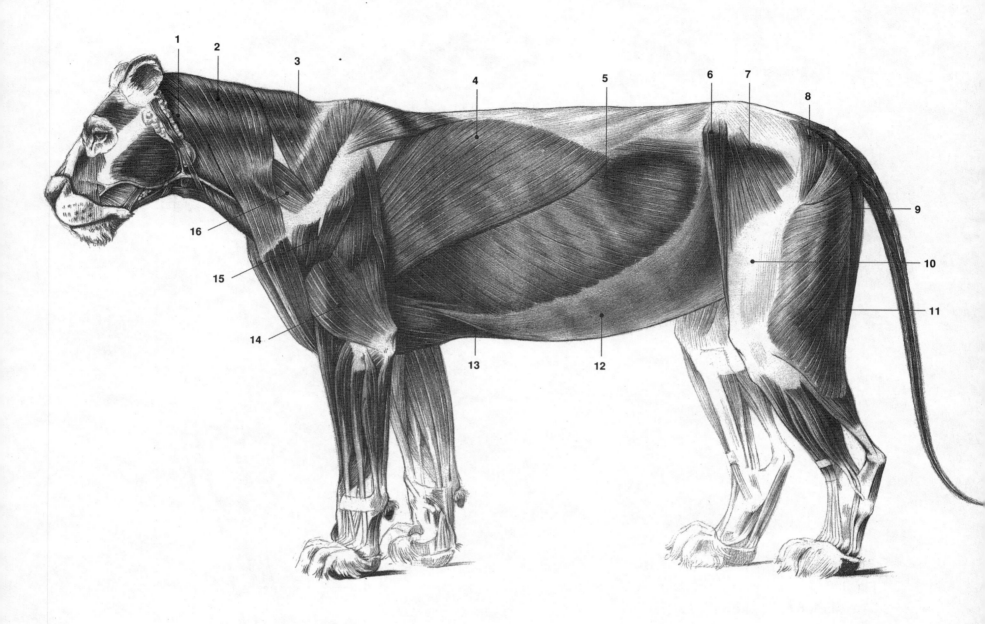

Fig. 2

The muscles of the lioness

The superficial muscles are well developed. A huge masticatory musculature is supported by strong cervical extensors. Muscles helping the many functions of the thoracic limb like hitting, climbing, catching prey etc. (the thoracic girdle as a whole, and particularly the pectoral, shoulder and elbow muscles, as well as the digital flexors) are the most developed. The muscles of rotation are also well developed in this species.

1 Sternocephalicus muscle *(7)*
2 Brachiocephalicus muscle *(6)*
3 Trapezius muscle *(14)*
4 Latissimus dorsi muscle *(16)*
5 Obliquus externus abdominis muscle *(36)*
6 Sartorius muscle *(102)*
7 Tensor fasciae latae muscle *(95)*
8 Gluteus superficialis muscle *(96)*
9 Semitendinosus muscle *(107)*
10 Quadriceps femoris muscle *(112)*

11 Biceps femoris muscle *(106)*
12 Vagina recti abdominis *(40)*
13 Pectoralis profundus muscle *(30)*
14 Triceps brachii muscle *(52)*
15 Deltoideus muscle *(43)*
16 Omotransversarius muscle *(15)*

The muscles of the head are demonstrated in Figs. 12 and 13, those of the limbs in Figs. 4–6 and 8–10, respectively.

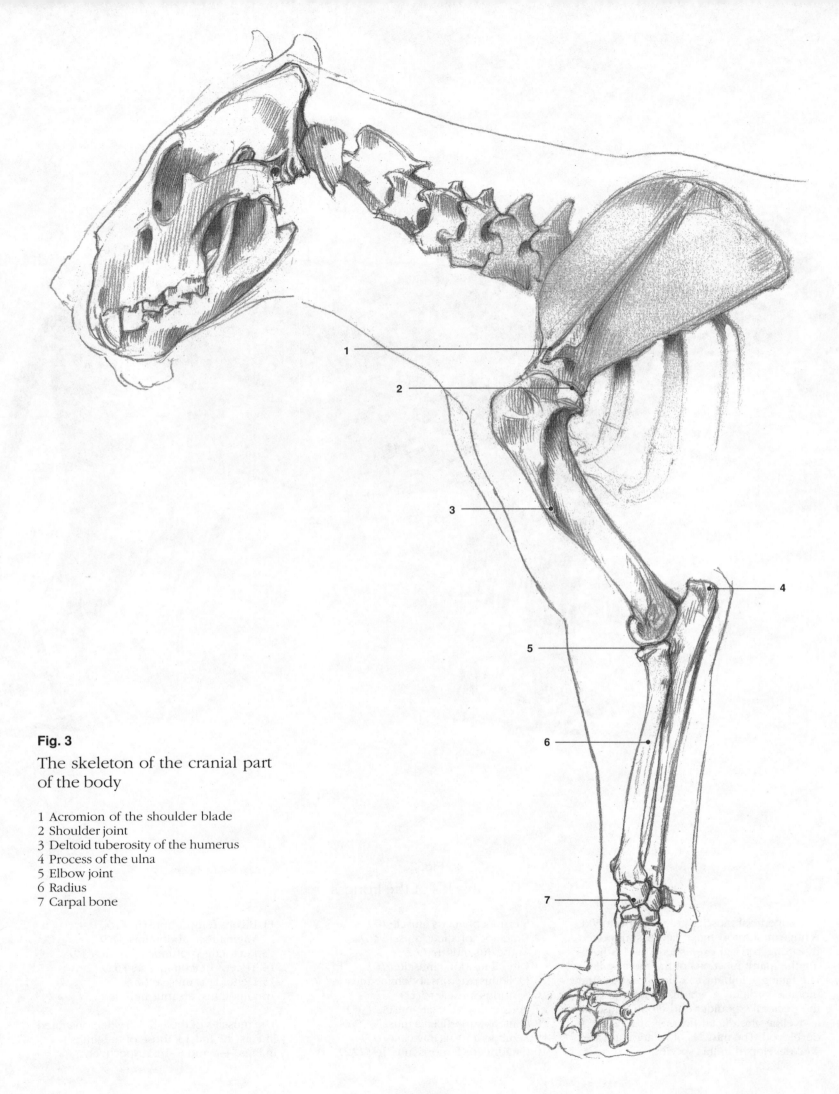

Fig. 3

The skeleton of the cranial part
of the body

1 Acromion of the shoulder blade
2 Shoulder joint
3 Deltoid tuberosity of the humerus
4 Process of the ulna
5 Elbow joint
6 Radius
7 Carpal bone

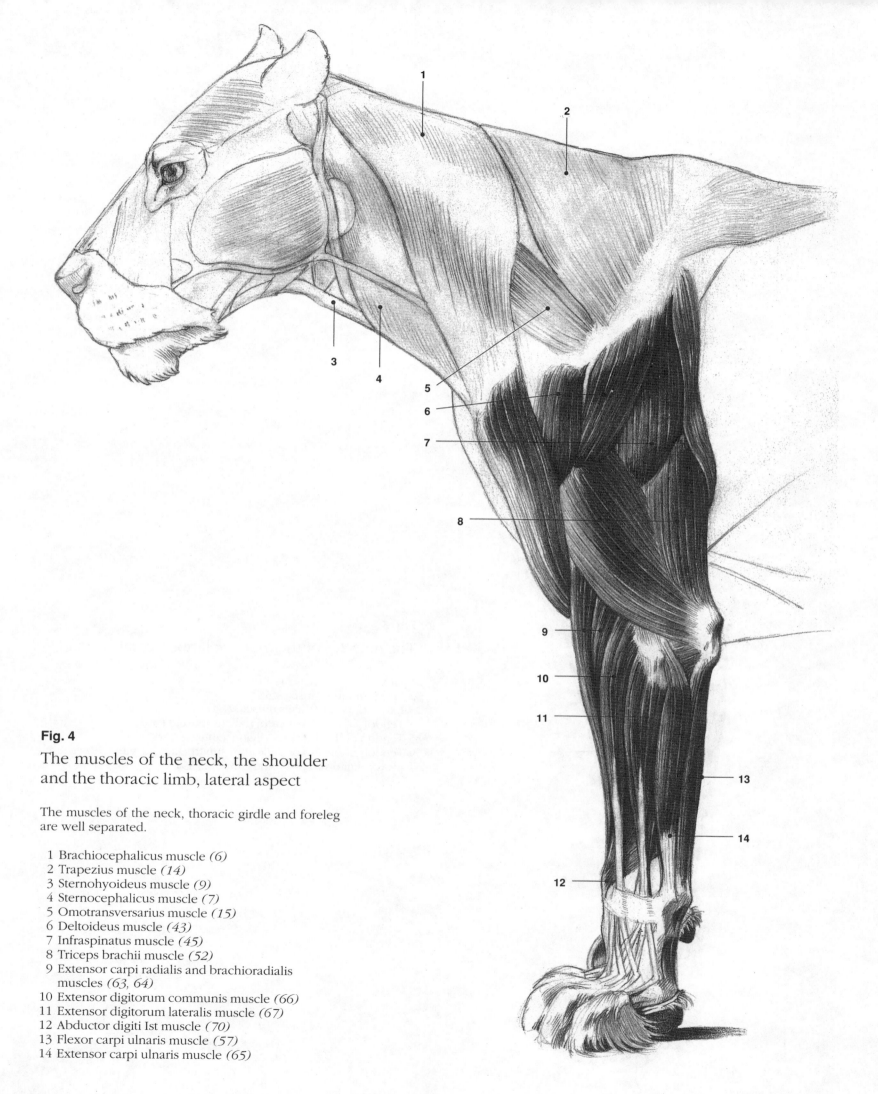

Fig. 4

The muscles of the neck, the shoulder
and the thoracic limb, lateral aspect

The muscles of the neck, thoracic girdle and foreleg
are well separated.

1 Brachiocephalicus muscle *(6)*
2 Trapezius muscle *(14)*
3 Sternohyoideus muscle *(9)*
4 Sternocephalicus muscle *(7)*
5 Omotransversarius muscle *(15)*
6 Deltoideus muscle *(43)*
7 Infraspinatus muscle *(45)*
8 Triceps brachii muscle *(52)*
9 Extensor carpi radialis and brachioradialis
 muscles *(63, 64)*
10 Extensor digitorum communis muscle *(66)*
11 Extensor digitorum lateralis muscle *(67)*
12 Abductor digiti Ist muscle *(70)*
13 Flexor carpi ulnaris muscle *(57)*
14 Extensor carpi ulnaris muscle *(65)*

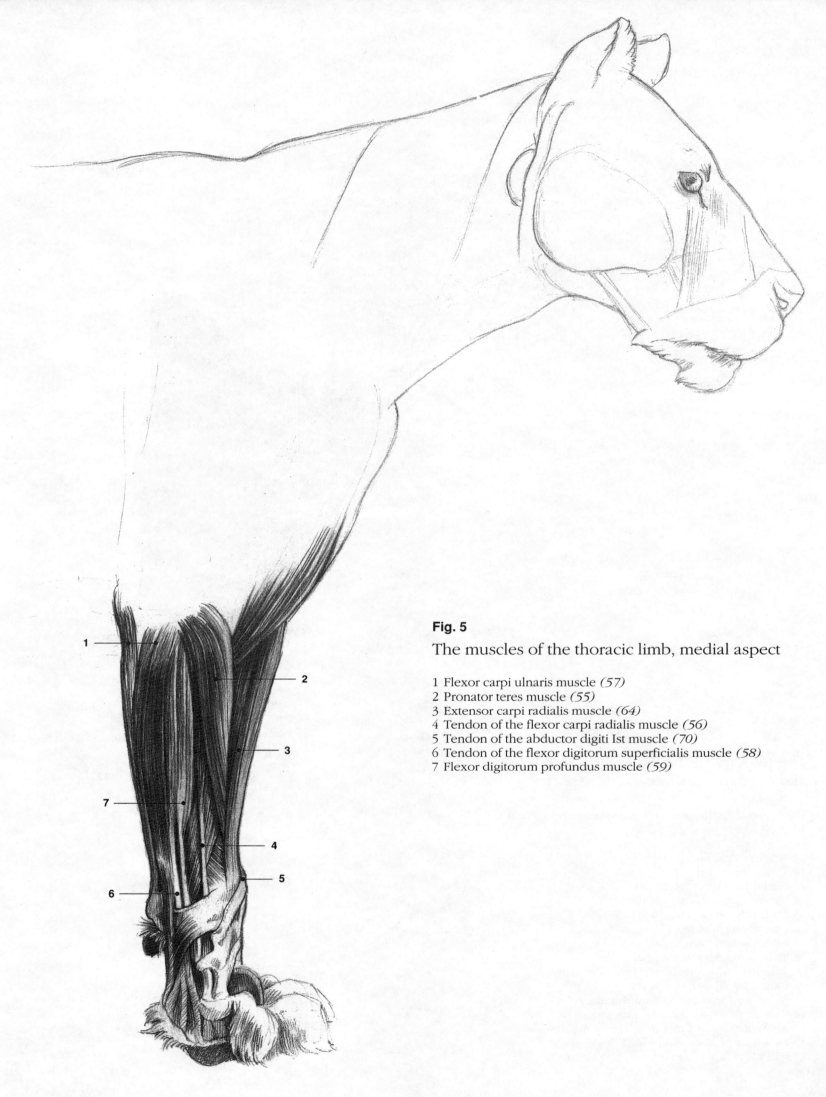

Fig. 5

The muscles of the thoracic limb, medial aspect

1 Flexor carpi ulnaris muscle *(57)*
2 Pronator teres muscle *(55)*
3 Extensor carpi radialis muscle *(64)*
4 Tendon of the flexor carpi radialis muscle *(56)*
5 Tendon of the abductor digiti Ist muscle *(70)*
6 Tendon of the flexor digitorum superficialis muscle *(58)*
7 Flexor digitorum profundus muscle *(59)*

Fig. 6

The skeleton and the muscles, cranial aspect

The spine of the shoulder blade is high, the acromion is large. The massive, pointed humerus is long, and rotable around its axis. The radius and the ulna are equally well developed; the two bones cross each other and have a mobile attachment between them. The carpal bones are arranged in two rows; the metacarpal bones are relatively long. The musculature of the shoulder is bulky, the shoulder is wide. The well developed muscles of the elbow and lower leg are spindle-shaped and long.

1 Trapezius muscle *(14)*
2 Brachiocephalicus muscle *(6)*
3 Sternohyoideus muscle *(9)*
4 Omotransversarius muscle *(15)*
5 Sternocephalicus muscle *(7)*
6 Deltoideus muscle *(43)*
7 Cleidobrachialis muscle *(6)*
8 Triceps brachii muscle *(52)*
9 Extensor digitorum communis muscle *(66)*
10 Extensor digitorum lateralis muscle *(67)*
11 Abductor digiti Ist muscle *(70)*
12 Pectorales muscles *(27–30)*
13 Pronator teres muscle *(55)*
14 Flexor carpi radialis muscle *(56)*
15 Extensor carpi radialis *(64)* and brachioradialis muscle *(63)*

The bones are demonstrated in Fig. 3.

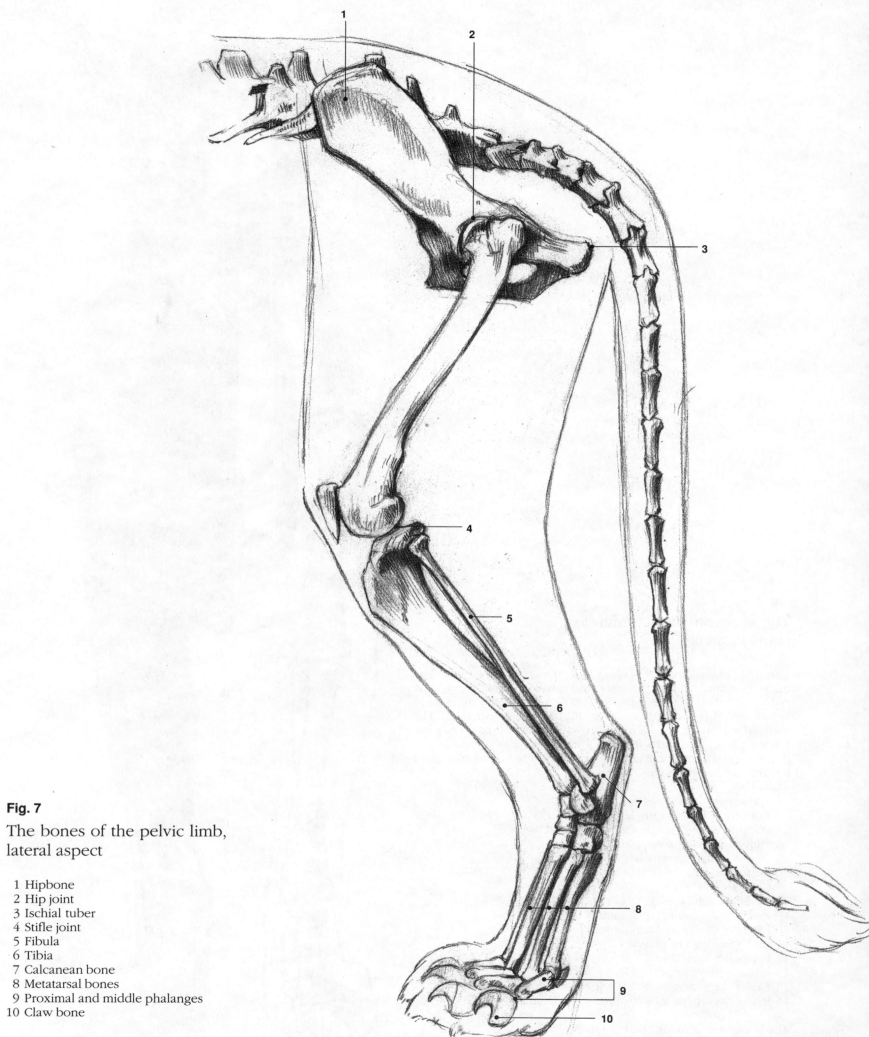

Fig. 7

The bones of the pelvic limb,
lateral aspect

1 Hipbone
2 Hip joint
3 Ischial tuber
4 Stifle joint
5 Fibula
6 Tibia
7 Calcanean bone
8 Metatarsal bones
9 Proximal and middle phalanges
10 Claw bone

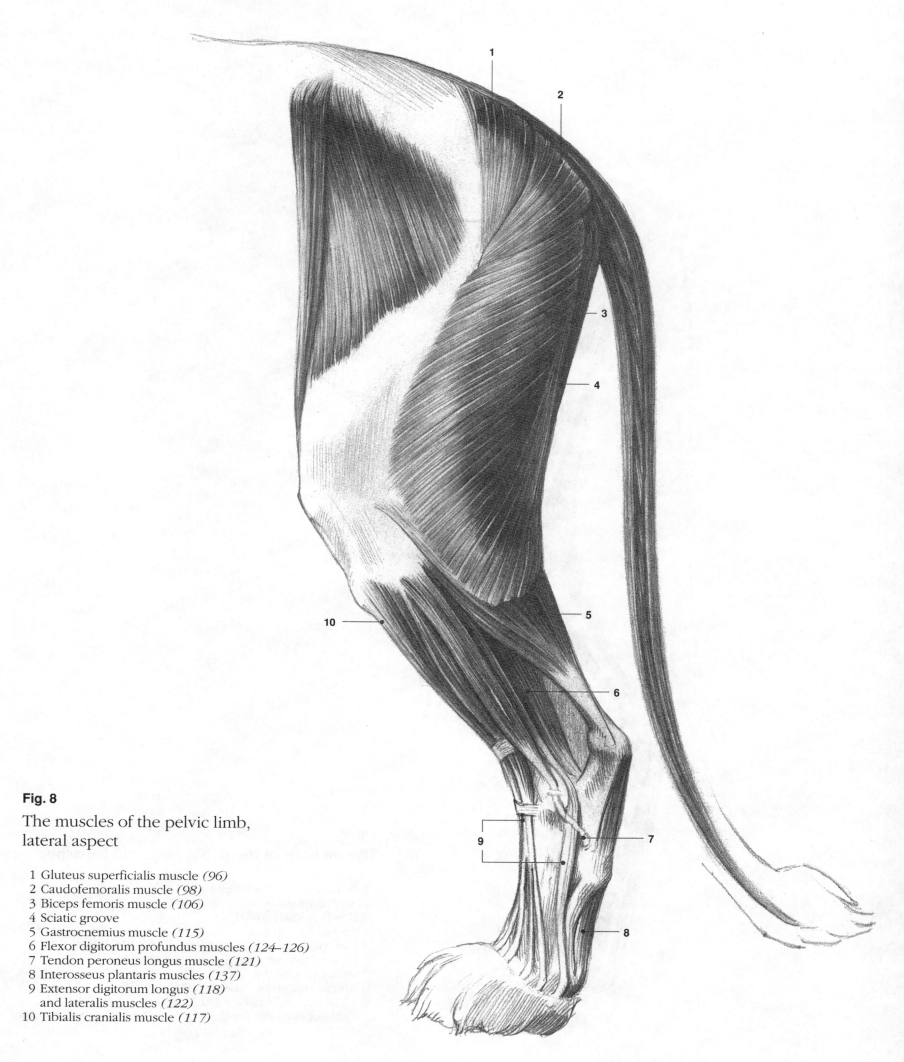

Fig. 8

The muscles of the pelvic limb,
lateral aspect

 1 Gluteus superficialis muscle *(96)*
 2 Caudofemoralis muscle *(98)*
 3 Biceps femoris muscle *(106)*
 4 Sciatic groove
 5 Gastrocnemius muscle *(115)*
 6 Flexor digitorum profundus muscles *(124–126)*
 7 Tendon peroneus longus muscle *(121)*
 8 Interosseus plantaris muscles *(137)*
 9 Extensor digitorum longus *(118)*
 and lateralis muscles *(122)*
10 Tibialis cranialis muscle *(117)*

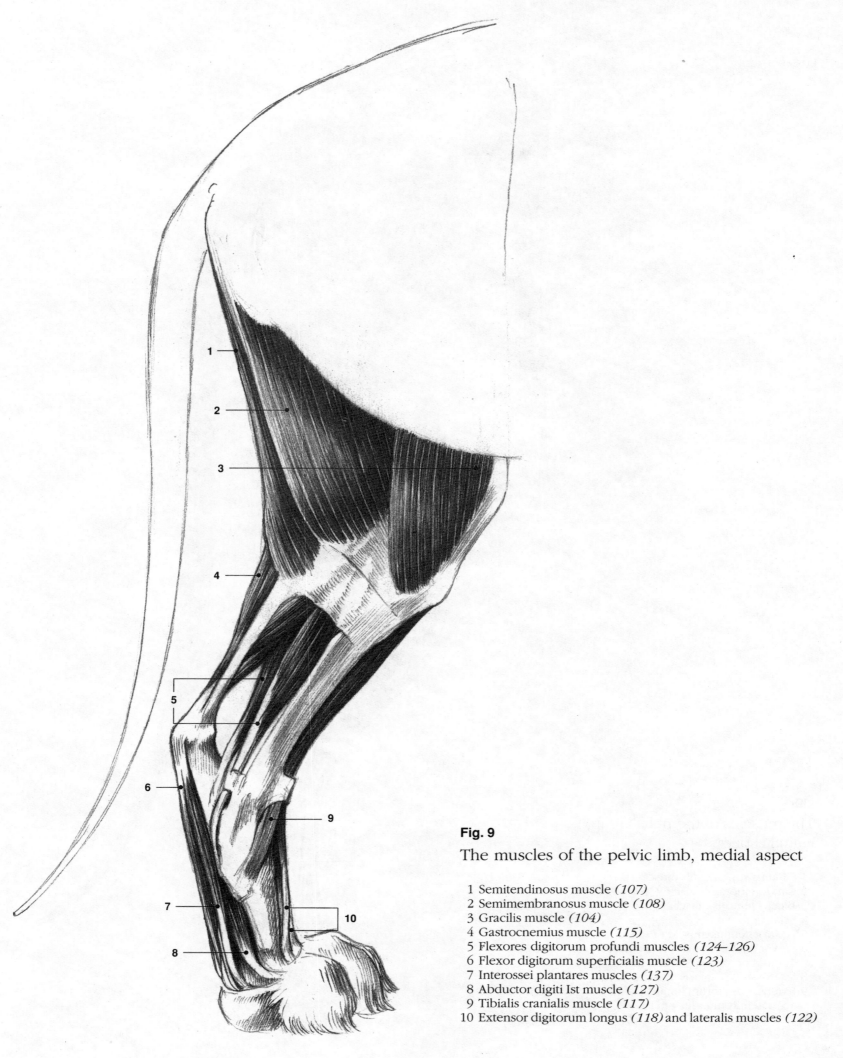

Fig. 9

The muscles of the pelvic limb, medial aspect

1 Semitendinosus muscle *(107)*
2 Semimembranosus muscle *(108)*
3 Gracilis muscle *(104)*
4 Gastrocnemius muscle *(115)*
5 Flexores digitorum profundi muscles *(124–126)*
6 Flexor digitorum superficialis muscle *(123)*
7 Interossei plantares muscles *(137)*
8 Abductor digiti Ist muscle *(127)*
9 Tibialis cranialis muscle *(117)*
10 Extensor digitorum longus *(118)* and lateralis muscles *(122)*

512

Fig. 10

The muscles and the bones of the pelvic limb, caudal aspect

The rump is flat, the thigh is flattened on the side and well-muscled. The muscles of the individual digits are also well developed.

Muscles
1 Gluteus superficialis muscle *(96)*
2 Caudofemoralis muscle *(98)*
3 Biceps femoris muscle *(106)*
4 Semitendinosus muscle *(107)*
5 Semimembranosus muscle *(108)*
6 Gracilis muscle *(104)*
7 Gastrocnemius muscle *(115)*
8 Extensor digitorum longus *(118)* and lateralis muscles *(122)*
9 Flexores digitorum profundi muscles *(124–126)*
10 Flexor digitorum superficialis muscle *(123)*
11 Interossei plantares muscles *(137)*

a) Sciatic groove

Bones
1 Hipbone
2 Hip joint
3 Ischiatic tubercle
4 Stifle joint
5 Fibula
6 Tibia
7 Calcanean bone
8 Metatarsal bones
9 Phalangeal bone
10 Claw bone

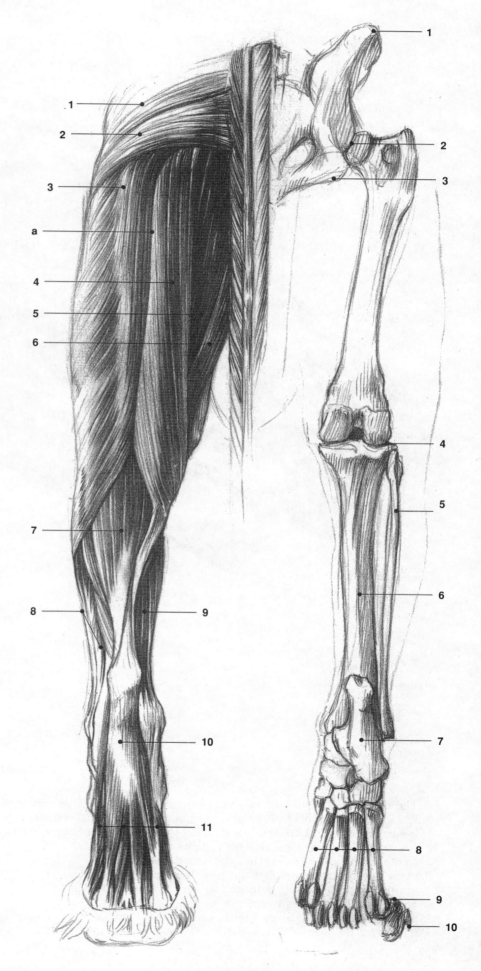

513

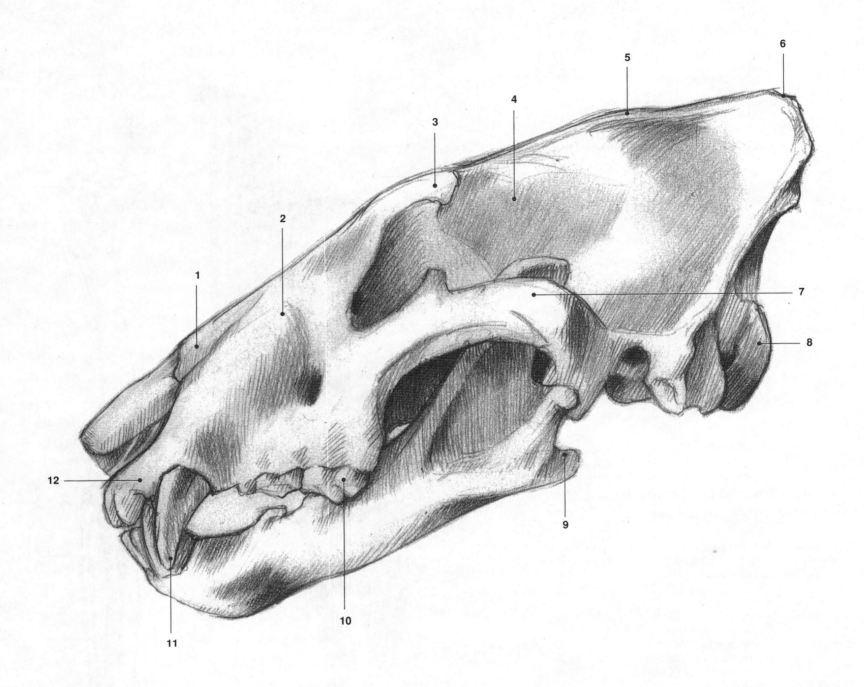

Fig. 11

The skull

The neurocranium and the face are nearly the same length, the incisive and maxilla bones are short and massive, the mandible is strong. The zygomatic arch is huge, it protrudes firmly on both sides. The orbit is relatively small, and is incomplete caudally. The temporal fossa located behind it is very large. Due to the sharply emerging longitudinal frontal and transverse nuchal crests a deep fossa is formed. The condyle of the occiput is large and forms a joint with the first cervical vertebra. The insertion sites of the head muscles, the occipital processes, are massive.

1 Nasal bone
2 Maxilla
3 Orbital process of the frontal bone
4 Temporal fossa
5 Sagittal crest of the neurocranium
6 Nuchal crest
7 Zygomatic arch
8 Occipital condyle
9 Angle of the mandible and its muscular process
10 Huge crested laniary teeth functioning like scissors
11 Canine tooth
12 Incisive bone

514

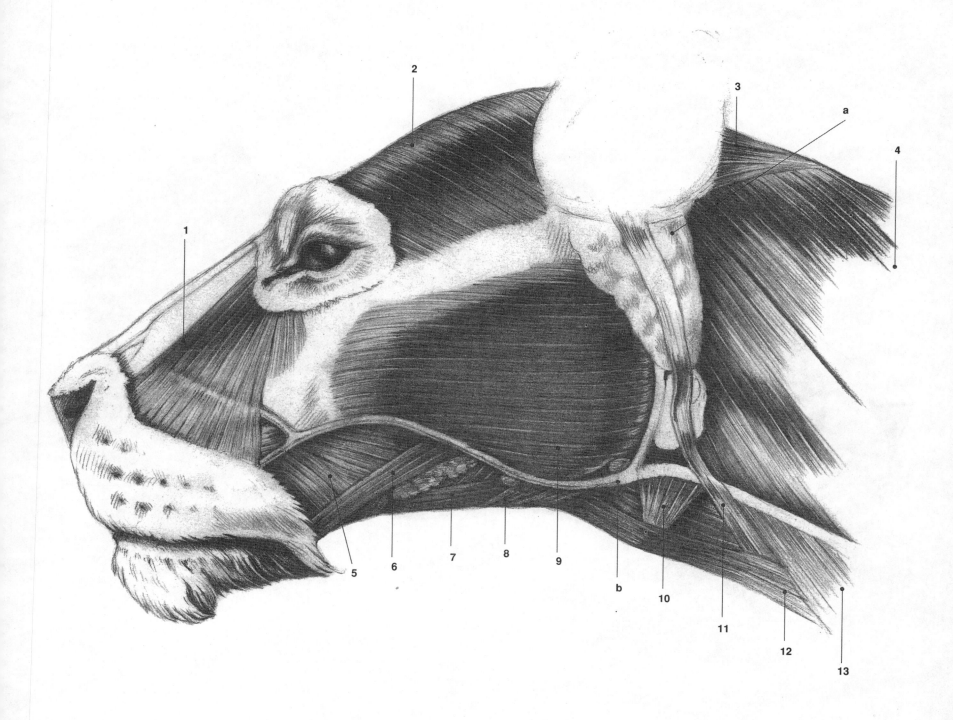

Fig. 12

The muscles of the head

The naso-labial region is wide, the nose is blunt, the mouth is large, the lips are strong. The masticatory and particularly the closing (biting) muscles of the mouth are enormous. The levator muscles and those turning the head to the side are bulky.

1 Levator nasolabialis muscle *(164)*
2 Temporalis muscle *(179)*
3 Rectus capitis dorsalis muscle *(3)*
4 Brachiocephalicus muscle *(6)*
5 Buccinator muscle *(175)*
6 Levator anguli oris muscle *(174)*
7 Depressor labii mandibularis muscle *(170)*
8 Transversus mandibulae muscle *(177)*

9 Masseter muscle *(178)*
10 The muscle of the larynx
11 Parotideoauricularis muscle *(150)*
12 Sternohyoideus muscle *(9)*
13 Sternocephalicus muscle *(7)*

a) Parotid gland
b) Facial vein

515

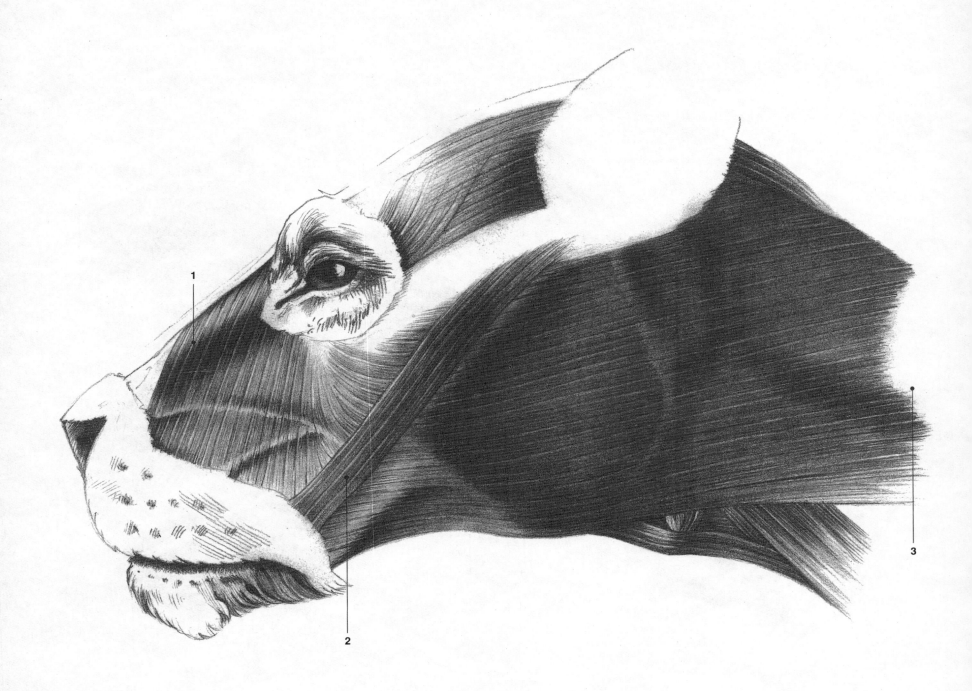

Fig. 13

The superficial muscles of the head

1 Levator nasolabialis muscle *(164)*
2 Zygomaticus muscle *(174)*
3 Platysma
 (cutaneus faciei muscle) *(1)*

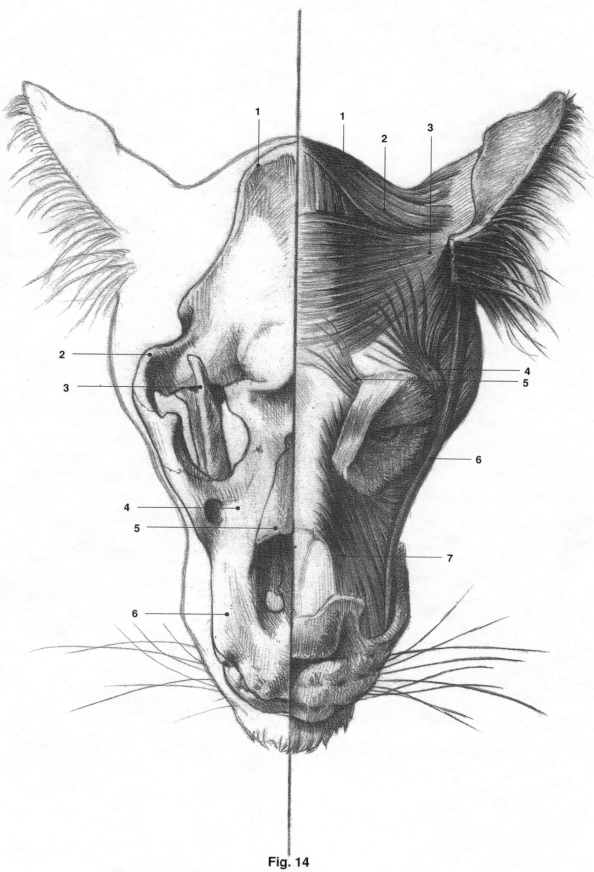

Fig. 14

The bones and the muscles of the skull, dorsal aspect

Bones
1 Nuchal crest
2 Zygomatic arch
3 Muscular process
 of the mandible
4 Maxilla
5 Nasal bone
6 Incisive bone

Muscles
1 Cervicoauricularis profundus muscle *(149)*
2 Cervicoauricularis superficialis muscle *(149)*
3 Parietoauricularis muscle *(147)*
4 Retractor anguli oculi lateralis muscle *(158)*
5 Levator anguli oculi medialis muscle *(157)*
6 Zygomaticus muscle *(174)*
7 Levator nasolabialis muscle *(164)*

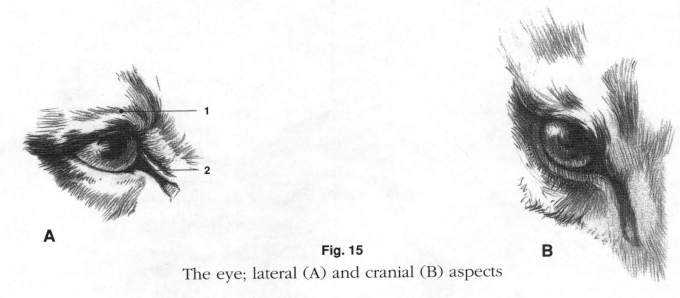

A

B

Fig. 15

The eye; lateral (A) and cranial (B) aspects

1 Supraorbital region
2 Fossa of the lacrimal canal

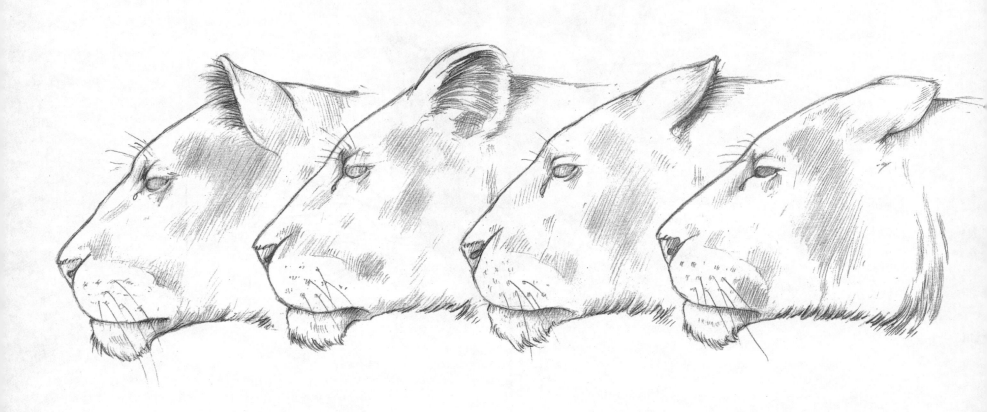

Fig. 16

The postures of the ear

cranially elevated turned to the side bent backward retracted

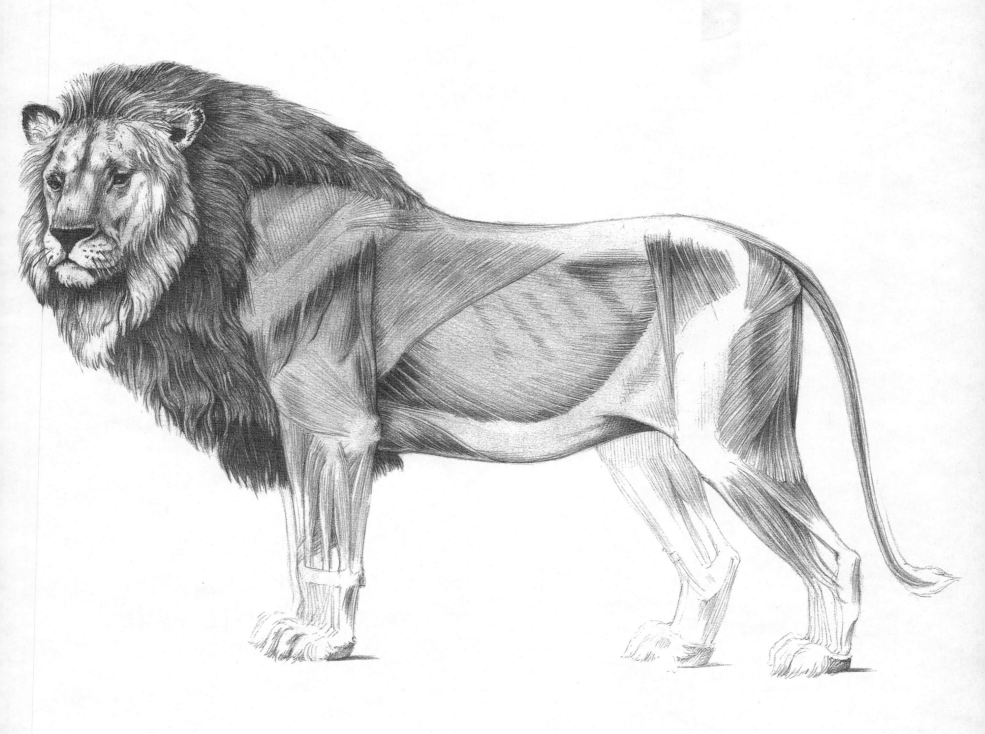

Fig. 17

The muscles of the lion

Proportionate body, quiet posture, and, mantle-like mane.
The muscles are demonstrated in Fig. 2.

COMPARATIVE ANATOMY

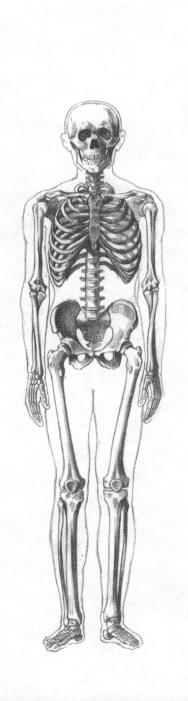

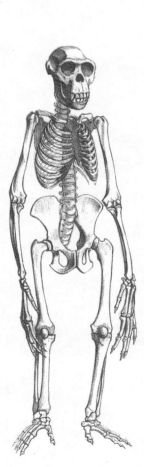

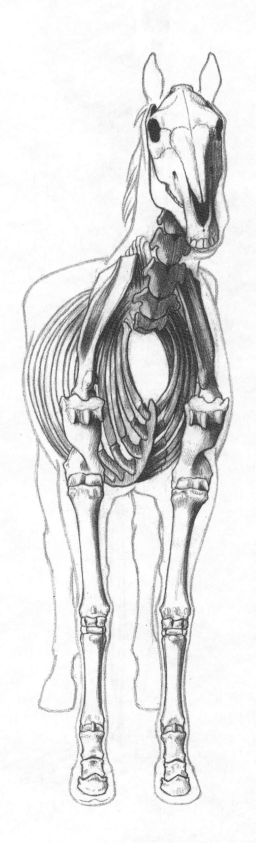

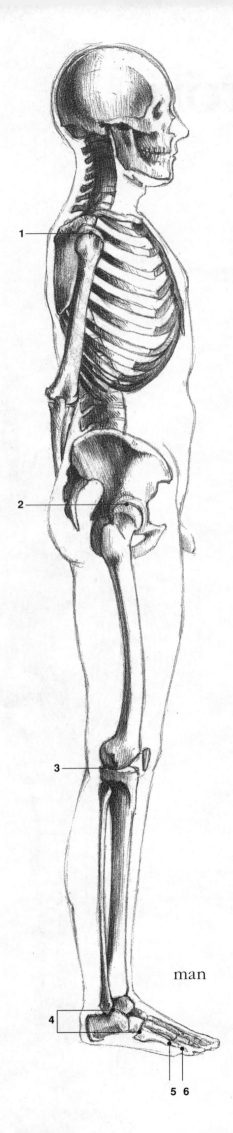

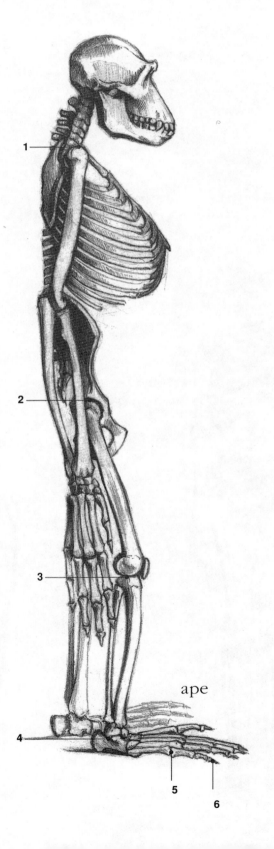

Fig. 1

The skeleton

The skeletons of humans, primates and some predators are constructed of relatively delicate bones. The limb bones are long, the chest and pelvis are oval, round or laterally flattened (carnivores).

1 Shoulder joint
2 Hip joint
3 Stifle or knee joint
4 Tarsal joint
5 Proximal phalangeal (pastern) joint
6 Distal phalanx (nail, claw, hoof)

man

ape

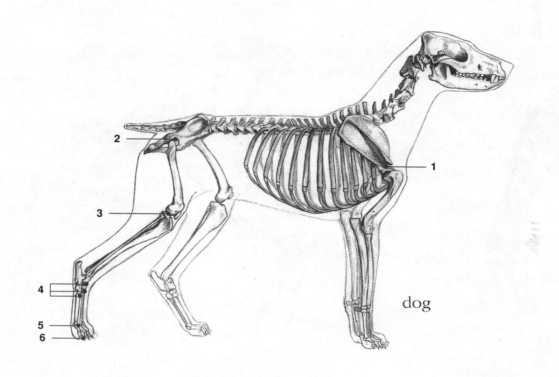

dog

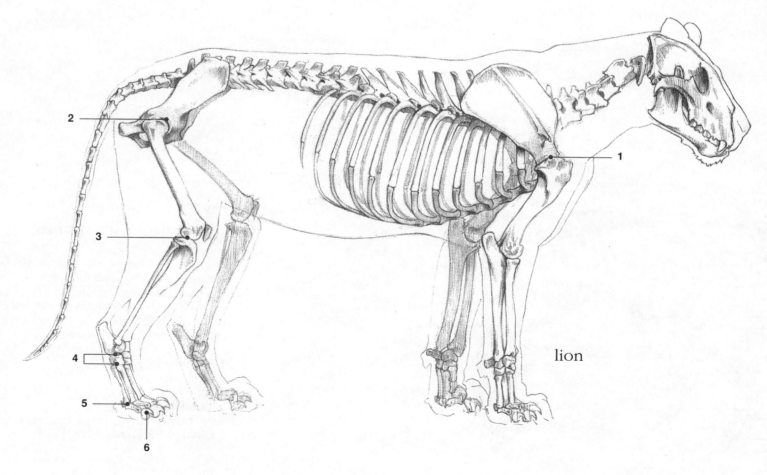

lion

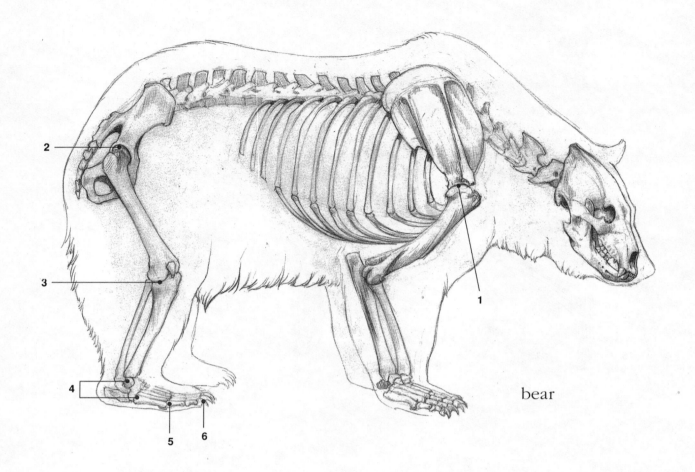

bear

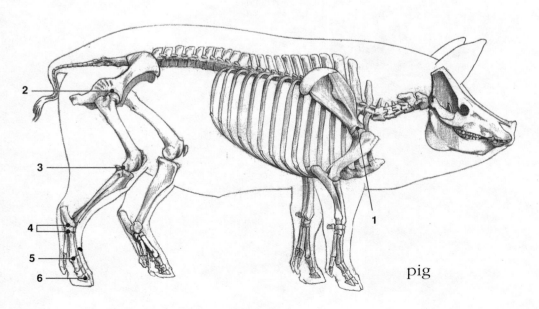

pig

Fig. 2

The skeleton *(continued)*

The bones of bears, pigs and particularly herbivores are short and thick, with a coarse structure and long, massive muscular processes. The chest and the pelvis are laterally flattened, the bones of the forelimb, thigh, and crus are relatively short.

1 Shoulder joint
2 Hip joint
3 Stifle joint
4 Tarsal joint
5 Proximal phalangeal (pastern) joint
6 Distal phalanx (nail, claw, hoof)

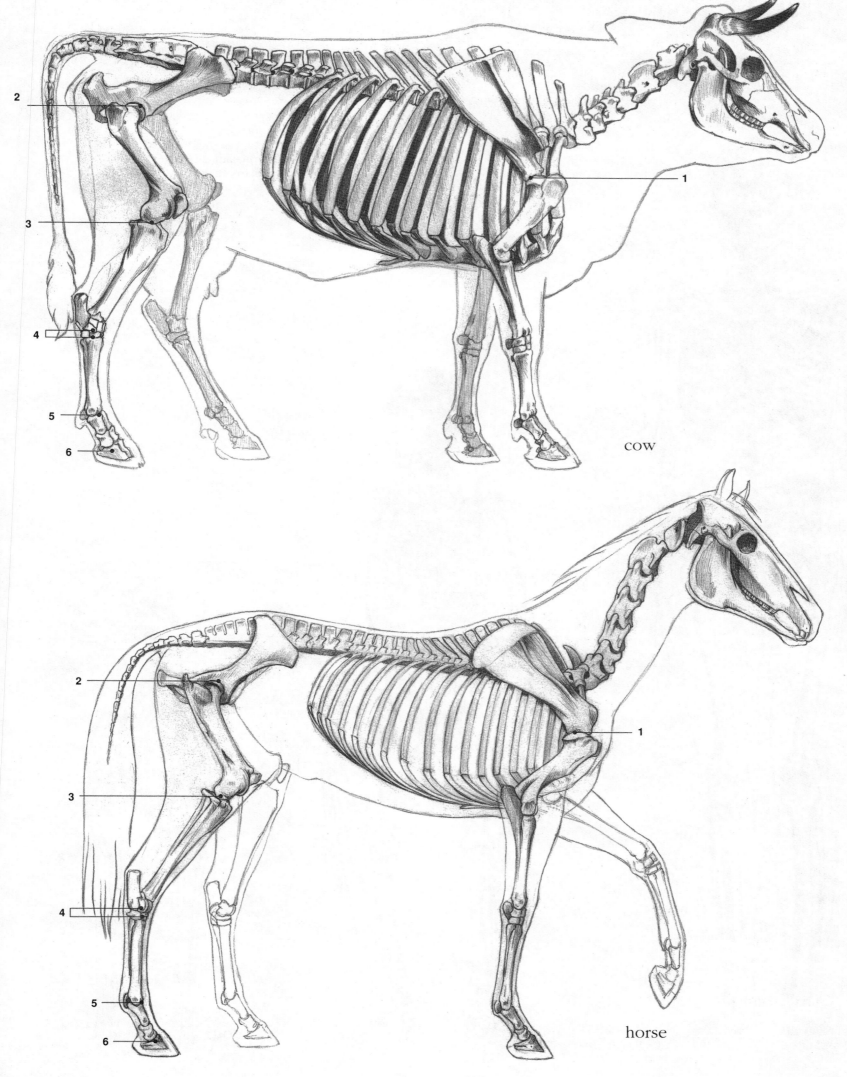

cow

horse

525

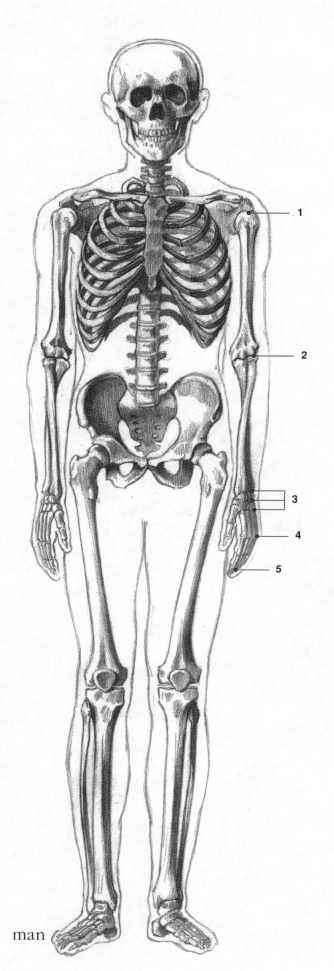
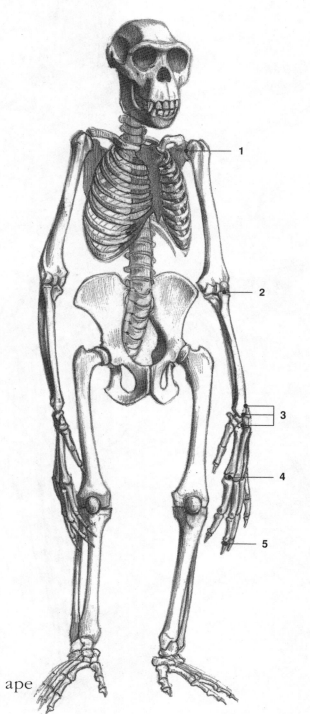
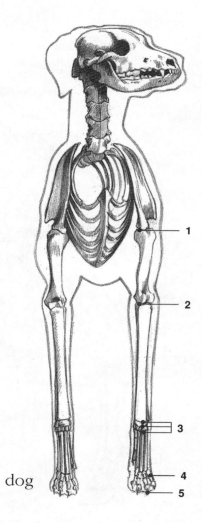

Fig. 3

The skeleton *(continued)*

1 Shoulder joint
2 Elbow joint
3 Carpal joint
4 Proximal phalangeal (pastern) joint
5 Distal phalanx (nail, claw, hoof)

1

2

3

4

5

man

1

2

3

4

5

ape

1

2

3

4
5

dog

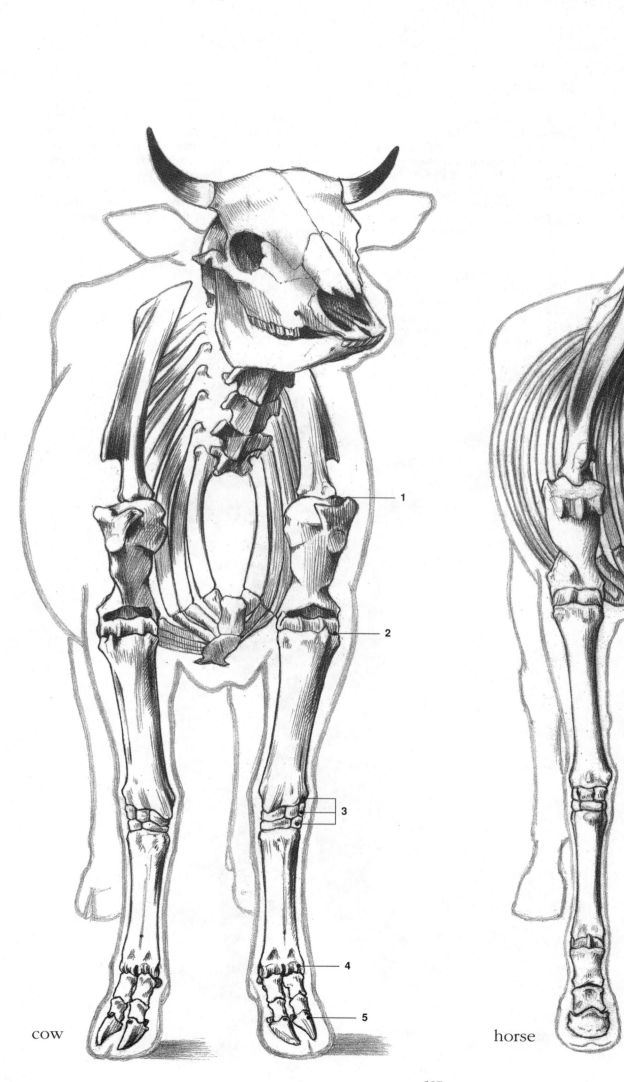
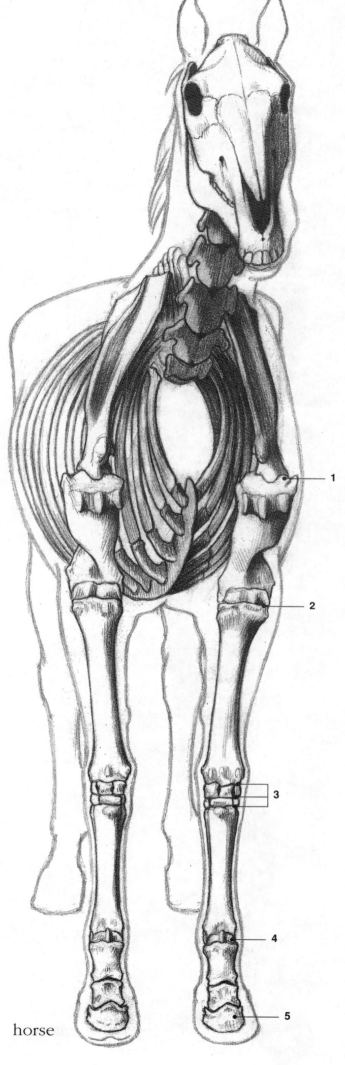

cow horse

527

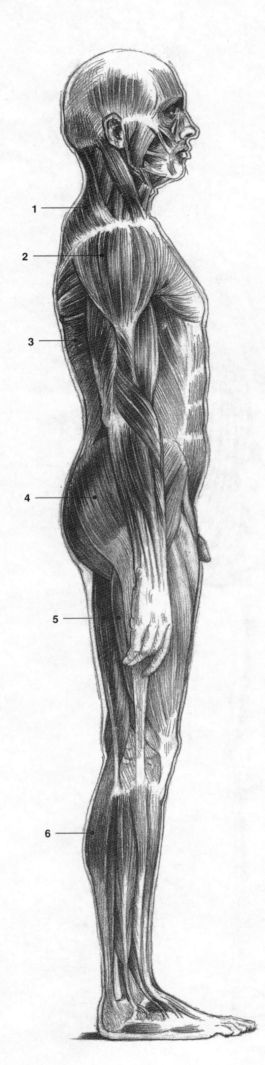

Fig. 4

The muscles

The human trunk resembles an upright rectangular block, that of animals a "horizontal" one. In the shoulder, the deltoideus muscle of humans and predators is well developed. In the case of predators, the muscles of the shoulder girdle are capable of many movements and are strong. The neck of primates is short and laterally flattened. The extensors of the head and those of the nuchal region are well developed. The neck of herbivores is flat on both sides and the jugular fossa is wide.

The abdomen of primates and carnivores is slim while that of herbivores is barrel-shaped. The thigh of primates is well separated from the torso, and the upper and rear rump muscles are separated by a deep transverse groove.

1 Trapezius muscle *(14)*
2 Deltoideus muscle *(43)*
3 Latissimus dorsi muscle *(16)*
4 Proximal rump muscles *(96, 97)*
5 Posterior rump muscles *(106–108)*
6 Gastrocnemius muscle *(115)*

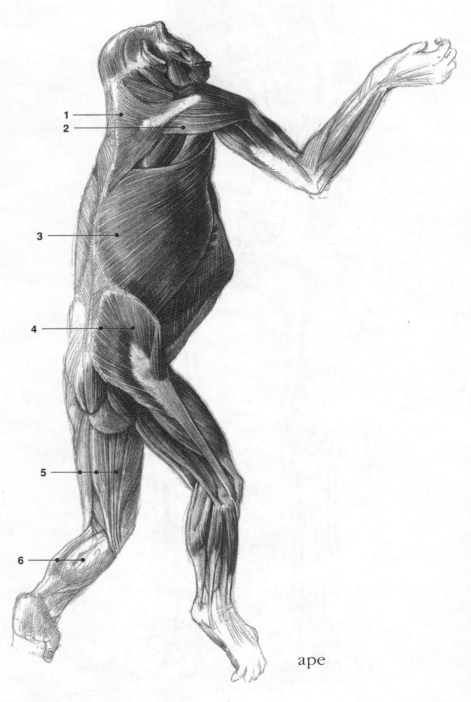

man

ape

528

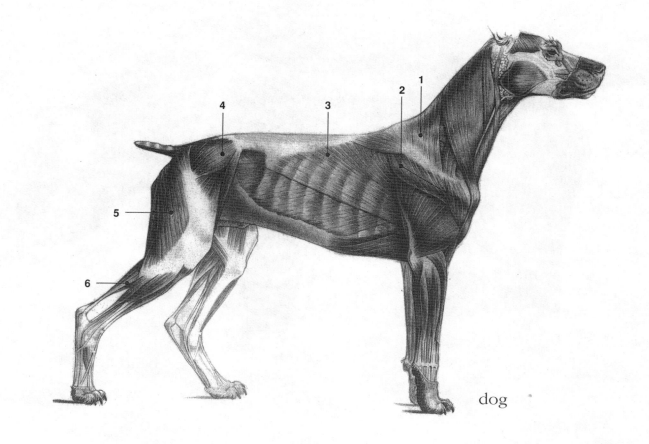

dog

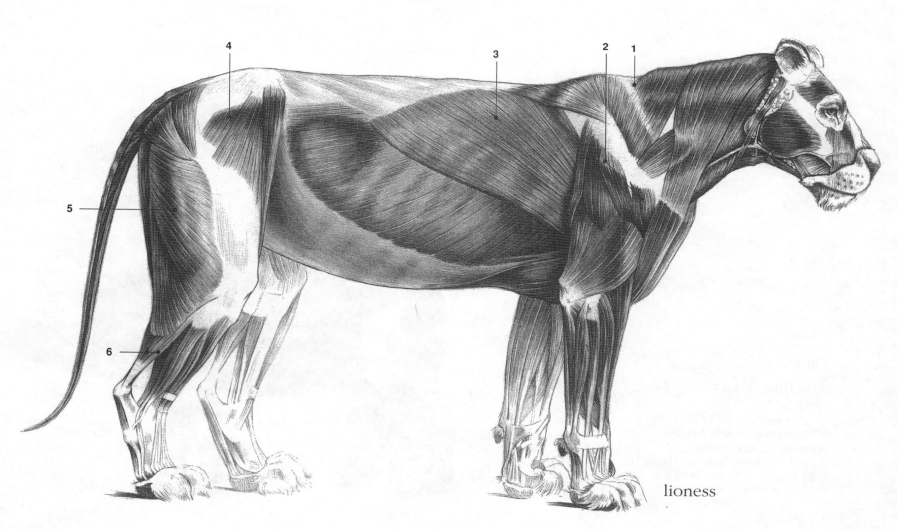

lioness

529

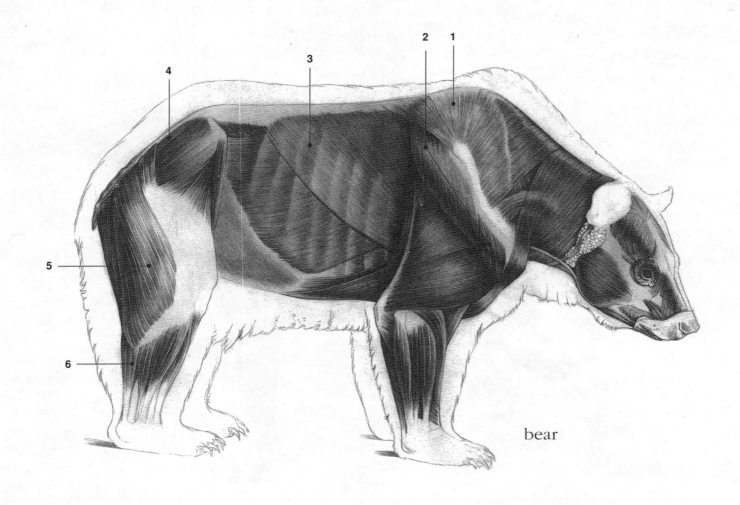

bear

Fig. 5

The muscles *(continued)*

1 Trapezius muscle *(14)*
2 Deltoideus muscle *(43)*
3 Latissimus dorsi muscle *(16)*
4 Proximal rump muscles *(96, 97)*
5 Posterior rump muscles *(106–108)*
6 Gastrocnemius muscle *(115)*

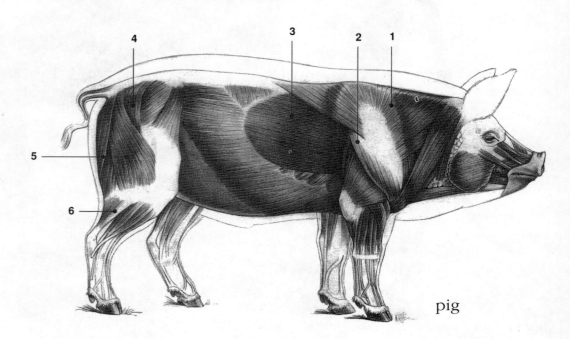

pig

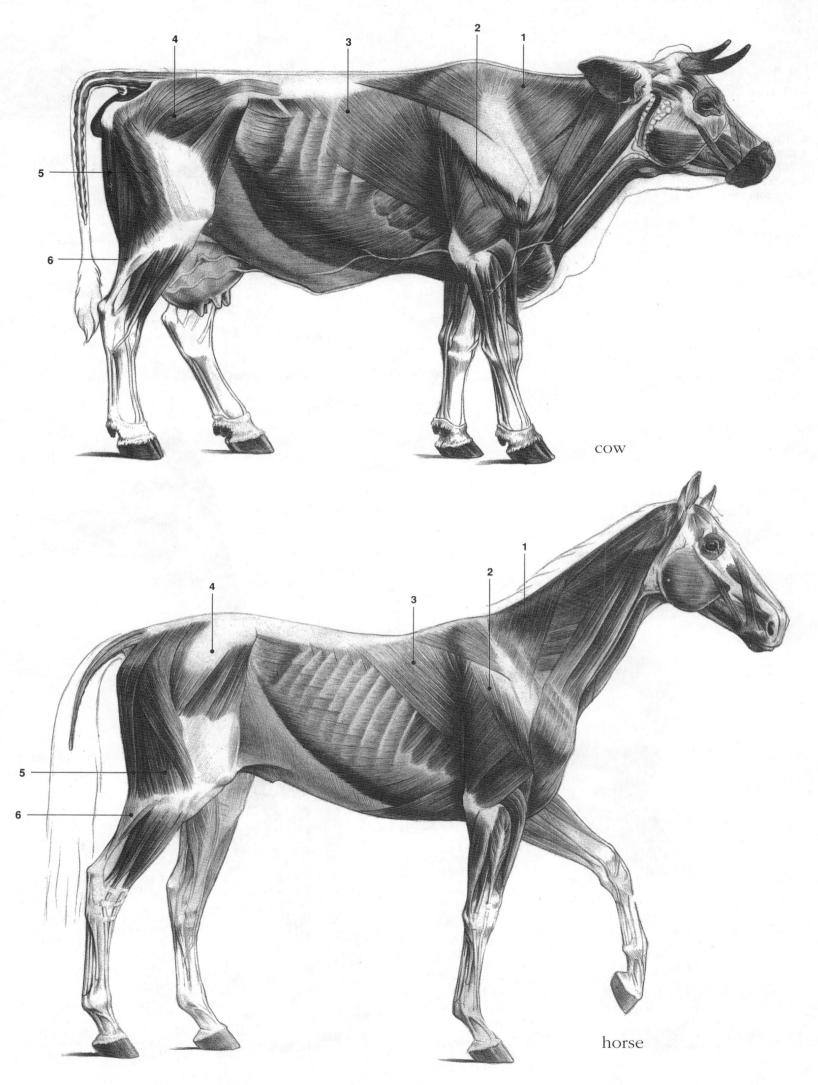

cow

horse

Fig. 6

The muscles *(continued)*

1 Trapezius muscle *(14)*
2 Deltoideus muscle *(43)*
3 Latissimus dorsi muscle *(16)*
4 Proximal rump muscles *(96, 97)*
5 Posterior rump muscles *(106–108)*
6 Gastrocnemius muscle *(115)*

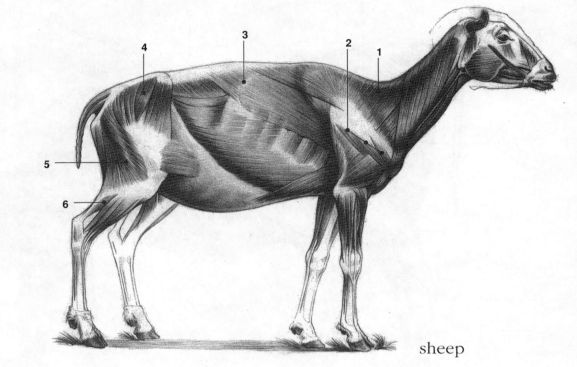

sheep

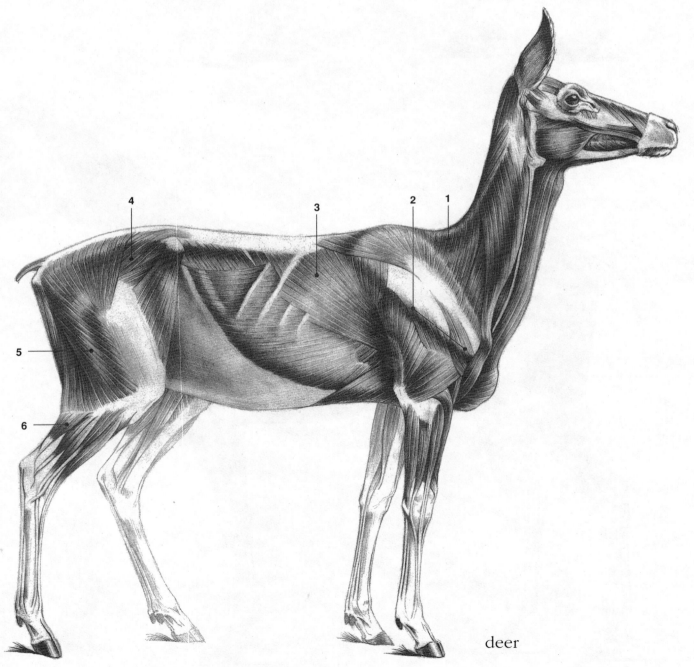

deer

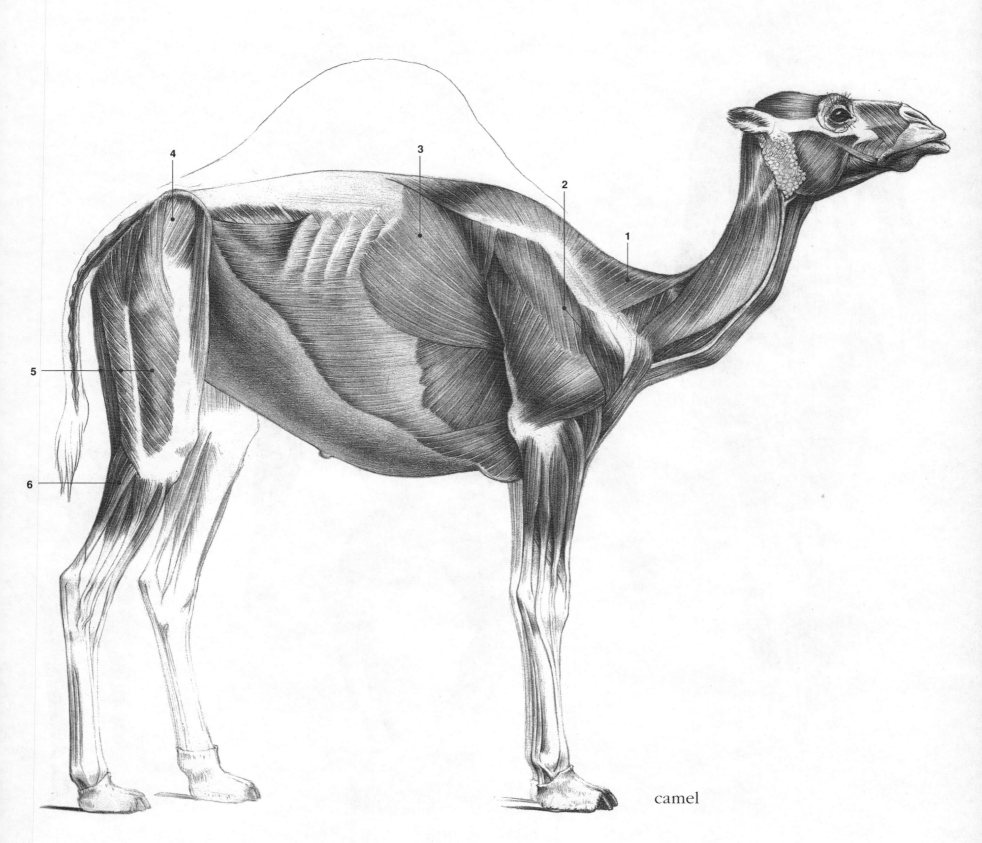

camel

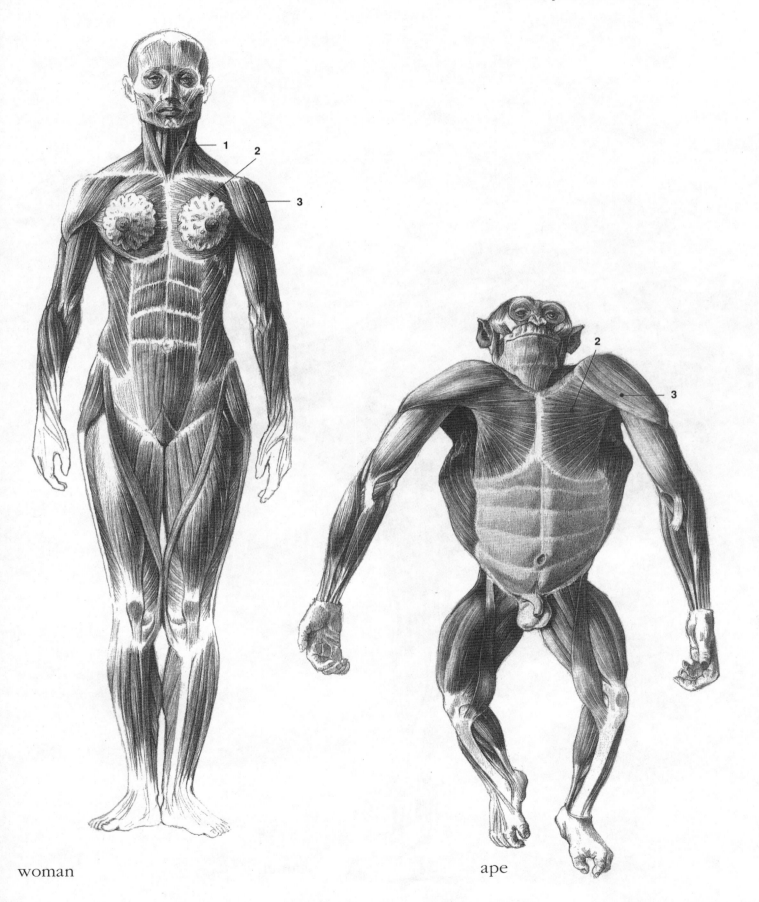

Fig. 7

The muscles *(continued)*

1 Sternocleidomastoideus muscle *(14)*
2 Pectoralis muscles *(27–30)*
3 Deltoideus muscle *(43)*
4 Sternocephalicus muscle *(7)*

woman

ape

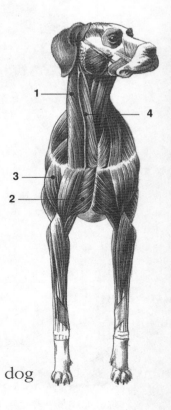

dog

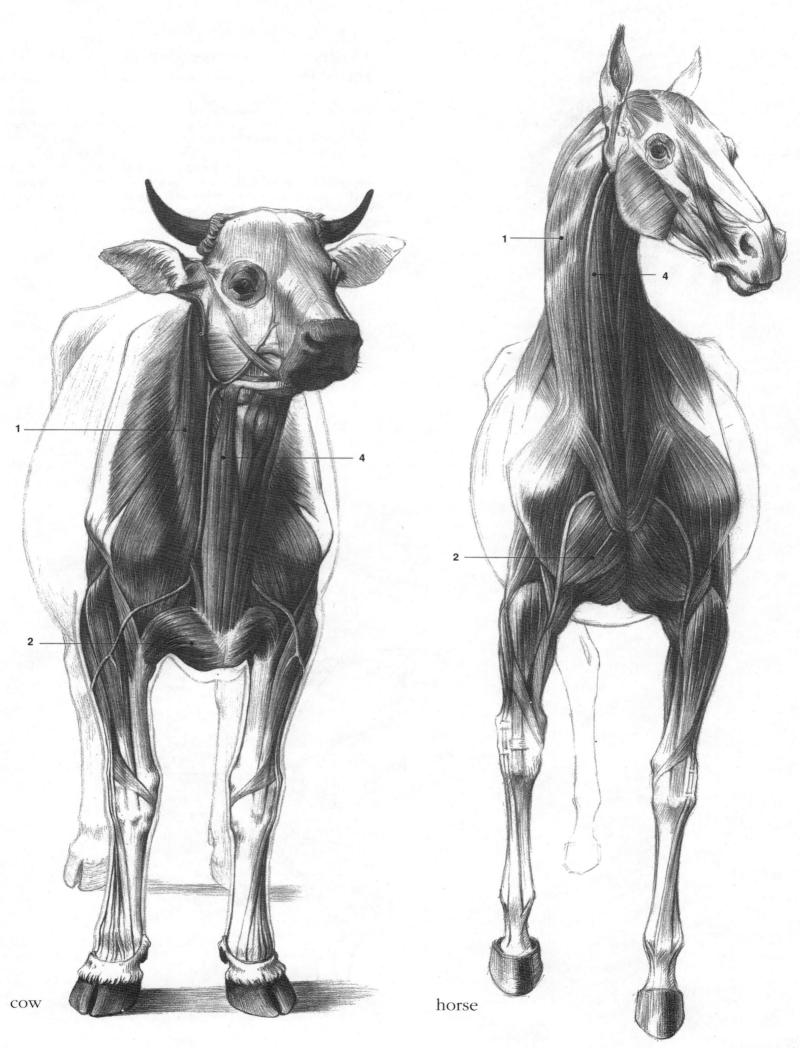

cow

horse

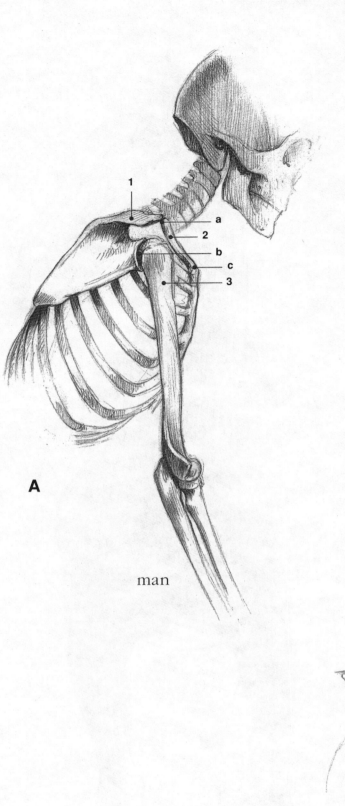

man

Fig. 8

The chest and shoulder girdle; lateral (A), cranial (B) and superior (C) aspects

Humans and other primates have shoulder blades and clavicles, while most animals have only shoulder blades. The morphology and bones of the shoulder girdle depend upon the type of movement of the thoracic limbs, i.e. whether the forelimbs are used only for forward locomotion or for grasping and climbing as well. The shoulder blades of seals are inflexibly linked to the back and to each other, while those of humans, primates and – to a certain extent – carnivores can be moved in several directions.

1 Shoulder blade
2 Clavicle
3 Humerus

a) Acromioclavicular joint
b) Shoulder joint
c) Sternoclavicular joint

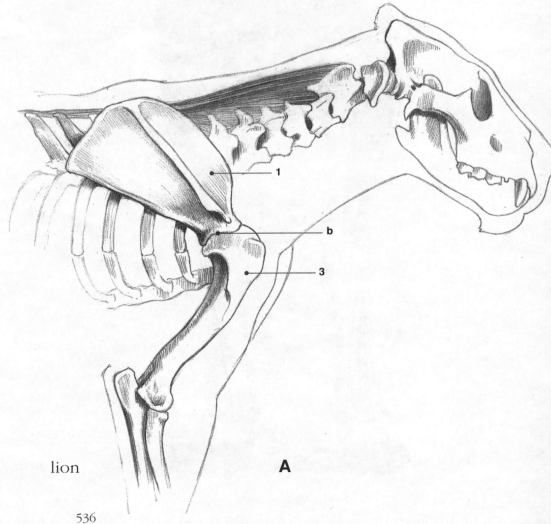

lion

A

b
a

1

3

c

2

B

crocodile

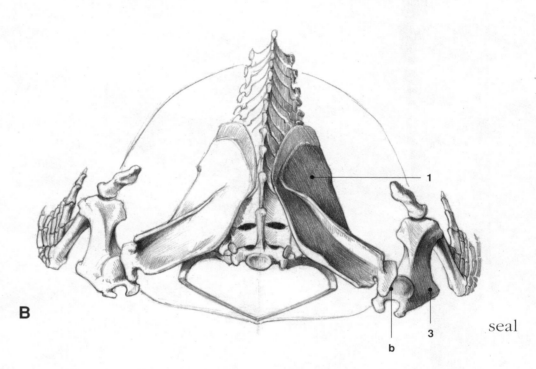

1

3

b

B

seal

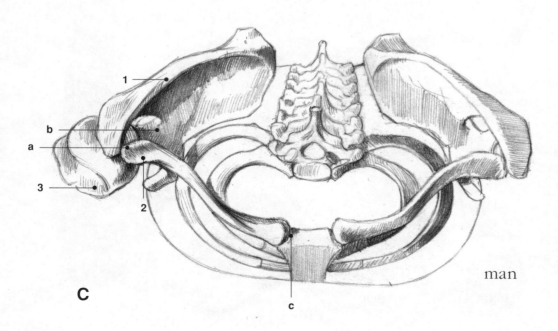

1

b
a

3

2

c

man

C

Fig. 9

The humerus, lateral aspect

The humerus of primates is long and slightly curved, while that of carnivores is slim and that of herbivores short and massive. From plantigrade to digitigrade species it becomes gradually shorter and heavier. The humerus is rotated laterally, its axis is directed caudo-laterally in carnivores and herbivores. With increasing speed and uniplanar movement its processes become progressively larger.

1 Head
2 Tubercle
3 Articular trochlea

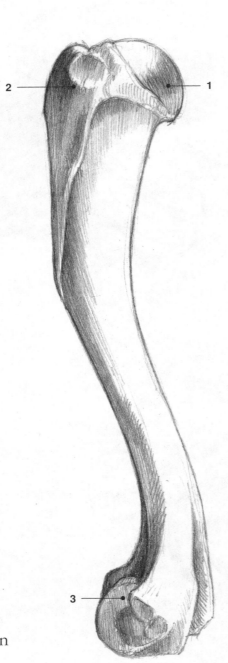

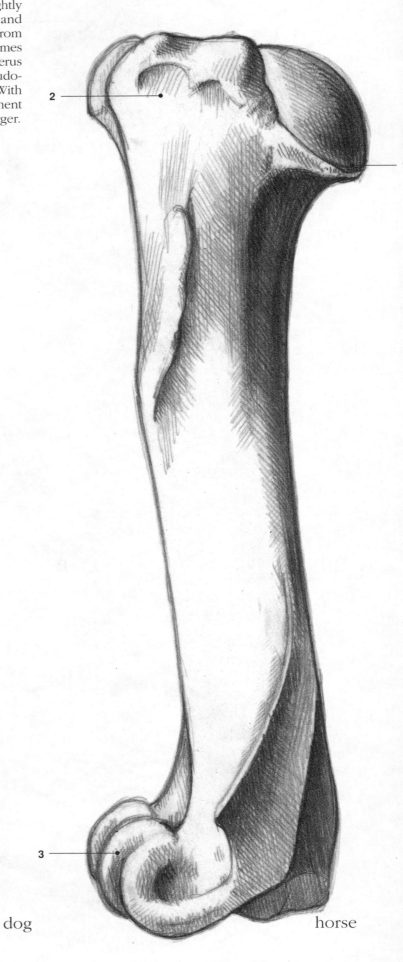

man

dog

horse

Fig. 10

The bones of the lower forelimb, lateral aspect

The bones of the lower forelimb (radius and ulna) are long and perpendicular. The lower forelimb is rotated medially (pronation). In dogs the two bones cross each other. In herbivores they eventually unite by the process of synastosis.

1 Process of the ulna (olecranon)
2 Radius
3 Styloid process

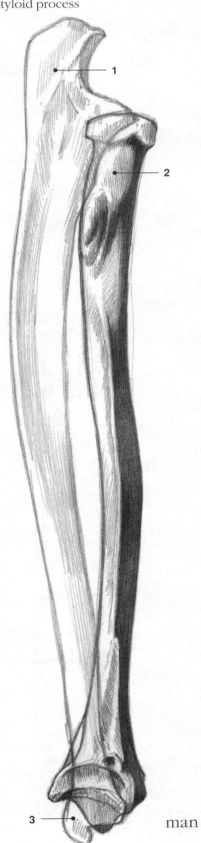

man

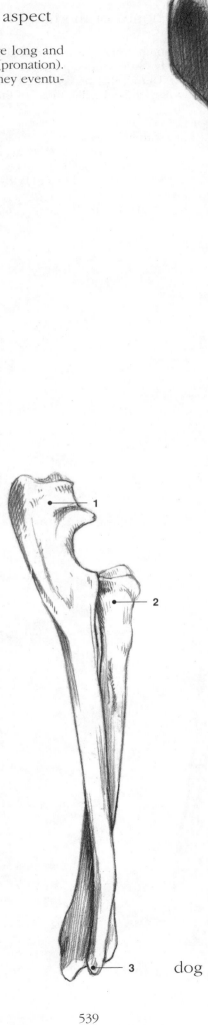

dog

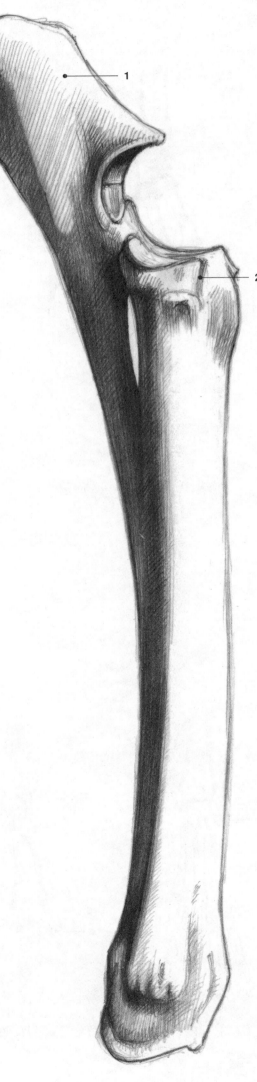

horse

539

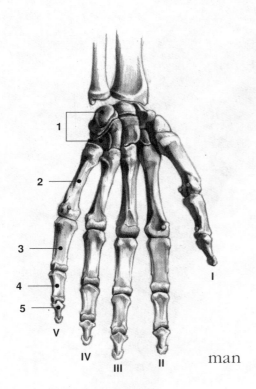

Fig. 11

The bones of the hand/forefoot, palmar aspect

The number of digits has gradually reduced during evolution. Plantigrade feet (man, ape, bear) have developed into digitigrade (carnivores) and unguligrade (horse and ruminants) ones. During this process the bones of the carpus and metacarpus have become longer and perpendicular like those of the lower forelimb.

1 Carpal bones
2 Metacarpal bone
 2/1 The fused IIIrd and IVth metacarpals
 2/2 IIIrd metacarpal bone
 2/3 Splinter bones IInd and IVth metacarpals
3 Proximal phalanx

4 Middle phalanx
5 Distal phalanx (nail bone)
 5/1 Claw bone
 5/2 Hoof bone
 5/3 Pedal bone

Ist–Vth fingers/digits

man

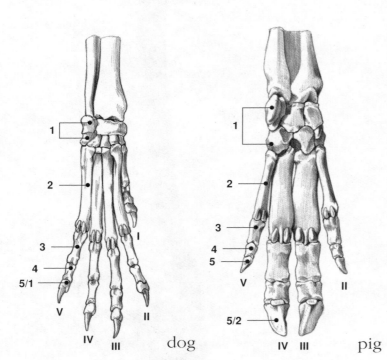

dog

pig

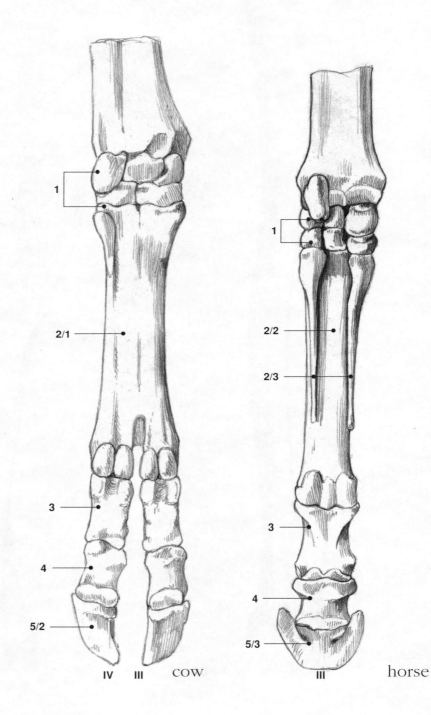

cow

horse

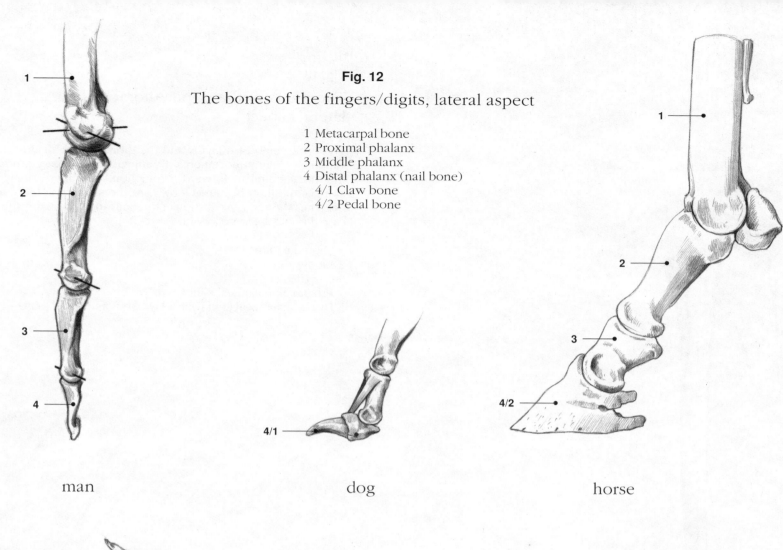

Fig. 12

The bones of the fingers/digits, lateral aspect

1 Metacarpal bone
2 Proximal phalanx
3 Middle phalanx
4 Distal phalanx (nail bone)
 4/1 Claw bone
 4/2 Pedal bone

man dog horse

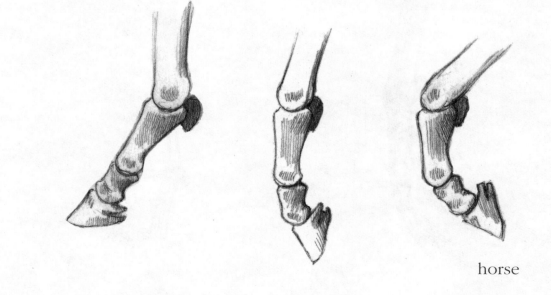

dog horse

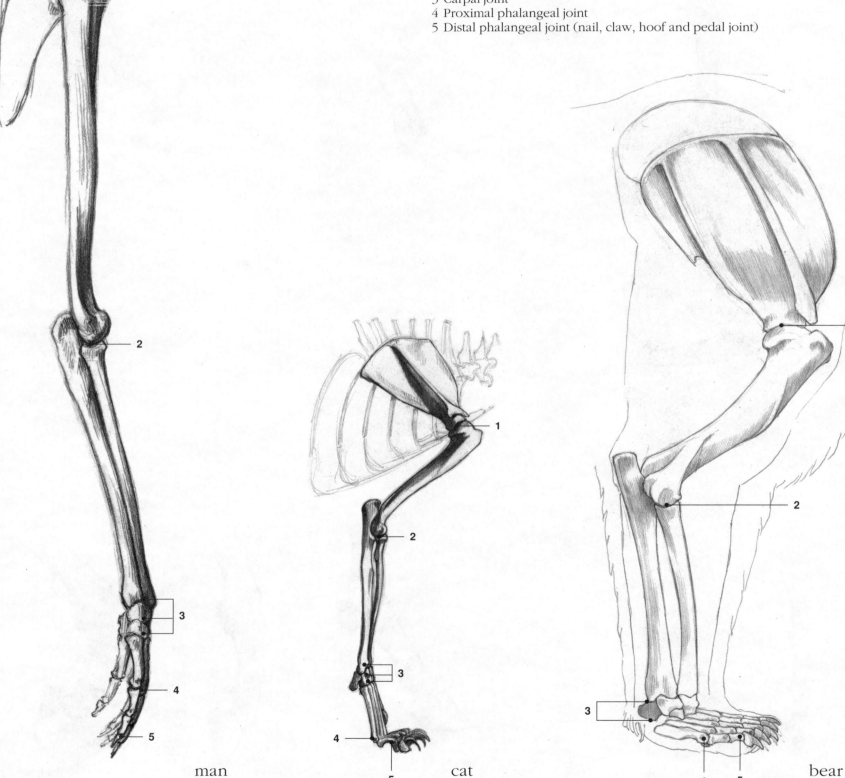

Fig. 13

The joints of the upper/thoracic limb, lateral aspect

The upper limb of humans and the thoracic limb of primates are capable of many movements. In animals the primary function of the thoracic limb is forward locomotion. With increasingly faster animals the limb becomes longer. At the same time the humerus becomes shorter, while the lower forelimb and particularly the meta-carpal bones become longer.

1 Shoulder joint
2 Elbow joint
3 Carpal joint
4 Proximal phalangeal joint
5 Distal phalangeal joint (nail, claw, hoof and pedal joint)

man cat bear

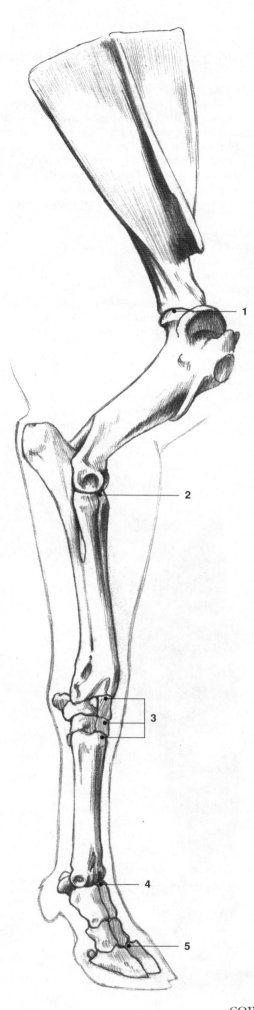

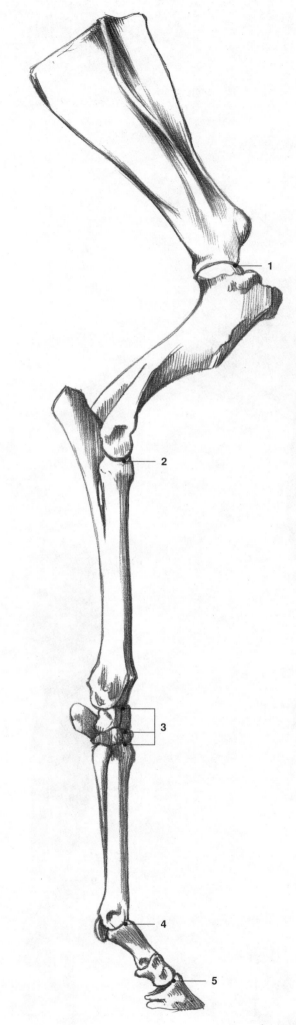

cow

horse

Fig. 14

The muscles of the upper/thoracic limb

Despite their wide range of movements, the muscles of the human shoulder and elbow joints are poorly developed. However, all the muscles of the forearm, carpus and fingers are well developed. The bellies of the muscles are long and the tendons are short. In animals, due to the increased power required for movement and support, the muscles of the shoulder and elbow joints are huge and the muscles of the carpus are strong and tendinous. The bellies of the digital muscles are situated in the lower forelimb, in the lower one-third of which they are tendinous.

1 Brachiocephalicus muscle *(6)*
2 Deltoideus muscle *(43)*
3 Biceps brachii muscle *(51)*
4 Triceps brachii muscle *(52)*
5 Brachioradialis muscle *(63)*
6 Extensor carpi radialis muscle *(64)*
7 Extensor carpi ulnaris muscle *(65)*
8 Extensor digitorum communis muscle *(66)*
9 Extensor digitorum lateralis muscle *(67)*

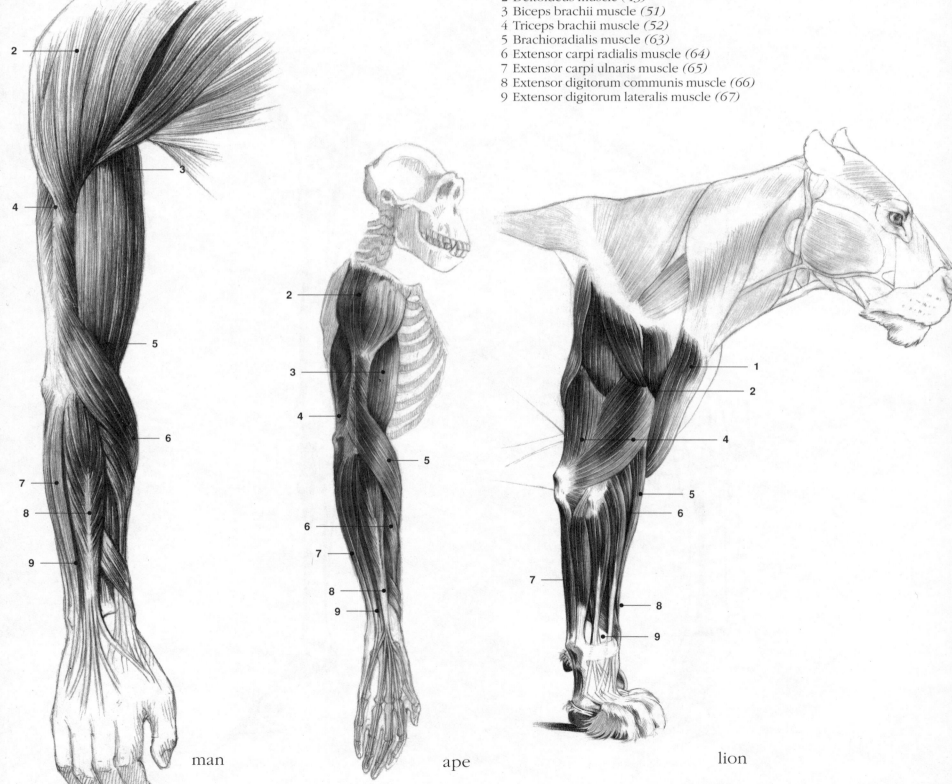

man

ape

lion

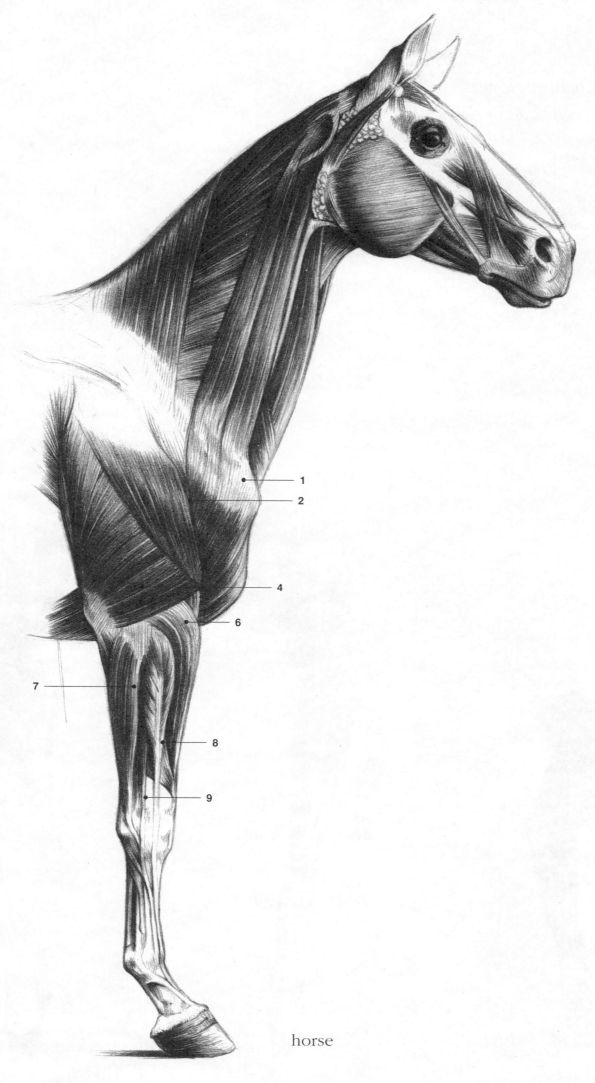

horse

Fig. 15

The muscles of the thoracic limb,
cranial aspect

1 Sternocleidomastoideus muscle *(6)*
2 Deltoideus muscle *(43)*
3 Biceps brachii muscle *(51)*
4 Triceps brachii muscle *(52)*
5 Brachioradialis muscle *(63)*
6 Extensor carpi radialis muscle *(64)*
7 Extensor carpi ulnaris muscle *(65)*
8 Extensor digitorum communis muscle *(66)*
9 Extensor digitorum lateralis muscle *(67)*

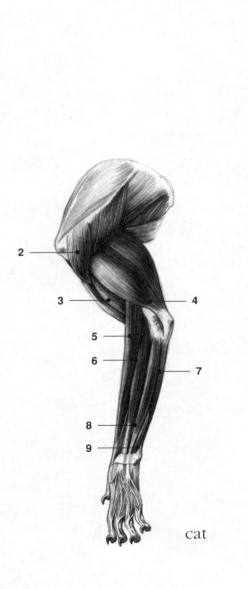

cat

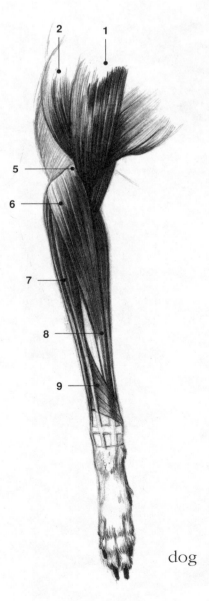

dog

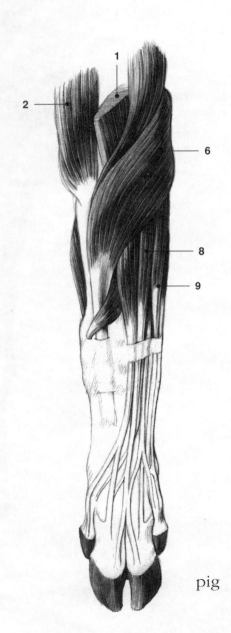

pig

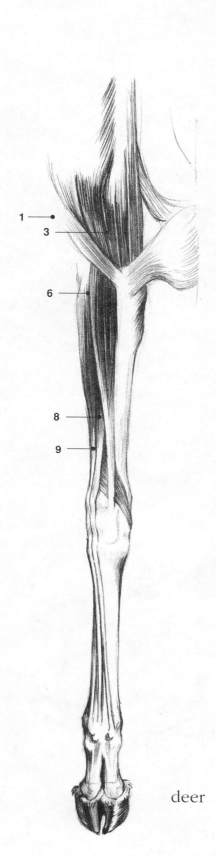

deer

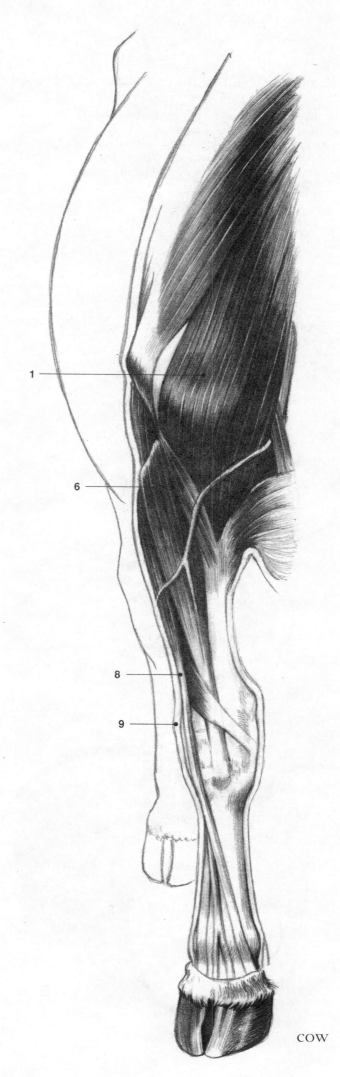

cow

Fig. 16

The pelvis; lateral (A) and anterior/cranial (B) aspects

When seen from above, the pelvis of humans and primates is oval and the wing of the ilium is fan-shaped. The pelvic aperture of herbivores is oval, with its long axis in the antero-posterior direction, and the iliac wings are tent-shaped. The pelvic aperture of carnivores is round, the ilium is narrow and nearly vertical.

1 Hipbone
2 Sacrum
3 Acetabulum
4 Pubic bone
5 Ischial tuber
6 Iliosacral joint
7 Cartilageous fusion (symphysis pelvis)

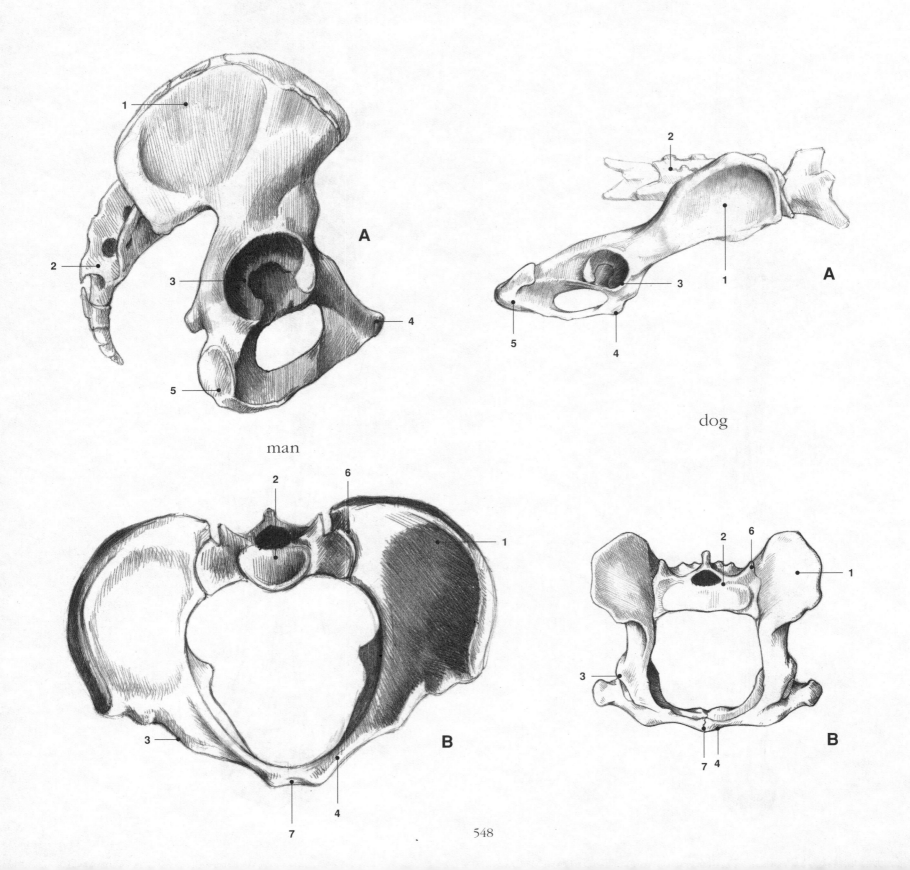

man

dog

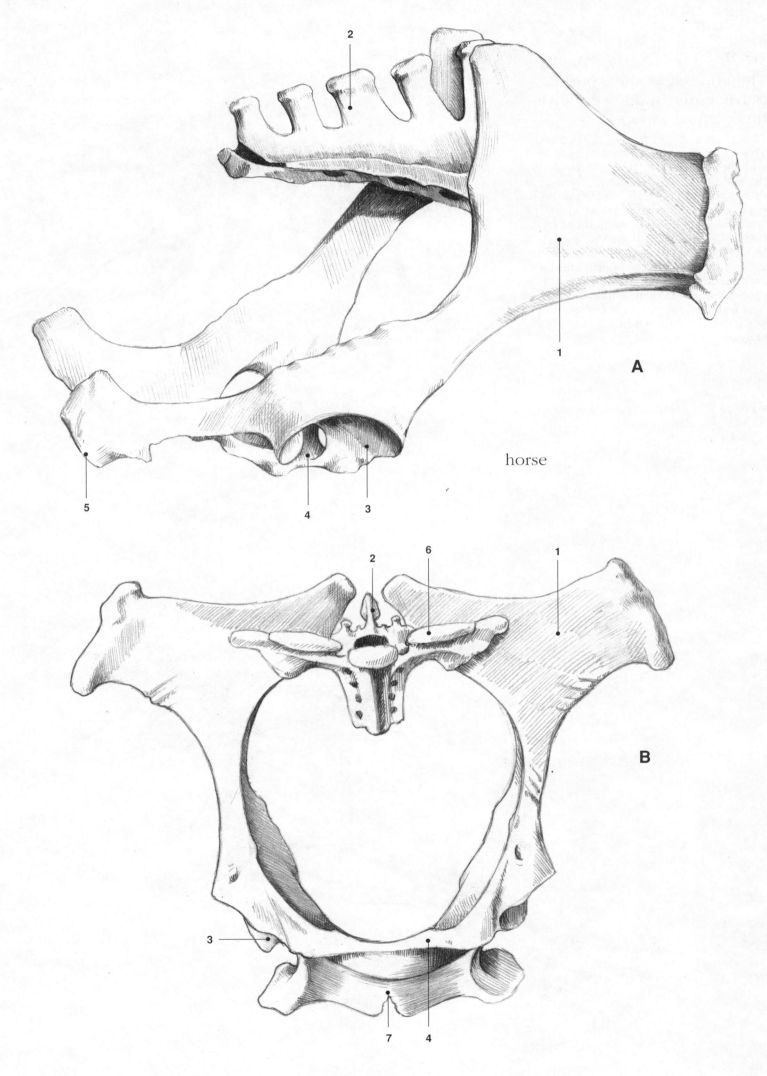

horse

A

B

Fig. 17

The bones and joints of the pelvic girdle and lower pelvic limb, lateral aspect

The femur of reptiles points laterally and, with the vertical crural bones, it constitutes the stifle joint. This is situated well clear of the torso. The long metacarpal and phalangeal bones point antero-laterally. The femur of seals is half as long as the crural bones. The femur of domestic animals is located close to the trunk. In humans, primates and carnivores, the bones of the thigh and the crus are long and slim, and their processes are small. The femur and tibia of pigs and herbivores are short and thick, while the tibia of some herbivores is rudimentary.

1 Hip joint
2 Stifle joint
3 Tarsal joint
4 Proximal phalangeal joint (pastern joint)
5 Distal phalangeal joint
 (nail, claw or pedal joint)

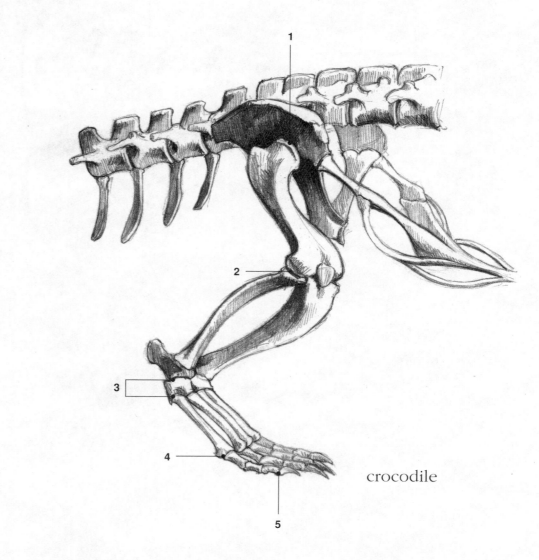

crocodile

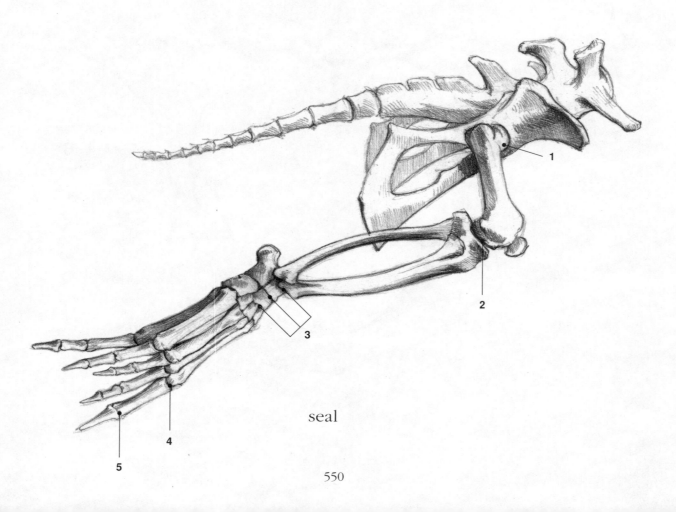

seal

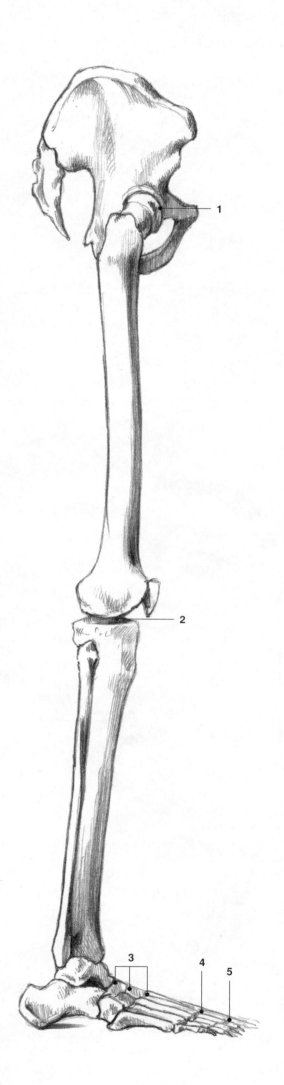

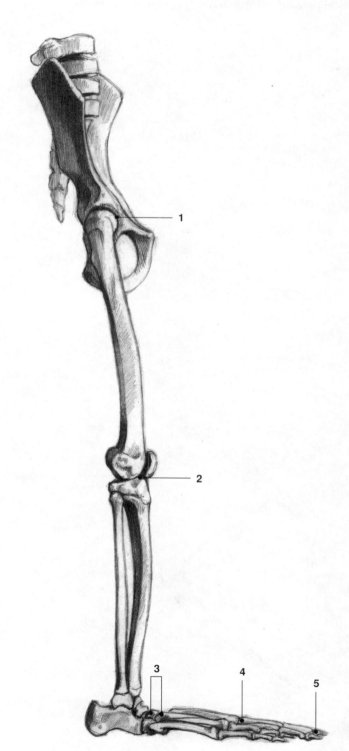

man

ape

Fig. 18

The bones and joints of the pelvic girdle and lower pelvic limb, lateral aspect *(continued)*

In plantigrade species (man, ape, bear) the tarsus contacts the ground. In carnivores the metatarsal bones are raised well clear of the ground (digitigrade). In unguligrade animals (herbivores) the axis of the metatarsal bone is perpendicular, the phalangeal axis forms an angle of 40–55° with the ground, and only the distal phalanx touches the ground.

1 Hip joint
2 Stifle joint
3 Tarsal joint
4 Proximal phalangeal joint (pastern joint)
5 Distal phalangeal joint (nail, claw and pedal joint)

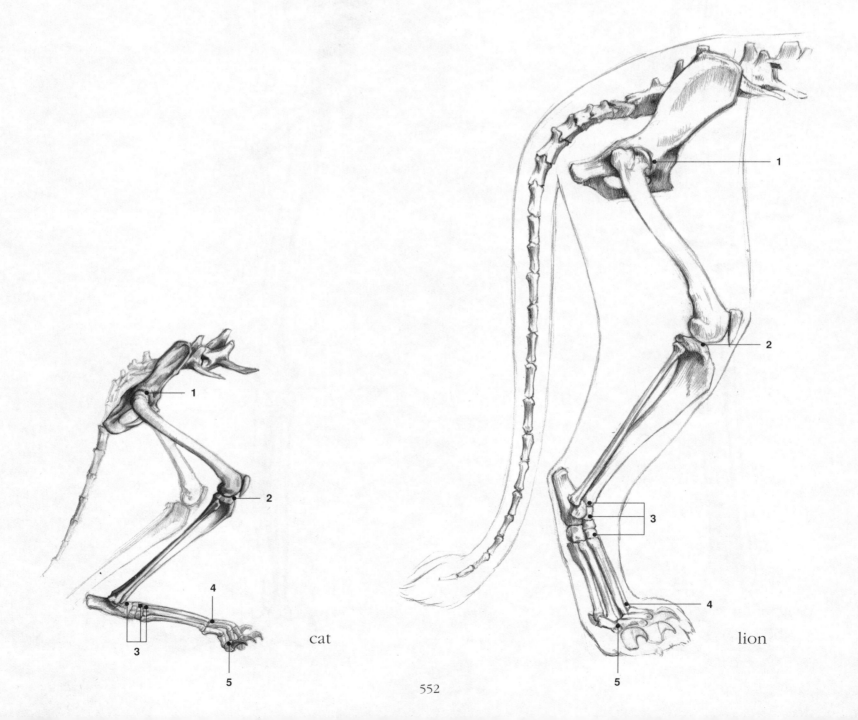

cat lion

552

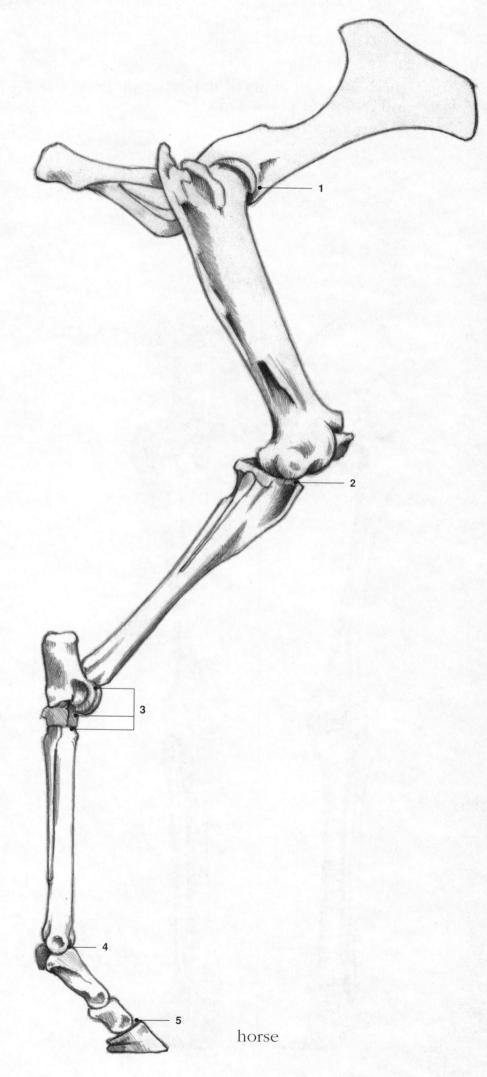

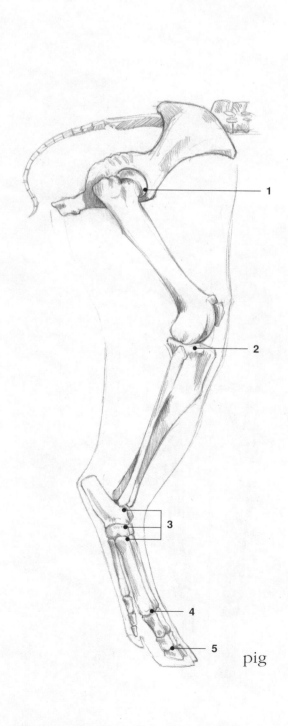

1

2

3

4

5

pig

1

2

3

4

5

horse

Fig. 19

The bones and joints of the pelvic girdle,
and the lower pelvic limb,
posterior/caudal aspect

1 Hip joint
2 Stifle or knee joint
3 Tarsal joint
4 Proximal phalangeal joint (pastern joint)
5 Distal phalangeal joint (nail, claw and pedal joint)

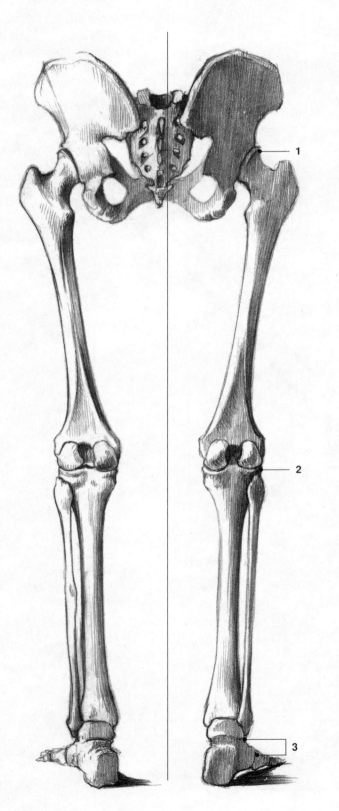

man

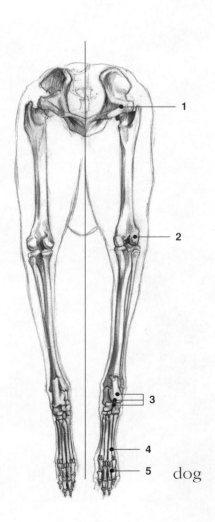

dog

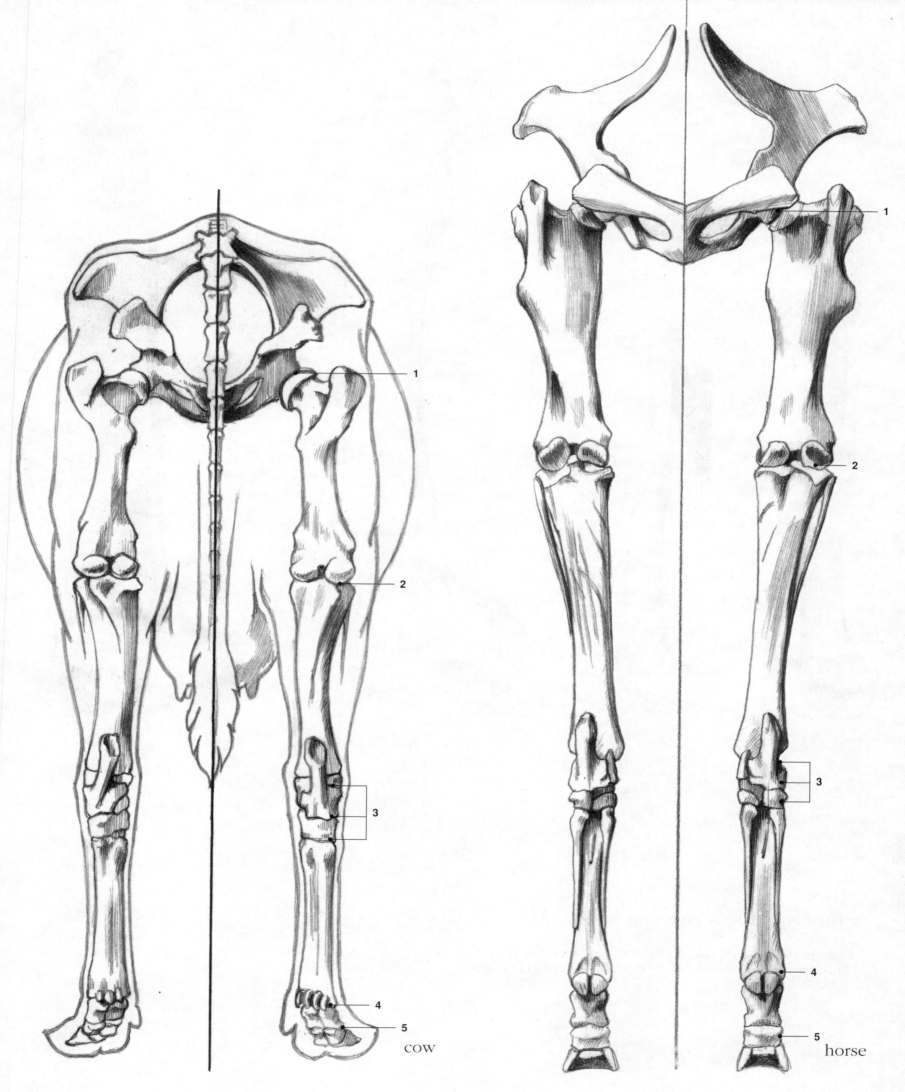

cow

horse

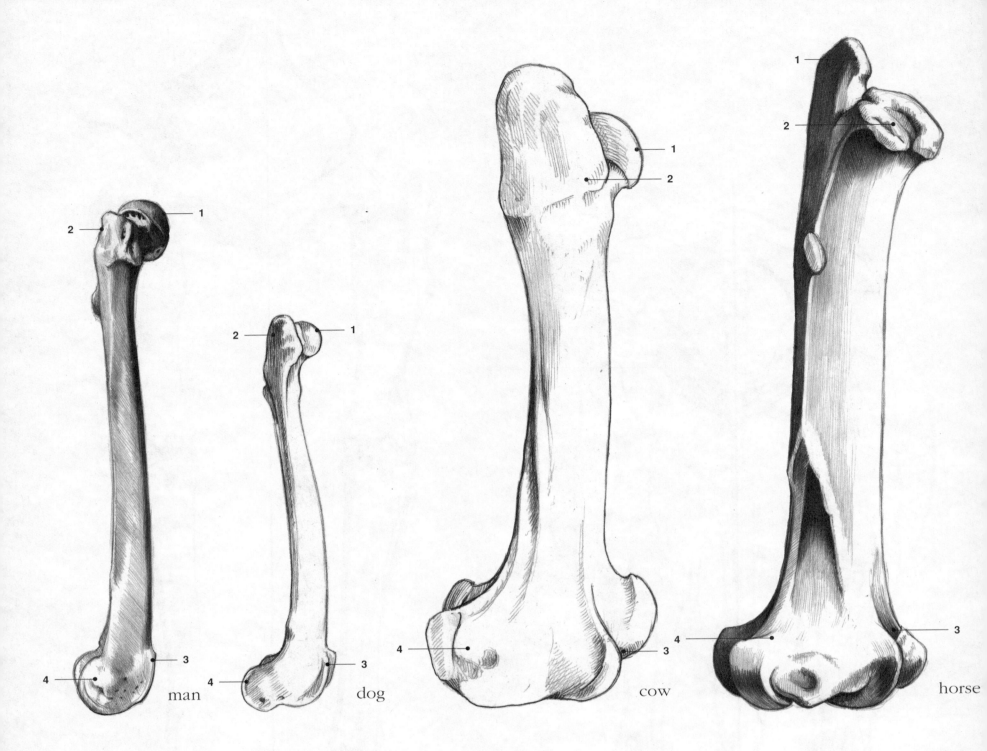

Fig. 20

The femur, lateral aspect

The femur of humans and carnivores is long and slim, with short processes. That of herbivores is relatively short and thick, with long, wide processes.

1 Head
2 Tubercle
3 Trochlea
4 Condylus

Fig. 21

The tibia and fibula, lateral aspect

The tibia (1) and fibula (2) of humans, primates and carnivores are slim. The fibula of herbivores shows only rudimentary development.

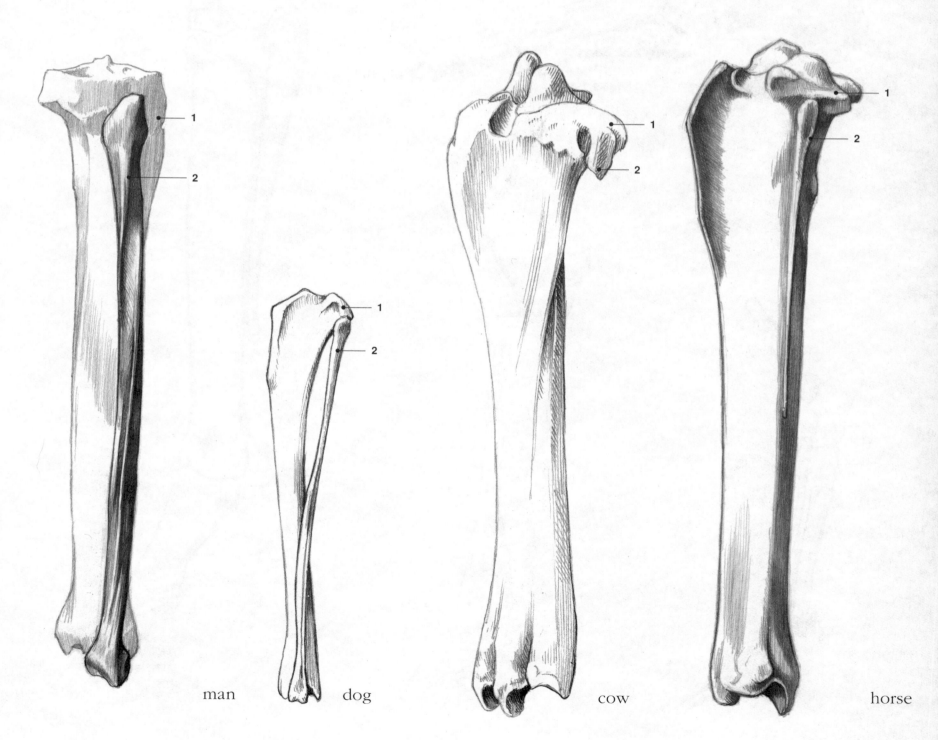

man dog cow horse

Fig. 22

The bones of the foot, lateral aspect

1 Tarsal bones
2 Metatarsal bone
 2/1 The fused IIIrd and IVth metatarsals
 2/2 IIIrd metatarsal bone
 2/3 Splinter bones IInd and IVth
 metatarsals
3 Proximal phalanx

4 Middle phalanx
5 Distal phalanx (nail bone)
 5/1 Claw bone
 5/2 Hoof bone
 5/3 Pedal bone

Ist–Vth toes/digits

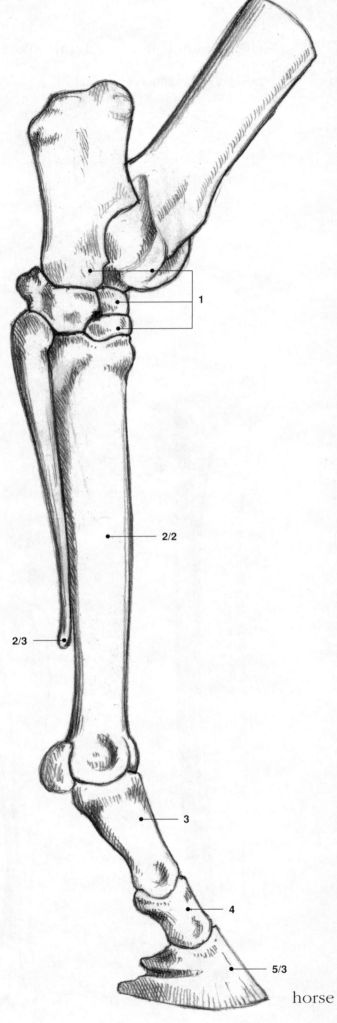

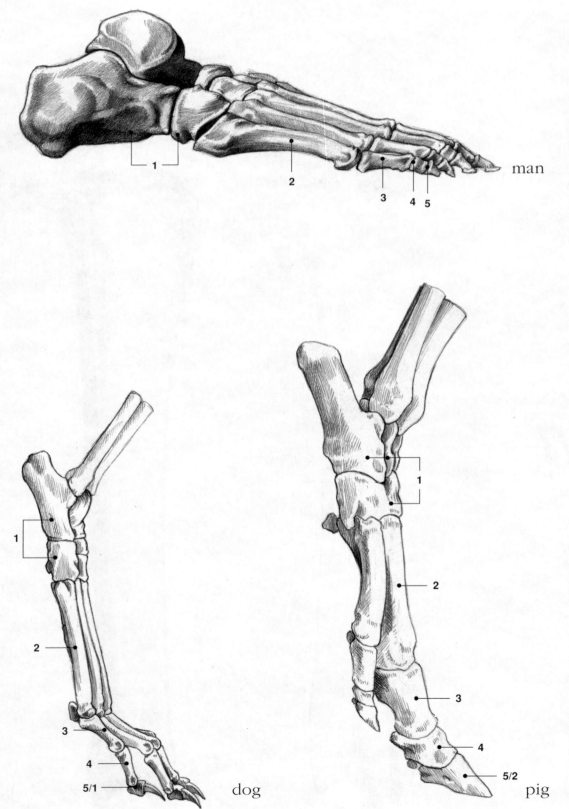

man

dog

pig

horse

558

Fig. 23

The bones of the foot, dorsal aspect

The changes in length and position of the tarsus, metatarsus and
digits are identical with those of the thoracic limb.

1 Tarsal bones
2 Metatarsal bone
 2/1 The fused IIIrd and IVth metatarsals
 2/2 IIIrd metatarsal bone
 2/3 Splinter bones IInd and IVth metatarsals
3 Proximal phalanx
4 Middle phalanx
5 Distal phalanx (nail bone)
 5/1 Claw bone
 5/2 Hoof bone
 5/3 Pedal bone

Ist–Vth toes/digits

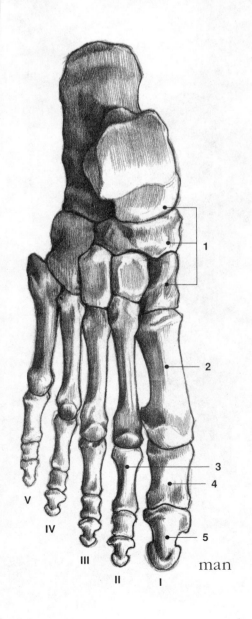

man

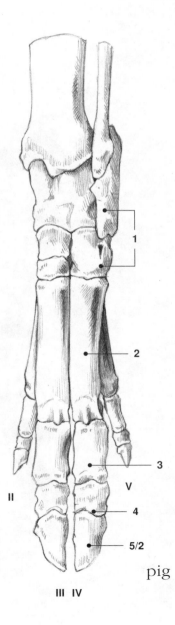

dog

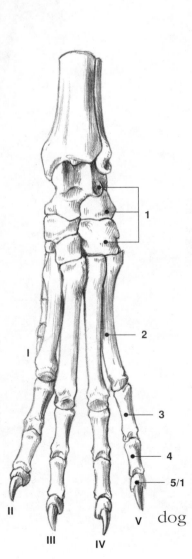

pig

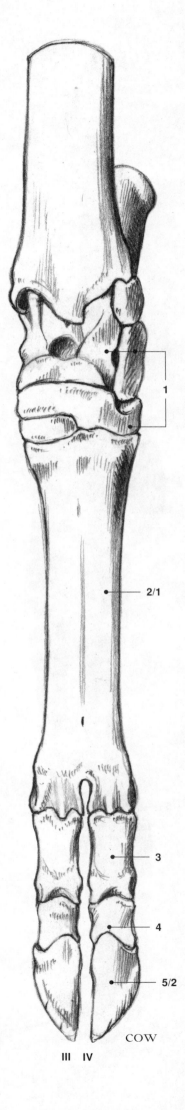

cow

559

Fig. 24

The muscles of the pelvic limb, lateral aspect

1 Gluteus medius muscle *(97)*
2 Gluteus superficialis (maximus) muscle *(96)*
3 Biceps femoris muscle *(106)*
4 Quadriceps femoris muscle *(112)*
5 Gastrocnemius muscle *(115)*

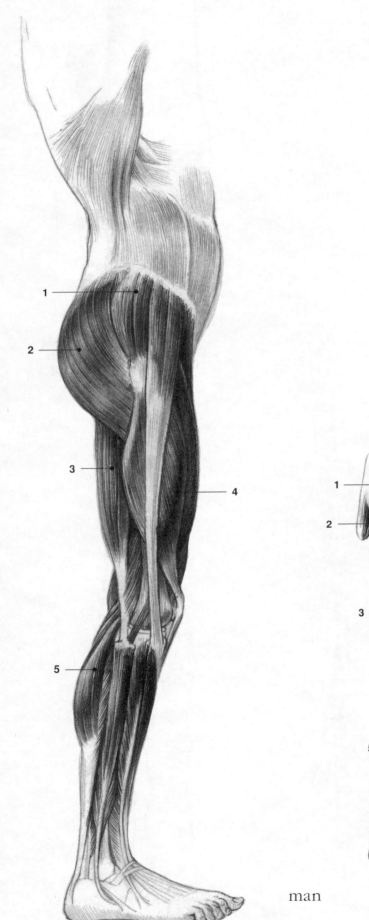

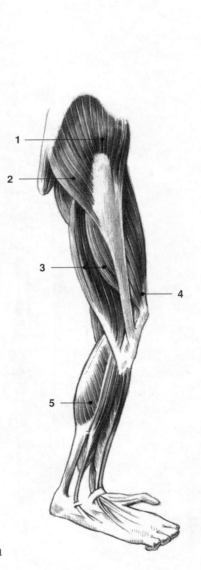

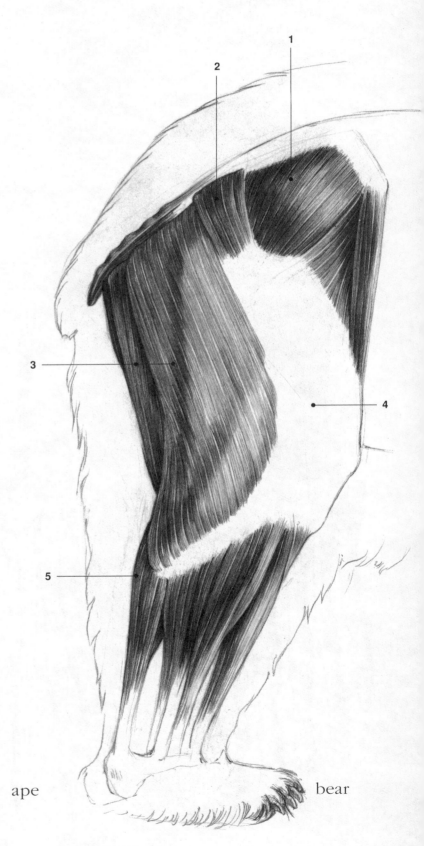

man ape bear

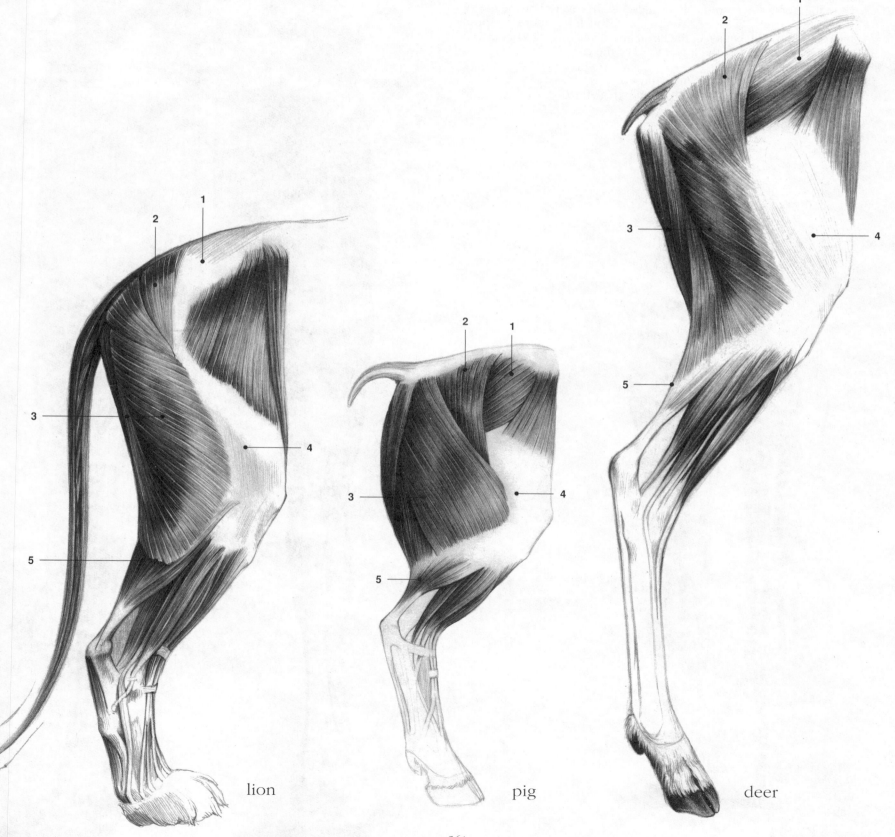

lion

pig

deer

561

Fig. 25

The muscles of the lower pelvic limb, posterior/caudal aspect

The gluteus maximus and gluteus medius muscles of humans and primates are well developed. In posterior and lateral views they are well separated from the thigh. Anteriorly, the protruding patella is clearly visible. In the upper third of the crus the triceps muscles, and above the tarsus the Achilles tendon, are clearly visible. The rump of domestic animals is tent-shaped or round, the thigh fuses with the rump both laterally and caudally and some of its muscles merge into each other. The stifle joint is visible only from the front. The gastrocnemius muscles are covered by the tendons of the caudally located rump muscles with insertions on the tarsus. The muscle bellies of the tarsal and digital muscles become tendons at the level of the lower third of the crus.

1 Gluteus superficialis (maximus) muscle *(96)*
2 Biceps (gluteobiceps; bo) femoris muscle *(99, 106)*
3 Semitendinosus muscle *(107)*
4 Gastrocnemius muscle *(115)*

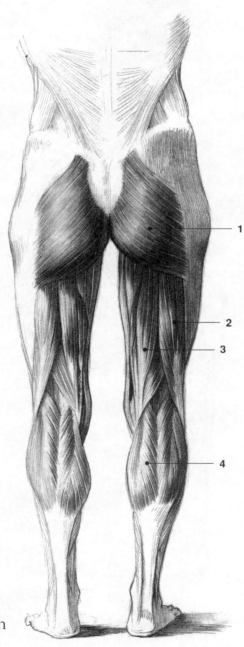

man

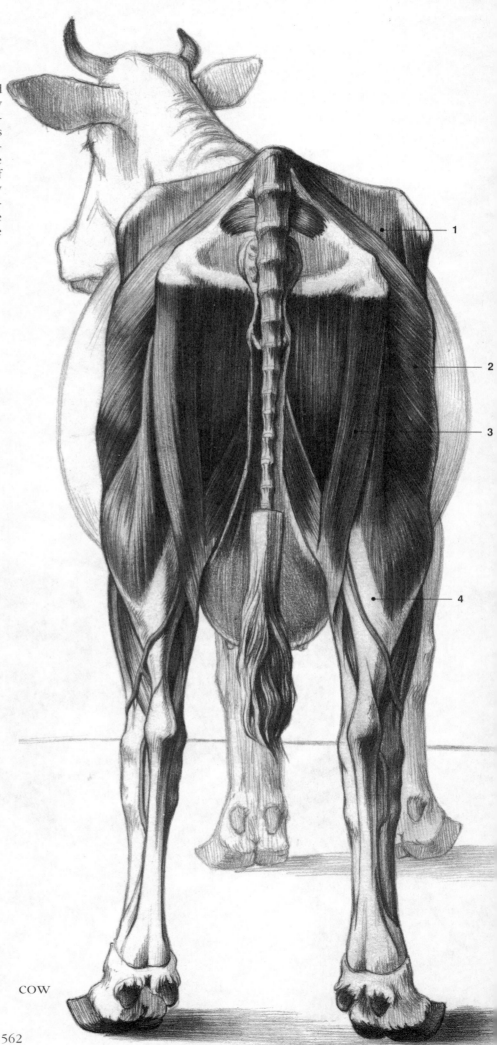

cow

562

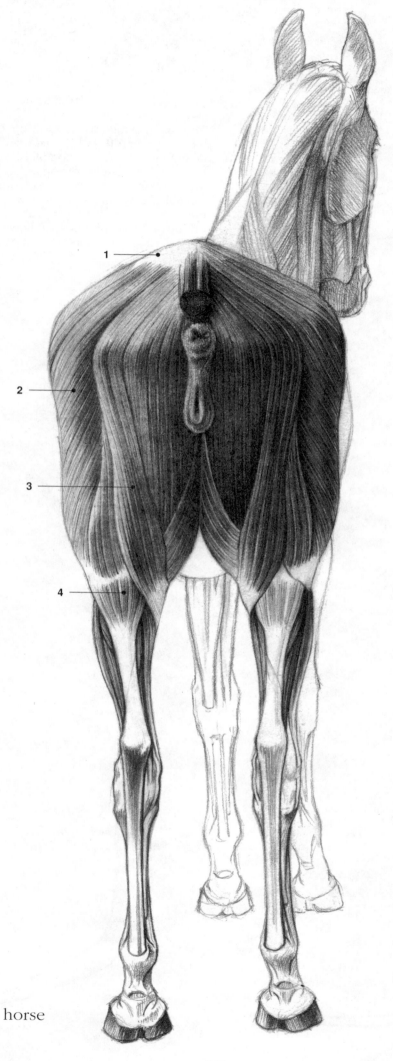

horse

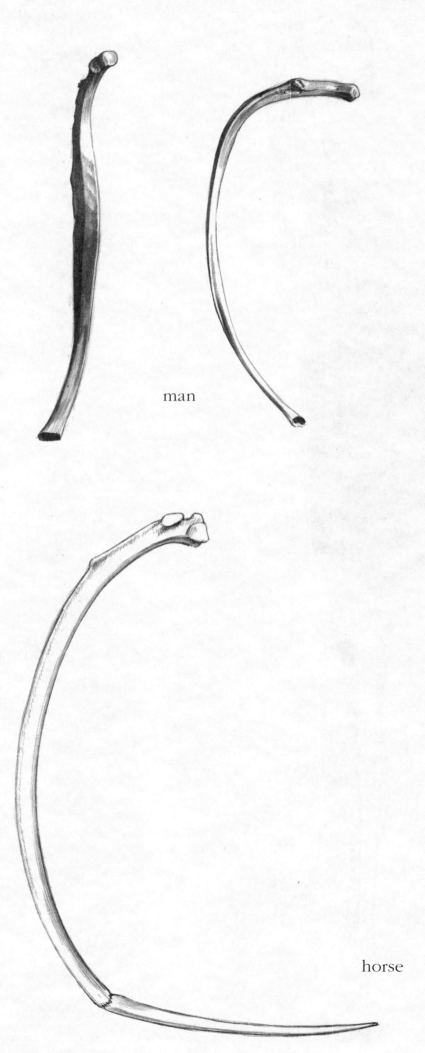

Fig. 26

The ribs

The ribs are curved flat (ruminants) or cylindrical (carnivores, horse) spongy bones.

The length of the ribs increases up to the VIII–Xth (humans), VIIIth (cow, pig) or VIII–Xth (horse), and then becomes shorter. They determine the cross section of the chest. Their numbers are identical with those of the corresponding thoracic vertebrae. The upper 3/4 are bone, the lower 1/4 is cartilage. The XI–XIIth and occasionally the Xth ribs of humans end freely in the muscular wall of the chest; these are termed false or floating ribs. The proportions of true and false ribs are as follows: 8:4 (humans and carnivores), 7:7 (pig) and 8:10 (horse).

man

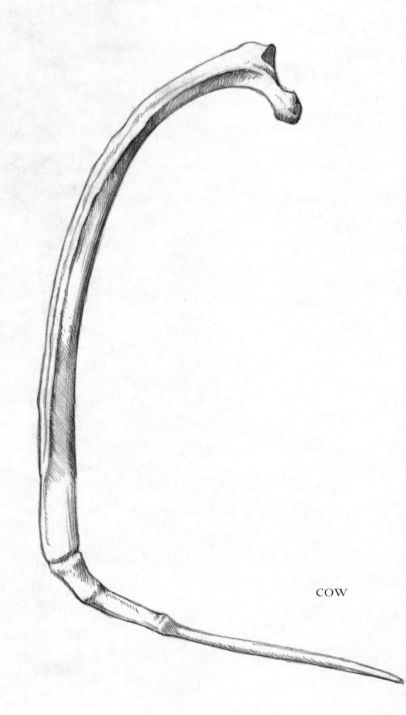

horse

cow

Fig. 27

The chest, dorsal aspect

1 Vertebral column
2 Ist rib
3 Costal arch

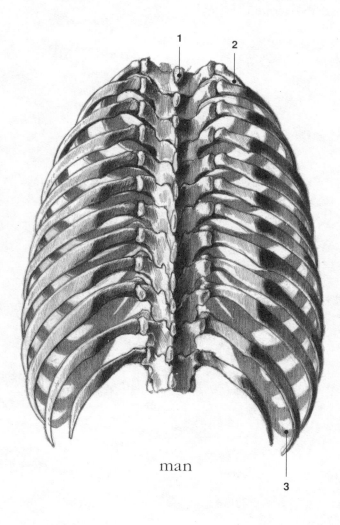

man

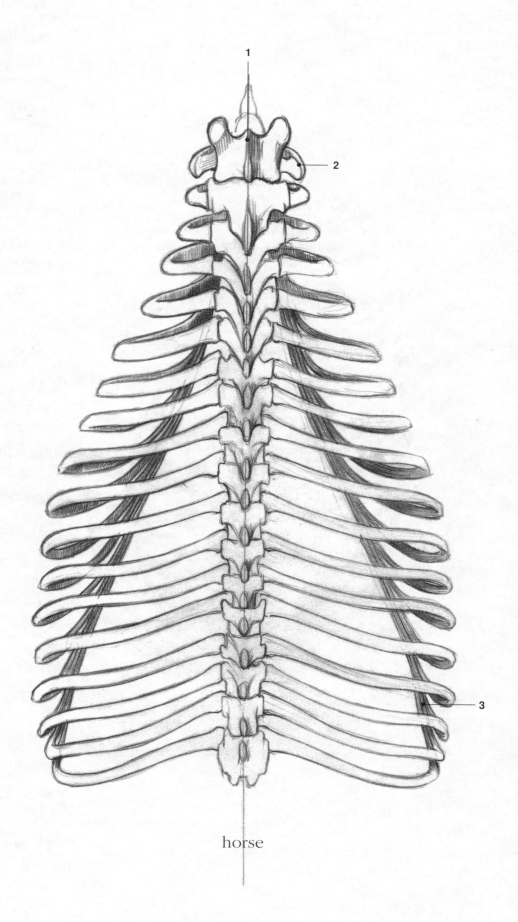

horse

Fig. 28

The chest, lateral aspect

The shape of the chest from the side resembles a truncated cone. From the anterior, the chest of humans is oval, that of animals more flattened laterally. The chest of herbivores is narrow and flattened laterally.

1 Spinous processes of the vertebrae
2 Ist rib
3 Cartilage of the Ist rib
4 Manubrium of the sternum
5 Xiphoid cartilage
6 Xth rib
7 Costal arch

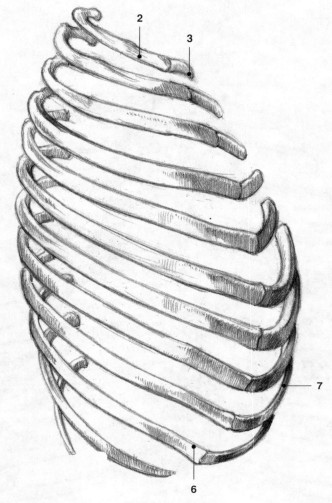

man

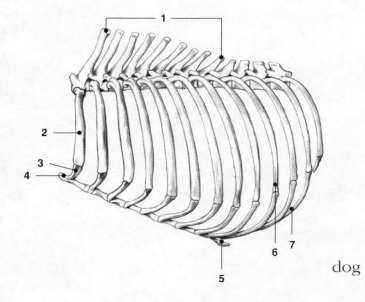

dog

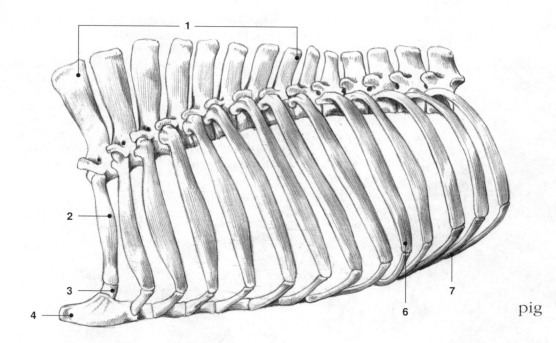

pig

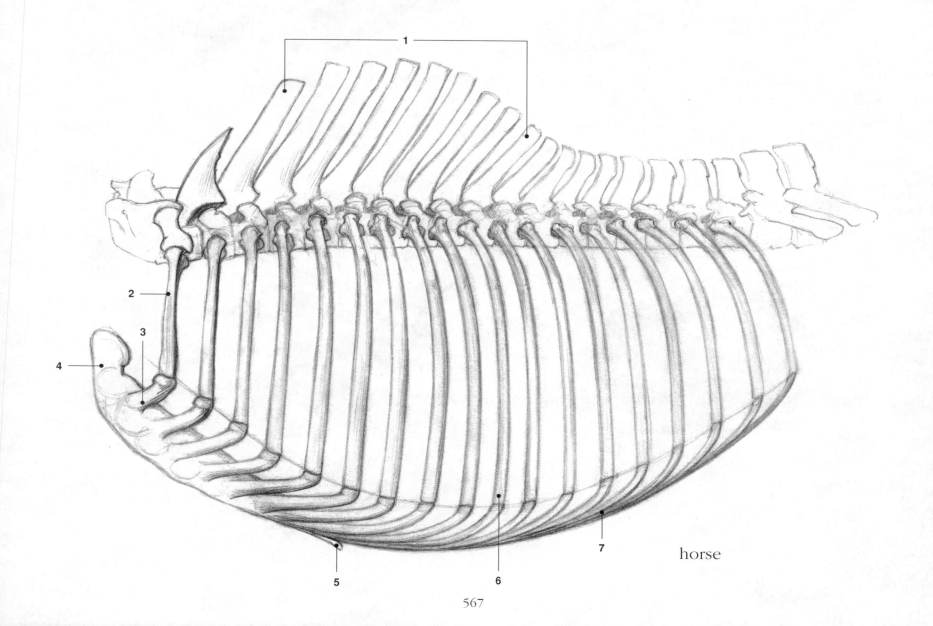

horse

The skull, lateral aspect

The skull consists of the neurocranium and the splanchnocranium, which are separated by an imaginary plane along a line from the inner corner of the eye to the external auditory meatus. The neurocranium of humans is larger than the splanchnocranium, that of animals is smaller. The proportions of the two are as follows: 3:1 (man), 2:1 (cat), 1:1 (dog), 1:3 (horse and cattle), 1:4 (deer). The degree of development is characterized by the Camper's angle, which is created by lines drawn from the edge of the nostril to the external auditory canal and to the most protrusive point of the forehead. These angles differ greatly according to species. The shape of the head shows great diversity.

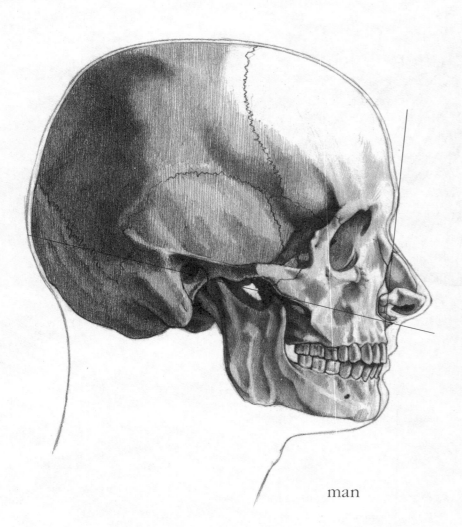

man

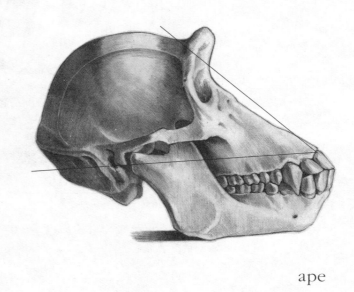

ape

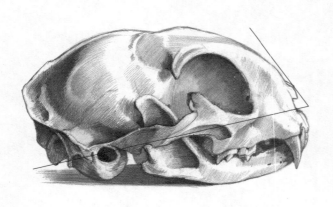

cat

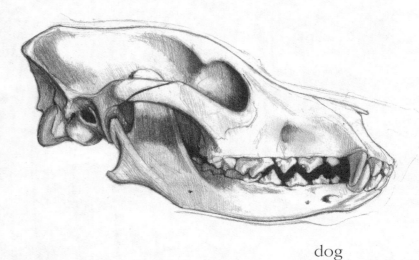

dog

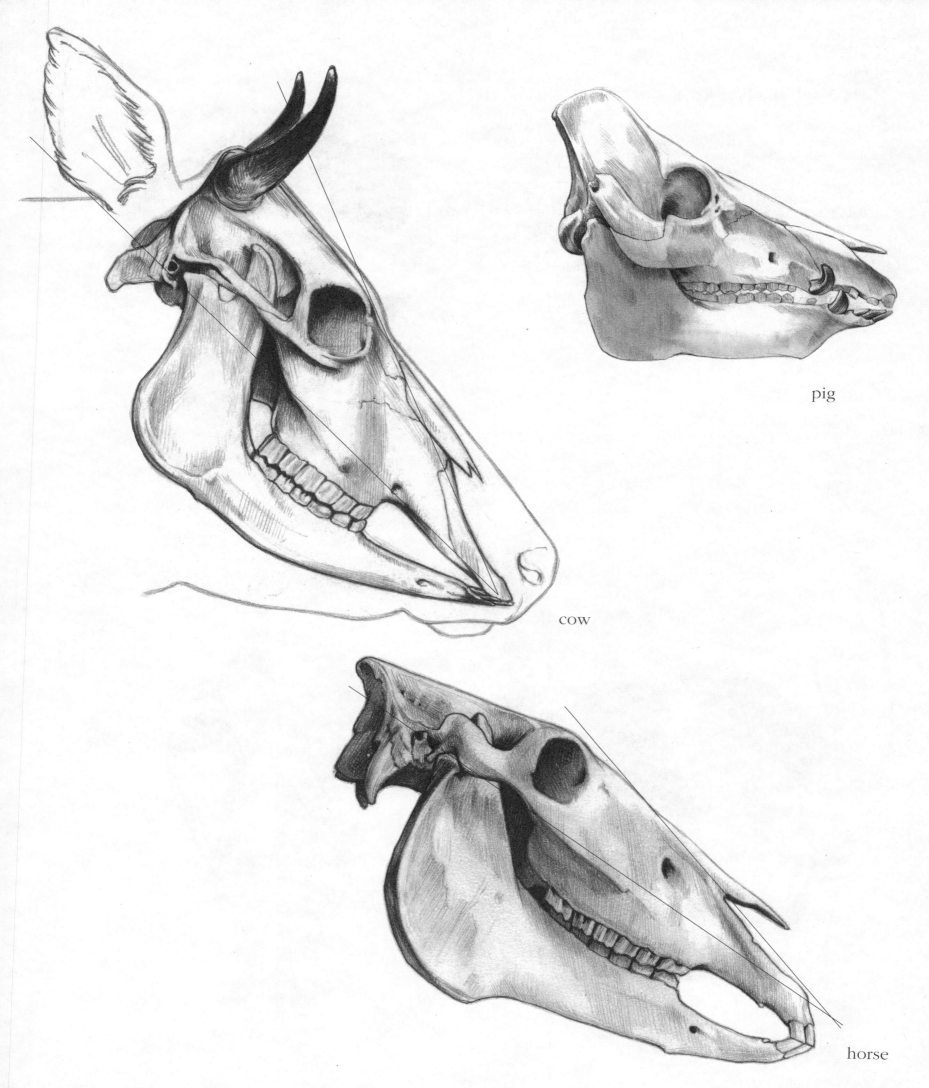

pig

cow

horse

Fig. 30

The skull, anterior/dorsal aspect

Characteristics like the shape and length of the skull also depend on the diet. Carnivores have short skulls and herbivores have long skulls, with omnivores somewhere between. In herbivores the large splanchnocranium is due to the enormously developed masticatory system.

The neurocranium of humans is round, that of animals is oval. The skull of horned animals expands horizontally from the forehead to the occiput. The skull of dogs, lions and cats is horizontally extended by the large temporal muscle which protrudes on both sides from temporal fossa. Horses, cattle and rabbits can look forwards or backwards without moving the head. When the head is held upright the base of the nose, eyeballs and external auditory canal all lie approximately on the same horizontal plane.

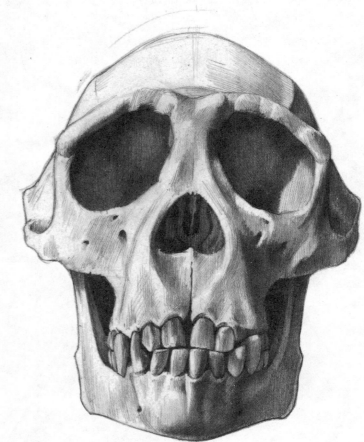

ape

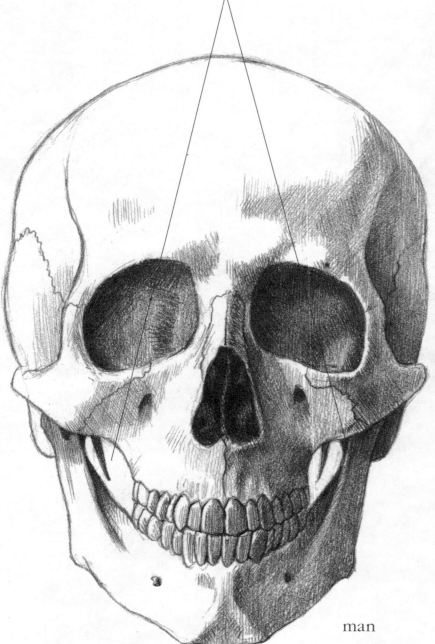

man

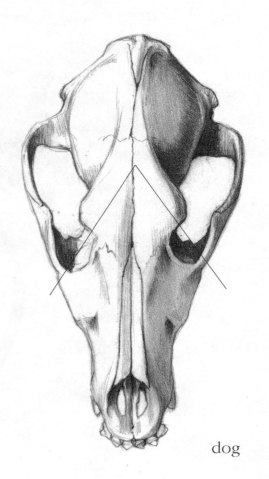

dog

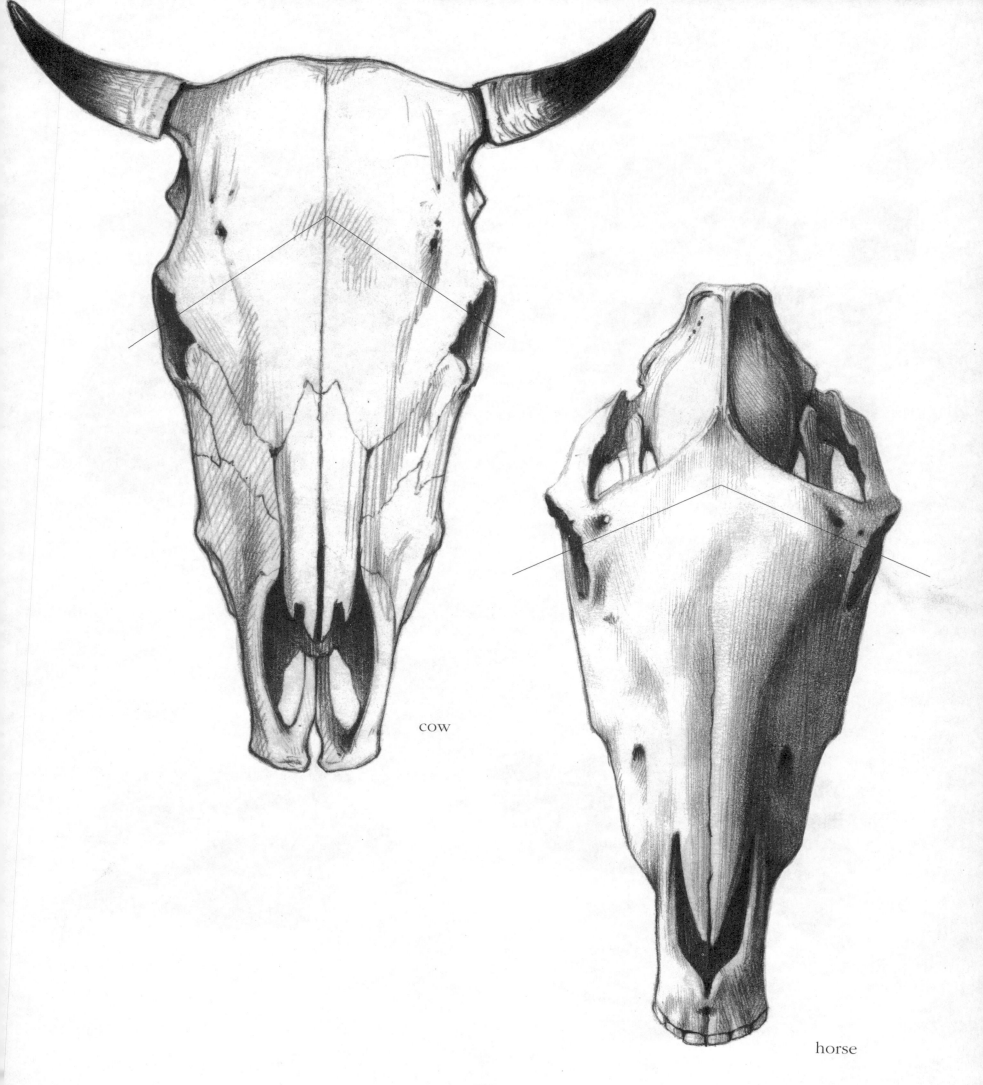

cow

horse

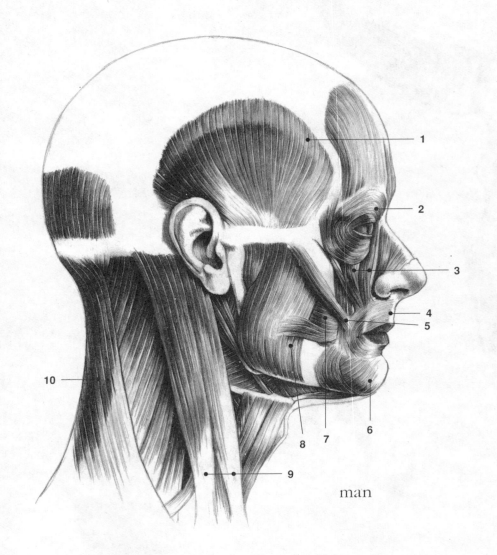

man

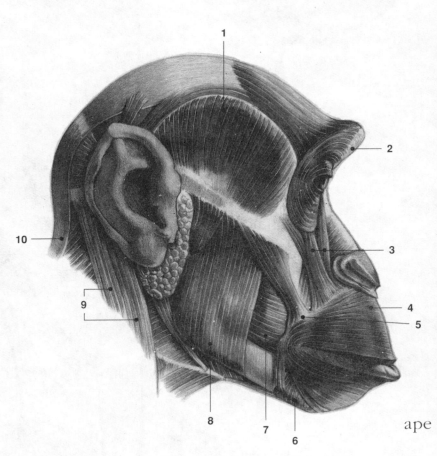

ape

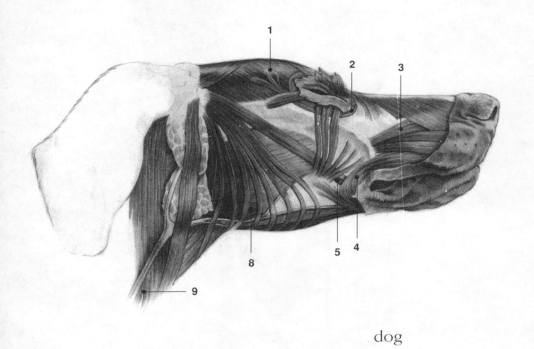

dog

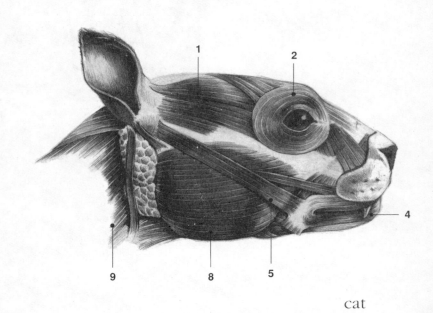

cat

572

Fig. 31

The muscles of the head, lateral aspect

In humans, the muscles of the lips, eyelids, mental region, temporal region, forehead and the cutaneus colli muscle are well developed.
Well developed temporal, nasal, upper labial and ear muscles are characteristic of carnivores. In herbivores the greatly developed masticatory and ear muscles dominate.

1 Temporalis muscle *(179)*
2 Orbicularis oculi muscle *(155)*
3 Levator labii superioris muscle *(168)*
4 Orbicularis oris muscle *(163)*
5 Zygomaticus muscle *(174)*
6 Mentalis muscle *(173)*
7 Buccalis muscle *(175)*
8 Masseter muscle *(178)*
9 Sternocleidomastoideus muscle *(6)*
10 Trapezius muscle *(14)*

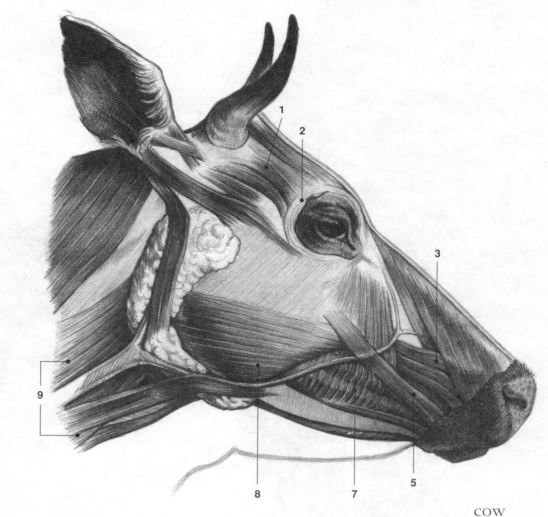

cow

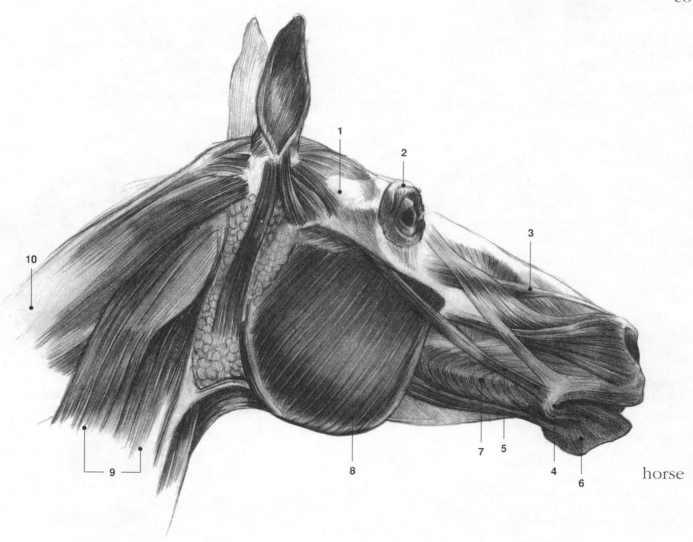

horse

573

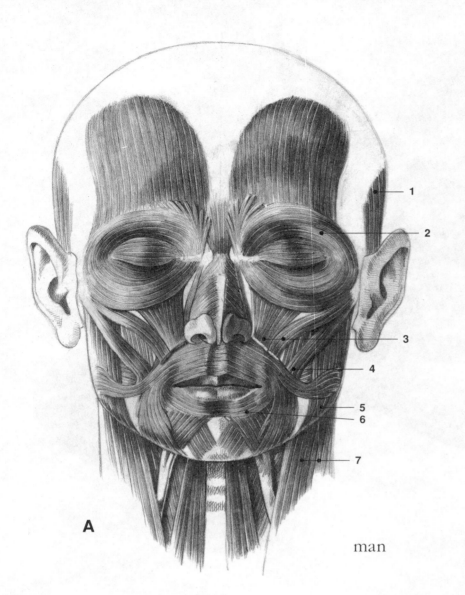

man

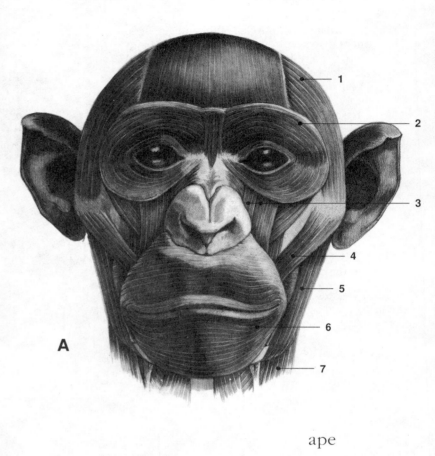

ape

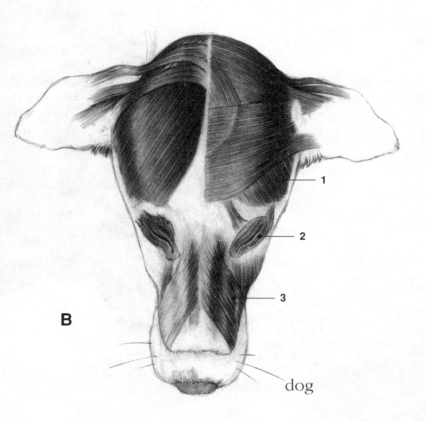

dog

Fig. 32

The muscles of the head; anterior (A) and dorsal (B) aspects

1 Temporal muscle *(179)*
2 Orbicularis oculi muscle *(155)*
3 Levator labii superioris muscle *(168)*
4 Zygomaticus muscle *(174)*
5 Masseter muscle *(178)*
6 Orbicularis oris muscle *(163)*
7 Sternocleidomastoideus muscle *(6)*

574

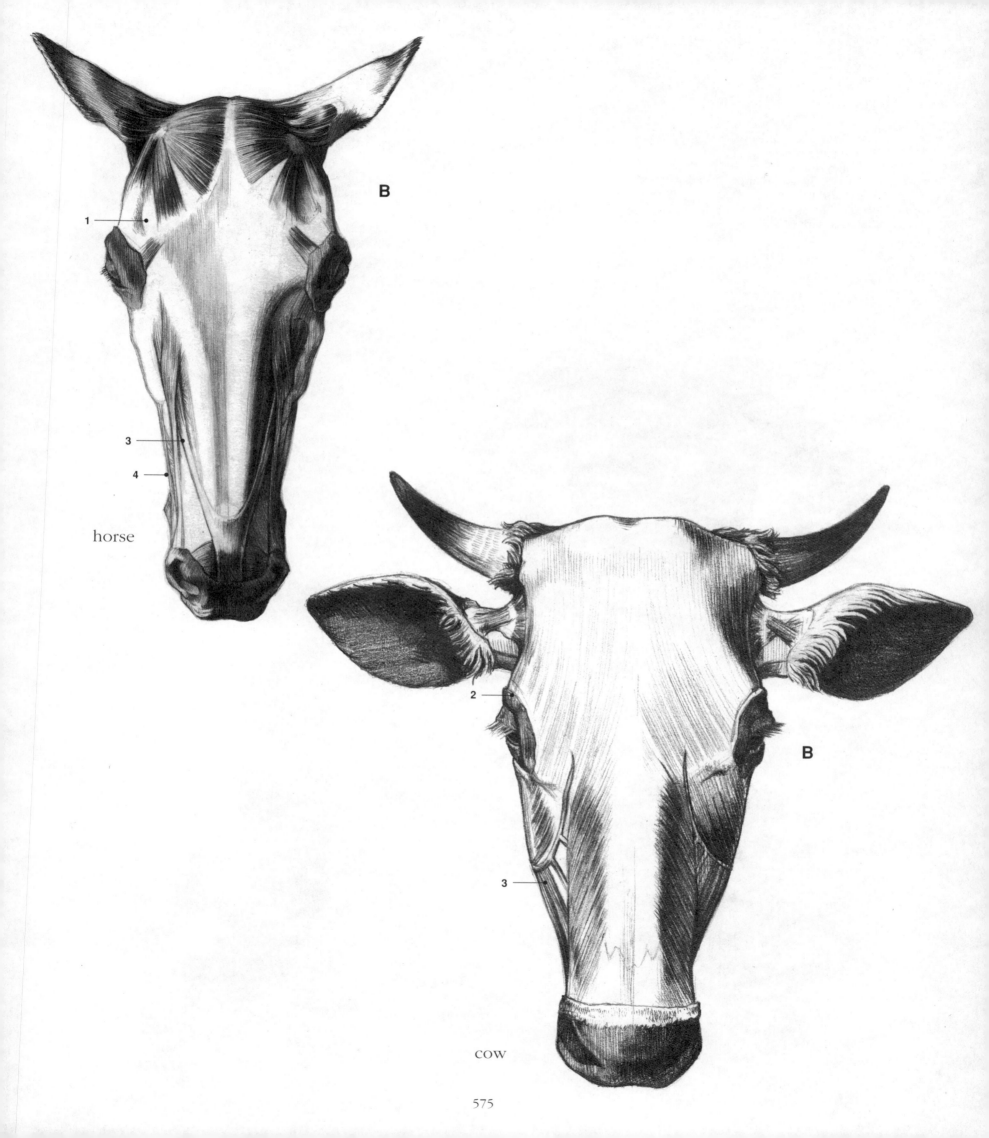

B

1

3

4

horse

2

B

3

cow

Fig. 33

The eye

1 Medial angle of the eye
2 Lacrimal caruncle
3 IIIrd eyelid
4 Ciliary edge of the upper eyelid
5 Supraorbital region
6 Lateral angle of the eye
7 Sulcus lacrimalis

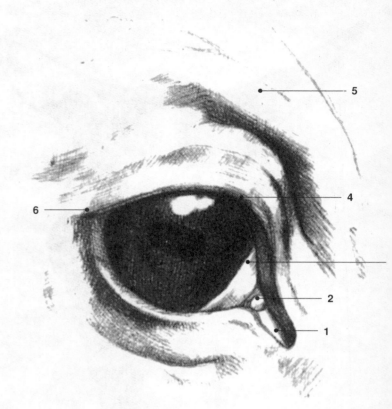

horse

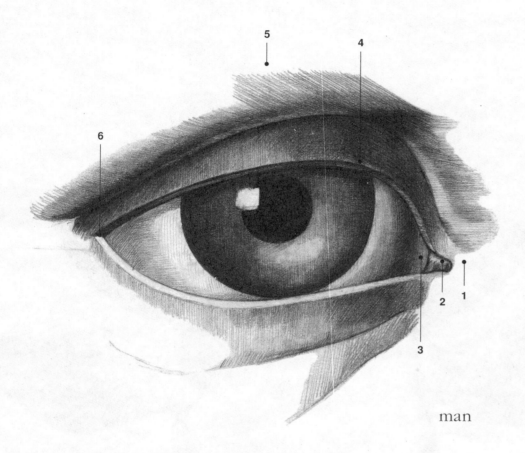

man

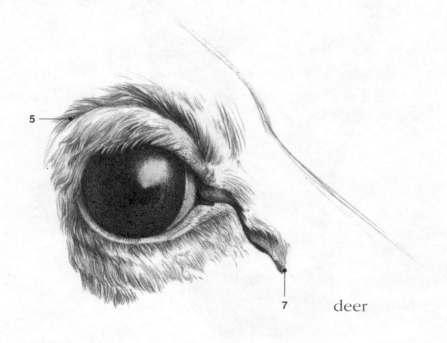

deer

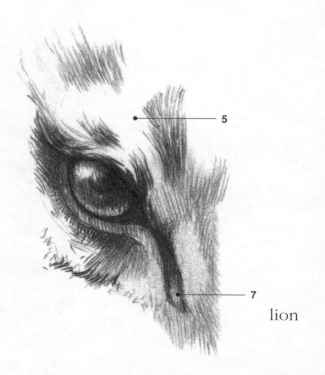

lion

576

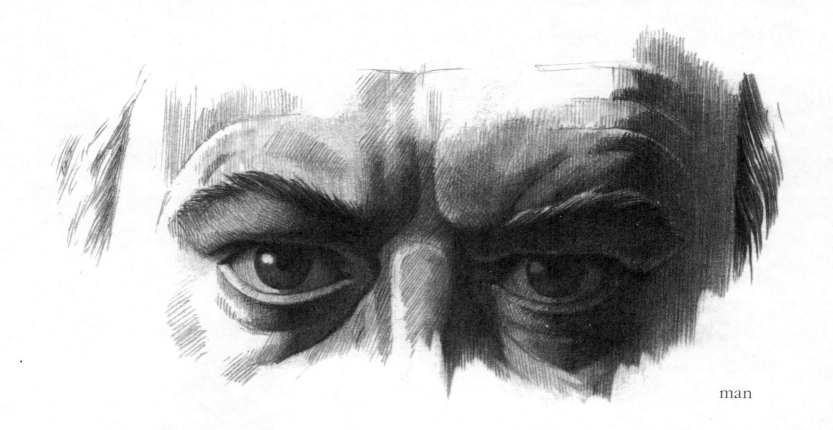

man

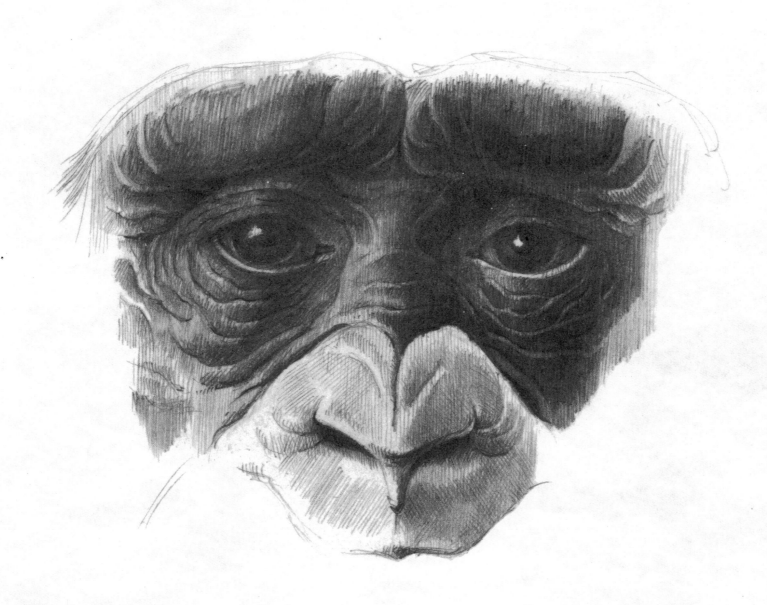

ape

Fig. 34
The nose and lips; lateral (A) and anterior/cranial (B) aspects

The nose of humans is well separated from the upper lip and protrudes from the face. The apex of the nose of apes is flattened. The nose of domestic animals is fused with the upper lip (horse).

The shape, development, mobility and structure of the lips differ according to species, and depend primarily on the type of nutrition. The lips are used for tearing, grasping and palpating.

1 Tip of the nose
2 Wings of the nose
3 True nostrils
4 False nostrils
5 Nasal septum
6 Labial groove
7 Angle of the mouth

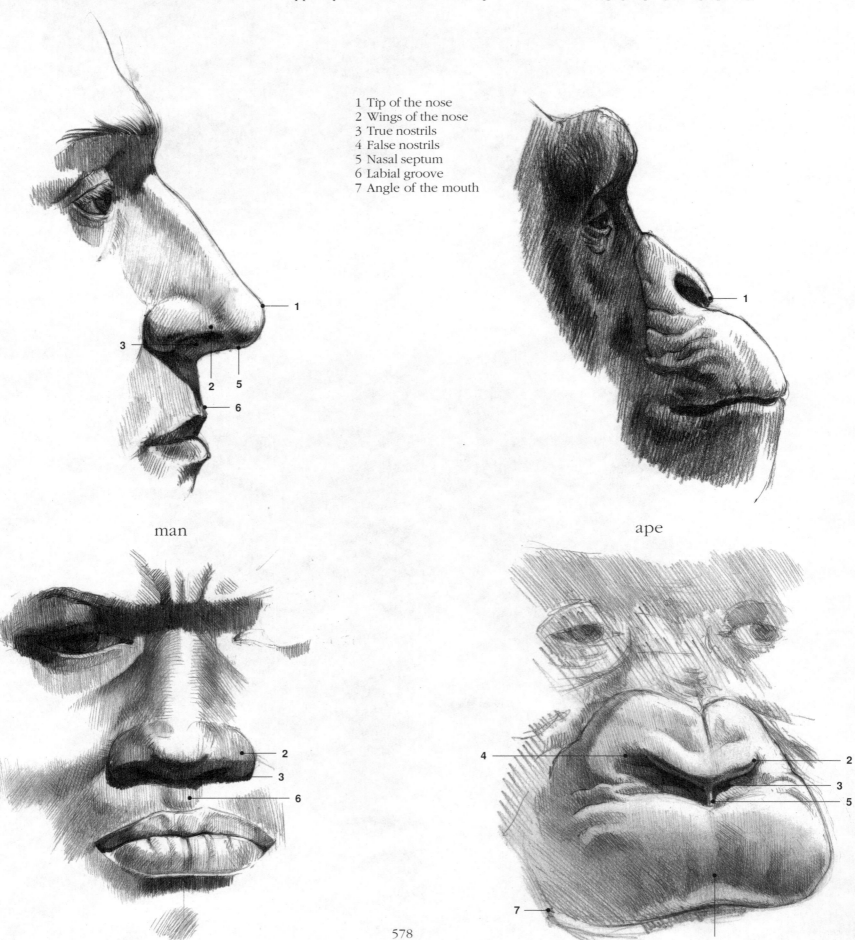

man

ape

Humans use their lips for speaking, feeling, eating and expressing their emotions. Carnivores use their lips for feeling, eating and expressing emotions. The lips of pigs are short, less mobile and sparsely haired. They search for food with the snout and take it into their mouths with their teeth and tongue. The lips of some ruminants are massive and hardly mobile. Sheep tear grass and take it into their mouths with their lips, which are also used for feeling. Cattle tear grass by surrounding a mouthful with the tongue. Horses are even able to select food with their long mobile lips as well as expressing feelings such as hunger or anger.

dog

sheep

Fig. 35

The nose and lips; lateral (A)
and anterior/cranial (B) aspects

1 Tip of the nose
2 Wings of the nose
3 True nostril
4 False nostril
5 Nasal septum
6 Labial groove
7 Angle of the mouth
8 Rostral plane

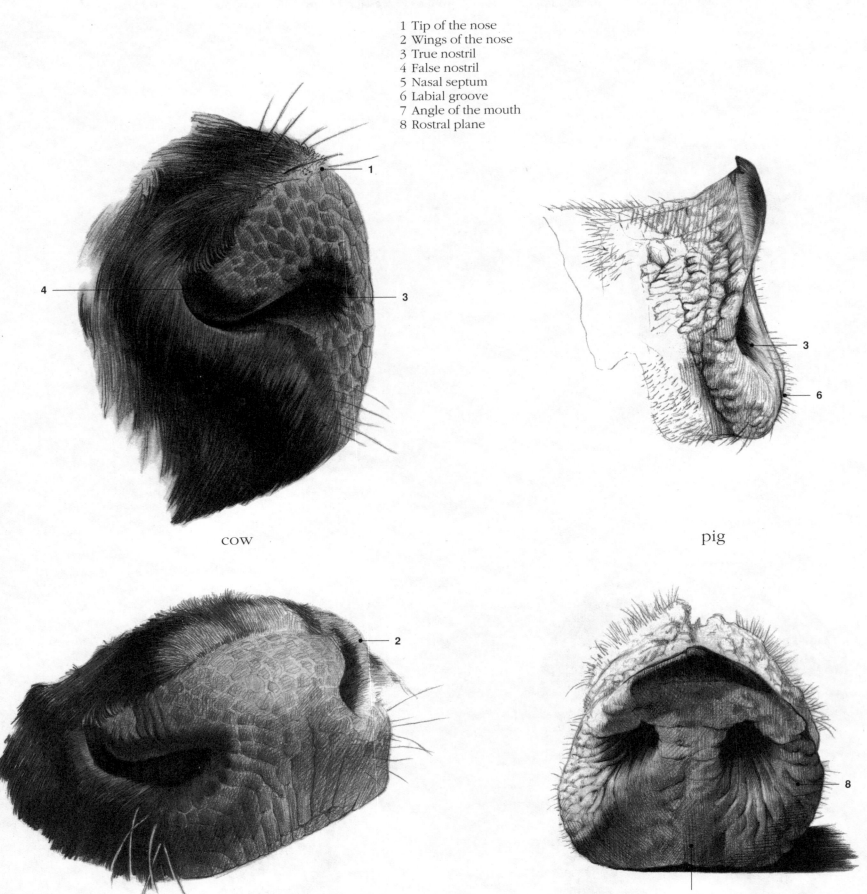

cow

pig

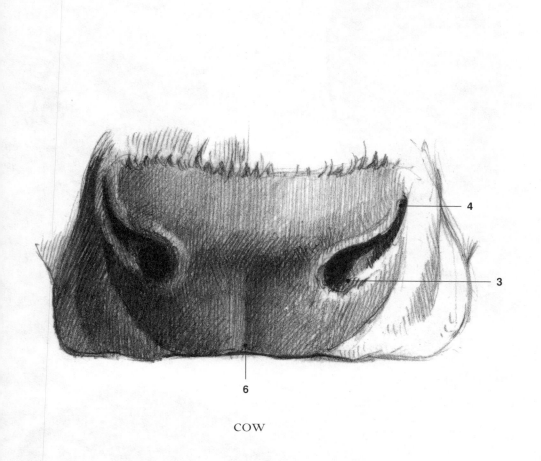

4

3

6

cow

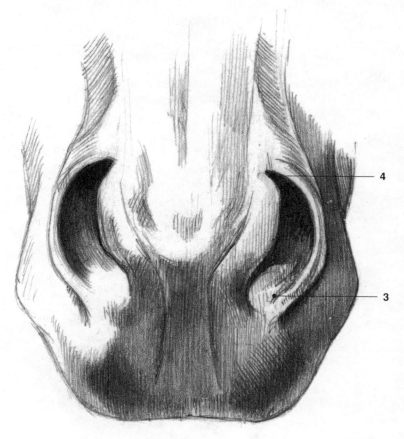

4

3

horse

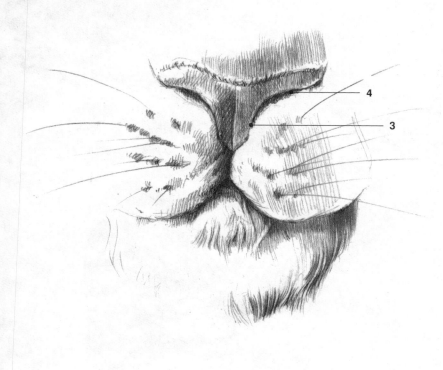

4

3

lion

bear

Fig. 36

The ear, lateral aspect

The auricle of humans and apes is small and shell-shaped.
It shows a considerable diversity in both shape and size according to species and breed.

1 Apex of the auricle, termed auricular hillock in man
2 Anterior (2/1) and posterior (2/2) edge of the auricle termed helix in man
3 Incisura intertragica
4 Ear lobe (limbus auriculae)
5 Auricular concha

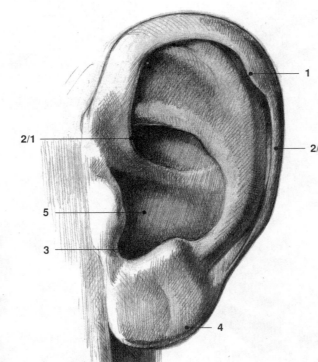

man

ape

lion

bear

camel

cat

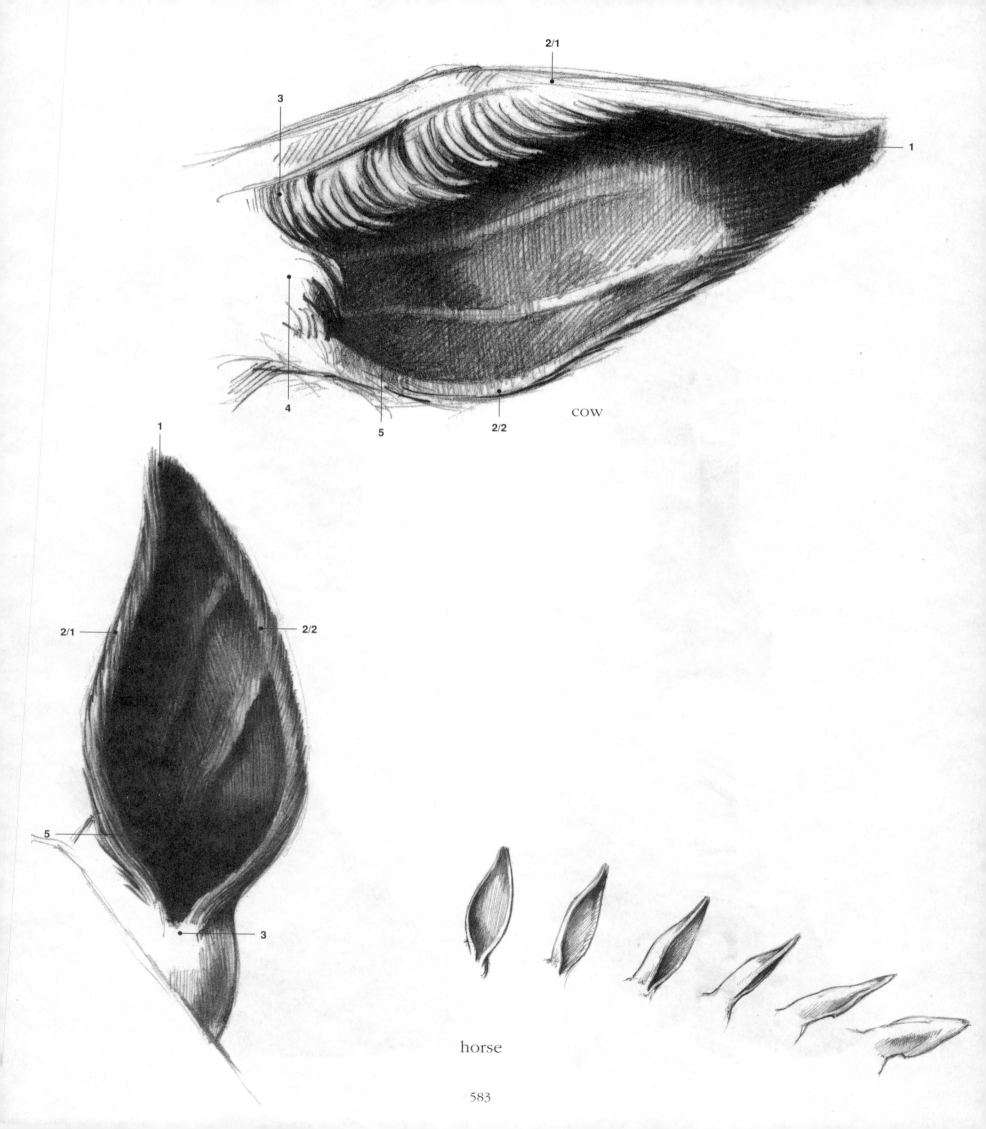

cow

horse

583

Fig. 37

The digit, lateral aspect

The claws of the pelvic limb are similar in shape to those of the thoracic limb. Their size reflects the size of the digits. However, the hooves of the pelvic limbs are steeper than those of the thoracic ones (the phalangeal axis forms an angle of 55° with the ground). The hoof capsule is narrower.

The surface of the digits which touches the ground is protected by elastic pillow-like formations of the dermis termed metatarsal, plantar (1) or digital pads (2). The digital cushions of ungulates serve the same purpose as the digital pads of carnivores.

Ist–Vth toes/digits

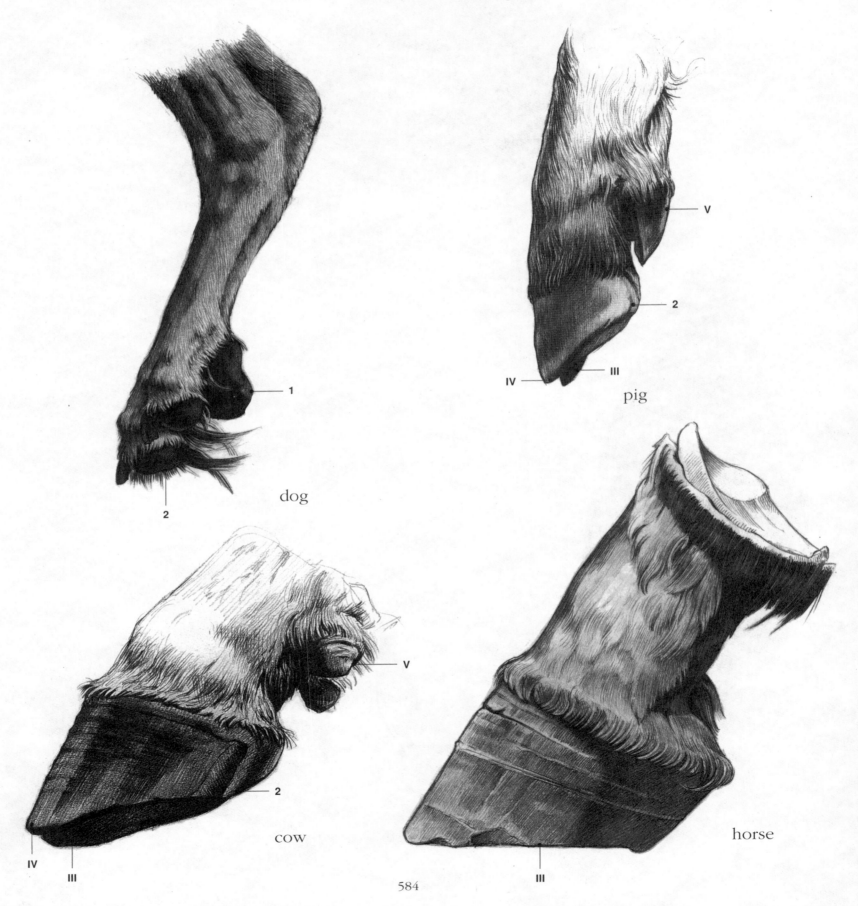

dog

pig

cow

horse

Fig. 38

The sole/digit, palmar aspect

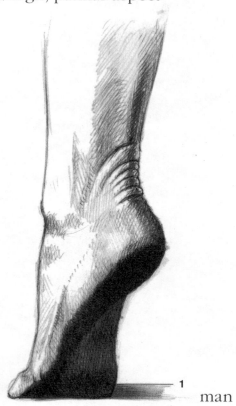

1 man

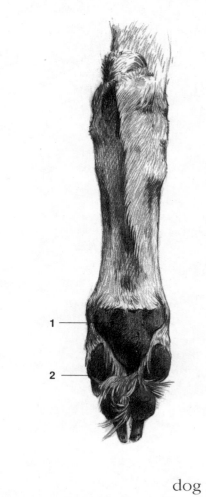

dog

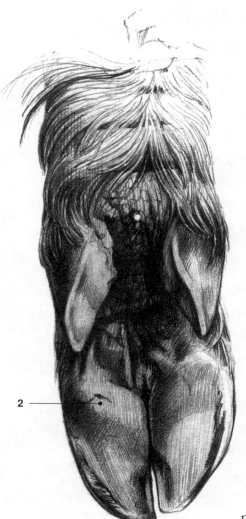

pig

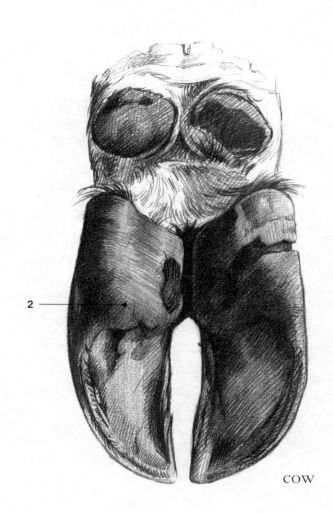

cow

MUSCLE CHART
THE NAME, ORIGIN, INSERTION AND FUNCTION OF THE MUSCLES

The body shape of any creature is largely determined by the size and position of its muscles, and is characteristic of the species to which it belongs. To help you gain an appreciation of the musculature and its contribution to form, many of the most important muscles are listed below, together with their functions and an indication of the species in which they are found.

The majority of muscles are attached to the skeleton at two points, one at each end; movement results when contraction of the muscle brings these points closer together. The attachment which usually remains stationary is known as the *origin* of the muscle and the one which moves as the *insertion*.

The numbers printed in italics and enclosed by brackets on the illustrated pages of this book refer to this chart. The names of the muscles are given first in Latin [Nomina Anatomica, 1980 (human); Nomina Anatomica Veterinaria, 1994 (animal)], and then in English, when they are italicized. The following Latin abbreviations are used:

m.	muscle
mm.	muscles
Car	Carnivora (carnivores)
Pon	Pongidae (apes)
Ru	Ruminatia (ruminants)
Un	Ungulata (ungulates)
bo	bos (cattle)
ca	canis (dogs)
eq	equus (horses)
ho	homo sapiens (man)
ov	ovis (sheep)
sus	sus (pigs)

THE MUSCLES OF THE NECK

	NAME	ORIGIN	INSERTION	FUNCTION
1	m. cutaneus faciei *cutaneus faciei muscle*	on the side of the neck, in the region of the mandible, nose and lower lips		wrinkles the skin
2	m. cutaneus colli *cutaneus colli muscle*	on the manubrium sterni		wrinkles the skin
3	m. rectus capitis dorsalis (posterior: ho) *rectus capitis dorsalis muscle*	on the Ist and IInd vertebrae	on the occipital bone, and the wing of the atlas vertebra	raises and rotates the head
4	m. obliquus capitis *obliquus capitis muscle* (cranialis and caudalis: animals; superior and inferior: ho)	on the Ist and IInd vertebrae	on the occipital bone and the wing of the atlas vertebra	raises, fixes the head and turns it to the side
5	m. splenius capitis et cervicis *splenius capitis and cervicis muscle*	on the IIIrd–VIIth cervical vertebrae (ho), the spinous processes of the thoracic vertebrae and the ribs, respectively	on the mastoid (ho), occiput, and transverse processes of the Ist–IIIrd cervical vertebrae	extends, turns to the side, and rotates (ho) the head and the neck
6	m. sternocleidomastoideus *sternocleidomastoideus muscle* sternal head (ho) clavicular head (ho)	on the sternum on the clavicle	on the mastoid process of the temporal bone on the nuchal crest (ho)	fixes the head and the neck, extends, flexes, turns to the side and rotates the head
6/1	m. brachiocephalicus *brachiocephalicus muscle*	on the body and deltoid tuberosity of the humerus	on the occiput, on the mastoid of the petrous bone	pulls the head to the side
6/2	pars occipitalis *occipital part* (Ru, sus)	on the clavicular tendinous septum	on the occiput	flexes the head
6/3	pars mastoidea *mastoid part* (Car, bo)	on the clavicular tendinous septum	on the mastoid of the petrous bone	pulls to the side and flexes the head and the neck
6/4	pars cervicalis *cervical part* (Car)	on the clavicular tendinous septum	on the nuchal ligament, and the transverse processes of the cervical vertebrae	raises the limb
7	m. sternocephalicus *sternocephalic muscle*	on the manubrium sterni	on the petrous bone and the mandible	flexes the neck and the head
7/1	pars mandibularis *mandibular part* (eq, bo)	on the manubrium sterni	on the body and angle of the mandible	flexes the neck and the head
7/2	pars mastoidea *mastoid part* (Car, bo, ov)	on the manubrium sterni	on the mastoid of the temporal bone	flexes the neck and the head
7/3	pars occipitalis *occipital part* (Car)	on the manubrium sterni	on the occipital crest	flexes the neck and the head
8	m. sternothyreoideus *sternothyreoideus muscle*	on the manubrium sterni	on the thyroid cartilage of the larynx	retracts the larynx
9	m. sternohyoideus *sternohyoideus muscle*	on the body of the sternum, Ist. on the costal cartilage (ho)	on the body of the hyoid bone	retracts the root of the tongue
10	m. omohyoideus *omohyoideus muscle*	on the cranial edge of the scapula, on the subscapular fascia	on the hyoid bone	retracts the hyoid bone
11	mm. scaleni *scaleni muscles*			
11/1	m. scalenus dorsalis (anterior: ho) *scalenus dorsalis (anterior: ho) muscle*	on the transverse processes of the IIIrd–VIth cervical vertebrae	on the Ist rib	pulls the neck to the side and forward, raises the Ist rib

NAME	ORIGIN	INSERTION	FUNCTION
11/2 m. scalenus medius *scalenus medius muscle*	on the transverse processes of the Ist and IInd cervical vertebrae, and the IInd–VIIth vertebrae (ho)	on the Ist rib	flexes and turns to the side the neck, raises the Ist rib (inspiratory muscle)
11/3 m. scalenus ventralis (posterior) *scalenus ventralis (posterior) muscle* (ho)	on the transverse processes of the Vth–VIth cervical vertebrae	on the upper border of the IInd rib	raises the IInd rib
12 m. biventer mandibulae m. digastricus *biventer mandibulae muscle* (ho)	on the jugular process of the occiput	on the medial surface of the body of the mandible	pulls down and retracts the mandible
	on the mastoid notch of the temporal bone	on the body of the hyoid bone, on the angle of the mandible	raises the hyoid bone and the larynx
13/1 m. stylohyoideus *stylohyoideus muscle*	on the posterior surface of the styloid process	on the lateral edge of the hyoid bone (ho) and the laryngeal process of the hyoid bone	raises the larynx, fixes the hyoid bone, pulls it up and forward (ho)
13/2 m. styloglossus *styloglossus muscle*	on the styloid process	on the side of the tongue	raises, retracts, shortens and pulls to the side the tongue
13/3 m. thyreohyoideus *thyreohyoideus muscle*	on the thyroid cartilage of the larynx	on the laryngeal horn of the hyoid bone	pulls the root of the tongue above the larynx, closes the larynx

THE MUSCLES OF THE BACK

NAME	ORIGIN	INSERTION	FUNCTION
14 m. trapezius *trapezius muscle* cervical, thoracic part	on the nuchal ligament and on the supraspinous ligament, on the nuchal line (ho)	on the scapular spine, on the clavicle, on the acromion (ho)	pulls the scapula forward and backward, partly abducts the limb, rotates the head, pulls the scapula towards the vertebral column (ho)
15 m. omotransversarius *omotransversarius muscle*	on the wing of the atlas, and the transverse process of the IInd cervical vertebra	on the scapular spine	turns the neck to the side, flexes the neck
15/1 m. claviculocervicalis *claviculocervicalis muscle* (Pon)	on the clavicle	on the transverse processes of the Ist and IInd vertebrae	raises the clavicle
16 m. latissimus dorsi *latissimus dorsi muscle*	on the spinous processes of the last 6 thoracic and of the IV–VIth lumbar vertebrae, the dorso-lumbar fascia, on the last 3 ribs (ho)	on the body of the humerus, on the teres tuberosity	flexes the shoulder joint, retracts the limb, suspends and raises the trunk, raises and turns the foreleg inward (ho)
17 m. rhomboideus *rhomboideus muscle* cervical, cephalic part, major. minor (ho)	on the nuchal ligament (minor) and on the supraspinous ligament (major)	on the medial border of the scapula, on the inner surface of the scapular cartilage	turns the neck to the side, raises, pulls the limb forward and backward, adducts the scapula towards the spinal column and the head (ho)
18 m. serratus ventralis (anterior) *serratus ventralis (anterior; ho) muscle* cervical, thoracic part	on the transverse processes of the IIIrd–VIIth vertebrae and on the Ist–IXth ribs	on the inner surface of the scapula, and on its angles (ho)	suspends and raises the trunk, moves the scapula, adducts the shoulder blades to each other
19 m. serratus dorsalis (posterior) *serratus dorsalis (posterior; ho) muscle*	on the spinous process of the VIth–VIIth cervical and Ist and IInd thoracic vertebrae	on the cranial surface of the IInd–Vth ribs	pulls the ribs cranially and laterally (inspiratory muscle)

589

NAME	ORIGIN	INSERTION	FUNCTION
pars cranialis (superior: ho) pars caudalis (inferior: ho)	on the spinous processes of the lumbar vertebrae, on the dorsolumbar fascia	on the caudal surface of the last 4 ribs	pulls the ribs backward (expiratory muscle)
20 m. erector spinae *erector spinae muscle*			
20/1 m. iliocostalis cervicis *iliocostalis cervicis muscle*	on the Ist rib, on the transverse process of the Ist thoracic vertebra	on the transverse process of the Vth cervical (IIIrd–Vth ho) vertebrae, on the wings of the atlas vertebra	extends the neck and turns it to the side
20/2 m. iliocostalis thoracis *iliocostalis thoracis muscle*	on the transverse processes of the thoracic vertebrae, on the transverse processes of the VIIth cervical and Ist–VIth thoracic vertebrae (ho)	on the inferior border of the VII-XIIth ribs (ho)	extends, turns to the side the vertebral column
20/3 m. iliocostalis lumborum *iliocostalis lumborum muscle*	on the sacrum, on the iliac spine, and on the dorsolumbar fascia (ho)	on the last (Vth–XIIth ho) ribs, on the costal angles	extends, turns to the side the vertebral column
21 m. longissimus *longissimus muscle*	on the sacrum, on the spinous and transverse processes of the lumbar and thoracic vertebrae	bridging the Vth–VIIIth vertebrae, it inserts on the transverse processes of the cranially situated vertebra, and on the costal angles	extends the vertebral column and fixes it
21/1 thoracis *longissimus thoracis muscle*	transverse processes of the thoracic vertebrae	on the caudal edge of the ribs	extends, turns to the side and fixes the vertebral column
21/2 cervicis *longissimus cervicis muscle*	on the transverse processes of the Ist–VIIIth thoracic vertebrae	on the transverse processes of the IIIrd–Vth cervical vertebrae	extends, turns to the side and fixes the vertebral column
22 m. levator scapulae *levator scapulae muscle* (ho)	on the spinous processes of the IInd–Vth cervical vertebrae	on the cranial border and upper angle of the scapula	raises the shoulder blade
23 m. transversospinalis, *transversospinalis muscle*			
23/1 m. semispinalis *semispinalis muscle* thoracis cervicis	on the spinous processes of the cervical and thoracic vertebrae	on the articular and transverse processes of the cervical and thoracic vertebrae	raises, turns to the side and extends the neck, makes the spinal column upright (ho)
23/2 m. multifidus *multifidus muscle* thoracis cervicis	on the sacrum, and the articular and transverse processes of the thoracic and lumbar vertebrae	on the sides of the spinous processes of the cervical, thoracic and lumbar vertebrae	fixes the vertebrae and turns to the side the vertebral column
23/3 mm. interspinales *interspinalis muscles*	bind the neighbouring spinous processes to each other		fixes and turns to the side the vertebral column
24 mm. intertransversarii *intertransversarius muscles*	bind the transverse, articular and mastoid processes together		fixes and turns to the side the vertebral column

MUSCLES OF THE THORAX

NAME	ORIGIN	INSERTION	FUNCTION
25 m. cutaneus omobrachialis *cutaneus omobrachialis muscle*	1 cm thick muscle plate in the horse, covers the shoulder blade and the shoulder joint with its fibres directed forward and upward		moves and wrinkles the skin
26 m. cutaneus maximus *cutaneus maximus muscle*	covers the side of the chest and belly with nearly horizontal fibres		moves and wrinkles the skin
26/1 m. cutaneus plicae lateris *cutaneus plicae lateris muscle* (ov)	on the lateral abdominal wall in the skin anterior to the stifle joint		moves the skin

	NAME	ORIGIN	INSERTION	FUNCTION
27	mm. pectorales superficiales *pectoralis superficialis muscles*			
27/1	m. pectoralis major *pectoralis major muscle* (ho), homologous with No. 27	on the clavicle, on the Ist–VIth costal cartilages, on the sternum	on the body of the humerus below the head	adducts the arm, turns it inward, when hanging by the arms it raises the trunk, pulls down the arm
28	m. pectoralis transversus *pectoralis transversus muscle*	on the sternum and on the costal cartilages (Ist–VIth)	on the fascia of the forearm	adducts and pulls the limb forward and backward
29	m. pectoralis descendens *pectoralis descendens muscle*	on the manubrium sternum	below the lateral tubercle of the humerus	adducts and pulls the limb forward and backward
30	m. pectoralis profundus *pectoralis profundus muscle*	on the sternum and on the costal cartilages	on the medial tubercle of the humerus	carries the weight of the trunk, pulls back the limb, swings the trunk forward
31	m. pectoralis minor *pectoralis minor muscle* (ho) homologous with No. 30	on the IIIrd–Vth ribs	on the coracoid process	pulls the shoulder downward and forward
32	m. subclavius *subclavius muscle*	on the sternum, on the yellow fascia abdominis	on the fascia of the supraspinatus muscle, or on the lateral tubercle of the humerus	carries the weight of the trunk, pulls back the limb, swings the trunk forward
	in man (ho)	on the cartilage of the Ist rib	on the clavicle	pulls downward and inward and fixes the clavicle
33	m. intercostalis externus *intercostalis externus muscle*	on the caudal border of the ribs	on the cranial border of the subsequent rib	raises, pulls forward the ribs (inspiration)
34	m. intercostalis internus *intercostalis internus muscle*	on the cranial border of the ribs	on the caudal border of the preceeding rib	lowers the ribs (expiration)
35	m. rectus thoracis *rectus thoracis muscle*	on the Ist rib on the outer surface of the costal cargilages	on the IInd–IVth ribs on the outer surface of the costal cartilages	inspiration

THE MUSCLES OF THE ABDOMEN

	NAME	ORIGIN	INSERTION	FUNCTION
36	m. obliquus externus abdominis *obliquus externus abdominis muscle*	on the chest, starting from the IIIrd and IVth ribs	in the "linea alba", in the median suture of the abdominal muscles, on the inguinal ligament, on the hipbone (ho)	supports the abdominal organs, flexes and turns the trunk to the side (ho)
37	m. obliquus internus abdominis *obliquus internus abdominis muscle*	on the lateral iliac angle, on the transverse processes of the lumbar vertebrae	in the "linea alba"	supports the abdominal organs (discharge of faeces, parturition etc.)
	iliocostal part (ho)	on the anterior superior iliac spine	on the last 3 ribs	flexes the trunk (ho)
38	m. transversus abdominis *transversus abdominis muscle*	on the lateral iliac angle, on the transverse processes of the lumbar vertebrae, the inner surface of the last 6 costal cartilages	in the "linea alba"	supports the abdominal press (discharge of faeces parturition etc.) retracts the abdomen (ho)
39	m. rectus abdominis *rectus abdominis muscle*	on the sternum and on the cartilages of the last true ribs	on the pubic bone, on the outer pubic surface of the pelvis	supports the abdominal organs (discharge of faeces parturition etc.) flexes the trunk to the front (ho)

NAME	ORIGIN	INSERTION	FUNCTION
40 m. vagina recti abdominis *m. vagina recti abdominis*	the rectus abdominis muscle moves freely in the rectus sheath formed by the obliquus externus, internus and transversus abdominis muscles and by the fasciae of the abdominal wall		
41 "linea alba" *white line*	the muscular laminae of the two oblique and the transversal abdominal muscles are fused into a uniform line-shaped tendinous raphe in the middle-line of the abdomen		
42 m. pyramidalis *pyramidalis muscle* (ho, Pon)	on the suture of the pubic bone	in the "linea alba"	pulls the "linea alba" downward, supports the function of the rectus abdominis muscle

MUSCLES OF THE THORACIC GIRDLE

The muscles of the shoulder joint

NAME	ORIGIN	INSERTION	FUNCTION
43 m. deltoideus *deltoideus muscle* scapular, acromial part	on the caudal edge of the scapula and scapular spine, on the acromion	on the deltoid tuberosity of the lateral surface of the humerus	flexes the shoulder joint, retracts the arm
clavicular part	it fuses with the brachiocephalicus muscle		in man raises the arm, pulls forward and backward and rotates the arm
44 m. supraspinatus *supraspinatus muscle*	in the fossa in front of the scapular spine	on the lateral and medial tubercle of the humerus	extends the shoulder joint, in man raises the arm to the side and rotates it
45 m. infraspinatus *infraspinatus muscle*	in the fossa behind the scapular spine	on the lateral tubercle of the humerus	flexes the shoulder joint, in man rotates back and outward and adducts the arm
46 m. teres minor *teres minor muscle*	on the caudal edge of the shoulder blade	on the lateral part of the humerus below its neck	flexes the shoulder joint, in man rotates and abducts the arm outward and adducts it
47 m. teres major *teres major muscle*	on the caudal edge of the shoulder blade	on the medial surface of the humerus, on the teres tuberosity	flexes the shoulder joint, in man adducts the humerus, rotates and abducts the arm inward and raises it
48 m. subscapularis *subscapularis muscle*	in the inner fossa of the scapula	on the medial tubercle and bony crest of the humerus (ho)	it serves as the inner ligament of the shoulder joint, supports the extensors and flexors, in man rotates inward, adducts and abducts the arm
49 m. coracobrachialis *coracobrachialis muscle*	on the coracoid process of the scapula	on and below the medial tubercle of humerus	extends the shoulder joint, adducts and pulls the arm forward

The muscles of the arm and elbow joint

NAME	ORIGIN	INSERTION	FUNCTION
50 m. brachialis *brachialis muscle*	on the medial surface of the humerus, below the neck	on the proximal part and tuberosity of the radius (in animals) on the coronoid process of the ulna (ho)	flexes the elbow joint
51 m. biceps brachii *biceps brachii muscle*	on the supraglenoid tubercle of the scapula, in man on the coracoid process as well	the posterior part of the tuberosity of the radius, its tendinous bundle turns to the extensor carpi radialis muscle	extends the shoulder joint, flexes the elbow joint, fixes both of them and the carpus too, in man it turns the arm outward

	NAME	ORIGIN	INSERTION	FUNCTION
52	m. triceps brachii *triceps brachii muscle*	on the caudal edge of the scapula, on the neck of the scapula (ho), on the medial and lateral surface of the humerus	on the olecranon of the ulna	extends the elbow joint, fixes the arm (ho)
53	m. anconaeus *anconeus muscle*	in the fossa at the distal end of the humerus, in man on its lateral epicondyle	on the upper surface of the olecranon	extends the elbow joint
54	m. tensor fasciae antebrachii *tensor fasciae antebrachii muscle*	on the caudal edge of the scapula, on the latissimus dorsi muscle	continued in the antebrachial fascia on the inner surface	extends the antebrachial fascia

The muscles of the carpal and phalangeal joints

	NAME	ORIGIN	INSERTION	FUNCTION
55	m. pronator teres *pronator teres muscle*	on the medial epicondyle of the distal end of the humerus, in man on the radius also	on the cranio-lateral edge of the radius	rotates the forearm inward
56	m. flexor carpi radialis *flexor carpi radialis muscle*	on the medial epicondyle of the distal end of the humerus	on the IInd (ho) or IIIrd metacarpal bone	in man it rotates inward, in animals it flexes the carpal joint
57	m. flexor carpi ulnaris *flexor carpi ulnaris muscle*	on the medial epicondyle of the lower end of the humerus and on the radius, on the posterior surface of the ulna (ho)	on the accessorial carpal bone (ho), on the Vth metacarpal bone (ho)	flexes the carpus, turns the forearm slightly outward
58	m. flexor digitorum superficialis *flexor digitorum superficialis muscle*	on the medial epicondyle of the lower end of the humerus, and on the radius	on the middle phalanges of the IInd–Vth digits, on the tuberositas flexoria (eq)	flexes the phalangal joints of the IInd–Vth digits, and the pedal joint (Ung)
59	m. flexor digitorum profundus *flexor digitorum profundus muscle* humeral, ulnar and radial heads	on the medial epicondyle of the distal end of the humerus, and on the radius and ulna (ho)	on the distal phalanges of the IInd–Vth digits	flexes the IIIrd phalangeal joints, or the hoof joint
60	m. flexor digit I. (pollicis) longus *flexor digit I. (pollicis) longus muscle* humeral head (ho)	on the upper third, anterior surface of the radius on the lateral epicondyle of the humerus	on the flexorial surface of the distal phalanx of the first finger	flexes the first finger
61	m. palmaris longus *palmaris longus muscle* (ho)	on the medial epicondyle of the humerus	spreads on the palmar transverse ligament of the carpus	flexes the carpal joints
62	m. pronator quadratus *pronator quadratus muscle*	on the medial surface of the radius, on the cranial surface of the ulna (ho)	on the medial surface of the ulna, on the lateral edge of the cranial surface of the radius (ho)	turns the forearm inward
63	m. brachioradialis *brachioradialis muscle*	on the lateral epicondyle of the lower end of the humerus and above it (ho)	on the lateral surface of the distal end of the radius, on the styloid process (ho)	flexes the elbow joint, turns the forearm inward and outward
64	m. extensor carpi radialis *extensor carpi radialis muscle* long and short (ho)	on the lateral epicondyle of the distal end of the humerus (short) or above it (long)	on the upper ends of the IInd and IIIrd (short and long, respectively) metacarpal bones	extends the carpal joint
65	m. extensor carpi ulnaris *extensor carpi ulnaris muscle*	on the lateral epicondyle of the lower end of the humerus	on the base of the Vth (ho), and the IIIrd–IVth metacarpal bones	extends (ho) and flexes (eq and bo) the carpus

	NAME	ORIGIN	INSERTION	FUNCTION
66	m. extensor digitorum communis *extensor digitorum communis muscle* extensor of the IIIrd digit (Ru)	lateral epicondyle of the humerus	on the distal phalanges of the IInd–Vth digits, and the extensor process of the distal phalanx (eq)	extends carpal and phalangeal joints
67	m. extensor digitorum lateralis *extensor digitorum lateralis muscle* extensor of the IVth digit (Ru)	on the lateral surface of the fibula and the collateral ligament of the femor-tibial joint.	on the proximal and middle phalanges of the IVth and Vth digit	extends the phalangeal joints
68	m. supinator *supinator muscle*	on the lateral epicondyle of the distal end of the humerus and on the lateral surface of the ulna (ho)	on the inner or outer surface of the upper third of the radius	rotates the forearm outward
69	m. extensor indicis proprius *extensor indicis proprius muscle*	on the body of the ulna, on the ligament between the radius and the ulna	on the distal phalanx of the IInd digit	extends the IInd digit
70	m. abductor digit I. (pollicis) longus *abductor digiti I. (pollicis) longus muscle*	on the caudolateral surface of the radius, on the interosseal ligament at the upper third of the ulna (ho)	on the Ist metacarpal (ho), on the IInd (eq, sus), on the IIIrd one (bo)	extends, adducts the carpus, extends and abducts the Ist digit
71	m. extensor digit I. (pollicis) *extensor digiti I. (pollicis) muscle* short and long (ho)	on the distal end of the ulna, on the interosseal ligament (ho) at the middle part of the forearm	on the proximal phalanx of the Ist digit, on the distal phalanx of the IInd digit (long, ho)	extends the proximal phalangeal joints of the Ist and IInd digits
72	m. extensor digiti II. *extensor digiti II. muscle*	on the middle part of the ulna	on the distal phalanx of the IInd digit	extends the IInd digit
73	m. flexor digitorum brevis *flexor digitorum brevis muscle*	on the bones of the forearm above the carpus	on the Ist–Vth digits	supports the function of the other flexors
74	m. flexor digiti I. (pollicis) brevis *flexor digiti I. (pollicis) brevis muscle*	on the palmar surface of the carpus, on the transverse ligament, on the multiangular bones, on the capitate bone	on the proximal phalanx of the Ist digit on its sesamoid bone	flexes, adducts the proximal phalanx of the Ist digit (ho)
75	m. adductor digiti I. (pollicis) *adductor digiti I. (pollicis) muscle*	on the palmar surface of the carpus, on the transverse ligament	on the proximal phalanx of the Ist digit	adducts, opposes and flexes the Ist digit, (ho)
76	m. abductor digiti I. (pollicis) brevis *abductor digiti I. (pollicis) brevis muscle* (ho)	on the transverse ligament of the carpus, on the navicular bone	on the medial sesamoid bone of the proximal phalanx of the Ist digit	abducts, opposes and flexes the Ist digit
77	m. opponens digiti I. (pollicis) *opponens digiti I. (pollicis) muscle* (ho)	on the palmar surface of the carpus, on the fascia and on the big multiangular bone	on the medial border of the metacarpal bone of the Ist digit	opposes the thumb to the other digits, adducts it
78	m. abductor digiti II. *abductor digiti II. muscle*	on the palmar surface of the IInd metacarpal bone	on the lateral surface of the proximal phalanx of the IInd digit	abducts the IInd digit
79	m. flexor digiti II. *flexor digiti II. muscle*	on the palmar surface of the IInd metacarpal bone	on the medial surface of the proximal phalanx of the IInd digit	flexes the IInd digit
80	m. adductor digiti II. *adductor digiti II. muscle*	on the palmar surface of the IInd metacarpal bone	on the lateral surface of the proximal phalanx of the IInd digit	adducts the IInd digit

	NAME	ORIGIN	INSERTION	FUNCTION
81	m. abductor digiti V. *abductor digiti V. muscle*	on the lateral surface of the accessorial (pisiform) carpal bone and on the transverse ligament	on the proximal phalanx of the Vth digit	abducts the Vth digit
82	m. flexor digiti V. *flexor digiti V. muscle*	on the carpal bones, on the IVth metacarpal bone	on the proximal phalanx of the Vth digit	flexes the Vth digit
82/1	m. flexor digiti V. brevis *flexor digiti V. brevis muscle* (ho)	on the process of the unciform bone, on the transverse ligament	on the proximal phalanx of the Vth digit	flexes the Vth digit
83	m. adductor digiti V. *adductor digiti V. muscle*	on the plantar surface of the carpus, on the IV–Vth metatarsals (oblique head), on the IIIrd metatarsal (transverse head)	on the proximal phalanx of the Vth digit, on the sesamoids	adducts the Vth digit
84	m. extensor digit V. proprius *extensor digiti V. proprius muscle* (ho)	on the lateral edge of the carpus (detached part of No. 83)	on the middle and distal phalanges of the Vth digit	extends the Vth digit
85	mm. lumbricales *lumbricalis muscles*	on the metacarpals, on the two sides of the tendon of the flexor digitorum profundus muscle, on the triangle ligament		supports the function of the flexors
86	mm. interossei dorsales *interosseus dorsalis muscles* (ho)	on the middle part of the metacarpals	on the anteriolateral surfaces of the proximal phalanges, on the triangular ligament	abducts the digits from each other
87	mm. interossei palmares *interosseus palmaris muscles* (ho)	on the bodies of the IInd, IVth and Vth metacarpal bones, and on their palmar surfaces	on the sesamoids of the IInd–Vth digits, on the triangle ligament	adducts the digits toward each other, flexes the fingers
88	m. interosseus medius *interosseus medius muscle* (eq, Ru)	on the caudal surface of the carpus	with 2 stems on each sesamoid	flexes the fetlock joint, (static muscle)
89	m. opponens digiti V. *opponens digiti V. muscle* (ho)	on the process of the unciform bone, on the transverse ligament	on the bodies of the Vth metatarsals	opposes the Vth digit to the thumb

THE MUSCLES OF THE PELVIC (REAR OR LOWER) LIMB

The lumbar muscles

	NAME	ORIGIN	INSERTION	FUNCTION
90	m. iliopsoas *iliopsoas muscle*			
91	m. psoas minor *psoas minor muscle*	on the body of the last 2–3 thoracic- and Ist–Vth lumbar vertebrae	on the body of the hip bone, on the minor trochanter of the femur	flexes the vertebral column, protracts the pelvis, rotates the femur outward (ho)
92	m. iliacus *iliacus muscle*	on the medial surface of the sacrum and ilium	on the medial surface of the body of the femur (on its trochanter minor)	flexes the hip joint and the vertebral column
93	m. psoas major *psoas major muscle*	on the last thoracic and lumbar vertebrae	on the medial surface of the body of the femur (on its trochanter minor)	turns outward, fixes the stifle joint
94	m. quadratus lumborum *quadratus lumborum muscle*	on the transverse processes of the lumbar vertebrae, on the last rib (ho)	on the wings of the sacrum, on the ilium	turns outward, fixes the stifle joint

The muscles of the rump, the upper rump muscles

	NAME	ORIGIN	INSERTION	FUNCTION
95	m. tensor fasciae latae *tensor fasciae latae muscle*	on the tuber coxae (on the anterior superior iliac spine; ho)	becomes the fascia of the thigh and crus	extends the fascia, flexes and abducts the hip joint
96	m. gluteus superficialis (maximus) *gluteus superficialis muscle (maximus) (ho)*	on the ala and crest of the ilium, on the sacrum, on the coccygeal bones (ho)	on the greater trochanter of the femur and below it	flexes the hip joint, (in Car extends it), in man extends, abducts and rotates
97	m. gluteus medius *gluteus medius muscle*	on the ala of the ilium, on the sacrum	on the upper (eq) trochanter and the lateral surface of the greater trochanter	extends the hip joint, abducts and rotates it inward and outward (ho)
98	m. caudofemoralis *caudofemoralis muscle*	on the IInd–IVth coccygeal vertebrae	on the patella, on the fascia lata of the thigh	pulls the limb outward and backward, pulls the tail to the side
99	m. gluteobiceps *gluteobiceps muscle*	on the tuber coxae, on the sacrum	on the trochanter major of the femur	flexes the hip joint
100	m. gluteus profundus *gluteus profundus muscle* minimus (ho)	on the body of the ilium, on the iliac wing between the lower and upper line	on the trochanter major of the femur	extends the hip joint, abducts the limb, extends the hip joint, rotates and abducts the limb
101	m. piriformis *piriformis muscle*	on the lateral edge of the sacrum and on the broad pelvic ligament	on the trochanter major of the femur and below it	extends the hip joint, abducts and rotates the limb

Adductors of the thigh

	NAME	ORIGIN	INSERTION	FUNCTION
102	m. sartorius *sartorius muscle*	on the tuber coxae, on its crest on the iliac fascia, on the tendon of the psoas minor muscle	on the medial straight ligament of the patella, on the crural fascia, on the medial surface of the tibia (ho)	adducts and pulls forward the limb
103	m. pectineus *pectineus muscle*	on the pecten of the pubic bone	on the medial surface of the femur above the lower end	adducts, flexes the limb, rotates it outward (ho)
104	m. gracilis *gracilis muscle*	on the lower, cranial surface of the pelvis	on the crest of the tibia, on its medial surface (ho), on the crural fascia	adducts the limb
105	m. adductor *adductor muscle*	on the lower, cranial surface of the pelvis	below the head of the femur on the medial surface	adducts the limb
105/1	magnus	on the pubic bone, ischium and sciatic tuberosity	on the gluteal tuberosity and quadrate tubercle of the femur	adducts the limb
105/2	brevis	on the pubic bone	on the linea aspera and medial lip of the femur	adducts the limb and rotates it outward (ho)
105/3	longus	at the fusion of the upper and lower rami of the pubic bone	on the rough line of the femus at its middle part	adducts the limb and rotates it outward (ho)

Caudal rump muscles

	NAME	ORIGIN	INSERTION	FUNCTION
106	m. biceps femoris *biceps femoris muscle* short and long head (ho)	on the sacrum, ischial tuberosity, on the femur (short head (ho))	on the patella, on the crural fascia, on the calcaneum, on the head of the fibula (ho)	extends and flexes the knee joint, abducts and rotates the limb outward (ho)
107	m. semitendinosus *semitendinosus muscle*	on the sacrum, on the coccygeal vertebrae, on the ischial tuberosity (in Ru and Car, on the latter only)	on the crest of the tibia, on the tuberosity of the calconeum	flexes the stifle joint, extends the tarsus, rotates the limb inward (ho)

	NAME	ORIGIN	INSERTION	FUNCTION
108	m. semimembranosus *semimembranosus muscle*	on the Ist coccygeal vertebrae, on the ischial tuberosity (Ru, sus), in carnivora on the latter only	on the medial condyles of the femur and the tibia	extends the stifle joint, pushes the trunk forward, flexes the stifle joint, rotates the limb inward (ho)

Medial thigh muscles (deep muscles of the hip joint)

	NAME	ORIGIN	INSERTION	FUNCTION
109	m. obturatorius internus *obturatorius internus muscle*	within the borders of the foramen obturatum	in the fossa situated beside the head of the femur	abducts the thigh
110	m. quadratus femoris *quadratus femoris muscle*	on the lateral surface of the ischium	below the fossa situated beside the head of the femur	rotates the thigh outward
111	mm. gemelli *gemelli muscles* superior and inferior heads (ho)	on the less sciatic notch of the ischial spine (superior), on the ischial tuberosity (inferior) (ho)	below the fossa situated beside the head of the femur	rotates the thigh outward

The muscles of the stifle joint

	NAME	ORIGIN	INSERTION	FUNCTION
112	m. quadriceps femoris *quadriceps femoris muscle*			
112/1	m. rectus femoris *rectus femoris muscle*	on the anterior inferior iliac spine and groove above the acetabulum	on the patella (ho) on the tibial crest	extends the stifle joint
112/2	m. vastus medialis *vastus medialis muscle*	below the trochanter major of the femur on the craniomedial surface	on the patella and tibial crest	extends the stifle joint
112/3	m. vastus intermedius *vastus intermedius muscle*	below the femoral head on the medial surface	on the patella and the tibial crest, medial surface	extends the stifle joint
112/4	m. vastus lateralis *vastus lateralis muscle*	on the craniolateral surface of the femur below the head up to the lower condyle (ho)	on the patella and the tibial crest	extends the stifle joint
113	m. popliteus *popliteus muscle*	in the fossa situated on the lateral femoral condyle and on the fibular head (ho)	on the caudomedial surface of the proximal end of the tibia	flexes the stifle joint, rotates inward (ho)

The muscles of the crus (tarsus and phalangeal joints)

	NAME	ORIGIN	INSERTION	FUNCTION
114	m. triceps surae *triceps surae muscle*			
115	m. gastrocnemius *gastrocnemius muscle*	on the femoral condyles (ho), and above and behind it	on the calcanean tuber together with the Achilles tendon	extends the tarsal joint, the superior talocrural joint (ho), flexes the stifle joint
116	m. soleus *soleus muscle*	on the head of the fibula, and the caudal surface of the tibia	on the calcanean tuber together with the Achilles tendon	extends the tarsal joint
117	m. tibialis cranialis *tibialis cranialis muscle*	on the lateral tibial condyle	on the craniomedial surface of the tarsal and metatarsal bones	flexes the tarsal joint, rotates it outward
	anterior (ho)	on the lateral surface below the tibial condyle and on the interosseal ligament (ho)	on the Ist cuneiform bone	raises the foot-dome (ho)
118	m. extensor digitorum longus *extensor digitorum longus muscle*	on the lateral femoral condyle, in the fossa in front of it, on the head, body of the fibula, on the tibia (ho)	on the distal phalanx of the IInd–IVth digits	extends the digital joints

NAME	ORIGIN	INSERTION	FUNCTION
m. extensor digitorum brevis 118/1 *extensor digitorum brevis muscle* (ho, sus)	on the calcanean bone cranially (ho), on the IIIrd and IVth metatarsals cranially (sus)	on the distal phalanges IInd–Vth digits (ho), on the distal phalanges of the IInd–IVth digits (sus)	extends the digital joints
m. peroneus tertius 119 *peroneus tertius muscle*	in the fossa in front of the lateral femoral condyle	on the tarsal bones and the bases of the metatarsals	flexes, fixes (eq) the tarsal joint, rotates inward (ho)
m. extensor digitorum I. (hallucis) longus et brevis 120 *extensor digitorum I. (hallucis) longus and brevis muscle*	on the fibula, on the interosseal ligament (ho)	on the middle phalanx of the Ist digit, on the distal phalanx (ho)	extends the joints of the Ist digit
m. peroneus longus 121 *peroneus longus muscle*	on the fibular head and lateral tibial condyles, laterally below the fibular head (ho)	on the Ist tarsal and Ist metatarsal bones, on the Ist cuneiform and Ist metatarsal bones (ho)	flexes the tarsal joint, raises the lateral edge of the foot, fixes the foot-dome (ho)
m. peroneus brevis 121/1 *peroneus brevis muscle*	on the distal end of the fibula	on the Vth metatarsus	flexes the tarsal joint, raises the lateral edge of the foot (ho)
m. extensor digitorum lateralis 122 *extensor digitorum lateralis muscle*	on the head of the fibula	on the middle phalanges of the IVth and Vth digits	extends the middle phalangeal joints
m. flexor digitorum superficialis 123 *flexor digitorum superficialis muscle*	in the femoral fossa above the condyle	on the calcanean tuber and the proximal and middle phalanges	fixes the tarsus, flexes the middle phalangeal joint
mm. flexores digitorum profundi 124 *flexor digitorum profundi muscles*			
m. flexor digiti I. (hallucis) longus 124/1 *digiti I. (hallucis) longus (lateralis) muscle*	on the lateral tibial condyle, on the fibula, on the interosseal ligament (ho)	on the distal phalanges of the Ist–Vth digits, on the distal phalanx of the Ist digit (ho)	flexes the phalangeal joints, the Ist digit (ho)
m. flexor digitorum longus (medialis) 125 *flexor digitorum longus muscle* (ho)	on the lateral condyle of the tibia, on the fibula, on the caudal surface of the tibia (ho)	on the distal phalanges of the Ist–Vth digits, on the distal phalanges of the IInd–Vth digits (ho)	flexes the phalangeal joints
m. tibialis caudalis (posterior) 126 *tibialis caudalis muscle* (posterior, ho)	on the caudal surface of the lateral condyle of the tibia, on the fibula, in the middle part of the caudal surface of the tibia (ho)	on the distal phalanges, on the navicular bone, on the Ist and IInd cuneiform bones, on the bases of the IInd–Vth metatarsal bones (ho)	flexes the phalangeal joints and the tarsus, rotates the lateral edge of the foot inward, fixes the foot-dome
m. abductor digiti I. (hallucis) 127 *abductor digiti I. (hallucis) muscle*	on the medial surface of the calcanean tuber (ho), on the plantar surface of the tarsus	on the lateral surface of the Ist digit	abducts the Ist digit
m. adductor digiti I. (hallucis) 128 *adductor digiti I. (hallucis) muscle* (ho)	on the proximal ends of the Ist–IVth metatarsal bones (oblique head), on the medial lateral ligaments of the phalangeal joints (transverse head)	on the proximal phalanx of the Ist digit and on its sesamoids (ho)	adducts the Ist digit
m. flexor digiti I. (hallucis) brevis 129 *flexor digiti I. (hallucis) brevis muscle*	on the plantar surface of the tarsal bones, and on the Ist metatarsal bone	on the proximal phalanx of the Ist digit, and on the sesamoid bones (ho)	flexes the Ist digit

	NAME	ORIGIN	INSERTION	FUNCTION
130	m abductor digiti II. *abductor digiti II. muscle*	on the plantar surface of the tarsus	on the lateral surface of the IInd digit	abducts the IInd digit
131	m. abductor digiti V. *abductor digiti V. muscle*	on the plantar surface of the tarsus, on the lateral and medial surfaces of the calcaneum, and on the navicular bone (ho)	on the lateral surface of the proximal phalanx of the Vth digit	abducts the Vth digit, fixes the foot-dome (ho)
132	m. adductor digiti V. *adductor digiti V. muscle*	on the plantar surface of the tarsus	inserts obliquely on the medial surface of the proximal phalanx of the Vth digit	adducts the Vth digit
133	m. flexor digiti V. brevis *flexor digiti V. brevis muscle*	on the plantar surface of the cuneiform bones, on their ligaments	on the sesamoids of the proximal phalanx	flexes the Vth digit, fixes the foot-dome (ho)
134	mm. flexores digitorum brevis *flexor digitorum brevis muscles* (ho)	on the medial process of the calcaneum, it is embedded in the tendons (below the tarsus) of the superficial flexors	on the middle phalanges of the IInd–IVth digits	flexes the digits
135	m. quadratus plantae *quadratus plantae muscle* (ho)	on the lateral process of the tuberosity of the calcaneum, on the plantar surface	on the tendon of the flexor digitorum longus	stretches the tendon of flexor digitorum longus
136	mm. lumbricales *lumbricalis muscles*	on the two sides of the flexor digitorum longus muscle	on the lateral and dorsal surfaces of the IInd–Vth digits	flexes the proximal phalangeal joint
137	mm. interossei plantares *interosseus plantaris muscles*	on the medial (ho), and the plantar surfaces of the tarsus and of the IInd–Vth metatarsal respectively	on the sesamoids, on the base of the proximal phalanx	flexes the proximal phalangeal joints, adduct the IIIrd–Vth digits
138	m. abductor digiti II. *adductor digit II. muscle* (ho, sus)	on the lateral surface of the tarsus (sus)	on the medial surface of the proximal phalanx of the IInd digit	abducts the IInd digit
138/1	mm. interossei dorsales I.–IV. *interosseus dorsalis I.–IV. muscles* (ho)	on the axial surfaces of the metatarsal bones	on the lateral and medial surfaces of the proximal phalanges	abduct and flex the digits

THE MUSCLES OF THE HEAD

Epicranial muscles

139	m. occipitalis *occipitalis muscle* (ho)	from the upper nuchal line to the root of the mastoid	covers the vertex (ho)	retracts the skin and wrinkles it
140	m. frontalis *frontalis muscle*	on the arch of the eyebrow (ho), on the caudal edge of the orbit (animals)	covers the anterior protrusion of the forehead, and the flat vertex (bo)	wrinkles the skin
140/1	m. procerus *procerus muscle* (ho)	between the two eyebrows	turns to the bridge of the nose	wrinkles the skin of the bridge of the nose

The muscles of the ear

auricularis rostralis (anterior, bo) muscles

141	m. frontoscutularis *frontoscutularis muscle* frontal part parietal part	on the zygomatic process of the frontal bone on the parietal bone	on the scutum of the ear	pulls the ear forward indirectly
142	m. zygomaticoscutularis *zygomaticoscutularis muscle*	on the zygomatic arch	on the scutum of the ear	pulls the ear forward indirectly

	NAME	ORIGIN	INSERTION	FUNCTION
143	m. zygomaticoauricularis *zygomaticoauricularis muscle*	on the zygomatic arch	on the cartilage of the concha	pulls the ear forward indirectly
144	m. scutuloauricularis superficialis et profundi *scutuloauricularis superficialis and profundus muscle*	on the scutum of the ear	on the cartilage of the concha	pulls the ear forward indirectly

The auricularis dorsalis (superior, ho) muscles

	NAME	ORIGIN	INSERTION	FUNCTION
145	m. parietoscutularis *parietoscutularis muscle*	on the median crest between the parietal bones	on the median angle of the scutum	pulls the ear inward
146	m. interscutularis *interscutularis muscle*	on the temporal part of the frontal bone	on the medial angle of the scutum	pulls the scutum inward
147	m. parietoauricularis *parietoauricularis muscle* ·	on the median crest between the parietal bones	on the posterior surface of the conchal cartilage	raises the ear

The retractor muscles of the ear

	NAME	ORIGIN	INSERTION	FUNCTION
148	m. cervicoscutularis *cervicoscutularis muscle*	on the upper occipital line	on the scutum	retracts
149	m. cervicoauricularis superficialis medius et profundus *cervicoauricularis superficialis medius and profundus muscle*	on the occipital region, on the occipital bone	on the laterocaudal surface of the conchal cartilage	retracts outward and backward

The depressor muscles of the ear

	NAME	ORIGIN	INSERTION	FUNCTION
150	m. parotideoauricularis *parotideoauricularis muscle*	on the fascia of the parotid gland	on the conchal cartilage	dilates and shortens the external auditory canal, pulls the ear downward
151	m. styloauricularis *styloauricularis muscle*	on the big ramus of the hyoid bone	on the conchal cartilage	pulls the ear outward and downward
152	m. mandibuloauricularis *mandibuloauricularis muscle* (Ca)	on the dorsal border of the mandibular ramus at the root of the condylar process	on the conchal cartilage	pulls the ear downward

The rotators of the auricular concha

	NAME	ORIGIN	INSERTION	FUNCTION
153	m. rotator auris longus *rotator auris longus (profundus) muscle*	on the inner surface of the scutum	on the base of the concha	rotates the concha forward
154	m. rotator auris brevis *rotator auris brevis (parvus) muscle*	on the outer angle of the scutum	on the base of the concha, opposite its depressor	rotates the concha backward

The outer muscles of the eyelids

	NAME	ORIGIN	INSERTION	FUNCTION
155	m. orbicularis oculi *orbicularis oculi muscle*	at the medial angle of the eye (ho)	at the lateral angle of the eye (ho)	wrinkles the eyebrow, constricts, closes the palpebral fissure
	orbicularis muscle of the orbital edge			
	orbicularis muscle of the palpebral edge			
156	m. depressor supercilii m. corrugator supercilii *depressor (corrugator) supercilii muscle* (ho)	on the nasal part of the frontal bone	at the medial end of the eyebrow	moves the two eyebrows towards each other

NAME	ORIGIN	INSERTION	FUNCTION
156/1 m. levator palpebrae superioris *levator palpebrae superioris muscle*	on the nasal part of the frontal bone	spreads into the upper eyelid	raises the upper eyelid
157 m. levator anguli oculi medialis *levator anguli oculi medialis muscle*	on the deep fascia of the frontal region	on the medial part of the superior eyelid	raises the medial part of the upper eyelid
158 m. retractor anguli oculi lateralis *retractor anguli oculi lateralis muscle* (Car)	on the inferior edge of the orbit	on the lateral part of the lower eyelid	retracts the lateral canthus
159 m. malaris *malaris muscle*	on the deep fascia of the face, in the region of the lacrimal and zygomatic bones	into the lower eyelid	pulls the lower eyelid downward

The muscles of the nose

NAME	ORIGIN	INSERTION	FUNCTION
160 mm. nasales *nasalis muscles* (transverse part (alar part, ho)	on the incisal bone	on the anterior part of the nose it fuses with its contralateral part	constricts the nostril dilates the nostril
160/1 m. dilatator naris apicalis *dilatator naris apicalis muscle*	on the incisal bone, at the apical edge	on the medial nasal wing, on the parietal cartilage	dilates the nostrils
161 m. transversus nasi *transversus nasi muscle*	unites the laminae of the parietal cartilages		dilates the nostrils
162 mm. dorsalis et lateralis nasi *dorsalis and lateralis nasi muscles*			
upper	on the lateral edge of the nasal bone	spreads into the wall of the nasal diverticulum	dilates the nostrils
apical	on the upper parietal cartilage	spreads into the wall of the nasal diverticulum	dilates the nostrils
inferior (caudal) (eq)	on the process of the incisal bone	spreads into the wall of the nasal diverticulum	dilates the nostrils

The muscles of the lips

NAME	ORIGIN	INSERTION	FUNCTION
163 m. orbicularis oris *orbicularis oris muscle*	forms the border of the lips, (ho)		purses the lips and closes the oral orifice
164 m. levator nasolabialis *levator nasolabialis muscle*	on the dorsum of the nose on the forehead	turns to the upper lip and the lateral part of the nostril	raises the upper lip, dilates the nostril
165 m. caninus *canine muscle* (animals)	on the maxilla and behind and below the infraorbital foramen (sus, ca), anterior to the facial crest (eg) below the zygomatic process (Ru)	turns to the nasal wing, and the upper lip	retracts the upper lip, the nasal disc, dilates the nostrils
166 m. levator anguli oris *levator anguli oris muscle* (ho)	in the canine tooth fossa	at the corner of the mouth in the orbicularis oris muscle	raises, retracts the corner of the mouth
167 m. risorius *risorius muscle* (ho)	on the fascia of the masseter muscle	in the corner of the mouth	pulls the corner of the mouth to the side
168 m. levator labii maxillaris (superioris; ho) *levator labii maxillaris muscle maxillary part* (ho)	on the maxilla and the zygomatic bone	in the upper lip	raises the upper lip

	NAME	ORIGIN	INSERTION	FUNCTION
	m. levator labii superioris alaequae nasi	on the root of the nose	on the outer nasal wing	dilates the nostril
168/1	*levator labii superioris muscle nasal part* (ho)	on the lacrimal bone		
169	m. depressor labii maxillaris *depressor labii maxillaris muscle*	on the maxilla	in the upper lip, nasolabial plane, rostral plane	pulls the upper lip, nasolabial and rostral plane downward
170	m. depressor labii mandibularis (inferioris) *depressor labii mandibularis (inferioris) muscle* (ho)	on the anterior edge of the mandibular ramus	turns into the orbicularis muscle of the lower lip	pulls down and retracts the lower lip
170/1	m. depressor anguli oris *depressor anguli oris muscle*	on the mandibular body	at the corner of the mouth, in the lower lip	pulls down and retracts the corner of the mouth
171	m. triangularis *triangularis muscle* (ho), homologous with No. 170/1	on the mandibular body	in the lower lip	pulls down the corner of the mouth
172	m. quadratus labii inferioris (ho) *quadratus labii inferioris muscle* (ho), it is homologous with No. 170	on the lower mandibular border	turns to the corner of the mouth and the lower lip	pulls the lower lip downward
173	m. mentalis *mentalis muscle*	on the anterior surface of the mandible	spreads into the skin of the mental region and the orbicularis muscle of the lips	wrinkles and stretches the skin of the mental region
173/1	m. transversus menti *transversus menti muscle* (ho)	on the anterior surface of the mandible	in the skin at the mental region and the orbicularis muscle of the lips	wrinkles and stretches the skin of the mental region
174	m. zygomaticus *zygomaticus muscle* (major and minor) (ho)	on the fascia of the masseter muscle, on the zygomatic bone and arch, on the scutum (Ca)	turns to the corner of the mouth	retracts the corner of the mouth

The muscles of the throat and buccal regions

	NAME	ORIGIN	INSERTION	FUNCTION
175	m. buccinator *buccinator muscle*	on the maxilla, mandibular body	at the corner of the mouth	constricts the vestibule of the mouth
175/1	m. buccalis *buccalis muscle*	on the masseter muscle, the maxilla and molar part of the mandible	at the corner of the mouth, spreads into the orbicularis oris muscle	pushes food between the teeth
175/2	m. molaris *molaris muscle*	on the muscular process of the mandible, on its alveolar border, and the alveolar border of the maxilla	at the corner of the mouth, spreads into the orbicularis oris muscle	pulls the corner of the mouth to the side
176	m. mylohyoideus *mylohyoideus muscle*	joins the inner surfaces of the opposite mandibular bodies	on the side of the body of the hyoid bone (ho) and on the mandibular crest situated opposite	raises and pulls the hyoid bone forward and pushes it against the hard palate
177	m. transversus mandibulae *transversus mandibulae muscle*	the transverse muscle between the opposite mandibular bodies		

The masticatory muscles

	NAME	ORIGIN	INSERTION	FUNCTION
178	m. masseter *masseter muscle* (superficial, deep)	on the facial crest and the zygomatic arch	on the mandibular angle and the caudal edge of its ramus	adducts and pulls to the side the cheeks, closes the mouth

602

	NAME	ORIGIN	INSERTION	FUNCTION
179	m. temporalis *temporalis muscle*	on the edge and the wall of the temporal fossa	on the muscular process of the mandible	raises the mandible, retracts it, closes the mouth

THE MUSCLES OF THE TAIL

	NAME	ORIGIN	INSERTION	FUNCTION
180	m. coccygeus lateralis *coccygeus lateralis muscle*	on the sacrospinotuberal ligament and on the ischial spine (ca)	on the transverse processes of the first coccygeal vertebrae	the muscle of one side pulls the tail to the side, when the muscles of both sides function simultaneously the tail is pressed to the anus and the vaginal orifice
181	m. sacrocaudalis (coccygeus) *sacrocaudalis muscle*			
181/1	m. sacrocaudalis dorsalis lateralis *sacrocaudalis dorsalis lateralis muscle*	on the transverse processes of the lumbar and sacral vertebrae	on the articular and transverse processes of the coccygeal vertebrae	raises the tail
181/2	m. sacrocaudalis dorsalis medialis *sacrocaudalis dorsalis medialis muscle*	on the spinous and articular processes of the last sacral vertebra	on the spinous and articular processes of the coccygeal vertebrae	raises the tail

ARCHITECTURE & DESIGN LIBRARY

FRENCH COUNTRY

ARCHITECTURE & DESIGN LIBRARY

FRENCH COUNTRY

Barbara Buchholz and Lisa Skolnik

MetroBooks

MetroBooks

ISBN 0-7607-5486-1

Color separations by Bright Arts Singapore Pte. Ltd.
Printed in China by C.S. Graphics Shanghai Co., Ltd.

3 5 7 9 10 8 6 4 2

Contents

INTRODUCTION

8

CHAPTER ONE

THE OUTSIDE VIEW

14

CHAPTER TWO

ROOMS FOR LIVING

36

CHAPTER THREE

THE COMMUNAL KITCHEN

56

CHAPTER FOUR

ROOMS FOR RETREAT

82

INDEX

96

INTRODUCTION

Nothing conjures up the notion of French country style more vividly than the vignettes that have been etched in our memories over the years, gleaned from sources as varied as our travels, foreign films, restaurants, and the works of renowned artists.

Sometimes, just one element is enough to immediately suggest French country design. Picture a pair of handmade white lace curtains that cover multipaned windows through which bright sunlight streams from an azure sky. Or, imagine a Louis XV walnut armchair with hand-carved slats and woven rush seats. An imposing armoire with paneled double doors and intricate carvings covering its richly burnished cherry exterior also conveys a French impression.

In other instances, the effect is carried out by an entire roomful of elements that work together to embody the French country mood. Envision a large country kitchen with colorful tiles hiding crusty stone walls, a long wooden harvest table surrounded by mismatched chairs, an antique cooker adjacent to a working fireplace providing physical warmth, and an array of copper pots suspended from a ceiling rack and gleaming overhead. A living room graced with a magnificent old hearth, worn ceiling beams, and a stone floor can exude an equally classic French ambience, particularly when the upholstery consists of tiny provincial prints.

The best part about French country style is that no single ideal truly defines it. France is the only country in Western Europe that belongs to both the northern and southern portions of the continent, resulting in a wide diversity of design and architectural elements. Each of the provinces, and even many of the towns within a particular province, has its own colloquial style. All these regional characteristics contribute to the common vernacular that has come to be known as French country style.

In Brittany, a northwestern province popular for country getaways, old houses in myriad configurations (from small manors—the two-room dwellings dating from the sixteenth century that first allowed a family and its domestics to have their own spaces—to farmhouses and row houses built to house several families around communal fields) are constructed from indigenous granite and topped with tufted thatch. In Normandy, just northwest of Paris, charming half-timbered structures

OPPOSITE: *The Rhone river flows through the gentle landscape of southeastern France, making it a fertile farming region. Among the region's crops is lavender, which lends its evocative scent to perfume.*

ABOVE: *Much of the charm of French country style lies in the attention to detail that is so typical. Here, potted plants and a window box bring warmth and color to the façade of an ivy-draped home, while sunshine peeks through the lace-curtained second-story window.*

faced with clay and punctuated with steeply sloped roofs prevail. In Alsace, at the far northeastern border of the country, the same materials have been used to produce houses that are heavily ornamented with colorful hues and gingerbread trims, reminiscent of nearby Germany.

To the south, the same kind of diversity reigns supreme. Large whitewashed dwellings with canal-tiled roofs dot the Basque landscape in the western part of the region. These homes were often built three stories tall to house a cart shed on the first floor, the living quarters on the second floor, and a balconied attic, where harvests were stored and clothes were hung to dry in the open air, on the top level.

Provence, perhaps most famous as the standard bearer of the French country style, is located in the southeastern portion of France, and its homes exude a Mediterranean flavor. The exteriors of limestone rubble structures are smoothed down and drenched in earth tones that reflect the cheerful countryside. Produced from oxides in the local sand and rocks, such hues as rose, ocher, wisteria, and sienna adorn the otherwise plain façades and are punctuated by contrasting colors used on the shutters. Over time, the sun bleaches the colors to more subdued tones.

Inside the abodes, local construction styles are equally distinct, for they are highly dependent on the modest materials native to the particular region. Although many of these architectural elements were originally designed primarily with the intention of providing structural support, they also serve as stunning decorative details. For instance, a beamed and trussed ceiling is a breathtaking sight that radiates old-world charm, but such a ceiling was actually designed because it offered the sturdiest and most sensible construction technique. The joists and supports were traditionally crafted of local timber, with many retaining their natural curves since entire trees sometimes were used at one time. The treatment of the timbers varied by region; some were left natural, while others were whitewashed or stained with walnut oil for a richer look.

Fireplaces and hearths, which served as the original center of the home because they were used for heating the household and cooking, also reflect regional differences. Some were built with niches set into the wall to provide extra storage; others had benches off to one side for resting by the fire. The most imposing were built in dressed stone, though most were constructed of simple rubble, which ages gracefully.

Walls were constructed of the same materials as the exterior of a structure. They could be timbered and filled in with lime or mud plaster, or they could be made of brick. Floors often consisted of flagstones or brick in northern France and clay tiles in the South.

LEFT: *The past is ever present at this warm-hued Alsatian farm-house, where a creative gardener has transformed an old well into a unique planter, brimming with colorful blooms.*

TOP: *Plentiful and enduring, limestone was a major building material in the south of France. Here, in the town of St. Jeannet, a doorway dating to 1834 is set into the limestone façade.* ABOVE: *A delightful farmhouse in Normandy features the half-timbered construction and thatched roof that are so typical of this region.*

Just as the architectural components of various regions are distinct, so too are the furnishings, though they bear striking similarities in their general forms and functions. There are a couple of aspects that account for the parallels. First, French country furnishings were made,

primarily, to serve specific needs that people throughout France shared. Thus, the same types of pieces are found throughout all the regions, though these pieces differ in ornamentation.

Second, the styles that slowly seeped into the provinces where working-class people lived came from the same sources—the courts of such design tastemasters as King Louis XIII and King Louis XV (the latter having had the greatest impact on French country design). As styles traveled to the different regions after decades of popularity among the wealthy, they were slightly altered to suit the particular climate, geography, and financial resources.

Thus, a *dressoir* (a buffet topped with rows of shelves) would be decorated in a spare manner if it was made in Auvergne in central France, but would have intricately carved details if it were crafted in Normandy. In Brittany, turned spindle plate guards would embellish shelves, while painted flowers would enhance an Alsatian piece. Beds were totally enclosed by richly carved wooden panels in Brittany, semi-boxed and hung with drapes in Normandy, and made with four short posts, then draped with canopies, in the South.

Further differences in style arose from the preferences of individual craftsmen, how much or how little embellishment they favored, and their degree of skill. In fact, it is the individual interpretations and the odd or eclectic details that worked their way into country pieces, rather than any literal copying of high styles, that give French country furnishings their true charm and charisma.

Today, the French country look is coveted for its casual elegance and originality. Ironically, though, this much beloved style defies the notion of decorating as we know it, since it evolved, for the most part, from working-class roots. Many individual pieces may be quite magnificent and grand, but these were often commissioned for special occasions, such as weddings, where specific pieces were given as part of a dowry. Granted, as the population living in the countryside became more affluent in the nineteenth cenury, more pieces were made and the trappings of decor, such as wall and floor treaments, became more

ABOVE: *Roofs of terra-cotta tiles characterize the venerable dwellings found in the oldest section of this quintessential Provençal town.*

refined. But this is a style that evolved from the realities of country life, and as such does not need to be strictly confined.

Thus, bringing the French country style into our homes does not require a perfect duplication of the elements, for there were few, if any, hard and fast rules to begin with. Furthermore, every single element need not be ostensibly French country. An individual piece—be it a distinguished French armoire or simple harvest table—can work beautifully with furnishings from other countries as well as with traditions that are older or more modern.

In the following pages, we will examine the individual components and rooms that best define the French country style, as well as the exteriors and their settings. Each of these aspects has the almost magical power to create a mood that unmistakably spells *la belle France.*

THE OUTSIDE VIEW

Throughout France, the homes and landscaping reflect the geography, climate, and natural resources of the province in which they are situated. Hence, the regional, or vernacular, designs that have emerged over time are as distinct in France as they are in the United States, where narrow townhouses rise vertically in the urban centers of the Northeast to compensate for the scarcity of land and where mansions with immense porches proliferate in the deep reaches of the South.

In rural areas of Normandy, where wood has traditionally been plentiful, timber-framed buildings are commonplace. In Brittany, modest farmers would construct thatched or stone houses, which they shared with family members and animals. Wooden chalets with sloping roofs were designed to protect occupants and the structures themselves from heavy rains in the mountainous Alps. And in Provence, inhabited long ago by Romans, clay tile roofs in different hues have dotted the landscape for centuries.

At the same time, similarities have abounded and continue to be present. Throughout France, in both cities and the countryside, home-owners share a deep love for their abodes and pay great attention to the choice of architectural details, such as the windows, doors, and trim, as well as to the colors used to enhance the façades. They eagerly call upon their own skills or those of their area's craftspeople—the thatcher, brick maker, stone mason, carpenter, and gardener—to make the exteriors of their homes as enticing as the interiors.

OPPOSITE: *The rough-cut stone street and the half-timbered home with a brick foundation are typical of Normandy, where the wooded countryside traditionally offered a rich source of timber for construction. Sometimes the timbers were laid in a diagonal display to show the craftsperson's skill and artistic bent. Thatched roofs, once common, gave way to slate in the nineteenth century, as slate was sturdier, more fire-resistant, and provided a more dignified demeanor.*

LEFT: *French country cottages often put on a painted face. Their owners either completely cover the surface of the structure with pigment, or simply focus on the building's prominent architectural elements, making them even more eye-catching by painting them in bright hues. Here, cream-colored limestone bricks are left in their natural state, but the characteristic Mediterranean windows and doors, which tend to be narrow, deep, and flanked by slat-board shutters, are painted a clean sky blue. Red and pink flowers, lush foliage, and lace curtains are additional characteristically French elements.*

RIGHT: *In Nice, homes are painted brilliant colors with pigments made from local rocks. The paints not only dazzle the eyes, but waterproof the exteriors as well. With deep crimson walls and turquoise blue louvered wooden doors, this home is a vivid example. The white frames around the doors and the lacy wrought-iron detailing, which has a Spanish feeling, make the crimson and blue even more prominent. With time and sunlight, the bright colors will weather to a softer palette.*

OPPOSITE: *There are many ways in which the French introduce a welcoming feeling to the home. In this case, the feat is accomplished by trellised plants climbing along the window-framed front door, two pots housing rose bushes that add color and fragrance, and foliage that softens the brick walkway. But the handmade lace curtains, known as* dentelle, *make the strongest statement by inviting onlookers to behold the home within, rather than by shielding it from view.*

RIGHT: *Gargoyles such as this can be seen on churches in the French countryside, as well as on some grand country homes that sport Gothic styling. Although they appear to be nothing more than fanciful embellishments, gargoyles were actually designed to serve as practical drainage spouts. These fantastic figures were thought to embody fallen angels who were being given a second chance to redeem themselves by guarding buildings. The action of water rushing through their spouts was said to wash away evil.*

RIGHT: *Stone houses dating back centuries are found in the celebrated wine-producing area of Bordeaux. Here, a stately home rests atop the hill, its unadorned façade emphasizing its simple grandeur. Nestled into the hillside below is a smaller cottage-style residence, graced with exuberant foliage and vines. Adding a sense of warm welcome is a planter bursting with colorful blooms set upon the wrought-iron balcony.*

LEFT: *Already flanked by old white shutters and luxurious leafy vines, the windows in this master's house, or* maison de maître, *are given an additional decorative boost by window boxes filled with vibrant bougainvillea. A skillful use of dark and light materials provides soft contrast between the roof, graced with tiny dormers, and the commanding stonework.*

RIGHT: *Located in a small village, this stone house was built close to its neighbors, a tradition that developed partly because of space constraints and also for security reasons. Stone was always favored over timber when available, and the irregular sizes and shapes—no two stones alike—lend an air of individuality.*

OPPOSITE: *Breton blue, a favorite color in Brittany because of the area's many boating and fishing activities, is used on the shutters, window trim, front door, and wooden gate of this home. Only a side door boasts a deep brick red. Both hues enhance the exterior by enlivening the whitewashed façade.*

Getting away from the big city and finding refuge in the country is just as much a French phenomenon as it is an American one, and the choice of weekend abodes takes many forms. For example, a tiny half-timbered Alsatian house (RIGHT) set deep in the woods offers the desired change of pace with its sloping roofline and the privacy provided by its massive stone walls set with relatively few small windows. Another family's preferred getaway is a small stone cottage in Auvergne (BELOW). Quaint dormered windows, stones bearing different hues, and a secluded location create the appeal of this retreat.

ABOVE: *Espaliers have long been a popular gardening device, creating wonderful decorative effects within a fairly small amount of space. From a central vertical stem attached to the wall of a house, branches are trained to grow sideways in tidy rows. Sometimes, the branches yield apples and pears, other times fragrant flowers. Here, an espalier growing against the side wall of a brick home fans out its greenery and red bouquets of color.*

ABOVE: *Whether stopping for a drink at a Parisian café or relaxing at a country home, the French favor taking their meals outdoors, capturing the best view for enjoyment. Here is proof that they know how to set as elegant a table in the fresh outdoors as they do within their homes. All they need are favorite candlesticks, white china, simple crystal, and light-toned linens. Bon appetit.*

ABOVE: *Though the walls were constructed from rough stone, which has been washed with a pale yellow hue, and the door was made of crude wood, the owners of this barn still felt it important to leave a personal touch by carving a tiny heart in one door panel and fronting it with an exuberant garden of tulips and lilacs.*

RIGHT: *Grapes are an important crop in France, and the process of producing wine is a time-consuming labor. In spring new vines are planted; in summer they are tended; and in autumn the grapes are picked, crushed, and fermented. Just as no two grapes are alike, neither are two "high houses," or* maisons en hauteur, *prevalent in the provinces where wine is made. These centuries-old structures were designed to have the upstairs serve as living quarters, while the ground level would serve as a wine store. Originally a Mediterranean innovation, the style quickly caught on in Burgundy, Provence, and Languedoc.*

RIGHT: *In Provence, a palette of warm, earthy hues made from the oxides in the local sand are used to embellish the homes. Shutters and trims are often painted in contrasting colors, and the overall effect is both picture-pretty and quite polished despite the simplicity of the structures. Here is a perfect example of the magic wrought by this practice: with just a piece of faience and a simple lace shawl, a cottage in Provence looks elegantly turned out thanks to its already exquisite façade.*

Multipaned windows that extend down to the
floor but are used like doors to gain access
to or exit from a room are known as French
windows and can be dressed up or down to suit
a residence. The windows on a countryside
chateau in France (ABOVE) sport louvered doors,
while those on a limestone farmhouse (RIGHT) are
framed with rustic slat shutters. In either case,
flowers add a great deal of charm to the façade.

LEFT AND ABOVE: *Many farmhouses in the provinces were built of limestone rubble, with granite framing stones and simple wood plank shutters and doors. Such drab materials left residences looking quite somber, a situation easily remedied in summer months with foliage. With the addition of simple boxes filled with flowers, these two farmhouses in Auvergne go from pallid to picturesque.*

LEFT: *Renaissance-style carvings are found on manors and religious monuments throughout lower Brittany, where granite was frequently used to build homes. Here the moldings and jambs are still perfectly intact on a sixteenth-century Breton manor, framing a massive oak door that was the standard of the day (it was supplanted by framed versions in the seventeenth century). While the dusty red hue seems like an authentic touch, the door was a rich honey color when it was first built and was repainted to suit twentieth-century taste.*

LEFT, TOP: *In Normandy, windows boasting two rows of small panes typically appear in pairs with a structural post dividing them. Thanks to such detailing, they are charming in their own right. In this half-timbered house, the windows need no further adornment than a mass of red flowers.*

LEFT, BOTTOM: *With its swirling lines and heart-shaped designs, this wrought-iron gate creates a welcoming entrance filled with old-fashioned charm. A delicate praying angel offers a sense of reassurance, as she seems to keep watch over those within the farmhouse. Further evidence of hospitality is seen in the house number, which has been lovingly stenciled in blue and white to stand out against the gray stone and hence can be seen easily by visitors.*

RIGHT: *Home sweet home. At the end of a long gravel driveway lined with shade-providing trees, the sight of home—in this case a turreted château, the French equivalent of a large country home—is a welcome visage.*

ROOMS FOR LIVING

While the archetypal French country living room of today is a charming space outfitted with all the right trappings, it is actually a rather recent innovation. Until the nineteenth century, many French living quarters (save for the communal abodes that sheltered multigenerational families in parts of southern and eastern France) consisted of only one or two rooms.

The one room that these homes were sure to have was the *salle*, which served as a sort of kitchen-cum–living room. All the activities of a household—from cooking and eating to gathering around the fire and sleeping—took place in the *salle*. If a home was divided into two rooms, the second was a sparsely furnished bedroom, or *chambre*, which was often located to the side of the *salle* or under the eaves of the attic.

Yet despite the limited number of rooms, many newly restored cottages and farmhouses in France sport stunning living rooms, loaded with architectural details and striking pieces of furniture that reflect the provincial style. So where did these special spaces come from?

Most were once living quarters for the family livestock. Households kept their valuable animals on the ground floors of their homes and lived either above them or off to one end of the structure. As animals were slowly evicted from these spaces, the rooms underwent a series of upgrades until they ended up as the sort of living rooms we

know today. Other living rooms (especially those with hearths) originated as *salles* and were converted to their present incarnations when a contemporary kitchen was added on to the home.

The architectural elements of these rooms—beamed ceilings, timbered fittings, and stone floors—have been somewhat refurbished to ensure structural safety but have been left primarily intact to retain their rustic charm. Massive limestone hearths, which were often hidden behind newer walls as cottages were modernized over the years, have been unearthed, restored, and enhanced with every sort of fireplace accessory. Although these spacious rooms are not always filled

OPPOSITE: *There is no need to sacrifice high style in the French countryside. Here, simple pieces are paired together for a country version of Empire styling, exuding the same sort of symmetrical balance and glamour found in that type of decor. But the vignette also retains an aura of earthiness thanks to the cunning way in which design elements of the Empire period, such as gilt trim and yellow walls, have been manipulated; gilt is seen here only in small doses (on the mirror, the pulls of the commode, and the rims of the topiary pots), and the walls are mellow instead of bold.*

with strictly provincial furnishings, they certainly include enough of these kinds of pieces to create a French country ambience.

Achieving this look in a contemporary room can be as simple as incorporating a massive provincial armoire, some lace curtains, or a few Louis XV–inspired banquettes into the decor. Or, the architectural bones of a room can be manipulated to create the desired mood. Installing a French country–style beamed ceiling, a large stone hearth with copper accessories, or a tiled floor will do the trick. Regardless of which route is chosen, the result will be the same: the room will be imbued with classic French country charm.

BELOW: *Like a crusty old cauldron brimming with all sorts of tasty ingredients, this antiquated space is filled with a wide range of appealing pieces. Shapely and light, these pieces cast their sunny dispositions upon the room, preventing the massive dark Gothic architecture from making the space seem archaic. A blue fleur-de-lis pattern stenciled on the chalk white walls, along with checkered upholstery in the same shades, provides a cheery counterpoint to the dank-looking limestone cornices and hearth and gives the space its French country spark.*

ABOVE: *Since a hearth is the heart of many a French home, clever decorating devices were enlisted to suggest a fireplace in this country living room. Now a stylized version, complete with a faux mantel created by cornice molding, is the focal point of the space. But it is actually the matched pair of classic eighteenth-century settees, complete with rush seats, that gives the room its French country aura. Pillows and curtains made out of traditional Provençal fabrics (patterned after the printed cottons originally imported to France from India in the seventeenth century) and a Kashmir shawl covering the coffee table further imbue the room with unusual authenticity.*

OPPOSITE: *Since hearths are such an important and beautiful part of regional style in France, country kitchens are often turned into living rooms when homes are rehabbed. Here, a typical fireplace in Brittany, which was clearly once the functional center of a kitchen, has become the dramatic focal point of a sitting room. The hearth is surrounded by a hodgepodge of local pieces collected by the homeowners, and it is warmed up with a new floor that boasts a traditional pattern, covering the cold antiquated flagstones underneath.*

ABOVE: *A once humble country space becomes a bit more highbrow by playing on its natural attributes. The imposing open fireplace, edged with dressed stones, used to be the center of the original kitchen before the space was transformed into a living room. Now surrounded by pieces that have a polished country appeal, such as a posh winged chair, a sumptuous sofa, and a gleaming ladder-back chair, the fireplace takes on an air of grandeur.*

LEFT: *A cavernous living room in an old country home in France becomes downright cozy thanks to an array of French antiques that come from a variety of periods. An ornate eighteenth-century marble mantel and a gilt mirror anchor the room while helping to cut the ceiling height down to size. Meanwhile, a whimsical play on symmetry draws the eye toward such fabulous matching decorative elements as the torchères, sconces, Deco chairs, and pieces of pottery, thereby diverting attention away from the excess of space and rendering the setting more intimate.*

RIGHT: *Do not be deceived by the apparent simplicity of a country tableau. Here, the chalky white tones of a coarse plaster wall and rugged hearth are enriched by a seemingly casual, but actually carefully planned, arrangement of accents in rich hues of blue. The accessories, which include refined pieces of Chinoiserie pottery, rustic seascapes, and a modest wood chair, strike just the right balance to give the setting a polished but still provincial appeal.*

RIGHT: *A mantel in a modest French country cottage goes from mundane to magnificent when it is used as a topiary form. The gilt-edged mirror and matching urns add a touch of glamour to the setting, balancing the earthy ambience prompted by the foliage and lending an air of elegance to the funky approach.*

LEFT: *An innovative use of pattern is responsible for the casual yet cosmopolitan elegance of this living room in the South of France. While the scheme appears at first glance to be quite bold and forthright, it actually demonstrates subtle variations, for there are different types of stripes on the sofa, chairs, and walls. As these elements play off one another, they create the illusion of cohesiveness.*

ABOVE: *Although this living room in a French country home sports all the touches of a formal decor, the features have been relaxed a bit to fit the locale. The damask sofa is overstuffed enough to be comfortably casual, while a typical Provençal cotton print makes a stately Louis XV bergère seem less intimidating and far more inviting. A traditional soft yellow hue warms up the entire space.*

ABOVE: *Provincial furnishings were made by anonymous craftsmen in every region of France, often reflecting the distinctive styles of their period. But precise dating is difficult because some forms, such as the domed cherry Louis XV armoire in this sitting room, were popular and continued to be made in the provinces long after the specific style fell out of favor in Parisian workrooms. As this cabinet clearly shows, a piece of this scale can have a major impact on an entire room.*

RIGHT: *The adventurous use of color can make a traditional space seem far more engaging. Here, deep azure, the shade of the sky right after sunset, gives a sense of drama to what is for the most part a fairly traditional country room. Another novel touch is the mixing of contemporary pieces with such French provincial elements as classic ladder-back armchairs, Empire fauteuil, and a Regency corner cabinet.*

RIGHT: *Sometimes, just one powerful detail can imbue a room with a specific flavor. These vibrant curtains made of a hand-blocked Provençal cotton give a huge dose of French country styling to a plain window in a city apartment. Coupled with a simple metal window box filled with flowers of a similar hue, the curtains help to create a vignette that is far more dynamic than the individual components.*

Regardless of pedigree, when similar objects are
gathered together en masse, the sum is greater
than the parts. Here, two tableaux from French
country homes—one created from ordinary vases
filled with freshly cut flowers (LEFT) and the
other from antique decanters and a tea caddy
(ABOVE)—illustrate the point. Despite the fact
that they are in the midst of rustic surroundings,
these vignettes demonstrate the chic savoir faire
for which the French are renowned. Both settings
are bathed in sunny yellow, a color that not only
has a history of tradition in the French country-
side, but can add warmth and depth to any style
of room.

RIGHT: *The nooks and crannies of this secretary have been mined to display a charming collection of Limoges boxes, plus a few larger pieces of traditional tole. While these classics are right at home on the Louis XVI piece, virtually any antique desk or cabinet can acquire a French country tone when accessorized with provincial collectibles.*

LEFT: *Formal French furnishings can be equally at home in the countryside. Here, a Louis XV sofa, covered with pillows inspired by Aubusson tapestries, anchors a distinctly Victorian living room in a country home. The piece works well with the eclectic elements of the room, which range from floridly romantic statues of angels to Gothic Revival lamps.*

ABOVE: *Reproduction fabrics and furnishings can be used to evoke a French country feeling. The flowery print of this chintz was inspired by the prints of Provence, while the detailing of the carved armoire takes its cues from the provincial pieces of the eighteenth century.*

The trappings of grand country living, such as intricate wall treatments, elaborate hearths, and beautiful wood and stone floors, take center stage in these living rooms in the French countryside. Although one room (RIGHT) is purely Louis XV and the other (ABOVE) is a romantic milieu that borrows from many periods, both spaces contain fine examples of French antiques. But thanks to the comfortably lived-in looks of the furnishings and the obvious signs of wear and tear on the hearths, the rooms also radiate rustic spirit. Like elegant outfits that should be worn instead of stored away in a closet, lavish spaces seem far less pretentious when they are used every day.

THE COMMUNAL KITCHEN

Throughout French history, good food and drink have been raised to the level of art, which is why the kitchen has been not only a place to prepare meals, but a forerunner of today's heart-of-the-home room. Here, food is prepared, meals are savored, and people join together for sustenance of both the spirit and stomach.

Because the communal kitchen has traditionally served all these functions—and still does today—it has needed to include areas for cooking and cleaning as well as for eating and gathering. Whether these spaces remain distinct or are melded together depends to a large degree on the room's square footage.

Stylistically, there is great latitude in the choice of materials, colors, and design styles. However, the architecture of the home, the furnishings used in other rooms, and the age-old traditions passed down through the various provinces provide the greatest incentive for one kitchen to take on the charm of a Brittany farmhouse and another the splendor of a Loire Valley château.

Several features appear more frequently and have become almost trademarks of the French communal kitchen. A working fireplace was originally an essential because it provided the home's main source of heat. Today, many homes still have a large hearth—sometimes functional, sometimes decorative—as well as a mantel and walk-in—size alcove.

Generous storage is also characteristic of the French country kitchen. Pieces range from richly carved *dressoirs, vaisseliers* (cabinets or dressers with shelves), *buffets-bas* (waist-high cupboards used as sideboards), *panetières* (intricately shaped and carved cupboards for storing bread), and armoires down to simple slabs for shelves and unadorned cabinets. Some owners prefer to keep everything within view; others like to conceal the contents.

A large table and comfortable seating are critical elements for eating and lingering in the communal kitchen. The most common setup consists of an unadorned rectangular wooden farmhouse-style table surrounded by rush-bottomed ladder-back chairs, appearing sometimes in an assortment of styles.

OPPOSITE: *Knowing the superb culinary skills of the French, it is easy to understand why they have tradtionally coveted copper pots. Most households had collections of such cookware, which would be hung on racks because storage space was minimal. Arrayed in this manner, the pots were out of the way yet always within reach.*

Rustic earthy materials—the most popular being brick, wood, stone, and terra-cotta—are used in a variety of shapes and sizes to line kitchen walls, floors, and countertops. These elements offer age-old elegance as well as practicality.

And last but not least, pot racks (known as *crémaillères*) are integral components of the communal kitchen, having had a long and fruitful history in the French countryside. Along with the requisite copper pots that dangle from them, these highly practical elements also make beautiful, gleaming decorative accessories.

R I G H T : *This contemporary kitchen pays clever and indisputable homage to French country styling. The hard-wearing black-and-white tile floor, laid in a bold diamond pattern, is linoleum instead of clay, and the requisite baker's rack has been replaced by high-tech stainless steel industrial shelves to provide open storage. But the most prized elements of the French country kitchen remain perfectly intact, such as pots suspended from the ceiling and burnished walls rubbed with an earthy-colored hue.*

RIGHT: *A kitchen emanating a French country feeling does not necessarily have to sport anything specifically French in style. Here, a British Aga cooker, which heats food as well as the home's water system, serves as an anchor. Displays of pots and dried flowers lend a true country feeling to the space. But the ornately patterned tiles used in the backsplash, along with a set of intricately embellished chairs caned in colored stripes, give the kitchen the kind of panache that says French country.*

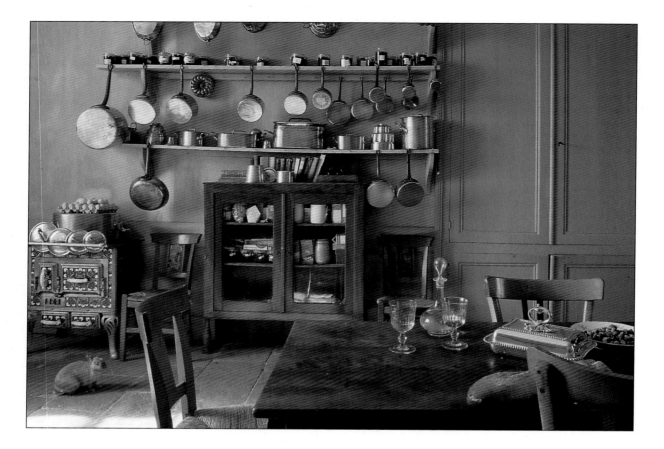

ABOVE: *Prized copper pots hang like medals on a wall in this French country kitchen, which boasts an elegant hodgepodge of furnishings achieved through years of tasteful, and heartfelt, accumulating. The wood pieces warm up the flagstone floor and contrast with the intricately enameled cast-iron wood-burning stove traditionally used for warming winter soups and stews. Note the elegant glasses and decanter on the table, which show that entertaining is one of the many activities that take place in this multifaceted room.*

OPPOSITE: *Thanks to similarities in shape, scale, and condition, a medley of ruggedly disparate pieces creates sweet harmony in the eating area of this French country kitchen. The armoire and decorative door bear characteristics of different provinces but are unified by their height, while the traditional slat-style garden chairs and a walnut dining table are equally overscale. All the pieces in the room display bold angles and possess the same raw-boned feeling brought on by years of beloved use.*

RIGHT: *Even breakfast takes on a festive mood in a kitchen where the dichotomy between fancy and plain is palpable. The antique table and characteristically mismatched chairs are simple in style and made of the most basic wood. Nonetheless, silver and pressed linen napkins adorn the table, giving the room a slightly dressy air. More favorite platters, pitchers, bowls, and cups are displayed on the shelves above the built-in buffet.*

ABOVE: *Cooking and entertaining are frequent rather than novel events among most French families, which explains why their kitchens are often designed with row upon row of open shelving laden with bowls, platters, casserole dishes, and other culinary necessities. While practical, the contents also make for an attractive display. In this kitchen, where preparations for a party are under way, everything is within arm's reach, including pitchers, canisters, and some wooden spoons, forks, and a rolling pin crammed into an old jar.*

LEFT: *Used as a crucial ingredient in many dishes and imbibed during family and company meals, wine is just as integral a part of the French country kitchen as are appliances, cookware, food, and utensils. In the corner of such a kitchen, far enough from the sources of heat so that the contents are not endangered, sits a simple, painted-blue farmhouse rack that houses the family's stash. The bottles have been lovingly collected through the years and gingerly laid on their sides to age.*

RIGHT: *In this inviting kitchen, ceramic tiles sporting a shade of blue that is reminiscent of the Mediterranean on a sunny day line the backsplash, create an easy-to-clean resting spot for food and utensils, and adorn the hood of the stove. Other characteristically French country elements include a pot rack with heavy copper pots and saucepans, handcrafted wooden cabinetry, a framed fruit print, an old hanging lamp, and a cherished white porcelain stove that has been in the family for decades.*

LEFT: *Kitchens are for relaxing as well as for eating and cooking. In this large multipurpose kitchen, a small recess in the stone wall proved the perfect place for a banquette. Upholstered in a geometric blue-and-white fabric, the piece echoes the collection of faience above. The white metal bread box, a modern twist on the traditional wood* panetière *carved to store bread, was included more as a whimsical decorative touch than as a practical place for safekeeping fresh baguettes.*

BELOW: *In the spirit of a typical French country kitchen, this space includes a variety of materials, styles, and proportions that combine to create an eclectic whole, causing the room to appear as though it evolved through the years. Moreover, various specific elements of French country styling have been integrated into the cabinetry: the center island manifests deep carving typical of Normandy, and the spindled plate guards on the corner unit are taken from the* dressoirs *of Brittany. The cabinetry, beams, floorboards, table, chairs, and stools bring in a wide range of woods, while the green marble on the island acts as an elegant contemporary foil.*

OPPOSITE: *Traditional furnishings that would look just as proper in a living room or dining room are used in French country kitchens to add dignity as well as to provide practical services. Here, a long pine buffet with drawers and a bottom shelf adds charm while housing cookbooks. The piece mixes well with a walnut china rack that displays a favorite collection of faience and Chinese-inspired dessert plates and cups. Baskets for plants and bread contribute to the casual ambience, as does the border paper, which boasts a simple cornucopia motif.*

LEFT: *Aside from the pot rack, nothing epitomizes quintessential French style like the baker's rack, which is used for storage and display. Here, a baker's rack made of wrought iron and brass shows off an eclectic collection of objets d'art, plants, and wine in a kitchen that has been handsomely papered in two distinct fabrics sharing the common denominator of a blue-and-white color scheme. Both designs—large checks and a toile de Jouy—are equally representative of French country style and are never passé.*

BELOW: *In this corner of a French country kitchen, French ladder-back armchairs with rush seats are grouped around a plain wood table that has been dressed up with a handsome white linen cloth. A fireplace graced by a wooden mantel, as well as a cloth frill twisted across the opening to give the chimney draw and prevent soot from darkening the wall, offers visual warmth while the fire within provides comfort on cold winter days. A nearby built-in floor-to-ceiling cabinet stores dishes and other items for table settings.*

ABOVE: *An attractive still life with a French country flavor can be fashioned from such simple elements as a big bouquet of fresh flowers placed in front of bottles of oil, vinegar, and flavored liqueurs. And the best part of the arrangement is that it can change frequently, bringing something new to the kitchen on a regular basis.*

RIGHT: *An imposing eighteenth-century walnut* vaisselier *from Brittany features the province's classic spindled plate guards. With its deep red painted back, the piece provides a dramatic resting spot for a collection of different Limoges china dinner plates. Adding more personality to the scene are a large glass vase of fresh flowers and a generous soup tureen, the latter of which is also from Limoges.*

BELOW: *This ceiling, with its joists supported by and embedded in the tops of the beams, is so characteristic of the French farmhouse that the style is referred to as à la française. Although the rest of the kitchen is not specifically French, the ceiling sets an overwhelmingly French tone. Herbs dangling from old recycled beams at the tops of some of the windows contribute to this feeling, as does the selection of rustic materials, including the brick used to face the cabinet that houses a cooktop and oven.*

ABOVE: *An important part of life in the French countryside has been drying herbs and flowers, a craft that is still being practiced today in this kitchen. Together with collections of kitchen utensils and various odds and ends, the dried herbs and flowers make the space come alive in a crowded yet appealing way. Small wrought-iron skillets, old knives, and other kitchen bric-a-brac adorn the brick wall beside the now purely decorative fireplace, which is currently home to some brass and copper tea kettles. Heavy ceramic jugs, once filled with wine but now only ornamental, rest peacefully on the floor.*

BELOW: *The spirit of this eat-in kitchen resonates with an American country feeling on account of its wooden walls, flooring, and door, along with its simple painted furnishings. However, the space does boast some distinctly French touches, including a large tin pail filled with dried flowers and the mixing of pieces of furniture painted in different hues.*

ABOVE: *An old stone farmhouse kitchen with a restored open timbered ceiling has been modernized for a family that likes to cook, though the room still retains its country feeling. The roof has been opened with skylights; a two-level center island was constructed to offer distinct spaces for cooking and cleaning; and a wooden table and chair have been added to provide another place for labor-intensive cooking chores. Irregularly shaped flagstones line the floor, helping to visually unify the kitchen's many textures, materials, and subtle wood tones.*

RIGHT: *In a small landscaped courtyard off a kitchen, a former butcher's table has been topped by festive blue-and-white tiles, transforming it into a place to enjoy a game of dominoes and some wine on a pleasant afternoon. The Breton blue color scheme is carried through in the painted chair (brought outdoors from the kitchen) and lovely cut crystal goblets that seem almost too good to be used outdoors.*

RIGHT: *Touches of French country styling permeate this kitchen, which has a decidedly dressy instead of typically casual demeanor. The Provençal-inspired tablecloth has been deepened for a richer look; the white country lace curtains have been gussied up with shirring; and the traditional pot rack has been relegated to an out-of-the-way alcove.*

BELOW: *In this quaint kitchen, pale pine faces all the cabinetry, which is enhanced by both delicately patterned and solid blues. Square blue-and-white tiles in two patterns line the backsplash, echoing the collection of plates that accent the area above the windows. Further splashes of blue include the painted window casements and chairs. Even the hand towel boasts a blue-and-white Provençal design.*

ABOVE: *As in many French kitchens, the china—or at least a large portion of it—is perpetually on display. The almost all white background of this room adds a crisp freshness and timeless appeal, also typical of Scandinavian design.*

LEFT: *Rows of hardworking copper cookware and a long trestle table make this French country kitchen appropriate for a large family that entertains frequently. But it is the beamed ceiling that gives the space its authenticity. Other rustic elements, such as the fireplace and the stone floor, inspired the owners to refrain from painting over the wall's rough stucco finish. Adjacent to the double range is an old stone country sink, which is useful for filling pots.*

RIGHT, TOP: *A limestone-and-tile sink, decked in traditional blue and white, was the inspiration for the striking blue shade of paint used on these walls. A built-in wall cupboard, set off from the rest of the room with a deeper hue, provides space-efficient storage in the small kitchen, which receives natural light from a small dormer window.*

RIGHT, BOTTOM: *A fancy Louis XVI–style armchair brings an elegant touch to the casual blue-and-white cotton skirted table at one end of a small kitchen. The painted blue window frame adds more color and eliminates the need for curtains so that the lush landscape outdoors is always in view.*

ABOVE: *The old-style French kitchen frequently becomes a beehive of activity, as evidenced by this room. Atop the tiled counter, fresh greenery is readied for use in a centerpiece; a lower counter is covered with fresh vegetables that will be made into a salad; and the ledge above the stove is crammed end-to-end with jars of preserves and pickled vegetables. Copper cookware decorates the walls, while blue-and-white pottery and tiles provide refreshing color. The recycled wooden gate, a charming reminder of the home's farmhouse origins, leads into the living room beyond.*

RIGHT: *The eating area in this French country cottage kitchen demonstrates the wonders of the simpler things in life. A bouquet of colorful garden flowers in an old tub, a rustic wooden plank table that coordinates beautifully with the kitchen walls, and fetching painted-blue chairs that add a welcome splash of color create a wonderful spot for a* tête-à-tête *that is just as appealing as a much grander setting. An assortment of old stainless steel utensils hanging on the wall brings additional panache to the setup.*

BELOW: *Large cast-iron cookers, now defunct, anchor this simply furnished room, the windows of which were deliberately left uncurtained to contribute to the no-nonsense ambience. Above the cooking area, an assortment of tiles is configured to resemble a piece of artwork. These tiles, along with similar ones lining the dado and big copper pots and earthenware casually arranged on shelves and against walls, are the prime sources of color in the decor. Simple ladder-back chairs and an absolutely plain rectangular wooden table occupy the center of the space, creating a good work surface as well as a fine place to dine.*

BELOW: *Tall topiary bushes stand guard at the end of a dining table in a kitchen that is classically French and casually chic with its stone arch, overhead beams, and pine table and ladder-back chairs. Distinguishing the host from the rest of the diners, a tapestry-covered wing chair is positioned at the head of the table, where it adds an air of importance. A simple armoire with a nonetheless commanding presence stands tall and proud nearby, making dining essentials easily accessible.*

BELOW: *A decrepit old clock in the room shown at left is transformed into an attention grabber. Framed with a hand-painted border and topped with a slew of dried roses, it becomes an architectural element.*

ABOVE: *In this modest home, the kitchen was designed to look like and function as a space meant more for romantic old-world entertaining than cooking. The walls of the room were painted to resemble paneling, with the insets a subtle blue-gray, ringed by the palest taupe and an antique gold. Blending in harmoniously with the color scheme, terra-cotta tiles line the floor and mirror the color of the painted ceiling. Even the accessories reflect old-world styling, including a painted Louis XV chair, an elegant lace tablecloth, and dried flowers turned upside down to fill a former hood.*

ROOMS FOR RETREAT

Bedrooms, at least as we now know them, were rarely found before the nineteenth century in the French countryside, where the habit of sleeping by the fire in the *salle* was widespread. Any bedrooms that did exist were used to house the girls of a family, and such spaces were sparsely furnished with merely a bed or two and a simple wardrobe.

Loft-style sleeping alcoves under the rafters were more common for those not sleeping by the fire. Eventually, many of these were adapted to become entire rooms. This evolution led to the quintessential French country bedroom tucked away under the pitched beamed ceilings of a provincial cottage.

Since the bedroom (if a household was wealthy enough to have one) was a communal space, provincial beds were constructed so as to provide privacy as well as warmth. Many were draped with hangings so the occupants could dress without being seen. These textiles also performed the helpful duties of keeping out dust, dirt, bugs, and cold air.

As the wealth of a household increased, so too did the beauty of its beds. Most were at least four feet (122cm) wide, designed to accommodate two occupants. The beds had thick mattresses made of straw or, in wealthier homes, feathers, and they were topped with large feather quilts and homemade sheets and blankets. Because they were usually placed against a wall or in an alcove, they were heavily carved on one side and plainly finished on the other.

Different types of beds became popular in different regions of France. High box beds *(lits-clos)*, totally enclosed by wooden panels that were often richly carved and colorfully painted, were prominent in Brittany, Normandy, Auvergne, and parts of the Alps. (In the Alps, sheep slept underneath them, serving as bedwarmers.)

Beds with canopies attached to the bedposts or suspended from the ceilings, running the gamut from full overhangs to half-testers, prevailed throughout all the provinces but reflected regional differences. Angel beds *(lits d'ange)* with four short posts, a plain headboard, no footboard, and half-testers were commonplace in the South, as were *litoches* (the same bed sans the hangings). Elegantly draped beds with full canopies totally concealing the mattress were referred to as *à la duchesse* and could often be found in the North, where the colder climate dictated a more enclosed space.

OPPOSITE: *Despite the fact that these furnishings are pure Louis XV, they look right at home in this French country residence. Though once formal and grand, they now radiate a faded glory that comes from years, perhaps generations, of use. The aura of warmth and comfort is further evoked by the slightly decayed trompe l'oeil paint finishes on the headboard and nightstand and the faded Aubusson-inspired fabrics.*

Creating a French country bedroom today is often as simple as outfitting a room with an ornate bed topped with a canopy of some configuration or a simple bed covered with a traditional provincial textile, such as a *boutis* (an intricately quilted, brightly colored coverlet of Provençal design) or a hand-worked white lace spread. Add a wardrobe, be it simple or elaborate, a coffer, and perhaps a few comfortable country chairs, and *voilà*—the French country bedroom is reborn.

BELOW: *Heavy snow white linens alter the look of this bedroom in a French country home. The dark* lit en bateau *goes from simple to stunning thanks to the pristine spread, while curtains transform the area around the bed into an intimate alcove. A delicate row of lace trim on the bottom of the drapes along with satin cording and tassels keep the textiles from seeming too austere. Meanwhile, a subtle Provençal-style flower pattern on the walls imbues the room with just a hint of color.*

LEFT: *A dark, masculine Empire-style bed becomes airy and romantic with the right trappings in this French country room. By suspending gauzy white cotton from the ceiling, the bed is transformed into an alluring* lit en baldaquin *(canopy bed). The blue-and-white color scheme gives the room its lively spirit and makes the space seem as though it has been patterned after a set of Chinese-inspired faience from a French village.*

BELOW: *A picture is worth a thousand words, and the stunning* toile de Jouy *that envelops this bedroom radiates the message that this is a stately French room. The traditional fabric originated in Jouy in the mid-eighteenth century and is well known for its large pictorial repeats appearing in a single bold color. The grand aura that such a pattern usually imparts is toned down a bit here with a white linen coverlet and a white ladder-back chair.*

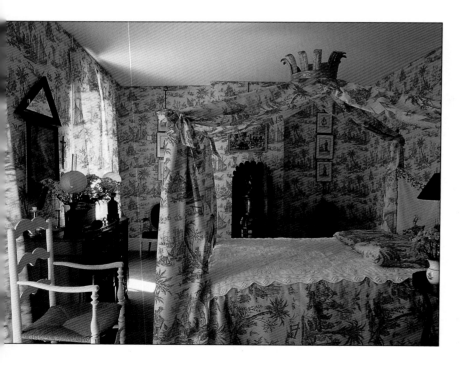

ABOVE: *An eclectic mix of elements adds up to definitive French country style in this attic bedroom. Its charm comes from a blend of fine period pieces of disparate pedigrees, including an Art Nouveau brass bed and an Empire chest, as well as the subtle contrasting color scheme of white and pale gray. The deep earthy hues of the furnishings, which include not only the bed and chest but also a stack of rattan storage cases and an old wooden chair, serve as the unifying element.*

OPPOSITE: *Lace textiles were de rigueur in fashionable European homes during the eighteenth and nineteenth centuries, and were made into curtains, coverlets, and tablecloths. They were particularly adored in the French countryside, almost as much as the hand-blocked floral fabrics of Provence. In this bedroom, a provincial lace coverlet gives the space its French country ambience, though the other furnishings—an Art Nouveau wrought-iron bed and basket and a painted rush-seat chair—are also authentic French country pieces.*

ABOVE: *Box beds, which were enclosed on three sides and shuttered or draped on their fourth edge, were popular in the French countryside for their privacy and capacity to keep out drafts. Outfitted with huge straw mattresses and large feather-filled duvets, they were beautifully carved and sometimes sported painted finishes like the one shown here. Today, they are more romantic than pragmatic, possessing the ability to infuse a contemporary room with a country tone.*

Since clay was abundant in some of the southern French provinces, many homes in those areas had tile floors. These surfaces offered the benefits of being cool in the summer, warm in the winter, and easy to clean year-round. Here, two Provence-inspired bedrooms have such floors, as well as small windows and mosquito netting to keep the heat and bugs at bay. The creative use of some other trappings typical of Provençal interiors, including a border inspired by the fabrics of the region (LEFT) and a traditional boutis (ABOVE), effortlessly imbues these rooms with the flavor of the French countryside.

LEFT: *Often, all it takes is one strong element to bestow a certain style upon a room. The bed in this simply furnished room could be from Sweden or Belgium, and the cream-colored linens with lace edging are ubiquitous throughout Europe. But the charming chair, with its regal gilt finish and an endearing fleur-de-lis emblazoned on its medallion back, is unmistakably Louis XV, thereby giving this otherwise generic country look a French flavor.*

LEFT: *Instead of the furnishings, it is the fabrics and decorative moldings that give this room its romantic country appeal. The exuberant French chintz is used as a duvet and repeated on part of the back wall to simulate a headboard. Cream accents in the molding and pure white linens soften the loftiness of the setting, making it far less formal.*

ABOVE: *Set in an alcove topped with an ornate cornice, a Louis XVI daybed is effectively separated from the rest of the room. Matching fauteuils that face the hearth make it clear that the space does double duty as a sitting room. The two areas are unified by two small Oriental rugs bearing similar hues and by the dramatic shade of red used on the daybed and the chairs' upholstery.*

BELOW: *With the help of a bed crown, a traditional* lit d'ange *has been recreated in this room. But instead of being draped in opulent tapestries, the bed is graced by a rustic chintz that gives the room its country flavor. Other modest textiles used in unusual ways include a gauzy cotton backdrop for the vanity and translucent window curtains caught with tiebacks and puddled to perfection on the floor.*

ABOVE: *The ambience projected by a simple window dressed in white and accented with a few well-chosen accessories can be sufficient for certain rooms when a spare, rather than overdone or crowded, look is desired. A humble French lace hankie may have served as raw material for these country curtains, but the overall effect of the tableau, which exudes charisma, is anything but plain.*

RIGHT: *This
nineteenth-century
wrought-iron daybed
could be of any
origin, but it takes
on a distinctly French
persona in these
surroundings thanks
to creamy lace-
trimmed linens and
the magnificent
French windows that
lie beyond. Draping
these windows with
layers of simple
billowing cotton
instead of something
more ornate also
contributes to the
effect and keeps the
tone of the space
on track.*

ABOVE: *Outfitted with aged, but not vintage, fixtures, this predominantly white bathroom, or salle de bain, is bathed in country appeal thanks to a winsome bucolic mural. Even such refined French antiques as a crystal chandelier, a Louis XVI–style stool, gilt-framed prints, and fancy sconces cannot deprive the space of its rustic grandeur.*

LEFT: *Here, decorative devices derived from French country styling spruce up what otherwise would be considered a fairly plain washroom. A Provençal-inspired floral cotton was used for the balloon shades, the skirt of an old porcelain sink, the liner of the clothing hamper, and the trim of the fauteuil. Note the crisp white lattice work, which masks a thoroughly routine tub, making the cleansing experience in this space somewhat akin to bathing outdoors.*

BELOW: *The vernacular of this Normandy cottage, with its timber detailing and chalky walls, shows up even in the washroom, which was probably a bed chamber when the home was originally built. Because of the strong architectural elements of the room, the furnishings become less important. At the same time, though, certain pieces stand out, including a primitive milking stool, a wicker armchair softened with a large cushion, and a dressy Oriental carpet, all of which assume a country demeanor thanks to the surroundings.*

INDEX

Alsace, 10, 11, 12, 26
Armoire, 46, 53, 57, 61, 80
Art Nouveau, 86, 87

Baker's rack, 68
Banquette, 67
Baskets, 66, 67
Bathrooms, 94–95
Bedrooms, 82–93
Beds, 83
 Art Nouveau, 86, 87
 box, 83, 88
 canopy, 83, 85
 daybed, 91, 93
 lit d'ange, 83, 92
 lit en bateau, 84
Bergère, 45
Bougainvillea, 22–23
Breton blue, 24, 25, 73
Brittany, 9, 12, 15, 24, 25,
 33, 40, 41, 70
Buffets, 12, 62–63, 66, 67,
 70

Ceilings
 beamed, 37, 38, 71, 76
 open timbered, 72
Chairs
 caned, 59
 Deco, 42
 ladder-back, 41, 46, 57,
 69, 79, 80, 86
 Louis XV, 81, 82, 83, 90
 Louis XVI, 77
 mismatched, 62–63
 painted, 72, 73, 79, 86, 87
 slat, 61
Château, 31, 34, 35
China, 30, 51, 66, 67, 70,
 75
Chinoiserie, 43
Colors
 blue and white, 68, 73,
 74, 77
 Breton blue, 24, 25, 73
 Mediterranean, 16–17, 30
 yellow, 37, 45, 49
Copper pots, 56, 57, 58, 60,
 65, 76, 78, 79
Cupboards, 57, 69
Curtains
 cotton, 39, 48, 92, 93
 lace, 9, 10, 16, 17, 18,
 19, 74, 75, 92

Doors
 louvered, 11, 17
 Mediterranean, 16–17
 plank, 32
Dressoir, 12, 67

Empire style, 36, 37, 85
Espaliers, 27

Fabric. *See also* Curtains.
 Aubusson-inspired,
 52–53, 83, 84
 checkered, 38
 chintz, 91, 92
 damask, 45
 lace, 84, 86, 87, 90, 93
 Provençal, 39, 45, 48, 53,
 74, 75, 89, 95
 toile de Jouy, 86
 walls, 68
Faience, 30, 66, 67
Fireplaces and hearths, 10,
 57
 with cloth frill, 69
 faux mantel, 39
 imperfections on, 50,
 54–55
 marble mantel, 42
 stone, 37, 38, 40, 41, 43
Floors, 10
 diamond pattern, 40, 41,
 58
 stone, 54, 60, 62, 72, 76
 tile, 81, 89
Flowers, dried, 59, 71, 72,
 81

Gargoyles, 19
Gates, wrought-iron, 34
Gothic style, 19, 38, 53
Grapevines, 29

Half-timbered houses, 14,
 15, 26, 34
Herbs, dried, 71
Houses
 château, 31, 34, 35
 cottage, 16, 17, 26, 30
 half-timbered, 14, 15, 26,
 34
 high (*maisons
 en hauteur*), 29
 limestone, 12, 16–17, 31,
 32
 manor, 33
 master's (*maison de
 maitre*), 22–23
 painted, 17, 30
 stone, 20–25, 26, 33

Kitchens, 9, 56–81

Lace
 bed linens, 84, 86, 87,
 90, 93
 curtains, 9, 10, 16, 17,
 18, 19, 92
Limoge, 51, 70
Living rooms, 36–55

Mirrors, gilt, 42, 44

Normandy, 9–10, 12, 14,
 15, 34, 67, 95

Pillows, 39, 52–53
Plants
 espaliers, 27
 grapevines, 29
 potted, 10, 11, 19
 topiary, 44, 80
 trellised, 19
Pot rack, 56, 58, 65, 68, 74
Pottery, 42, 43, 78
Provençal fabrics, 39, 45,
 48, 53, 74, 75, 89, 95
Provence, 10, 13, 30

Roofs
 slate, 15
 terra-cotta, 13
 thatched, 12, 15

Secretary, 51
Settee, 39
Shelving, open, 64
Shutters
 painted, 16, 17, 24, 25,
 30
 plank, 32
 slat, 31
Sofas
 damask, 45
 Louis XV, 52–53
Stencil, 38
Stoves, 60, 65, 76

Tables
 farmhouse-style, 57, 58,
 61, 79
 plank, 79
 tiled, 73
 trestle, 76
Table settings, 28, 62–63
Table top tableaux, 49
Tiles, ceramic, 59, 65, 73,
 74, 78, 79
Topiary, 44, 80

Vaisselier, 70

Walls
 brick, 71
 colors of, 37, 45, 46–47,
 77, 81
 frescoed, 81
 imperfections on, 50
 patterned, 44
 plaster, 43
 stenciled, 38
Window boxes, 10, 22–23,
 32, 48
Windows
 dormer, 22–23, 26, 77
 French, 31
 Mediterranean, 16–17
 Norman, 34
Wine rack, 65